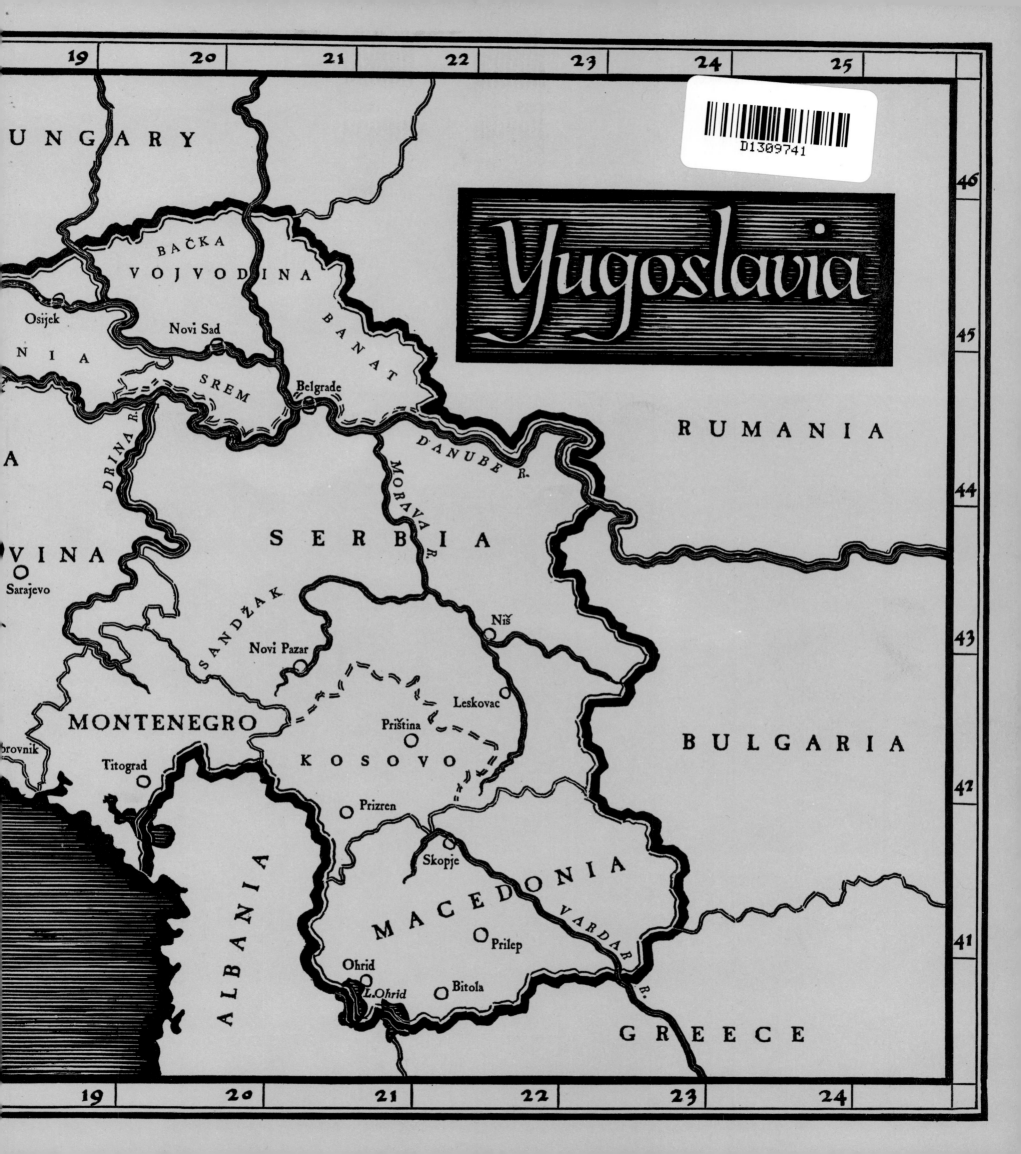

# Yugoslavia

HUNGARY

RUMANIA

BULGARIA

GREECE

ALBANIA

MONTENEGRO

SERBIA

MACEDONIA

KOSOVO

VOJVODINA

BAČKA

SREM

BANAT

SANDŽAK

VINA

NIA

A

Osijek

Novi Sad

Belgrade

Sarajevo

Novi Pazar

Niš

Leskovac

Priština

Prizren

Titograd

brovnik

Skopje

Prilep

Ohrid

L.Ohrid

Bitola

DRINA R.

MORAVA R.

DANUBE R.

VARDAR R.

19    20    21    22    23    24    25

46

45

44

43

42

41

19    20    21    22    23    24

# Art Treasures of Yugoslavia

# Art Treasures of

*Texts by:* Milutin Garašanin · Dragoslav Srejović · Marcel
Antonije Nikolovski · Mirjana Šakota · Jovanka
Kruno Prijatelj · France Stelè · Dejan

*Edited by:* Oto Bihalji-Merin

# YUGOSLAVIA

Gorenc · Vojislav Jovanović · Zdenko Vinski · Dušan Tasić
Maksimović · Emilijan Cevc · Alojz Benac · Husref Redžić
Medaković · Marjan Mušič · Miodrag B. Protić

Harry N. Abrams, Inc., Publishers, New York

ILLUSTRATIONS ON THE JACKET

*Front, left:* Neolithic figurine from Vinča, fired clay, height 6 $^1/_2''$, National Museum, Belgrade

*Front, right:* A young apostle, from a fresco in the church in Sopoćani, c. 1265

*Back, left:* Icon of the Archangel Gabriel, 12th century, height 44″, Icon gallery, Church of St. Clement, Ohrid

*Back, right:* Figure of Adam by Master Radovan, west portal of Trogir Cathedral, 1240

LIBRARY OF CONGRESS CATALOGING IN PUBLICATION DATA

Bihalji-Merin, Oto, 1904–
  Art Treasures of Yugoslavia.

  Bibliography: p. 425
  1. Art—Yugoslavia—Addresses, essays, lectures.
2. Art, Yugoslav—Addresses, essays, lectures.
I. Title.
N7241. B47        709′.497        72-5237
ISBN 0-8109-0548-5

*Library of Congress Catalogue Card Number: 72-5237*
*Copyright 1969 in Yugoslavia by Jugoslavija, Belgrade*
*Harry N. Abrams, Incorporated, New York*
*Printed and bound in Yugoslavia*

# CONTENTS

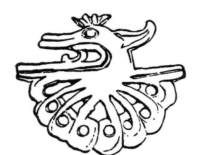

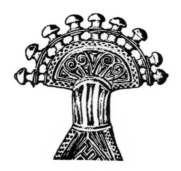

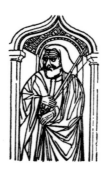

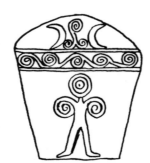

# I HORIZONS, LIMITS, AND BOUNDARIES

Oto Bihalji-Merin
*Art Critic and Historian, Belgrade*

In an unending progression of artistic representations, from prehistoric paintings to the optical manipulations of the twentieth century, traces of the path mankind has traversed have been preserved. Wherever we stop to excavate these traces, whatever knowledge we acquire, we still achieve only a relative approximation of the original. Each fragmentary experience opens up new worlds of the unknown. Events not only lie concealed in the past but are hidden from us in the future, and man, in interpreting his distant origins with the perseverance peculiar to him, is at the same time concerned with that which is still in the process of emerging.

Prehistoric highways intersect the entire area of present-day Yugoslavia. They lead from Asia Minor through the Pannonian plain to Central Europe, from the Bay of Trieste through the Ljubljana gateway to the Balkan Peninsula, along the Danube, Morava, and Vardar rivers to the Aegean Sea and its islands. By these highways powerful empires pursued the course of their commercial and political expansion. From the Greeks to the Byzantines, from the Great Migrations to the Turkish Wars, from the Venetian and Austro-Hungarian incursions to the wars waged by German and Italian aggressors in the recent past - time and again we encounter the magnetic line of destiny represented by those paths along which events have unfolded.

Whatever has happened in the course of history, events — whether brought to fruition or lost forever in the depths of time — are reflected in works of art: fraught with presentiment of the future, they bear testimony to the past. In the unity underlying their apparent contradictions we can divine the meaning and essence of art as the vehicle of self-enlightenment and of self-development — for mankind and for individual peoples.

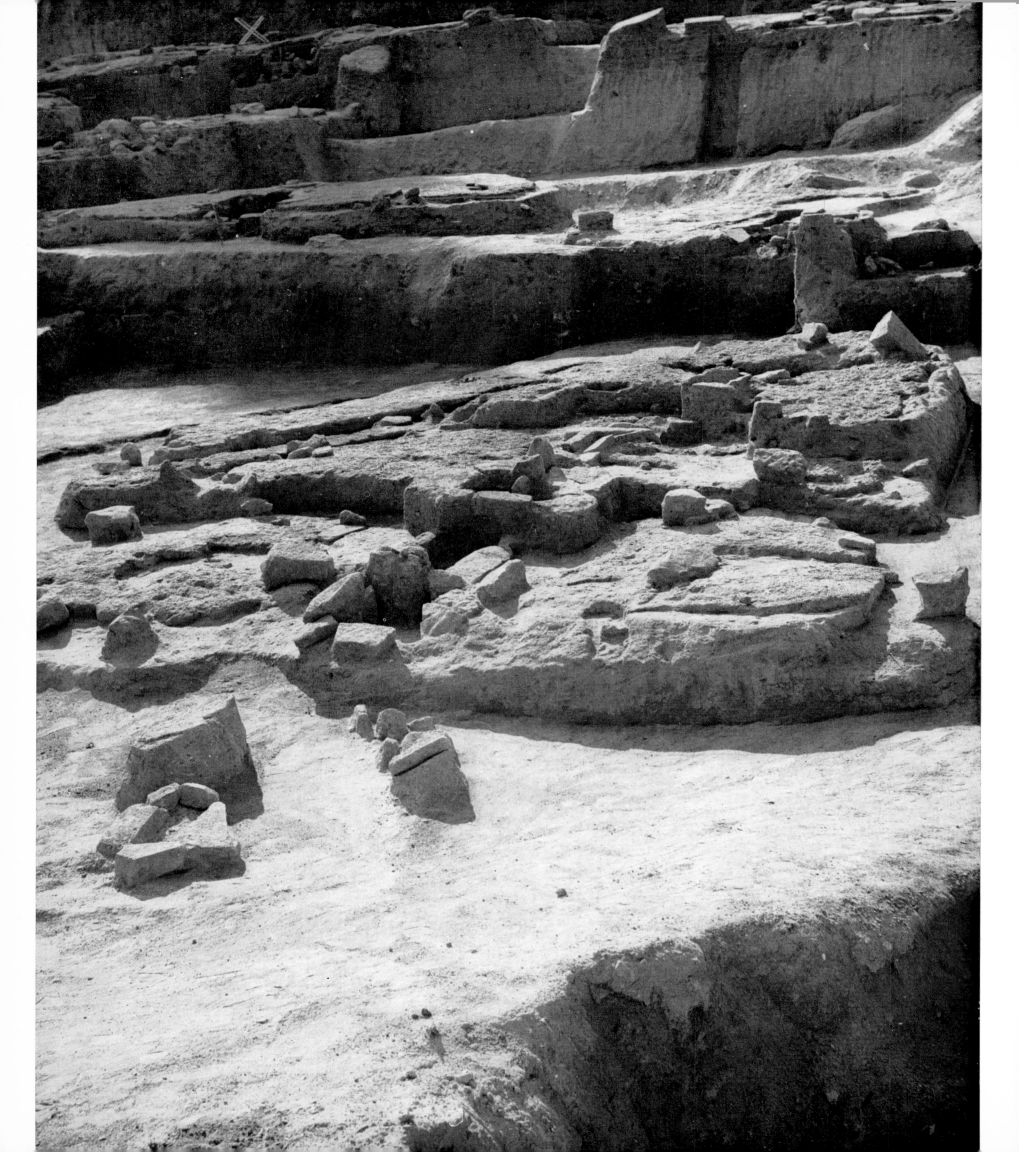

Integrally conceived, the present series of essays attempts, probably for the first time, to provide a condensed chronological and geographical survey of art in what is today Yugoslavia. In many places, to be sure, prehistoric and Classical sites still await excavation and precise dating.

While this text was in preparation, word arrived of archaeological discoveries in Lepenski Vir near Donji Milanovac on the Danube, a large settlement dating from about 6000 B.C. The results of these excavations are changing concepts about the course of early history in this sphere of culture. (See Chapter II.)

The history of art is not a clear-cut course from the past to the future; its path has been punctuated by interruptions and leaps, barren periods and radical upsets. The art of the situla has not yet yielded up its secrets. The significance of the medieval carvings in the necropolises of Bosnia and Herzegovina has been interpreted in diverse ways. Nonaesthetic considerations are still operative here and there in the appraisal of Byzantine-Slav art in the Balkans. Multifaceted, often apparently contradictory, the knowledge we acquire, sketching a history of art in space and time, is ever in movement; like time itself it never becomes a final possession and must always be acquired afresh.

The beginnings of art, no matter how obscured by the mists of time they may seem to us today, were the efflorescence of a mankind already mature. For millions of years this planet had spun upon its axis before plants and animals emerged, about a billion years ago. Less than a million years ago the earliest anthropoids made their appearance. The world of stone has a history of its own. If a time machine could telescope the geological movement of millions of years, valleys would be seen to split asunder only to close again, mountains to slide across the earth, hills to sink into the continental mass, islands to emerge from the bottom of the sea. Thus it was that the unstable Mediterranean region emerged from the troubled waves in the Tertiary Period, creating the Dinaric region and the Carpatho-Balkan arc. The Adriatic Sea, seen with the eyes of a geologist, appears as the remnant of an ocean once extending from the Iberian Peninsula to the Himalayas. Isolated mountain massifs, remains of an old continent, resulted from eruptions and dislocations: Paleozoic and Mesozoic strata rose where the sea once lay.

In the later Tertiary Period, tectonic movements shattered the old crystal mass between the Dinaric region and the Carpatho-Balkan arc. Its parts settled and were transformed into valleys and lakes; thus came into being the lakes of Ohrid, Prespa, and Dojran. The corrugations of the ancient ocean bed are now

15

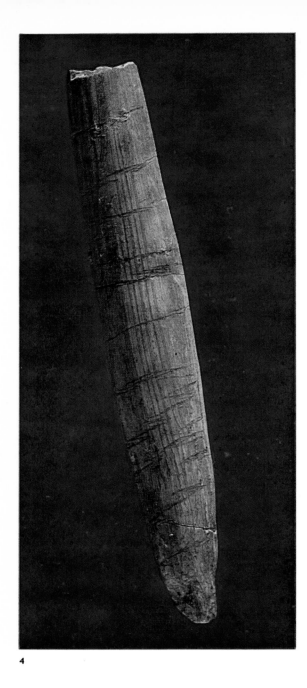

4

4 Artifact, from Potočka Zijalka on Olševa (Karawanken). Paleolithic (c. 30,000 B.C.). Length 2 3/8", width 3/8", thickness 1/4". Regional Museum, Celje

plateaus and terraces. Miocene remains can still be found on high mountain peaks like Triglav. Fossils of diluvial man taken from the cave at Hušnjak's Hill, near Krapina, are preserved in the Museum of Geology and Palaeontology in Zagreb. They include some three hundred artifacts of stone and a few of bone, the remains of hearths, and the bones of animals that roamed the area in the days of Krapina man: mammoths, cave bears, extinct species of rhinoceros. Contemporaries of the inhabitants of the Krapina cave were the men of Spy, Brno, Naulette, and Neanderthal.

Human prehistory began long before there was any artistic activity in the area now comprising Yugoslavia. (It must be borne in mind that the very concept "prehistoric art" runs counter to the idea of its being fitted into the framework of national and political boundaries.) The few artifacts of bone, decorated with primitive drawings, excavated in archaeological sites in the Karawanken range of the Alps, in Slovenia, belong to the Aurignacian phase of the Upper Paleolithic. The early Neolithic culture of Lepenski Vir, still largely uninvestigated, is characterized by a style of art that hovers between realism and abstraction: lifesize human heads and animal heads with linear ornament, probably the work of hunters and fishermen.

The first known change of style in art came about during the transition from the Old Stone Age, or Paleolithic, to the New Stone Age, or Neolithic. Primitive naturalism, the product of observation and experience, gave way to geometric stylization arrived at through meditation and acquired knowledge. Neolithic man began to abandon the nomadic life of instinct natural to the hunter and food-gatherer, to modify the rhythm of his life in accordance with seasonal changes, as he turned to domesticating plants and animals, tilling the soil, and keeping livestock. The process of increasing independence of nature is reflected in the condensations and pictographic signs of an art tending toward the abstract.

Forms representing no object or being, or rendering the object or being in altered guise, have existed in art since the earliest times. Geometric art can evolve as a stylization of the visual impression of the real world or merely as the expression of a mental process. Step by step the artist departs from the naturalistic representation of models: the form he creates no longer reproduces the subject but expresses its essence.

The dotted bands and geometric incrustations on vessels from Vinča, which date from the middle of the fifth millennium, exhibit a close relation to the cultures of the Aegean and of Asia Minor in the Neolithic period. The double disk on the terrine from Vučedol, near Vukovar (first half of the third millennium), with its concentric circles toothed to suggest the rays of a star, and the spiral relief decoration on the bowl from Nebo in the Bila Valley, near Travnik (middle of the third millennium), indicate that the spiral and the circle were the central motifs in the ornamentation of the late Neolithic and the Bronze Age.

The symbolic signs of the circle and spiral were engendered by man's observation of the movement of sun, moon, and stars, of the succession of day and

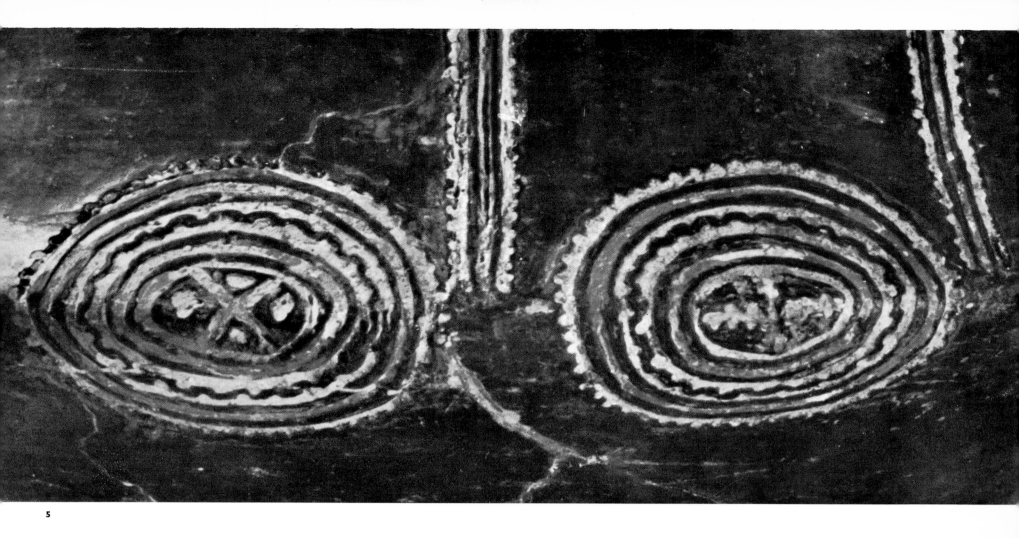

5

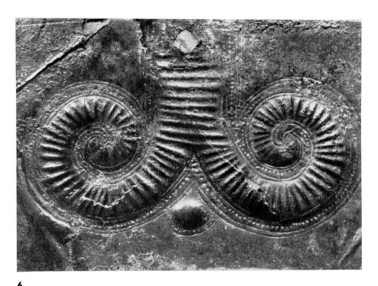

6

night, of the cycle of birth and death. Although the original meaning of symbols cannot always be fathomed, ornament unquestionably signified much more than mere decoration.

The materials available also had a decisive influence on form, the technique of the potter inspiring circuity — the geometric line of the circle and the spiral, and the plastic rotundity of the sphere. But the fact that creative volition was so persistent in utilizing these artistic elements points to their deeper meaning: roundness was the symbol of fertility and birth. In the visual art of India and the Far East, the circle (Sanskrit *mandala*) is the usual pattern of the religious images that serve as instruments of meditation designed to establish the link between man and the universe. The spiral was the symbol of life's course through the labyrinth of fate, the end meaning death and, in religious terms, redemption.

The artist of primeval times has points of contact with the artist of our day. Basic forms that had, in the course of the evolution of civilization, been reduced to the function of decoration, and relegated to a subordinate place, have in the twentieth century been emancipated from that function and have begun to figure independently in kinetic and optical art.

The transition from naturalistic images to symbolic abstractions that took place gradually between the Old and the New Stone Age can be seen in the anthropomorphous figurines from Predionica, near Priština, and Vinča, although these have not yet reached the full geometric abstraction of the violin-shaped Great Mother idols from Paros and Amorgos.

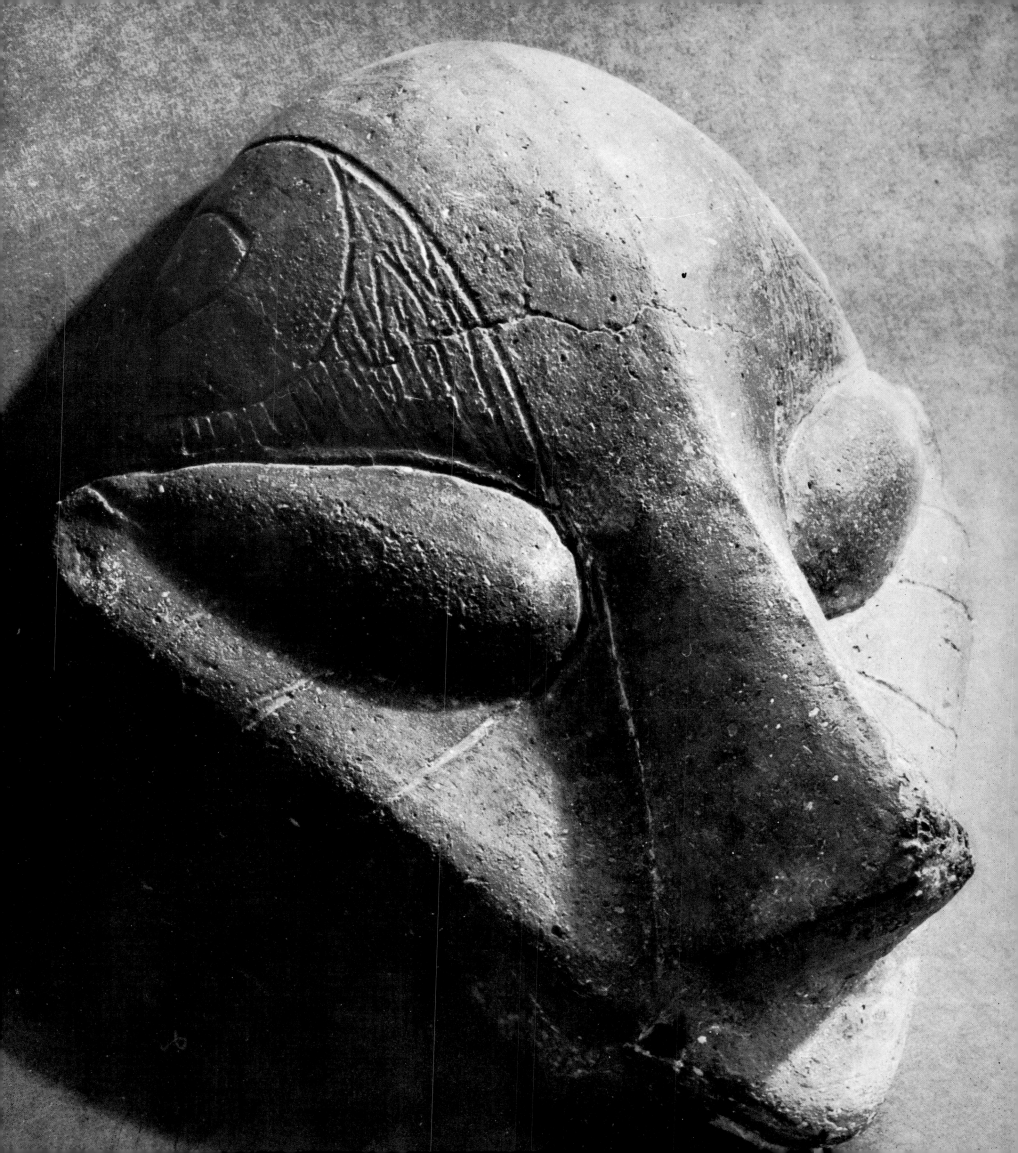

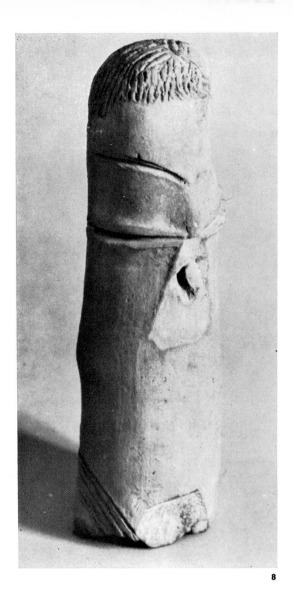 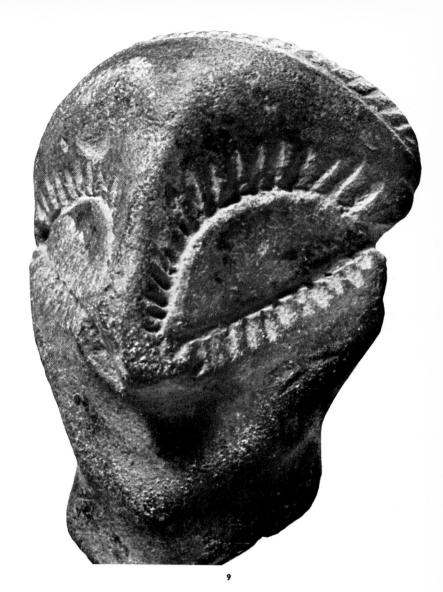

8 9

Physical fecundity, the elementally parturient, is represented in simplified, schematized form in the Neolithic figures of female idols. The figurines from Vinča present the suprapersonal, elementary attributes of fertility. There is only a suggestion of the face, sometimes eyeless and mouthless, gleaming as if in the dim light of awakening thought. An ancient goddess from the Butmir site, near Sarajevo, in a closely pleated skirt, sits upright on her throne. In her stylized simplification and veiled corporeality she stresses the link with the earth. Her sedentary pose signifies settled habitation. Seated female figurines have also been brought to light among the Vinča finds. The severely stylized, mysterious figure from Predionica, with designs scratched on its face and body, must be approached in terms of its magic function: the maker's purpose was to propitiate leading incomprehensible natural forces, not to produce a work of art. A seated female torso found in Gradac, near Leskovac, belongs, despite its miniature size, to the group of representations of the Great Mother. Seated on her capacious lap as on a throne is the child she suckles. This is the primeval image of the mother, the beginning of the line of development that leads from Isis, with Horus at her breast, to the Christian Mother of God.

Although the heads of the idols of Neolithic sculpture were never meant, so far as we know, to be identified with specific persons, or to present a portrait-like resemblance, some of the heads are artistically significant by reason of their symbolic power. The mouthless face of an anthropomorphous figure from Valač, near Kosovska Mitrovica, with its triangular geometric mask of a face, lashes etched on the nonsculptural, barely indicated line of the eyelid,

19

has the imperturbability and endurance of mute timelessness. A mask from Vinča, with overlarge, slanting eyes and a magic monumentality compressed into its small form — very similar to the heads from Vinča whose faces bear a radiating design of latticed eyelashes — emanates a mysteriously poetic quality of hermetic detachment.

Changes occasioned by technological advances began to be felt about the middle of the third millennium. The adoption, or the discovery, of the technique of bronze working made it possible to fashion new tools, initially in forms inherited from the Neolithic tradition, and then gradually in more developed forms based on firsthand experience.

The Illyrians and Thracians, the Dacians and Macedonians, formed a stratum that was superimposed on the stratum of indigenous inhabitants known to the Greeks as Pelasgians. When the Bronze Age culture which had extended

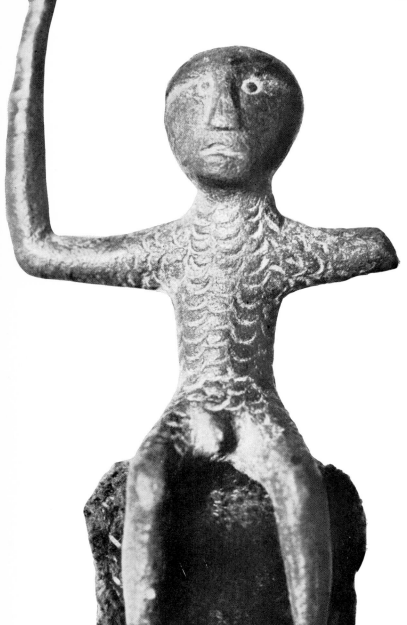

10 *Rider, from Kladovo. Late Iron Age (4th–1st century* B.C.*). Bronze, maximum height 3 1/8". National Museum, Belgrade*

11 *Funerary mask, from Trebenište, near Bitola. 6th century* B.C. *Gold, height 6 1/4", width 8". National Museum, Belgrade*

12 *Funerary mask, from the royal tombs of Mycenae. 1580-1550* B.C. *Gold, height 8". Archaeological Museum, Athens*

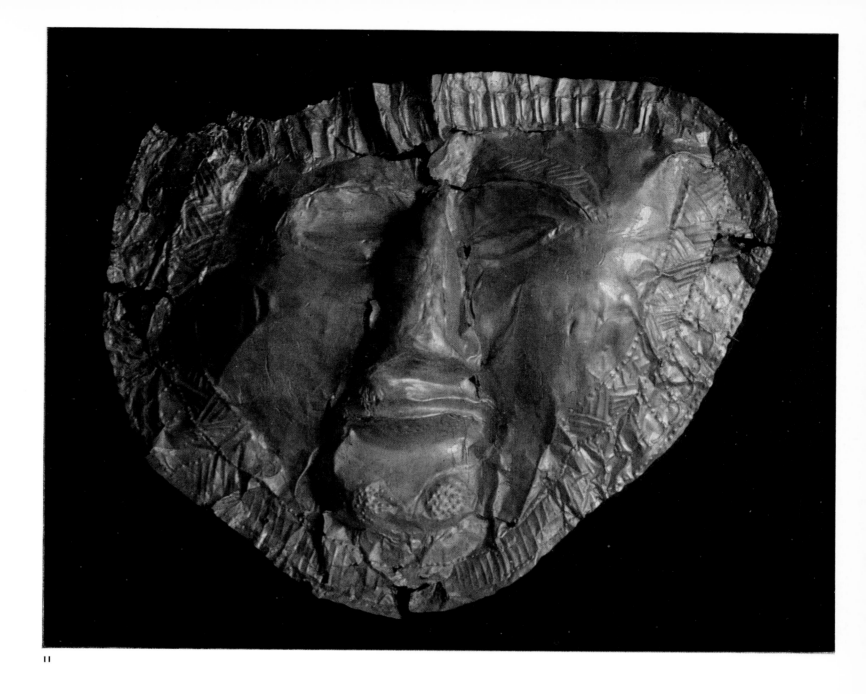

11

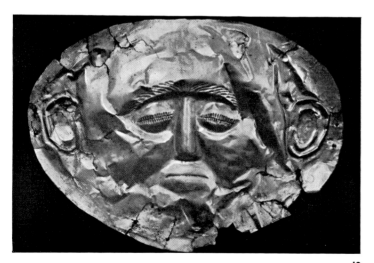

12

throughout the Balkan area ebbed, it left behind important testimony to its existence. The gold death masks and ornaments from nobles' graves in Trebenište and Novi Pazar were perhaps imported from early Greek urban centers. They bear witness to close ties with Mycenae and the Greeks. We have become accustomed to attributing such a relation solely to the radiating power of Greek culture; many signs, however, attest a combination of influences, even including the effect of the Balkan style on the Aegean world, where the influence of products from Asia Minor, Mesopotamia, Egypt, and Syria was already discernible. It was only in the mature archaic period that Greek art achieved the independence of form so highly esteemed as the foundation of European culture. As such, Greek influence spread abroad, penetrating the Balkan area and establishing economic and spiritual colonies.

The finds from Magdalenska Gora, Stična, and Vače belong to the culture distinguished by urn burial and known as the Urnfield culture, which has ties with the Hallstatt period; they bear similar decorative motifs yet show a variety stemming from the creative power of the individual artists represented by the art of the situla.

In the territories now comprised in Italy, Austria, and Yugoslavia, the masterpieces of the Bronze Age that were produced by the common culture of the

21

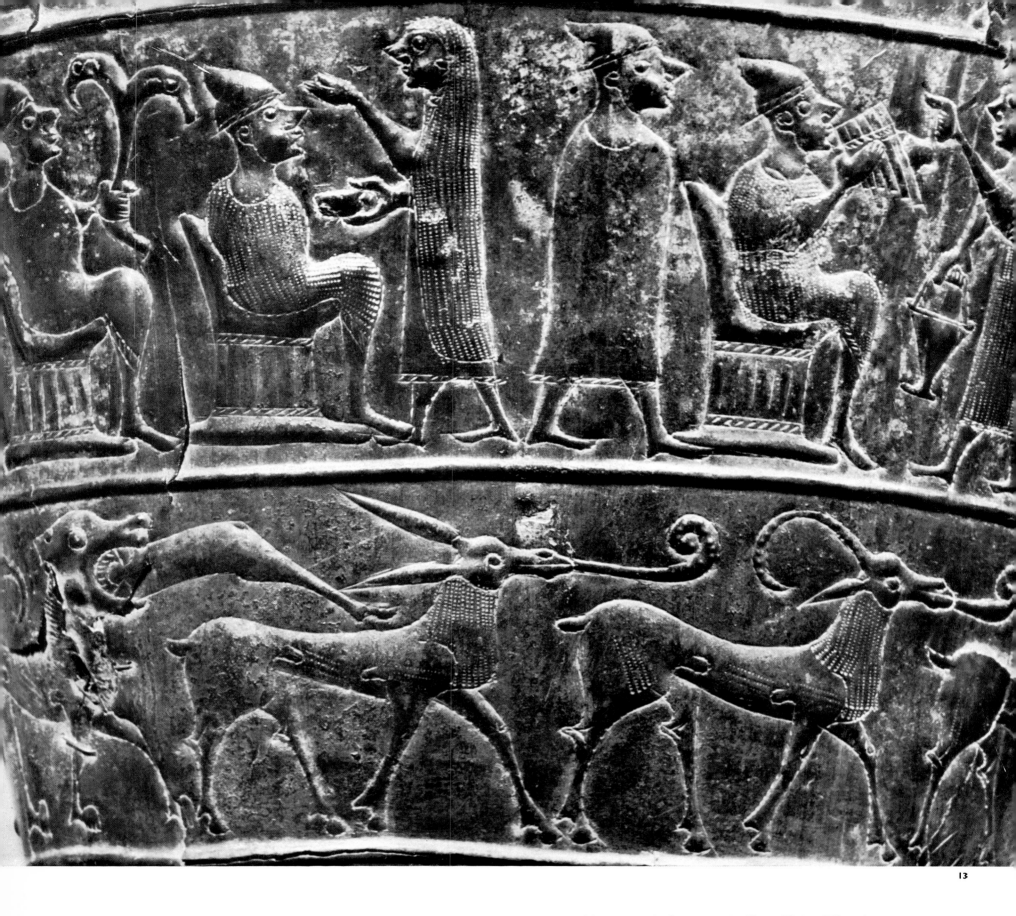

situla carry the names of Benvenuti, Certosa, Kuffarn, Vače. They bear to contemporaneous Greek sculptures the same relation that the primitive paintings of the Douanier Rousseau bear to the symbolic idealism of the works of Gustave Moreau, whom he so greatly admired. It is not virtuosity or harmony that impresses us here but rather a naive immediacy: horsemen with great pointed noses, round, bulging eyes, and flat caps (recalling Mesopotamian warriors), holding in powerful hands the reins of steeds with narrow, elongated bodies. Neither the stylized charioteers of Assyria nor the elegant horse-drawn chariots of Aegean

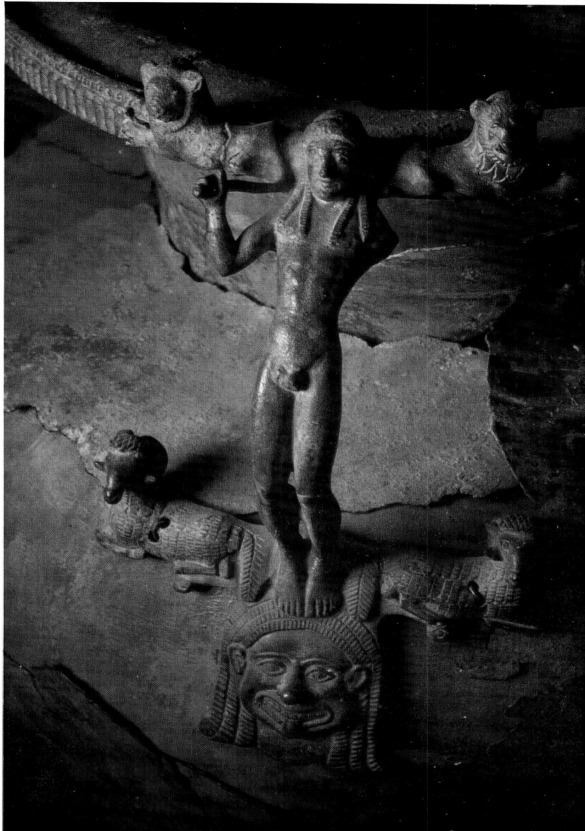

13 *Situla, from Vače, detail. Early Iron Age (c. 500 B.C.). Bronze, height 9 3/8". National Museum, Ljubljana*

14 *The Certosa Situla, detail. Early 5th century B.C. Bronze, full height 12 5/8". Museo Civico Archeologico, Bologna*

15 *Hydria handle in the form of a* kouros *(the youth holds the tails of the two lions lying at the edge of the spout and stands on the head of a gorgon, on an axis terminating in reclining rams), from Petrova Crkva, near Novi Pazar. Archaic Greek (end of 6th century B.C.). Bronze, height 4". National Museum, Belgrade*

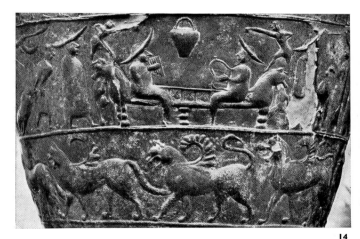

14

15

artists are as imaginatively picturesque as are those on the embossed reliefs of the bronze situla from Vače. The rhythmic processional scene unfolds like a moving picture, telling the story of rituals, knightly tournaments, and feasts, evoking mental connections and formal associations with the gold rings from Mycenae, the geometric figures and compositions on the monumental amphorae of archaic Hellas, distant echoes of the rhyton of Hagia Triada, of the stylization of Etruscan wall painting, perhaps even of the exuberant imagination of Syrian artists. Instead of hazarding any conclusions regarding the influences

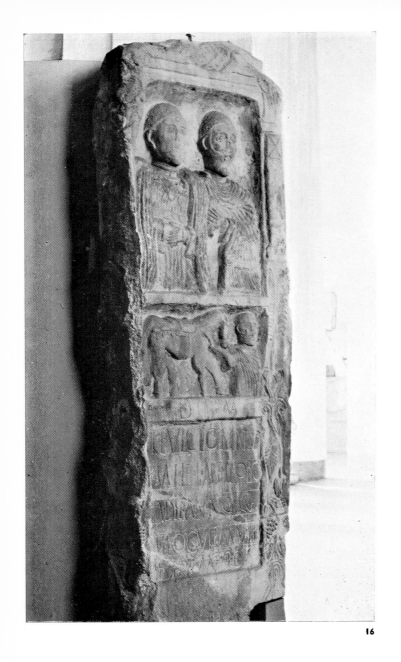

brought to bear on the art of the situla and the repercussions of these masterly artistic creations, suffice it to say that they have, in their poetry and intensity of expression, transcended transience.

Woven into the fabric of the curtain through which we dimly view the prehistoric period are the varied threads of Celtic and Illyrian-Iapydian art. Our knowledge of these peoples would indeed be minimal were it not for the testimony of their works of art. The belated archaic Classicism that emerged among the Illyrian tribe of the Iapydians proved to be, despite centuries of contact with Helleno-Roman culture, an original rustic expression of primitive power. The elemental symbolism of frontally posed women dancing their reels with the irresistible rhythm of ritual solemnity impresses us above and beyond any considerations of style. The total rejection of the sculptural possibilities — the space-defining functions — of stone and its utilization merely as a drawing board give the incised scenes the significance and ingenuity of a child's sketch.

16

17

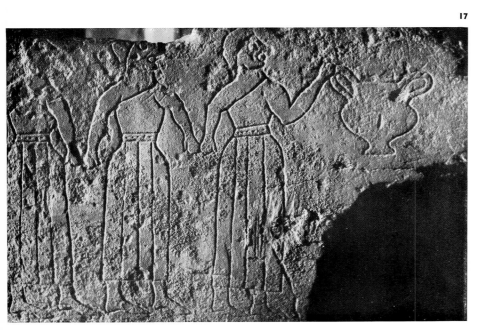

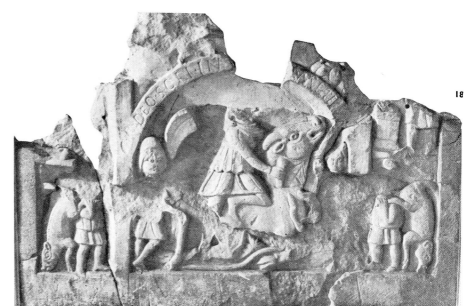

18

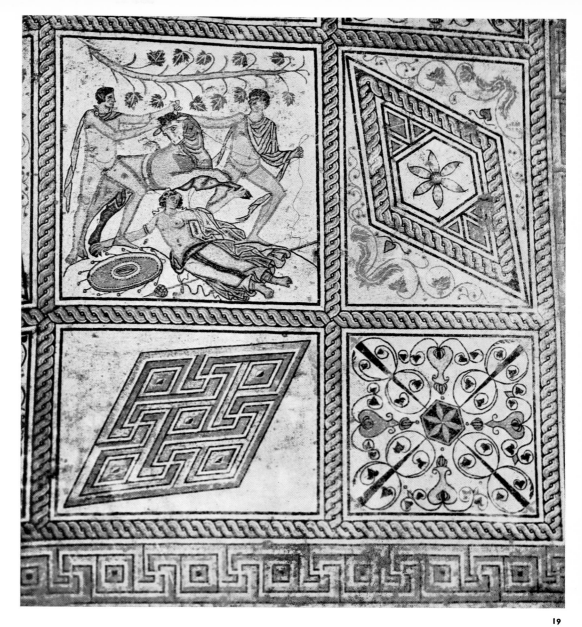

19

16 *Memorial tombstone, from Zenica (anc. Bistua Nova). Erected by Lucinius Victorinus of the Roman Second Legion to his parents (shown in relief with their servant and their horse). 4th century* A.D. *73 1/2 × 26". National Museum, Sarajevo*

17 *Women performing rite, detail of relief on Iapydian urn from Ribići, near Bihać. Beginning of 1st millennium* A.D. *Marble, dimensions of urn 20 5/8 × 45 1/4 × 9 3/4". National Museum, Sarajevo*

18 *Mithraic relief, from Konjic. First half of 4th century* A.D. *Limestone, 20 1/2 × 32 1/4". National Museum, Sarajevo*

19 *Detail of mosaic with the Punishment of Dirce (upper left-hand field). Early 4th century* A.D. *Archaeological Museum of Istria, Pula*

20 *Thracian horseman, relief from Buljesovac, southeastern Serbia. 2nd-3rd century* A.D. *Marble, 9 1/4 × 8 5/8". National Museum, Belgrade*

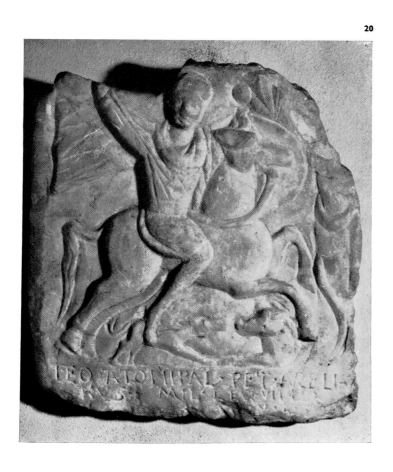

20

The attraction of the ancient Macedonian Empire into the magnetic field of Greek culture determined the development of the southern part of present-day Yugoslavia. The Hellenization of the Macedonia of antiquity was launched in the sixth century B.C. This was the period when Heraclea Lyncestis (mod. Bitola) was founded, perhaps by Philip II of Macedonia, who had reached as far as Stobi, in 354 B.C. His descendants took possession of the region up to Titov Veles (anc. Bylazora). This was also the period when traders from Orchomenus plied the Dalmatian coastal waters, and when envoys of Dionysius of Syracuse set up their strongholds. To this time may be traced the establishment of Lissus (mod. Lesh), Pharos (mod. Hvar), Issa (mod. Vis), and the construction of Trauguryon (mod. Trogir), Epetion (mod. Stobreč), and Epidaurus (mod. Cavtat) by Greek colonists. It was the period when Illyrian tribes, defending the Dalmatian coast from Greece, Macedonia, and the growing menace of Rome, were finally conquered by the she-wolf of the Capitol and the legions of Augustus.

From the third century B.C. onward, Rome was engaged in taking over the positions upon which Greek colonial power had rested. As they waged their wars of conquest, the Roman legions became the bearers of Hellenistic culture. In museums in Split, Zagreb, Ljubljana, Sarajevo, and Belgrade, storehouses of departed times, stone fragments preserve portraits of the deposed and forgotten rulers of earth and heaven — ancient tidemarks of the ebb and flow of great states. Already alongside the Eastern divinities — Cybele, the Great Mother,

and Mithras, the distant light-giver — stands Christ. The propagandist power of the mysterious gods of the East was strong, but their aesthetic aspect seems barbarous in comparison with the universal consciousness of Greek philosophy and Roman technology. In the second century A.D., before the Roman legions had erected their temples to the god Mithras in Ptuj, Cavtat, Konjic, Jajce, and at other sites, the Greek poet and philosopher Lucian mocked the primitiveness of the Eastern divinity: "What does that Mithras want, that Mede in his caftan and tiara? That Mithras who can barely utter a few words of Greek and does not even understand when his health is drunk...."

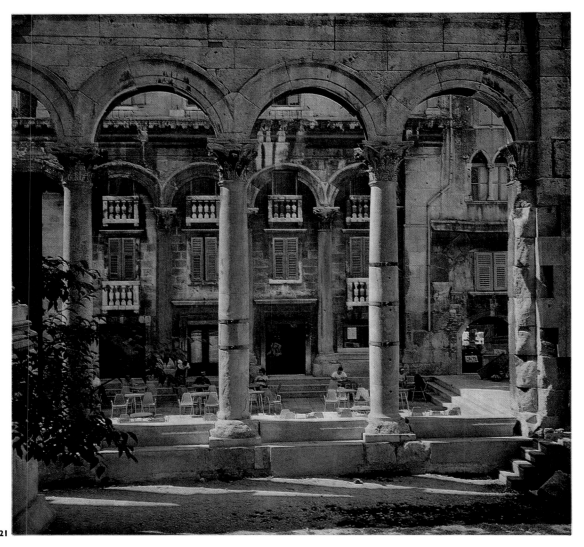

21

26

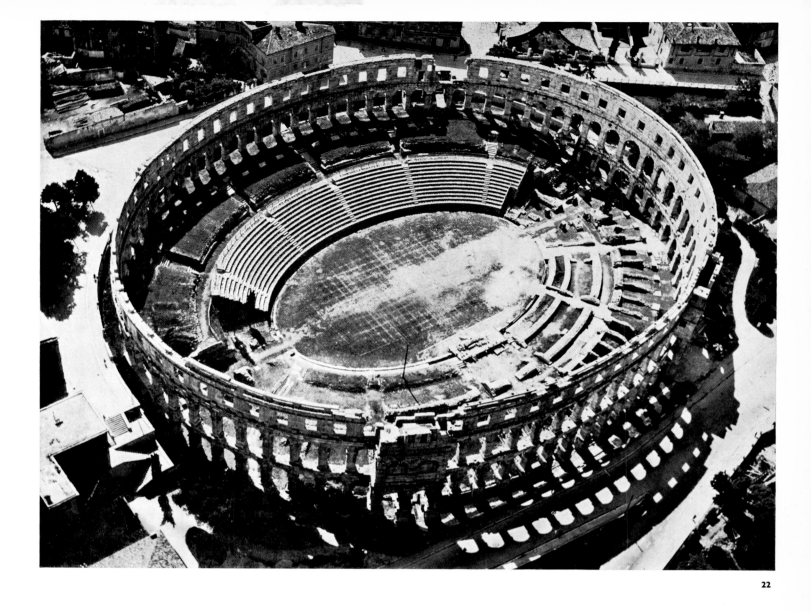

21 *Arcade of peristyle in Diocletian's Palace (completed 305 B.C.) in Split, where the Roman emperor spent the years after his abdication*

22 *Roman amphitheater, Pula. 2nd century A.D. Limestone; exterior 435 × 345', height 106'*

On the Istrian seaboard an ancient architect of the Augustan period described a stone circle — the richly arcaded amphitheater of Pula. Broad-spanning arches, Roman aqueducts, elaborately ornamented sarcophagi, and slender pillars were the legacy of Rome to Salona (mod. Solin). Even more impressive are the walls of Diocletian's Palace in Split. Late antiquity was a time of catacombs and Christian martyrs, a time when Rome and the world were ruled by an Illyrian, the emperor Diocletian. In keeping with his declared intention of ruling only twenty years, the emperor renounced supreme power, to live as a private citizen in the palace he had commissioned in his native Illyricum. As vast as the palaces of the Persian kings in ancient Pasargadae, and foreshadowing the Escorial of Philip II of Spain in its severe isolation and grandeur, Diocletian's Palace was destined through the centuries to become the framework of a town that continued to grow at an accelerating pace. Refugees from Salona, razed by the Avars in 639, settled inside its walls.

The fortresses of the Roman Empire were charged and captured by Sarmatians, Goths, and Avars in turn, pouring out of an unknown, legendary region. In the sixth and seventh centuries the Slavs set up their early states along the Adriatic coast south of the Neretva and in the valleys of the Drina, Piva, and Sava rivers. These tribes of shepherds had covered many hundreds of miles, from the Dinaric Alps to the foothills of the Pindus range, crossing and recrossing the Balkan Peninsula in their search for summer and winter

27

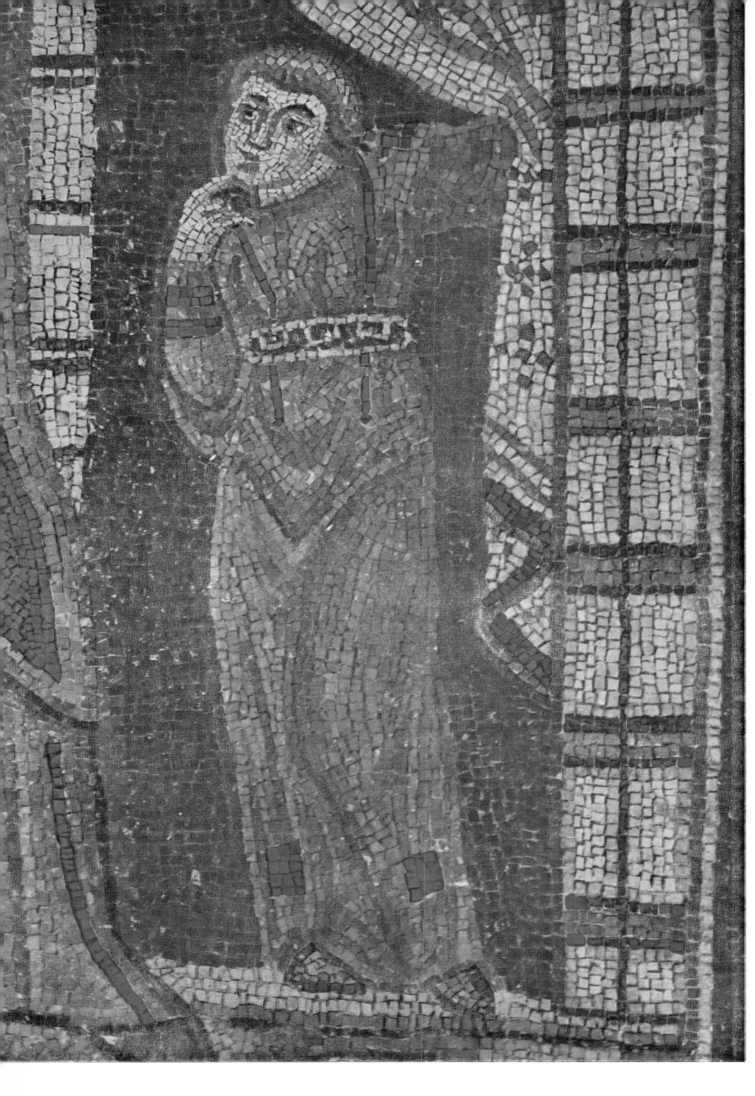

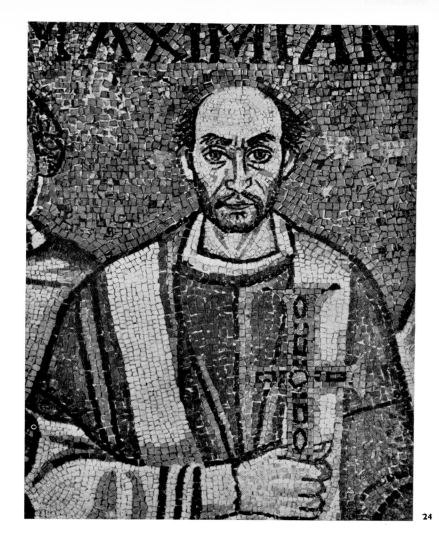

**24**

23 *Figure of a girl, detail of* The Visitation, *mosaic in the apse of the Basilica of Euphrasius, Poreč. Mid-6th century*

24 *Bishop Maximian, detail of mosaic in the chancel of the Church of San Vitale, Ravenna. Mid-6th century*

pasture. With them they carried their archaic divinities, who were slowly transformed from shepherds and nomads into farmer-defenders of the native soil. Perun became St. Elijah, and Svantevit, god of the mountains, became St. Vitus.

One of the major monuments of sixth-century Byzantine art was erected a few decades before the Slavs poured into the Balkan Peninsula. This was the Basilica of Bishop Euphrasius in Poreč. The mosaics in the church date from about 530-35. At almost the same time, masters of the mosaic art were working in the Church of San Vitale in Ravenna. In their portrayals, whether of Deacon Claudius and Bishop Euphrasius in Poreč or St. Maximian in Ravenna, these mosaic artists exhibited a fine sense of reality and individuality. Depicted with sweeping strokes, their figures radiate, in their simplicity, a feeling of profound humanity. The reserve of the poses appears to have drawn its inspiration from the traditions of antiquity; the restraint and the reversion to the depiction of essentials recall the masterly Roman art of portraiture.

The Byzantine-inspired conversion of the South Slavs to Christianity through the efforts of the disciples of Cyril and Methodius, and the spirit imbuing Byzantine art, influenced the formation of the mental outlook and the artistic inclinations of the South Slavs. The double pull of East and West made its mark at an early stage and remained a lasting feature.

The art of Byzantium, the noblest form of post-Classical art, dominated the European artistic consciousness in this period just as the art of the school of Paris held sway in the first half of the twentieth century. The influence of the Eastern artistic idiom persisted in Cimabue and Giotto. The Venetian Renaissance absorbed and reworked that influence and it is perceptible even

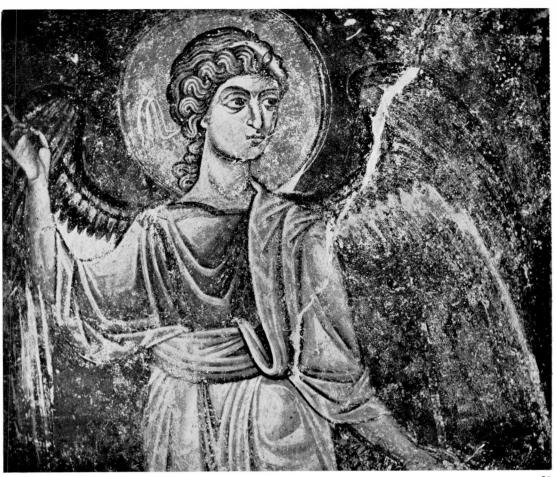

in the Baroque period, in the meeting of Venice and Spain in El Greco's vision.

The most precious frescoes in Macedonian territory are those in the Church of St. Sophia in Ohrid, dating from the eleventh century. The master who created these frescoes was a powerful draftsman with a highly refined sense of color. The apostles approach the sacred Host with dignity and yet with emotion; their gestures of grief and adoration, beyond time and space, are far from the reality of earthly life.

Whereas in the art of antiquity, and later during the Renaissance, visual experience reached the boundaries of the illusion of reality, looking to nature for models and idealizing them, the art of the Byzantine sphere sought less to depict life in concrete terms than to fathom the infinite.

In 1164 a Comnenian prince, Alexius, commissioned the building of a small church dedicated to St. Panteleimon near the village of Nerezi. In their perfect, unhampered forms, their harmonious color scheme, the frescoes in this church achieve a freedom of expression that is profoundly touching. This is one of the peaks of Byzantine art, and we must assume that it was the work of a Constantinopolitan master. The saintly figures were selected with a discerning eye and portrayed with great sensitivity: the grieving Virgin, the apostles and youths bowed by the burden of their sorrow, the tragic Descent from the Cross, and the Lamentation. With courtly dignity St. Panteleimon, physician and scientist, stands in the plaster frame. The shadows of his face are worked in subtle green and azure tones. His eyes speak more of earthly love than of holiness. Slender, in the manner of antiquity, meditative and noble, this saint is youthful and yet world-weary. Among the celebrated paintings in this church is the *Presentation*. Joseph bears a pair of doves to the Temple as offerings: gently and sweetly they perch on his right arm; his left hand is raised as if to caress these little creatures — eternal symbols of innocence and harmony, from the dove that flew

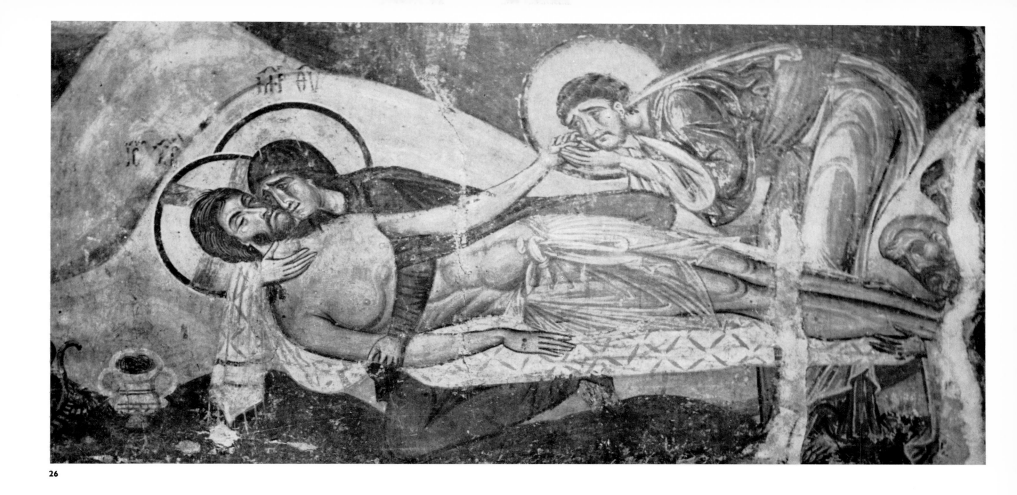

26

27

28

31

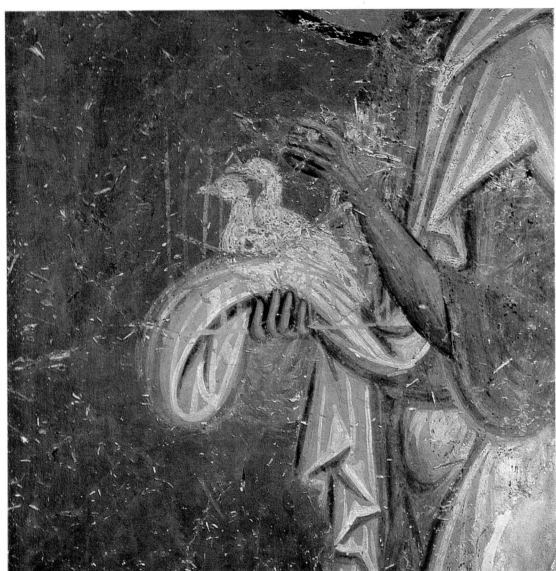

back to the Ark after the Flood, bearing a message of renewed hope, to Picasso's harbinger of world peace.

The flowering of the building art in Serbia began in the second half of the twelfth century during the reign of Stephen Nemanya, founder of the great medieval Serbian state in the Balkans. It was Stephen who centralized the administration of the country, previously divided among feudal overlords. Crafts and trade developed, mines were opened, and a national Serbian coinage minted. The prevailing forms in the building of monasteries and churches were the single-aisled, vaulted structure with a dome centered over the elongated nave and the vaulted basilica with narthex, three apses, and cupolas. Church interiors were decorated with wall paintings in the fresco technique, which, developing

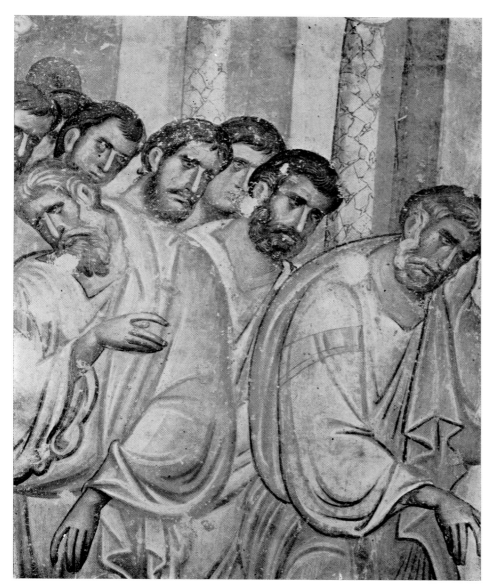

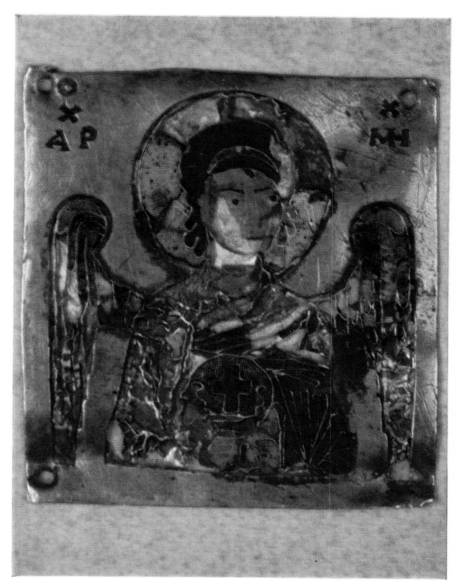

31

32

parallel with the art of mosaic, gradually achieved its own unique idiom along-side that of the courtly tradition of Byzantium. Largely anonymous, the painters who created these frescoes had at their disposal no expensive decorative materials; they obtained their effects simply with the glow of their inspired colors, drawing from canons and from visions the subject matter for their unforgettable series of paintings. The frescoes in the monasteries of Studenica, Mileševa, Peć, So-poćani, Prizren, Gračanica, Dečani, Manasija (Resava), and elsewhere are counted among the masterpieces of medieval art.

In the frescoes of the monastery of Sopoćani, painted about ten years after the building was constructed, in 1256, under the Serbian king Stephen Uroš I, the feeling for clarity, probably decades in the making, reached a peak of per-

fection. Here in classical harmony the Christian saints and holy figures become the serene kin of the gods of Olympus. The shepherds' scene in the composition of the Nativity recalls a bucolic idyll, while Christ in his youthful power suggests comparison with Dionysus. In this church, beauty and the divine are one, just as they were in Classical art. And whereas the Middle Ages usually cloaked the Classical model in Christo-metaphysical forms, the master of Sopoćani gave the Christian story the corporeality and the resonance of antiquity. In flowing rhythm the great wall paintings present, in horizontal zones, scenes from the life of the Virgin. The Fathers of the Church and the apostles and their disciples move with solemnity in their richly pleated, flowing robes. The ancient theme, the canonized action, is transformed under the impact of creative intuition: the death of the Mother of God evokes a mass manifestation of grief and farewell. Exaggeratedly elongated, her dark, slender figure lies on a greenish-violet bier edged in gold. In contrast to the somber horizontal lines of the bier is the bright upright figure of the Son. He is handing over to an angel the Virgin's soul in the form of an infant in swaddling clothes. We are shown simultaneously the end and the beginning of life. The scene is framed by worshipers and believers expressing their sorrow by gentle gestures and bowed heads. Above stretches an endless procession of the heavenly host bearing lighted torches. Only the keening of the women in the background, on the roofs of fantastic structures, breaks the silence of this supremely solemn moment. This is the last ecstatic echo of the archaic lament. The Byzantine-Slav art of monumental painting here achieved its full stature. Sopoćani is the Sistine Chapel of medieval Serbia.

The fourteenth century saw the emergence of other fertile periods which, though never attaining the solemnity and inner power of Sopoćani, did in many ways, through the elaboration of forms developed earlier, achieve great harmony.

The powerful empire of medieval Serbia was not destined long to outlive Stephen Dušan (r. 1331-55). But art lived on, following, as it were, in the footsteps of the Serbian rulers, who, while constantly giving battle, were forced to retreat before the Islamic incursions. The fresco paintings in the monasteries of the later Morava school were neither so impassioned nor so powerful; the compositions are smaller, the draftsmanship is gentler, the colors more sensitive. Using a harmonious color scheme of blue-green, wine-red, and subdued ocher, the master of the church of Kalenić portrayed the Marriage at Cana as a courtly feast of farewell.

Like seals on an ancient charter, churches and monasteries dot the forested districts of Serbia, preserving the grandeur and brilliance of a medieval and yet very contemporary art of mankind. Byzantine Christianity continued the cult of the Great Mother, transferring her attributes to the Virgin Mary.

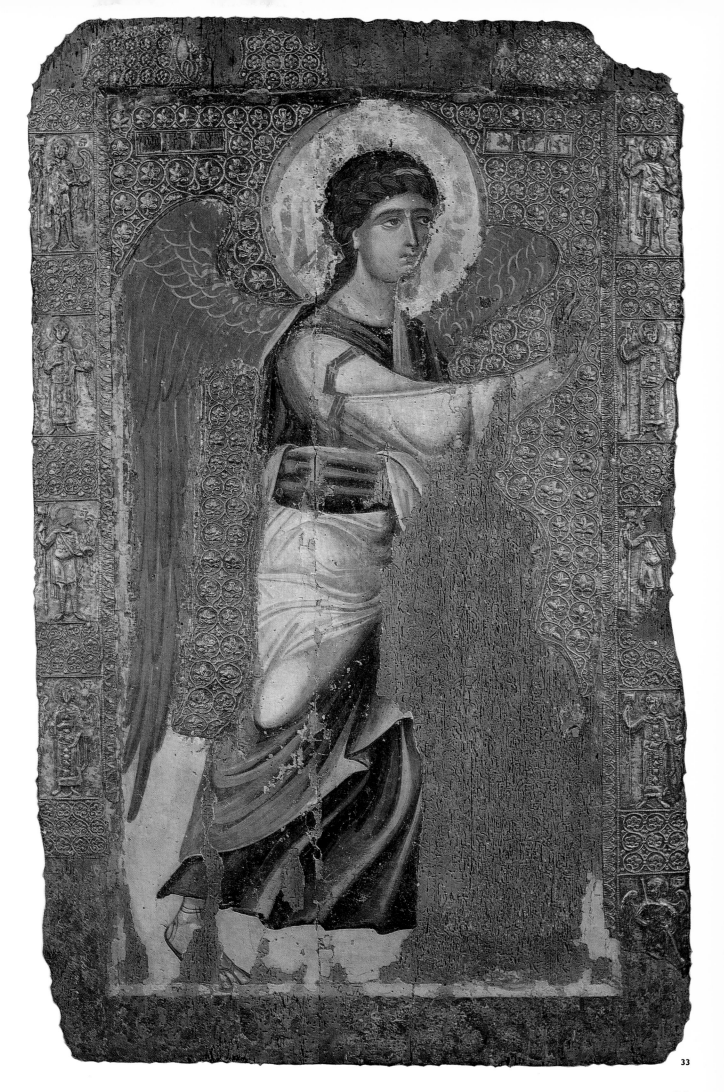

*33 Icon of the Archangel Gabriel.
43 7/8 × 26 3/4″. Icon gallery,
Church of St. Clement, Ohrid.
12th century*

The Church inspired many generations to present bright female beauty and eternal motherhood in the new spiritualized form created by Byzantium.

The earliest icons surviving in Macedonia date from the twelfth century and belong to the school of Ohrid. They show the measured serenity and profound harmony of form and color that characterize late Comnenian painting. In the fourteenth century the school of icon painting connected with Dečani Monastery was particularly productive. In essence its works were related to Serbian fresco painting: the artist-monks clung to the established practices of traditional painting, especially after the independent state had collapsed. Their severe and beautiful art represented an integrated phenomenon up until the time when contact with Westernized trends toward spatial illusionism and plasticity broke the metaphysical spell of two-dimensionality.

The Eastern Byzantine cultural influence and the contemporaneous Christian art of the West — culminating in the Romanesque — were counterpoised: the Slav tribes penetrated into a cultural sphere which had up to their advent borne the stamp of the Romanized population living along the Dalmatian coast. There emerged the chapels and basilicas of the Early Christian and the pre-Romanesque in Solin, Rab, Split, Trogir, and elsewhere, as well as monumental structures like the Church of St. Donat in Zadar, mentioned for the first time in 949 by the Byzantine emperor Constantine Porphyrogenitus. According to legend, it had been constructed by Bishop Donat, a contemporary of Charlemagne. The two-story circular structure, with two concentric walls, was erected

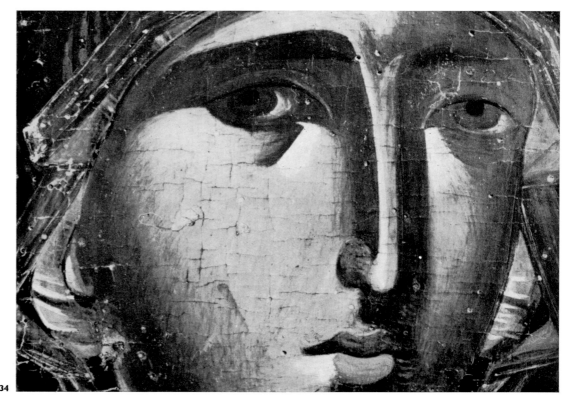

34

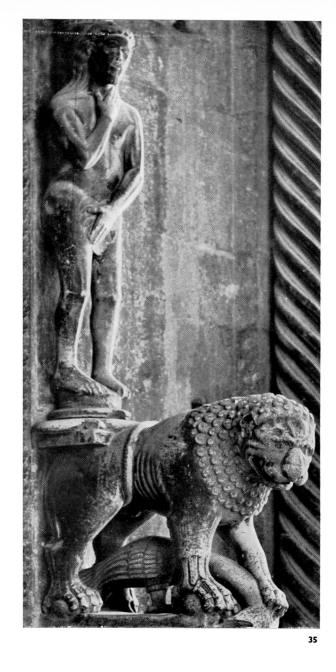

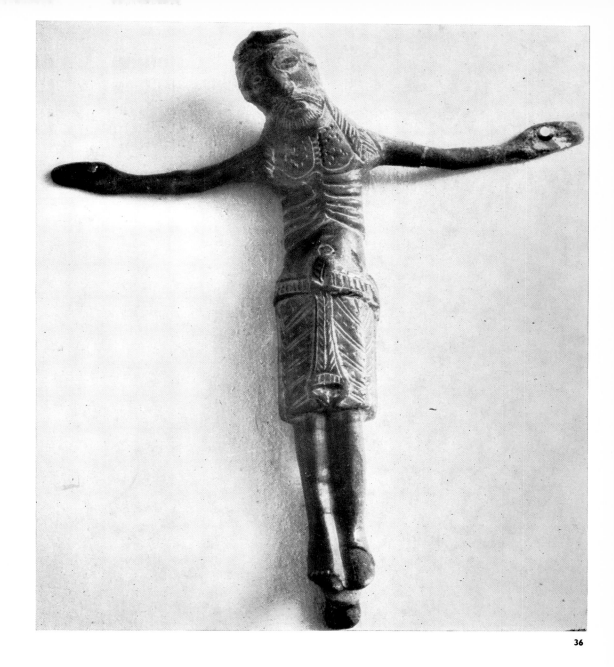

35

36

on the site of an ancient forum. The huge stones used for the foundations and walls, resembling defense towers, not only tell of the economical utilization of old building materials but also symbolize the worship of the Christian God, into the fabric of whose church the obvious remains of altars to Jupiter and Juno were built. The severe, rhythmic shape of the church, with its powerful vertical thrust, gives the Early Romanesque architecture a monumental expressive force.

Romanesque carvings from the turn of the first millennium speak to us with an impressive naiveté: the simple reliefs in the baptistery of Diocletian's Palace in Split tell of the power and dignity of an ancient Croatian king. In his left hand he holds an orb, symbol of the ruler's authority, and in his right the Cross of the faith. Upright and stiff, the king sits on his throne, his counsellor at his side and one of his subjects at his feet.

Powerful yet delicate, as though carved of ivory, is the portal of the Cathedral of Trogir, fashioned by Master Radovan and his assistants: a work based on a childlike sense of reality, interspersed with a number of mythical beings from fairy tales. Adam and Eve, each standing on a lion, seem somewhat ashamed of their nudity, which is a novel feature, unusual in the sculpture of the times. Master Radovan's creative forms, taking as their point of departure the

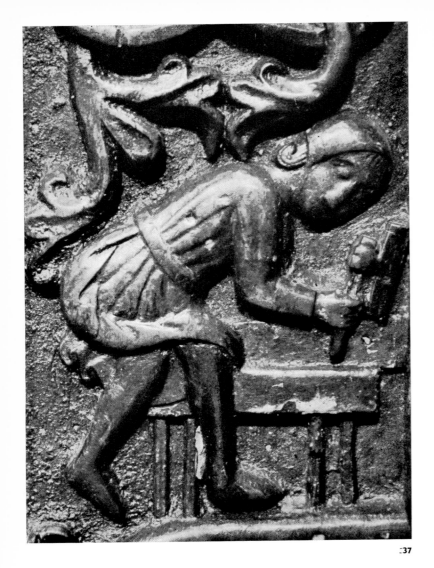

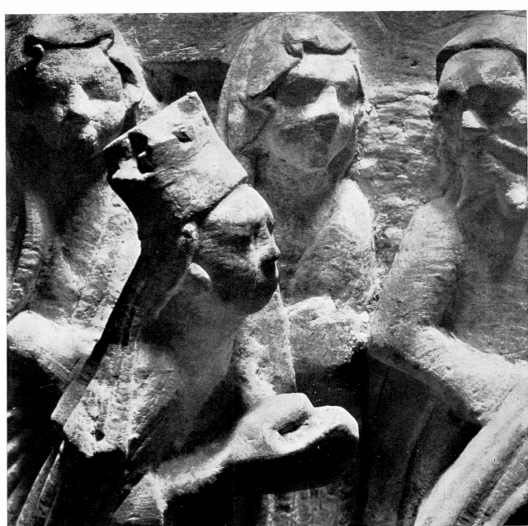

Romanesque concept of the church, are already invested with the nascent spirit of the Gothic. The Romanesque portals in southern France and Spain, the Gallus portal in Basel, and Bonanno Pisano's bronze doors for the Cathedral of Pisa come to mind.

Western European styles, late in appearing in the Slavic regions, were also often transitional in form. Romanesque, on the way toward being transmuted into Gothic, was adapted to the spirit of the times and to local requirements. The monastic orders of the Cistercians, Dominicans, and Franciscans introduced new stylistic elements into the church architecture of the Croatian and Slovenian coastal region. With the Gothic came what might be described as a cosmopolitan feeling. Here too, the advances in technical knowledge and the new outlook on the problems of existence gave rise to Gothic edifices — though they never achieved the monumental proportions of the cathedrals of France. These buildings followed upon a great wave of collective enthusiasm that came in the wake of the religious movement which had supported the Gothic workshops. The major examples in Croatia were destroyed during the wars against the Turks. In Slovenia the Gothic lingered long: in Celje, where the Lady Chapel breathes the spirit of the Sainte-Chapelle in Paris; in Ptujska Gora, whose church has a relief of the Madonna of Mercy sheltering under her cloak some eighty souls — actual personages of the period. In its Mediterranean variant, the Gothic, approaching the sublime, humanized the sacred: whereas in Western Europe the method of building, of articulating the walls — the substantive expression of the dematerialization of space — left no room for frescoes and

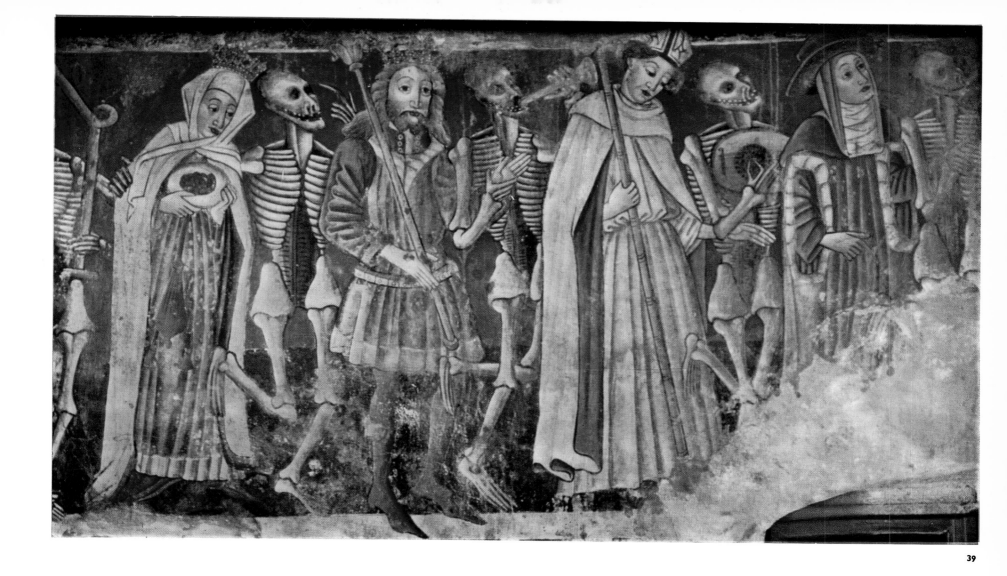

39

mosaics, the small Gothic churches gracing the landscape in Slovenia and the several Gothic churches in Istria are decorated with artistically notable murals.

In the vicinity of the Istrian hamlet of Beram stands a small chapel, St. Mary on Škriline, with frescoes executed in 1474 by Vincent of Kastav and assistants. As though in a fairy tale, a noble and gracious cavalcade files along the main wall. Mounted on white steeds and grasping brown bridles, the courtly procession from the East arrives to worship the Madonna and the Holy Infant and to present offerings. In a lower zone, beneath the worldly knights and nobles, run illustrations of popular sayings and parables, their mocking folk wisdom providing a witty counterpoint to the solemn bearing of the knights. Above the chapel portal is a depiction of the Dance of Death: king and knight, bishop and pope, merchant, innkeeper and peasant — each accompanied by a skeleton, each portrayed with a keen sense of observation as to apparel and movement — tread the path marked out for all on this earth, regardless of worldly rank and power.

In the Istrian hinterland, near the mountain village of Hrastovlje, is a small Romanesque fortified church (the defensive walls offered protection against possible Turkish incursions) in which is preserved a scene from the *Dance of Death* painted in 1490 by Ivan of Kastav, a disciple of Vincent. Seated on a dark throne is the skeleton, greeting an endless procession including kings and ordinary folk, great ladies and infants. Nearby, a group of hunters ride up to pay homage to the Madonna. This small church indicates how ever-present to the consciousness was the idea of death in those times. The theme of the Dance

of Death, as a *memento mori*, appears in European art from the fourteenth century on. Intended to convey not only the vanity of all that is earthly but also the idea of the equality of all men in the face of mortality, the Dance of Death, or *danse macabre*, which is thought to have originated in France, provided numerous artists with inspiration. The idea behind it is of course a very old and basic one; analogous subjects suggesting the transience of human life are found, for example, from the tenth century onward in the art of Lamaism.

In the fourteenth and fifteenth centuries the Ottoman Turks conquered the eastern and central districts of what is now Yugoslavia. The *jihad*, or holy war, took those who participated in its crusading zeal across the Balkan Peninsula and as far as Vienna. When the tide of Turkish power began to ebb, it left behind in certain areas a Slavo-Byzantine civilization with Islamic overtones and

40 *View from minaret of Mosque of Sinan Bey (1570), Čajniče*

41 *Rosette in Sinan's tekke, Sarajevo*

42 *Detail of gateway to Mosque of Hadži Alija (1563), Počitelj*

numbers of Slavs who, at least in part, looked to the East and bowed to Allah. The dome and minaret, the bazaar, tekke, and turbeh, remained long after the swords of the one-time conquerors had disappeared.

The invading Ottoman Turks had found Serbia, Bosnia, and Herzegovina rich in the traditions of their own culture. The art of the Seljuks, introduced by the Ottomans, pertained to the Persian idiom. Although the mosques then raised in the Slavic towns were not the invention of Islam alone — they constituted a harmonious blend of the basilica, the Mazdaist fire temple, and the Early Christian martyrium — the Ottomans did invest them with Oriental features. Whenever purity of form, spirit, and the poetry of mathematics embodied in stone are invoked, the structures, great and small, scattered throughout Bosnia, Herzegovina, and Macedonia must be recalled. The Yeni Mosque in Bitola comes to mind, as do many others, among them the Sinan Bey Mosque in Čajniče, the Karagoz Bey Mosque in Mostar, the Ferhad Bey Mosque in Banja Luka, and the mosque commissioned by Ghazi Husref Bey in Sarajevo in 1529.

The contemporary artist may well feel an affinity for the ornamentally conceived abstract enchantment of the nonrational aesthetic represented here, in which the spiral and the circle, braid and interlace, linear and undulating geometric forms reflect a cosmos of emotion.

Noteworthy works of art in Yugoslavia include the medieval Bosnian and Herzegovinian tombstones *(stećci)* sometimes called "Bogomil stones." These monuments were perhaps the last manifestation in Europe in a Christian setting of a still insufficiently studied cult of the dead. Vast cemeteries, with over fifty thousand tombstones, testify to the upsurge of emotional power that gave impetus to this primitive world of art. "The Bosnian tombstones," a well-known Yugoslav author has written, "represent a continuous tradition running from the eleventh century until 1463, when Bosnia, land of the Patharenes, lost its

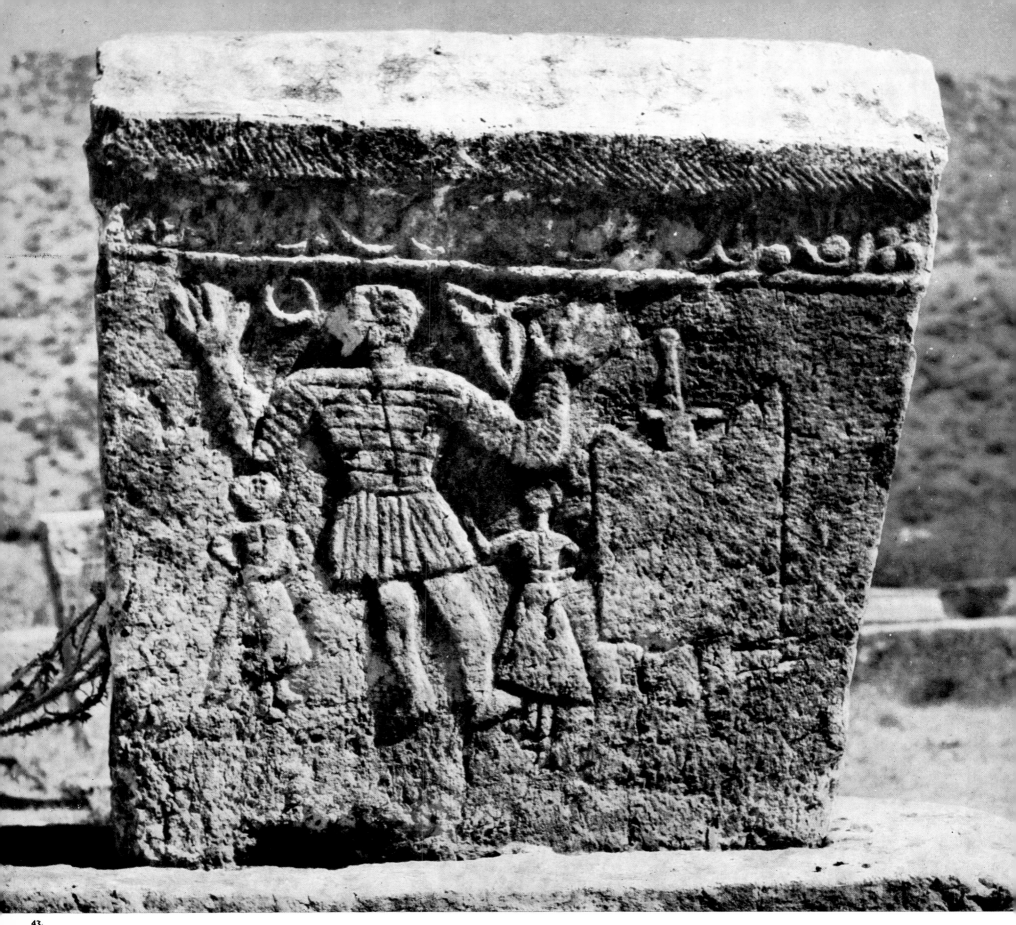

43

42

*43 Tombstone (stećak) with relief showing the
deceased and children. Necropolis in Ra-
dimlja, eastern Herzegovina*

*44 Detail of relief on Catharist sarcophagus
from Domazan in the south of France*

independence. Bosnia was under Manichaean and Bogomil influence for cen-
turies, remaining so until its downfall during the papacy of Pius II, the brilliant
humanist and former Bishop of Trieste (Enea Silvio Piccolomini). During this
period Bosnia was a haven for Western European Manichaeans, the seat of a
Manichaean antipope, and, after the fall of Provence, the spiritual center of
Albigensian resistance. These Bosnian tombstones, so defiantly pagan in spirit,
so eloquently devoted to the pleasures of life — dancing, hunting, the animal
and plant worlds — are clear proof of a powerful current of ethical and artistic
nonconformism which endured for centuries..." (Miroslav Krleža, "The Bo-
gomil Tombstones," in the Belgrade *Književne novine* [Literary Gazette], June
3, 1954; quoted in A. Benac and O. Bihalji-Merin, *Bogomil Sculpture*, New
York, 1963).

Not far from Mostar, skirting the picturesque locality of Stolac and extend-
ing along the banks of the river Radimlja, is a sacred district of graves. It is
one of numerous cemeteries still demonstrating the exclusiveness of the cult
communities. Without hesitation this site can be described as one of the most
singular and exciting phenomena produced by the European artistic imagi-
nation. To these monoliths and sarcophagi, lying side by side in all their orig-
inal immensity, contemporary forms of artistic creation offer nothing compa-
rable. Velvety gray, with an olive-green patina, the braid-enwreathed stone
surfaces bear portraits, emblems, and a wealth of ornamentation. The frequently
repeated male figure with disproportionately large hand upraised and impassive
round face makes a powerful impact. Carved in low relief, memorable images
simplified to the point of abstraction, these works unequivocally demonstrate
that no attempt was made to copy natural forms; the desire was rather to convey
the meaning of reality. The charm of this type of representation lies in its supra-
individual and symbolic features. The horizontal and vertical folds of the gar-
ments are executed as though the medium were wood — perhaps in the ancient
tradition of wood carving as practiced by the Slav shepherds and tenders of
livestock. These medieval stonemasons, active until about the end of the fif-
teenth century, often carved gentle does and powerful stags on their stone
tablets. Their naiveté and gift for spirituality of expression lent all their images
of living things a solemnly poetic, rhythmic simplicity: the reel dance, hunting
scenes, animals, human beings — all were transformed into a record of a com-
munal way of life. Faced with the exalted immobility of these stone figures,
so full of inner movement, we feel some skepticism about virtuosity in the illu-
sionistic imitation of life.

Almost at the same time that the Ottoman invaders were making their
incursions into South Slav territories, gleams of the cultural and intellectual
illumination of the Renaissance were striking the seaboard regions. The tight

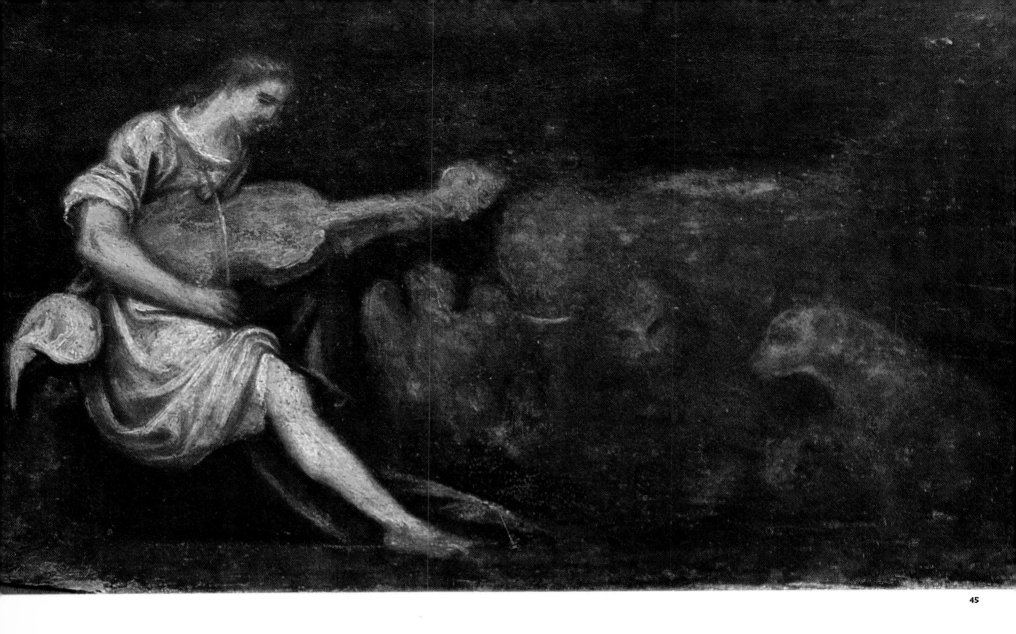

stone wall of the medieval urban economy was now broken, and with the advent of a commodity economy the self-awareness of enterprising patricians and merchants developed rapidly. Life in this period involved knowledge of an objectively determinable world, and thus art was close to life and oriented toward the outer world.

The spirit of humanism was never altogether alien to the Dalmatian towns, which had always maintained links with the legacy of the Classical age. The cosmic outlook of the Renaissance developed in Zadar, Šibenik, Split, Korčula, and Hvar, and above all in the prosperous city-state of Dubrovnik. Although existing in amicable symbiosis with Venetian Gothic, the architecture of Dubrovnik was nonetheless unique, a product of its own native soil. This alone could account for the fact that in 1464 the Grand Council of Dubrovnik rejected a plan for the reconstruction of the Rector's Palace submitted by the great Tuscan architect Michelozzo Michelozzi because it was less well suited to the spirit of the town than the plans of local builders and sculptors, including Juraj Dalmatinac. Nikola Firentinac drew up the plan for the facade of the Cathedral of St. James in Šibenik, which served as a model for the cathedrals in Hvar, Dubrovnik, and Zadar; his sculptures *John the Baptist* and *Peter and Paul* in the Sv. Ivan Ursini Chapel in Trogir Cathedral bear the stamp of a sculptural genius akin to Donatello's. The painter Mihajlo Hamzić produced compositions illustrating simple, homely legends of the saints. Nikola Božidarović, a completely har-

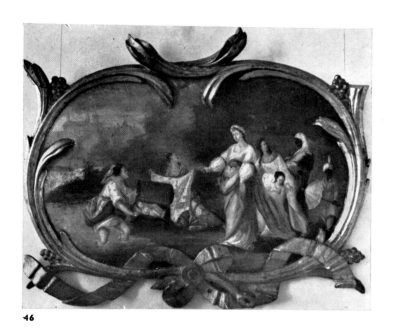

*45 ANDRIJA MEDULIĆ (Andrea Meldola, called Schiavone; 1500-1563). Orpheus. Oil on wood panel, 9 × 15 3/4". Art Gallery, Split*

*46 TEODOR KRAČUN. The Finding of Moses. c. 1770. Oil on wood, 21 1/4 × 30 1/4". Art Gallery of the Matica Srpska, Novi Sad. Property of Serbian Orthodox Church*

monious artistic personality, was responsible for the 1517 triptych in the small church nestling at the foot of the municipal park on the promontory of Danče in Dubrovnik. A gentle beauty and earthly sweetness expressive of the humanistic sentiments of the Renaissance invest his maidenlike Madonna. Many of the local artists received their training in Italy, some of them spending their lives there, so that their work was incorporated into the mainstream of the Italian Renaissance. Thus Franjo Vranjanin is better known as Francesco Laurana, Andrija Medulić as Andrea Meldola, Ivan Duknović as Giovanni Dalmata, and Julije Klović as Giulio Clovio Croata.

All the coastal area, both of the mainland and of the islands, was permeated by the harmonious spirit of multifaceted artistic life: architecture and the fine arts as well as religious and secular music, poetry, and drama. The Renaissance poet of Dubrovnik Marin Držić (1508-67) zestfully expressed the essence of the times in his comedy *Dundo Maroje*, a play of love and prodigality, presenting a picture of the society of the time and containing a fund of folk wisdom delivered in the *buffo* voice of the servant Pomet, precursor of Figaro.

From the Gothic city walls of Dubrovnik, a road leads to the town's formal center, where the Baroque Church of St. Blaise dominates the scene. Serene and powerful, it was built after the great earthquake of 1667, in what was already the time of the dawn of the Enlightenment in Western Europe. It therefore bears no shadow of the somberness, the severity, of the Counter-Reformation but radiantly represents the power and wealth of the Church and of the Republic — though both were on the verge of decline.

Just as the Gothic, arriving late in Yugoslav regions, never engendered here the steeply vertical structure of a transparent universe — for the otherworldly aspirations of the Scholastics had by then been leavened by the natural sentiments and secular tendencies of the early Renaissance — so the Baroque in this area was divested of aesthetically superfluous elements of mysticism and yearnings after the infinite. On the eve of the great clash between the Reformation and the Counter-Reformation, the antipapist movement in Croatia, and to an even greater extent in Slovenia, fused with national sentiment and the Slav will to freedom. Primož Trubar (1508-1586) and Matija Vlačić (Mathias Illyricus Flacius, 1520-1575) gave voice to the feelings of protest in their demands for a Slav liturgy and Bible and the creation of a secular literature.

The Baroque style was able to come to full fruition in Slovenia. Introduced by the Jesuits, fostered by feudal lords, this monumental backdrop to spiritual and temporal power could develop most freely here, in relative safety from the Turkish menace. Toward the end of the seventeenth century an intellectually and artistically important center was formed in the academy founded

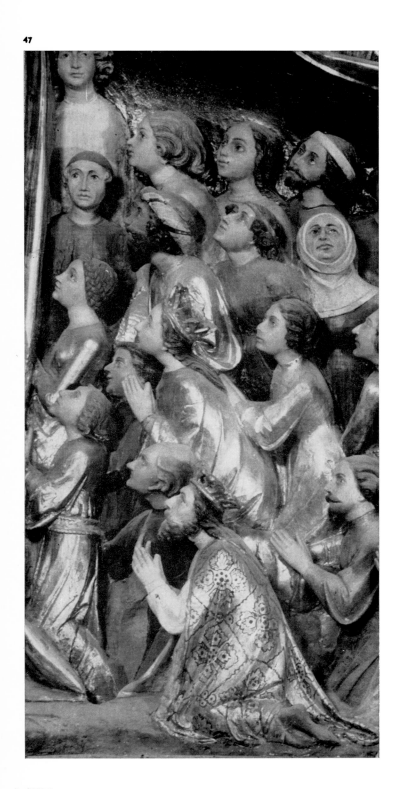

in Ljubljana, whence the Baroque spread out to influence Croatia as well. The variety of artistic trends encompassed by the concept of Baroque corresponds to the differentiation in social patterns and spiritual currents that was taking place in this period. Despite antagonistic elements, certain common features are discernible: the new world view, inspired by progress in the natural sciences; the emergence in Europe of a pantheism which was operative even where art was exploited in the service of religion and bent to the task of influencing believers and nonbelievers alike with its powerful visual means.

The teaching of Copernicus had upset the geocentric image of the earth as the hub of the universe. In his new awareness of the cosmos man perceived how infinitesimally small he was; at the same time his awareness of himself grew as he came to understand natural laws previously shrouded in mystery. An important contribution to the new picture of the world was evolved by Rudjer Bošković of Dubrovnik, who, though a member of the Jesuit order, was held in suspicion by clerical and monarchistic circles in Rome and Vienna for his work in astronomy, mathematics, physics, and philosophy. In 1758 Bošković advanced a molecular theory of matter. In contrast to Newton, who considered the spatial and chronological distribution of phenomena in the universe as absolute and of divine origin, as a *sensorium dei*, Bošković, two centuries before Einstein, perceived the relativity of space and time. His was an early vision of the distant and decisive developments that were to determine our picture of the world in the twentieth century.

We cannot but welcome the scientific knowledge that leads mankind to increased self-awareness. The humanistic system of thought emancipated man from the burden of the nonrational. In art, however, other forces are at work. If rational modes of knowledge were to take control, dreams and imaginings might die out altogether. This may be why the archaic and the naive make so powerful an impact on man's field of vision in this age of technological bustle and excursions into outer space.

*47 Members of secular and religious orders, detail of relief, Madonna of Mercy, by an anonymous master, in the church in Ptujska Gora. Early 15th century*

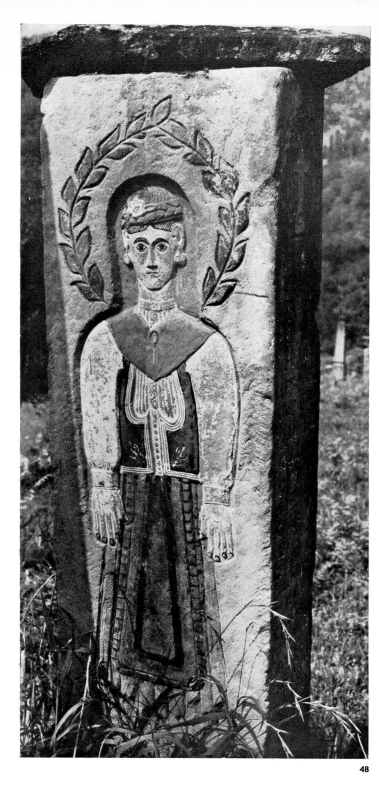

48

Twentieth-century artists derive their inspiration from the totality of the past and the present. For forms and images they can draw upon a vast range of artistic subject matter. Comprehensiveness, the simultaneity of old and new, the parallelism of proximity and distance, these are the elements of the modern view of the world. The artist of our day lives with the idols from Vinča, stands astride the archaic bronze chariot on the situla from Vače, is present at that magnificent mass manifestation of grief on the walls of the monastery of Sopoćani, *The Dormition of the Virgin.* The mysterious figures on the *stećci* in the great necropolises stimulate him to creativity. Need we mention Ivan of Kastav's Gothic *Dance of Death*, with its repercussions in modern drawing? Is the fleeting *Biedermeierstil* smile in the portraits by eighteenth- and nineteenth-century Serbian miniature painters in the Museum of Vojvodina in Novi Sad alive still only on the canvases of the naive?

The turn of the century saw stylistic fluctuations involving Impressionism, Fauvism, and then Cubism. These various movements, from Intimism to Abstraction in all its varieties, found exponents in Yugoslavia. Many Yugoslav artists, like their colleagues throughout the world, responded to the inspiration of the school of Paris. Today there is probably no one principal art center; the new optical art brings together artists of all countries and makes possible their simultaneous and many-sided development. The cultural proximity of all the nations of the world brought about by speed of transportation, rapid communication, and the conquest of space is creating a universal climate of the spirit.

49

50 *Vjenceslav Rihter*. Systematic Plastics, SP. 7.
*1964. Plastic composition, 39 3/8 × 39 3/8".
Collection the artist, Zagreb*

# II  LEPENSKI VIR

Dragoslav Srejović

*Associate Professor of Archaeology, University of Belgrade*

The earliest remains of prehistoric art to be found anywhere on Yugoslav soil were discovered in 1967 in the center of the Djerdap (Iron Gate) region, at Lepenski Vir, in a horseshoe-shaped cove bounded by steep slopes: a planned settlement with impressive architectural remains and remarkable stone sculptures. As these were underneath an early Neolithic settlement belonging to the Starčevo culture, they must be assigned to a time before 5000 B.C. and must be classified as elementary prefigurations of the later Neolithic civilization of the area comprising the continental part of the Balkan Peninsula and the larger region of central and southeast Europe.

The Lepenski Vir culture is distinguished by original architectural forms and sculptures of exceptional artistic interest. These finds must be examined from two points of view: the archaeological, which concentrates on placing the newly discovered Lepenski Vir culture in time and space, and the historico-artistic, which, by analysis of stylistic features and basic architectural and sculptural forms, concentrates on throwing light on the social, economic, and sociological determinants of this first great art on Yugoslav soil.

Research in either direction is extremely difficult. There are no known archaeological finds from the broader Eurasian area that can be directly linked with the artifacts discovered at Lepenski Vir. Moreover, there are not yet available reliable criteria that are applicable to an art which, like that of Lepenski Vir, emerged within the framework of the closed community of prehistoric times, marked by primitive socioeconomic relations, in which, most probably, there was as yet no conflict between individual aspirations and the collective life, nor any unchanneled energy free to be turned to artistic ends. However, this culture was unquestionably not merely a regional phenomenon, and the forms of its architecture and sculpture depended on definite social, economic, and psychological factors.

For an understanding of Lepenski Vir, more accurate knowledge is required of the natural environment, the cultural tradition, and the general historical situation that obtained in the wide Eurasian region during the time when it engendered this remarkable culture. Unfortunately these three fundamental determinants of any culture can in this case be only generally indicated: the Lepenski Vir settlement emerged in the wild, mountainous region of the Djerdap; it was related to the great but distant tradition of the Upper Paleolithic Danubian cultures; and it developed at a turning point in history when the communities in Asia Minor and in parts of Europe were in transition from the hunting and food-gathering economy to a food-producing economy, in which land was cultivated and animals domesticated.

By formal analogy Lepenski Vir can be associated with the proto-Neolithic and early Neolithic cultures of the Near East, chiefly Palestine and Syria, and with certain forms of European post-Paleolithic or Mesolithic culture. However, the basic forms of its architecture and sculpture are so exceptional that for the present they can only represent for

us a series of isolated indications of the power and independence of the earliest known prehistoric art of the Danubian area.

The architectural and sculptural forms at Lepenski Vir have an elemental purity. Architecturally the basic plan was invariably a well-proportioned trapezoid in which the elements were distributed with geometric precision; the contours of the carvings are determined by the shapes of the material, mostly large round boulders. All forms were functional and clear, the creator never departing from the established artistic formula.

The dwellings excavated (59 in all) have, regardless of differences in size, not only identical plans and proportions but also the same interior arrangement. Their trapezoidal shape follows the natural form of the horseshoe-shaped cove in which the settlement was situated. All the buildings stood in straight lines on terraces progressively shorter as they ascended from the banks of the Danube toward the narrow end of the cove; thus the entire settlement was in the shape of a gigantic trapezoid. This overall plan, clearly logical in spirit, reveals an exceptional feeling for harmony between architecture and terrain, achieved as it was by a slight stylization of the natural configuration of the land. The shape of the settlement was thus not in conflict with the natural site but rather a deliberate, rationalized, human adaptation to it.

The sculpture is permeated with the same spirit. The sculptures from Lepenski Vir are in point of fact simply architectural elements, for they were found exclusively in buildings and were regularly fixed to the floor in front of rectangular hearths constructed of great stone blocks. Within the basic architectural framework of the buildings they act as markers dividing the sacred and the secular areas.

The sculptures (54 in all) discovered on the floors of the buildings are, like the architecture, basically cubic in form. They may be classified into two groups in accordance with their modeling: figural sculptures carved naturalistically, with markedly expressionistic features, and puzzlingly abstract carvings that seem to be arabesques. The human and animal heads, which form the bulk of the naturalistic sculptures, are often of monumental size, and the facial features are always clearly delineated. There also seem to be in the second group some figural motifs, possibly complicated compositions (a deer in the forest, ritual scenes, hunting scenes) which the artist, owing to the restraints imposed by the natural form of the boulders themselves, simplified to the extreme and transformed into abstract shapes in the actual carving. But the artist of Lepenski Vir was primarily obsessed with the human figure and its most expressive element — the head. Although he modeled the faces in accordance with a conventional scheme — with exaggeratedly prominent lips, long nose, and enormous eyes — some of the heads approach genuine portraiture. This feeling for the human, for the rational, is a fundamental feature of the architectural and sculptural finds at Lepenski Vir, and a principal characteristic of all subsequent Balkan and European art.

The severe, almost prescriptive, forms of both architecture and sculpture suggest that their creators lived under social conditions in which the individual was entirely subordinate to the group and was economically wholly dependent upon the community, in which numerous taboos were imposed by custom and inspired by magic beliefs. These forms differ from all known forms of the proto-Neolithic and Neolithic cultures of the Near East, which have up to now been generally considered to have been the fertilizing influence on civilization in the Balkans. It must be remembered that the art of Lepenski Vir is the work of Paleolithic men — food-gatherers, hunters, and fishermen, men with an uncertain future, burdened with grave and frequently insurmountable problems — not of members of a Neolithic community, freed by its production of food from the necessity of waging a bitter struggle for bare existence and from fear for the future. It was precisely in the precarious circumstances of the food-gathering society of the Old Stone Age that these artistic forms, which reveal an original and powerful vision of the world, were created.

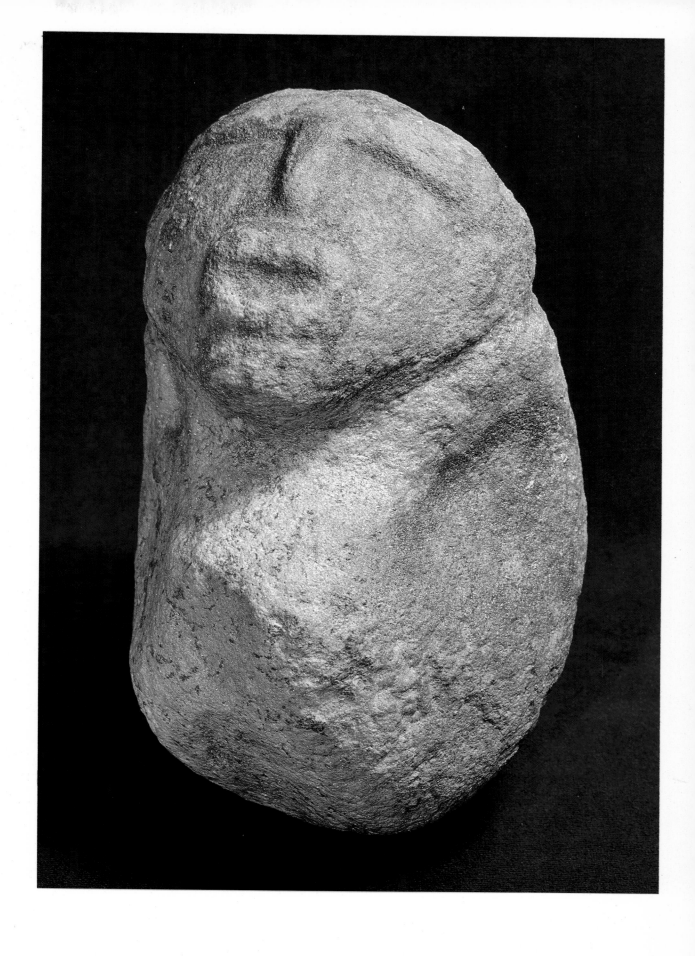

*Sculpture from house no. 28, belonging to the earliest settlement at Lepenski Vir and to the first structural level (Lepenski Vir Ib). Coarse-grained yellow sandstone, 8 3/4" high. In the earliest sculptures, the modeling follows the natural form of the large boulders. The impress of the artist's idea and vision leaves intact the stone's original outline and compactness of mass.*

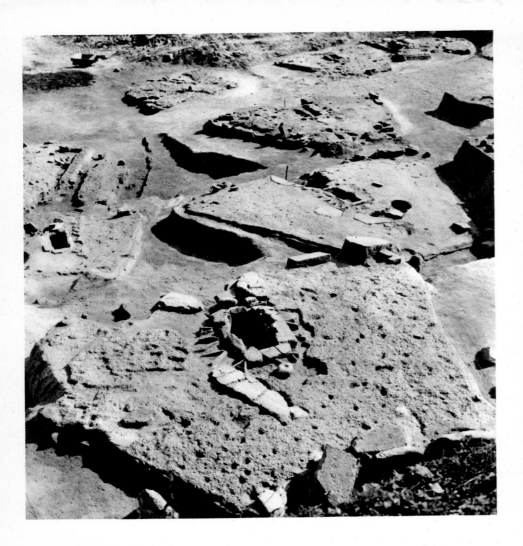

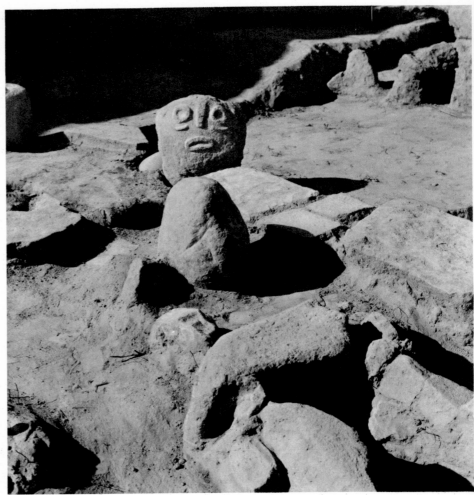

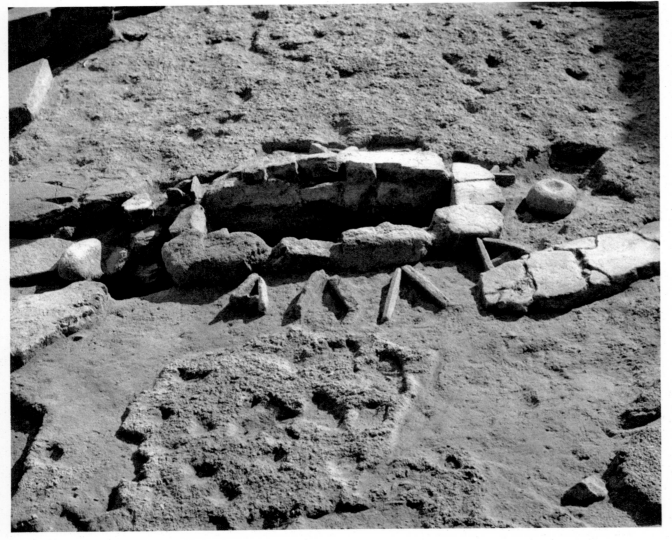

*Above, left. The northwest section of the settlement (the earliest structural level Lepenski Vir Ia), with the foundations of houses nos. 24, 19, 16, and 9. All the structures, regardless of their dimensions, which range from about 6 1/2 to 35 sq. yds., have a trapezoid plan with a long bowed front. The sides of the house foundations are almost parallel with the oblique sides of the cove. The wider, bowed side is toward the Danube and follows the line of its banks, while the narrower sides are wedged into the slope of the cove. Each structure is fitted into the natural configuration of the terrain, so that its contours and dimensions are emphasized and take on a clear architectural form.*

*Above, right. House no. 44. In the foreground is part of the rectangular hearth and in the background one of the four sculptures fixed to the floor around the hearth.*

*Below. Foundation of house no. 24. In the center, toward the longer side of the trapezoid floor, are imbedded large stone blocks forming a hearth in the shape of a rectangular basin. The hearth is surrounded by an ornamental frieze formed by a series of acute triangles composed of thin red-stone slabs imbedded in the floor.*

*Right. Sculpture from house no. 44, belonging to the later level of the Lepenski Vir culture (Lepenski Vir II), the immediate forerunner of the early Neolithic settlement of the Starčevo cultural group (Lepenski Vir III). Coarse-grained yellow sandstone, 18 1/2" high. In this phase the earlier, naturalistic style begins to take on markedly expressionistic features: the faces appear convulsed; the eyes grow wider; the lips are contorted into a grimace. The figures seem pervaded by the presentiment of an approaching doom.*

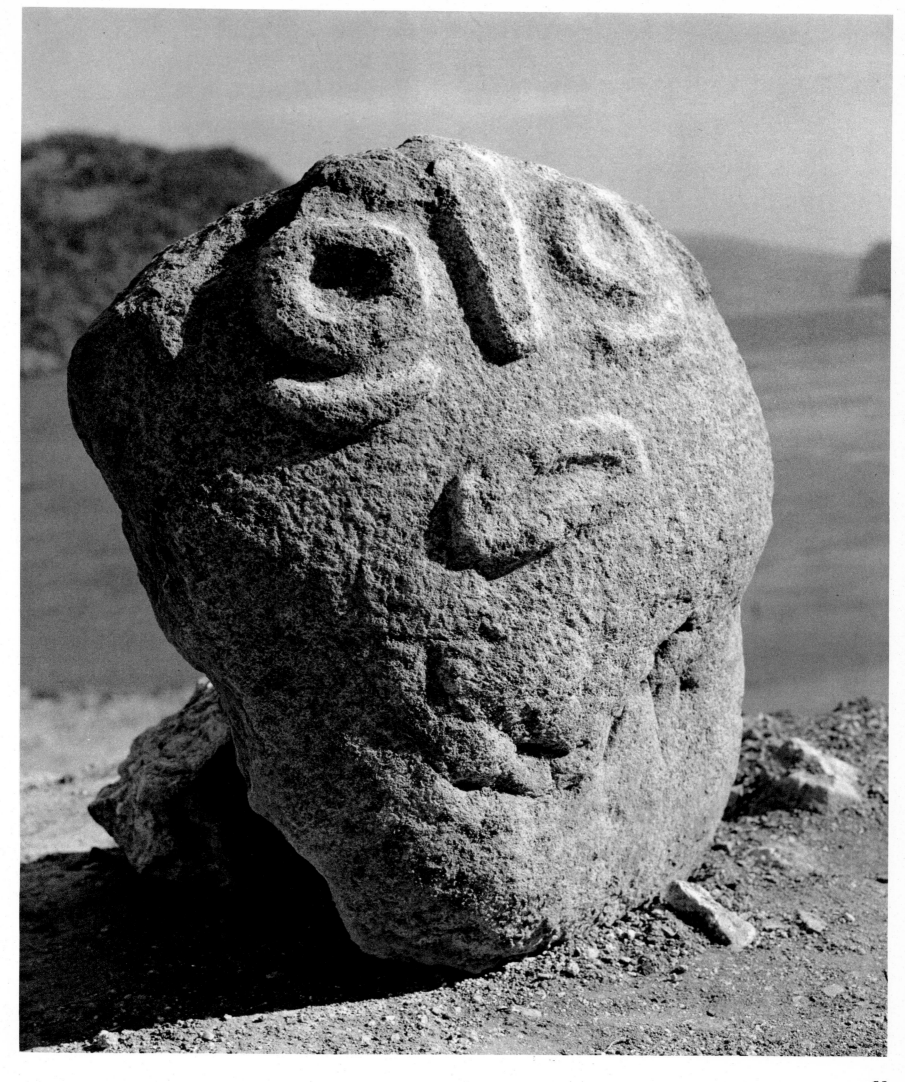

*Above, left. Tool fashioned from a deer horn, 3 7/8" long.*

*Above, center. Tool fashioned from a deer horn, 3 3/4" long.*

*Above, right. Tool, perhaps for spearing fish. Fine-grained gray sandstone, 13 5/8 × 1 9/16 × 1 5/8". All surfaces are engraved with a complex of designs which individually seem to have no specific meaning but as a whole suggest a fish or a snake.*

*Below, left. Large carved stone found in the vicinity of house no. 19. Coarse-grained reddish sandstone, 23 5/8" high. The complex carved design perhaps represents a deer in the forest, but this is conjectural. It would appear that some canon prohibited the artist's violating the natural form of the stone, which must have had an intrinsic value as a sacred cult object.*

*Below, right. Sculpture from house no. 31, belonging to the earliest settlement but found on a later structural level (Lepenski Vir I c). Coarse-grained yellow sandstone, 8 5/8" high. Here, as in the sculpture from house no. 28, the modeling represents a synthesis of the artist's projection and the framework provided by the several raised points of the stone, with little individualization of detail. This approach retains the natural continuity of form and basic rhythm of the stone, while ensuring a clear impression.*

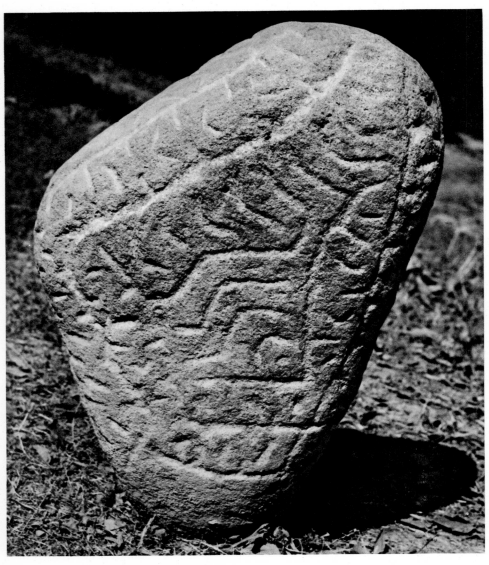

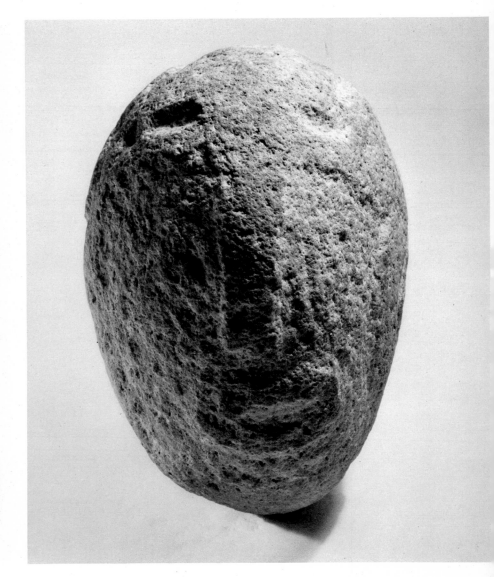

# III   THE NEOLITHIC AGE

Milutin Garašanin

*Professor of Archaeology, University of Belgrade*

In the New Stone Age, or Neolithic, an art specific in form and character spread throughout the entire region extending from the Pannonian plain and the Carpathians to Mesopotamia and from the lower Danube across the Balkans to Asia Minor. Within this region the territory that is now Yugoslavia was characterized by features unique to it. Too little is generally known about the character and attributes of the art of this area, which up to now has not been accorded its just place in the history of the general development of art.

The Neolithic art that has come to light in the regions constituting present-day Yugoslavia is outstanding above all for its complexity and variety. It appears, on the one hand, as decoration and ornament on a multitude of objects, including articles of everyday use, and, on the other, in association with cult ritual, specific religious conceptions and functions, and magic rites. As to form, it appears either free and independent (chiefly in the guise of sculpture in the round) or as applied art. It must also be studied from the standpoint of the materials used and of the types of objects to which decoration was applied. We are especially familiar today with pottery and stone, more rarely with bone, and exceptionally — in the final stages of the Neolithic period, during the transition to the age of metals — with metal. The techniques used range from free carving (sometimes even modeling from molds) through painting, engraving (chiseling, grooving, deep-incising), to the subtle effects obtained by the application of colors to pottery through the refined technique of firing at temperatures of varying intensity.

Despite its variety and its complexity, Neolithic art by no means presents a disjointed, disconnected, or splintered aspect. On the contrary, in approach and tendency, in its conceptions generally, and in its diverse local forms, which are to be sure marked by considerable differences in detail, Neolithic art was essentially an integrated phenomenon throughout the relatively long time span it covered, certainly over a millennium. Its homogeneity is reflected in two fundamental features — geometricism and stylization. The Neolithic art of the regions making up Yugoslavia was severely geometric; only as an exception do we find such figural decoration as reliefs featuring human beings or animals. Parallel bands — horizontal, vertical, angled, meandering, rhomboid, triangular, spiral — were the prin-  *Pl. 54, 58* cipal patterns in Neolithic art. The motifs were initially described on ceramics by the most primitive means: incised by fingernail, impressed by fingertip, pinched while the clay was still soft, or applied over the surface to create the sculptural ornamentation in relief known as barbotine. But this most primitive ornamentation, known even to the earliest Neolithic culture in this region, the Starčevo, was soon replaced by a more complex and deliberate system of ornamentation using various techniques. Thus already the technique of painting decoration was known to the Starčevo group. Vertical parallel bands were drawn, sometimes in white but more frequently in black, on a red background, distributed so as to emphasize the elegant forms of Neolithic pottery and its marked tendency toward

the vertical. Later there appeared in the Vinča group incised ornamentation of angular bands and meanders that ranged freely over large areas of the surface of the vessel, primarily those areas that most immediately catch the eye. In a later phase of the Vinča group, various kinds of geometric motifs were employed, either in bands, usually horizontal and encompassing the entire vessel, or divided into smaller rectangular fields. Thus we find in the Neolithic art of this region, as in the art of other areas in southeastern Europe during this period — the Dimini culture of Greece, for example — a full development of the decorative principle of dividing surfaces into friezes and metopes, without regard for continuity of subject matter, which was to reach its culmination in the decoration of the monumental works of Greek architecture — the Greek temples.

*Pl. 53, 55*

An outstanding example of harmonious decoration is the pattern of vertical spirals applied in relief on a pottery bowl discovered at Butmir, near Sarajevo, and dating from the end of the Neolithic era. A few centuries later, in the middle of the second millennium B.C., we find this motif in the ornamentation of the monumental mausoleums of the Mycenaean period in Greece, particularly in Orchomenos in Boeotia. The wealth of decoration, presented as an integral whole or in sections (that is, arranged in friezes and metopes), is highly reminiscent of the decorative designs of the textile arts of weaving and rug making. The incised ornamentation of pottery exemplified by the Butmir spirals and various other motifs worked in similar fashion in the period of the transition from the Neolithic to the age of metals — often made more effective by incrustation in white — is related to work in wood. This fact alone suggests how limited and fragmentary our knowledge of Neolithic art is: no examples of the decorative arts fashioned in such perishable materials, which could not withstand the ravages of time, have come down to us. For all their rich decoration, ceramics afford only a faint reflection of a whole which, unfortunately, we shall never be able to piece together in its entirety.

*Pl. 58*

The other distinctive feature of the art of the Neolithic period — stylization — finds expression particularly in sculpture, which is rich in human and animal figures. There is in this art no striving for realism, for faithful portrayal of detail, for depiction of living movement or action. Rather, we are faced with simplification of form — neglect or omission of the nonessential. Neolithic sculpture is neither portraiture nor composition. It is a sublimated, synthetic depiction of a specific concept, a symbol rather than a representation, abstraction rather than realism.

*Pl. 8, 9*

Here too lies an essential difference between this art and the art of the Old Stone Age — the Paleolithic — well known through the marvelous cave paintings in Western Europe and the widely scattered mobiliary sculptures of human beings and animals. Concentrated in these works was an exceptional power of observation and an acute sense of detail, even of anatomical minutiae; there is also a feeling for movement, no matter how subtle, for motion, dynamics, and action. We need only recall the portrayal of a bison on the run, of reindeer feeding, or even of entire herds of reindeer in motion.

The divergence in fundamental conception and in forms of expression between the art of these two periods is essentially the consequence of profound differences in social and economic relations. Paleolithic man, hunter and food-gatherer, lived exclusively on nature's bounty, harvesting the fruits of the forest. Conditions for the maintenance of life were favorable, for an abundant nature provided rich hunting grounds. Primitive man, however, early hit upon the idea that certain actions and rituals, magic of various sorts, could help him influence the forces of nature and even assist him in the hunt. Thus emerged imitative magic, whereby man mimicked acts that he would later actually perform; he acted out hunting scenes in the conviction that this would, in the world of reality, in life itself, serve him in his effort to bring nature under his control. Art played an important role in these naive attempts in the abstract to influence natural forces and conditions. Just as in the performance of the magic ritual it was necessary to play out hunting scenes as faithfully

and realistically as possible, to ensure success in real life, so the depiction of the animals on which that ritual was centered had to be as faithful, as realistic, as close to truth and actuality as possible.

The case was altogether different in the New Stone Age. It has rightly been emphasized that the Neolithic was the era of a great economic revolution in the life of man. By engaging in agriculture, the basic economic activity of this epoch, man for the first time made the transition from the gathering to the producing of food, began deliberately and systematically to harness nature and to make it hearken to his command — no longer by engaging in abstract ritual but by actually selecting certain plants for cultivation and animals for domestication. Needless to say, the fertility of the earth and the reproduction of animals held a special place in the life of Neolithic man. He came to worship fertility as a divine force on which his life depended, associating it with the earth, the mother who bore the fruits that nourished and sustained him.

This attitude explains the origin, in the Neolithic period, of the cult of the earth-mother or mother goddess, thought of as a woman accompanied by her male partner-spouse. Myths about this goddess and her spouse were known for millennia to the ancient world, first in Mesopotamia, and later throughout the entire Mediterranean area — myths such as those of Ishtar and Tammuz in Mesopotamia, and Cybele and Attis in Asia Minor, whose beginnings may also certainly be traced, through Neolithic carvings, to the Neolithic period in this region. But these carvings, shaped by the living conditions and conceptions of the primitive agriculturists, possessed properties peculiar to them alone. The mother goddess and her spouse were not conceived of as definite personalities. They were symbols of fertility and the life principle of male and female, simultaneously impersonal and universal, the goddess representing the earth, the woman, the mother, and the god her male counterpart. They were therefore represented in Neolithic art in simplified and stylized fashion, with only the most essential — primarily the sexual — physical attributes and characteristics specified. Neolithic art neither wove them into illustrations of myths nor showed them in action. The power of the goddess was manifest in her being seated on a throne (a position, instanced by the classic figure from Čaršije, in which *Pl. 63* she was frequently depicted) and her significance as a goddess of fertility could hardly be more clearly symbolized than by her representation as the *kourotrophos*, or goddess nursing an infant. Her connection with her male partner, the link between these two symbols of fertility, is expressed only in a number of two-headed figures in the Vinča group. Only exceptionally do we find erotic scenes; in these regions there are none at all resembling those from Hacilar in Anatolia, or the late Neolithic figural representations from Romania.

Out of such conceptions developed the tendency toward stylization in Neolithic art in the Yugoslav region, which is present always and everywhere, even when the figure in question is most carefully modeled. Thus in a statuette from Vinča with fastidiously and precisely modeled legs and lower torso stylization was not neglected. The head of this figure, like the heads of other Vinča statuettes, is a typically expressionless mask; the arms appear as short horizontal stumps, the extreme stylization of arms bent at the elbow and crossed over the breast, an attitude typical of figures of the great goddess of fertility throughout the Near East. It is altogether atypical to find the measure of realism — even of actual portraiture — that is seen in a terra cotta from Vinča and another from Butmir, both isolated *Fig. a, c* phenomena.

In this connection, reference must be made to the functional qualities of these carvings, as of Neolithic art generally. Primitive man, the early farmer of the Neolithic era, like his remote Paleolithic forebears, was above all practical. That aspect of his art — the fusion of the practical with the beautiful, with the desire to decorate for the sake of beauty — suggests the perspective from which his efforts should properly be viewed. This applies also to cult objects, although here the practical approach, the effort to achieve certain results

through the performance of specific cult rituals, was associated with the abstract, the unreal, inherent in every religion. Functionalism undoubtedly played a major role in the artistic creativity of Neolithic man: its influence is all-pervasive, manifest everywhere to a greater or less degree. This is true especially of ceramics, the products of a domestic handicraft, worked by hand and not with the wheel; the forms of these vessels were governed and dictated by the uses for which they were intended. But the feeling for beauty was operative here too. No one can dispute the elegance, sense of proportion, and harmony of form of the bowl *Pl. 52* from Tečić, dating from the early Neolithic, of the slender, long-legged, and graceful bowls belonging to the Vinča group, or of the bizarre multi-legged vessels also found in the Vinča excavations.

To an even greater degree cult objects exhibit the functionalism associated with specific *Fig. b* ritual or primitive religious concepts. On the anthropomorphous lids from Vinča, which are among the examples of sculpture in the round to which reference was made earlier, figural presence is concentrated in the two enormous eyes. These eyes protect the contents of the vessel from evil spirits or spells; they exercise the apotropaic power attributed to the miraculous *Wedjat*, or "sound eye," of the Egyptian god Horus. The same power to *Pl. 70* ward off evil was thought to be a property of the bucranium, or earth-covered bovine head, fixed on the gable above the house door, as demonstrated by the model of a dwelling from Stželice in Czechoslovakia and found also in Vinča and other sites. The very models of dwellings in Neolithic settlements, like those constructed with such extraordinary precision at Porodin, near Bitola, have cult associations. Yet another example of the primitive agri-*Pl. 57* cultural fertility cult is the vase (also from Vinča) in the form of a marsh bird. Water fowl have figured in cult lore through the centuries. In the myth of the Delphic Apollo, symbolizing renewal of life in the springtime after the long winter months, Apollo, returning from the dark, cold, misty land of the Hyperboreans to the sunny clime of Greece, arrives in a chariot drawn by marsh birds. Behind the ornamentation of the Neolithic period there may in fact be concealed a great deal of more profound and largely unfathomable symbolism. It has been claimed, for instance, perhaps not without reason, that the spiral represents the extreme stylization of the snake, a creature closely associated with the cult of the earth and the nether regions in virtually all religions.

How the Neolithic figures were used, how they discharged the role assigned them in the life of Neolithic man, is extremely difficult to determine. But the large number of figurines that have been brought to light and the fact that they have not been found in a particular place or in a specific building in the settlement would seem to signify that special cult places did not exist. Rather it might be deduced that the statuettes were used in individual dwellings for rituals associated with the fertility cult, were used, that is, within the framework of the domestic cult, which does not seem to have been on an organized basis throughout the community. However, certain phenomena of the late Neolithic period challenge this conclusion. At Valač, near Kosovska Mitrovica, at the very entrance to the Ibar gorge, lies a small Neolithic settlement. The land on which it is situated is inaccessible, *Pl. 56, 68* steep, forbidding—unsuitable for habitation. An abundance of Neolithic figurines, most of them very fine and some exceptionally large, was found here. In contrast, the ceramic ware excavated is both minimal and very poor in quality. The impression gained is that this was not a place where food-producers lived but a special place set aside by them for the performance of rites.

Finally, it must be asked, who were the creators of Neolithic art? Who were the anonymous craftsmen that fashioned the works of art which have come down to us; where did they work and how? So far as ceramics are concerned, there is little difficulty in providing answers. Ceramic pieces and their ornamentation are the work of women's hands. By analogy with peoples currently at a parallel stage of socioeconomic development we infer that in these settlements there was a clear-cut division of labor between men and women.

*a. Fragment of figurine with conical cap, from Vinča, near Belgrade. Late Neolithic (3000 B.C.). Fired clay (dark), height 3". National Museum, Belgrade*

*b. Face-urn lid, from Vinča, near Belgrade. Late Neolithic (3000 B.C.). Fired clay (dark); height 4 7/8", diam. 5 1/8". National Museum, Belgrade*

*c. Head of figurine, from Butmir, near Sarajevo. Late Neolithic (3000 B.C.). Fired clay, height 6 7/8". National Museum, Sarajevo*

The impressions of women's fingers on the pottery of the Neolithic era, for example on a vessel from Vinča, bear out this theory. And what of the sculptured idols? The fact that they are so numerous points to their having been fashioned, like the pottery, in the home, for the use of the individual household. However, certain examples of unusual dimensions, approaching lifesize, give us pause. Were they the work of exceptionally skillful individuals in the Neolithic settlements, or of special craftsmen who fashioned particular types of figures for the performance of cult rites on a large scale? These are questions that must remain unanswered at least for the present.

Neolithic art gives us an insight into a whole world—the way of life, attitudes, beliefs, conceptions of primitive man in the remote past. It helps us to visualize the life and understand the spirit of the Neolithic people, and to pierce, at least to a degree, the veil of mystery that obscures their culture and their outlook. Naive and crude, but nonetheless complex, specific in style, bound by certain principles and conceptions, it represents a clearly defined stage in the general development of the art of mankind. Within this scope, Neolithic art in the lands making up present-day Yugoslavia occupies a place of prominence.

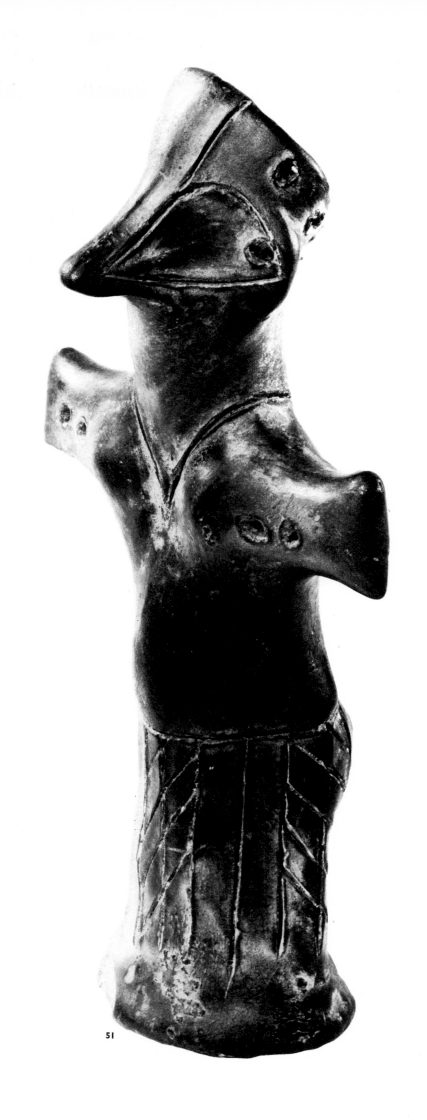

*51 Figurine, from Vinča. Late phase of Vinča culture (3rd millennium B.C.). Fired clay (dark gray with traces of reddish color), height 6 1/2". National Museum, Belgrade*

51

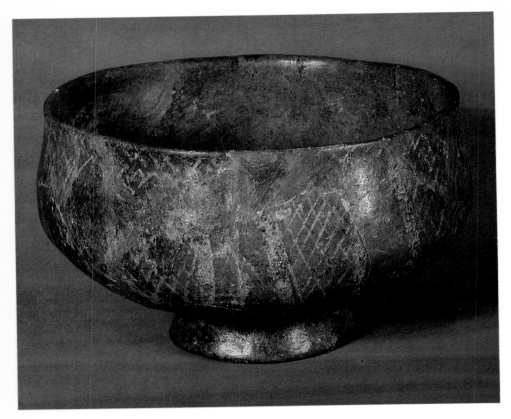

52

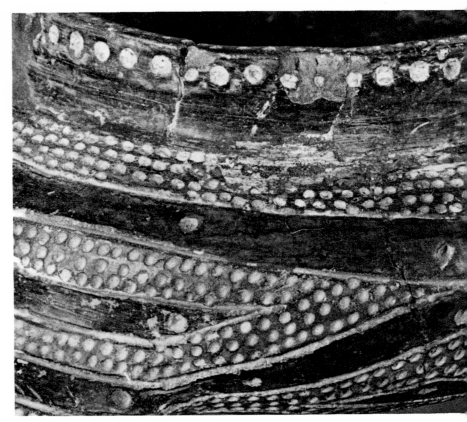

53

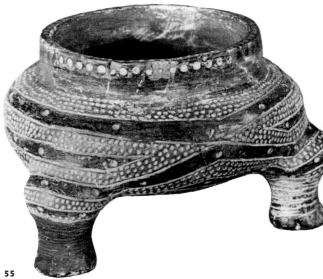

55

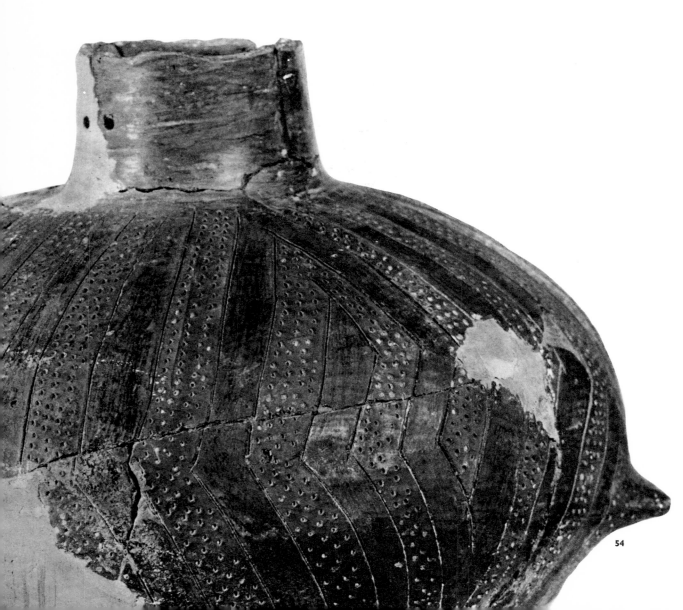

54

52 Footed bowl with white painted decoration, from Tečići, Starčevo culture (early Neolithic, 4th-3rd millennium B.C.). Fired clay, height 4 1/2". National Museum, Belgrade

53 Detail of Plate 55

54 Lugged jar with incised meander ornament, from Vinča. Earlier phase of Vinča culture (c. mid-3rd millennium B.C.). Fired clay, height 14 3/8". Archaeological Collection, University of Belgrade

55 Three-legged vessel, from Vinča. Late Neolithic (end of 3rd millennium B.C.). Fired clay (gray), with incised decoration and white incrustation; height 3 3/8". National Museum, Belgrade

56 Head of a figurine, from Valač. Earlier phase of Vinča culture (end of 3rd millennium B. C.). Height 22 1/8", width of the face 21 1/8", length of the eyes 8 1/4". Fired clay (gray) National Museum, Kosovska Mitrovica

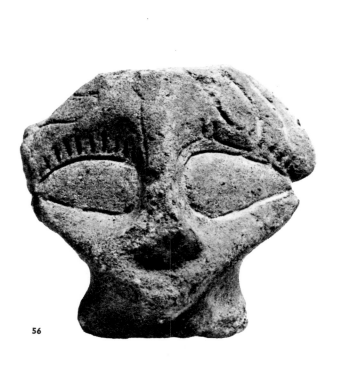

56

57

57 *Bird-shaped rhyton for ritual use, known as the "Hyde vase," from Vinča. Earlier phase of Vinča culture (c. mid-3rd millennium B.C.). Fired clay, height 8 1/4", length 14 1/4". Archaeological Collection, University of Belgrade*

58 *Bowl with relief spiral decoration (barbotine), from Nebo. Late Neolithic (3rd millennium B.C.). Red fired clay, height 5 3/4". National Museum, Sarajevo*

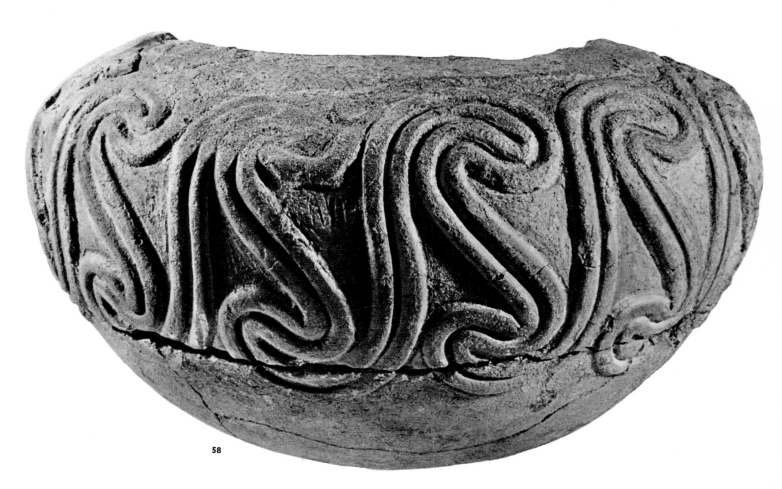

58

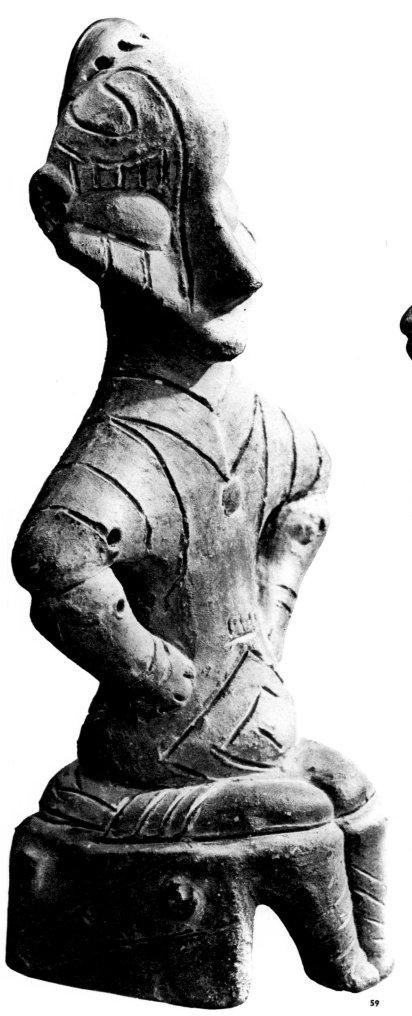

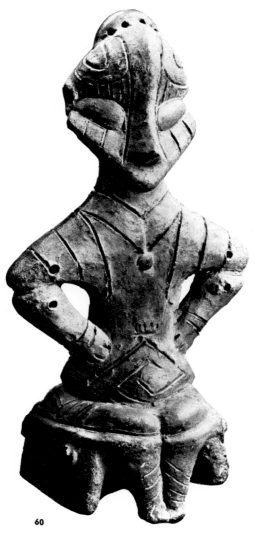

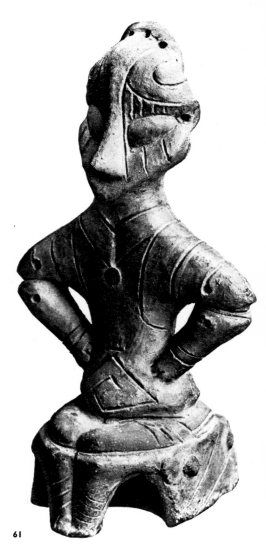

59, 60, 61 *Seated figurine, from Predionica. Late Neolithic (second half of 3rd millennium* B.C.*). Red fired clay, height 7 1/4″. Kosovo Museum, Priština*

62 *The so-called "Lady of Vinča," figurine from Vinča. Late Neolithic (second half of 3rd millennium* B.C.*). Gray and black fired clay, height 5 7/8″. Archaeological Collection, University of Belgrade*

63 *Seated figurine, from Čaršija. Late Neolithic (3rd millennium* B.C.*). Fired clay (gray), height 6 1/4″. National Museum, Belgrade*

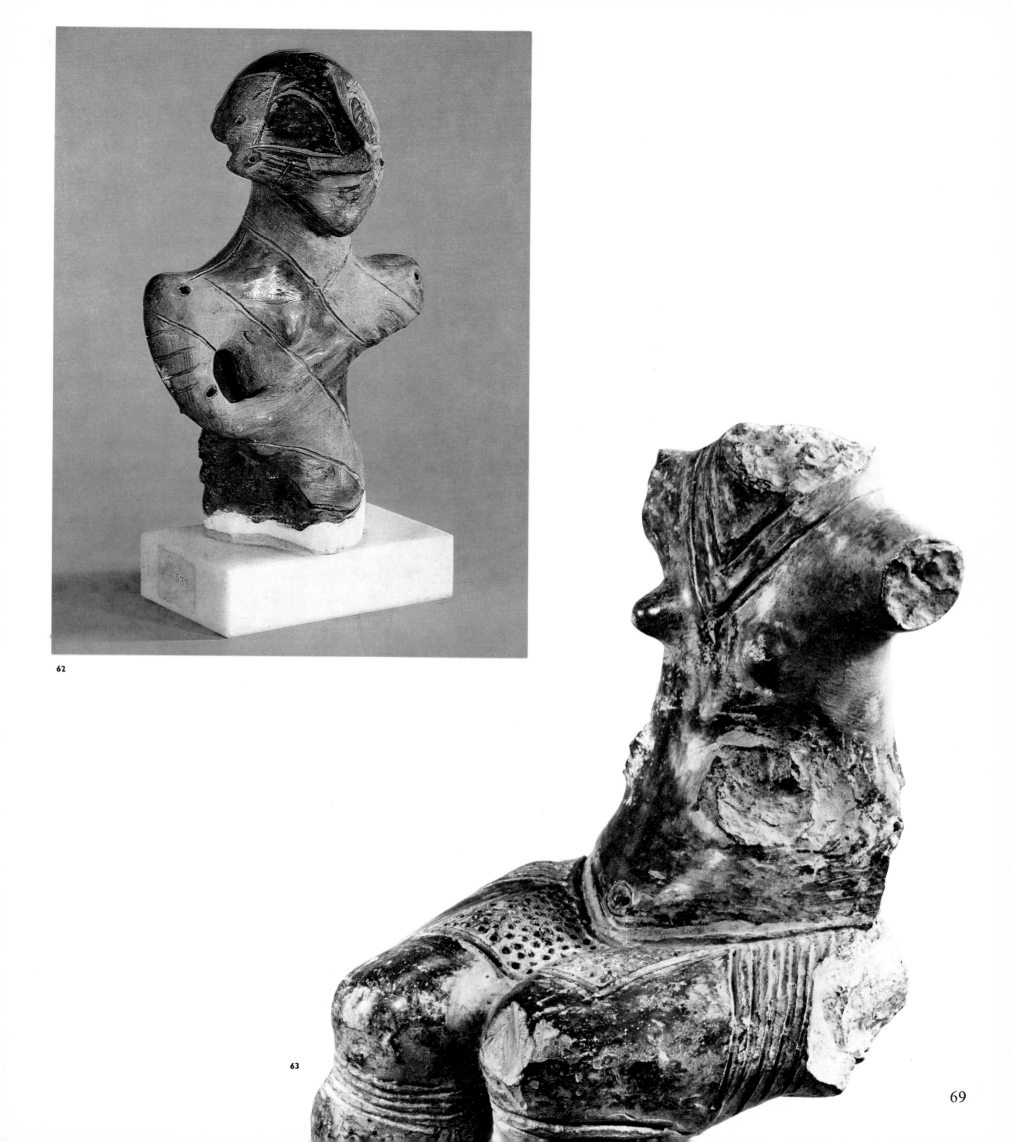

62

63

69

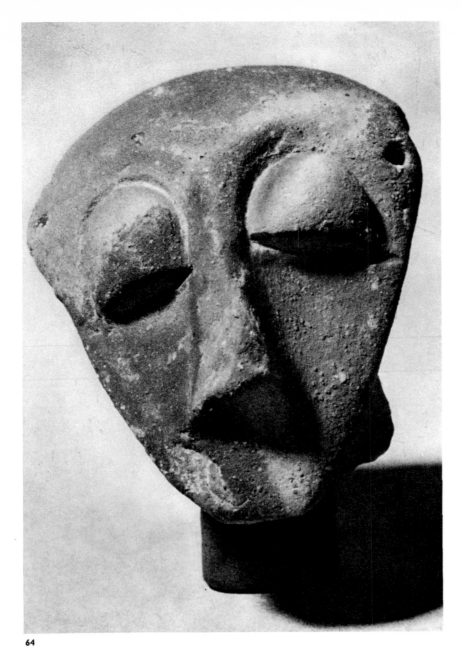

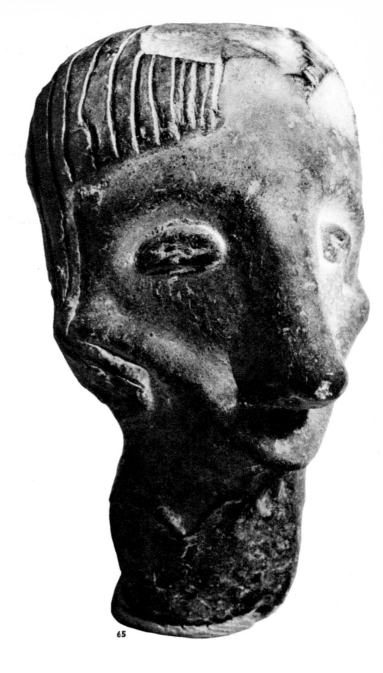

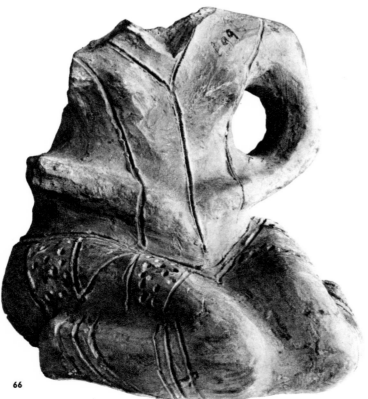

64 *Head of a figurine, from Lipovac. Later phase of Vinča culture (late Neolithic, 3rd millennium B.C.). Fired clay, height 1 3/4". National Museum, Belgrade*

65 *Head of a figurine, from Predionica. Late Neolithic (3rd millennium B.C.). Fired clay (gray), height 3". Kosovo Museum, Priština*

66 *Kneeling figurine, from Vinča. Late Neolithic (mid-3rd millennium B.C.). Fired clay (gray), height 3 1/8". Archaeological Collection, University of Belgrade*

67 *Head of a figurine, from Predionica. Late Neolithic (second half of 3rd millennium B.C.). Fired clay (dark), height 4". Kosovo Museum, Priština*

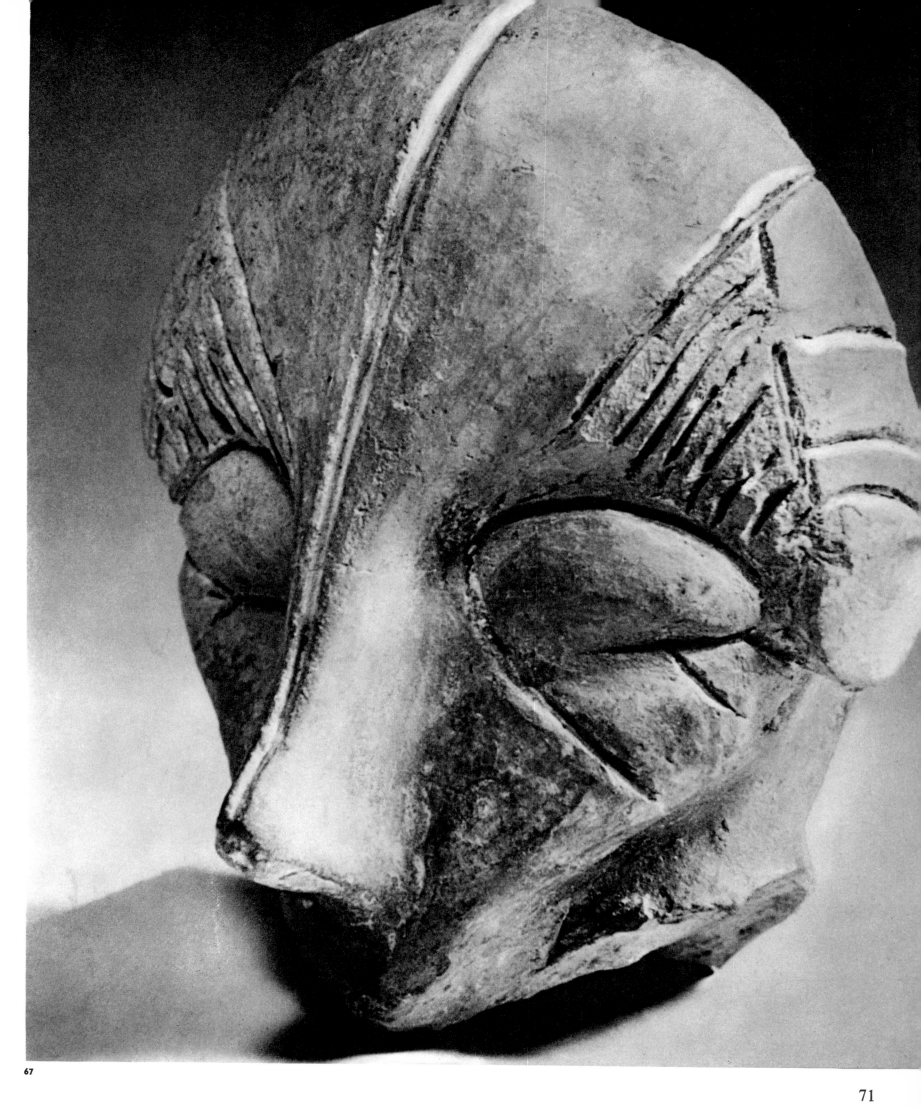

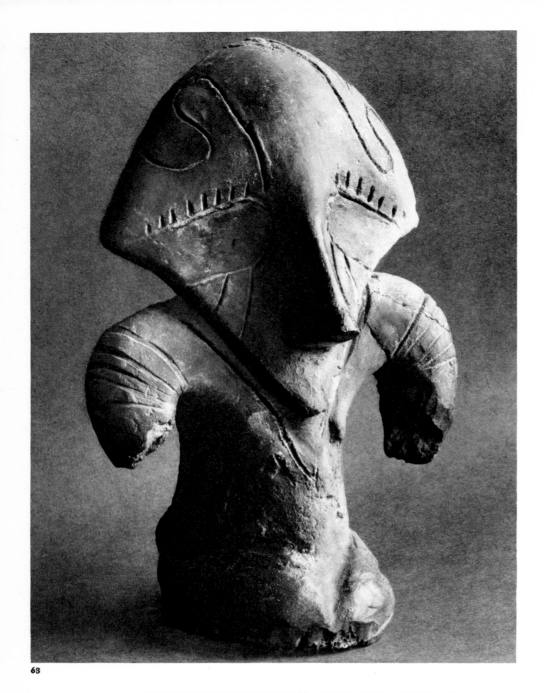

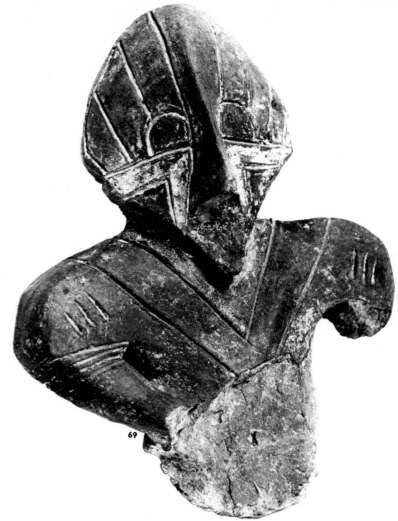

68 *Seated figurine, from Valač. Late Neolithic (3rd millennium* B.C.*). Fired clay (dark), height 8 5/8". National Museum, Kosovska Mitrovica*

69 *Bust of figurine, from Pločnik, near Prokuplje. Late Neolithic (second half of 3rd millennium* B.C.*). Red fired clay, height 7 1/8". National Museum, Belgrade*

70 *Bucranium, from Vinča. Vinča culture (second half of 3rd millennium* B.C.*). Width, with horns, 27 3/4". National Museum, Belgrade*

# IV  ART IN THE AGE OF METALS

Dragoslav Srejović

*Associate Professor of Archaeology, University of Belgrade*

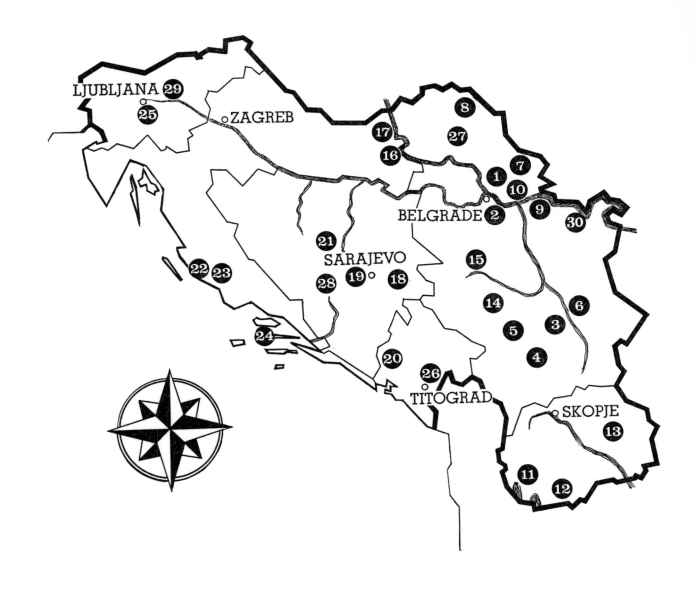

PREHISTORIC FIND SITES

| | | | | | |
|---|---|---|---|---|---|
| 1 | Starčevo | 11 | Trebenište | 21 | Nebo |
| 2 | Vinča | 12 | Porodin | 22 | Smilčić |
| 3 | Pločnik | 13 | Vršnik | 23 | Danilo |
| 4 | Predionica | 14 | Novi Pazar | 24 | Markova Špilja |
| 5 | Valač | 15 | Atenica | 25 | Ljubljansko Barje |
| 6 | Bubanj | 16 | Vučedol | 26 | Medun |
| 7 | Vršac | 17 | Dalj | 27 | Čurug |
| 8 | Mokrin | 18 | Glasinac | 28 | Lisičići |
| 9 | Žuto Brdo | 19 | Butmir | 29 | Vače |
| 10 | Dubovac | 20 | Crvena Stijena | 30 | Lepenski Vir |

The pattern of the Neolithic world began to disintegrate as soon as the first metals — copper and gold — were discovered. As the discovery of metallurgical processes brought to light other metals and alloys, which came to be widely used for everyday purposes, the old way of life gave way to new patterns. Two basic epochs are clearly defined in the art of this era of the discovery and use of metals: the earlier embracing art forms that emerged during the period of the recognition and restricted use of the pure metals copper and gold (Aeneolithic or Chalcolithic Age); the later characterized by forms which appeared with the general use of bronze (Bronze Age) and subsequently iron (Iron Age). While the earlier forms, despite their clear augury of future development, were still linked with Neolithic traditions, the forms of the Bronze and Iron ages were conceived in an individual manner and in an entirely new spirit and style.

The life of Neolithic man was on the whole shaped by group thinking, in which archetypes, instinct, and the subconscious had the most important place. Neolithic art was consequently characterized above all by complete impersonality and a synthesizing style that ignored the exceptional and the individual. Frequently there is a discrepancy between content and artistic form, between idea and aim on the one hand and power of expression on the other. Despite many attempts the Neolithic Age did not completely succeed in expressing general ideas and concepts in artistic form. A greater measure of success came only after the knowledge of metals had broken down agrarian particularism at the economic level and strong tribal ties and local traditions at the social and religious level. Possession of a new kind of material, metal, led to a division of labor within the community between cultivators of the land and artisans and to the breaking down of the primitive social organization founded exclusively on blood relationship. It was natural for this new climate to foster a changing mentality, in which a larger role was played by the rational functions of consciousness and by defined concepts, and frequently by individual thinking and volition. Thus the prehistoric art forms of the age of metals in the regions making up present-day Yugoslavia are characterized by a stylistic mode that in its general morphology differs markedly from the prehistoric art of Neolithic times.

Viewed as a whole, the art of the age of metals is distinguished by abstract forms and extreme rationality in artistic procedure, that is, it eschews free organic forms and deliberately avoids crude imitations of reality. In contrast to Neolithic forms, which frequently represented specific content — concrete objects or details — the new forms were fashioned to suggest general or abstract concepts, universal principles which find their fullest artistic expression in irrational symbols and ornamental signs combined to form fluent arabesques. The delight in discovery and artistic representation of basic forms and details observed in nature, so manifest toward the end of the period of Neolithic art, was replaced by a desire to plumb the essence of observed forms, to experience them beyond the specific

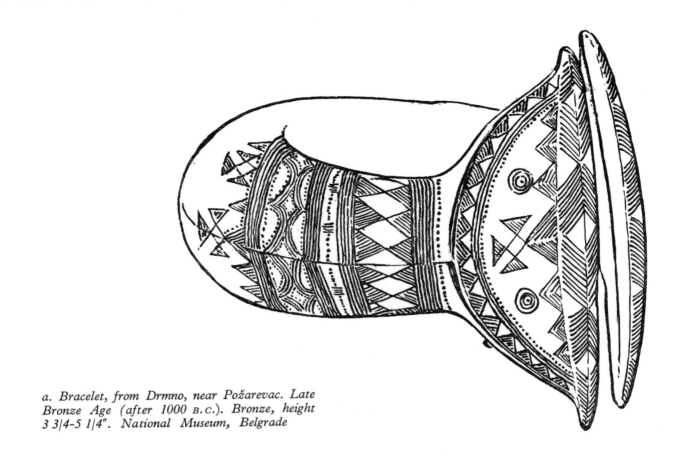

*a. Bracelet, from Drmno, near Požarevac. Late Bronze Age (after 1000 B.C.). Bronze, height 3 3/4-5 1/4". National Museum, Belgrade*

context of time or place, and to raise them, thus conceived, to the level of eternal forms. To achieve this, the reality of the objects portrayed was formally denied; they were presented in the abstract, as the new artistic expression no longer corresponded to the realistic depiction of the world. In the age of metals art forms were shorn of the details which would be crudely reminiscent only of a particular concrete form, or of individual content. Consequently, as this art pursued the long line of its development the figural, particularly the representation of human beings and animals, was shunned. Even when figural motifs were portrayed, their general appearance was subordinated to the emphasis on a single basic feature associated with their essence. Alternatively, real forms often had superimposed upon them so many associations and so many generalized, complicated images that, in the artistic representation, the basic natural form — the point of departure — was inevitably shattered. Far from representing the individual and the real, art forms of the age of metals were ordered into rigid schemes in which abstract concepts and ideas took precedence over concrete subjects. This separation of art and life did not mean the negation of life but rather the fullest possible affirmation of life, because it answered the need to introduce sense and order so that the life of both group and individual might be freer and happier.

The same tendency is manifest in other spheres of thought and culture in the age of metals, particularly in religious concepts and funeral rites. Neolithic beliefs, based largely on magic associated with everyday life, were replaced when a knowledge of metallurgy produced a more sophisticated religiosity, often transcendental in tone and abstract in approach. Instead of burying, post-Neolithic man cremated his dead — cremation, like abstract art forms, possessing a symbolic value enabling individual and community to deal with inner and outer pressures.

The fundamental characteristics marking the thought and culture of the post-Neo-

ithic prehistoric epoch stemmed from the particular socioeconomic pattern that the utilization of metals gave rise to. However, as new metals and alloys were gradually discovered it was natural that the basic artistic forms of expression should alter over the centuries, especially under the influence of a variety of outside factors, such as the Great Migrations and the attendant penetration of elements from other cultures. Thus there are perceptible in the art of the age of metals various phases of development associated, on the one hand, with major historical events and discoveries and, on the other, with spontaneous changes in the foundations of culture, that is, in continuing social and psychological development. The utilization of metals accelerated the general rhythm of economic, social, and cultural advance, made possible closer relations between various ethnic groups, and opened up possibilities for the development of regional art styles and their wider adoption.

In the regions making up Yugoslavia the art of the age of metals may be divided into five basic stylistic stages, corresponding to the operation of significant external and internal factors:

*Stage of invasion styles.* Forms characteristic of cultural groups of the Aeneolithic (Chalcolithic) and the early Bronze Age (c. 2500-2000 B.C.).

*Stage of stylistic stabilization.* Forms characteristic of cultural groups in the advanced Bronze Age (c. 2000-1200 B.C.).

*Stage of transitional styles.* Forms characteristic of urn-burial culture at the end of the Bronze Age (c. 1200-750 B.C.).

*Stage of major stylistic synthesis.* Forms characteristic of the culture of the early Iron Age (c. 750-350 B.C.).

*Stage of the final prehistoric styles.* Forms characteristic of the culture of the late Iron Age (c. 350 B.C. up to the establishment of Roman culture in the Yugoslav regions).

The first objects fashioned of copper and gold, for the most part jewelry of various

kinds, made their appearance in Yugoslav territories alongside material typical of the late Neolithic Age, in a still predominantly agricultural setting. The sporadic appearance and unusual forms of these objects clearly indicate their foreign origin and stylistic conception. It is easy to understand why in the plains, especially in the Danubian area in Yugoslavia, where conditions favor agriculture, these forms could not immediately affect the still vital Neolithic culture or bring any essential influence to bear on the continued spontaneous development of Neolithic styles. Thus, for example, the abstract linear form of the gold *Pl. 74* anthropomorphous clasp found at Progar was for the time a foreign and exceptional manifestation, significant only as a precursor of a new style that was, somewhat later, to take root in the Yugoslav territories.

A decisive break with Neolithic traditions and the achievement of original artistic expression came only in the Aeneolithic, or Chalcolithic, Age as other cultural groups made incursions into the region. These groups originated in the Carpathians (Baden culture) and Alps (Vučedol culture), where conditions were ideal for the development of metallurgy. Concurrently, the influx of new ethnic groups, partly from the eastern steppes and partly from Aegean Macedonia, forced the native population to retreat from the fertile plains, giving way before the newcomers, largely nomads, in whose culture metals also figured significantly. Thus the initial phase in the development of art on Yugoslav territory in the age of metals was characterized by invasion styles, by forms that stood in contrast to all that had hitherto been achieved in the local artistic tradition.

The basic art form of this initial stylistic phase was arrived at by two procedures: by transforming active, organic forms into static, severely tectonic ones and by restricting the free development of decoration by enclosure within the framework of friezes and metopes. Both procedures tended in the same direction — toward the achievement of a decorative geometric style, through stereotypes of natural form, by abandoning freedom of form and figuration.

The Yugoslav Danubian area, broadly conceived, was the first to be affected by the powerful expansion of the Baden cultural group, which, moving southward from the northeastern Pannonian plain, destroyed all earlier settlements on the territory conquered and brought about the final disruption of the stylistic conceptions associated with Neolithic art. This mobile, distinctly nomadic culture left behind a large number of short-lived settlements containing both dugouts and apsidal structures above ground in which there were found characteristic cups having ornately modeled handles and grooved ornaments and also large vessels decorated with geometric motifs and perforations.

Somewhat later, as metallurgy developed, the Vučedol cultural group took shape in the eastern Alpine area and Slavonia, the earliest of its artifacts being found in the Ljubljan-*Pl. 78* sko Barje (Ljubljana marshes). This culture, characterized by vessels with deeply incised ornament, reached the culmination of its development in Slavonia, where fortified settlements with large buildings of the megaron type have been found.

While the forms in the Baden culture were still spatially unrestricted, retaining the gentle contours and undulating surfaces traditional in Neolithic times, in the earlier forms of the Vučedol culture the contours are sharper, volume has been articulated tectonically, and geometric ornament is distributed over flat surfaces within the framework of restricted *Pl. 5, 76* friezes or closed metopic fields. Decoration is always two-dimensional — pictorially conceived — and hence has no organic link with the structure of basic three-dimensional forms. The rare figural representations from this epoch follow the same principles: modeling of human or animal figures was subordinated to schemes based on the tectonic principle rather than on natural organic divisions; forms that actually make up a whole are broken down into parts, while forms that are in reality separate are made to unite. The third dimension is practically abolished; broad, flat surfaces are formed to which pictorial procedures are then applied.

*c. Torque and clasp, from Živaljević, Bosnia. Late Bronze Age (12th-11th century B.C.). Maximum width 5 1/2". National Museum, Sarajevo*

In the formation of this new stylistic approach a more advanced, more abstract religiosity, reflected in the form of irrational symbols (the double ax, birds, consecrational horns), *Pl. 73* was certainly influential. Furthermore, the settlement at Vučedol, with its sanctuary and separate living quarters for the tribal chieftain, shows that in the Aeneolithic Age certain families enjoyed a position of privilege and that private property was known — in other words, that new socioeconomic relations had emerged in which both the community and the individual were subjected to powerful pressures.

Greater moderation is evident in the stylized forms scattered throughout the eastern and southern regions of Yugoslavia, associated with the incursion of cultures and ethnic groups (the Bubanj, Hum III, and Belotić-Bela Crkva) from the eastern steppes and Aegean Macedonia. Here too the basic structure is tectonically articulated, surfaces are either plain or somewhat monotonously divided by horizontal and vertical bands; nevertheless a stereotyped geometric design was avoided and in some cases pure three-dimensional forms were achieved.

Tectonic forms, geometric ornamentation, and the insistence on symmetry and conventional design are clear indications that the first stylistic stage shows the effects of unrest and social crisis engendered by ethnic regrouping and the introduction of metals into everyday use. The new artistic expression was an outgrowth of inner psychological turbulence in the face of the complicated phenomena of the outside world, a compensatory

subjective reaction to insurmountable obstacles. It was natural for local cultures to adapt gradually to new living conditions in the course of time, and the forms produced by cultural groups in the mature Bronze Age were the result of just such a gradual establishment of equilibrium. All the art forms that emerged in the stage of invasion styles were carried over into the next phase, the stage of stylistic stabilization.

Initially, the old local traditions began to be revived. Vessels from graves in Mokrinje and Pančevo, Omoljica and Slatina are far simpler than the Baden and Vučedol ceramics, and they recall earlier local forms. It was precisely this return to the archaic that provided the best means for reducing the effect of alien influences and discovering fresh sources of artistic inspiration. It is characteristic that during the Bronze Age there were no great integral cultures, there was no generally accepted artistic style. Rather, each region, settlement, and necropolis reveals an astonishing abundance of original forms.

The names of rich sites at Vatin, Vršac, Dubovac, and Žuto Brdo mark stages in the continuing development of Bronze Age culture in the Yugoslav Danubian area, while the finds from numerous graves under the tumuli at Glasinac represent another important integral culture on the territory of Bosnia. The development of artistic styles in the Pannonian groups can be followed primarily on the basis of ceramic forms, and in the Glasinac area on the basis of the forms of bronze objects.

In both regions, traditional, definitely archaic forms served as the foundation for future cultural development and new artistic expression. But once the dangers of past centuries were forgotten, tradition became too much of a burden. Consequently, in later phases of the Bronze Age, a complete break with traditional frameworks is noticeable in material culture, economy, social relations, art, and religious conceptions.

During the stabilization of local cultural groups in the mature Bronze Age a stylistic approach based primarily on the free movement of mass in space grew up in opposition to the tectonic, linear-abstract style of the preceding epoch, which had tended toward static forms and clarity. The new tendency gave rise to ceramic forms and certain bronze objects which show that the inner structure was so strained by the tendency to reach out into space that outer surfaces seem to be but a thin membrane, barely succeeding in organizing the basic mass and bringing it under control. The previous flat surfaces and linked rectilinear

*Pl. 75*     decoration gave way to wavy or broken surfaces and curvilinear motifs. Basic form was no longer approached from a strictly tectonic point of view but rather as a separate visual whole, freely occupying space. Decoration became flamboyant (spirals, volutes, sprays, garlands, concentric circles); it was no longer treated independently but in relation to the whole.

The same superb decoration was applied to anthropomorphous figures with bell-shaped skirts. Attention was focused in these "idols" on the designs on the garments rather

*Pl. 77, 79*     than on the faces, which were often strangely stylized and devoid of individuality. In the earlier statuettes, probably figures representing deceased persons, the accent is on the splendor of jewelry and richly embroidered apparel; in the later examples (from Žuto Brdo and Korbovo), this predilection for picturesque detail deprives the human figure of anatomical articulation and reduces it to the status of symbolic sign. In general concepts, as in religious thinking, the link with the narrowly local environment had been disrupted,

*Pl. 71, 72*     and, as we may conclude on the basis of the groups of carvings from Dupljaja, new perspectives were opened up in all directions in terms of both earthly existence and the afterlife. Natural forms continued to be conventionalized and frequently assumed the shape of generalized symbols; the basic artistic expression was nonetheless free, reflecting a strong

*Pl. 92*     inclination to approach life with optimism and confidence.

The aspirations of this stage were thwarted, however, by a new wave of unrest, which began about 1200 B.C. in the territories now constituting Yugoslavia and lasted, with brief interruptions, until the middle of the eighth century B.C. The Sava and Danube basins, with the exception of the easternmost sections of the Banat and Serbia, were overrun by

foreign ethnic groups bringing with them new forms of material and spiritual culture. The indigenous population was in constant flux; uncertainty, attended by unrest on all sides, was the climate of the period. This was an epoch in which the laws of war and death prevailed. In the new world thus created, life appeared reduced to an ephemeral phenomenon hardly meriting attention; the grave alone was deemed worthy of respect and care. Under the impact of the new forces and ideas, the basic structure of Bronze Age art was disrupted and transitional styles took shape which foreshadowed future cultural development influenced by the use of iron. In the regions encompassed by the migratory movements appeared heavy and gloomy ceramic forms and bronze weapons and jewelry with repetitive, severely *Pl. 84* geometric decoration. The earlier variety of forms with their abundance of imaginative elements yielded to monotonous forms which, fraught with the horror of death, denied the dynamics of life and reduced movement and figural representation to simple geometric signs. In other regions, which were spared actual conflict and the incursions of foreign *Fig. a, c* groups, the forms simply repeated traditional models with mannered artificiality, apparently reflecting a general atmosphere of weariness.

By the middle of the eighth century all externally superimposed elements had been assimilated into the local cultures and the antagonisms of the preceding epoch resolved. However, the introduction of iron into more general usage at this time led to an intensification of stress and strain in social relations, so that, despite a general stabilization of culture, the traditional geometric style continued to be nurtured. By this stage of the early Iron Age the organization of society was no longer based on kinship but on economic forces that gave rise to a hierarchical structure.

Although the new stage of cultural and stylistic synthesis included elements characteristic of the preceding stage of invasion styles, its foundations were firmly grounded in traditional indigenous forms. In this case, however, respect for tradition was not the reflection of uncertainty or creative impotence; rather it emphasized the confirmation of indigenous values and rights. In order to achieve fuller affirmation, the indigenous population had to make up culturally for all that had been lost in the preceding period of ethnic stabilization; the result was that a great variety of diverse elements were freely incorporated into the new artistic forms.

Apart from assimilating the material features of the invading Urnfield culture, the indigenous culture quickly adopted a number of new forms from the Thraco-Cimmerian, the Scythian, the Italic, and particularly the Greek culture. Greek traders, craftsmen, and *Fig. b* artists even in the seventh and sixth centuries were aware of the great purchasing power of the Illyrian tribal chieftains. Princely graves in Trebenište, Novi Pazar, and Glasinac contain costly objects of archaic Greek origin, and forms taken over from Italic regions are to be found in the northwestern districts of present-day Yugoslavia. These forms imported from Mediterranean cultures, figural and realistic in conception, did not merge either immediately or uniformly with the powerful native culture. They represented only one component in the great stylistic synthesis achieved in the Yugoslav territories during the final phases of the early Iron Age. On the basis of variations in the adaptation of Mediterranean forms it is possible to differentiate three separate groups in the indigenous culture of the sixth century B.C. and three specific artistic syles: those of Vače in the northwest, Trebenište in the southeast, and Glasinac in the central region.

Finds from Vače, Stična, Magdalenska Gora, and Brezje are in the specific style of *Pl. 82, 86, 88, 92* Veneto-Hallstatt art: elements were taken over from the Urnfield culture (certain forms and techniques for decorating bronze vessels) and blended with East Mediterranean naturalistic forms that had already been adapted in the Veneto, through the medium of the Greeks and the Etruscans, to the taste of the indigenous population. Thus adapted, the figural decoration was taken over without demur even by local masters, who showed great facility in decorating the surfaces of bronze situlae with extremely picturesque scenes. *Pl. 13, 14*

*d. Belt buckle, from Jezerine. Late Iron Age (5th or 4th century B.C.). Bronze, 2 3/4 × 1 5/8". National Museum, Sarajevo*

The style of the situlae was fundamentally naturalistic, although with marked expressionist features. It was as far from the real as were the linear-abstract forms, but in the opposite direction. On the situlae the concreteness of figures and faces was retained, ostensibly, as a primary value: certain organic forms were given exaggerated emphasis but attention was nevertheless concentrated on details and stress was always laid on a single outstanding feature of the figure or situation depicted. Only the barest feeling for the abstract is perceptible. Dissociation from reality was further underlined by the constant presence of the traditional geometric preoccupation, clearly revealed in figural compositions both by the rigorous confinement of space (friezes on situlae, decorative bands on gold masks) and by the general composition (heraldic distribution of figures, symmetry, repetition of motifs). This merger of the realistic Mediterranean mode with local geometric styles engendered an original artistic style characterized by forms superficially equivalent to the natural — that is, seeming to be objective and realistic while essentially remaining abstractions revealing only indirectly the deeper meaning of the forms depicted.

An entirely different concept underlies the forms created in the art of the Trebenište group. Figural pendants of amber found at Novi Pazar and Atenica, representations on
Pl. 85     gold pectorals, sandals, and gloves from Trebenište, and richly decorated silver and gold

pins reflected the spirit of Ionic art, which, in the newly conquered Balkan regions, seemed to renew its earlier power and glory. Finds from the wealthy princes' graves indicate that archaic Greek forms arrived here as a direct import into an environment whose culture and art were still closely linked with Bronze Age traditions. The indigenous population drew from the treasury of the alien culture only those elements that suited its current socioeconomic situation. It was not a coincidence that out of the abundance of Ionic art forms the ones that were borrowed were the early Mycenaean motifs on which that art was founded. The gold death-mask portraits from Trebenište could have emerged only in an environment which with its fortified settlements, monumental graves, and autocratic military system was a living reminder of the heroic period described in Homer's epics. Only such socioeconomic conditions can explain the renaissance of Mycenaean forms and *Pl. 11, 83* the specific character of indigenous artistic expression in the southeastern regions of Yugoslavia.

The material from the princely graves in the Glasinac necropolis (Ilijak, Čitluk, Osovo, Brezje) presents still another picture. In richness these finds cannot measure up to those from Trebenište and Novi Pazar, but they do reflect an utterly independent and powerful spirit. Foreign imports, and by the same token foreign models, are relatively seldom in evidence in the Glasinac necropolis, and the local artistic style shows no wavering between what was wanted and what could be achieved. Basically the Glasinac style remained consistently popular and accessible to all sections of the population. Characteristic Glasinac forms were therefore adopted in all areas inhabited by Illyrian tribes.

For an understanding of art trends in the late Iron Age it must be kept in mind that the period between 550 and 450 was not one of economic and cultural prosperity exclusively for the indigenous tribes inhabiting what is now Yugoslavia. From Duvanlij in Thrace, through Trebenište, Glasinac, and Vače, and all the way to Vix in Gaul, extends a cultural belt characterized by rich princely graves: the entire area had witnessed a rapid upsurge of the local Thracian, Illyrian, and Celtic tribal aristocracy. It was only a question of which one of these great ethnic groups would take the lead and offer resistance to the menacing growth of Greek and Roman civilization. The lot fell to the Celts.

The Celts arrived in the Danubian area about the middle of the fourth century B. C. but settled on Yugoslav territory somewhat later, probably only toward the end of the fourth or in the early decades of the third century. The indigenous population was at this time torn between the Celtic and Hellenic cultures, two utterly different but equally powerful influences. Consequently the initial phase of the late Iron Age on Yugoslav territory was characterized by three cultural trends: the Celtic in the wider Danubian area, the Illyrian in the interior, and the Hellenic along the Adriatic coast.

The Celtic, or La Tène, culture was far superior to the indigenous. As a result, even those areas never occupied by the Celts found themselves in the sphere of Celtic cultural *Fig. d* and economic influences. The Celts brought with them many skills and practices acquired from the Greek civilization which had embraced the Adriatic coast somewhat earlier: the building of urban settlements, the use of money for trading, the use of the potter's wheel and of complicated technological procedures in metalwork. Even as the first contacts were established, characteristic Celtic forms were contaminated by forms from the indigenous culture. This is illustrated by finds from Čurug: a set of precious silver jewelry *Pl. 89-91* showing an organic merging of naturalistic and geometric motifs in a Celtic-style design. Yet, despite intensified influence from the south, especially from Hellenic towns on the Adriatic coast, the culture of the indigenous tribes now reflected reminiscences only of Mycenaean forms (domed graves, Cyclopean walls) or, exceptionally, archaic ones. This disparity between what was offered and what was taken clearly indicates that even in the period between the fourth and the first century the indigenous tribes in the interior of the country did not enjoy suitable conditions for organized urban life but still maintained

socioeconomic relations that had advanced very little beyond the traditions of the early Iron Age.

Neither the powerful influx of Celtic tribes from the northwest and the north in the fourth century nor the penetration of Hellenic culture from the coastal towns brought forms worthy of replacing the great synthesis achieved in the indigenous art toward the end of the sixth century. Despite their adoption of certain elements of the Celtic style, *Pl. 87* with its love of coloristic effects and the play of light and shade, and the various forms of Hellenic culture, which in Yugoslav territories primarily played a civilizing role, the indigenous tribes remained profoundly attached to their own early mode of artistic expression. They cultivated this even after their incorporation into the mainstream of Roman culture and tended to emphasize it whenever they found it necessary to assert their traditions, uphold their rights, and maintain their dignity in the face of an invader. The faces of the princes immortalized on the gold death masks of Trebenište occur in somewhat altered form on the tombs of the Roman era. Even today their features, reflecting a powerful and independent spirit, may be recognized on the simple tombstones in village churchyards or on the unassuming roadside memorials to the dead.

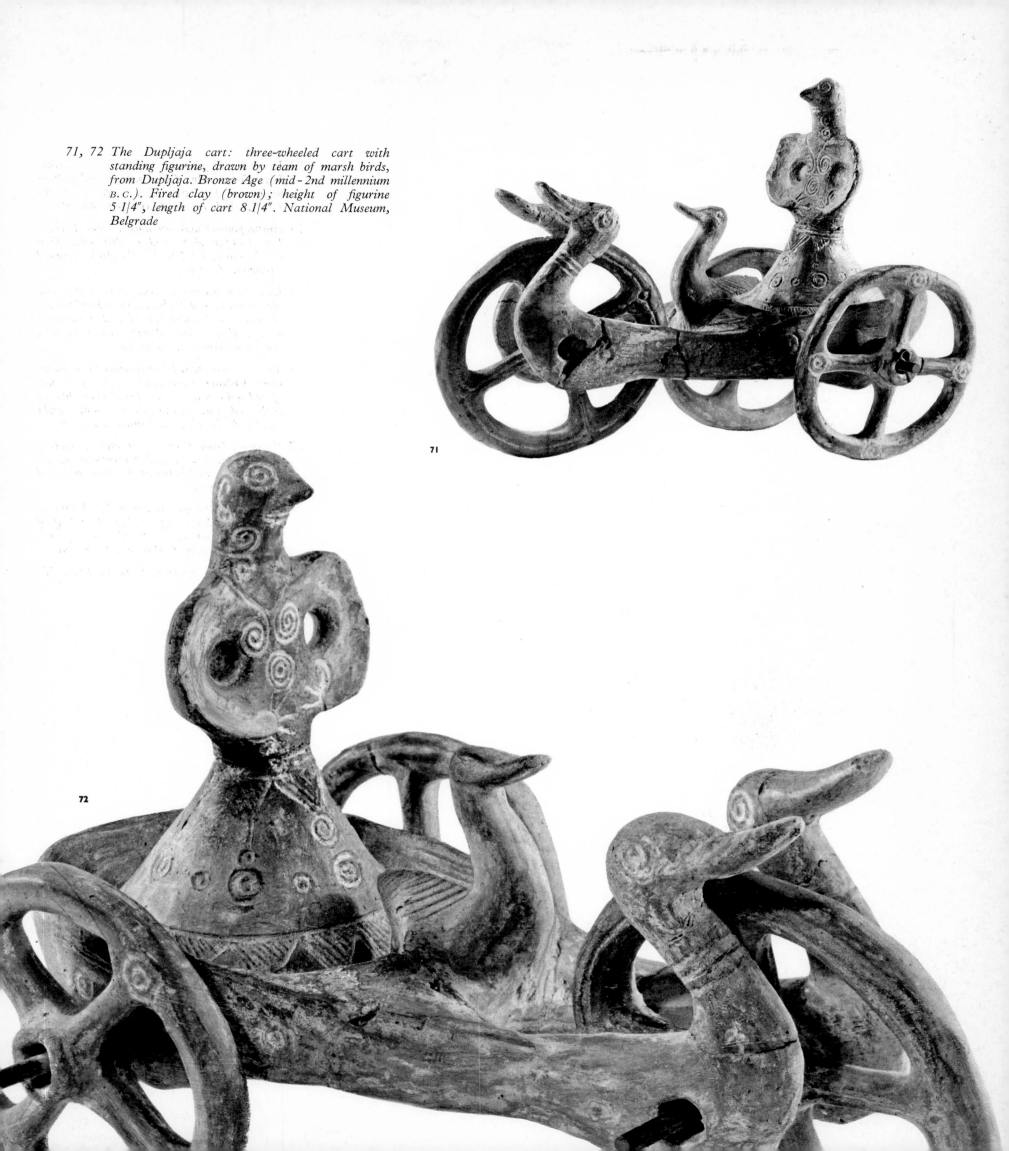

71, 72 The Dupljaja cart: three-wheeled cart with standing figurine, drawn by team of marsh birds, from Dupljaja. Bronze Age (mid-2nd millennium B.C.). Fired clay (brown); height of figurine 5 1/4", length of cart 8 1/4". National Museum, Belgrade

71

72

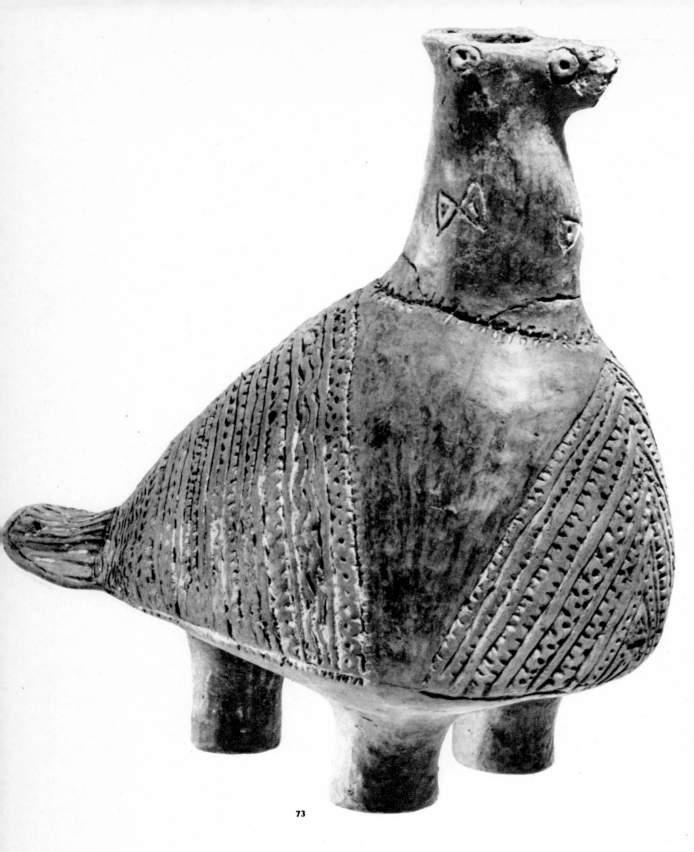

73

73 Vessel in the form of a bird, from Vučedol. Late Copper Age (first half of 3rd millennium B.C.). Fired clay (gray), height 7 5/8″. Archaeological Museum, Zagreb

74 Anthropomorphous ornament, from Progar. Late Copper Age (end of 3rd millennium B.C.). Gold, 3 1/2 × 2 7/8″. Archaeological Museum, Zagreb

75 Urn with geometric ornaments and white incrustation, from Dubovac, near Kovin. Late Bronze Age (second half of 2nd millennium B.C.). Fired clay (dark), height 11 1/4″. National Museum, Belgrade

76 Terrine with incised and incrusted ornament, from Vučedol. Late Copper Age (first half of 3rd millennium B.C.). Fired clay (black) with red and white incrustation, height 8 1/4″. Archaeological Museum, Zagreb

77 Figurine, from Dalj (front view). Mature Bronze Age (early 2nd millennium B.C.). Fired clay (dark), height 9″. Archaeological Museum, Zagreb

78 Anthropomorphous vase, from Ig (Ljubljansko Barje). Late Copper Age (first half of 3rd millennium B.C.). Fired clay (gray), height 8″. National Museum, Ljubljana

79 Back view of figurine shown in Plate 77

74

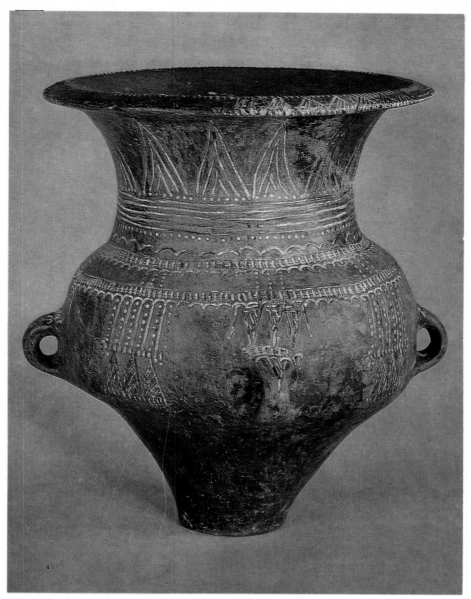

75

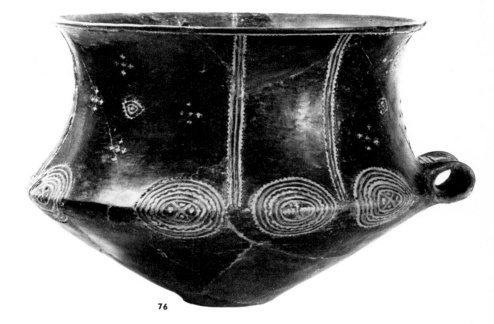

76

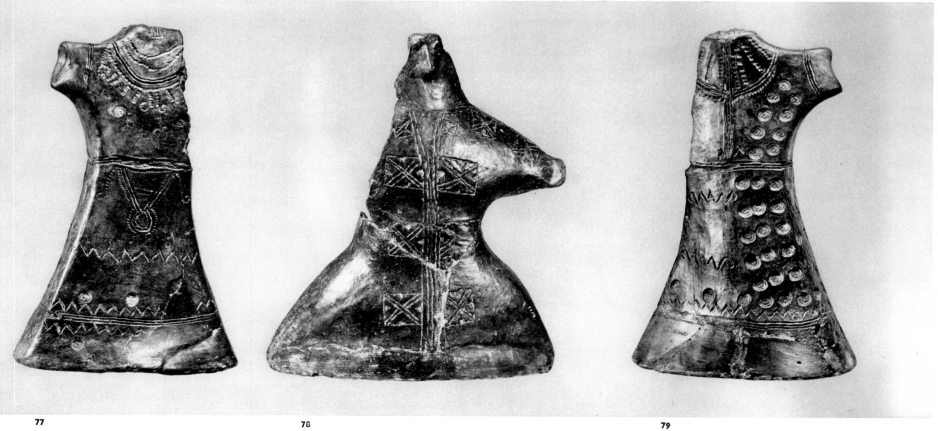

77

78

79

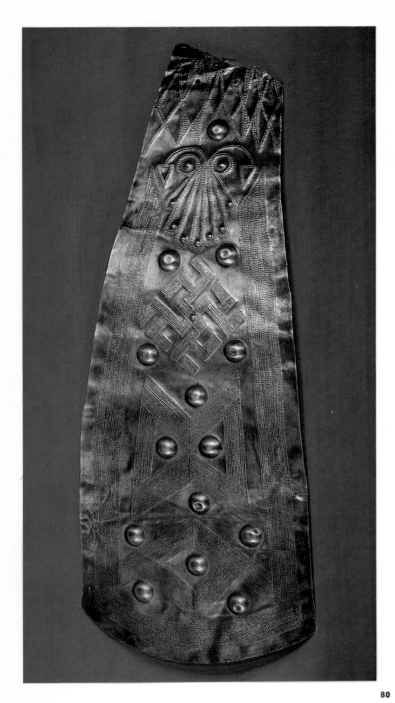

80

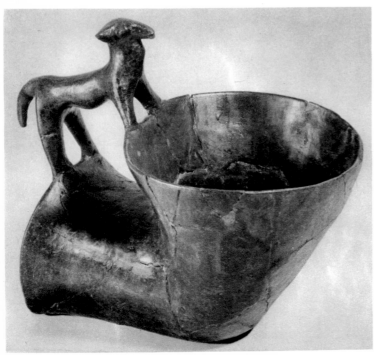

81

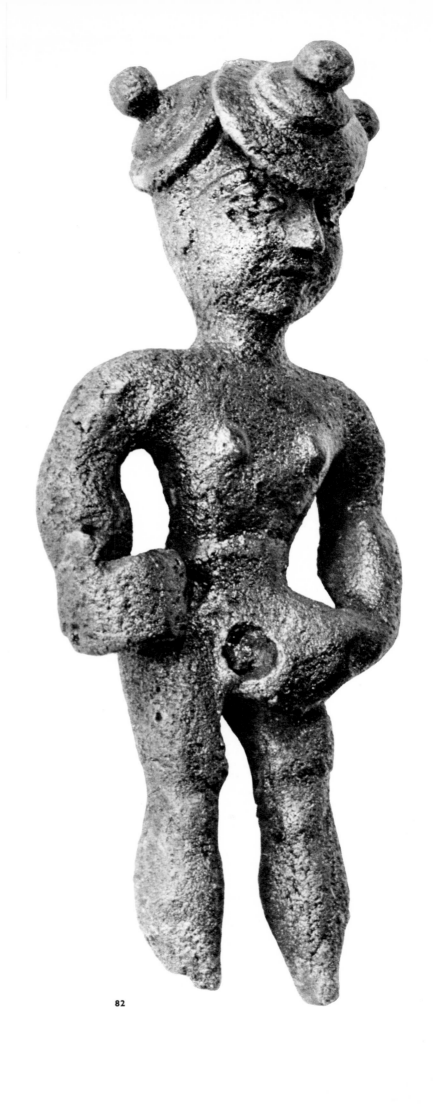

82

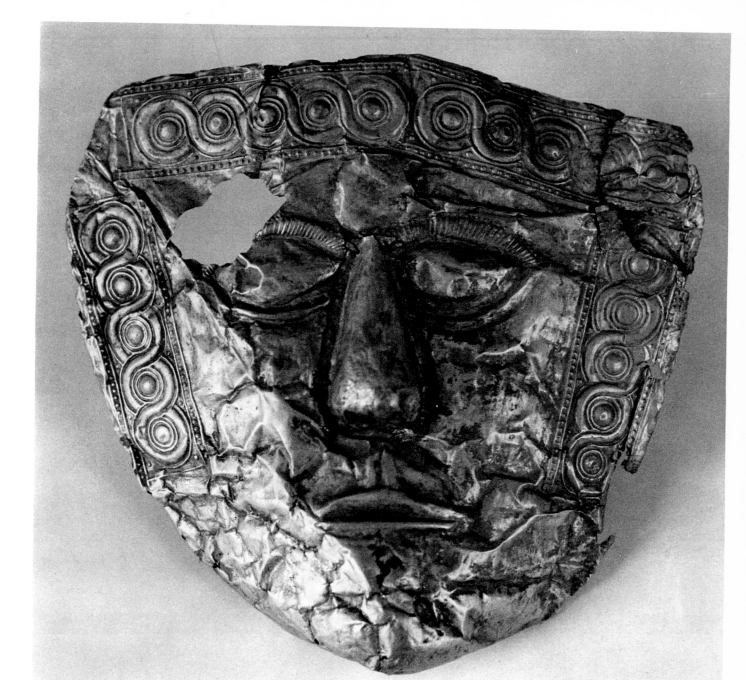

80 *Belt (portion), from Umčari. Early Iron Age (late 6th century* B.C.*). Silver-plated, with embossed ornament; length as shown 17 3/4", width 3 3/8 - 6 7/8". National Museum, Belgrade*

81 *Rhyton, from Dalj. Early Iron Age (c. 600* B.C.*). Fired clay (red), height 6 1/8". Archaeological Museum, Zagreb*

82 *Figur*.*e of an Illyrian warrior, from Vač*.. *Early Iron Age (c. 650* B.C.*). Bronze, height 2 1/2". National Museum, Ljubljana*

83 *Funerary mask, from Trebenište. Early Iron Age (c. 520* B.C.*). Gold, height 6 7/8", width 7 1/4". National Museum, Belgrade*

84 *Sword, from Veliki Mošunj. End of Bronze Age (beginning of 1st millennium* B.C.*). Bronze, length 19 5/8". National Museum, Sarajevo*

83

84

85

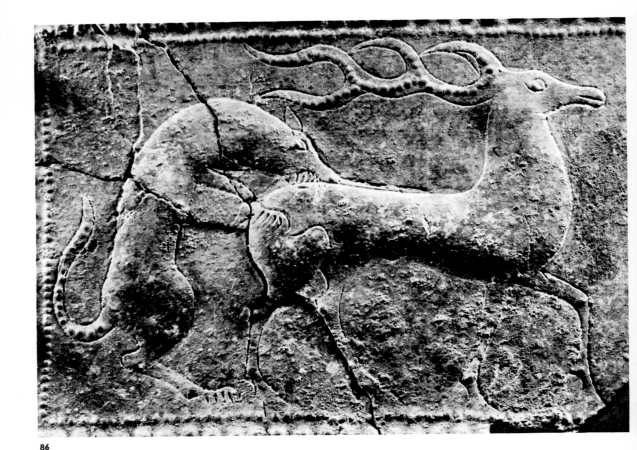

86

85 *Pectoral, from Novi Pazar. Early Iron Age (c. 530 B.C.). Gold, diameter 8 1/2″. National Museum, Belgrade*

86 *Clasp with savage beast attacking a deer, from Zagorje. Early Iron Age (beginning of 5th century B.C.). Bronze, length 8 5/8″. National Museum, Ljubljana*

87 *Fibula, from Jezerino. Late Iron Age (4th century B.C.). Bronze, length 5 1/2″. National Museum, Sarajevo*

88 *Bird (detail of bronze situla), from Vače. Early Iron Age (c. 500 B.C.). Bronze, height of situla 9 3/8″. National Museum, Ljubljana*

89 *Bracelet, from Čurug. Late Iron Age (4th century B.C.). Silver, diam. 2 3/4″, width 1 1/8 - 1 7/8″. National Museum, Belgrade*

90 *Fibula, from Čurug. Late Iron Age (4th century B.C.). Silver, length 4 3/4″. National Museum, Belgrade*

91 *Ring, from Čurug. Late Iron Age (4th century B.C.). Silver. National Museum, Belgrade*

87

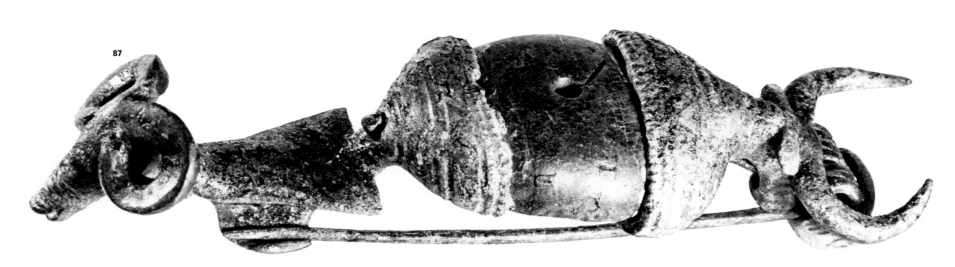

90

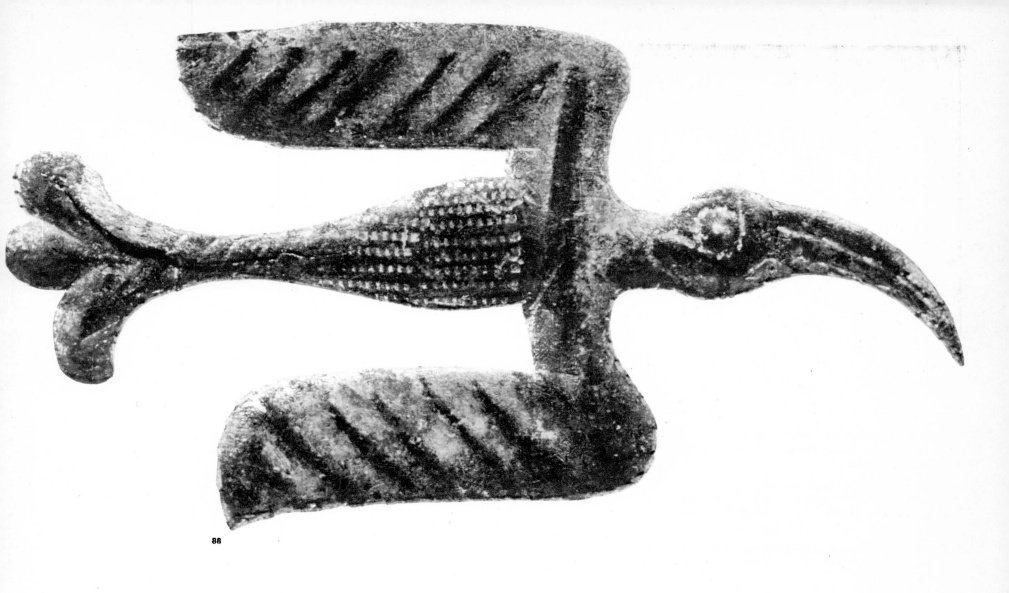

88

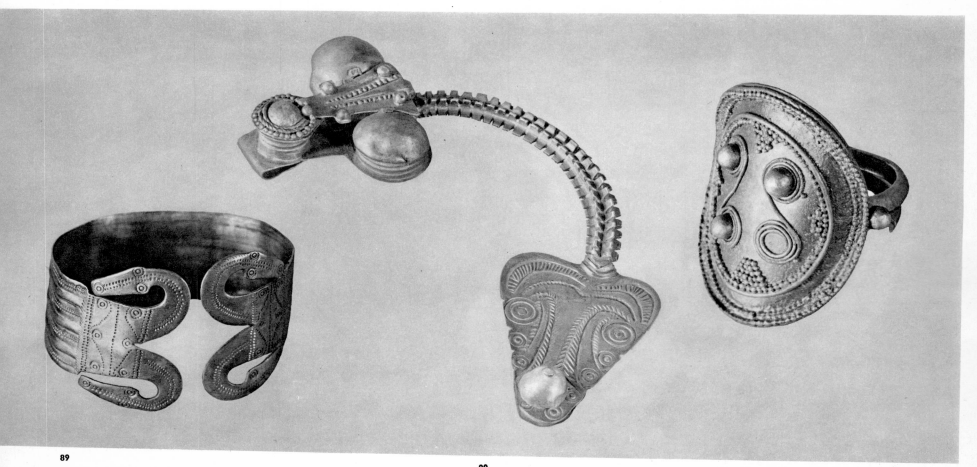

89

90

91

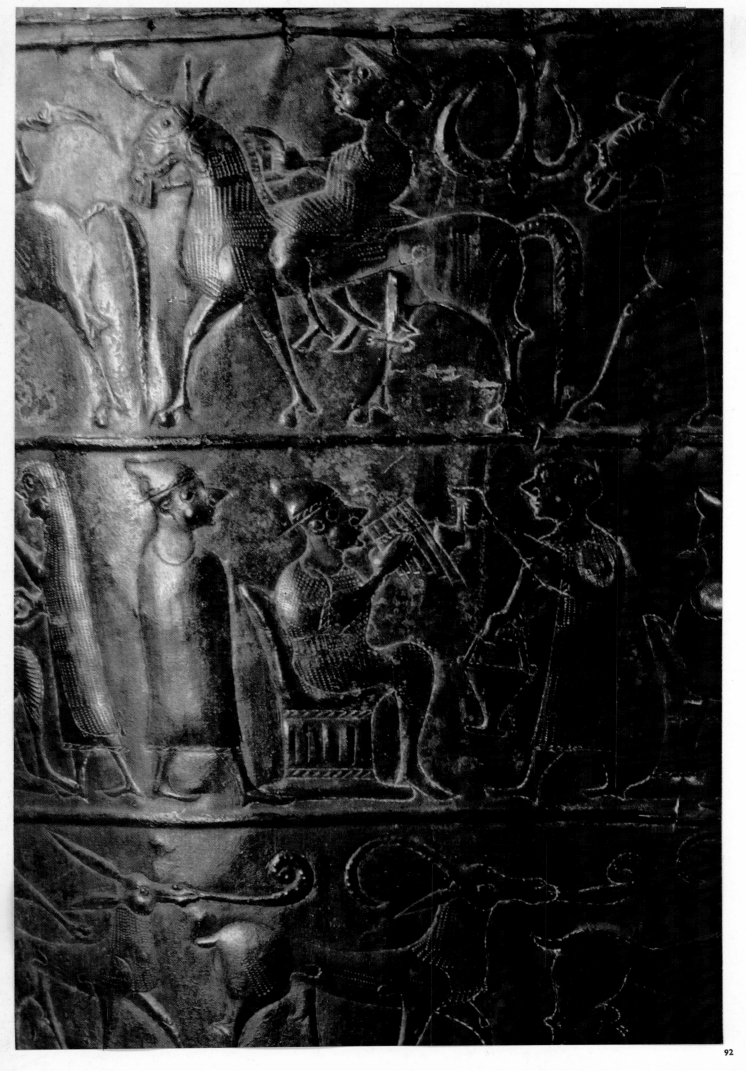

92 *Situla, from Vače (vertical section of front side). Early Iron Age (c. 500 B.C.). Height of situla 9 3/8". National Museum, Ljubljana*

92

# V  THE ART OF ANTIQUITY

Marcel Gorenc
*Curator, Archaeological Museum, Zagreb*

# ANCIENT FIND SITES

1 Graešnica
2 Trebenište
3 Heraclea Lyncestis
4 Lychnidus (mod. Ohrid)
5 Scupi (mod. Skopje)
6 Stobi (mod. Gradsko)
7 Ulpiana
8 Iustiniana Prima (mod. Caričin Grad)
9 Naissus (mod. Niš)
10 Gamzigrad
11 Transdierna (mod. Tekija)
12 Pontes (mod. Kostol)
13 Viminacium (mod. Kostolac)
14 Singidunum (mod. Belgrade)
15 Sirmium (mod. Sremska Mitrovica)

16 Berkasovo
17 Mursa (mod. Osijek)
18 Teutoburgium (mod. Dalj)
19 Bistue Nova (mod. Zenica)
20 Doclea (mod. Duklja)
21 Buthua (mod. Budva)
22 Konjic
23 Aquae S. (mod. Ilidža)
24 Narona (mod. Vid, near Metković)
25 Aspalatos (mod. Split)
26 Salona (mod. Solin)
27 Traugurion (mod. Trogir)
28 Tilurium-Gardun
29 Iader (mod. Zadar)
30 Ribići

31 Kompolje
32 Senia (mod. Senj)
33 Ad Fines (mod. Topusko)
34 Siscia (mod. Sisak)
35 Aquae Iasae (mod. Varaždinske Toplice)
36 Poetovio (mod. Ptuj)
37 Šempeter
38 Celeia (mod. Celje)
39 Rimske Toplice
40 Emona (mod. Ljubljana)
41 Tarsatica (mod. Rijeka)
42 Pola (mod. Pula)
43 Parentium (mod. Poreč)

The art of antiquity in Yugoslavia documents a complex life cycle which left a legacy of artistic achievements, outstanding for their power and originality, created over a period beginning several centuries before the Christian era and continuing until the middle of the first century A.D. Restless striving characterized the efforts to achieve artistic expression in a cultural environment marked by insufficiently firm and determinate geographical and ethnic boundaries. Contrasts of terrain, sharp relief, sea routes and waterways were the typical geographical features that set the great historical scene for the Pannonian plain, Illyria, and the Balkan Peninsula. The art of antiquity may have come to this region by many roads, but the time of its penetration was strictly determined by the rhythm of history in the territories constituting the Yugoslavia of today. The fusion of Illyrian art with the art of antiquity was not a matter of the reproduction and vulgarization of Greek originals or of the mechanical transfer and adoption of ready-made models and goods; it is clear that the Greek colonies were isolated outposts in the stretches of Illyria until the period of Hellenism and the Roman invasion of the Balkans. Indigenous settlements (strongholds, shelters, hamlets, etc.) reflect an originality that can be traced in stages from prehistoric times up to the urban planning of a large number of ancient towns of this region in the period of the Roman Empire. Taking advantage of rich sources of building material and utilizing circular or elongated ground plans in their layout, the indigenous settlements that had developed in the coastal and continental areas of what is now Yugoslavia meshed, in terms of urbanistic conception, with the rectangular lines of the towns dating from the period of the Roman Empire.

Thanks to intensive trading, there are among the wealth of objects left behind by the Illyrians many artifacts that undoubtedly had their origin in archaic Greek and Italic *Pl. 15* art. The very number of these objects, which come from various centers in Greece, Italy, and the Black Sea area, constitutes evidence that this is not a matter of coincidence, while the quality of manufacture attests their selection in accordance with criteria reflecting the taste of the patrons and their milieu. It is also worth noting that the ceramics turned out in imitation of, and at the same time as, the ceramic products of Greece and her colonies are not below the level of the latter. This also holds for metalwork — weapons, personal effects, jewelry, and vessels.

The precious artifacts that have come down to us are significant not only for their number and quality but also for the fact that they represent a creative selectivity on the part of the indigenous population in their choice of articles to be used for special occasions. Motifs are skillfully rendered as representations of heads and figures and as abstract ornament on jewelry worn on such occasions. Characteristic are the graves in Trebenište, *Pl. 93-98* with their wealth of finds, and similar sites in other inland and coastal regions.

As the centuries passed, the Greek colonists, from within their town walls, continued

*a. Helmet, from Berkasovo. 4th century. Gold-plated, embossed, set with imitation precious stones; height 13 7/8". Museum of Vojvodina, Novi Sad*

their efforts to maintain regular connections with their distant homeland. Land and water routes, difficult to negotiate and fraught with risk, were used to transport goods to enrich the social and artistic environment of these isolated towns. Contrary to their own interests, which lay in establishing contacts with potential partners in trade, these towns systematically pursued a policy of dissociating themselves from the native population. From Macedonia to the Adriatic Sea, this was the way of life of Greek and Hellenistic settlements, and it was against this background that figural art — a secondary and individual product — sustained itself.

*Pl. 99, 104*

In the cultural and artistic sphere, growing differentiation was attended by divergence in expression and style; the traditional forms of indigenous Illyrian art did not spontaneously develop toward the ideals and practices of Greek art, to which they had been

closely related in the preceding, archaic phase. Thematically and iconographically the Illyrian art of antiquity discreetly combined the tendency toward abstract and ornamental decoration with the stylized depiction of animals, human figures, and events.

Research has hitherto concentrated for the most part on three aspects: first the determination of the specific archaic style; then the study of the small group of stone urns found in the remote Bihać march; and finally the establishment of the chronology of these finds within the first and second centuries of our era. Formal stylistic analysis has led all researchers so far to the interesting but paradoxical conclusion that, in terms of stylization, these finds reflect elements of artistic expression spanning several centuries and ranging over the entire area from Greece to Britain, from Spain to Denmark.

The archaic stylization of figural and ritual compositions found on the Iapydian stone urns of the Yugoslav regions is usually regarded as having an affinity with archaic Greek art in its broader aspect. We must also consider the fact that the Iapydian urns were discovered on the margins of a highly developed civilization; it would seem logical for such phenomena to result from the stylistic lag that would naturally characterize the artistic practices of a conservative environment.

*Pl. 17, 100, 101, 102*

But we must rule out the assumption that Illyrian stone carvers attempted to imitate Greek artists of the archaic period during the time when Greek expansion was at its peak. The Illyrians had no need of such a specific ritual and representational art, and, furthermore, the Iapydian urns have been found in a small area and date from a period when Greek expansion had as a whole declined in intensity. The question then comes up as to what motivated the Iapydian craftsmen to copy models so far removed from them in time and space. If we assume that they used models which came down to them from earlier periods, we must ask how it is that no objects attesting similar attempts in earlier periods have come to light. Even if there had been a long tradition of using wood for artistic purposes, it would still be virtually incredible that the taste of both patrons and artists should have remained at the same level for several centuries, all the more since other indications for the same period testify that the cultural repertory and artistic taste of the Illyrians and Iapydes changed surely if slowly.

Little effort is needed to ascertain that this artistic manifestation did not occur purely by chance, or under the historical or sociological conditions of a "stagnant" indigenous conservatism. This is a matter of a specific need, conditioned by the life of the times, for monumentalizing the funeral rite, a step which in its own way definitely made a break with accepted tradition. The resolution of this task was not, however, left to chance; it was achieved by methods of artistic manufacture reflecting the living continuity of original traditions and a genuinely autochthonic style, the archaic expression of which was neither a *retardataire* reflection nor an imitation of contemporary Greek or European models but rather a general developmental phase which has not elsewhere left traces in this form.

Just as the phenomenon of this cultural group is a unique one, so its disappearance is the reflection of newly emerged conditions under which representational art in the Yugoslav regions manifested itself after these regions had been incorporated definitively into the Roman Empire.

In contrast to the scattered and sporadic penetration of the Greeks over large areas, the Roman rulers were methodical in forging a system of linked provinces, each of which played a specific military and economic role in the empire. Initially this system was not designed so as to include the indigenous population in the conduct of public affairs. Only if we are aware of these conditions can we grasp, on the one hand, the maturing of certain traditional and artistic enterprises and, on the other, their suppression and gradual disappearance.

During the first century of Roman rule in the regions constituting Yugoslavia the area was broken up into administrative units and a systematic endeavor was made toward

organization, more effort being expended on this comprehensive task than on the establishment of a measured rhythm and style of life. A feeling of stability came to replace the initial insecurity of the individual inhabitants, despite the fact that their incorporation into their environment lagged behind their opportunities for making a military and administrative career for themselves or acquiring wealth.

It is known that during this period many old tribal centers were reorganized and developed into towns to meet the new requirements; traditional experience and solutions were often relied on in the process of adaptation to the new conditions. Craftsmen and tradesmen working in materials suitable for artistic production rapidly grouped themselves around the sources or deposits of such materials. But many requirements, particularly that for luxury goods, were satisfied by importation from other provinces, as was the demand for the works of artists of established workshops. The period is difficult to define in terms of a uniform style, as is most evident from examples of a form of artistic production that was especially congenial to the Roman sensibility — the portrait.

*Pl. 103*

*Pl. 105, 106*

The antagonisms and contradictions characterizing the history of the Roman Empire and the regions of present-day Yugoslavia in the second century continued to be reflected in the representational arts. The social elite of privileged foreign settlers and functionaries expanded to include native landowners, entrepreneurs, and high-ranking administrative officials. The freshness of their outlook lent new life to the variety of official art, leading in some cases to polarization, in others to a synthesis of the accepted and the new principles and forms.

The century got under way with the great triumphal conquests of Trajan and Hadrian, who expanded the empire to unprecedented dimensions. Within its bounds, the Pannonian legions and the miners and metalworkers from Dalmatia (which then extended all the way up to western Serbia) represented all that is conveyed by the concepts of self-determination, loyalty to the state, and professional skill. All these qualities were taken full advantage of in the great undertakings launched during the first half of the century.

*Pl. 107, 108*

Particularly outstanding during this period was the work of a stone carvers' and sculptors' workshop which, utilizing marble from the Pohorje, functioned on the border between what was then southeastern Noricus and southwestern Pannonia (now Štajerska and western Croatia).

A quantity of art works produced by this workshop were recently excavated at the ancient cemetery in Šempeter, near Celje, the Celeia of antiquity. The cemetery had been ravaged by the Savinja River in flood, probably in the middle of the third century, and until its recent discovery had been covered by a thick layer of deposit and gravel. Outstanding among the tombstones and shrines that have been unearthed and reconstructed are a rectangular marble cinerary chest with a relief of Heracles and Alcestis, and the funerary monument of the Ennius family, with family portraits and a panel with the Rape of Europa. The products of this workshop reflect a gradually changing artistic approach to the work commissioned by patrons (who either specified what they wanted or submitted models to be copied). It is equally interesting to note how perfection was attained in the working of materials and how freedom from rigid clichés and an increasingly imaginative craftsmanship were achieved. The resulting authenticity and originality were the effect not of coincidence but rather of the cooperation of a considerable number of master craftsmen, of the division of labor among them, with specific tasks assigned to specialists, and above all of the enthusiasm engendered by the opportunity to create freely.

*Pl. 110, 108, 109*

The flowering of this form of expression may be traced in a variant of the motif of the Rape of Europa in Šempeter — the relief from the nymphaeum at Varaždinske Toplice (anc. Aquae Iasae), in which the mythological subject sheds all theatricality and the maiden Europa becomes the personification of youthful freshness and simplicity. Although we may not be able to ascertain the exact site of the workshop (in any case a matter of

*Pl. 114, 112*

secondary importance), it is essential to perceive and grasp fully its organizational and creative originality. Within the context this workshop afforded, Italic, Aquileian, and Pannonian-Noric traditions provided only the framework for the spontaneous development of expressive power on the part both of individuals and of the entire group. It was a disaster that the plague and the devastation wrought by the Marcomannic War during the rule of Antoninus Pius, Lucius Verus, and Marcus Aurelius interrupted, along with everything else, the activity of this workshop, for its achievement could neither be renewed nor repeated afterward.

From the middle of the second century on, and into the third, there were adequate grounds, both human and historical, for the paramountcy of realism, restraint, and contemplation. These elements could not but find expression in the psychological approach discernible in many of the contemporary portraits. The girl's head from Solin demonstrates, *Pl. 115* by the most simple and eloquent formal means, how convincing the artistic creator could become. In this case, as in others, he renders the conventional female coiffure of the period but gives it just enough attention so that the barely suggested, skillfully modeled strands and waves bring out the contrast between the richly nuanced sculptural treatment of the details of the face and its pervasive individuality. The form of the forehead is discreetly emphasized by the gently curved arches of the eyebrows. The suggested animation in the cheeks, the rhythm created by the relation between the tip of the chin, the oval of the lips, and the (unfortunately now damaged) projection of the nose, all combine to create a very personal expression. The portrait impresses us as a fusion of elements bespeaking the masterly stylization of naturalistic detail, transformed through the creator's talent into a new artistic reality.

The intensity of the pulsebeat of the urbanized settlements, towns, and rural estates in the areas of the Roman Empire included in present-day Yugoslavia is remarkable in view of their number and their distribution throughout certain provinces and also in view of the functions they discharged. It should cause no wonder that there developed within them activities which, through reciprocal influences, shaped their profiles not only in terms of economy and production but of town planning and architecture. Before focusing on individual examples, however, it is worthwhile to point out the rather characteristic functions of imperial settlements in the various regions. Some of the settlements in what are today Bosnia and Serbia were mining centers whose products were sent far afield for manufacture at distant processing points. The mining basin of northwestern Bosnia gravitated toward the great production center of Siscia (mod. Sisak), whereas the products of eastern Bosnia gravitated toward Sirmium (mod. Sremska Mitrovica). Both the foregoing towns are situated along the east-west route from Tergeste (mod. Trieste), via Emona (mod. Ljubljana), to Singidunum (mod. Belgrade) and eastward along the Danube. This ancient transcontinental route was extended northward by connecting roads and by the equally ancient routes of the Drava basin linking the rich farmlands of southern and northern Pannonia with the well-known centers of Poetovio (mod. Ptuj), Iovia (mod. Ludbreg), Mursa (mod. Osijek), Teutoburgium (mod. Dalj), via Acumincum (mod. Stari Slankamen) and — again along the Danube — with Belgrade. Along these routes a continuity with pre-Roman settlements was preserved, as was the Roman frontier *(limes)* in various phases of its emergence and functioning.

This vital politico-military system of roads was completed westward by a branch of the ancient amber route connecting Istria with Parentium (mod. Poreč) and Pola (mod. *Pl. 22* Pula), via Tarsatica (mod. Rijeka), Senia (mod. Senj), Iader (mod. Zadar), Salona (mod. Solin), Narona (mod. Vid, near Metković), and Epidaurus (mod. Cavtat), and with the densely populated areas bordering the Gulf of Kotor and Butua (mod. Budva), and not only linking north with south but shunting trade and traffic from the southwestern part of ancient Bosnia and Herzegovina toward the administrative centers on the eastern

Adriatic littoral. The eastern north-south route ran along the valleys of the Morava and the Vardar, providing an outlet for the mining and farming districts of Serbia, Kosovo-Metohija, and Macedonia, and linking them with many settlements, among which the best-known were Transdierna (mod. Tekija), Viminacium (mod. Kostolac), Horreum Margi (mod. Ćuprija), the castrum in modern Gamzigrad, Naissus (mod. Niš), Iustiniana Prima (mod. Caričin Grad), Ulpiana (near Gračanica), Scupi (mod. Skopje), Stobi (mod. Gradsko), Heraclea Lyncestis (near mod. Bitola), Stena (mod. Demir Kapija), Lychnidus (mod. Ohrid) on the shore of Lake Ohrid, and Doclea (mod. Duklja) to the west, near Titograd.

The now vanished defensive bulwarks and the ravaged public buildings, squares, and cemeteries once harbored workshops wherein labored weavers, carpenters, woodcutters, metalworkers of various kinds, potters, glassblowers, and other artisans and artists whose craftsmanship has long since been a thing of the past. As has been suggested, the founding of towns was one of the fundamental features of Roman civilization. In Roman town planning, based as it was on the application of the grid layout, a certain monotony was inevitable in the symmetrical disposition of streets and squares and the architecturally grouped masses of the colonnaded buildings. As arcades were erected to enclose squares, to run along streets, or to frame the peristyles of the courtyards of houses and mansions, the intercolumnar space, which initially represented perforation of the wall mass, also, *Pl. 118, 119* because of its repetitive rhythm, gave rise to the need for representational sculpture of a public nature. This development was not a feature specific to these regions but rather reflected a reliance on generalized models of imperial architecture, which, since it took as its point of departure the sunny Mediterranean clime, had, in the continental and northern zones of the territory of present-day Yugoslavia, to be adapted to the economical retention of heat in wintertime, as well as to the desire for satisfying the principle of representation.

Consequently the architecture of the continental regions soon began to display a tendency toward the contraction of freestanding columns into half-columns and pilasters, the rhythm of which was designed to relieve the monotony of facade surfaces while strengthening the structure of the walls and breaking up the architectural mass vertically. This tendency is reflected particularly in the construction of public baths and in the installation of heating in urban houses and mansions. Functional considerations made it necessary to refrain from additive repetition of rectangular spaces in the ground plan and to substitute interlinking and recessed combinations of semicircular or segmented architec- *Pl. 123* tural members. The new approach to the organization of space based on strengthened walls made it possible to construct rounded or hemispherical vaults.

On the Adriatic coast — from the capital city of Salona to the smaller administrative and municipal centers — owing to the climate, the continuity of tradition, and contacts with the Mediterranean area at large, urban architecture developed for several centuries without interruption. The construction of Diocletian's Palace not far from Salona, in what is now the city of Split, marked a new situation that had momentous repercussions, throughout the whole empire, on production and the economy, while also representing a creative turning point in city planning and architecture. Without going into detail as to why the emperor chose this particular site for the construction of his palace, and ruling out fortuitous factors for the moment, it must be admitted that the spot was well chosen from the standpoint both of access and of the proximity of ample sources of excellent building stone, particularly the island of Brač.

The layout and dimensions of the palace certainly owe their inspiration to the East. Research has established the participation in its construction of craftsmen from the Eastern provinces, where Diocletian had once lived and where he had also commissioned large-scale projects. The idea of a well-defined and representative palace containing the richly

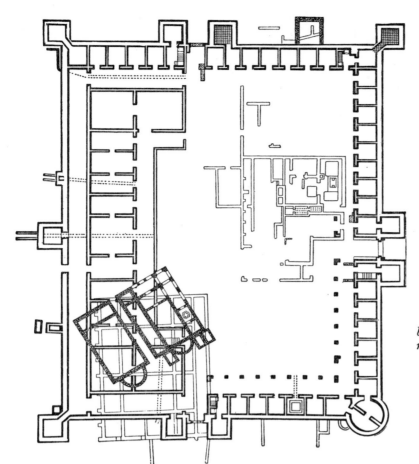

*b. Ground plan of ancient villa at Mogorjelo, near Čapljina. 1st-5th century*

appointed apartments of the imperial household, cultural and ritual centers, and a mauso-leum (conceived of not only as the final resting place of the emperor but also as the temple where he was to be worshiped as a divinity) is redolent of the East. Be that as it may, this complex and intricate task was handled with a great deal of originality and the application of many fresh creative concepts. The abundantly recessed areas of the palace substructure *Pl. 121* were covered with unusually inventive vaulted constructions. It is these quarters that fill in and supplement our image of the upper parts of the palace, which have either vanished or suffered damage over the centuries. The peristyle of the palace, with its portico and *Pl. 21, 122* flanking colonnades, represented an integral urbanized area, designed for the public ven-eration of the ruler. The architectural approach to the function of the portico was derived in the original from the simple and consistent implementation of the idea of integrating the architraves of the two flanking colonnades and linking them organically with the archi-trave of the portico, which, as the background for the tribune, surmounts the supporting columns of the single sculptured archivolt of the gable. This monumental and sculptural emphasis on space was brilliantly implemented in the open-air areas of the palace. A unique union of the functions of volume and relief was achieved in the dome of the mau-soleum and the architectural-sculptural design of its interior. The dome does not appear to place any load at all on its base, from which columns and colonnettes rise freely, betraying no hint of their supporting role but rather, by the carving of their shafts and capitals, suggesting soaring verticality to the greatest possible degree, enhanced by the projection of capitals and festoons.

Particularly in the continental areas of what is present-day Yugoslavia, the climatic
*Pl. 120* and social conditions combined to provide a setting for the rich flowering of Classical
architecture during the Late Empire, from which emerged solutions to the problems of
space and form confirming that in this discipline the creative power of art knew no stag-
nation or decadence such as was formerly, and erroneously, ascribed to Late Antique art.
It is also interesting to note that the conception of the country mansion with defensive
walls and towers is found, in general contour and ground plan, not only in the well-known
*Fig. b* architectural composition of the great villa at Mogorjelo but also in modest Pannonian
structures of the same type.

The wealth and variety that graced architectural expression extended to other artistic
disciplines, also concentrated in and around particular centers or areas whose geographical
location or local productivity favored such development. The continuity in the functioning
of certain workshops and in the work of their craftsmen under increasingly unstable gen-
eral conditions reflected a growing tendency toward standardization and made it possible
for life in all its variety to find adequate expression in a multitude of subjects and methods
of artistic treatment. The view that the art of the Late Antique period was the expression
of a unified artistic trend has been modified as new monuments affording greater insight
into the entire civilization and art of the period have come to light and been fully inter-
preted. Late Antique and Early Christian art flowered in a unique atmosphere of conflicting
beliefs, knowledge, and activities, in which traditional forms of paganism, Mithraism, Chris-
tianity, and various other religious sects and philosophical schools — with their fanat-
icism, liberalism, exclusiveness, or refined skepticism — were restructured and inter-
woven.

The richly wrought and decorated front of the well-known sarcophagus from Solin
*Pl. 125, 127* with the relief of the Good Shepherd solves the problem of discreetly conveying Christian
symbolism in a manner that unequivocally demonstrates the relative importance, to the
craftsman and the patron, of the motif of Christian belief and the desire for posthumous
representation of the family of a powerful personage. On the sarcophagus from Solin
*Pl. 124, 126* decorated with the relief of the Israelites Crossing the Red Sea the multifigured motif
is presented against an abstractly flat background by the emphatically schematic arrange-
ment in parallel zones of figures of a certain height and specific head movement. The
portrayal of the horses rearing as they drown gives the impression of immediacy. The
entire scene is observed by three Nereids, personifying the waves of the sea.

As a result of its size and continuing importance over a number of centuries, Salona
*Pl. 111, 113, 116* afforded many generations of artists and artists' workshops the possibility of uninterrupted
activity, whereas other towns and regions experienced discontinuity of creative effort
or the sporadic appearance of talented individuals and well-organized workshops. Initially,
Siscia (mod. Sisak) imported stone carvings from as far away as the Pohorje; later, local
stonecutters set up their own workshops. Siscia's ceramic products were also known and
were marketed far afield. Mention has already been made of the importance of this center
in metal processing, including the production of fibulae (brooches), sculptures, and above
all coins (the mint there produced money bearing its own mark or stamp). While Siscia
was outstanding in late antiquity as a creative center, Poetovia (mod. Ptuj) was a typical
*Pl. 117* garrison town, and as such contributed to the spread in popularity of the Mithraic cult
with its shrines and votive monuments. In some of the monuments local craftsmen, relying
on the rich Mithraic repertory, fashioned extremely original compositions; in certain
cases the details show that the occasional similarity between Mithraic and Christian themes
was not at all a coincidence but emerged rather as a deliberate combination.

Iovia (mod. Ludbreg), situated on the Drava, has yielded data indicating, subject
to further research and systematization of available information, that it was a center for
the forging and working of metals. Mursa (mod. Osijek) was a vigorous stonecutting

and stone-carving center, whose products are among the monuments from Cibalae (mod. Vinkovci). A sudden and exceptional upsurge of artistic energy in late antiquity was experienced in Sirmium (mod. Sremska Mitrovica), to judge from the large and imposing architectural monuments unearthed there; the wealth of other finds connected with everyday life and the arts reflects the vitality of this large center and accords with the fact that it was at one time the seat of the government of the entire Roman Empire. Its established connections and its traditions of metalworking, which entered into its production of weapons for the Pannonian legions, were certainly the grounds for founding an imperial mint there, an establishment whose fate was affected by the unrest plaguing not only this town and province but the entire empire. It is interesting to note the popularity in this period of mineral springs and baths, the best-known among which were at Aquae Iasae (mod. Varaždinske Toplice), Aquae S... (mod. Ilidža), present-day Rimske Toplice, and Ad Fines (mod. Topusko). (The theory that Split was selected as the site of Diocletian's Palace because of the nearby sulphur springs has recently come into increasing favor.) In the aforementioned localities and towns, and in others as well, wall paintings and mosaics have been found side by side with noteworthy architectural and sculptural monuments of all categories. A high level of creative and artistic expression was achieved in all these techniques in the territory under consideration.

In Bosnia and Herzegovina, Late Classical carving stands out for its singular style of flat relief, used for various purposes and portraying a variety of themes. As in the case of the Iapydian urns and other early artifacts, this work cannot be written off as primitive. In large measure the carving on the tombstones, votive objects, and reliefs, although execut- *Pl. 16* ed in a flat style, reveals a wide range of working methods, capacities, and talents on the part of the creators, while at the same time reflecting the taste and the desires of those who commissioned the works.

The frame of the niche on the pillar-shaped tombstone from Zenica (anc. Bistue Nova) *Pl. 128, 129* seems to indicate that the craftsman either did not understand his model or was not capable of reproducing it "correctly." He simplified the ornamental detail and reduced it to the point where it gives the effect of a drawing. Nonetheless it is notable that the rosette on the gable was executed in an emphatically sculptural technique; certainly a similar rosette, symmetrically placed, was embedded at the other end of the gable, in the center of which was a decorative or symbolic composition, now lost. The four pear-shaped, sche- *Pl. 128* matically portrayed frontal heads, with their abstract details, yield little in the way of individual data. On the whole, however, the impression gained is that the persons here portrayed could be differentiated by certain characteristic minor details and thus presumably were recognizable. The note of conviction is heightened by the contrasting background, the unbroken course of the long, narrow, fluted folds of the garments, and the disposition of jewelry and hands on the upper and central parts of the figures. The task of the craftsman was to portray four men making a public appearance in all their finery. The sentiments of the times dictated that this was the way civic virtue, and perhaps affiliation with Christianity, was to be brought home to the people.

Given this interplay of psychological and stylistic contrasts, it is no occasion for surprise that the narrative relief with the Mithraic feast, from Konjic, is most abstract in *Pl. 18, 130* approach, from the point of view of both composition and style. All descriptive elements have shed their reality and been subjected to surrealistic transformation by a soaring imagination.

Fragments from the artistic inventory of the still insufficiently explored site of Singidunum (mod. Belgrade) indicate great contrasts in artistic levels, with an intermingling of local characteristics, Eastern elements, and official imperial art. In other settlements and towns of Moesia, along the Danube, as in the interior of Serbia, can be traced the various levels of organized life in late antiquity and of the artistic expression that attended

and enriched it. Incursions by the barbarians, as they either obstructed or completely disrupted normal life, particularly along the Danubian border areas, figure significantly. Owing to its location, Naissus (mod. Niš) was outstanding among the towns of Serbia. Here urban life progressed in an organized fashion; metalworking was especially important, its excellence being accorded official recognition when Naissus was chosen for the location of a mint. As was everywhere the case, the operation of the mint was intimately bound up with the work of carvers, modelers, engravers, and other craftsmen in fine metals. The wider importance of Naissus even in the second half of the fourth century has been further *Pl. 1* corroborated by the most recent discovery of a treasure of silver at Kaiser-August (anc. Augusta Rauricorum) in Switzerland; a finely modeled silver plate from this treasure bears an inscription indicating that it was made by Master Euticius of Naissus.

The bronze head which may be a portrait of Constantine the Great was a predictable *Pl. 132* find in the remains of Naissus. Its artistic level clearly indicates the position and character of official portraits in the first half of the fourth century. It was the function of such a portrait to suggest the dignity and exceptional qualities of the personage portrayed, thereby elevating him above the ordinary rank and file — a depersonalization alien to the modern temper but understandable in the context of a time of crisis when the concept of man was suffering a general devaluation. Facing everyday life with distrust and discomfiture, the man of power in late antiquity endeavored to assert himself through the medium of formal monumentality and artificial magnification. In this endeavor the sculptured portrait is one of the fundamental documents attesting the variety and the exacerbating nature of the contradictions pervading the life and art of the fourth century.

The tendency to link the representational with the theatrical is characteristic of the art of the late fourth century, as reflected in articles worked in white bone, niello, and certain *Pl. 133* types of stone. A cameo fragment of onyx from Kusadak shows the figure of a ruler, spear raised, on a rearing horse, surrounded by dead and defeated barbarians. The composition has been executed with such lightness of touch, convincing detail, and expert handling of space that we forget the hardness of the stone, a difficulty the artist had to surmount in order to achieve so living an effect; the work stands in contrast not only to the monumental portraits but also to similar historical or pseudo-historical compositions of the time. It is certainly no exception; rather, it confirms that throughout the fourth century a struggle was going on, in architecture, sculpture, and other artistic disciplines, between two fundamental and conflicting artistic currents, one drawing inspiration from the richness of reality and from its direct representation, the other — mirroring a lack of faith both in man and in the meaning of life — striving to transcend reality by monumentality and abstraction.

The consequences of the hermetic attitude which regards man and humanity in general as lost were necessarily reflected in the art of a time when, owing to the effect of new historical factors, the old social system was disrupted and its world view shattered. And it was not in the old centers but in newly emerged social and political communities that the revival of activity sprang up. What was taken over from the past was the surface brilliance manifested in the decorative and representational depiction of details and in the *Pl. 131* reproduction of visions of another world.

Finally, after all the values of urban civilization, culture, and art had been debased, all that was left was the struggle for day-to-day survival; in this the emphasis was on the *Fig. a* courage and determination of warriors who carried with them everything they owned. The glitter of gold and precious stones was the price paid everywhere for the tribute in blood attending the birth of the new world.

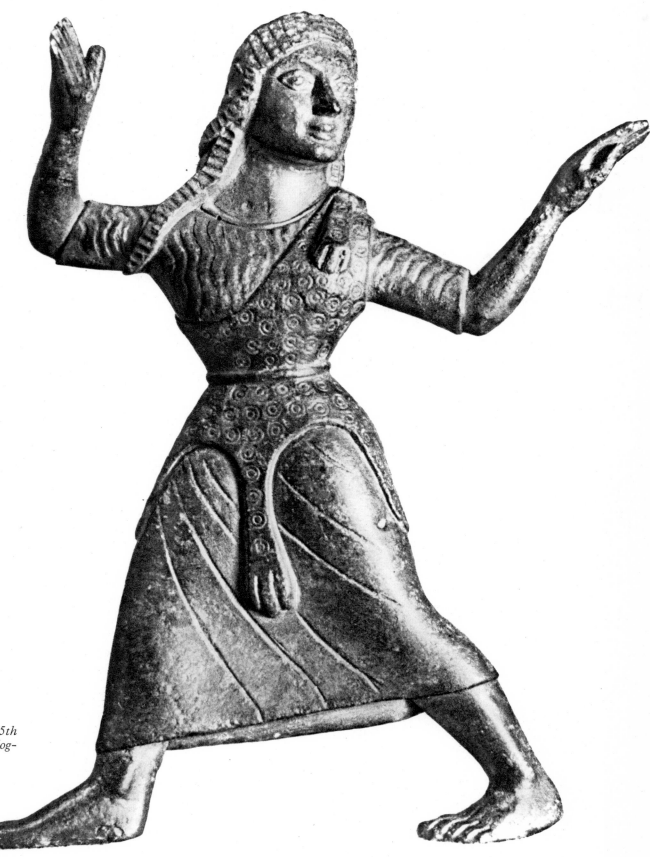

93 *Maenad, from Tetovo. Late archaic (early 5th century* B.C.). *Bronze, height 4 3/4". Archaeological Museum, Skopje*

93

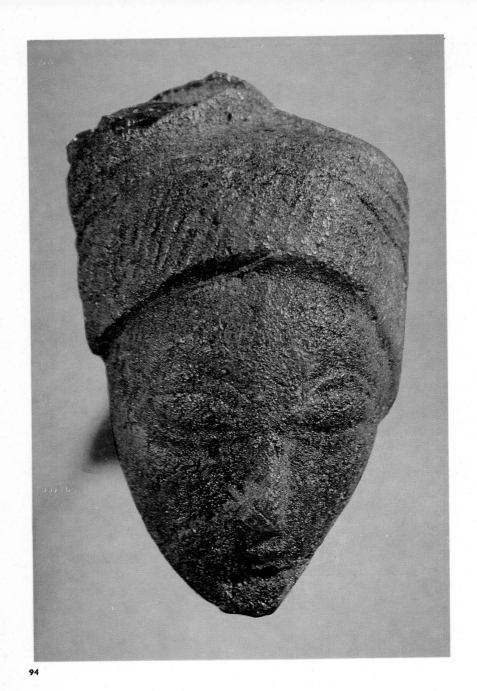

94

95

94 Head of a woman, from the Iapydian cemetery in Kompolje. Late 6th century B.C. Amber, height 1 5/8″. Archaeological Museum, Zagreb

95 Head of a woman wearing a high cap, from the Iapydian cemetery in Kompolje. Late 6th century B.C. Amber, height 1 1/4″. Archaeological Museum, Zagreb

96 Horseman (detail of Plate 97)

97 Volute krater on tripod, from the Illyrian cemetery in Trebenište. Archaic (second half of 6th century B.C.). Bronze, height 28 3/8″. National Museum, Belgrade

98 Horse's head (detail of Plate 96)

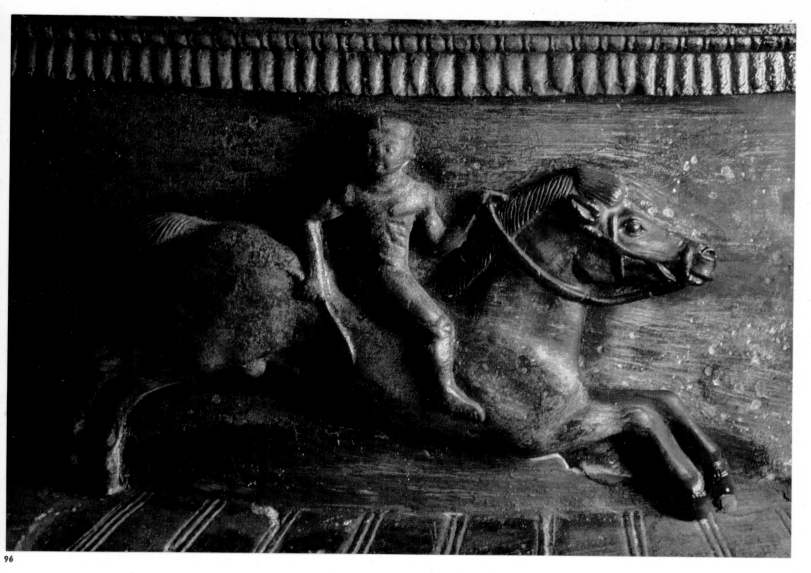

96

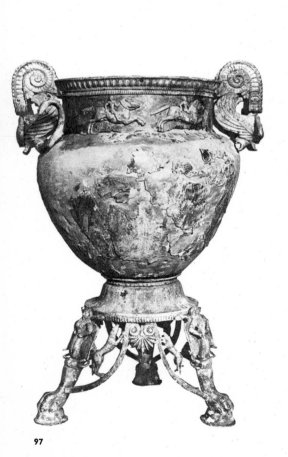

97

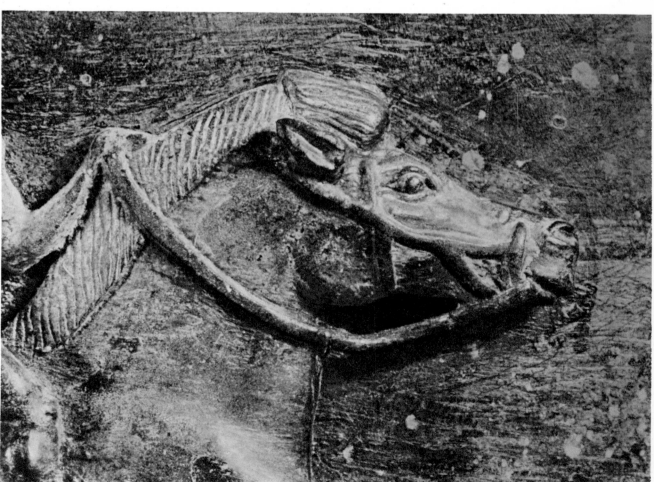

98

99

100

99 *Figurine, from Graešnica. Hellenistic (4th–3rd century B.C.). Terra cotta, height 9 1/4". National Museum, Belgrade*

100 *Women performing rite, relief decoration on Iapydian marble urn from Ribići. Beginning of Christian era. Height of urn, 21 5/8". National Museum, Sarajevo*

101 *Cattle with birds, relief decoration on back of Iapydian marble urn from Ribići (Plate 100)*

102 *Woman with volute krater (detail of Plate 100)*

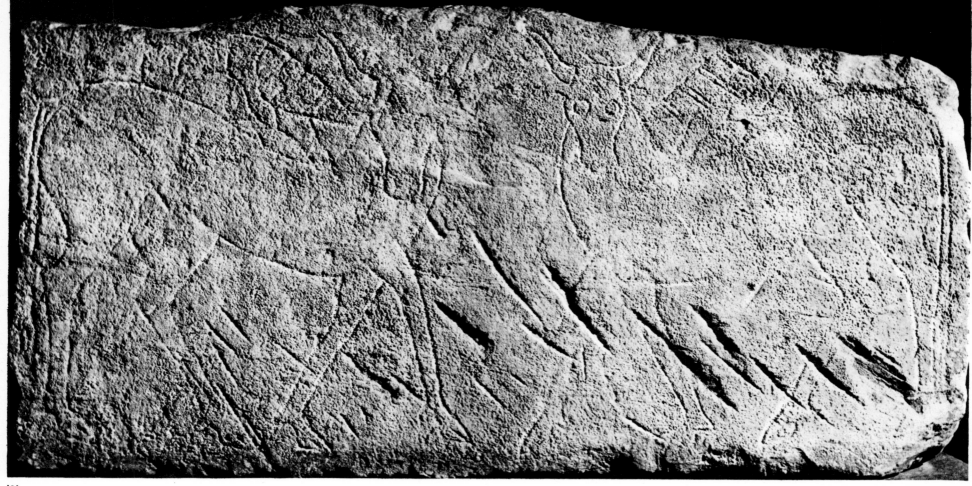

101

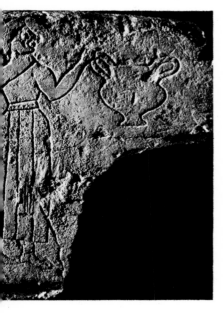

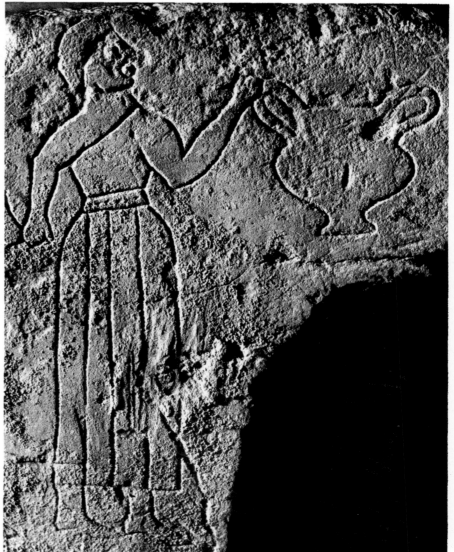

102

103

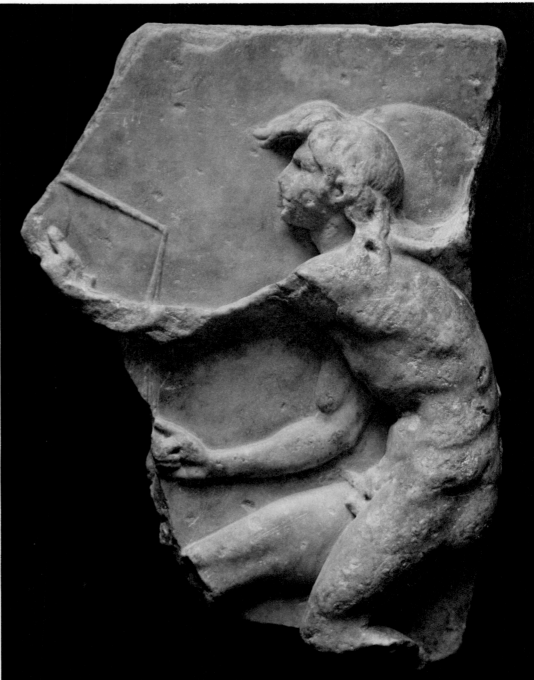

104

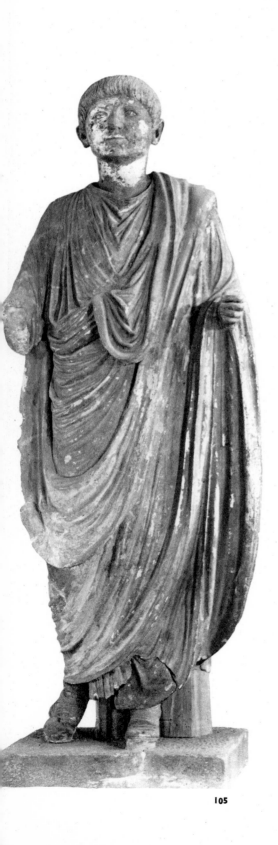

106

103 *Athena Parthenos (detail), from Heraclea Lyn-*
*cestis (near mod. Bitola). Roman copy. Marble,*
*full height 21 1/4". National Museum, Belgrade*

104 Kouros, *fragment of relief from Trogir. 3rd-1st*
*century* B.C. *Marble, height 18 1/4". Monastery*
*of St. Nicholas, Trogir*

105 *Statue of a Roman citizen, from Ljubljana.*
*Early 1st century* A.D. *Bronze with traces of*
*gilt, height 61 3/8". National Museum, Ljubljana*

106 *Head of a woman, from Solin. Middle of 1st*
*century* A.D. *Marble, height 8 1/4". Archaeological*
*Museum, Zagreb*

107

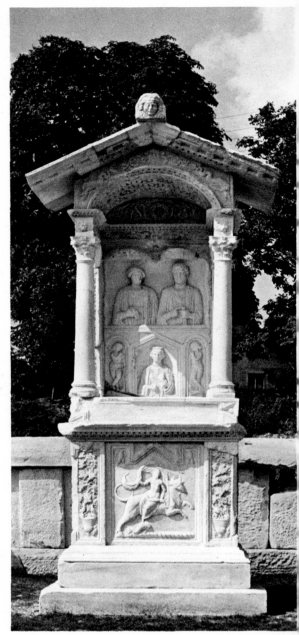

108

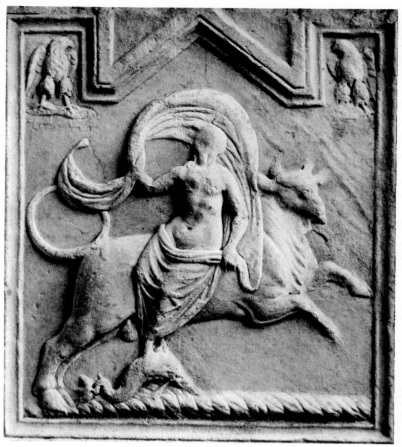

109

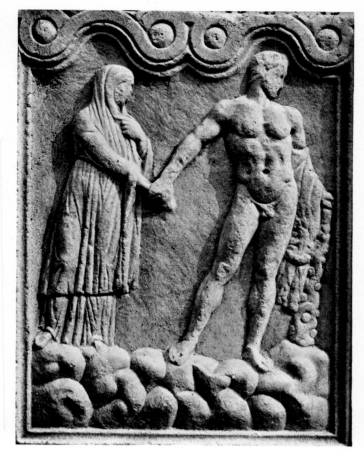

110

111

107 *Head of a man, from Kostol. Early 2nd century* A.D. *Bronze, height 7 1/8". National Museum, Belgrade*

108 *Funerary monument of the Ennius family in the ancient cemetery in Šempeter (restored in situ). First half of 2nd century* A.D. *Marble and limestone, height c. 20'*

109 *The Rape of Europa (detail of Plate 108)*

110 *Heracles and Alcestis, relief on sarcophagus in the ancient cemetery in Šempeter. First half of 2nd century* A.D. *Marble, 19 3/4 × 39 3/8"*

111 *Mask of a parade helmet, from Trstenik. Late 2nd century* A.D. *Bronze, 8 1/8 × 7 3/4". National Museum, Belgrade*

113

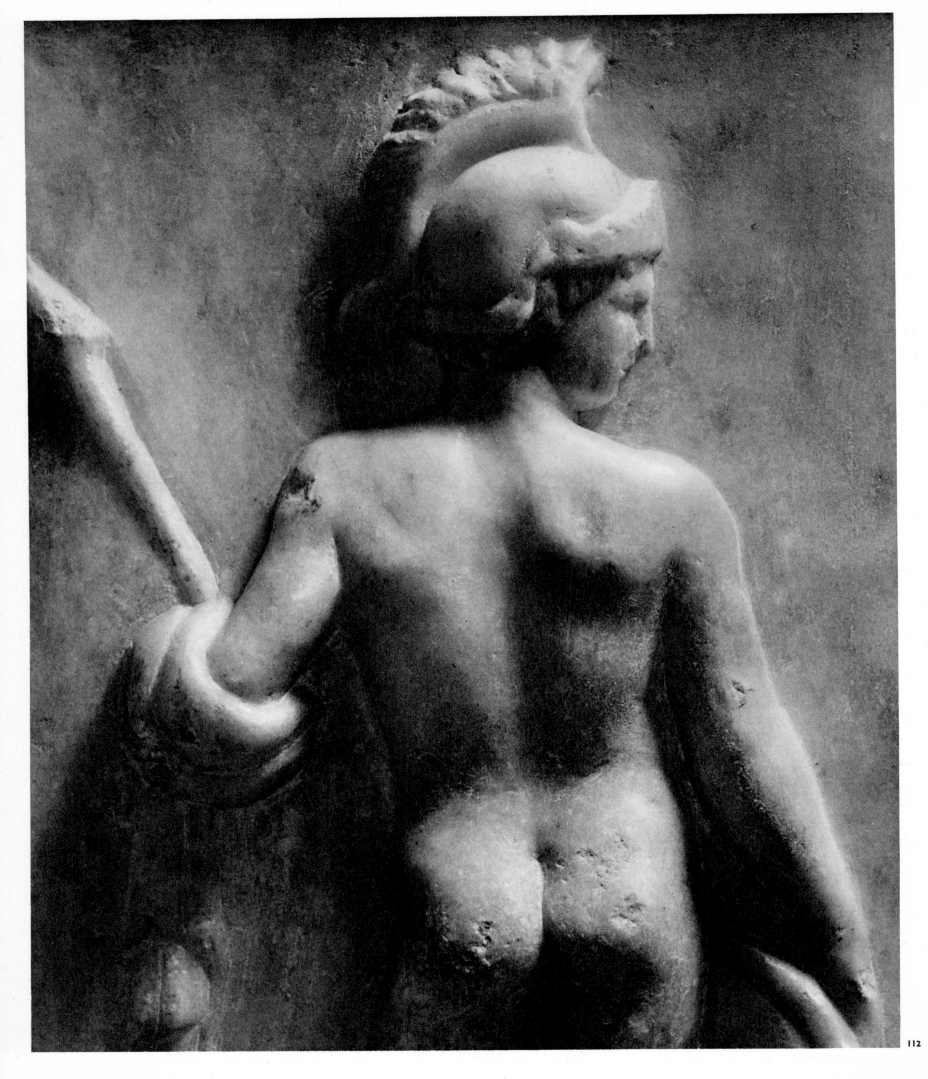

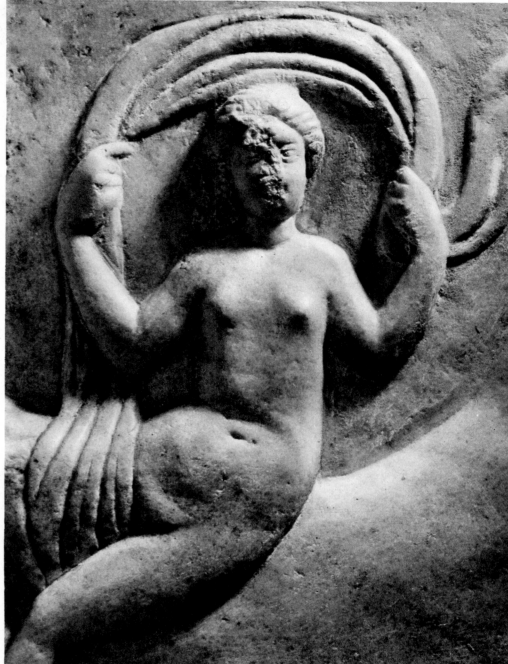

113

114

*112 Warrior, detail of marble relief from the nymphaeum of Varaždinske Toplice. Middle of 2nd century A.D. Museum of Varaždinske Toplice*

*113 Sylvanus, detail of votive relief, from Gardun. 3rd century A.D. Limestone, 11 3/4 × 11 3/4" Archaeological Museum, Split*

*114 Europa, detail of marble relief from the nymphaeum of Varaždinske Toplice. Middle of 2nd century A.D. Museum of Varaždinske Toplice*

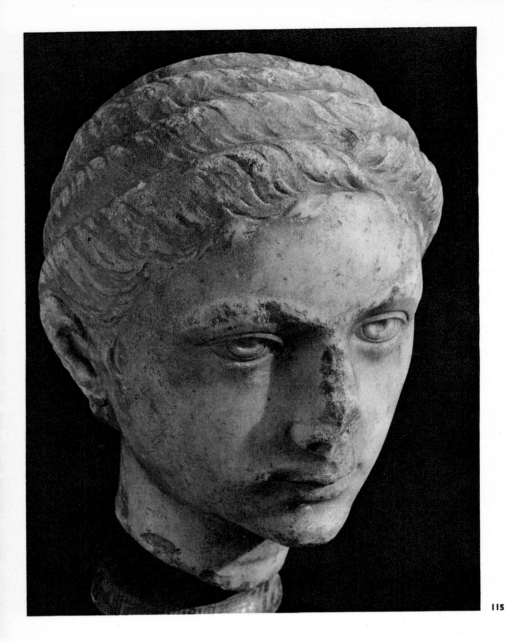

115

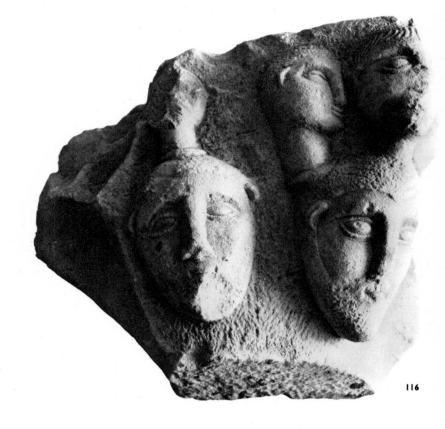

116

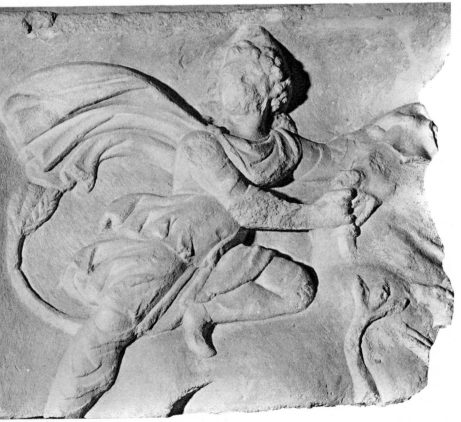

117

115 *Head of a girl, from Solin. Early 3rd century* A.D. *Marble, height 7 7|8". Archaeological Museum, Zagreb*

116 *Fragment with group of heads in high relief, from Topola. 2nd-3rd century* A.D. *Sandstone, 7 1|2 × 10 5|8". National Museum, Kragujevac*

117 *Mithra victorious, fragment of relief, from Ptuj. Late 3rd century* A.D. *Height 20 5|16", width 35 3|16". Regional Museum, Ptuj*

118 *Memorial statue of T. Flavius Orestes. Early 2nd century* A.D. *Marble, height 72 3|4". In situ, Heraclea Lyncestis (near mod. Bitola)*

119 *Peristyle of Partenius Palace in Stobi. 4th-5th century* A.D. *Stone, marble, and brick*

119

118

117

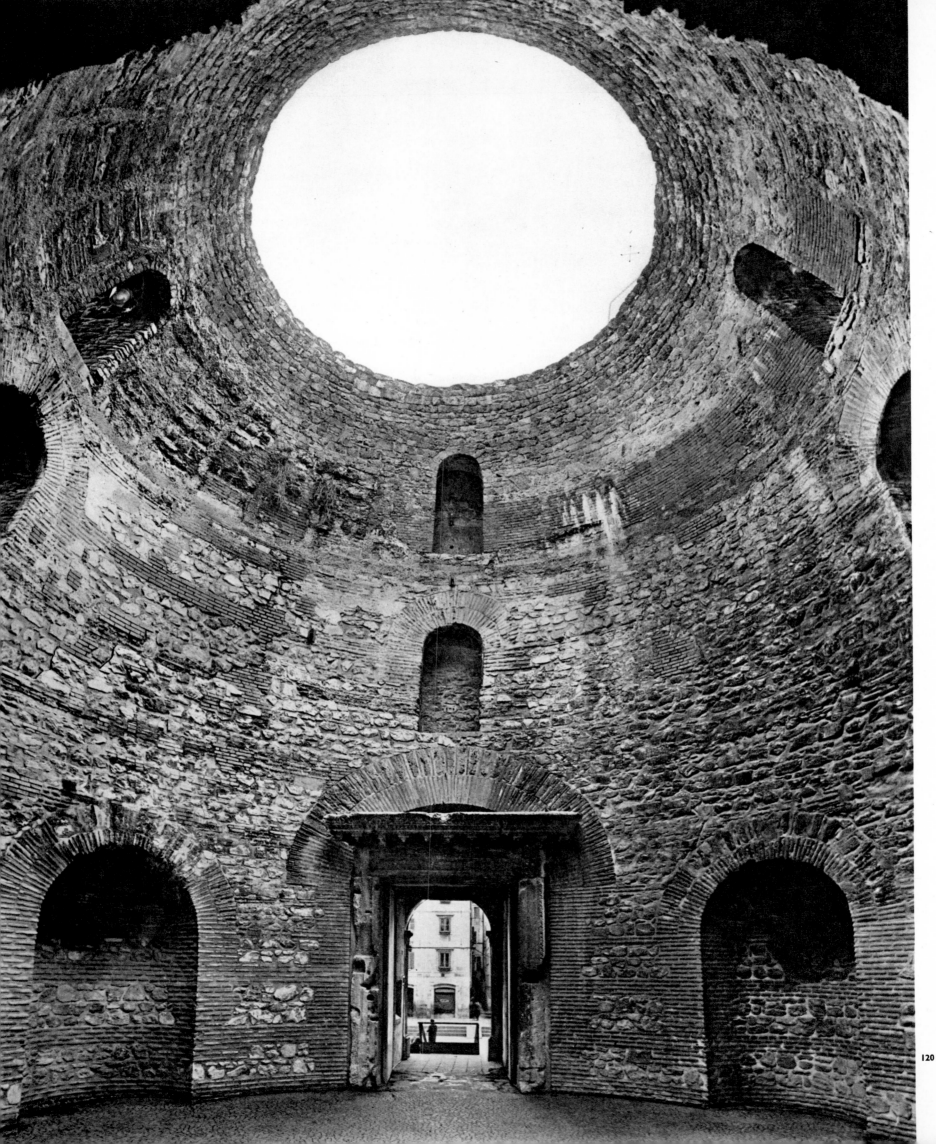

120 *Interior of vestibule, with cupola, of Diocletian's Palace in Split. End of 3rd – beginning of 4th century A.D. Stone and brick (restored)*

121 *Subterranean vaulted hall in Diocletian's Palace in Split. End of 3rd – beginning of 4th century A.D. Stone and brick*

122 *Porch of Diocletian's Palace in Split. End of 3rd – beginning of 4th century A.D. Shafts of columns, Egyptian granite; capitals of columns, and archivolt, Brač stone*

123 *Palace with baths in Sremska Mitrovica (anc. Sirmium; restored in situ). 3rd-4th century A.D. Stone and brick*

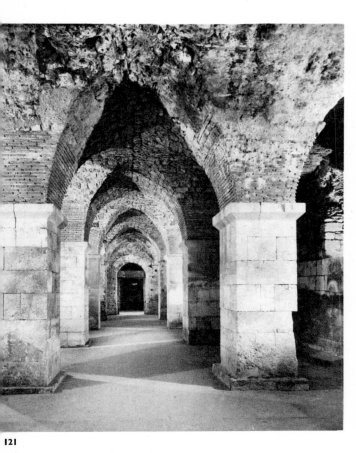

121

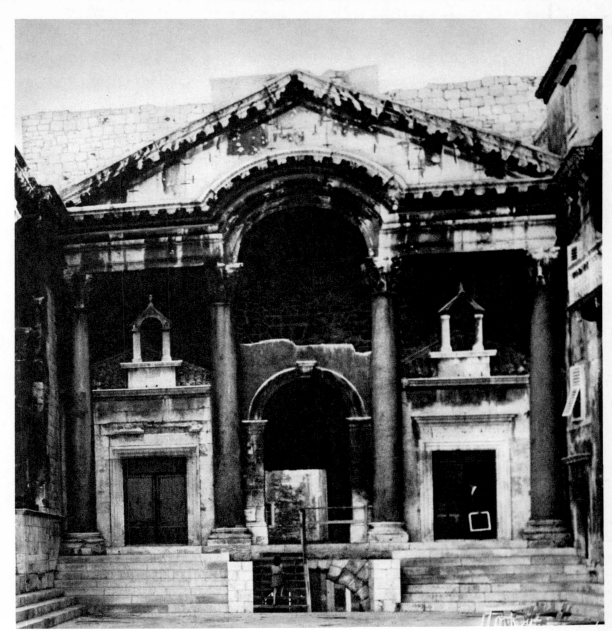

122

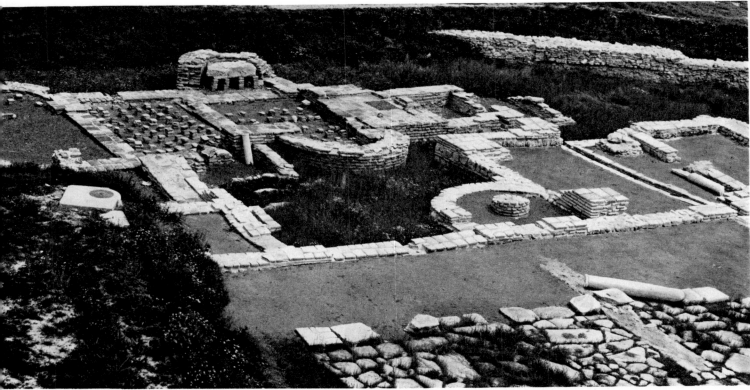

123

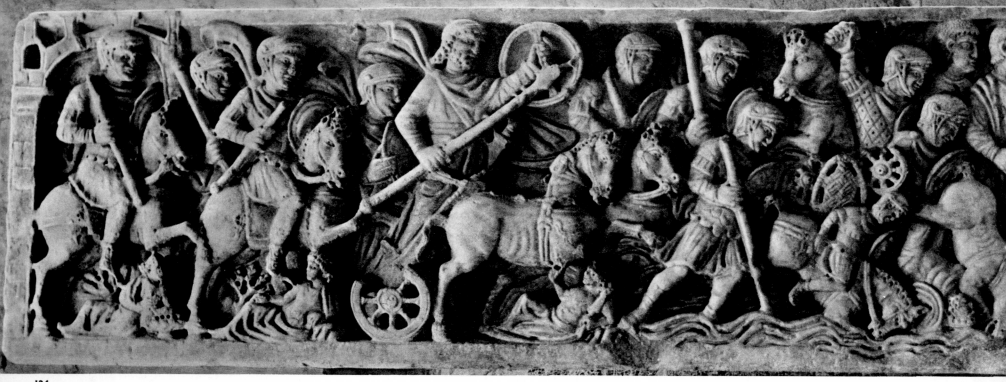

124

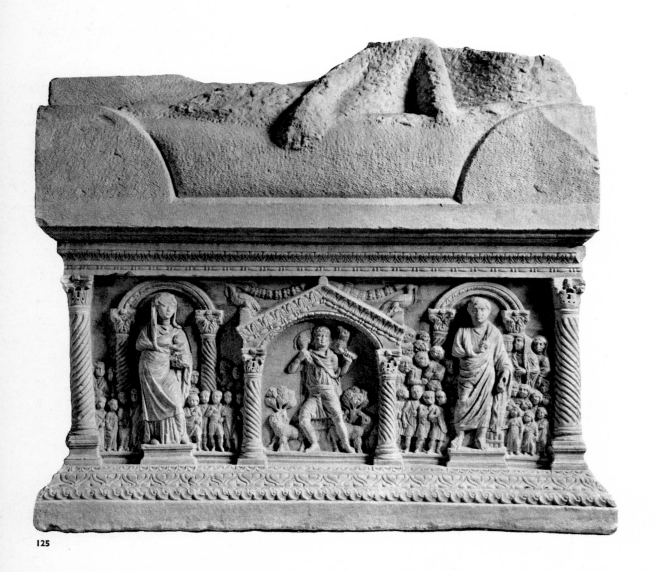

125

124 *The Israelites crossing the Red Sea, relief on sarcophagus from Solin. First half of 4th century* A.D. *Marble, 21 5/8 × 87 × 26 3/8". Archaeological Museum, Split*

125 *Sarcophagus with relief of the Good Shepherd, from Solin. Early 4th century* A.D. *Marble, 51 1/2 (without lid) × 99 5/8 × 54 1/4". Archaeological Museum, Split*

126 *Destruction of the Egyptians in the Red Sea (detail of Plate 124)*

127 *Detail of Plate 125*

120

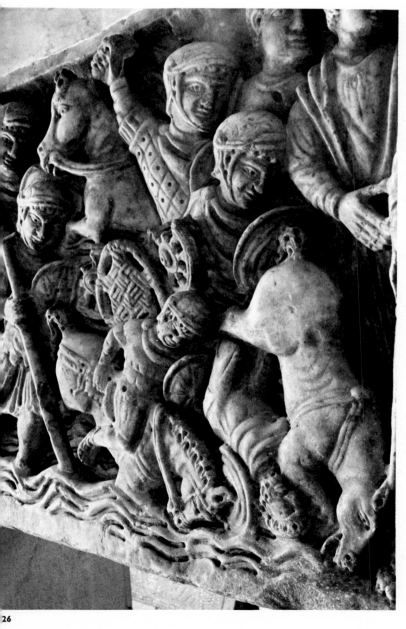

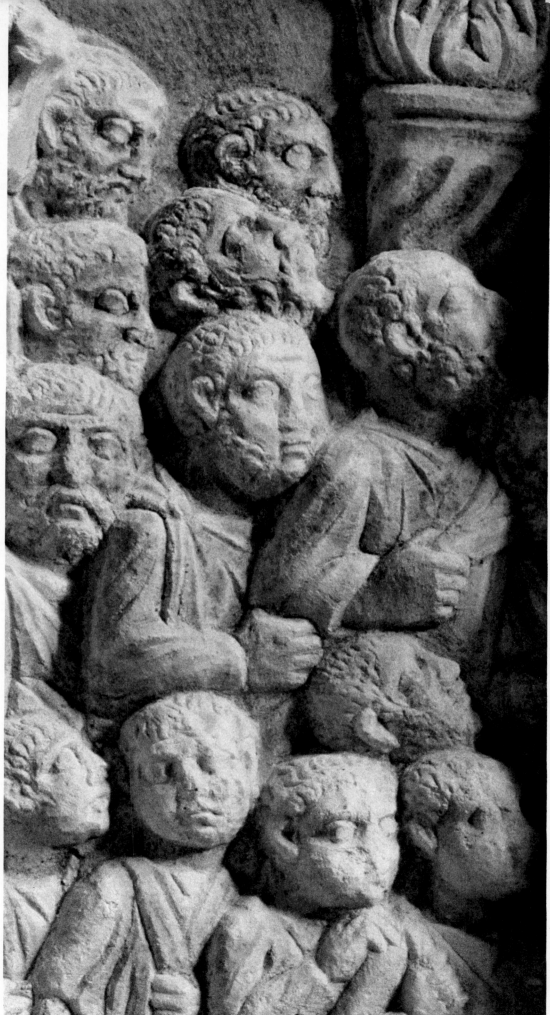

26

127

121

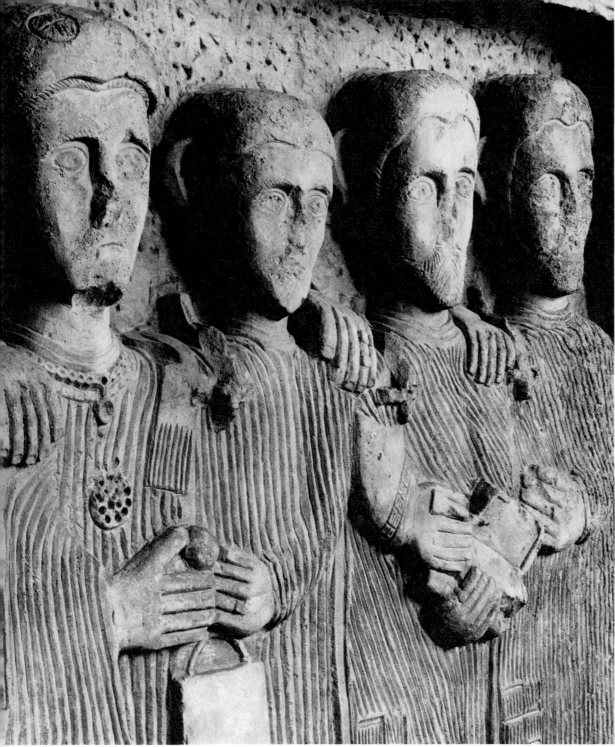

128

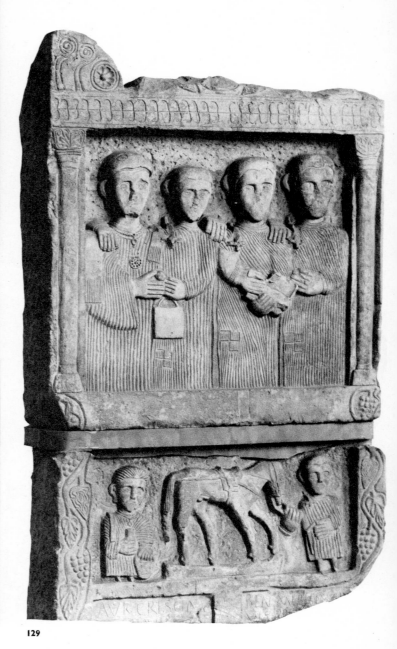

129

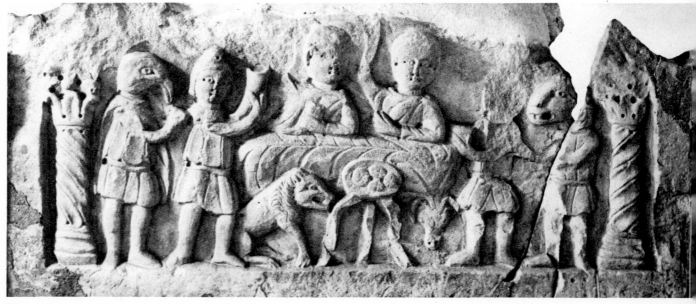

130

122

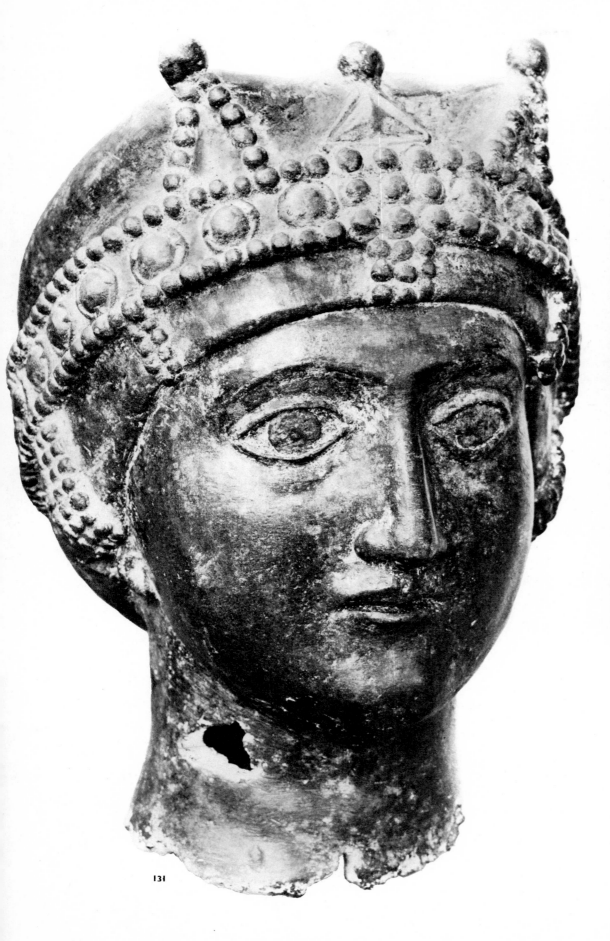

131

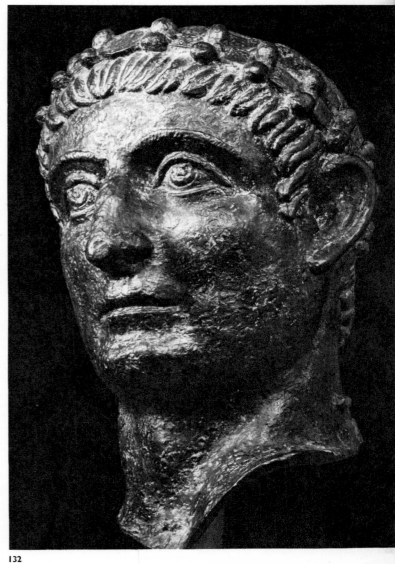

132

128 *Detail of Plate 129*

129 *Tombstone, from Zenica. 4th century* A. D.
*Limestone, upper panel 37 3/8 × 40". National
Museum, Sarajevo*

130 *Mithraic feast, reverse of Mithraic relief from
Konjic (Plate 18). First half of 4th century*
A. D. *Limestone, 20 1/2 × 32 1/4". National
Museum, Sarajevo*

131 *Head of a woman, from Balajinac. Early 4th
century* A. D. *Bronze, height 11 3/8". National
Museum, Niš*

132 *Head of Constantine the Great (?), from Niš.
First quarter of 4th century* A. D. *Bronze, height
12 5/8". National Museum, Belgrade*

123

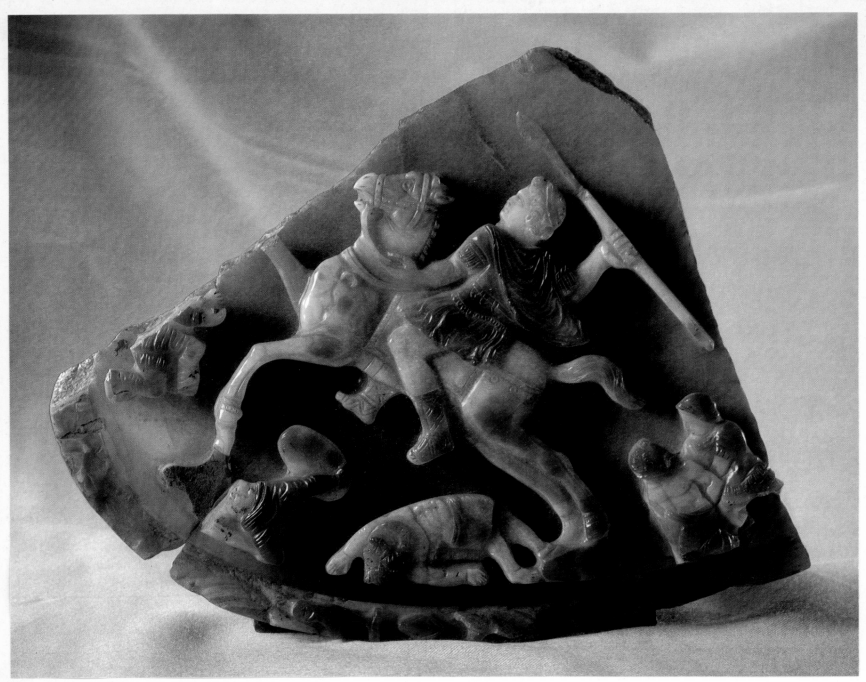

133

133 *Ruler in battle, fragment of cameo, from Kusadak.*
*Onyx, height 7 1/2". Second half of 4th century*
A.D. *National Museum, Belgrade*

# VI  MOSAICS OF ANTIQUITY

Vojislav Jovanović

*Assistant Professor of Archaeology, University of Belgrade*

As an integral feature of the Roman and early Byzantine urbanization of the territory that makes up present-day Yugoslavia, mosaics — with their rich variety of themes, decorative motifs, and artistic approaches — form a copious source of knowledge not only of currents in the development of taste and aesthetic concepts but of all aspects of life in antiquity. While virtually all the mural mosaics in the area were destroyed in the chaos attendant on the Great Migrations, pavement mosaics were in large part preserved, since they were covered and protected by the rubble of ruined buildings. In general, pavement mosaics, constituting as they do part of the interior decoration of palaces, villas, thermae, and shrines, come under the heading of applied art. However, certain figural compositions are, by virtue of their artistic merit, worthy of being numbered among the great works of monumental painting. The significance of pavement mosaics is all the greater because in the area and period under consideration monuments of fresco painting have come to light only in small fragments.

The decoration in pavement mosaics was, by and large, geometric and floral, rarely figural. The repetition over the centuries of conventional motifs and the possibilities for endless combinations in the choice and disposition of the rich repertory of geometric and floral ornament make it extremely difficult to place the monuments stylistically and chronologically. This is less true of the figural mosaics; the stylistic features of these, despite set themes, are far more expressive and thus more amenable to precise dating.

In the classification and dating of indigenous artifacts the specific location of the Yugoslav territories must be kept in mind. As we know, despite the fact that this region linked the two leading states of the world of antiquity — especially in the earlier periods — it was a provincial environment into which new styles from the East and the West penetrated but slowly and in which conservative forces were always predominant. It was only in late antiquity that some areas within this territory acquired a broader outlook and that certain settlements even came to occupy a position of centrality in the Roman Empire's political and cultural life. As yet, relatively little systematic work has been done on the examination of mosaics in Yugoslavia; publication of the existing material in its entirety and excavation of at least some of the numerous monuments presumed to lie below the surface of the earth are still to come. (For example, though no mosaics from the period of Greek colonization have thus far been found, their discovery may be anticipated in view of the existence of remains of Greek settlements on the Adriatic coast and islands and in Macedonia.) But granted that the material now available does not provide a picture of an integrated, developmental whole, it undoubtedly makes an important contribution to the subject of the mosaic art of antiquity.

The earliest Roman mosaics known from this area belong to the first and second centuries; they were found for the most part in Istria and Dalmatia. They are largely

*a. Mosaic decoration, with geometric motifs, in so-called First Room of Roman villa in Risan (anc. Rhizon). 3rd century*

black-and-white, fashioned by setting black cubes in a white field (square or round) edged with braids, meanders, or other motifs; some are purely ornamental, others combine ornament with figural representations. One example found in Pula (anc. Pola) shows a dog chasing a goat; another, from Nin (anc. Aenona), depicts a gladiatorial struggle. Differing from these in stylistic concept are the polychrome mosaics recently discovered in a *villa rustica* at Višići, near Metković, in the hinterland of the central section of the coast. They are dominated by geometric motifs, frequently interwoven with conventional floral motifs; an occasional fish or dolphin appears. By analogy with examples found in central Italy, these mosaics can be dated in the second half of the second century. The finds in Višići are important in that they document the transmission of Italiot influence to the province of Dalmatia as the period of the early empire drew to a close.

A high level of the art was achieved by the craftsmen of a workshop in Salona, capital of the Roman province of Dalmatia, which functioned in the spirit of the Hellenistic tradition as the second century gave way to the third. Their highly decorative and animated polychrome compositions typically depict, in the central field, the figure of Triton or Pl. 134 136, 137 Orpheus, while around the central figure, in smaller frames, are animals, birds, fish, and plant motifs. A composition with Sappho in the center, surrounded by the Muses, is bordered with geometric ornamentation; the whole imitates a carpet — a reason for dating it later, perhaps toward the close of the third century. The same period can be postulated Pl. 135 for the exceptionally fine mosaic discovered on the tomb of the young Aurelius Aurelianus in Salona, evocative of the style of the mummy portraits from Fayum, but with a definite feeling for the detail of everyday life.

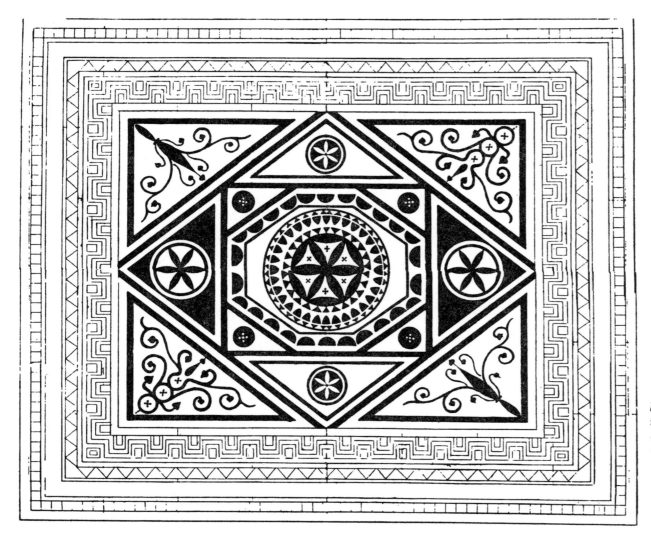

*b. Carpet-like mosaic pavement, with geometric and floral motifs, in so-called Second Room of Roman villa in Risan (anc. Rhizon). 3rd century*

The influence of the Salona workshop during the third century on inland areas some distance from the coastal belt could explain the appearance in a settlement near Stolac, in Herzegovina, of mosaics depicting the Minotaur and the labyrinth, and emblematic personifications of the seasons, months, and days. The same influence may account for a mosaic at Ilidža (anc. Aquae S...), near Sarajevo, characteristic for its mythological marine scenes with cupids, hippocampi, and dolphins.

*Pl. 140*
*Pl. 138, 139*

Among the mosaics brought to light thus far in a villa in Risan (anc. Rhizon) on the southernmost coast (Gulf of Kotor), only one — a representation of Hypnos — is figural; the others are dominated by geometrical ornaments, inventively varied and symmetrically distributed.

*Fig. a, b*

An exceptionally fine polychrome mosaic recently found in Pula is decorated with a predominantly geometrical design organized into a network of rectangular fields. One field has been given over to a figural composition portraying the punishment of Dirce. Although the mythological scene itself breathes the spirit of Hellenic-Pompeian art of the Augustan period, the character of the geometric decoration of other parts places this monument at the beginning of the fourth century.

*Pl. 19*

Such geometric decorative schemes, apparently inspired by the desire to imitate in pavements the meshlike system of coffering and similar stucco decoration used in ceilings, are seen in a number of mosaics from the period of the Tetrarchy. We find them in Diocletian's Palace in Split, in the palaces of Sirmium (mod. Sremska Mitrovica) and Bassiana, in a martyrium in Ulpiana, in villas in Medijana and Petrovac na Moru (Petrovac on the Adriatic coast).

Against the background of the general social and cultural changes that followed the emergence of Christianity and its eventual domination, after the Edict of Milan (A. D. 313) a series of religio-symbolic motifs began to find their way into official art. In mosaics they mingle at first with the pagan repertory, but gradually the decoration as a whole came to be adapted to the ritual requirements of the space in question. Throughout the empire, as monumental basilicas were erected where modest oratoria and martyria had once stood, mosaic decoration acquired growing significance. A taste for the picturesque and the lavish, formed under the strong influence of the Christian East, contributed to making mosaics a widespread branch of artistic production. Through the numerous workshops, particularly those in episcopal centers, and through the activities of itinerant master craftsmen, the art of mosaic made its way to all levels of the population; in the mosaic pavements of shrines in Poreč (anc. Parentium), Celje (anc. Celeia), Ulpiana, and elsewhere have been found inscriptions commissioned by renowned dignitaries as well as by humble, frequently anonymous, citizens.

During this period — indeed from the reign of Diocletian (284-305) on — the role of the areas of present-day Yugoslavia that formed the province of Illyricum continued to increase in importance in the political, military, and economic life of the empire. With its fortified frontier *(limes)* on the Danube, its rich mines and forests, and its essential lines of communication, Illyricum became the stage on which major historical events unfolded. The fact that rulers and other leaders took up permanent residence in the region, particularly in Aspalathos (mod. Split), Sirmium (mod. Sremska Mitrovica), and Naissus (mod. Niš), fostered intensified activity by builders and artists. This too was a period when mosaic flourished, as is attested by the mosaic pavement from the great palace of the castrum in what is now Gamzigrad (near Zaječar in eastern Serbia), one of the centers of the Roman province of Dacia Ripensis. Although only fragments of it have come down to us, the composition of two *venatori* fighting a lion must be recognized as among the major achievements of imperial art in the late fourth century. In this scene particular attention has been focused on the human actors, whose faces are subtly delineated by tiny varicolored stones. Despite the bodily movement, which is, to be sure, restrained, and the wide-open, staring eyes, underlining the drama of the action, the idealized faces, wavy hair, and richly adorned tunics make these *venatori* appear more like distinguished aristocrats for whom gladiatorial and venatorial contests were a favorite recreation than like men forced to defend their lives by sheer muscular strength against maddened beasts in the arena. This composition in mosaic may serve to exemplify the revival of the pagan spirit in the fourth century, an aspect of the attempt by Roman patricians to erase Christian and barbarian elements from the art of the time and to inaugurate a renaissance of Classical culture. The Gamzigrad mosaic has its closest stylistic parallel in a mosaic with hunting scenes from a villa of the Tetrarchic period in the town of Piazza Armerina in Sicily. The originality of the Gamzigrad master makes itself felt in the range of tone, in the audacious juxtaposition of complementary colors; in this carpet-like mosaic he practiced the art of painting with stone as his medium.

No Macedonian mosaic monuments of an early date are known. Later examples from the urban settlements (Stobi, Heraclea Lyncestis, Lychnidus, and others) reveal a relation to the Salonikan and Aegean workshops. The loveliest ensembles have been preserved at Stobi, one-time center of the Roman province of Macedonia Salutaris, where their development may be traced from the fourth to the sixth century. On the pavement of the great episcopal basilica and monumental secular buildings erected by the Stobi aristocracy, rich polychrome geometric and floral compositions come alive with animals, birds, and sea creatures; there are deer and birds at fountains, lions stalking deer, and similar motifs. The figures do not dominate the composition but rather are subordinated to the decorative scheme of the whole, conceived as a carpet; they are woven, so to speak, into the ornamentation. The influence of Eastern textiles is apparent in the emphasis on silhouettes. Outstand-

*Pl. 142*

*Pl. 141*

*c. The Good Shepherd, mosaic from the nave of the basilica in Caričin Grad, near Lebane. Mid-6th century*

ing among the Stobi mosaics for beauty of composition and figural representation is a carpet-like mosaic dating from the fifth century in the structure known as the Summer Palace; birds and baskets of fruit are framed by an interlacing pattern of rectangles. Two mosaics from Heraclea Lyncestis belong to the same period; on one is represented the Eucharist, with kantharos (chalice) and peacocks, on the other the elegant form of a deer in a conventional landscape.   *Pl. 143, 144*

Along the Adriatic coast, mosaics from the latter half of the fourth and the fifth century mostly show a variety of geometric ornament; more rarely they show floral motifs, and only exceptionally the symbolic representation of animals and birds. The finest examples have been found in the ruins of the great basilica of Salona, which, as an ecclesiastical and cultural center, particularly in the fifth century, ranked among the metropolitan cities of the world. Ethnically a mélange, it numbered among its population many immigrants from Africa and the Near East (especially Syria), and they exercised a strong influence on the work of local artists. This accounts for the tendency of the mosaic artists of the Salona workshop to imitate Eastern textiles. In doing so, they do not adhere to the decorative system that prevailed in the period of the Tetrarchy; they manifest a greater freedom in the selection and disposition of motifs — a freedom that led to a weakening in the inner unity of the compositions. The floor of the basilica of St. Anastasia, which has the appearance of an enormous mulitcolored carpet shot through with the sumptuous hues of the East, was fashioned by combining braids, circles, octagons, rosettes, and other motifs.

The mosaic art began to flower anew in Illyricum toward the close of the fifth century, after the Huns and the Goths had thundered across its northern regions. Construction was intensified particularly in the second quarter of the sixth century, when Justinian I (r. 527-65) reconstructed the frontier areas and old towns and erected new settlements in the devastated provinces of the empire. Founded at that time in the district of Dardania, his birthplace, was Iustiniana Prima (mod. Caričin Grad, near Lebane in southern Serbia). Its ruins give some indication of the importance of the settlement. A three-aisled basilica contains a polychrome ensemble whose decoration, inspired by mosaics of the early sixth century in the Great Palace of the Emperors in Constantinople, represents the final phase in

the development of pavement mosaics in late antiquity. Portrayed in emblemata are such subjects as struggles between *venatori* and wild beasts, Amazons and Centaurs; the Good Shepherd and birds and other motifs of Christian symbolism also appear. The whole represents the forging of heterogeneous themes into a decorative system in keeping with the specific requirements of liturgical use. Nevertheless, the artist's attention was focused on the figures of men and animals. The interesting thing is that the treatment is monumental, free, closer to that of a painting than of a carpet — all the more striking since figural representation

*Fig. c* was rare in the pavement mosaics of this period. In the scenes of struggle between the *venatori* and the lions and bears the men and beasts are shown in free motion with expressively realistic effect. There is fine shading of hues in the treatment of both the heads and the landscape. Portions such as these, in which the mosaic achieves the level of contemporary court art, are probably the work of a master from a metropolitan center, while the other sections are the work of a less accomplished local workshop. The principal attribute of the mosaics from Caričin Grad is the striving to continue the Classical tradition in figural pavement compositions.

Also within the limits of this period is the Basilica of Euphrasius in Poreč (anc. Parentium) in Istria, the sole Early Byzantine monument of large-scale architecture and mural mosaic that has been preserved on Yugoslav territory. A three-aisled basilica, it was constructed in the mid-sixth century on the foundations of earlier structures. The decoration of the interior, consisting of capitals, stuccowork, and incrusted marble facing (pavement mosaics have almost all been destroyed), is dominated by a well-preserved mosaic in the principal altar apse. Conceived in the spirit of Byzantine medieval iconography, although still imbued with the Classical tradition, this mosaic is of surpassing importance in its solution of artistic problems and in its value as a historical document. Glorification of the subject matter treated in the decoration was achieved by the polychrome effect of the glass, enamel, and marble tesserae and, more especially, the shimmer of the gilded ones.

The central place in the apse has been given over to a procession of the donors. The

*Pl. 146*
*Pl. 148* Virgin, seated on a throne in the center of the scene and holding the Child, is approached on the left by Bishop Euphrasius of Poreč, offering a model of his church. Interceding with the Virgin in his behalf is the local martyr Maurus. The Bishop is accompanied by his brother the Archdeacon Claudius and the latter's little son, Euphrasius. On the other side of the Virgin are three unidentified local martyrs. Whereas the other figures have been composed in a stereotyped fashion, the donors have been dealt with as individuals and their faces as portraits. The frontal pose and rigid stance of all those portrayed, their gaze directed fixedly ahead, lend a note of drama to the grave solemnity of the scene. The background combines naturalistic landscape elements and abstract gilded surfaces. A rather long band underneath the composition contains an inscription by the donor Euphrasius, refer-

*Pl. 147, 23* ring to the construction of the basilica. Beneath this are two other scenes: *The Annunciation* and *The Visitation*, in which the master of Poreč, influenced by Eastern iconography, displays a narrative tendency, illustrating details from the Gospel with a naively realistic charm.

The remaining surfaces of the apse mosaic have been filled in with whole and half

*Pl. 149* figures of saints, and the ornamental sections blend into an exuberant play of color. The Poreč mosaics are stylistically analogous to those in not far distant Ravenna, at that time the most important center for the extension of Byzantine art to the western border areas of the empire.

As Early Byzantine civilization disappeared under the onslaught of waves of invasion by Avars and Slavs in the early decades of the seventh century, the art of mosaic vanished from the soil of Illyricum. Though the Yugoslav regions in the Middle Ages saw the brilliant renaissance of other branches of painting, the art of mosaic work, as a complicated and costly technique, was relegated to almost total oblivion.

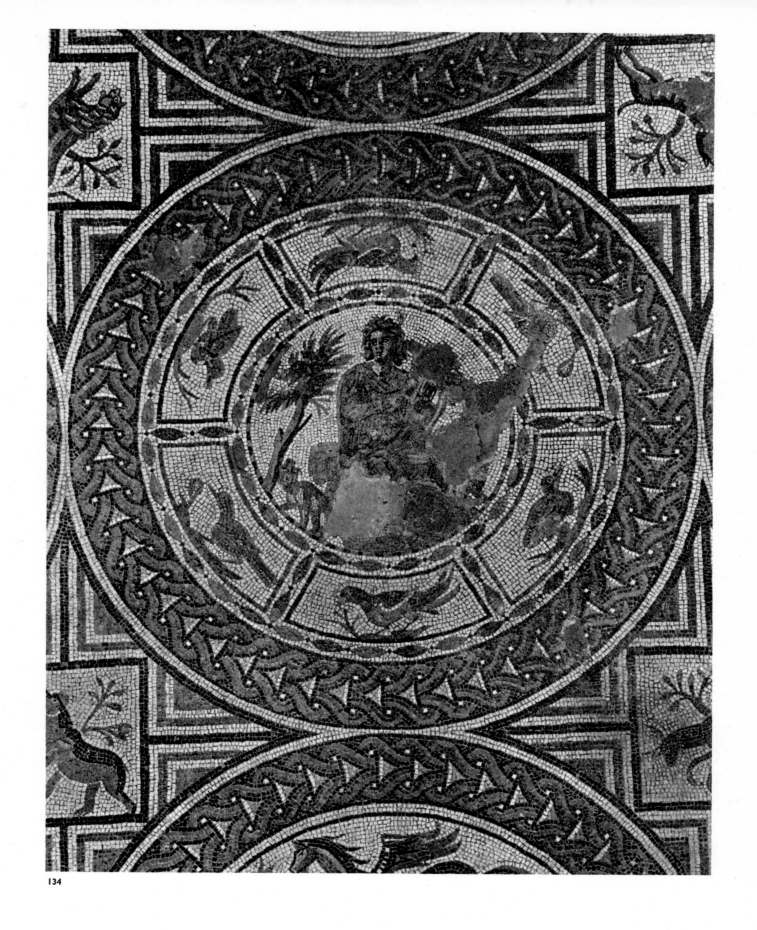

134

*134 Orpheus with his lyre, central roundel of a mosaic,
from Solin (anc. Salona). The encircling segments
contain birds; outside the chain-pattern frame
are small rectangles with wild beasts. Hellenistic
in approach, this is one of the finest figural mosaics
turned out by the Salona workshop. Late 2nd or
early 3rd century. Archaeological Museum, Split*

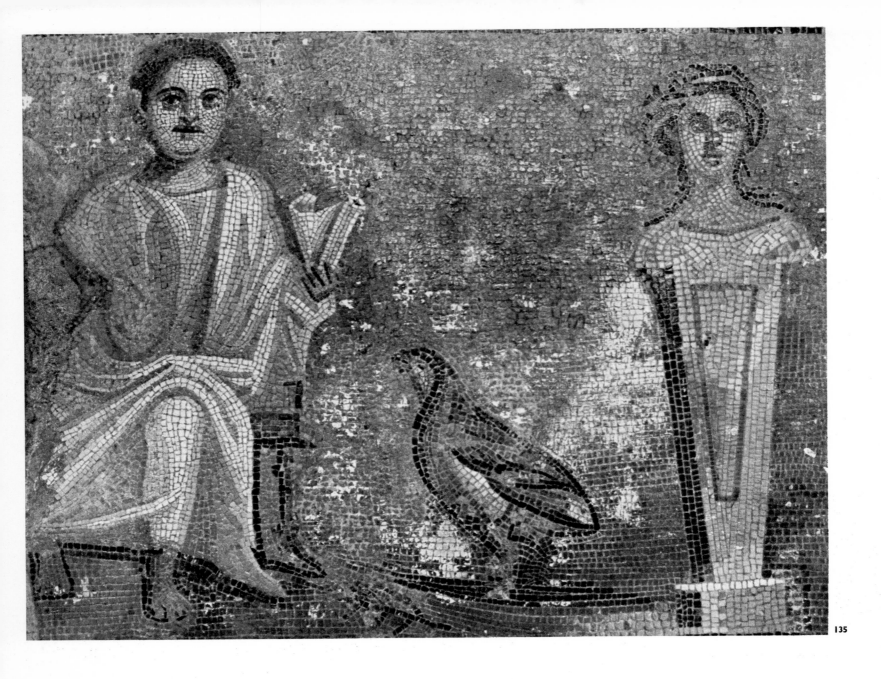

135

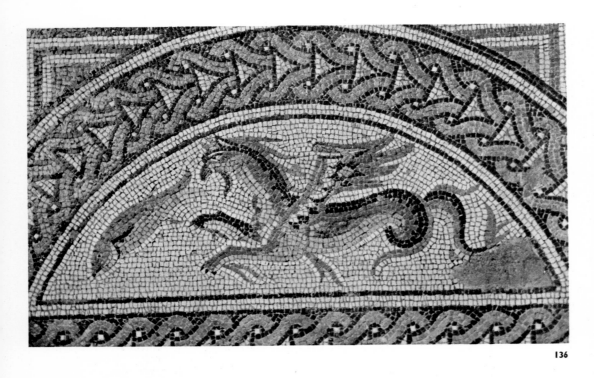

136

137

134

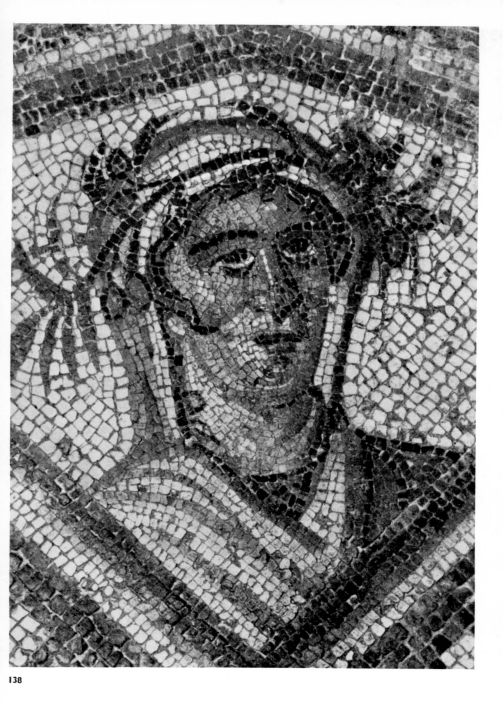

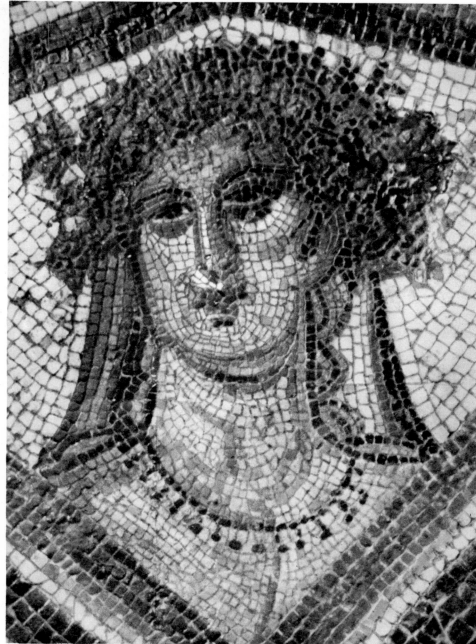

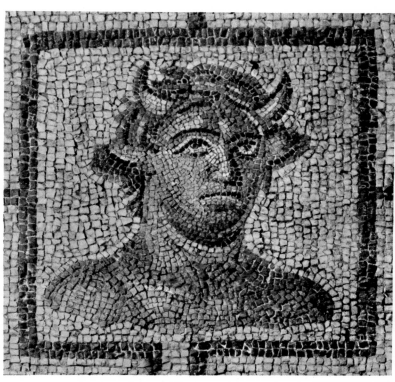

135 Aurelius Aurelianus, detail of a mosaic from Solin (anc. Salona). Late 3rd century. A unique tombstone in its use of the mosaic technique to portray the deceased. Archaeological Museum, Split

136 Hippocampus with fish in a hemispherical field (detail of Plate 134)

137 Bear with elements of landscape (detail of Plate 134)

138 Woman personifying Autumn, detail of a mosaic found in the Roman settlement near Stolac. 3rd century, perhaps the work of itinerant masters from Salona. National Museum, Sarajevo

139 Girl personifying Spring, detail of a mosaic from the Roman settlement near Stolac. 3rd century. National Museum, Sarajevo

140 The Minotaur, central emblem of a geometric mosaic, from the Roman settlement near Stolac. 3rd century. National Museum, Sarajevo

141

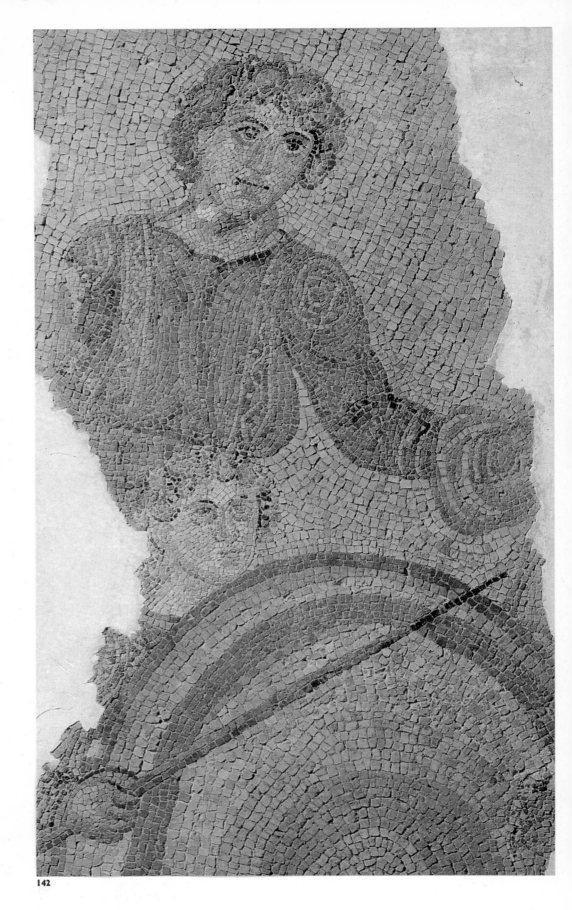

142

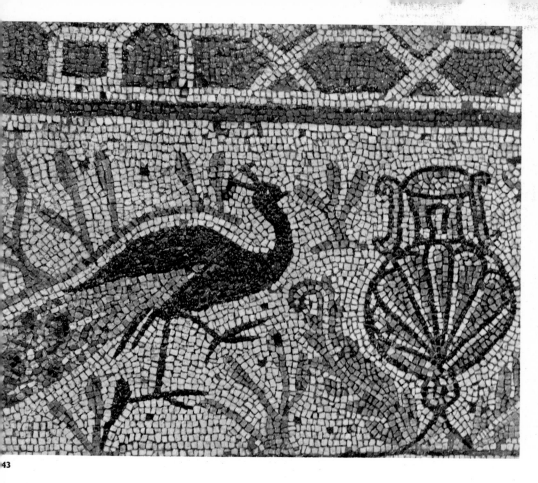

43

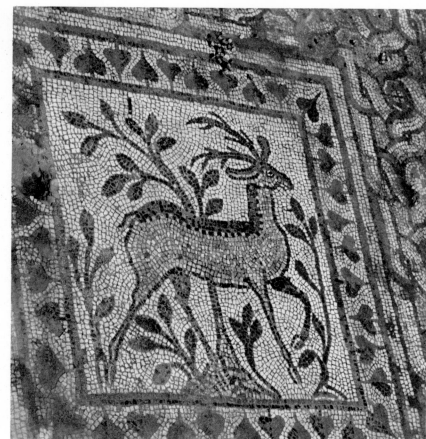

144

141 Birds, detail of a mosaic in Stobi, where the most beautiful Macedonian mosaics have been found. The central compartments of this carpet-like mosaic contain baskets of fruit; the birds are in the fields at the sides. 5th century. Stobi, Summer Palace, in situ

142 Two venatori fighting a lion, section of a mosaic from Gamzigrad. The venator in the foreground is defending himself with shield and spear while the one in the background is trying to lasso the beast. Late 4th century. "25th of May" Museum, Belgrade

143 Kantharos (chalice) and one of a pair of confronted peacocks, detail of an Early Christian symbolic representation of the Eucharist. 5th century. Heraclea Lyncestis (near mod. Bitola), Basilica "B," in situ

144 Deer, detail of mosaic in Stobi. A symbolic motif commonly found in Early Christian art, the deer is here portrayed in motion, with landscape elements. The decorative scheme and stylization are reminiscent of Oriental textiles. 5th century. Stobi, in situ

145 Kantharos (chalice) with branching tendrils, detail of a mosaic pavement in the earliest Christian shrine within the complex of what was to become the Basilica of Euphrasius. 4th century. Poreč, in situ

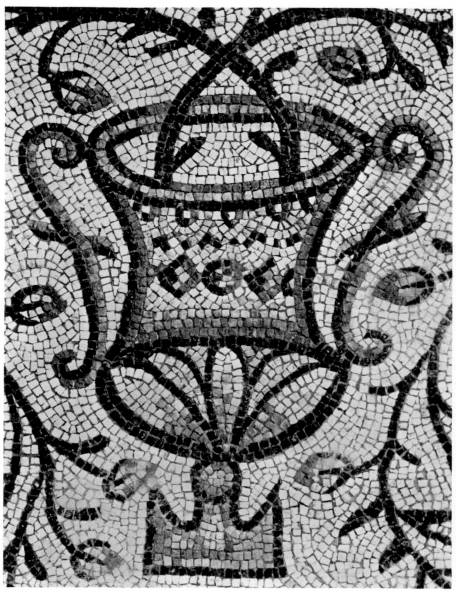

145

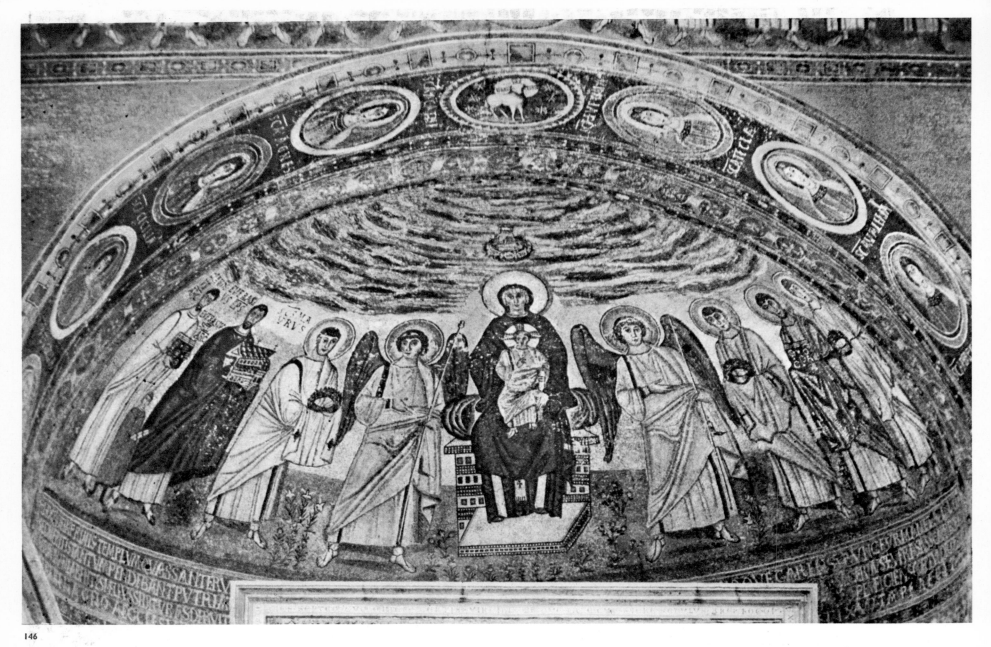

146

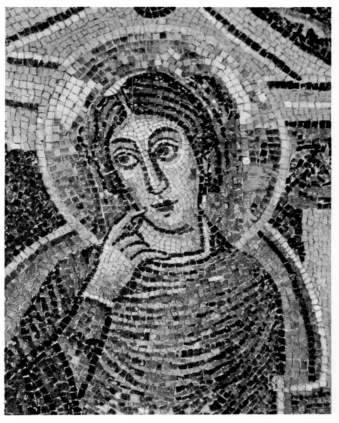

147

146 Church founders and donors, mosaic in the conch of the main apse of the Basilica of Euphrasius. To the left of the Virgin with the Christ child and angels is the Poreč martyr Maurus, bearing a wreath, escorted by Bishop Euphrasius, carrying a model of the basilica, his brother the Archdeacon Claudius, and his nephew Euphrasius; three unidentified local martyrs approach from the right. Mid-6th century. Basilica of Euphrasius, Poreč

147 Detail of The Annunciation in the main apse of the Basilica of Euphrasius: Mary has a look of surprise and confusion as she hears the tidings of the Archangel Gabriel. Middle of 6th century. Basilica of Euphrasius, Poreč

148 Bishop Euphrasius, detail of the scene in Plate 146. The Master of Poreč has introduced elements of individuality into his portrait of Bishop Euphrasius; the model of the basilica that he holds has the principal characteristics of buildings of this type in this period

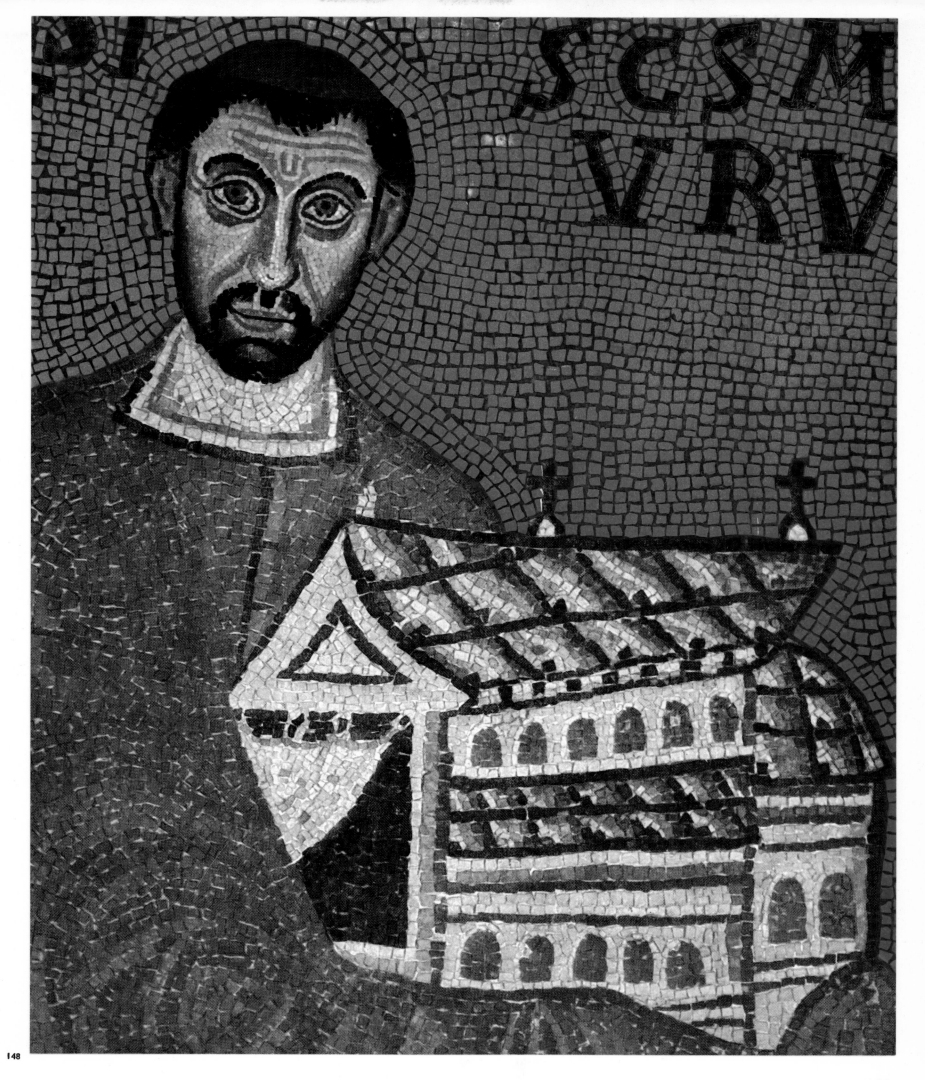

SCSM VRV

148

139

149 *Ornamental band, detail of mosaic on the soffit of the triumphal arch in the Basilica of Euphrasius, Poreč. Mid-6th century*

**149**

# VII ART DURING THE PERIOD OF THE GREAT MIGRATIONS

Zdenko Vinski

*Curator, Archaeological Museum, Zagreb*

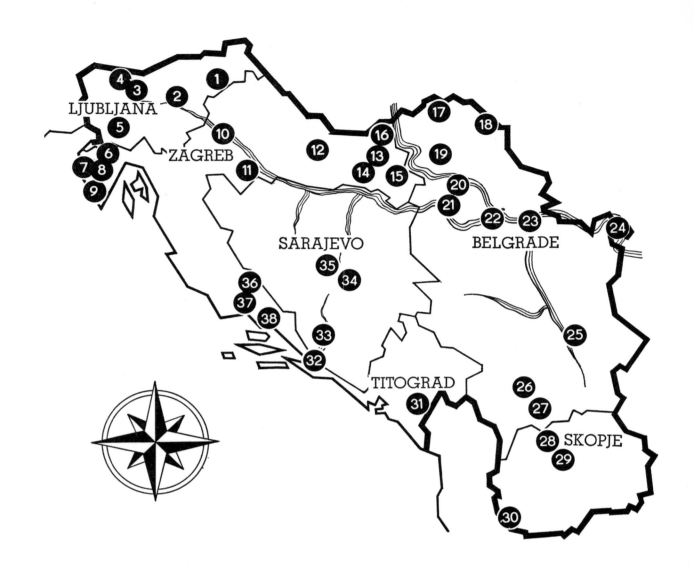

# FIND SITES OF GREAT MIGRATIONS PERIOD

1 *Poetovio (mod. Ptuj)*
2 *Rifnik*
3 *Carnium (mod. Kranj), Emona (mod. Ljubljana)*
4 *Bled (anc. Pristava)*
5 *Idrija (mod. Podmelec)*
6 *Pinquentum (mod. Buzet, Brežac)*
7 *Čelega*
8 *Brkač*
9 *Pola (mod. Pula)*
10 *Zagreb and nearby Kruge, Stenjevac, Velika Gorica, Samobor*
11 *Siscia (mod. Sisak)*
12 *Čadjavica*
13 *Mursa (mod. Osijek and nearby Bijelo Brdo), Teutoburgium (mod. Dalj)*
14 *Cibalae (mod. Vinkovci)*
15 *Vukovar, Cornacum (mod. Sotin), Cuccium (mod. Ilok)*
16 *Ad Miliare? (mod. Batina), Ad Novas? (mod. Zmajevac), and nearby Beli Manastir, Bački Monoštor, Kolut*
17 *Subotica, Nadrljan*
18 *Srpski Krstur, Majdan, Novi Kneževac, Čoka*
19 *Mali Idjoš, Kula, Zmajevo, Vrbas*

20 *Selenča, Neštin, Sremski Karlovci*
21 *Sirmium (mod. Sremska Mitrovica), Basianae (mod. Donji Petrovci), Vojka*
22 *Belgrade, Batajnica, Jakovo-Kormadin, Taurunum (mod. Zemun), Grocka, Pančevo, Kovin*
23 *Margun (mod. Dubravica-Orašje), Viminacium (mod. Kostolac), Sapaja*
24 *Pontes (mod. Kostol), Caput Bovis? (mod. Velesnica)*
25 *Naissus (mod. Niš)*
26 *Prima Iustiniana (mod. Caričin Grad)*
27 *Ulpiana (mod. Gračanica)*
28 *Stobi (mod. Gradsko)*
29 *Viničani*
30 *Lychnidus (mod. Ohrid), Radolište*
31 *Doclea (mod. Duklja)*
32 *Narona (mod. Vid)*
33 *Han Potoci*
34 *Sarajevo, Rajlovac-Mihaljevići, Breza*
35 *Pećinska Rika, Gornje Turbe, Rakovčani*
36 *Knin (anc. Ardube? Tenenum?), Plavno, Biskupija, Unešić*
37 *Smrdelji*
38 *Salona (mod. Solin), Sinj, Stara Vrlika*

The dynamics of history at the dawn of the Middle Ages are reflected in the complexities of artistic creation that mark the epoch known as the period of the Great Migrations. For southeastern Europe, this period extends from the close of the fourth century into the ninth century. The breakthrough of nomadic warriors from Asia, under the leadership of the Huns, catalyzed into action, beginning in 375, a flood of barbarian ethnic groups, primarily Germanic, but also Sarmatian, who moved toward the Black Sea and the Carpathian basin and, by 476, brought about the collapse of the Western Roman Empire. Hunnish domination broke up in the Danubian region in 453, with the death of Attila, giving way to penetration by the Ostrogoths, the Gepids, and the Langobardi, or Lombards; these were the principal peoples among those who, with greater or less success, endeavored to establish organized states in the Danubian area and in Italy, measuringt heir strength against and sporadically clashing with the power of the Eastern Roman Empire — Byzantium — beginning in the seventh century, in the course of which the emperor Heraclius (r. 610-41) made Greek the official language. New Asian tribal groups of nomadic warriors, dominated by the Avars, had penetrated into southeastern Europe in a series of waves as early as the second half of the sixth century (c. 560), during the first Avar khanate, bringing to heel the remaining Gepids and waging an offensive against Byzantium until well into the seventh century (the unsuccessful siege of Constantinople in 626 marked the climax of Avar power). This period coincides with the migration of the South Slavs, which is historically associated with the presence of the Avars in the territory that is now Yugoslavia. In the late seventh century the Avars, except the Kutrigurs, again made their way to the Carpathian basin, where they massed in the Pannonian plains during the second Avar khanate, which reached its apogee in the eighth century. In the eastern part of the Balkan Peninsula they clashed, not with Byzantium but with the Bulgars, who had arrived in the seventh century. Avar rule came to an end in Pannonia about 800, when the Slavs began to set up their first organized states, after their conversion to Christianity partly under the influence of the Byzantine Empire (the Eastern Church) and partly by way of Italy, under that of the Frankish Empire (the Western Church, then hostile to Byzantium).

One further circumstance is worthy of note: all the barbarian newcomers, beginning with the Huns, found the area occupied by an indigenous population that had been Romanized, more or less, especially in the Roman provinces which then covered the entire territory of present-day Yugoslavia (excepting Bačka, which was inhabited by Sarmatian Jazyges). For the most part the new peoples disappeared from the area, leaving only traces of their material culture here and there; the Slavs alone succeeded in colonizing it and in imposing themselves, at least linguistically, as a superstratum upon the ethnically heterogeneous indigenous population, which thus formed an ethnic substratum. This brief

*a. Fibula in the form of a cicada (a motif probably of Scythian origin), from Novi Banovci. 5th century. Silver, length 1". Archaeological Museum, Zagreb*

*b. Earring with polyhedral pendant, from a woman's grave (43/1907) in the necropolis in Kranj. Latter half of 6th century. Gold, with red glass; diam. of ring 1 7/8". National Museum, Ljubljana*

sketch is intended as a historical framework for the archaeological monuments characteristic of the epoch prior to and immediately following the arrival of the Slavs.

Between the fifth and the seventh century the world of antiquity was in upheaval and its social and cultural structure was shaken by the impact of change. The civilization of late antiquity entered a period of decline, especially in the Danubian areas along the frontiers of the Roman Empire, maintaining itself in somewhat more integral form, however, until the Avar invasion, in the Adriatic coastal area and large urban centers along the Sava River. In the Roman provinces the barbarian arrivals found the achievements of Roman urban civilization — integrated urban and rural settlements, an advanced architecture in stone and brick with a plenitude of architectural forms, and roads, bridges, aqueducts, and tombs — and they encountered the Latin and Greek scripts. Architectural monuments on Yugoslav territory dating from the period of the Great Migrations are for the most part characterized by Late Antique features, particularly in such urbanized settlements as Salona, Narona, Doclea, Emona, Celeia, Poetovio, Siscia, Mursa, Sirmium, Singidunum, but they also bear some of the marks of Early Byzantine civilization, in such settlements as Naissus, Iustiniana Prima, Ulpiana, Stobi. The life of these towns went on until the turn of the sixth century, when they were razed by the Avars and the Slavs. The Roman province of Dalmatia — especially the area comprising present-day Bosnia and Herzegovina and the Dalmatinska Zagora — has yielded a number of unpretentious Early Christian sacred monuments, including sixth-century basilicas marked by linear treatment of stone carvings in low relief (Zenica, Breza, Dabravina, Klobuk, Duvno, Dikovača, Otok near Sinj). This rustic art of the marginal areas peopled by indigenous Illyrian inhabitants, partially Romanized, came to flower in the sixth century, when Roman power was collapsing. Since Yugoslav authorities differ considerably as to the dating of these monuments (for instance, as to the appearance of runes on the pilaster in the basilica at Breza), this important but still controversial body of sculptural material in the basilicas will not be considered here. The same applies to architectural monuments that are not specific to the period of the Great Migrations but rather belong within the framework of Late Antique

art. Similarly, the sixth-century basilica of Euphrasius in Poreč, an ecclesiastical monument notable for its Ravenna-like mosaics, is outside the scope of this analysis.

Figuring significantly in the art of the period of the Great Migrations, and representing the specific cultural heritage of that epoch, are products of the minor arts, the artistic crafts — primarily metal jewelry and other ornamental objects — as exemplified in finds from graves. Briefly recapitulated, the several recognized stylistic phases begin with the filigree style as practiced by the barbarian peoples at the time of their initial contacts with the civilization of antiquity under the Roman Empire (second-third century), the decoration of precious metals with filigree and granulation, hammered sheet silver being added in the fourth and fifth centuries and later also punched or stamped metalwork. Then developed what is known as the polychrome style and chip-carved ornament (350-550). The polychrome style is characterized by a glittering effect achieved by the application of semiprecious stones, most frequently red (almandine), or of vitreous paste to a gold ground. This style had taken root in the Black Sea area, whence it was brought to Europe by the Huns, Alans, and Goths, as well as in the eastern Mediterranean area (Syria), whence it spread as far as Italy. Chip carving (curvilinear and geometric motifs) is a West Roman provincial technique of the fourth century which was applied from the fifth century onward to barbarian jewelry. Later stylistic combinations of filigree, polychrome, and chip carving can be traced, in the sixth century, to Italy during the rule of the Ostrogoths and Lombards and further into the seventh century on Merovingian and Anglo-Saxon jewelry. The next phase (550-800) is notable for Animal Style and interlace ornament. The Animal Style originated in Asia, although Germanic ornamentation during the Great Migrations period was also directly influenced by Late Roman barbarized motifs of wild animals, which are frequently found in company with chip carving. What is termed Animal Style I is distinctive for its abstract and chaotically intertwined animal heads and animal parts; this style of animal art extended in the sixth century from the Scandinavian and Anglo-Saxon area through central Europe and into Lombard Italy, where it merged with the south European motif of interlace, which supplanted the earlier curvilinear motifs. From this mixture emerged what is known as Animal Style II, characterized by the motifs of animal bodies, without legs, intertwined to form interlace; this style had several variants and was applied to toreutic art in a variety of techniques. Later in Scandinavia there evolved the extremely abstract interlace of animal ornament known as Animal Style III (eighth century), which influenced the art of the Vikings only — not, in the eighth and ninth centuries, the stylistic development of the Carolingians, which was conditioned primarily by Insular (Anglo-Saxon and Irish) but also by Mediterranean impulses.

These stylistic phases are also represented in finds in the burials of the migratory peoples on the territory of Yugoslavia, the extent depending on geographic location and historical factors. The filigree style is found rather frequently, already indeed in jewelry from Classical sites of Imperial Roman and Late Antique to Early Byzantine dating, sometimes in a combination of forms reflecting barbarian taste; it continues down through the centuries under Byzantine influence and was very widely used in Slav ornaments.

The polychrome style is represented by both of its characteristic types, the first with the gold ground visible between the cloisons with their inset almandines, either convex or ground flat, which are spaced at some distance from one another, and the second *(orfèvrerie cloisonnée)*, which shows a dense concentration of cloisons (mostly containing almandines ground flat) covering virtually the entire ground. The first technique was applied to Late Antique objects as early as the fourth century in accordance with the taste of barbarized antiquity. A representative example is a sumptuously fashioned parade helmet from Berkasovo, in the region of Srem, with multicolored vitreous-paste inlays. Definitely a stylistic manifestation of Attila's time, the polychrome style was common not only among the Huns but also among the Goths and other Germanic peoples, as well as among the Merovingians,

*Fig. a, Chap. V*

145

*c. Bow fibula with spiral and meander chip-carved ornament, from a woman's grave in Ulpiana, near Gračanica. Mid-6th century. Gilded cast silver, length 4 7/8". Kosovo and Metohija Museum, Priština*

to whom the Goths brought this Black Sea mode of ornament from the Carpathian basin in the second half of the fifth century.

Archaeological finds of works in the polychrome style, scattered throughout Yugoslavia, can be assigned to period and workshop. The earliest is a pair of slotted fittings from a sword scabbard which might, judging from the style, have originated in a Black Sea workshop during the Hun domination, that is, before the middle of the fifth century; this find was made in a fort on the Roman frontier at Zmajevac. There are a few other polychrome artifacts dating from the fifth century found in the Danube and Morava basins; judging from appearances, these were left behind by the Ostrogoths before their incursion into Italy. Other polychrome finds date from the sixth century; chiefly imports from Italy, they were adapted by the Late Roman workshops (skilled in this East Mediterranean goldworking technique) to the uses and taste of the Ostrogoth ruling class in Theodoric's time. Obviously imported by the Gepids in the Tisa Valley by way of Srem (before 535) is an elaborately worked woman's ring from Srpski Krstur; products of the same workshop are

*Pl. 151*

*Pl. 152*

the polychrome-style ornaments from certain Ostrogoth graves in the province of Dalmatia. A pair of brooches shaped like birds of prey (falcons), with inlaid almandines, from a *Pl. 160* Lombard grave in the cemetery in Kranj, approach the work done by the Merovingians. The polychrome technique was also employed in various types of women's ornaments; for instance, elaborate Late Antique earrings of gold with almandines were fashioned by goldworkers *ad usum barbarorum* as early as the fifth century and into the sixth. The latest examples, found in a rich burial in the cemetery in Kranj, date from the second half of *Fig. b* the sixth century and are perhaps of indigenous origin. A few of the finds of polychrome ornaments of the fifth and sixth centuries (for example, one from an East Roman grave in Gornje Turbe) should not be attributed to Germanic influence, since they show — on rings and on clips — crosses of inlaid almandines, which are an East Mediterranean rather than a Black Sea feature.

A most important component of the artistic activity of the Great Migrations period was the manufacture and decoration of fibulae as characteristic ornaments found chiefly on women's costumes. Among what are called the bow fibulae, the earliest from this period were fashioned of hammered sheet silver, having developed from earlier bow fibulae with returned feet, primarily from the Black Sea and Transylvanian areas. In the Danubian basin a considerable number of sheet-silver fibulae of various sizes have been found, out- *Pl. 153* standing among them being the large examples from Pannonia dating from the second half of the fifth century, mostly found in pairs in Ostrogoth burials of women. Showing the influence of the West Roman examples, these sheet-silver fibulae were frequently decorated with chip carving. Workshops in the Roman provinces were traditionally skilled in applying the chip-carving technique to metals, as is attested by numerous finds of high quality— decorative mounts, buckles, and other ornaments from the Late Empire, with spiral, triangular, and rhomboid motifs. In such as yet undisturbed Roman provincial urban cen- *Pl. 155, 174* ters in Yugoslav territory as Salona, Sirmium, Siscia, Poetovio, Emona, jewelry with decorative chip carving continued to be produced in the fifth century but in a form and style adapted to the requirements of the Hunnish and Germanic settlers who ordered them. During the migration of peoples in the fifth century the curvilinear style of decorating metal jewelry spread from Pannonia to the Black Sea workshops, the examples of such jewelry from the Pontic area being therefore somewhat later in date. The geometric chip-carving motifs, however, were a common tradition of the workshops of late antiquity, and the fifth-century examples from the Danube basin and the Black Sea area were produced concurrently; archaeologically important finds of jewelry with these motifs, dating from the second half of the fifth century, have also been made in Yugoslavia, in the Carpathian basin. A pair of Ostrogoth fibulae from Zemun, fashioned of gilded silver, are rare *Pl. 154* examples of the combination of the sheet-silver fibula form, in the casting technique, with geometric chip carving. Sumptuously fashioned fibulae from Sremska Mitrovica *Pl. 158* are for the most part decorated with curvilinear chip-carved ornament, combined with geometric motifs set with almandines, a reflection of the polychrome style. In the sixth century the chip-carved ornament experienced a sort of decadence, as reflected, for instance, in the Ostrogoth bow fibulae from the cemetery in Kranj; however, fine examples of chip- *Pl. 162* carved fibulae were still to be found even then, as is evidenced by one from a richly furnished Germanic female burial of Ulpiana, near Gračanica, a product of one of the Pannonian *Fig. c* goldsmiths' workshops that served the Lombards in the sixth century until their departure for Italy (568). The technique of chip carving, with the foregoing motifs, persisted even after the sixth century, as did the polychrome style; both influenced later gold- and silver-work, especially the Merovingian-Carolingian production in Europe, and affected toreutic styles throughout the Middle Ages.

The important role played by portrayals of animals, fashioned in a variety of styles, forms, and techniques, in the art of the period of the Great Migrations has already been

*d. Comb, from the necropolis in Kranj. 6th century. Bone, engraved with a design of animals and a human figure; length 5 3/8". National Museum, Ljubljana*

indicated. In many cases the bow fibula terminates in an animal head so highly stylized that its zoomorphic character is barely discernible. In the fifth century, an occasional motif in Hunnish and Ostrogoth artistic crafts is the cicada; it appears applied to jewelry of Pontic and Danubian origin, some twenty examples having been found in sites dating from antiquity in Yugoslavia. Ornamentation in Animal Styles I and II appears marginally *Fig. a* in Yugoslav territory, some of it found on Lombard jewelry brought to light in Kranj.

In contrast, the bird of prey is an extremely popular motif employed by a number of ethnic groups and extending over a considerable period of time. The motif itself is Asian in origin, having been brought to the Balkans both by way of the classical world and by nomads from the Black Sea area in Attila's time. It is a magic symbol associated with shamanistic beliefs. A most imposing portrayal of an eagle appears on the massive buckles of a woman's belt decorated in chip carving, with inlays of almandine or vitreous glass, found in the grave of a Gepid woman in Kovin. They originated in one of the workshops in Kerch, on the Black Sea, and reached the Yugoslav Danubian area together with other jewelry intended for the Gepids, individual examples also penetrating farther into *Pl. 150, 175* Europe. Smaller heads of birds of prey were often seen on similar Ostrogoth buckles, on *Pl. 161, 159* bow fibulae, and on S-shaped fibulae fashioned in a number of techniques, often inlaid with almandines. Germanic jewelry discovered in Yugoslavia is for the most part to be connected with the presence of the Lombards in the sixth century. In contrast to the famous Gothic eagle fibulae (in Italy, France, and Spain) the small falcon fibulae used by the Lombards in the sixth century came to Yugoslavia as imports from Merovingian workshops.

The motif of the bird of prey, along with certain other fauna, was also used in the artistic decoration of weapons. It is a typical adornment of the copper-gilt bands applied to sumptuous helmets produced during the time of the Great Migrations, often in combination with the motif of birds pecking at fish. A number of these precious helmets, scattered throughout Europe during the rule of the Ostrogoths in Italy, have been found along the Adriatic coast of Yugoslavia (Narona, Salona); they date from the first half of the sixth *Pl. 157, 156* century. One such helmet was found at Batajnica in the princely grave of a Gepid warrior buried in all likelihood during the collapse of Gepid power in Srem (567). Helmets of this type first appeared in the sixth century, probably in Italy, according to prevailing opinion, undoubtedly originating in workshops with an explicitly Mediterranean tradition of artistic expression, where they were fashioned for Germanic use up until the arrival of the Lom-

*e. Earring with star-shaped pendant, from a prince's grave near Čadjavica. Late 6th-early 7th century. Silver with granulation, height 2 1/4". Archaeological Museum, Zagreb*

*f. Earring with basket-shaped pendant, from a woman's grave (256) in the Pristava necropolis in Bled. Late 6th-early 7th century. Silver, height 1 1/4". National Museum, Ljubljana*

bards in Italy. In view of the most recent finds in Dalmatia, it is possible that they were produced in similar workshops in Salona or Narona.

A prominent role in the cultural achievements of the period of the Great Migrations was played by the ethnically heterogeneous indigenous population, more or less Romanized, which managed to maintain itself in those tumultuous times until the arrival of the Avars and Slavs in the late sixth century. It perpetuated a number of elements of both the prehistoric and the Classical cultural legacy and contributed to the shaping of the material culture of the Slav settlers in the Middle Ages. Recent excavations demonstrate that the cultural inventory of many graves from the sixth and seventh centuries on Alpine and sub-Alpine soil — in Istria, in the Roman provinces of Dalmatia, Pannonia, Moesia, and so on — originated with this indigenous population. To them must be attributed a considerable number of the artifacts found in the great cemetery in Kranj (sixth century), which bear evidence of both Classical and older survivals of artistic expression. A noteworthy example is a bone comb decorated with a figural scene of animals, stylistically related to the manner of treating *Fig. d* animals on the Late Antique fibulae but with far older roots, as is evidenced by the low reliefs of Thraco-Cimmerian origin going back to the eighth century B.C. (for instance, gold animal appliqués from Dalj, on the Danube). The tradition of late antiquity is evident in the peacock-shaped fibula (the peacock being an Early Christian symbol), which was *Pl. 163* fashioned in some local workshop in North Italy, worn by a Romanized native woman, and brought to light in the ancient cemetery (late sixth or early seventh century) of Pristava in Bled. During these centuries indigenous workshops turned out, among other things, fine examples of goldsmiths' work, including characteristic basket earrings in a variety *Fig. f* of shapes; these have been unearthed in considerable numbers in Bled's Pristava cemetery. At least three workshop centers where they were produced have been established so far; as a product fashionable in those times, they were used first by the native population and later taken over by Germanic ethnic groups.

One aspect of the complex artistic output dating from the Great Migrations can be discerned in the features characterizing metal ornaments associated with the migration of the South Slavs to the Danubian basin and Balkan Peninsula, as well as in the legacy of the Avars deriving from the first and second Avar khanates. Long fibulae, with the plate at the spring end shaped like an anthropomorphous mask, worn singly, are associated with the Slavs of the sixth and seventh centuries, who launched them; they represent a Black

*Pl. 166*

*Pl. 164, 165*

*Fig. e*

*Pl. 167, 168*

*Pl. 169, 172, 170*
*Pl. 171*

*Pl. 173*

Sea form of feminine jewelry, produced in the Pontic workshops under the influence of the Late Antique metalworking techniques. They are scattered from the Dnieper to the Morava basin, by way of the Danube basin; of the dozen or so examples known in Yugoslavia, the finest is one from Velesnica. These fibulae are associated with the appearance of what is known as the Martinovka style, exemplified mostly by silver products of high quality turned out by the workshops in the Ukraine under the influence of Early Byzantine work, with nomadic accretions. Rich finds of this type of jewelry are scattered from the Dniester and Carpathian basins to the Drava basin, where, at Čadjavica, one of the most outstanding sets of this sumptuous jewelry of the early seventh century was found. Martinovka-style jewelry vanished in the eighth century, the only type that remained in use being the star-shaped earrings, fashioned by a simple casting techique, that have been found in Slav graves up to the eleventh century.

During the first Avar khanate (late sixth and seventh century), common ornaments for belts and horses' harnesses were strap ends, mounts, and the like, most frequently of sheet metal with a stamped design bearing a strong stylistic resemblance to Early Byzantine work; from this period there are also gold jewelry and gold coins imported from Byzantium, which paid the Avars tribute from the reign of the emperor Flavius Tiberius Mauricius (582-602) to that of Emperor Constantine IV Pogonatus (668-85). There have been a number of such finds in Yugoslavia—in the Bačka and the Banat, for example in Novi Kneževac. Here and there on sheet-metal ornaments of the seventh century are found variations of Animal Style II, showing possible Gepid influence. After the crisis of the seventh century, during the second Avar khanate, changes appeared (mainly in the eighth century) in the artistic crafts typical of the Avars, for instance in the ornamental strap ends and mounts for belts; the casting techique was applied, and both forms and decoration are more subject to the Sarmatian-Hellenistic influence of Central Asian nomadic and Black Sea motifs, while Byzantine and other foreign influences are not found. The griffin is a common motif, as are fighting animals and plant ornaments, but representations of human figures, such as are to be seen on the interesting strap end from Pančevo, are rare.

After the collapse of the power of the Avars in the Danube basin, following their defeat about 800 in the wars with Charlemagne, there was a decline in the production of all the articles associated with Avar inspiration; these disappear altogether in the first half of the ninth century. The final phase of development, known as the Blatnica style, spread from the Morava basin to Pannonia, leaving traces in several sites in northern Yugoslavia. The Frankish Empire was then counterpoised to Byzantium, politically and culturally — culturally through Carolingian art, which infiltrated the regions that came under varying degrees of Frankish control in the late eighth and, more particularly, in the ninth century. On Yugoslav soil these influences were felt primarily in the Adriatic region, where they blended with the influences of Adriatic-Byzantine art in the towns of the Dalmatian orbit. The finest architectural monument is the early-ninth-century Church of St. Donat in Zadar, the ground plan of which closely resembles that of the Carolingian octagonal chapel in Aachen (Aix-la-Chapelle), their common prototype being the ground plan of the sixth-century Byzantine Church of San Vitale in Ravenna. A unique work of early Carolingian art is a censer from Stara Vrlika dating from the second half of the eighth century; stylistically it is the only one of its kind extant in Europe. It was imported into the Dalmatian part of Croatia during the process of the conversion of the population to Christianity in Charlemagne's time. Although it has certain features in common with the famous Tassilo Chalice (780-90), which was fashioned under the influence of the Insular style, it differs in having been inspired by the Late Antique traditions both in the use of the technique of chip carving and in the geometric motifs derived from Late Antique belt buckles.

Slav material culture of the late eighth and the ninth century was undoubtedly influ-

enced by Carolingian art, as is evidenced by a number of borrowed elements of form and decoration, particularly in the weapons and luxurious fittings for warriors unearthed in the graves in the Bishop's Palace at Knin, and by imported examples of the artistic crafts, for instance the silver reliquary of St. Asel in Nin. It is equally true that the Slavs, especially those living between Kotor and Krk on the Adriatic coast, had before their eyes the *Pl. 174* tangible evidences of the Late Antique civilization of the Romanized indigenous population, of which traces are still extant in a number of monuments from the seventh and, more especially, the eighth century: in stone, such works as the ciborium and font in Kotor, the sarcophagus of Giovanni da Ravenna in the Baptistery in Split, the ornamental arch in Kaštel Sućurac, the relief on the cross in the monastery of St. Euphemia in Rab (on the island of that name), the capitals in the monastery of Košljun on an isle near Krk; in silver, the reliquary from the island of Lopud. From northern Italy in the eighth century, as a component of church architecture, came stone carving with interlace, which, beginning with the ninth century, continued to figure in local stonecutters' workshops in Dalmatia and Istria as an element of the regional pre-Romanesque art, exemplified by many monuments that have come down to us, including the parish church in Nin, dating from about 800.

From the waning Classical world the Slavs took over the traditions of craft production and through them the forms of the material cultural legacy of late antiquity, including Eastern Byzantine and Western Carolingian influences, which were to serve in more or less transmuted form as the foundation for the development of regional Slav cultural groups in the regions of present-day Yugoslavia from about the year 800 onward. It was at this time that the Slav peoples set up their first states, characterized by early feudal organization and pre-Romanesque art, which both in time and in substance are outside the scope of the period of the Great Migrations.

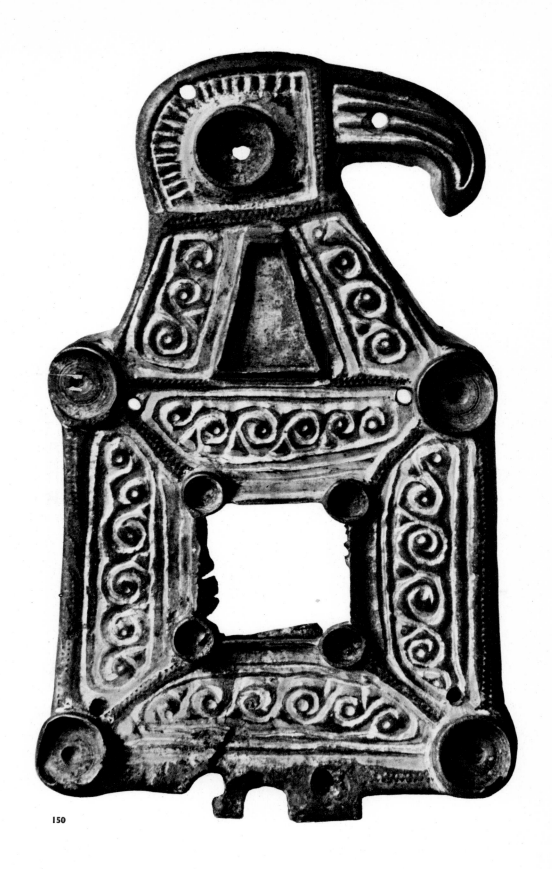

*150 Belt buckle in the polychrome style, from a Gepid woman's grave in Kovin. Black Sea area; 6th century. Silver gilt with chip carving and inlaid almandines or vitreous paste, height 4 1/8". National Museum, Vršac*

150

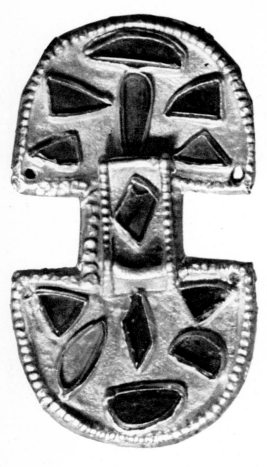
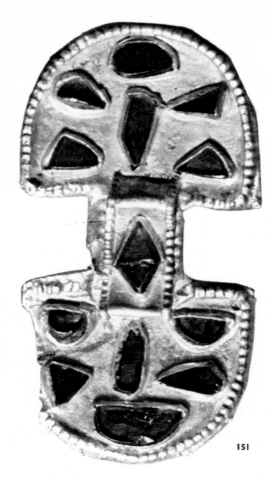

**151**

151 *Pair of polychrome-style slotted scabbard mounts, from Zmajevac. Black Sea area; first half of 5th century. Silver gilt with inlaid almandines, height 1 7/8". Archaeological Museum, Zagreb*

152 *Polychrome-style ring in the cloisonné technique, from a Gepid woman's grave in Srpski Krstur. Ostrogothic; first half of 6th century. Gold inlaid with almandines; diameter of band 5/8", of medallion 1". Museum of Vojvodina, Novi Sad*

153 *Bow fibula, from an Ostrogoth grave in Ilok. Mid-5th century. Silver plate, embossed and polished; length 8 3/8". Archaeological Museum, Zagreb*

154 *Bow fibula, from an Ostrogoth grave in Zemun. Latter half of 5th century. Gold-plated cast silver with chip-carved geometric ornament, animal-head motif on foot-plate; length 6 3/8". Archaeological Museum, Zagreb*

155 *Belt set (buckle, plate, and counter-plate) belonging to the uniform of an officer of the Late Empire, from Solin (anc. Salona). 4th century. Cast bronze, with chip-carved spiral ornament and plant and animal motifs; combined length 6 7/8". Archaeological Museum, Split*

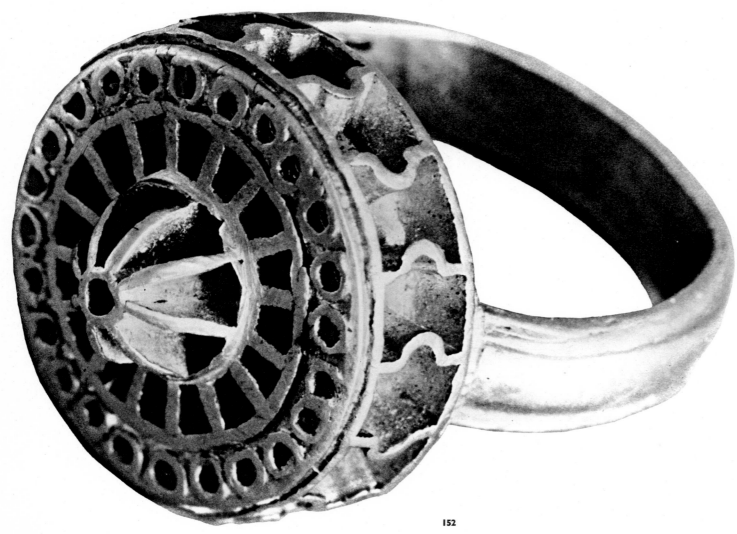

**152**

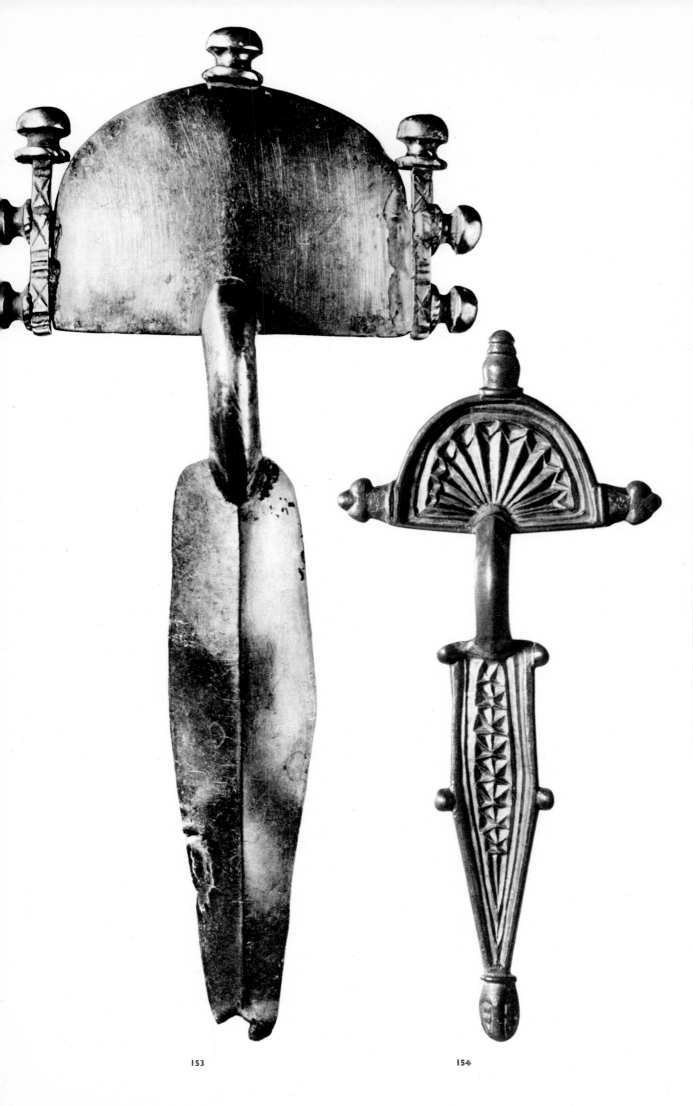

153

154

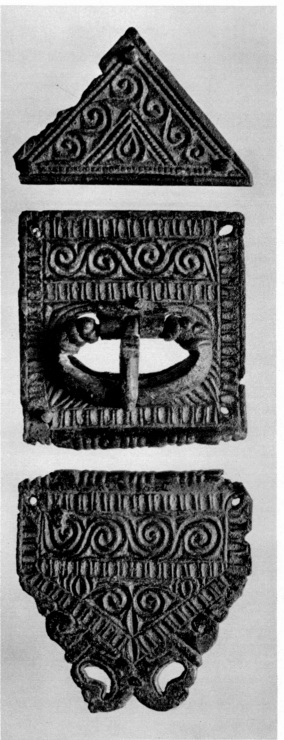

155

155

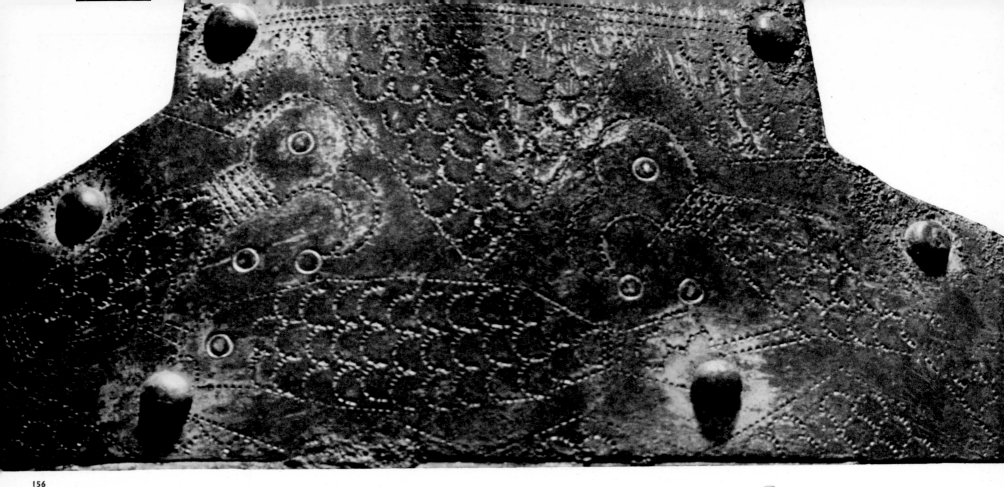

156

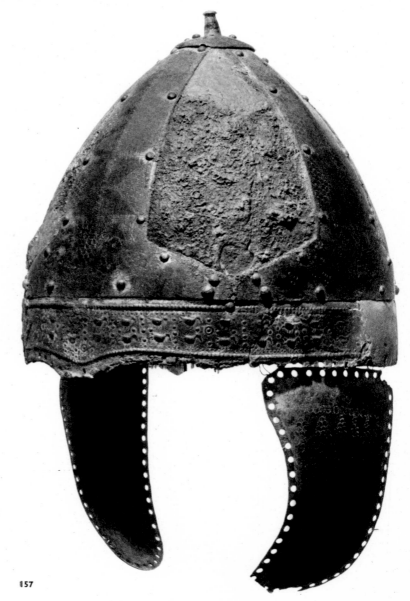

156 *Detail of Plate 157: section of gold-plated copper panel with two birds of prey and a fish, bordered by fish-scale motif*

157 *Helmet, from a Gepid prince's grave in Batajnica. Mid-6th century. Gold-plated decorated copper panels and bands riveted to iron; cheek plates of gold-plated copper. Height of helmet 8 1/8", diameter of forehead band 7 3/4", height of cheek plates 5 1/4". Archaeological Museum, Zagreb*

158 *Pair of bow fibulae, from a Gepid or Ostrogoth woman's grave in Sremska Mitrovica. Late 5th century. Gold-plated cast silver with niello work, almandines, chip-carved spiral ornament, and conventionalized animal-head motifs; length 6". Srem Museum, Sremska Mitrovica*

159 *S-shaped fibula with heads of two birds of prey, from Langobard grave 96/1904 of the cemetery in Kranj. Second half of 6th century. Bronze with inlaid almandines, maximum diam. 1". National Museum, Ljubljana*

160 *Pair of falcon fibulae, from a Langobard woman's grave (187/1907) in the cemetery in Kranj. Merovingian; latter half of 6th century. Silver with almandine inlays, height 1 1/8". National Museum, Ljubljana*

157

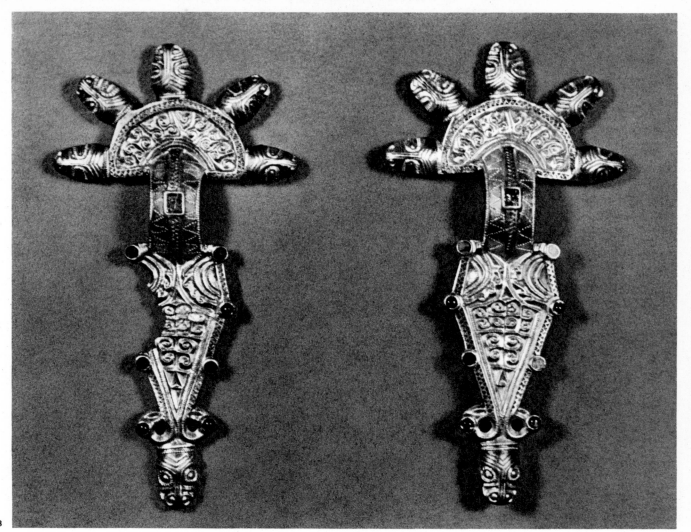

158

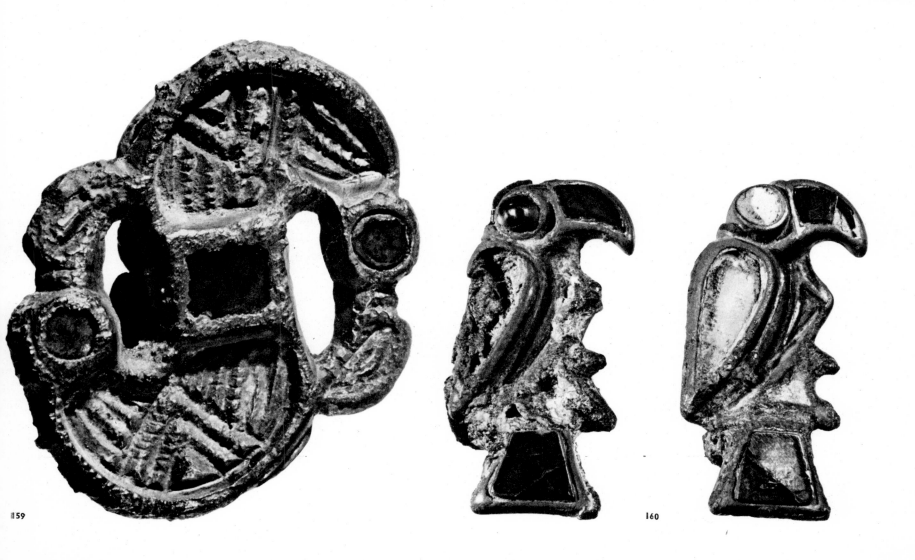

159

160

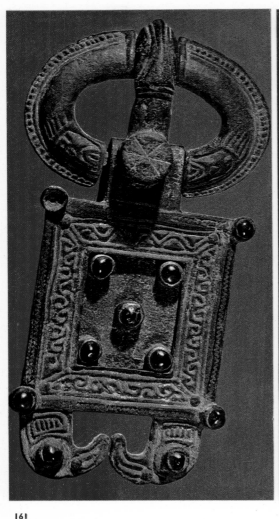

161

162

163

164

165

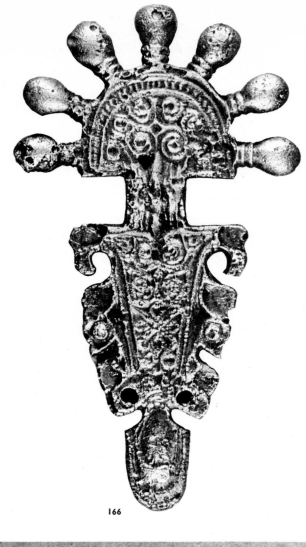

166

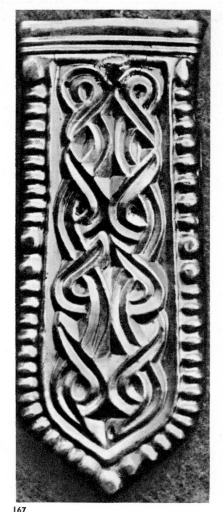

167

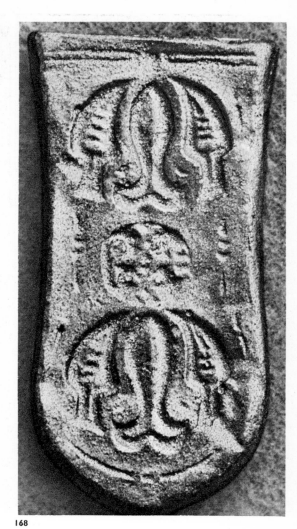

168

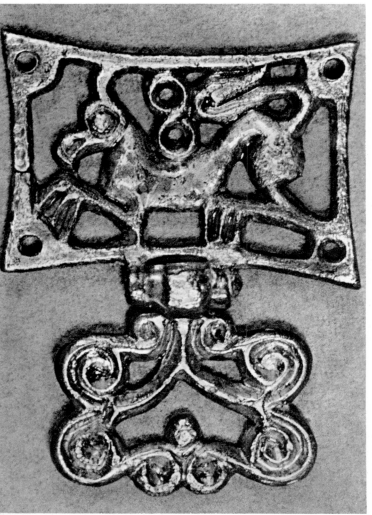

69

170

171

172

*173 Censer, from Cetina, near Vrlika. Mid-8th century. Bowl of cast silver, partly gold-plated (with copper liner), decorated with chip carving and niello work; chains of interlaced silver wire ending in links attached to a three-pronged center piece with stylized animal-head terminals. Height of bowl 2 3/8", length of chain 11". Institute of National Archaeology, Split*

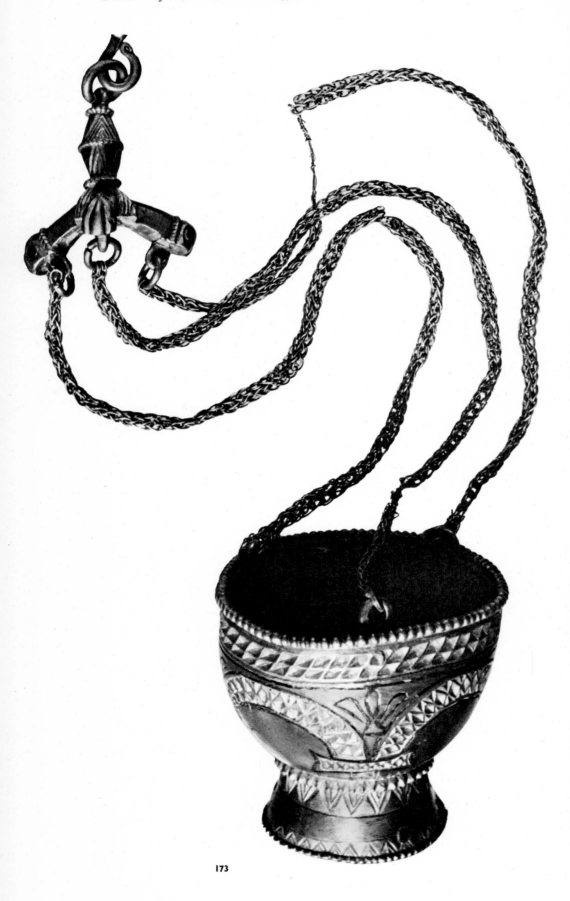

173

175

*174 Buckle of a Roman officer's belt, from Solin (anc. Salona). 4th century. Cast bronze with chip-carved geometric ornament, length 3 1/2". Archaeological Museum, Split*

*175 Woman's buckle plate, from the Pontic area, found in an unknown Serbian site. 6th century. Bronze or alloyed silver with traces of gold plating, height 3 7/8". National Museum, Belgrade*

# VIII MEDIEVAL WALL PAINTING AND ARCHITECTURE IN SERBIA AND MACEDONIA

Dušan Tasić
*Art Historian, Belgrade*

## BYZANTINE MONUMENTS

1 Ras, Church of St. Peter, 10th century

2 Ohrid, Church of St. Sophia, 11th–14th century

3 Veljusa, Church of Our Lady of Mercy, 1080

4 Nerezi, Church of St. Panteleion, 1164

5 Monastery of Djurdjevi Stubovi, near Novi Pazar, c. 1168

6 Kurbinovo (Lake Prespa), Church of St. George, 1191

7 Studenica: Church of the Virgin, 1209; King's Church, 1314

8 Žiča Monastery, near Kraljevo, c. 1220 and c. 1316

9 Mileševa, Church of the Ascension, 1236

10 Monastery of the Patriarchate of Peć: Church of the Holy Apostles (13th century), Church of St. Demetrius (14th century), Church of the Virgin (14th century)

11 Morača Monastery, 1252

12 Sopoćani, Monastery Church, 1265

13 Gradac, Monastery Church, c. 1280

14 Arilje, Church of St. Arhilije, 1296

15 Markova Varoš, Church of St. Nicholas, 1299

16 Ohrid, Church of St. Clement, 1295

17 Prizren, Church of the Virgin of Ljeviša, 1308

18 Church of St. Nikita, near Skopje, 1308

19 Staro Nagoričino, Church of St. George, 1318

20 Gračanica, Monastery Church, 1321

21 Treskavac, Monastery Church, 1334–43

22 Lesnovo, Monastery Church, 1341, 1346

23 Dečani Monastery, 1335–50

24 Zaum (Lake Ohrid), Monastery Church, 1361

25 Matejče Monastery, c. 1365

26 Psača, c. 1366

27 Marko's Monastery, near Skopje, c. 1371

28 Ravanica Monastery, c. 1381

29 Andreaš Monastery, near Skopje, 1389

30 Nova Pavlica, Church, c. 1398

31 Veluće, Church, c. 1395

32 Ramaća, Church, c. 1400

33 Ljubostinja Monastery, c. 1400

34 Rudenica, Church, c. 1410

35 Koporin, Church, first quarter 15th century

36 Kalenić Monastery, c. 1413

37 Manasija (Resava), Monastery, c. 1418

The earliest monument of medieval painting in Yugoslavia, the Church of St. Sophia in Ohrid, is classified, on the basis of both content and stylistic elements, as belonging to the mature Byzantine art of the Macedonian period. By the second half of the ninth century, after the defeat of the iconoclasts, in 843, a fixed system for the ornamentation of places of worship had emerged in the Byzantine Empire, which was to be adhered to for centuries with only minor innovations. A church was conceived of as God's temple on earth, and decoration was designed to emhasize this idea. The goal was achieved by a triple spatial division, vertical as well as horizontal. In the lower registers of the walls were depicted the martyred saints associated with life on earth; in the central zone, beings and events of a divine nature; and in the upper tier, celestial scenes. Similarly, the sanctuary of the church was reserved for liturgical scenes, the central section for scenes from the Gospels, and the narthex for compositions illustrating the church feasts and themes such as the Last Judgment. The iconographic scheme conformed to the concept that the earthly liturgy simply mirrored the celestial order.

Even this cursory enumeration of the fundamental themes that have recurred through the centuries makes it apparent that Byzantine art placed its entire system of expression at the service of Orthodox dogma. The Church not only decreed what was to be painted, however; it was also a determining factor in deciding how paintings were to be executed. Taking as a point of departure great Classical art, as earthly art, vibrant with the joy of life, and replacing it gradually with a spiritualized art that suppressed all elements not partaking of a spiritual, suprasensory character, the Byzantine Church succeeded, by and large, in articulating a visual idiom in which the values of inward experience, transmuted into symbols, were paramount. This Orthodox spirituality formed a framework from which Byzantine art was not to depart for centuries; the fixed iconography of Byzantine art stemmed from the conviction that ideas rather than individual appearances were of supreme importance. The immutability of forms followed from the concept that the essence of ideas was immutable. Hence it was essential to establish, not individual episodes but, rather, ideal prototypes. The system led to the fashioning of idealized figures of Christ, the Virgin, and the saints, and to the establishment of rigid patterns for compositions. The centralized art of Byzantium was a programmatic art designed to lead the believer toward heightened religious consciousness through sensory perception — to foreknowledge of eternal bliss, the supreme goal. The result was an art transcending time and space.

The paintings in St. Sophia in Ohrid were conceived, within the framework of a *Pl. 25, 176-178* mature Byzantine aesthetic, in a period that can be credited with a number of major achievements, among them the mosaics in the church of the Nea Moni in Chios, the church in Daphni near Athens, and the miniatures of the celebrated Menologion of the emperor Basil II in the Vatican Library. The original layer of Ohrid frescoes, from the first half

*a. Capitals of columns in the narthex of the church of the monastery of Dečani. c. 1355*

of the eleventh century, was the work of master painters from Constantinople or Salonika. The vault in the central section of the church is decorated with a monumental composition <span style="float:left">*Pl. 179*</span> of the Ascension of Christ and the remaining surfaces with figures of archbishops of Constantinople, Antioch, and Alexandria, and of Roman popes, with scenes chiefly from the Old Testament and the life of Christ. In their severe forms, somber flesh tints, and narrative style, and in the ascetic appearance of the saints, the frescoes of St. Sophia in Ohrid, executed during the time of Leo, Archbishop of Ohrid, conform to the eleventh-century tradition of Byzantine painting, created to the order of monks and clerics.

To th s integral whole belong two other monuments of the eleventh century, which are near Strumica, in Macedonia: the frescoes in the Church of the Virgin Eleousa (1080) in Veljusa and the fragments of frescoes in the ruined monastery in Vodoča. Apart from the usual figures of the liturgists (Basil the Great, St. John Chrysostom, Gregory the Theologian, and Athanasius the Great), and certain compositions *(The Descent into Limbo)*, the frescoes of Veljusa include a rare scene — *The Congregation of the Celestial Powers* (two archangels supporting a mandorla with an image of Christ). Despite the extensive damage suffered by the church in Veljusa, it is obvious that the artistic quality of the frescoes (the sure draftsmanship, the fine sense of color: dark shadowing on the faces, ocher on the cheeks, the pale green beards contrasting with the white crops of hair) is such as to justify ranking them with the finest monastic painting in Byzantine art. Moreover, a certain insistence on the outlines in the treatment of beards and hair heralds the advent of the linear predominance characteristic of the Comnenian period.

<span style="float:left">*Pl. 182*</span> The frescoes in the Church of St. Panteleimon (1164) in Nerezi, not far from Skopje, commissioned by a Comnenian prince, Alexius, may be considered as constituting one of the preeminent monuments of twelfth-century Byzantine painting and, for that matter, of all European painting of the period. Continuing the traditions which had been carried out or foreshadowed in the mosaics in Daphni, the Constantinopolitan masters of the Nerezi frescoes achieved their superb results within the framework imposed by the court artists of the day. The clearly visible compositions on the wall surfaces in the Nerezi <span style="float:left">*Pl. 30, 180*</span> church illustrate scenes from the great feast days, scenes of the Passion such as the Descent <span style="float:left">*Pl. 26, 181*</span> from the Cross and the Lamentation, events from the life of the Virgin, scenes from the <span style="float:left">*Pl. 183*</span> life of St. Panteleimon, to whom the church was consecrated, and, lastly, a host of holy hermits and warrior saints, among others. The Nerezi frescoes display all the features that are typical of Byzantine painting inspired by Hellenistic models: the stress on balance in the compositions, no less than on the masses within them, the manner of emphasizing

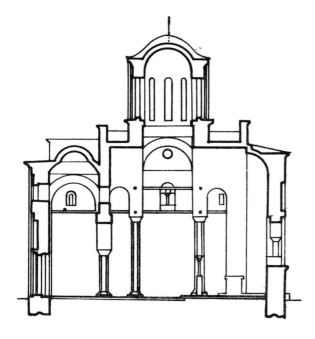

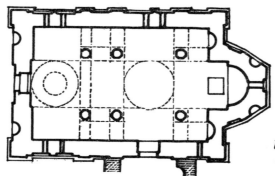

*b. Ground plan and section, Markov Manastir (Marko's Monastery). Late 14th century*

the protagonists, the indications of the feelings and inner spiritual life of the characters portrayed in the frescoes, and, not least, the color schemes. The treatment of color differs essentially from that in the frescoes of St. Sophia in Ohrid, which is based on chiaroscuro contrasts and directed toward endowing the figures with plastic relief. The Nerezi masters were fascinated above all by decorative color relationships. Their choice always fell on light tones, which they used in a harmonious interplay of line and surface. The elongated figures, the surely drawn, aristocratic heads, the pale green foundations overlaid with flesh tints, the hints at a stylized landscape — all combine to bring Nerezi painting close to Hellenistic artistic traditions and concepts. These frescoes may be ranked unequivocally among the most magnificent achievements ever attained by Byzantium, as heir to the great art of antiquity.

The impact of Nerezi painting on art in the second half of the twelfth century is illustrated by two other monuments in Macedonia dating from this period — the Church of St. George in the village of Kurbinovo on the shores of Lake Prespa, and the Church of St. Nicholas in Markova Varoš, near Prilep. The Kurbinovo church (1191) is in its entirety the product of a single period, while in the Church of St. Nicholas only the sanctuary *(Adoration of the Magi; Virgin with Angels)* dates from this time, the close of the twelfth century. The frescoes in these two churches belong to the school of painting that developed in the neighboring Greek town of Kastoria (Kostur). Deriving inspiration from the Nerezi wall paintings, the artists working on the Church of St. Nicholas of Kasnitzki in Kastoria produced there a somewhat cruder version of the type of painting found in Nerezi and in Kurbinovo.

These monuments in Macedonia are also significant for their approach to architectural form. Although all come within the scope of Byzantine sacred architecture as to type of foundation and manner of construction — the use of stone and brick — they depart considerably from typical monuments in Constantinople and Salonika in their treatment of details, thus affording evidence of the participation of local builders. Variation in ground plan is best illustrated by the monuments themselves: St. Sophia, a three-naved domed basilica (the dome is no longer extant); Vodoča, a cross-in-square shape with walls separating the main aisle from the side aisles; Veljusa, a quatrefoil; Nerezi, with its five domes over an irregular cross shape; and Kurbinovo, an elongated single-aisle structure.

In the seventies of the twelfth century we come upon the first monument whose building and decoration were commissioned by a Serbian ruler. The Church of St. George (Djurdjevi Stubovi) near Novi Pazar was endowed by the founder of the Nemanya dynasty,

the great prince Stephen Nemanya. Constructed in the turbulent times when the first genuinely independent states were taking shape, Djurdjevi Stubovi could only have been the product of foreign (Greek) masters working on the invitation of Nemanya. The fragments of the fresco work that remain (one section of the original is in the National Museum in Belgrade) indicate clearly that the authors of the frescoes in the nave (scenes of the great feast days; the Evangelists) belong to the same circle as the artists who were responsible for the Nerezi paintings. A few specific features set the masters of Djurdjevi Stubovi somewhat apart: the emphasis on outline, the painted architectural frames of the compositions, and the subdued palette.

Of the splendid decoration in the Church of the Virgin in Studenica, only a small portion of the original frescoes, which date from 1209, remain, and these in a state of disrepair. To mention only major ones, there are, in the sanctuary, the *Virgin with Angels*, the *Communion of the Apostles and the High Priests* from the *Adoration of the Sacrament;* on the pilasters, *St. John the Baptist, Our Lady of Studenica, Josaphat and Barlaam, St.* *Pl. 185, 186* *Nicetas;* and, on the west wall, the majestic and celebrated *Crucifixion*. In the serenity of the compositions, the monumentality of the figures, the mild expressions of the faces, and the uninhibited use of dark green flesh tints against the subdued tones of the drapery, the fresco painting in the Church of the Virgin in Studenica d splays features that signal a definite break with the style of the preceding epoch. These paintings were executed at a time when the great center of Byzantine art, Constantinople, had just fallen and the Latin Empire of Constantinople had been established, and when in the newly established state of Raška, little prestige was attached to the products of local workshops. The testimony of Theodosius — not always the most reliable source — to the effect that St. Sava invited the painters for the Žiča Monastery to come from the "city of Constantine" sounds convincing enough. The few surviving fragments of the original decoration of the Žiča Monastery, the bare outlines of which are still discernible in the choir area (*Crucifixion; Descent from the Cross;* figures of the apostles), are the work of the same group of masters as had worked at Studenica.

Because of the custom of entombment in churches practiced by the Serbian rulers of the Nemanya family, any number of monuments from the period are available for study. It is safe to assume that local painters' workshops were given the opportunity for activity on a large scale in Raška only after the second decade of the thirteenth century. There is no doubt that all the basic features marking the monumental style in Serbia during the thirteenth century already characterized the painting in Studenica. The epic sweep of the compositions, the power and monumentality of the figures, the absence of linear emphasis in the configurations (at least in the work of the ablest painters) are features common to all thirteenth-century works. Despite this general, shared orientation certain compositions, on closer inspection, give evidence of far more complex relations and differentiated artistic impulses.

A study of the earliest of the subsequent murals points clearly to the participation of local masters. In the frescoes, damaged by fire, in the chapel in the first story of the tower of the Žiča Monastery (c. 1220), with the figures of, among others, Archdeacon Stephen, Constantine and Helena, St. Sabas of Jerusalem, St. Theodore the Studite; in the fragments of frescoes in the ground-floor chapel in the belfry of the Church of St. Nicholas in Kuršumlija (c. 1330); in the frescoes of the narthex in Radoslav's chapel in Studenica (c. 1234), on whose south wall, among other paintings, is the *Translation of the Relics of St. Simeon Nemanya* — in all these the crude draftsmanship, the static figures, the extremely large eyes, the willful emphasis on the white outline of the eyes and the bridge of the nose, the inferior color, attest that the painting is the work of local masters who had learned their craft from the group of Constantinopolitan artists responsible for the frescoes in the great churches of Studenica and Žiča.

The magnificent painting in the church in Mileševa, founded by King Vladislav (r. 1233-42), demonstrates on the one hand the continued maturing of local masters and on the other the participation of outstanding artists who must have belonged to Byzantine artistic circles. Of the original decorations in the Mileševa church, completed about 1235, only about a third remain in a good state of preservation. In the central section are the *Descent from the Cross*, the *Annunciation*, the *Resurrection (The Angel at the Sepulcher)*, part of the *Dormition of the Virgin*, portraits of the donors, and a number of figures and medallions of individual saints. The best-preserved compositions in the narthex are those on the west wall: *The Agony in the Garden, The Betrayal of Judas*, figures of holy hermits, and a composition of donors with figures of *King Vladislav*, Radoslav and Stephen Nemanya II (Stefan Prvovenčani, the "First-crowned"), St. Sava and Simeon Nemanya. Though integrated into a fully coherent whole, the frescoes in Mileševa belong, in conception and technique, to different artistic currents. The finest section is certainly the work of the group of masters who painted the heads of the apostles in the *Dormition of the Virgin* and executed the *Angel at the Sepulcher*. The Classical beauty of the heads, the excellent draftsmanship, the epic expression of sorrow, the majesty of the monumental figures, the refined colors, coupled with the gradual replacement of the dark tones of the Studenica frescoes by the pale green foundation of the flesh-color enlivened by strokes of white and pink, combine to make this work one of the culminating points not only of the Mileševa frescoes but of contemporary European painting in its entirety. The beauty of these frescoes was to be surpassed only by the brilliant master of the *Dormition* in Sopoćani, described below.

The frescoes in Mileševa are p-rticularly significant for their portraits of potentates. In all the foundations of the Serbian kings, nobles, and prelates, figures of donors were regularly included, but the quality of these examples puts them in the forefront. If ever

*Pl. 193*

*Pl. 190*

*Pl. 192*
*Pl. 196*
*Pl. 191*

*Pl. 195*

*Pl. 194*

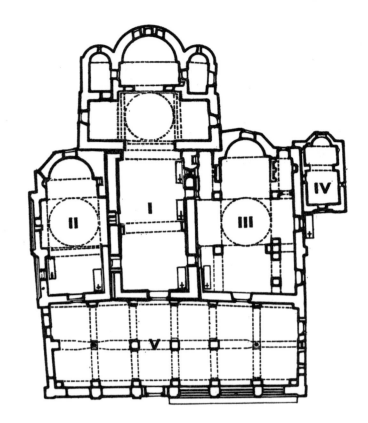

*d. Churches of the monastery of the Patriarchate of Peć: I. Church of the Holy Apostles, 13th century. II. Church of St. Demetrius, 14th century. III. Church of the Virgin, 14th century. IV. Church of St. Nicholas, 14th century. V. Narthex of Archbishop Danilo II, 14th century*

Byzantine stylization approached the realistic portrait, it was in the figures of Vladislav and St. Sava in Mileševa. The magnificent draftsmanship and the powers of realistic observation displayed here were never to be repeated in the galaxy of portraits found in the monuments dating from the time of the medieval Serbian state, the largest in Europe in its day; the Mileševa figures represent the climax of the complex process by which works of this type developed from the unassuming portraits of donors worshiping Christ and the Virgin in the thirteenth century to the triumphal glorification of power in the fourteenth century.

The church in Mileševa contains yet another group of frescoes which merit special attention: the scenes from the Last Judgment in the outer narthex, painted somewhat later but certainly not before the middle of the thirteenth century. Reverting in the modeling of the faces to a dark reddish hue that had been abandoned in the second half of the eleventh century, relying on a strong linear stress, and displaying a draftsmanship inferior to that of the other artists working in the same church, these painters represent the conservative trend in thirteenth-century Serbian art, which, while more advanced in its approach to color, was to nurture the archaic manner that led at its best to the painting in the Church of the Holy Apostles in Peć and at its poorest to the frescoes in the Church of St. Achilius in Arilje and the Church of St. Nicholas in Markova Varoš, near Prilep.

An entirely different group of artists was entrusted with the work (virtually contemporaneous with the decoration of the church in Mileševa) in the Church of the Virgin of Ljeviša in Prizren. The output of this group of artists, whose gradual growth in stature may be traced from the frescoes in the Church of St. Nicholas in Studenica (c. 1240) to the remains of the frescoes in the church in Morača (c. 1252), is of the utmost interest. A few fragments, from about 1230, are all that is left of the Ljeviša frescoes *(Christ Healing the Man Born Blind, The Marriage at Cana, The Unknown Miracle, The Virgin with Christ).* A somewhat larger number of frescoes have survived in the Church of St. Nicholas in Studenica *(Christ's Entry into Jerusalem, The Marys at the Tomb,* and others). The most

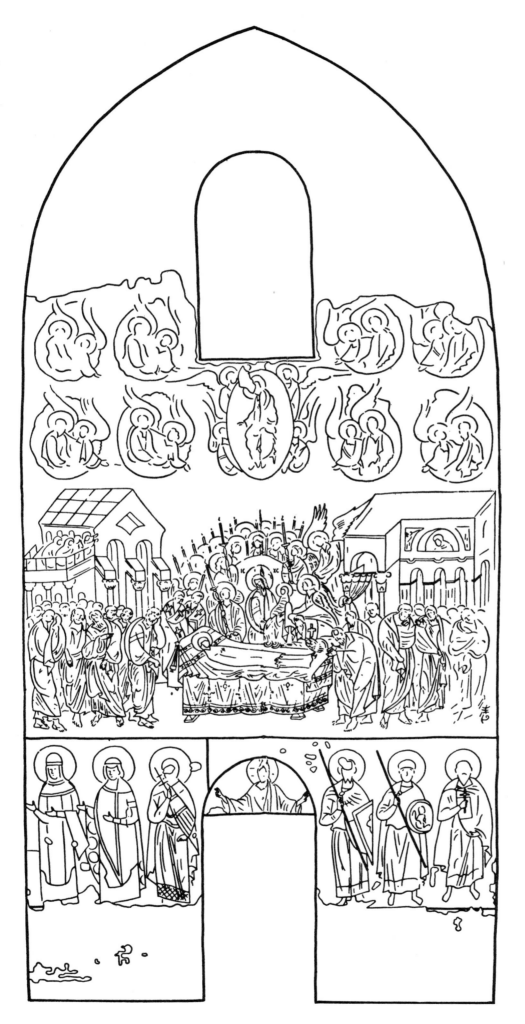

*e.* The Dormition of the Virgin. *Fresco on the west wall of the nave, church of the monastery of Sopoćani, c. 1265*

*Pl. 201*     outstanding remains are certainly those from the diaconicon in the Morača church, where in addition to the *Annunciation, Our Lady of the Sign*, and the *Deësis*, there are eleven scenes from the life of St. Elijah.

The painting of this group of artists represented in Prizren, Studenica, and Morača is characterized by virtually identical drawing of the heads, a uniformly light palette, and a common inclination toward sculptural treatment of the figures. These resemblances are so striking that there can be no doubt that the frescoes in question are the work of the same group of master painters. Judging both by the level of artistry and by the unique cycle illustrating the life of St. Elijah, the Morača frescoes must be ranked among the most mature achievements of mid-thirteenth-century Serbian painting. And, on the basis of the evidence, they must be attributed predominantly to the effort of local masters.

*Pl. 198, Fig. d*     In the unique complex of churches in the Serbian patriarchate of Peć, the earliest is the Church of the Holy Apostles, founded by Archbishop Arsenius I toward the middle

*Pl. 199*     of the thirteenth century. In addition to the majestic *Ascension* in the dome, the *Deësis*

*Pl. 197*     and the *Communion of the Apostles* deserve special attention. Despite certain differences of approach the original layer of paintings in the Church of the Holy Apostles is marked by a rare unity. It has already been suggested that the artistic conceptions which produced the frescoes of the *Last Judgment* in the outer narthex at Mileševa here attained full maturity and mastery. Adhering basically to similar coloristic principles dominated by strong, subdued tonalities applied in broad strokes, the masters responsible for the Peć Holy Apostles developed the visual relations to achieve a rather original impression of volume. Essentially they were striving — like the painters of Mileševa before them and the masters of Sopoćani after — for sweeping, modeled surfaces. The differences lie in the choice of colors, in the dark-green tones used as the foundation of the flesh tints and the ocher surfaces in the Holy Apostles — colors altogether unlike the lighter Sopoćani palette. The more archaic and austere selection of colors in the Holy Apostles coincides with certain obsolete iconographic motifs, examples of which may be found in late Comnenian painting of the twelfth century in Bačkovo, Bulgaria (the *Deësis* in the altar conch). And yet the predilection for unmistakably Classical heads (such as those of the angels bearing Christ's body in the *Ascension*) and even a certain sensuousness (the figure of the Virgin in the same composition) prove that the masters of the Holy Apostles executed these frescoes by combining what appear to be the most irreconcilable elements — monastic severity of theme and tranquil tonalities in contrasting hues — while reverting at the same time to the explicitly Hellenistic facial features known to us from works by court artists like those of Mileševa and Sopoćani.

Serbian monumental art was to surge upward only once more in the course of the thirteenth century. The frescoes in the celebrated church of Sopoćani, near Novi Pazar, commissioned and endowed by Stephen Uroš I, are indeed the highest achievement both of Byzantine painting and of European art generally during the thirteenth century. Dating from about 1265, the Sopoćani frescoes are not the outcome of a unified aesthetic outlook. The masters who began decorating the dome area, the pendentives, and the nearby recesses were sadly lacking in the skill, power, and talent of the great artists to whose genius

*Pl. 206, 207*     we owe the exceptional frescoes of the *Dormition of the Virgin*, the scenes of the *Nativity*, and the figures of the individual apostles. The first painters entrusted with the decoration of the church had, by and large, worked within the confines of antiquated concepts of linear configuration left over from a bygone period. But the most gifted of the subsequent masters brought to a most effective fulfillment the new views that were first hinted at in Studenica, then considerably developed in Mileševa, and still further cultivated by the workshops responsible for the wall paintings of Morača toward the middle of the century. Colors that seem to flow, limpid and refined (the greens, ochers, and violets striking a dominant chord), the majestic figures that had vainly haunted the first half of the thirteenth

century rising in almost tangible volumes — these reached their zenith in the work of the greatest of the Sopoćani masters.

The great art of the Sopoćani master of the *Dormition* rests on his exceptional sense of monumentality, whose like Byzantine painting neither had known before nor was to know again. Every means of pictorial expression is bent toward achieving that monumental effect. Balance in composition, serene stances, the rhythmical recurrence of extremely refined color surfaces, the omission of secondary details, consistent restra nt in the outward expression of inner experiences, all pursue the same aim — to conjure up an overwhelming monumental whole. To this must be added the fine draftsmanship of the classically noble heads, which, no less than the life-size figures, were painted in broad, free strokes by a master artist whose palette was a veritable hymn of color. None of this can be omitted if the grandeur of Sopoćani is to be conveyed, however inadequately. *Pl. 205*

The latest group of monumental paintings, which came into being after Sopoćani, is anything but homogeneous. Outdated iconographic and stylistic ideas persist in the frescoes in the Church of St. Nicholas in the village of Manastir near Prilep (1271), in the church dedicated to St. Achilius in Arilje (1296), and in the Church of St. Nicholas in Markova Varoš (1299), as well as in the surviv ng fragments of the third layer of the frescoes in St. Peter's Church in Ras (late thirteenth century), in the chapel of King Dragutin near Djurdjevi Stubovi (1283), and in Davidovica on the Lim River (1281). But the murals in Gradac, at least in part, and to a much greater extent those of the Church of Our Lady in Sušica (1280-90) and, especially, those of the Church of the Virgin Peribleptos in Ohrid (1295), better known as the Church of St. Clement, tackle the new problems that came in with the fourteenth century.

The paintings in Gradac, where the monastery with the Church of the Annunciation was founded by Queen Helena, consort of Stephen Uroš I, display distinct iconographic innovations, such as the extensive cycle from the life of the Virgin and the representation of Christ as *imago pietatis*. But the positioning of certain compositions (the *Nativity* on the south wall, the *Crucifixion* on the west, and the *Dormition* on the north) hark back to the first years of the thirteenth century and follow Studenica. Being badly damaged, the Gradac frescoes provide only a partial indication of the stylistic leanings of their authors. It is nevertheless patent that these artists were resolved to perpetuate the style of the masters responsible for the decoration of only the upper reaches of the Sopoćani church (dome, pendentives, etc.) and consequently belong to the conservative section of the great Sopoćani group. They strove for monumentality but achieved no more than rhetorical posturing. They aimed at being more expressive but remained merely mediocre. And yet the frescoes in Gradac are undoubtedly a positive contribution to the search for new artistic solutions in the transitional phase of the end of the thirteenth and the beginning of the fourteenth century.

Many more new elements heralding the style of the early fourteenth century are to be found in the Church of Our Lady in the village of Sušica (near Markov Manastir, in the vicinity of Skopje). Dating from the late thirteenth century, the wall paintings in this small church, predominantly illustrating the life of the Virgin, form an important link in the chain of artistic expression stretching from the twilight of one epoch to the dawn of the next. From the same transitional period comes a double-faced icon representing the Virgin Hodegitria and the Crucifixion, strikingly similar in artistic approach to the Sušica frescoes.

The group of Nemanya monuments provided a framework for the development of painting in medieval Serbia while at the same time laying the foundations for thirteenth-century Serbian architecture. The Raška school of architecture, as it is known, is characterized by a number of common constructional elements but considerable diversity in ground plan and types of building material. The typical form is a single-aisled vaulted

*Pl. 31, 204, Fig. e*

*Pl. 203*

structure with one dome on a square compartment giving on side apses; the altar apse is semicircular, and the narthex shares the facade and roof of the church itself. In most cases the church walls are of stone; this is frequently plastered and only exceptionally faced with marble slabs. The facade is broken only by shallow pilasters and an arcature under the eaves composed of a series of small blind arcades on consoles. Typical of this group of monuments is the absence of horizontal articulation of the facade. Over twenty *Pl. 184* of the monuments of the Raška school are still extant. The Church of the Virgin in Studenica and the church of the Žiča Monastery are without question the earliest. Djurdjevi *Pl. 193, Fig. d* Stubovi, Mileševa, and the Church of the Holy Apostles in Peć were constructed in the first half of the thirteenth century. Belonging to the second half of the same century are the outstanding structures singled out above for their monumental painting: in Morača in Montenegro, Sopoćani at the source of the river Raška, Gradac on the Ibar, Davidovica on the Lim, and Arilje on the Moravica. Though chronologically somewhat removed the major monuments of the fourteenth century also belong to the Raška group: the monastery of Banjska, in the vicinity of Kosovska Mitrovica, the famed Dečani Monastery, and the monastery of St. Michael the Archangel near Prizren.

The last great period of Byzantine art — the Palaeologan renaissance, or revival — takes its name from the dynasty that ruled from 1261 to 1453, long enough to put its mark on the period. Artistic complexes whose coherence was disturbed by only trifling deviations flourished during the earlier dynasties of the Macedonians (867-1081) and the Comnenes (1057-1185 in Constantinople); the Palaeologue era brought about a far more diversified art whose monuments often differed so considerably that there seems to be no connection between them other than their fortuitous inclusion in the same chronological framework. By now it is well known that this "renaissance" was far from being the expression of a basically new view of the world such as was being formulated in Italy at the time. Whereas the entire social structure of the Italian states was changing and a new concept of the creative role of the individual was gradually emerging, causing the importance of the Church more and more to wane, Byzantium, and in its wake the entire Orthodox world, preserved intact the foundations of the ruling feudal society, thus consolidating and increasing the influence of the Church. Thus Palaeologan art appears to have been no more than a continuation of inherited traditions, a development within a charmed circle doomed to a slow, self-inflicted death from the very moment in 1300 when it proved incapable equally of embracing the new world philosophy and of adopting the new structure of the pictorial image conceived by the great Giotto.

Although the Byzantine fourteenth century never altered its artistic expression in essence, new tendencies gradually made headway, beginning in the 1280s and by degrees infiltrating the very structure of the pictorial image until they altered its character substantially. These changes were not the result of accidental discoveries by gifted individuals; they were part of an extremely complex process that brought about also the diffusion of new architectural ideas and the appearance of new themes in literature. The monumental frescoes of the thirteenth century relied on the correspondingly broad and uninterrupted expanses of the walls in Raška architecture; the new articulated surfaces and play of light were not adapted to the older forms of pictorial composition. At the same time, the interest in fresh subject matter introduced numerous details, previously unknown, into the familiar narration of the thirteenth-century frescoes. Besides the Gospel, apocryphal texts and ecclesiastical poetry became popular because they were in harmony with the spirit of the time. The blending of vibrant interior architecture and increased narrative content was spontaneous and complete. The once striking monumentality of majestic compositions and outsize figures gave way to murals of narrative character whose reduced dimensions were suited to the new environment. It was natural that the epic style of exposition should be supplanted. The multitude of scenes in a dimly lit space called for a change

*f. Window in the north facade, monastery of Kalenić. c. 1415*

in the inner structure of the image if its impact on the beholder was to be maintained. This was to be achieved above all by the twin means of enhanced stage effects in the composition and emphasis on the gestures of the figures. In the tranquil earlier compositions the figures had stood before a neutral backdrop. But this relation had to undergo a radical change: the architectural background was divided into three sections, and the figures upon this imaginary stage appeared much truer to life precisely by virtue of their decreased dimensions. In addition, details of secondary importance were used to accentuate the scenic flavor of the fourteenth-century frescoes. New methods were also adopted for the sculptural effect of the draperies: the once ponderous but unruffled surfaces of the textiles were superseded by violent swirls of fabric, lit and emphasized by broad touches of white. Thus clad, the gesturing figures gained enormously in dramatic impact. But this new art was also moving toward a greater intimacy, underlined by an entirely new chromatic scale. Warmer ocher hues, with which the entire color scheme had to conform, were increasingly preferred to the blues and greens and subtle violet shades that had once lent a cool tone to most paintings.

The frescoes of the Church of the Virgin Peribleptos (Church of St. Clement) in *Pl. 216* Ohrid, painted in 1295, include all the innovations that were to inform the mature art of the fourteenth century. Founded by the Byzantine general Progon Zgur at the time when Ohrid was under Byzantine rule, the Church of St. Clement demonstrates the new tendencies developing both in the capital — Constantinople — and in the second-largest city of the empire — Salonika. The beginnings of this new art on the territory of the expanded medieval Serbian state, an art that was to attain full maturity in the churches built by King Milutin, repeat the pattern already seen in the early thirteenth century by absorbing artistic influences originating from the great Byzantine centers. The artistic development of Michael and Eutychios, authors of the frescoes in St. Clement, can be traced easily through the considerable number of their works that survive. By the end of the thirteenth century they had already completed the frescoes in the west bay of the Church of the Holy Apostles in Peć, namely the cycle of the Passion, as well as the frescoes in the Church of the Protaton in Karyes, on Mount Athos. It is highly probable that Milutin commissioned these masters and their helpers to decorate the restored monastery of Chilandari (c. 1303;

*Pl. 202*

covered by a layer of subsequent overpainting). They signed their work in the monastery of St. Nikita, near Skopje, in 1308, and then again in 1318, in the monastery of St. George in Staro Nagoričino, not far from Kumanovo.

*Pl. 217*

*Pl. 212, 213, 214*

During this period of intensive building activity on the part of King Milutin, whose reign came to an end in 1321, there were also erected the Church of the Virgin of Ljeviša in Prizren (1308), the King's Church in Studenica (1314), and the church of the monastery of Gračanica (1321). All these, as well as some other churches built or decorated in those years — Žiča, c. 1316; St. Peter at Bijelo Polje, c. 1320; Sv. Spas (Holy Saviour) in Kučevište, near Skopje, c. 1325; and the frescoes, now destroyed, of the great church of St. Stephen in Banjska, c. 1318 — are so strikingly similar in style that they must be, if not actually works by the same group of artists, at least the work of several groups of painters whose aesthetic views and methods differed hardly at all. Progressing beyond the primitive tension and crude colors of St. Clement in Ohrid and, further, beyond the tran-

*Pl. 215*

*Pl. 187, 188, 189*

sitional forms of the frescoes in the Church of the Virgin of Ljeviša in Prizren, Serbian art attained in this whole group of churches the noble harmonies and dignified stances of the truly superior art that culminates in the frescoes of the small church in Studenica. This is the only monument of Serbian art in the fourteenth century which could, by virtue of its outstanding stylistic coherence, stand comparison with the masterpiece of Byzantine art of the time — the Kariye Camii (Church of the Saviour in Chora) in Constantinople. This metropolitan church represents — as do the mosaics of the Church of Our Lady Pammakaristos, also in Constantinople, and the mosaics and frescoes in the Church of the Holy Apostles in Peć, among others — the final phase in the search that must have been going on in Constantinople toward the end of the thirteenth century. The Church of St. Clement in Ohrid is all the more important since it contains the only frescoes that have survived to reveal the gradual mutation of the visual idiom, as well as the changes brought about by a new age.

The stylistic coherence of this highly refined art of the beginning of the fourteenth century waned after the death of King Milutin. From the thirties of the century onward, through the reigns of Stephen Dečanski, Stephen Dušan, and Stephen Uroš V, to the artistic revival along the Morava Valley in Serbia in the late fourteenth and early fifteenth century, artists seem to have lost their visual bearings. In a suddenly enlarged state, at a time when the Renaissance in neighboring Italy must have exercised great fascination, the cogency of the Byzantine artistic idiom was bound to suffer. It is therefore not surprising that even the outstanding works of art of the mid-fourteenth century (1321-71) are far from displaying the conceptual maturity or the painterly perfection of the earlier epochs. And yet this era abounds in frescoes and icons; at least forty churches preserve frescoes of the period, entire or in part. Some are small churches built by obscure landed gentry or local clerics, such as Ohrid's Church of St. Nicholas Bolnički, Church of the Virgin Bolnička,

*Pl. 200*

Old St. Clement, St. Demetrius, and the Gregory Chapel in the Church of the Virgin Peribleptos (St. Clement). Others are somewhat larger, erected by prominent landowners or high-ranking prelates: the Church of Our Lady in Mušutište (c. 1320), the Church of the Virgin in Peć (c. 1330), Bela Crkva (the White Church) in Karan (1337), Ljuboten (1337), St. Saviour in Prizren (c. 1340), St. Demetrius in Peć (c. 1346), the Zahum Virgin (1361), Psača (c. 1366), Dobrun (1370 and 1383), Zrze (1369), Rečani (c. 1370), the choir of the Church of the Holy Apostles in Peć (c. 1375-80). A third group includes the churches built under the auspices of the most powerful noblemen or crowned rulers of the land — such as Banja Pribojska (1330), Treskavac (c. 1343), the outer narthex of Sopoćani (c. 1346), Lesnovo (1341 and 1346), the Archangels in Prilep (c. 1350), Dečani (1335-50),

*Pl. 208, 209*

Matejče (c. 1365), Konče (before 1366), Markov Manastir (c. 1371). Of the many more churches with frescoes, some have been demolished, others have had their frescoes completely destroyed. The imposing total of paintings testifies with certainty to the large-

scale cultural activity in the medieval Serbian state and eloquently evokes the prevailing spiritual climate, which spurred even obscure country squires to endow ecclesiastical buildings in their efforts to imitate, on a modest provincial scale, the munificence of the mighty rulers. It is self-evident that such well-meaning but haphazard efforts could not leave behind a coherent artistic legacy. Although the frescoes described above present some stylistic analogies, they are in the main virtually self-contained unities which it is difficult to relate. The most significant achievement of this period devoid of any specific orientation is the church of the Dečani Monastery. Its frescoes are to be taken as repre- *Pl. 210, 218, Fig. a, c* senting, not a convergence in the middle of the fourteenth century of various lines of pictorial development, but a panorama of the divergent endeavors of the artistic work- shops and of the gropings within each of the numerous groups of artists entrusted with the decoration of churches in the four corners of Dušan's vast realm.

The predominantly Romanesque appearance of the buildings of the Raška school changed completely during the fourteenth century. As a result of the extension of the state southward and the conquest of Byzantine territories, churches in Kosovo, Metohija, and Macedonia acquired explicitly Byzantine features. A typical device was the polychrome decoration of facades achieved by alternating layers of stone and brick. The ground plan *Pl. 217* was in most cases the cross-in-square shape resulting from the intersection of two hemi- spherical vaults, with the dome rising over the intersection and walls encircling the entire base in the form of a rectangle. The ground plan of structures belonging to this group was externally apparent from the roofs with their four arms jutting out from the dome. These transverse arms were frequently so short that the columns under the dome did not stand free but were attached to the flanking walls of the structure (ground plans of this type are known as "contracted"). The group of fourteenth-century monuments mentioned above may be classified according to the type of ground plan and the number of domes. Markov Manastir, Lesnovo, and the Church of the Virgin in Peć, for example, *Fig. b* have one dome with four freestanding columns. The Virgin of Ljeviša, Gračanica, and Matejče, among others, have the same type of ground plan but five domes. A third group, with contracted ground plan and one dome, includes the King's Church in Studenica and St. Demetrius in the Patriarchate of Peć. All these structures were characterized by, in addition to the stone and brick work described above, three- or five-sided altar apses, polygonal domes (predominantly octagonal), and unarticulated facades.

The fateful battle of the Marica (Maritsa) River in 1371 altered the course of cultural and political life in the medieval Serbian state. Within its former borders, in present-day Macedonia, there persisted an art firmly adhering to archaic models; its outstanding achievements were the works of the group surrounding the Metropolitan John and the frescoes of the Andreaš monastery near Skopje, dating from 1389. Meanwhile, in the new Serbia along the Morava Valley, the waning Middle Ages witnessed a new surge of crea- tive vitality that gave rise to the finest painting produced by the declining Byzantine genius in its last decades. Synthesizing the qualities of the early examples of a more expressive manner, found in certain of the frescoes in Ravanica (dating from the eighties of the four- teenth century), and of the great achievements of the early fourteenth century, with their Hellenistic echoes (Kariye Camii in Constantinople, Church of the Holy Apostles in Salo- nika, the King's Church in Studenica), the masters who worked in the Serbia of Despot Stephen Lazarević brought forth a new type of painting. From this period survive some ten churches, artistically of uneven quality and mostly notable for their florid architecture: Sisojevac, about 1390; Veluće, about 1395; Nova Pavlica, about 1398; Ramaća, about 1400; Ljubostinja, about 1400; Rudenica, about 1410; Koporin, about 1412; Donja Ka- menica, early fifteenth century; and, in a class by themselves, Resava (frequently called *Pl. 220* Manasija) and Kalenić. The last two are masterpieces of the Byzantine spirit and of Serbian art in the Middle Ages.

A cursory comparison of the Resava frescoes (1406-18) and the murals of the fourteenth century may give the impression that nothing had really changed. At first glance the pattern of the compositions may appear to be similar, and so may the selection of subjects and the relations of the figures to their architectural background. But such similarities are superficial. In fact, the entire character of the painting has undergone substantial changes: a new lyrical mood has superseded the earlier dramatic tension, and there is a predominance of pastel chromatic values much more attuned to this melancholy, elegaic style — and hence much closer to the refined tonality of the early fourteenth century. Most of the murals in Resava have been badly damaged, but fortunately the work of the most talented artist who worked there — the figures of the prophets Habakkuk, Gideon, and Ezekiel in the tambour of the dome and the Evangelists in the pendentives — is fairly well preserved. Such perfection of artistry had not been seen in the Byzantine world for a long time, at least not since the days of Sopoćani and the Kariye Camii in Constantinople. The sky-blue and golden harmonies of the Resava frescoes, their rendering of the resplendent attire of contemporary nobility, their scenes of religious inspiration, and their medallions encircled by intertwining ornamental bands seem to create a world of their own, raising to the highest possible level (as do most of the Moravian church facades) the attributes of rich beauty, realistic characterization, and decorative magnificence.

*Pl. 219*

The only monument of the period that bears comparison with the Resava frescoes is the just-mentioned church in Kalenić (1407-13). Along the Morava Valley, where a host of artists and men of learning had congregated to seek refuge from the Turkish invasion of the Serbian state, it was not uncommon to come across disparate elements. And yet, although the frescoes of Kalenić and Resava were painted by two entirely different groups of artists, they are linked by their common air of graceful refinement, their faultless draftsmanship, and, above all, by their lyrical mood. The gentle, red-ocher harmonies of the scenes from the life of the Virgin in the narthex at Kalenić and the famous *Marriage at Cana* surpass anything of the kind in medieval Serbian art. It is truly hard to dispel the suspicion that the gently modeled body of Christ in the niche of the proskomidion may be the work of some contemporaneous painter from Renaissance Italy, but the truth of the matter is quite other. The painters who came after the great artists of Kalenić and Resava, cut off from the mainstream of life, faced with a dark future, had nothing more to say.

*Pl. 218*

These monuments from the Serbia of the Morava Valley retained the earlier plan of fourteenth-century structures except that, owing to the influence of the churches on Mount Athos and the requirements of the Orthodox ritual, the northern and southern transverse arms ended in hemispherical apses, giving the entire structure (including the altar apse) the form of a trefoil. Two fundamental tendencies mark the buildings of this period: their vertical thrust and exceptionally decorative facades. Verticality was achieved by the engaged colonettes and, especially, by the construction of the dome, resting on a raised square base. It is worth noting that this way of raising the dome is found exlusively in the Morava Valley of Serbia. These buildings owe their decorative appearance to several elements: alternating courses of brick and stone cemented together by thick layers of plaster, the multicolored effect achieved by a variety of geometric ornamentation, and the richly carved reliefs over portals and windows. Frequently the sculptural decoration — two interlacing bands, stylized leaves, or animal and human figures — was also in colored material. Two foundations of Prince Lazar, Lazarica in Kruševac and Ravanica near Ćuprija, are prominent among the monuments in this group. They served as models for most of the Morava buildings: Neupara near Kruševac, Ljubostinja, Veluće and Rudenica near Trstenik, as well as Kalenić, not far from Ljubostinja. The churches of the monasteries of Resava and Vraćevšnica, with their facades of the Raška type, were the only ones to break out of the confines of this stylistic framework.

*Fig. f*

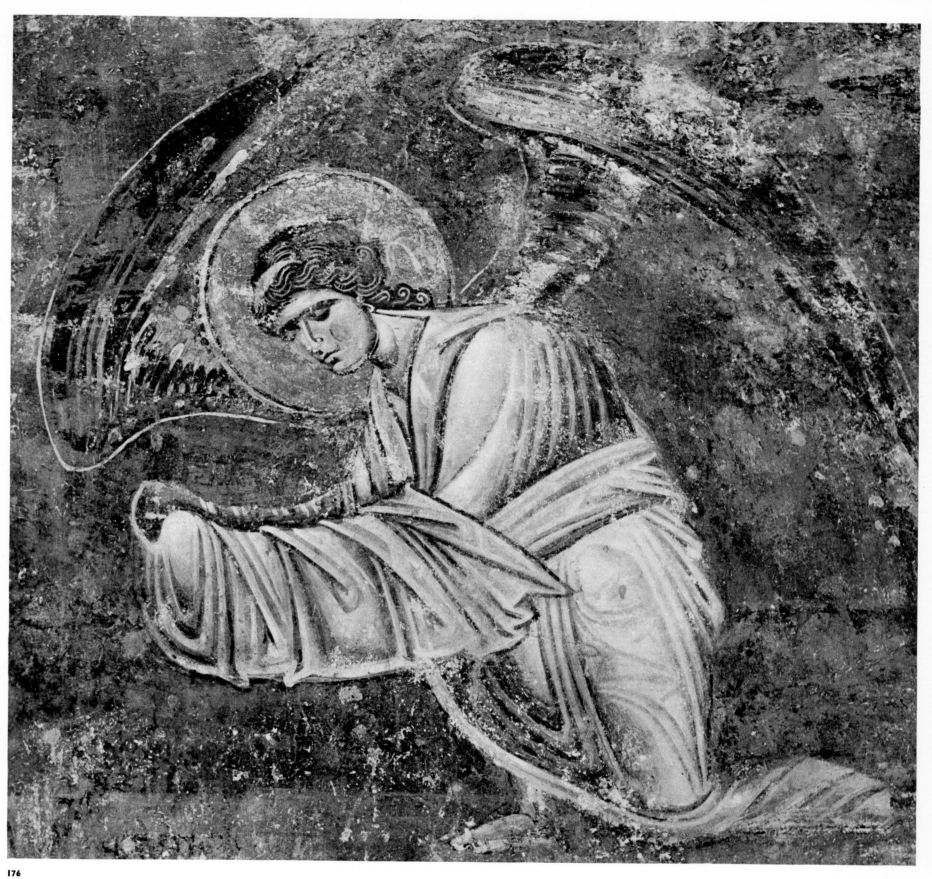

176

*176 Angel, detail of row of angels. Fresco, Church
of St. Sophia, Ohrid. First half of 11th century*

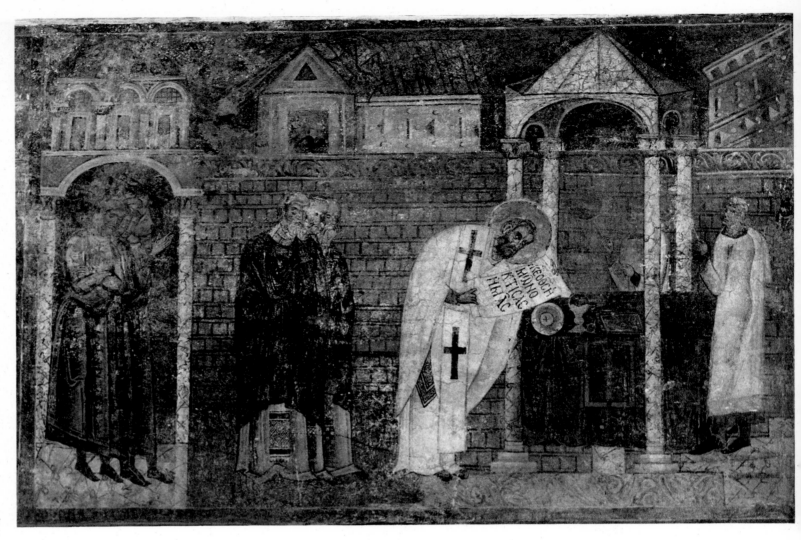

177

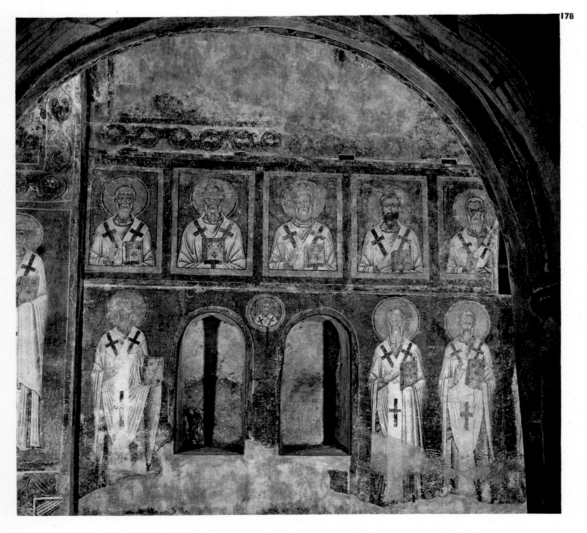

178

177 St. Basil Celebrating His First Mass. *Fresco, Church of St. Sophia, Ohrid. First half of 11th century*

178 Patriarchs. *Frescoes on south wall of diaconicon, Church of St. Sophia, Ohrid. First half of 11th century*

179 The Ascension. *Fresco on the vault, Church of St. Sophia, Ohrid. First half of 11th century*

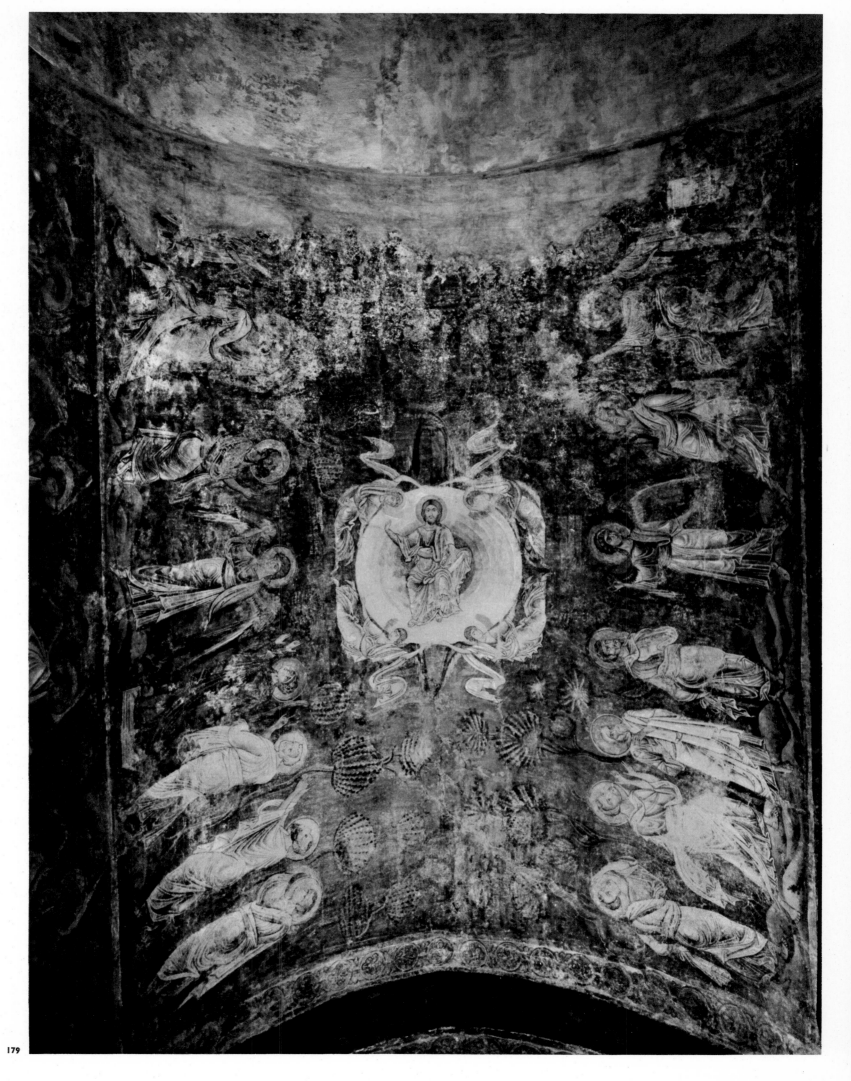

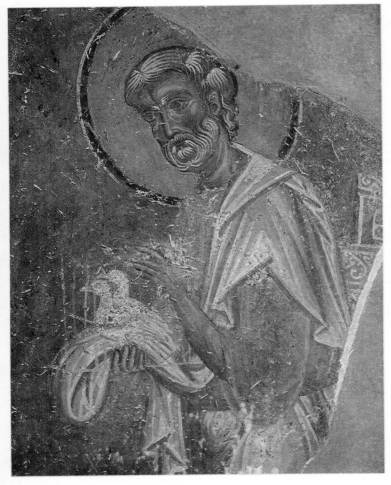

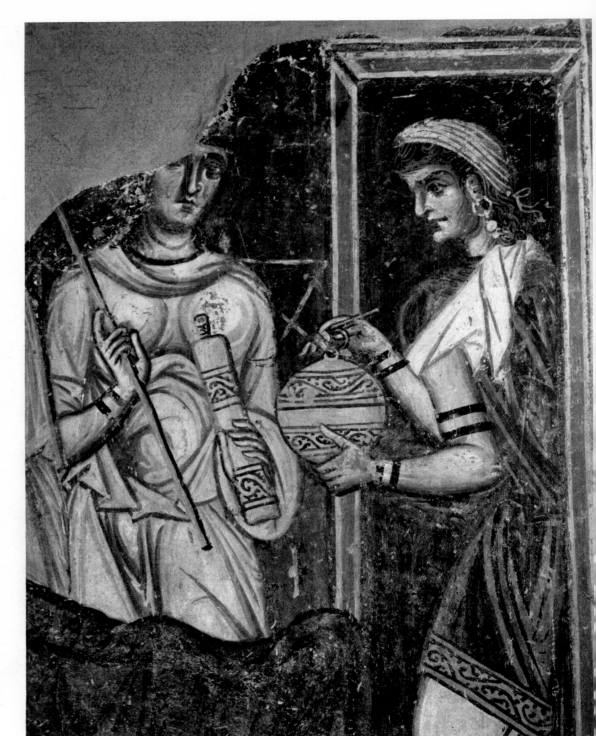

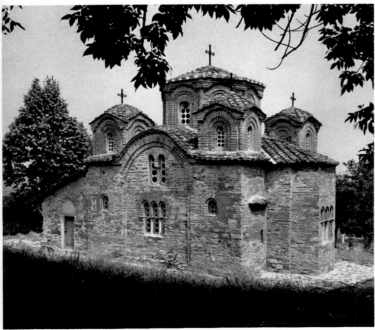

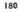

180 *St. Joseph, detail of* The Presentation of Christ in the Temple. *Fresco, Church of St. Panteleimon, Nerezi. 1164*

181 The Birth of the Virgin, *detail. Fresco, Church of St. Panteleimon, Nerezi. 1164*

182 *Church of St. Panteleimon, Nerezi. Founded by a Comnenian prince, Alexis. 1164*

183 *St. Panteleimon. Fresco, Church of St. Panteleimon, Nerezi. 1164*

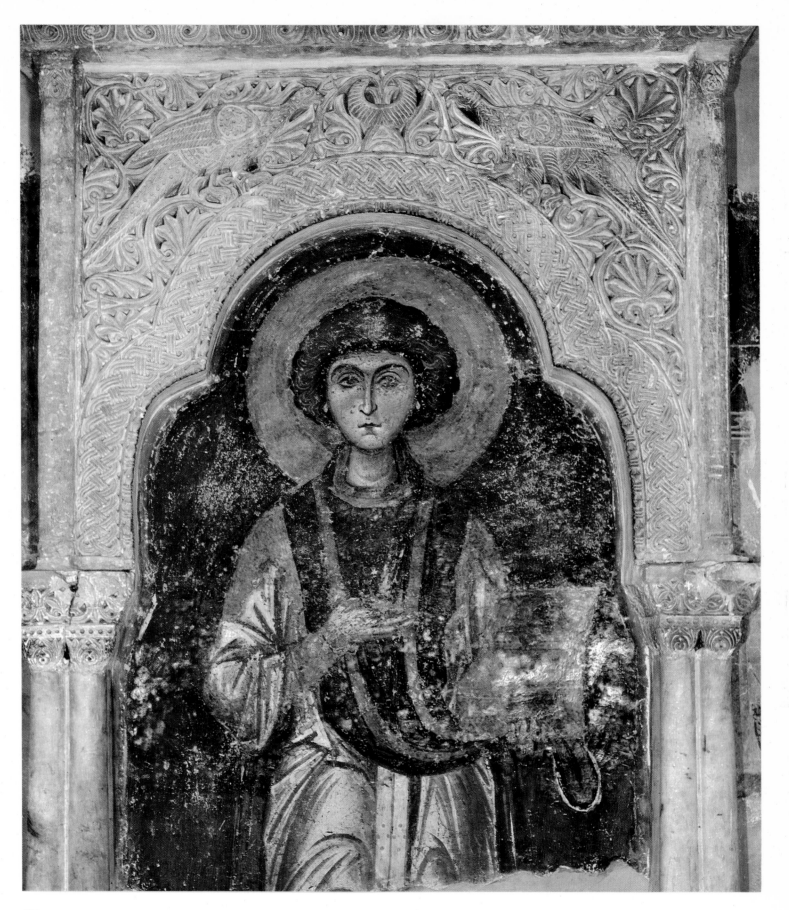

183

184

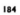

186

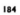

185

184 *Church of the Virgin, Studenica. Founded by Stephen Nemanya. Last decade of 12th century*

185 The Crucifixion. *Fresco on the west wall of the nave, Church of the Virgin, Studenica. 1209*

186 *The Virgin, detail of Plate 185*

187 *Apostles, detail of* The Dormition of the Virgin. *Fresco, King's Church (Church of St. Joachim and St. Anne), Studenica. 1314*

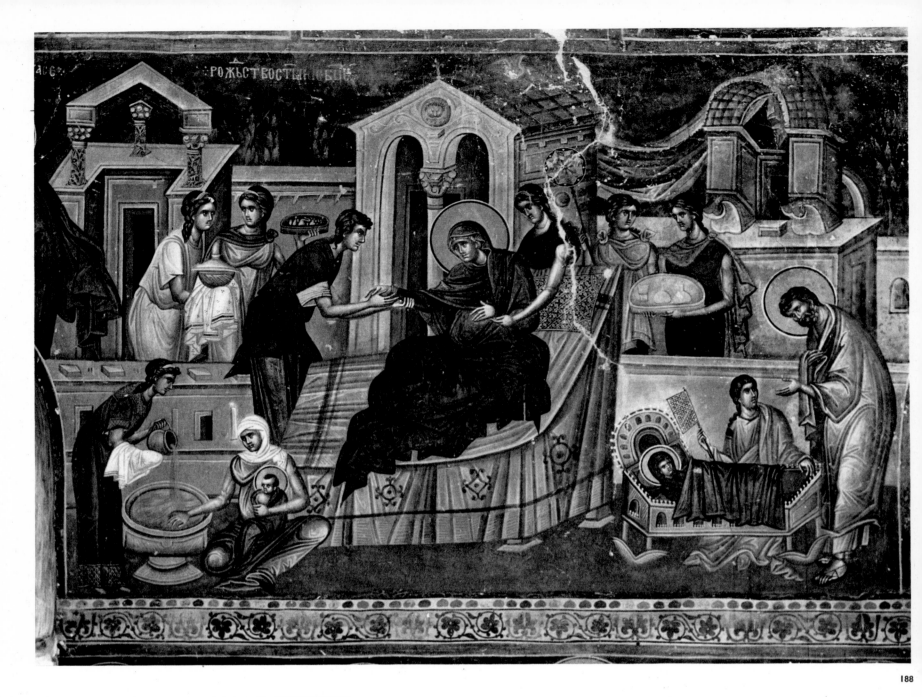

188

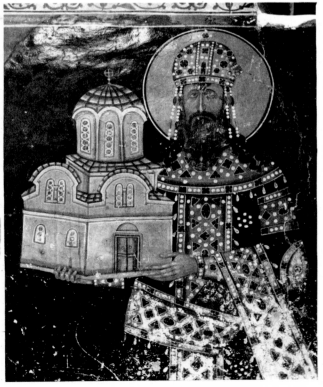

189

188 The Birth of the Virgin. *Fresco, King's Church (Church of St. Joachim and St. Anne), Studenica. 1314*

189 *King Milutin (Stephen Uroš II) as Donor. Detail of fresco, King's Church (Church of St. Joachim and St. Anne), Studenica. 1314*

190 The Descent from the Cross, *detail. Fresco, Church of the Ascension, Mileševa. c. 1236*

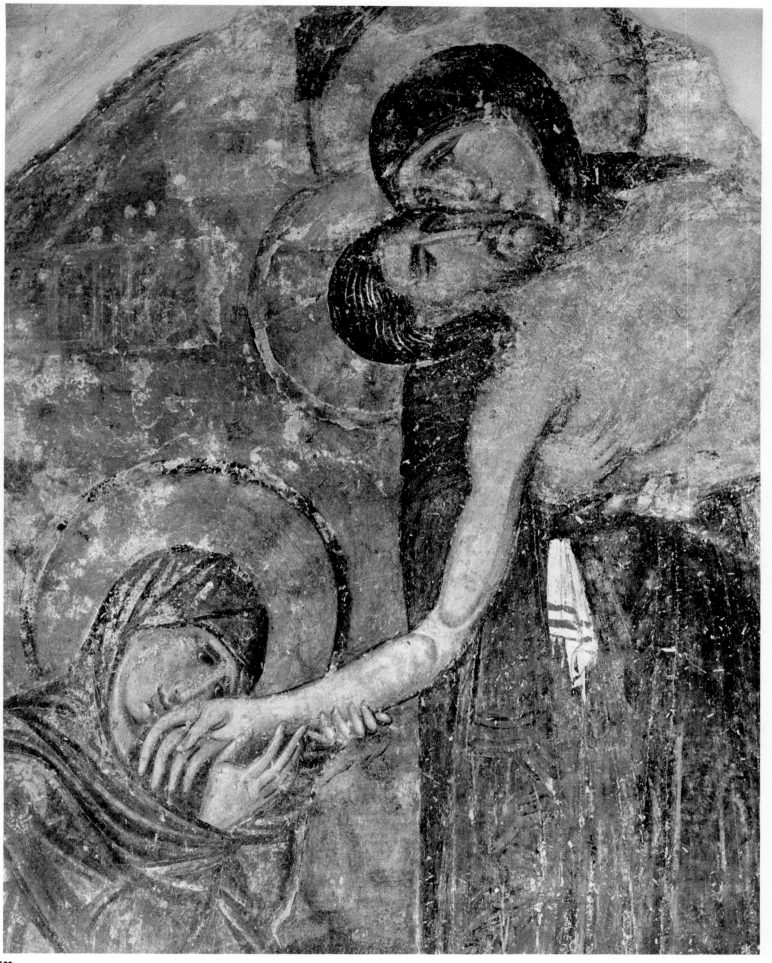

190

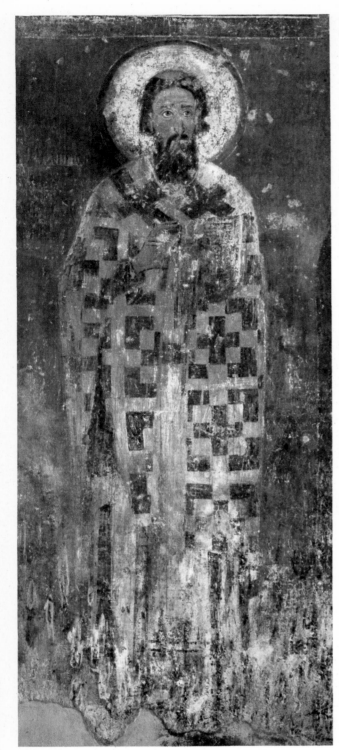

191

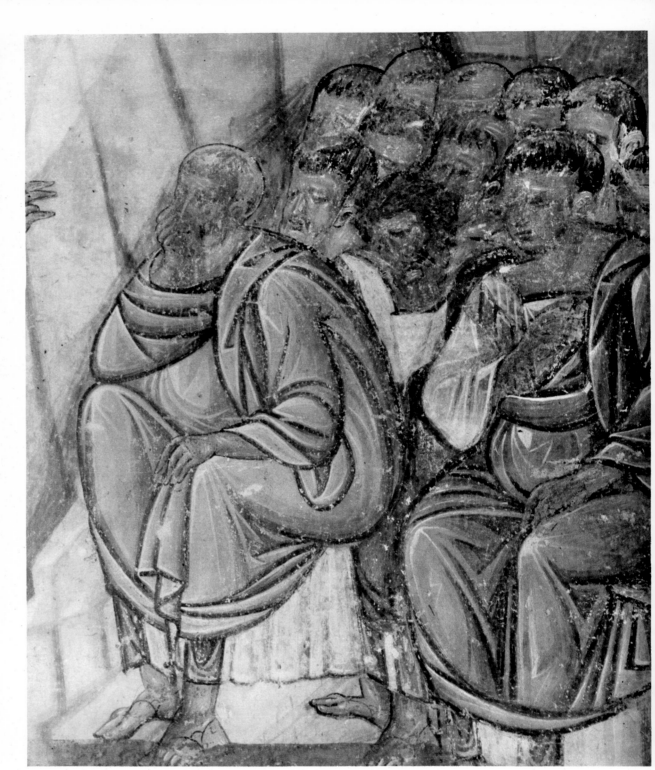

192

193

194

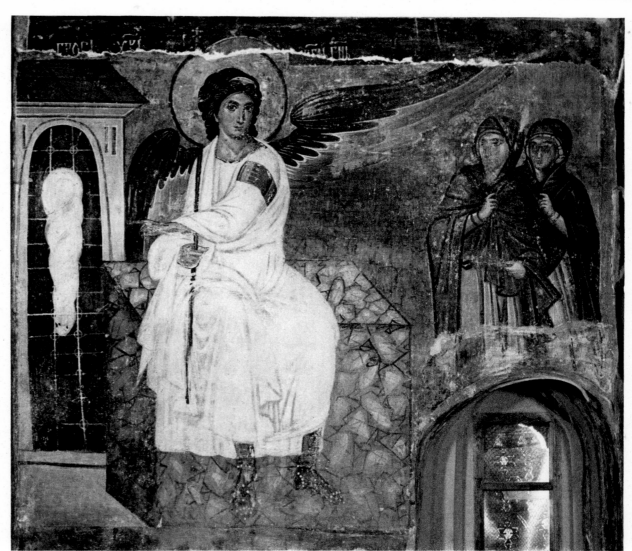

195

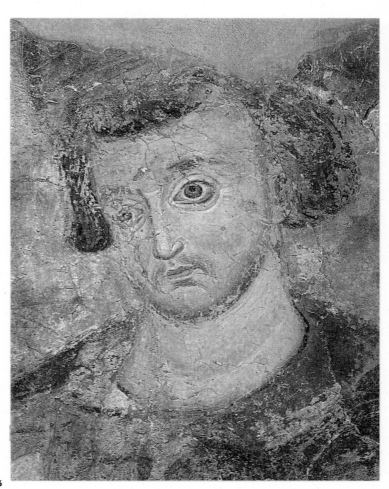

196

191 *St. Sava of Serbia. Fresco, Church of the Ascension, Mileševa. c. 1236*

192 The Agony in the Garden, *detail. Fresco, Church of the Ascension, Mileševa. c. 1236*

193 *Church of the Ascension, Mileševa. Founded by King Vladislav I, c. 1236*

194 *Emperor Constantine, detail. Fresco, Church of the Ascension, Mileševa. c. 1236*

195 The Angel at the Sepulcher. *Fresco, Church of the Ascension, Mileševa. c. 1236*

196 *King Vladislav. Detail of fresco, Church of the Ascension, Mileševa. c. 1236*

197

198

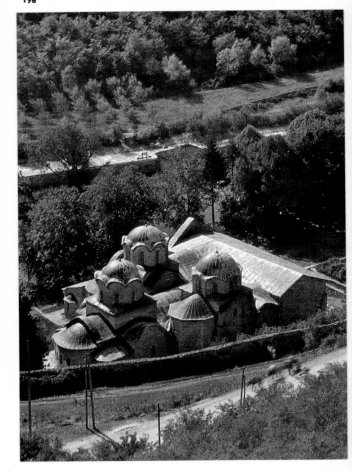

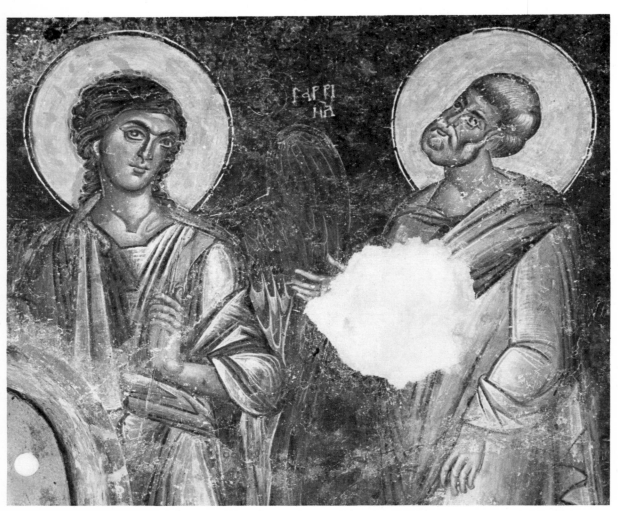

199

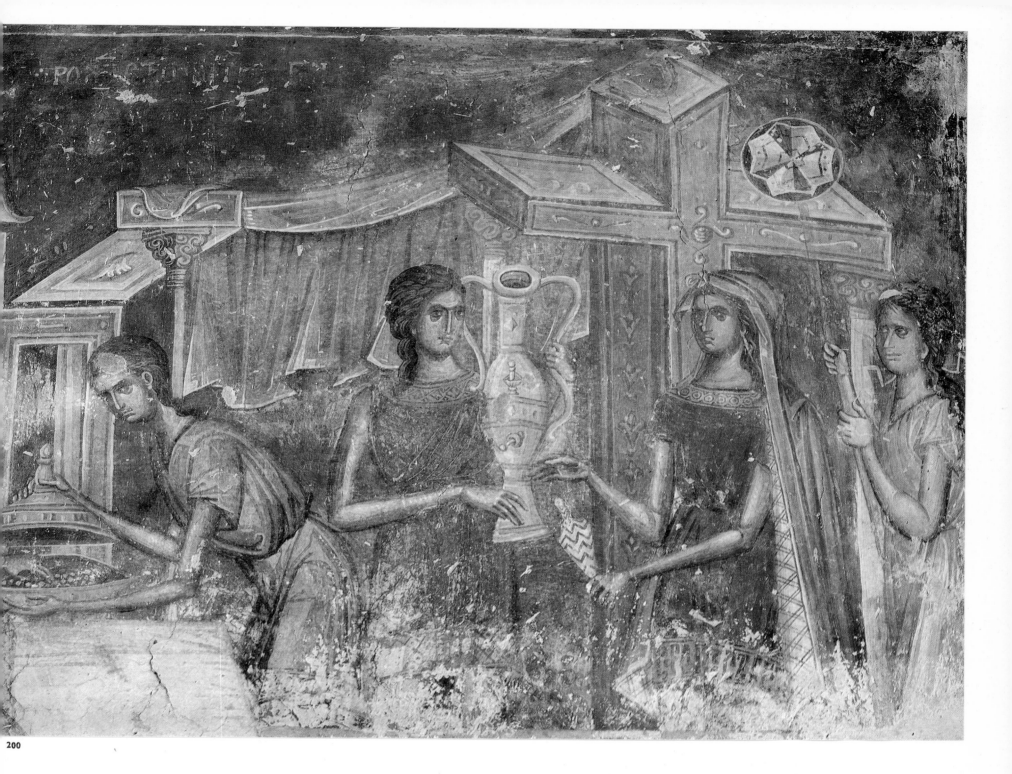

200

197 The Last Supper, *detail. Fresco, Church of the Holy Apostles, Peć. c. 1250*

198 *Complex of churches of the Patriarchate of Peć: Church of the Holy Apostles (13th century), Church of St. Demetrius (14th century), Church of the Virgin (14th century), Church of St. Nicholas (14th century), Narthex of Archbishop Danilo II (14th century)*

199 *The Archangel Gabriel and an Apostle, detail of* The Ascension. *Fresco, Church of the Holy Apostles, Peć. c. 1250*

200 The Birth of the Virgin, *detail. Fresco, Church of St. Demetrius, Peć. 1338-46*

201

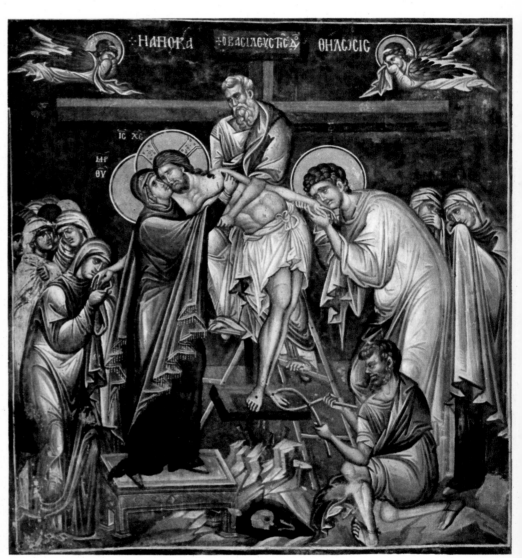

202

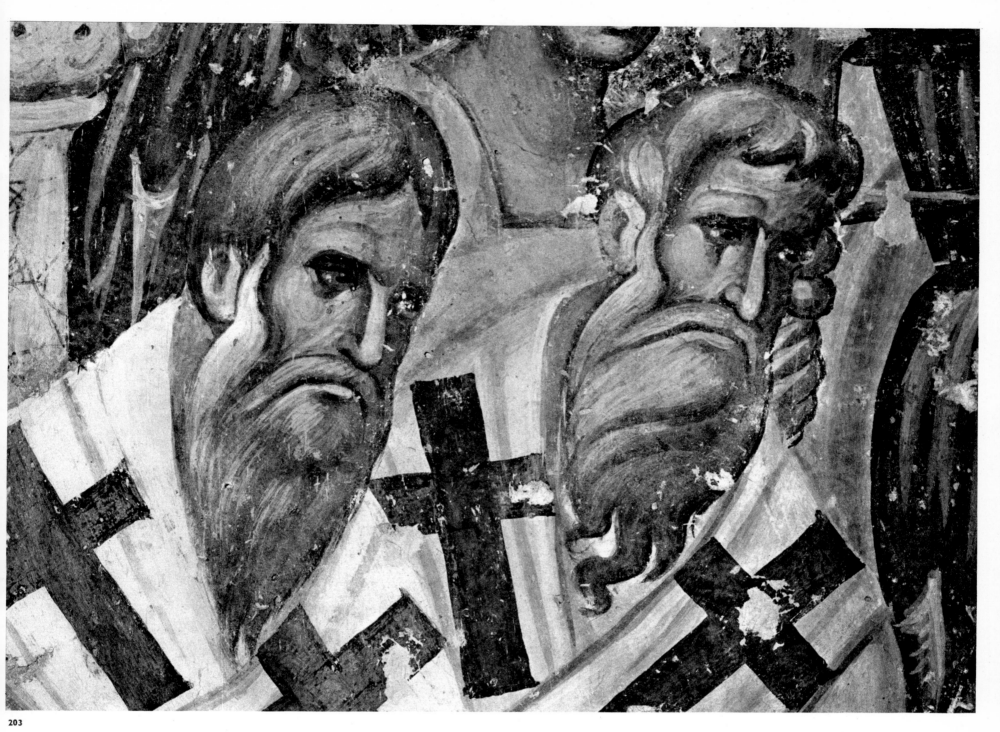

203

201 Elijah Fed by the Raven. *Fresco, Monastery Church, Morača. Founded by Prince Stephen, 1252*

202 The Descent from the Cross. *Fresco, Church of St. George, Staro Nagoričino. Founded by King Milutin, 1318*

203 Two Bishops, *detail of Plate 204*

191

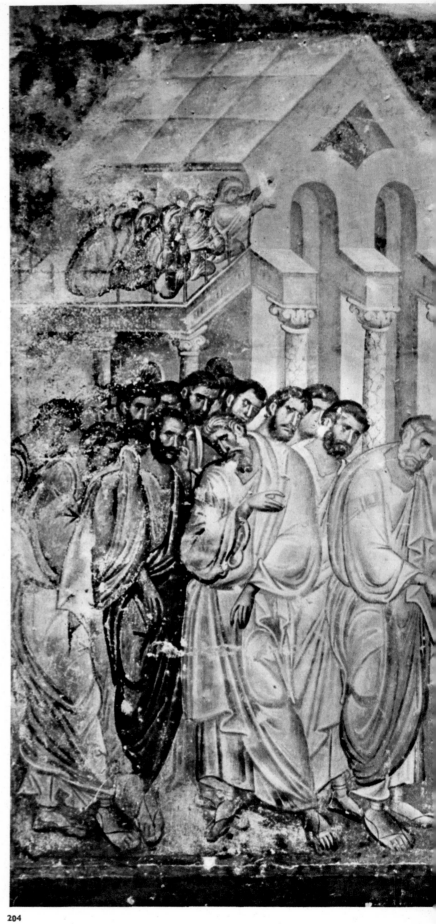

204 The Dormition of the Virgin. *Fresco on the
west wall of the nave of the Church of the Trinity,
Sopoćani. Founded by King Stephen Uroš I, c.
1265*

204

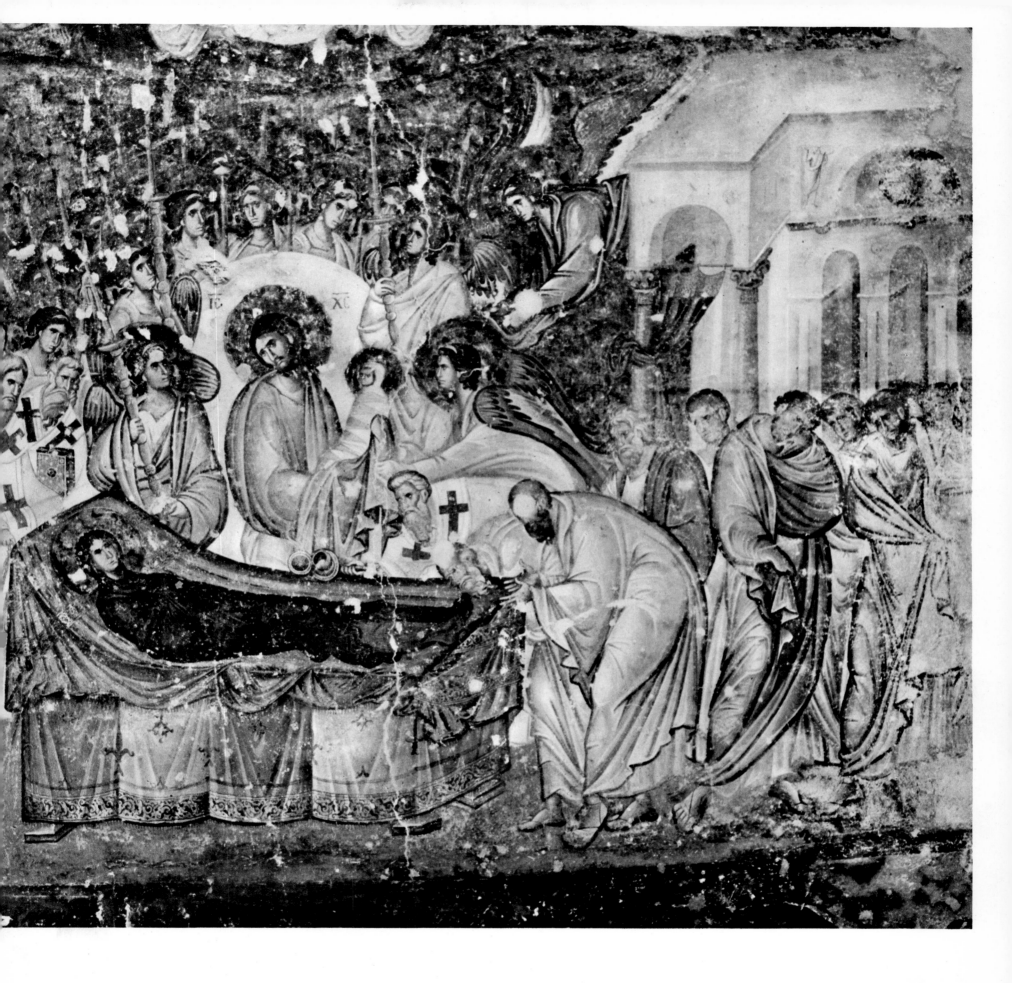

205

206

207

194

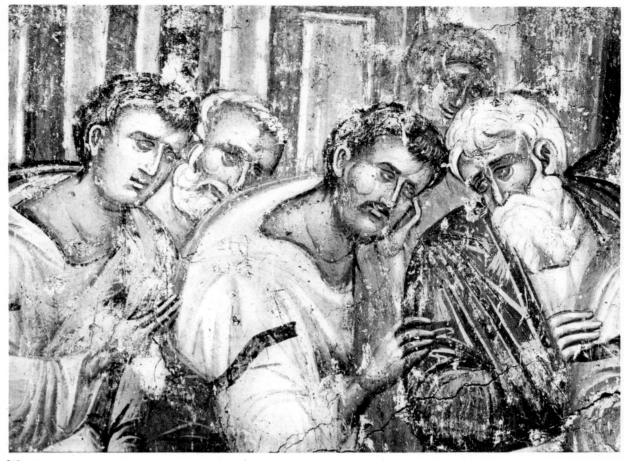

208

205 *The Archangel Gabriel, detail of* The Annunciation. *Fresco, Church of the Trinity, Sopoćani. c. 1265*

206 *Shepherds, detail of Plate 207*

207 *The Nativity. Fresco, north wall, Church of the Trinity, Sopoćani. c. 1265*

208 *Apostles, detail of* The Dormition of the Virgin. *Fresco, Monastery of Matejče. Founded by Empress Helena and her son Stephen Uroš V, 14th century*

209 *Caiaphas, detail of* Christ before Annas and Caiaphas. *Fresco, Markov Manastir (Marko's Monastery). Founded by King Vukašin and his son King Marko, c. 1371*

209

195

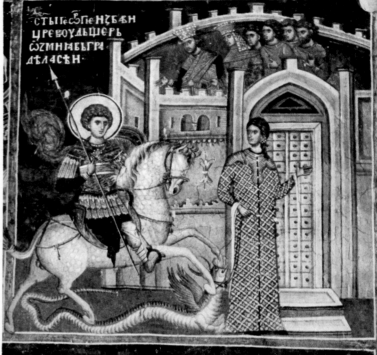

211

210

212

213

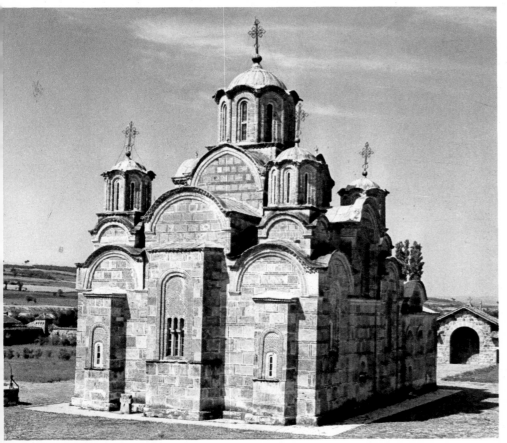

214

*210 The Nemanya family tree. Fresco, Monastery of Dečani. Founded by Stephen Dečanski (Uroš III), 1327, and completed by the Emperor Stephen Dušan, 1335*

*211* St. George Rescuing the Emperor's Daughter. *Fresco, Monastery of Dečani. 1350*

*212 The Virgin with Archangels, detail of* Paradise. *Fresco, Church of the Monastery of Gračanica. 1321*

*213* St. Mercurius. *Fresco, Church of the Monastery of Gračanica. 1321*

*214 Church of the Monastery of Gračanica. Founded by King Milutin, 1321*

197

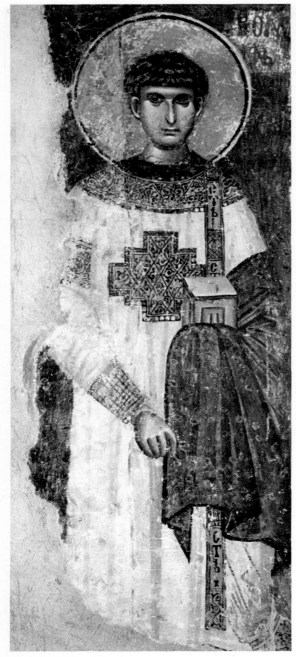

215

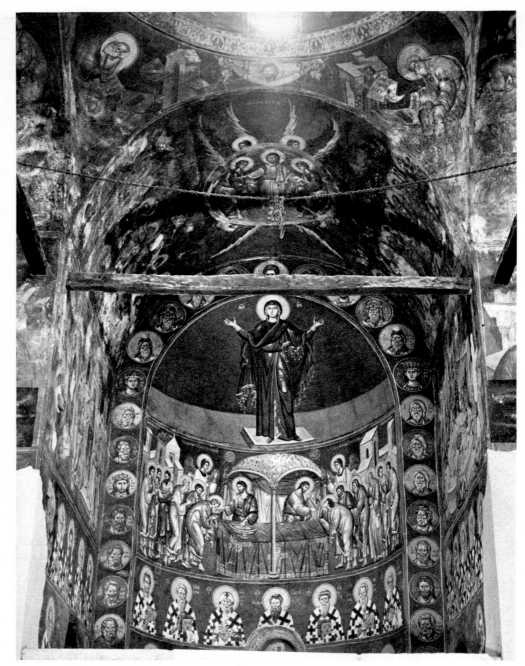

216

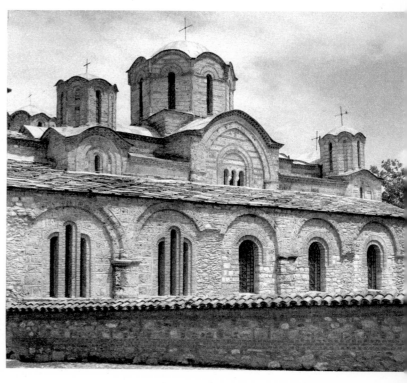

217

215  *St. Romanus the Melodist. Fresco, Church of the Virgin of Ljeviša, Prizren. 1307*

216  *Altar apse. Church of the Virgin Peribleptos (Church of St. Clement), Ohrid. Founded by Commander Progon Zgur, 1295*

217  *View of the south side of the Church of the Virgin of Ljeviša, Prizren. Founded by King Milutin, 1307*

218  *The bridal couple, detail of* The Miracle at Cana. *Fresco, Monastery of Kalenić. Founded by Presbyter Bogdan, 1407-13*

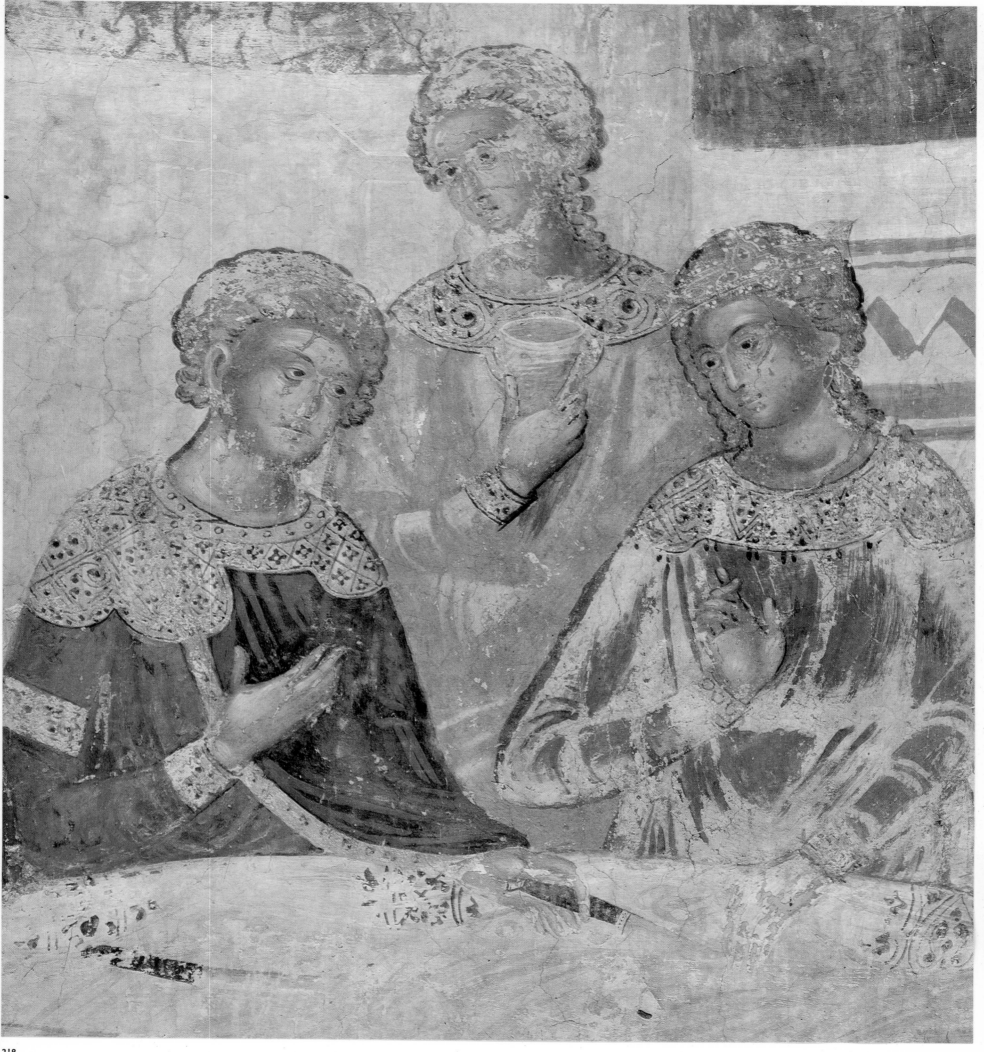

219 *The Prophet Habakkuk, detail. Fresco, Monastery of Manasija (Resava). 1406-18*

220 *The Monastery of Manasija (Resava). Founded by Despot Stephen Lazarević. 1406-18*

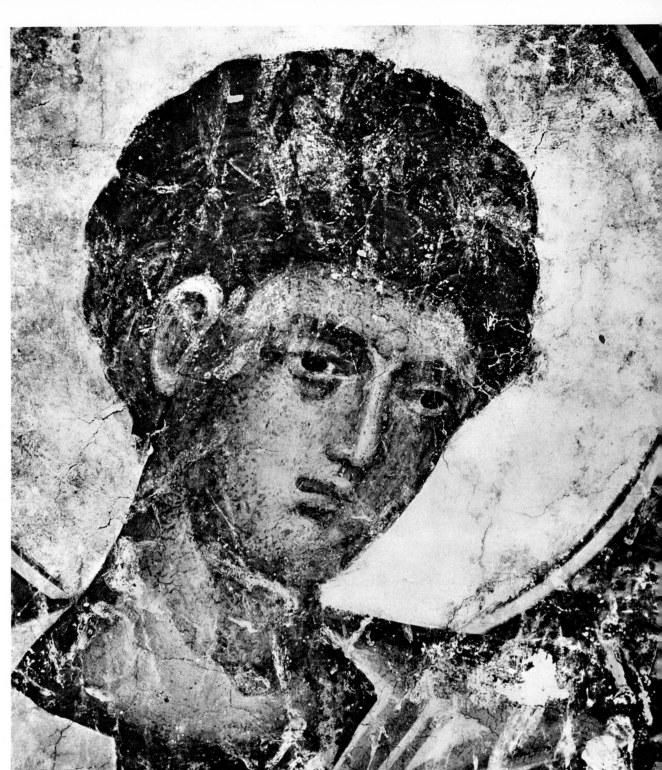

219

220

# IX THE ICONS OF SERBIA AND MACEDONIA

Antonije Nikolovski

*Director, Yugoslav Institute for the Preservation
of Historical Monuments, Skopje*

The development of icon painting in Yugoslavia, to judge from the existing examples, has from its inception been closely associated with the artistic traditions of monumental wall painting. The artistic framework provided by the mature Byzantine art of mural painting under the Macedonian dynasty, and later during the Comnenian and Palaeologan periods, also shaped the evolution of icon painting. Artistic trends in the Byzantine capital, Constantinople, and in the highly advanced center of art that was Salonika, set their stamp on the icon painting of Macedonia and Serbia. The Adriatic coast remained, by and large, under the influence of Western artistic styles — Romanesque, Gothic, Renaissance, and Baroque — although there was some penetration of Byzantine influence from southern Italy, leading to the production of works in what is known as the Italo-Greek manner.

A great number of icons were painted in the closing decades of the thirteenth and the first few decades of the fourteenth century, the period during which the iconostasis (the screen separating the altar from the nave), developing as a constant element in Orthodox church architecture, came to be decorated with an ever-increasing number of icons. Icons multiplied as donors — rulers, church dignitaries, and nobles — commissioned them for the embellishment of their numerous foundations. The stepped-up production of icons in and outside the monasteries having been dictated by religious factors, as the centuries passed centers of painting and art grew up to cope with the demand.

The earliest and most important icons to come down to us are intimately bound up with the churches in Ohrid, having either originated in them or been commissioned for them (St. Sophia, St. Clement, and others). The Ohrid icons produced from the eleventh through the fourteenth century constitute an integral whole, making possible the study of the changes of styles in the course of that long period — a unique opportunity, since most other artistic centers within the Byzantine cultural sphere were systematically destroyed in the centuries following the fall of Constantinople in 1453.

The icon of the Forty Martyrs, dating from the eleventh century (and considerably damaged), which is preserved in the Church of St. Clement (Church of the Virgin Peribleptos) in Ohrid, has its counterpart in fresco compositions of the same name in the Church of St. Sophia in Ohrid and the Church of St. Leontius in the monastery of Vodoča (of this, only fragments survive). The theme which it treats places it among the oldest examples of Byzantine icon painting.

The icon of the Holy Virgin and the icon of the Archangel Gabriel, from the composition of the Annunciation dating from the first half of the twelfth century, were created during the lifetime of Leo Mung, Archbishop of Ohrid. The treatment of the Virgin's features and, more particularly, of the robes of the Archangel Gabriel enlarge our knowledge of the paintings of those decades. *Pl. 222, 223, 33*

The icon of Christ Pantocrator dated 1262-63 has been traced back to the lifetime *Pl. 224*

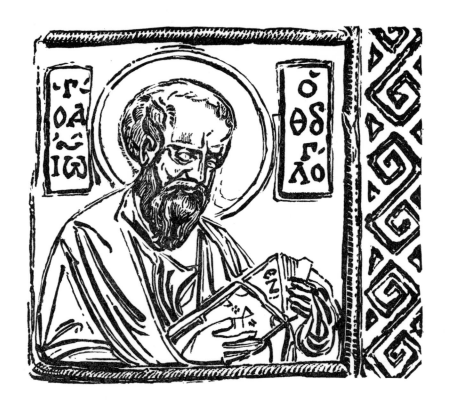

*a. St. John the Evangelist. Silver relief, detail of icon belonging to Archbishop Gregorius of Ohrid. Early 14th century. National Museum, Ohrid*

of Ohrid's far-famed Archbishop Constantine Kabasilas, years when new trends whose full flowering was to come during the Palaeologue period were making themselves felt in Macedonia. The figure of Christ has been given monumental treatment; it is worked in broad strokes with emphasis on the play of light and shade, and the firm modeling of the face gives an impression of great power.

A contemporary of the artist responsible for the icons just described — a painter named John — was commissioned in 1266-67 by Deacon and Referendary John of Struga to fashion a lifesize figure of St. George for an iconostasis in the Church of St. George in Struga. In his treatment of the saint's garb, John retained the linear emphasis characteristic of the Comnenian period, while demonstrating in the modeling of facial features the more highly developed sculptural feeling fostered in painting in the course of the thirteenth century.

Pl. 227, 225 The processional icon of the Virgin Hodegitria, with a composition of the *Crucifixion* on the reverse, was most probably brought from Constantinople; it must be counted among the finest achievements of the art of icon painting in the second half of the thirteenth century. The balanced harmony of the color scheme in the *Crucifixion* points up the strongly Pl. 226 stressed chiaroscuro of the Virgin's countenance. The diptych representing Christ and the Virgin (National Museum, Ohrid) embodies a cruder variation of this artistic approach.

A group of icons dating from the transitional years as the thirteenth century yielded to the fourteenth originated during the time when Progon Zgur, son-in-law of the Byzantine emperor Andronicus II Palaeologus (r. 1282-1328), was building his foundation the Church of the Virgin Peribleptos (Church of St. Clement) in Ohrid. Certain compositions, as well as the artistic and iconographic features common to a group of icons in the Church Pl. 232 of St. Clement (*St. Matthew*, the *Incredulity of Thomas*, the *Descent into Limbo*, the *Ascent* Pl. 230 *to Calvary*, the *Assumption*, the *Virgin Peribleptos*, the *Nativity*, the *Baptism*, and the *Presentation of the Virgin*) are closely associated with the work of the painters Michael and Euthychios or masters belonging to their studio. There is no doubt thar the work of Michael and Euthychios launched a new era in mural and icon painting, a fresh form of artistic expression destined to assert itself in the first half of the fifteenth century in Macedonia

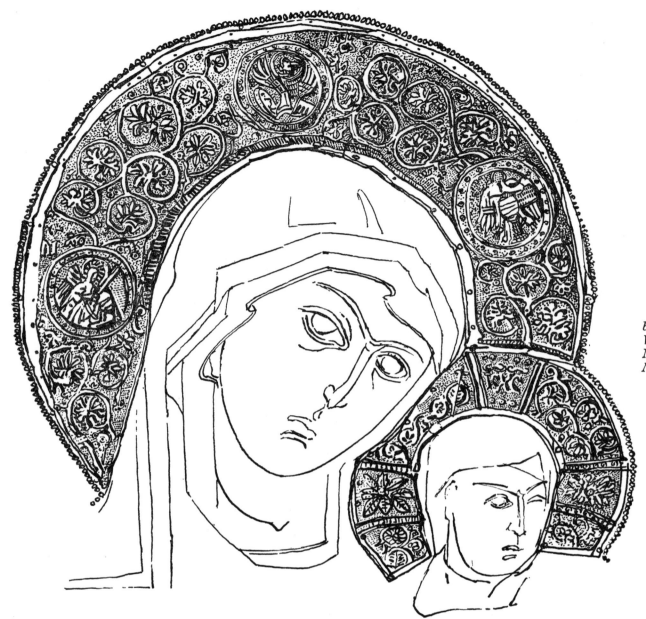

and Serbia. These artists were certainly acquainted with the mature Palaeologue style, and just as certainly were attached to one of the major art centers in Constantinople — or perhaps Salonika.

Pervading this entire group of icons is an artistic approach combining vivacity, grace, and movement in the figures with a Hellenistically inspired handling of garments, stance, and gesture. Furthermore, the scenic effects of the compositions (architectural and landscape features) are richer, figures abound, the illusion of the third dimension is created by suggestion, volume in space is treated with aspects of realism, and the psychological mood is externalized.

The processional icon of the Holy Virgin, Saviour of Souls, with the *Annunciation* on the reverse and the icon of Christ the Saviour of Souls with the *Crucifixion* on the reverse are excellent exemplifications of the artistic values marking the mature art of the Palaeologue epoch. These paintings are the work of a master painter of delicate taste gifted with an exceptional sense of color, wielding a light brush, and attuned to lyrical narration. Fashioned in Constantinople in the imperial workshop of Andronicus II, the first-mentioned icon was presented as a gift to Archbishop Gregorius of Ohrid in 1317.

*Pl. 228, 229, 231*

*Fig. a*

After passing into the hands of Serbian rulers and nobles (1334), Ohrid did not cease to function as a center of art offering training and experience and bringing forth new works. But the mid-fourteenth-century icons are characterized by emphatic linearism and an absence of the subtle transitions in the modeling of face and hands and the finesse in color schemes that were outstanding features of the work of the period of Byzantine rule.

*Fig. c*    The two large icons of Christ Pantocrator and Our Lady Saviour of Souls date from the mid-fourteenth-century period of Serbian rule. The face of Nicholas, Archbishop of *Fig. b*    Ohrid, on the silver cover of the icon of Our Lady Saviour of Souls leads us to assume that he commissioned it for the iconostasis of St. Sophia in Ohrid. These icons are the work of a single master painter who, though skilled in his craft of painting holy images, lacked refinement in his treatment of face and hands. An icon of the Virgin Hodegitria, with the *Annunciation* on the reverse, now in the National Museum in Belgrade, also shows the influence of nearby Salonika.

The second half of the fourteenth century produced numerous icons of modest quality; an exception is the icon of St. Naum and St. Clement, whose artistic merit sets it above and beyond the rest. Noteworthy among its excellences are the fine drawing and the warm, gentle harmony of tones.

In the course of time, there came into being in and around the monasteries of Macedonia, even during the period of Turkish domination, other artistic centers nurturing iconography and fostering artistic activity. Among the works of the late fourteenth and the early fifteenth century are the icon of Christ the Giver of Life of 1393-94 (Gallery of Art, Skopje), probably the work of John the Metropolite, brother of Makarios, and the icon of the Virgin of Pelagonija, executed by Makarios in 1421-22 while he was attached to the monastery of Zrze, near Prilep. The icon of the Virgin of Pelagonija belongs to a type of representation of the Virgin that originated in the plain of Pelagonija in Macedonia and was widespread in that region. In his handling of the theme of the Virgin and playful Christ child, Makarios proved himself a master of draftsmanship and harmonious color.

From the second half of the fifteenth century on, the art of the icon declined. A case in point is the work — which has little to recommend it — of the icon painter Dimitrije, from the village of Leunovo, for the iconostasis in the monastery of Toplice. The seventeenth and eighteenth centuries witnessed the abandonment of medieval iconographic and canonic norms as well as a diminution of creative effort and personal involvement.

Serbian icon painting began to develop, alongside monumental painting, when Stephen Nemanya became the ruler of Raška, or Serbia proper (c. 1167). Its continuous development, even during the period of Turkish domination, can be traced up to the close of the eighteenth century. As has been said, Serbian icon painting bears the marks of late Comnenian and mature Palaeologan art styles. Within the framework imposed by familiar Byzantine artistic solutions, there came into being a form of painting that favored a frequently emphatic realism or a strongly emotional note, thus departing from the strict Byzantine models.

The mosaic icon of the Virgin Hodegitria in the monastery of Chilandari on Mount Athos is considered one of the oldest works from the reign of Stephen Nemanya. Dazzling in color — a quality attributable in part at least to the technique employed — it shares the characteristic features of the monumental wall painting of the late twelfth century.

Although the development of Serbian icon painting in the thirteenth century was in the main parallel to that of fresco painting, there are unmistakable signs of its having lagged behind in terms of artistic solutions. Belonging to a stylistically more advanced group are several icons in Chilandari — the icon of Christ of 1262, the icon of the Holy Virgin with Christ of 1265, and the icons of Our Lady of Mercy and of Christ Pantocrator from the second half of the thirteenth century. By contrast, a markedly archaic style is reflected in the icon of SS. Peter and Paul with portraits of Queen Helena and her sons Dragutin and Milutin, from the end of the thirteenth century, in Rome, and the icon of St. Nicholas, in Bari.

*c. Ornamental detail of the icon of Our Lady Saviour of Souls. Late 13th–early 14th century. Icon gallery, Church of St. Clement, Ohrid*

For the ascendant Serbian state under King Milutin, the beginning of the fourteenth century brought a powerful upsurge of artistic creativity generally. A goodly number of icons can be traced to the initial decades of the century; of these the outstanding examples belong to a group in Dečani and a group in Chilandari. The master painters responsible for the frescoes in the monastery of Dečani were also commissioned to paint the iconostasis; among the large icons (totaling five), especially noteworthy are the icon of the Virgin Eleousa, *Pl. 233, 234* the icon of St. Nicholas, and the icon of John the Baptist; despite a certain crudity in the coloring, they are outstanding in their painterly immediacy and maturity. In the Chilandari group, consisting of ten icons known as the *čin* ("hierarchy"; c. 1360), the figures of the Evangelists and the apostles Peter and Paul should be singled out. For their warm color tones, exceptionally refined draftsmanship, and general harmony these icons are deservedly ranked among the finest paintings of the second half of the fourteenth century in Serbia.

Several extremely fine small icons have been preserved from the time after the Turkish conquest of Constantinople when Serbia was governed by the petty Christian rulers, tributary to the Turks, termed despots. Among these are the icon of the miracle at Chonae, the icon of St. Sava and St. Simeon, and the icon of St. Demetrius. In the handling of *Pl. 235* the face of St. Demetrius there is evidence of a striving to achieve greater freedom in portraying the warrior saints, to reflect a spirituality encompassing the secular as well as the sacred. The feather-light strokes and vigorously rhythmical color schemes of these icons are hallmarks of the master painters belonging to the Morava school.

The thread of iconic creativity did not snap with the appearance of the Turks, but the loss of political independence was a precursor of declining productivity in icon painting and of retrogression in artistry. The revival of the independent Serbian Patriarchate of Peć in 1557 did, it is true, create somewhat more favorable conditions for artistic activity. In an attempt to maintain and continue the Serbian tradition, the master painters of the period reverted to earlier times, particularly the fourteenth century, for their models. Longin, a monk of Peć, was a preeminent representative of this trend; at the same time, his painting is imbued with the spirit of his own personality. Initially compensating with a fresh palette for his rather poor draftsmanship, he later turned to the play of light and dark tones. Longin is known to have painted, among other places, in Dečani, Piva, and Lomnica (the *Virgin with Christ and Prophets*, the *Virgin with Christ, Angels and Prophets*). His later works reflect the influence of Russian painting.

Figuring significantly in the early seventeenth century (Ottoman period) was a monk of Chilandari named Georgije Mitrofanović, who drew upon his knowledge of Greek and Russian painting in forging his own personal style. His mature work is notable for its avoidance of strong modeling and stylization. A peculiar lightness of touch, achieving a certain softness in the colors, marks his frescoes for the refectory of the monastery of Chilandari and for the iconostasis gates in the ancillary Church of St. Tryphon in Chilandari. While in Montenegro, Georgije Mitrofanović painted for the monastery of Morača the frescoes on the facade and the icon of the Virgin. The fact that icon painting in Montenegro reached its apogee in these decades is attributable without question to the activity of Georgije Mitrofanović and his followers, monks of Chilandari.

*Pl. 221, 237* With icon painting as a whole in crisis in the seventeenth century, the painter John (Jovan) stands out in the first half of the century, as does Master Cosmas, certainly without peer in the period in which he lived. Cosmas is especially admired for his masterly handling of color harmonies and his fine plastic modeling of faces (the icon of SS. Simeon Nemanya and Sava, with scenes illustrating the legends connected with their names, and the icon of the Assumption of the Virgin, both in the monastery of Morača).

In Montenegro in the second half of the seventeenth century the guardians and cultivators of the painterly tradition were the monk-priest Avesalom Vujičić of Morača and the master painter of the patriarchate, Radul. In this period the function of color is still important, but the draftsmanship has become inferior, to the point where facial features are not differentiated. Characteristic are the icon of St. Luke with events from the life of Absalom and the icon of Cosmas and Damian, by Radul.

The development of icon painting in the towns along the Adriatic coast had the advantage, by virtue of their location, of being open to the influence of a variety of styles — Byzantine, Italo-Greek, Romanesque, Gothic, and Renaissance. The wealth and economic prosperity of the communities and the spirit of political liberalism pervading them provided a background favorable to the flowering of diverse artistic styles and conceptions. Almost until the fourteenth century, when local workshops and master painters launched a more vigorous activity under Italian influence, Byzantine painting was in the forefront. Worthy of mention among the large number of icons attributable to this area are the groups of icons from Zadar and Split dating from the end of the thirteenth century, and the icon of the Virgin Eleousa with Christ and Donor (fourteenth century) from the collection belonging to the Order of All Saints on the island of Korčula. It was the large group of anonymous masters of the coastal region who paved the way, surely and firmly, for the later appearance of such prominent Renaissance painters of local origin as Mihajlo Hamzić and Nikola Božidarović.

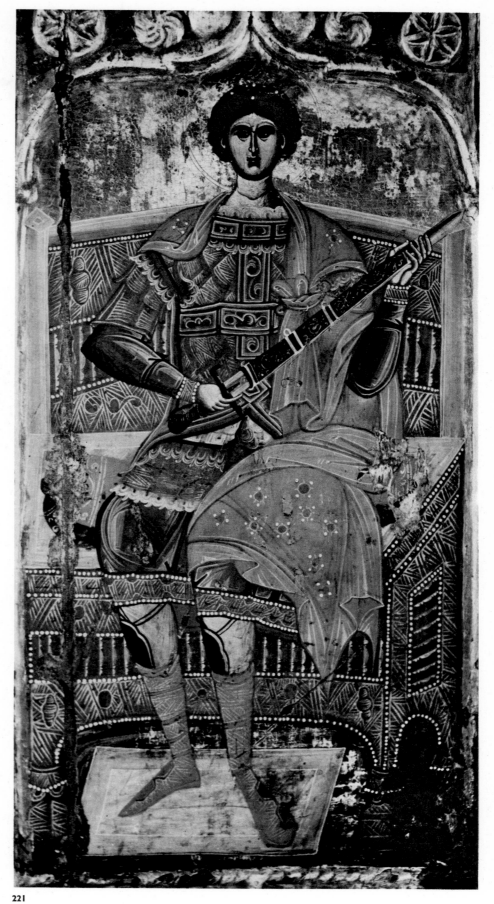

*221 Icon of St. George, central portion Mid-17th century. Tempera on wood, 47 1/4 × 31 7/8". Treasury of the Patriarchate of Peć*

221

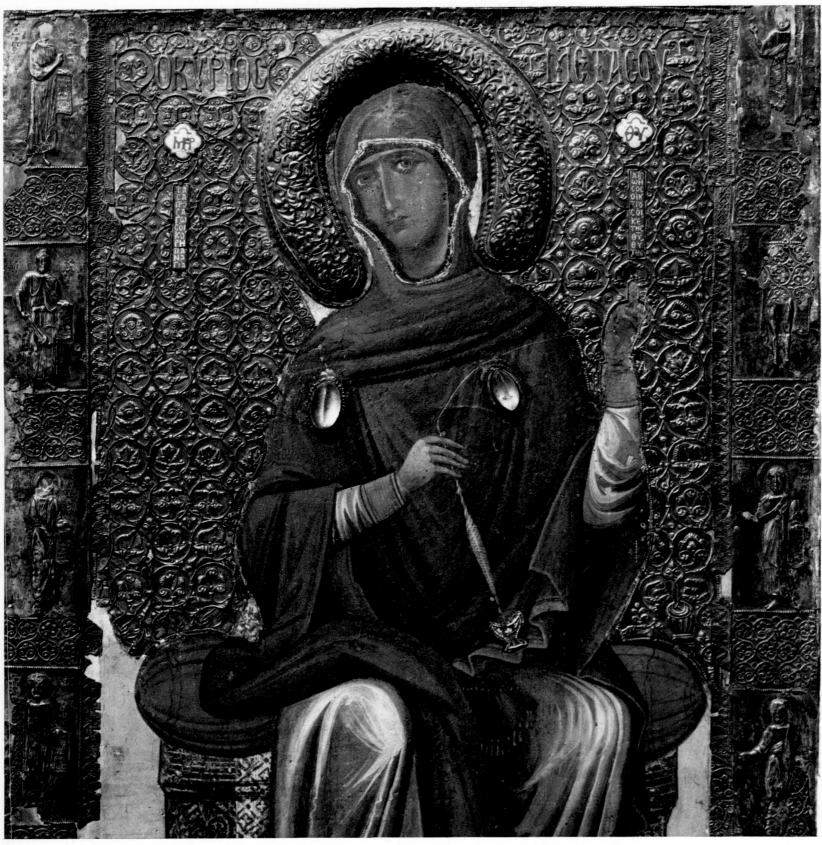

222

222 Icon of the Virgin from the composition of the
Annunciation (donor, Archbishop Leo Mung).
12th century. Tempera on wood, 43 7/8 × 26 3/4″.
Icon gallery, Church of St. Clement, Ohrid

223 Icon of the Archangel Gabriel from the compo-
sition of the Annunciation (donor, Archbishop
Leo Mung). 12th century. 44 × 26 3/4″. Icon
gallery, Church of St. Clement, Ohrid

224 Icon of Christ Pantocrator. Inscribed and dated
1262-63. Icon gallery, Church of St. Clement,
Ohrid

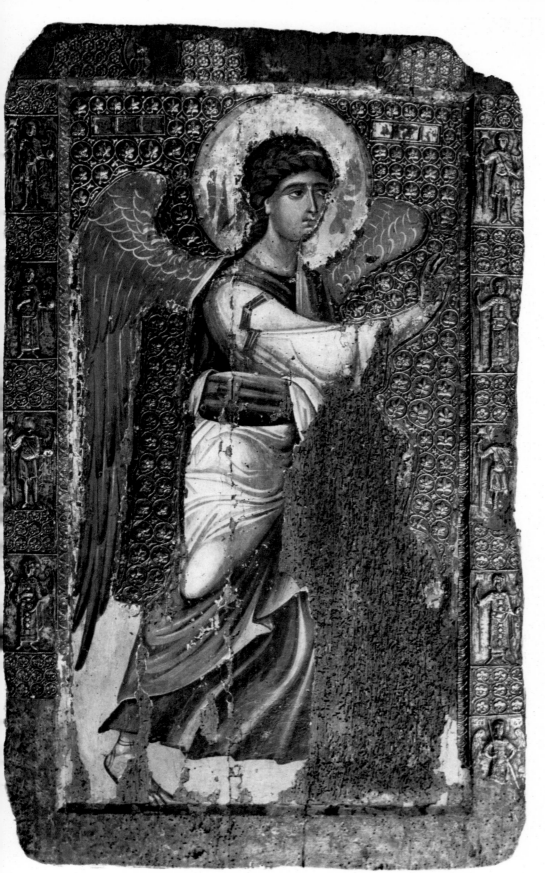

223

224

225

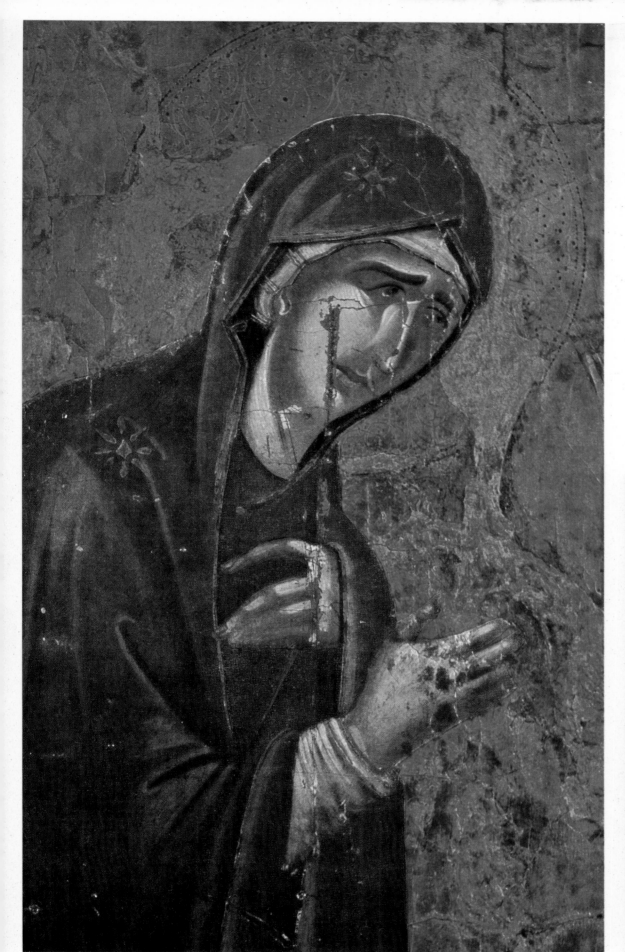

226

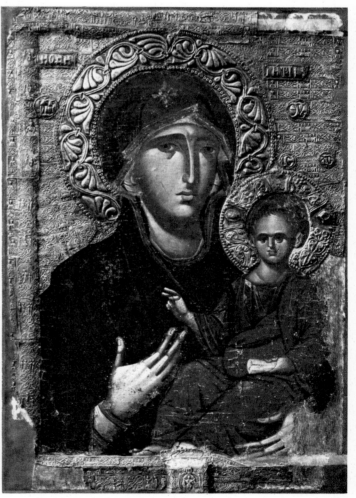

227

213

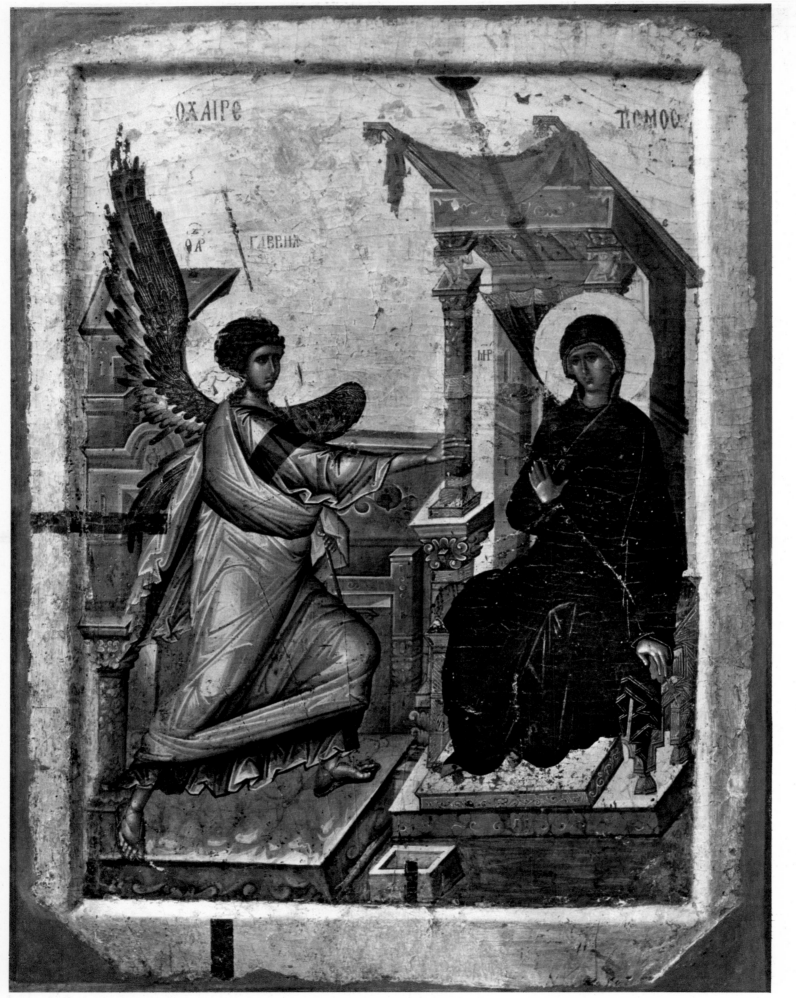

OXAIPE
ΘΑ ГАВЕНΛ
ПCMOC
hFP

228

*228 The Annunciation, reverse of processional icon of the Holy Virgin, Saviour of Souls, presented to Archbishop Gregorius. Early 14th century. Tempera on wood, 36 1/4 × 26 3/4″. Icon gallery, Church of St. Clement, Ohrid*

*229 The Archangel Gabriel, detail of Plate 228*

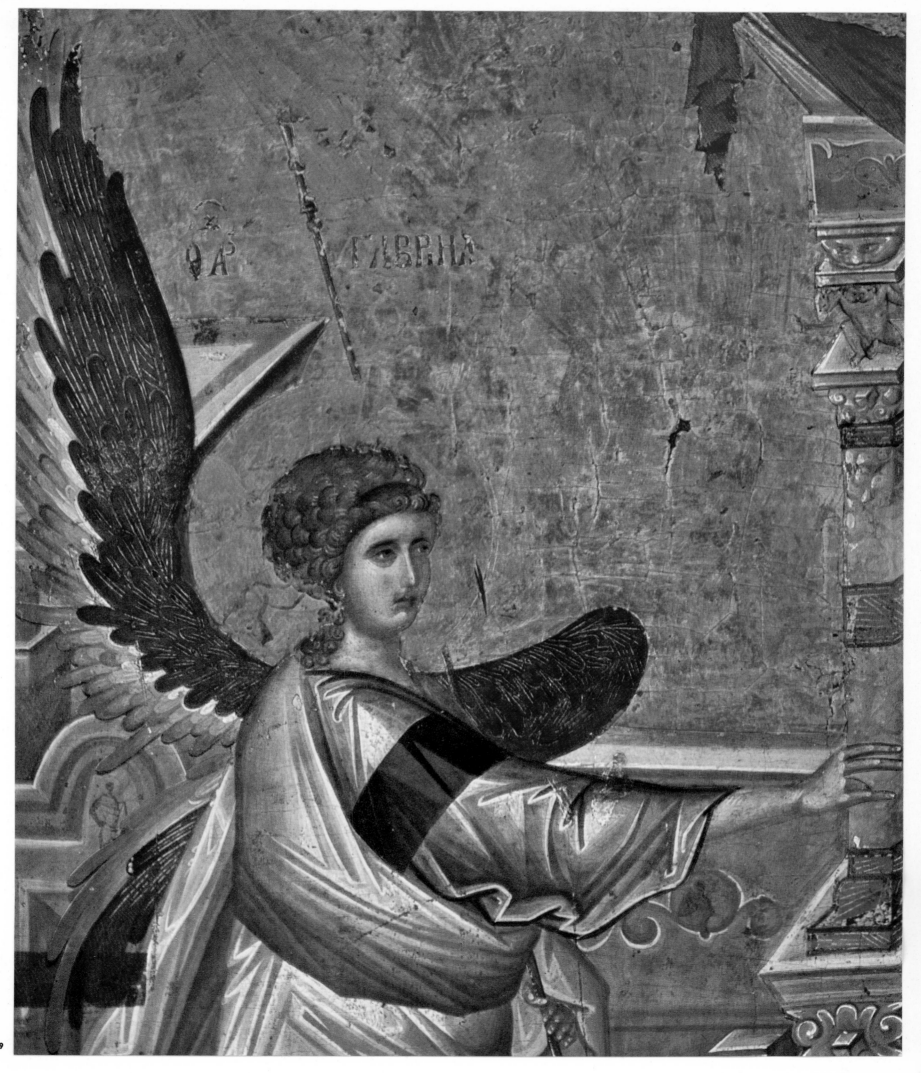

229

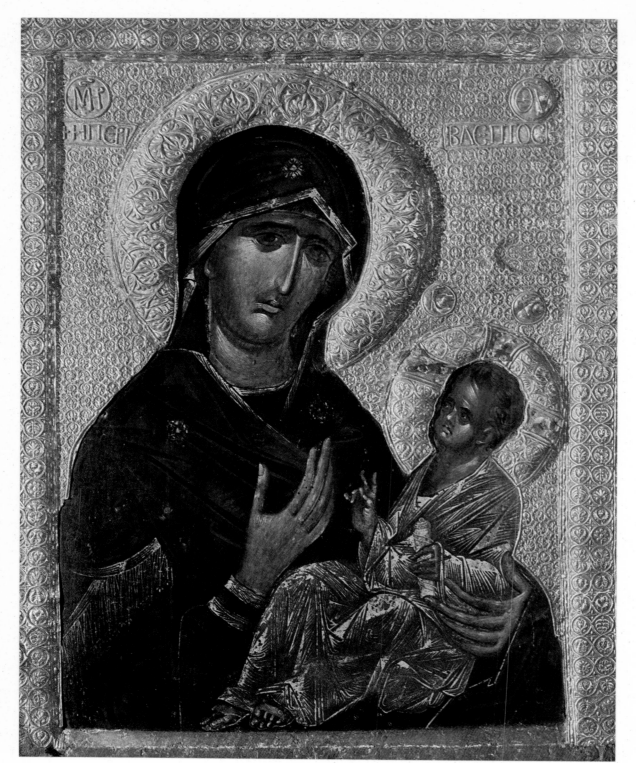

230

230 Processional icon of the Virgin Peribleptos. First half of 14th century. Tempera on wood, 34 1/4 × 27". Icon gallery, Church of St. Clement, Ohrid

231 Icon of Christ the Saviour of Souls. Late 13th or early 14th century. Tempera on wood, 37 1/4 × 27 3/4". Icon gallery, Church of St. Clement, Ohrid

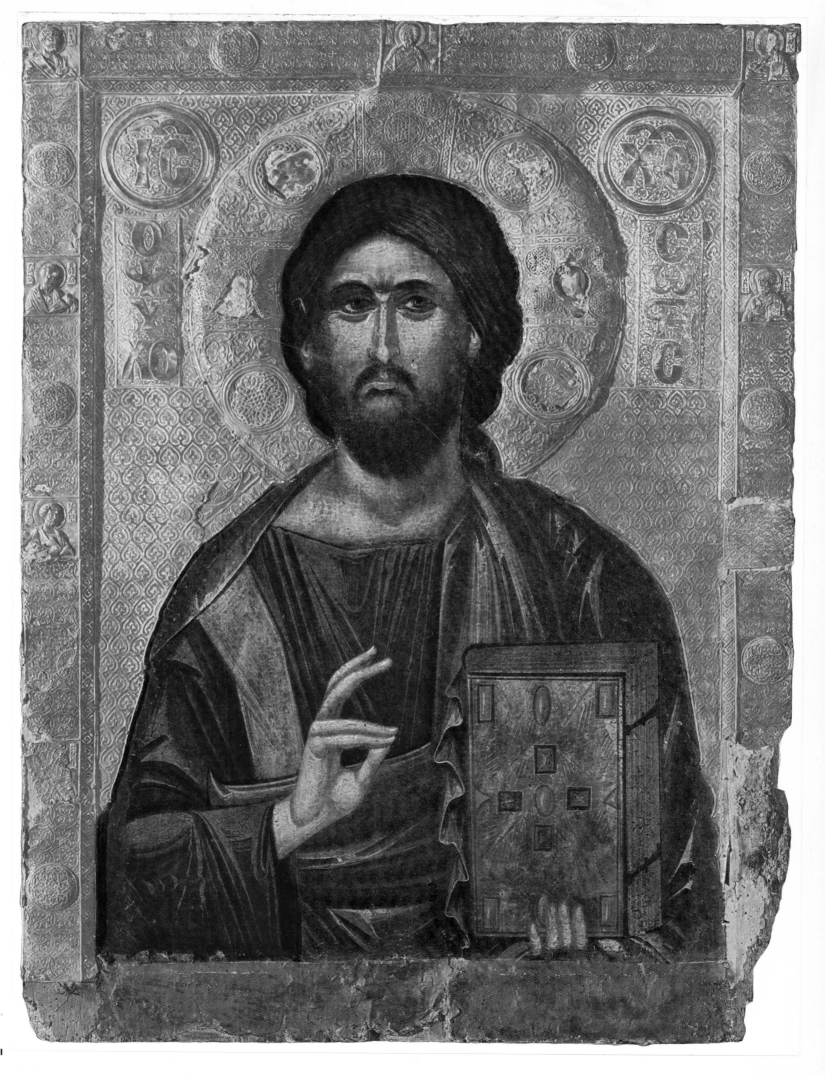

231

232

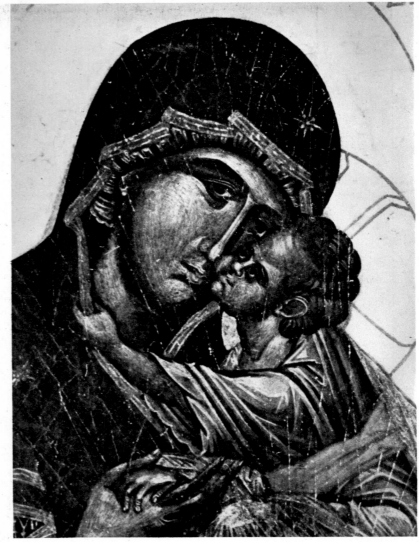

233

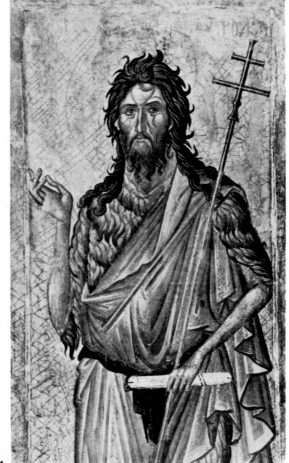

234

232 *Icon of the Evangelist Matthew. Late 13th century. Tempera on wood,*
*61 5/8 × 22 1/4". National Museum, Ohrid*

233 *Icon of the Virgin Eleousa with Christ, detail. Early 14th century.*
*Tempera on wood, 65 3/8 × 21 5/8". Monastery of Dečani*

234 *Icon of John the Baptist. c. 1350. Tempera on wood, 65 5/8 × 21 7/8".*
*Monastery of Dečani*

235 *Icon of St. Sava and St. Simeon of Serbia. Early 15th century.*
*Tempera on wood, 12 3/4 × 10 1/4". National Museum, Belgrade*

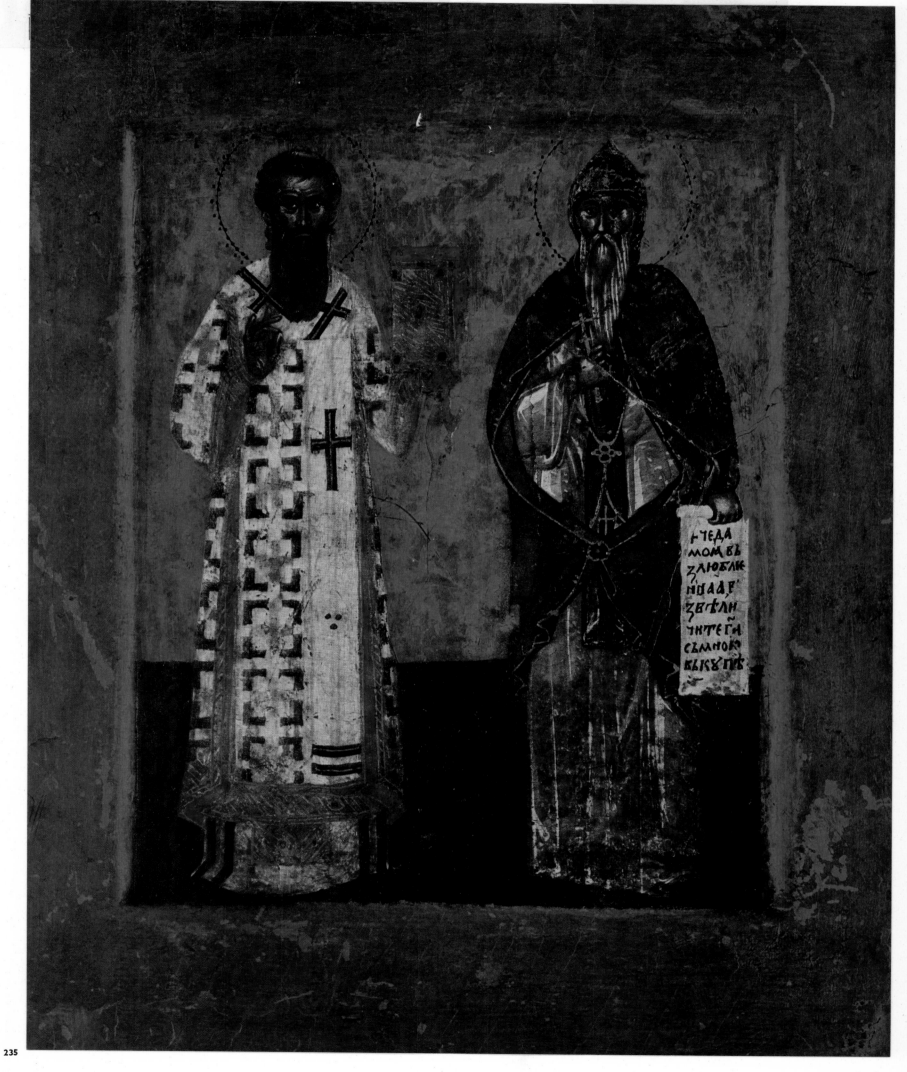

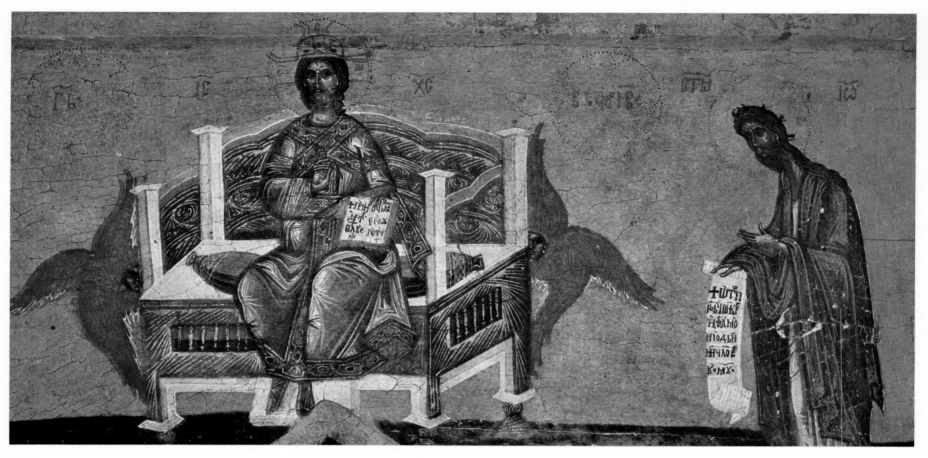

236

236 *Christ Enthroned and John the Baptist, detail*
*of Deësis. 16th century. Tempera on wood,*
*28 × 17". National Museum, Belgrade*

237 *Icon of Lamentation over the Dead Christ. 17th*
*century. Tempera on wood, 16 3/4 × 21 5/8".*
*Treasury of the Patriarchate of Peć*

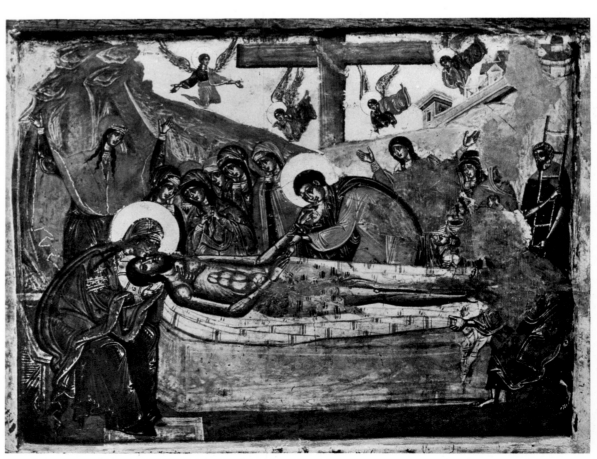

237

# X  ILLUMINATED MANUSCRIPTS

Mirjana Šakota

*Custodian, Yugoslav Institute for the Preservation of Historical Monuments, Belgrade*

The differing conditions under which the ethnic groups making up the population of present-day Yugoslavia lived in earlier times indelibly affected the development of illumination and miniature painting in this region. During the Middle Ages, which witnessed the proliferation of the paged book, or codex, and the efflorescence of illumination and miniature painting, books were almost exclusively religious in content, their language and alphabet depending upon confessional affiliation, whether to the Western or the Eastern Church. Ecclesiastical books originating in areas inhabited by Serbs, Macedonians, and Montenegrins were written in Slavonic and in the Cyrillic alphabet. Books for Croats and Slovenes were penned in Latin, but alongside the official Latin texts there existed a vernacular literature using the earliest form of Slavonic script, the Glagolitic alphabet, confined to certain regions in Istria and Dalmatia. These bodies of literature developed independently, and intertwined with their development was the stylistic evolution of the painted embellishment and illustration of the codex. In the course of this evolution the common features of style that marked the early centuries diversified, and miniatures should be considered within the framework of the particular literature that, in the final analysis, determined its specific characteristics.

From the fifteenth century onward, there appeared also in the Yugoslav regions an Islamic literature, whose development paralleled those of the others but was marked by features of its own. To complete the story of miniature painting in Yugoslavia mention must also be made of a number of important Hebrew manuscripts now preserved in Yugoslav libraries.

Devised toward the close of the ninth century for the purpose of advancing Slav literacy — and through it Greek influence in the Balkans and Eastern Europe — Cyrillic soon replaced the complicated Glagolitic script as the alphabet of the large proportion of the Slavs who looked to Byzantium for cultural direction. An idea of the general appearance and ornamentation of the first Cyrillic books may be gained from the unpretentious and primitively drawn initials with their teratological motifs in the early Slav manuscripts (eleventh century): the Zograf Gospel, from the Zograf Monastery on Sveta Gora and now in Leningrad; the (incomplete) Gospel of Sava, now in Chilandari; and the Suprasalj Manuscript, found in the monastery of that name in Bialystok and now preserved in Ljubljana, Warsaw, and Leningrad. Workshops for the copying of manuscripts (scriptoria) in the central Balkans, chiefly in Raška, maintained this archaic Slav style in use even after artistic creation had in other spheres reached the high level of development to which the frescoes of Sopoćani are an index. It was distinctive for its stylized and extremely distorted human and animal figures, reduced to the function of ornament; plaited bands enclosing animals devouring each other provide the fundamental leitmotiv for this fresh folk art. A few later survivals afford a more representative image of the inception of Ser-

*a. Ornamental detail from the Homily of St. Ephraim, ms. 91 (60), f. 2. 1337. Archives of the Serbian Academy of Sciences and Arts, Belgrade*

*Pl. 246*

bian miniature painting. For example, the page embellishment in the Four Gospels of Peć, dating from mid-fourteenth century, with its rough draftsmanship and simple, vivid color schemes, contains the ancient motif of a circle of serpents, each swallowing the tail of the next.

*Pl. 238, 242, 243, 244*

The most celebrated Serbian manuscript is the Gospel Book of Prince Miroslav, the work of the scribe *(dijak)* Gligorije, dating from about 1180. Originating at the court of Miroslav, Prince of Hum, a brother of Stephen Nemanya, this codex is illustrated with miniatures imbued with the spirit pervading contemporaneous artistic achievements in the West. Showing only the barest trace of Eastern, or Byzantine, influence, the entire ornamentation, consisting exclusively of initials, is patently Romanesque in inspiration. Almost three hundred large ornamental letters, with plant and animal motifs and portrayals of the human figure that are no longer purely conventional, decorate all the pages, virtually without exception, of this sumptuous Gospel book. A number of the initials are rudimentary figural compositions, some interpreting the text, others symbolically didactic or purely decorative.

The style set by the Gospel of Prince Miroslav was continued in thirteenth-century Serbian manuscripts, as is particularly evident in the initials embellishing the Four Gospels of Chilandari (No. 22), which also have certain features in common with the sculpture in Studenica. However, in Bosnia this style continued to prevail in the fourteenth century,

*Fig. c*

where crude and debased imitations of the decorative elements in the Gospel of Miroslav were applied to the illumination of Bogomil manuscripts. In the recently discovered Gospel of Divoš Tihoradić, dating from the thirties of the fourteenth century, the unknown master invested the bizarre world of fantastic beings (composed into initials, to resemble the style of Dijak Gligorije) with new Romanesque-Gothic forms whose details are reminiscent of the contemporaneous sculpture in Dečani.

Illumination of thirteenth-century Cyrillic manuscripts also reflected other, contrasting tendencies; this is exemplified particularly by the miniatures of two extremely important works. The influence of contemporaneous Byzantine art was manifest in the Evangelistary of Prince Vukan, of 1202 (in Leningrad), as was a strongly Eastern cast in the Evangelistary of Prizren (unfortunately destroyed by fire in 1941). The latter was remarkable for its figural compositions; dominated by the human figure, the depictions reflected a striving, emphasized by the completely abstract patterns in color, to convert all forms into ornament. A decided Eastern influence was also evident in certain details of garments and furniture.

The fourteenth century has been singled out as the golden age of Serbian miniature painting. Leaving behind the hesitant searching of earlier generations, the miniaturists, or at least those from the elite scriptoria, had matured into genuine artists deriving their inspiration from classical Byzantine miniatures, although the slow decline of the latter had then already begun. Having learned much, both artistically and technically, from their models, these artists went on to develop their own personal style, and brought forth works that were in every way equal to the attainments of the monumental painting of the time. Perhaps more than any other work, the Gospel of Patriarch Sava of Chilandari brings home to us the high level of Serbian miniatures in the fourteenth century. With their refined draftsmanship and rich coloring in tempera and gold, the portraits of the Evangelists, inspired by the beautiful Muses of the Classical tradition, are framed in splendid ornament. Among the manuscripts illustrated with miniatures of surpassing excellence is the Serbian Psalter of Munich (Bayerische Staatsbibliothek Cod. Slav. 4).

One set of manuscripts from the fourteenth century — the most distinctive among them the Gospel book No. 227 in the Serbian Academy of Arts and Sciences, Belgrade — was decorated exclusively with ornamental motifs flowering out into great intertwined chapter headings painted in a subtle palette. Such chapter headings were to become the principal decorative element in a large number of representative books dating from the fifteenth and sixteenth centuries. The almost flawlessly executed square page embellishments by Vladislav Gramatik, dating from the second half of the fifteenth century, as well as those, a hundred years later, from the brush of Dijak Demetrios, with their clearly defined tendency toward Eastern motifs, are the best documentation we have of this style.

During the Ottoman period (sixteenth to seventeenth century), figural miniatures continued, as before, to be painted; aside from the portraits of the Evangelists as authors — for example in the Four Gospels of Cetinje, of 1613 — they appear throughout the illustrated manuscripts of the time, as can be gathered from the copy of the Serbian Psalter of Munich which dates from the 1630s and the *Topographia christiana* of Cosmas Indicopleustes from the Monastery of the Holy Trinity in Pljevlja, dating from 1649 and containing numerous miniatures after the Russian style by a famous artist of the day, Andrija Raičević. The miniatures illustrating this sixth-century treatise are symbolic and didactic; characteristic is the Rotation of the Stars, which interprets the pagan zodiac in Christian terms.

Few secular miniatures have come down to us. For this reason the recently discovered copy of the Code of Mining issued by Despot Stephen in the sixteenth century, with miniatures representing the panel of judges in the Court of Mining, is of special interest. It is as significant from the point of view of research in early miniatures as it is from the point of view of medieval law.

Reduced, by the eighteenth century, to repetition of the same formulas and solutions, miniatures in Cyrillic manuscripts gradually disappeared, surrendering their place to engravings, which completely superseded them in their function of providing book illustration.

In the regions of Yugoslavia where Latin was the language of manuscripts, that is, in

*Pl. 249*

*Pl. 248*

*Pl. 250*

b. *Decoration for the month of April from a Menologion, ms. 32 f. II v. 1348. National Museum, Ohrid*

c. *Evangelist, from Kopitar's Bosnian Gospels, ms. 24. f. 106 v. Latter half of 14th century. National and University Library, Ljubljana*

d. *The Archangel Michael, initial from the cover of a Glagolitic breviary, ms. 153 (b. 205 v.). 15th century. National and University Library, Ljubljana*

the western sections of the country, three centers of copying activity stand out as focuses of miniature painting: the Adriatic towns in Dalmatia (Split, Trogir, Zadar, etc.), then Zagreb, and finally the Slovene monasteries of Stična, Kostanjevica, and Bistra. The local output of splendid illuminated manuscripts was supplemented by a large number of imports from the finest foreign scriptoria of works which, because they were written in Latin, played a positive role in stimulating domestic production. It is frequently difficult to determine the provenance of the miniatures, owing to the mingling of the two streams and the anonymity of the authors; they must therefore be studied as an entity, without regard to source.

The curve of the development of miniature painting in these regions follows in general the outline of artistic achievement in the West, with certain differences deriving from proximity to the Byzantine cultural sphere. At first the pre-Romanesque influence filtered through from the Monte Cassino manuscripts; they provided the inspiration for the earliest miniatures, such as the meager initials in the Split Evangelistary of the eighth century. In the eleventh and twelfth centuries illumination was still relatively modest, based for the most part on plant and bird-and-animal ornament, the role of the human *Pl. 241* figure being still negligible. In the eleventh-century Zagreb Evangelistary No. 153, whose illuminations are based on ancient models, the depiction of the Evangelist Luke is an imaginative blend of human and animal figures, combined with plant ornament. The somewhat distorted human figure has an ox's head and towering wings; together with the fresh colors, unfalteringly stylized draftsmanship, and painterly relation between miniature and text, it produces a highly picturesque effect.

The Romanesque approach, merging with elements of the Gothic, is found in thirteenth-century miniatures. Among the loveliest of the manuscripts is the antiphonary from Zadar, its outsize initials providing a frame for skillfully drawn figural compositions in lively colors. But in the same century the art of illumination was to produce different *Pl. 239* results in Dalmatia. The Trogir Evangelistary of 1230-40 is illustrated with miniatures strongly influenced by contemporaneous Byzantine art. The superb figures of the Archangel and the Virgin Annunciate — whose transcendental qualities are enhanced by the unreality of the surroundings, the curious architecture, and the stylized vegetation, reduced to virtually pure ornamentation — add to the exceptionally harmonious color scheme of the entire composition and place this miniature among the finest achievements of its type and time. The miniature of the Crucifixion from St. Mary's Monastery in Zadar, with its Greek signatures, is also pervaded by the spirit of late-thirteenth-century Byzantine

art. The tragedy implicit in the scene is accentuated by the motif of the two weeping angels overcome with grief.

In the fourteenth century the majority of manuscripts give evidence of being influenced by Bologna miniaturists, while in others a link with French illumination is discernible. Thus the *Legenda aurea* from Šibenik is illustrated along the margins with typically French *drôleries*, and in the Slovenian Carthusian monastery of Bistra there are fourteenth-century illuminated manuscripts executed in the spirit of the French school.

Fifteenth-century Zagreb had a highly developed art of copying and illuminating. There, in 1495, originated the Missal of Juraj de Topusko, illustrated with miniatures *Pl. 253* probably by Johannes (Hans) Alemanus, a Zagreb citizen of German descent. Obviously German Gothic in inspiration, the miniatures in the margins of the manuscript show, in addition to interlacing plant and ribbon ornament harboring birds and animals, independent compositions with religious or secular content, executed in a provincial style.

Libraries in Yugoslavia preserve a number of manuscripts known to be of foreign origin. One such is the Book of Hours in the Strossmayer Gallery of Old Masters in Za- *Pl. 254* greb, a French work that originated in Rheims or Paris in the second half of the fifteenth century. Its wealth of illustrations includes figures of saints and genre scenes from peasant life, all displaying a freshness and immediacy of artistic approach. The same gallery boasts the Breviary of the duke Ercole I d'Este, an exceptional example of Renaissance manu- *Pl. 252* script illumination of the Ferrara school dating from the beginning of the sixteenth century, probably executed by Matteo da Milano. Events from the lives of the saints are set against the background of a broadly conceived Renaissance landscape, framed in a wide border containing a wealth of ornamentation, putti, and minute religious scenes. These miniatures afford a typical demonstration of the decline of this type of painting in the West: the illuminations became totally divorced from the text and calligraphy, to which they had previously been organically related, and were transformed into small easel paintings. Thus divested of their *raison d'être*, they readily yielded to printed engravings, which replaced them completely and irrevocably.

The Glagolitic alphabet, a phenomenon peculiar to Slav culture and associated mainly with Yugoslav regions, underwent a definite evolution which included the development of illumination. Having emerged in the ninth century as a result of the same factors that brought about the inception of the Cyrillic alphabet, the Glagolitic script spread to the Moravo-Pannonian, Bulgaro-Macedonian, and finally the Croato-Istrian regions, showing the greatest staying power in the last-named. All in all, the format of these Glagolitic

manuscripts is extremely modest. Apart from the decorative nature of the letters themselves, the main ornaments were the initials, wrought with simple geometric and floral motifs and unpretentious applications of animal and anthropomorphous details. Certain manuscripts, principally from the fourteenth and fifteenth centuries, are illustrated with figural miniatures that are stylistically and artistically on a par with those in contemporaneous Latin manuscripts. Outstanding among these is the Missal of Hrvoje (Duke of Spalato), dating from the early fifteenth century and preserved in the Topkapi Palace Museum, Istanbul. Most frequently, however, the execution of the miniatures with figural motifs was primitive, in terms of both technique and painterly values. A typical example of such illuminated decoration is a Breviary from Beram in Istria, dating from the first half of the fifteenth century. The manuscript abounds in naively drawn and vigorously colored figures of saints reminiscent in their immediacy of a child's imaginings and of folk naturalism.

The first Islamic manuscripts arrived in the Yugoslav regions toward the close of the fourteenth century, when the Turks captured and vassalized certain areas. As Muslim culture was adopted by the Islamized portion of the local population, books originating in the conquered areas appeared alongside books brought by the invaders. Most of the former were very modest, their ornament frequently consisting of decorative headings composed in the form of portals, crowns, or domes. This was true of renderings of the Koran, as Islam in principle forbids the depiction of living beings. However, poetry in particular and scientific works and chronicles as well were illustrated with figural compositions. Only a few of these richly produced books are in Yugoslav collections. The most *Pl. 251* beautifully illuminated among them is the copy of the *Shah-nama*, or Book of Kings, the Persian national epic composed in the eleventh century by the celebrated poet Firdausi; now in Zagreb, this manuscript, which originated in Constantinople in the seventeenth century, is in its painterly conceptions closely associated with the art of the Safavids. All the features of this art are in evidence in its twenty extraordinary compositions of battles, hunting scenes, and scenes from the private lives of the Persian kings: finesse and purity of draftsmanship, a decorative approach to the flat compositions, presented with no trace of a striving for volume or perspective, a fresh and dazzling palette marked by the absence of modulation and nuance, realism being sacrificed completely to the decorative values of the tones.

The few Greek illuminated manuscripts that have been preserved in Yugoslavia's libraries have a multiple significance: as more or less successful artistic achievements in their own right, and as models used by local miniaturists in the illustration of books in *Fig. b* Cyrillic. A Greek manuscript of the twelfth to thirteenth century noteworthy for the *Pl. 245* beauty of its illumination is the Čelnice Evangelistary, in the National Museum of Ohrid. The richly polychrome floral ornaments, painted with precision and purity and blending harmoniously into a sumptuous gold background, clearly wielded a strong influence on miniature painting in Cyrillic manuscripts of a later date.

Before World War II wrought its havoc in Yugoslavia, there were in the country a considerable number of Hebrew illuminated manuscripts. Only a few remain, the most *Pl. 255* outstanding being the fourteenth-century Sarajevo Haggadah. This book contains the prayers, stories, psalms, and hymns recited in the home during the celebration of the first nights of Passover. The Sarajevo codex, which originated in or near North Spain, contains numerous miniatures with scenes from the Old Testament, page embellishments with ornamental and figural motifs, and highly decorative vignettes, the products of Spanish-Jewish artist-illuminators whose work shows the influence of contemporaneous French and Italian book artists. On account of its numerous illustrations, and particularly its artistic excellence, the Sarajevo Haggadah is one of the most celebrated Hebrew manuscripts in the world.

238 *Scribe at his lectern. Gospel Book of Prince*
*Miroslav. c. 1180. National Museum, Belgrade*

238

239 The Annunciation. *Trogir Evangelistary. 1230-40.*
Cathedral Treasury (f. 83 v.), Trogir

240 Illuminated initial F. *Biblia sacra. Late 11th cen-*
tury. *Dominican Monastery (f. 185), Dubrovnik*

241 The Evangelist Luke. *Zagreb Evangelistary. 11th*
century. *Metropolitana (Ms. MR 153, f. 17),*
Zagreb

242 Chapter heading with Evangelists. *Gospel Book*
of Prince Miroslav. c. 1180. *National Museum,*
Belgrade

243 Illuminated initial V. *Gospel Book of Prince*
Miroslav. c. 1180. *National Museum, Belgrade*

244 Herod the Tetrarch. *Gospel Book of Prince*
Miroslav. c. 1180. *National Museum, Belgrade*

242

243

244

231

245

246

245 *Chapter heading. Čelnice Evangelistary. 11th-12th century. National Museum (Ms. 70, f. 3), Ohrid*

246 *Chapter heading. The Four Gospels of Peć. Mid-14th century. Monastery of the Patriarchate of Peć (Ms. 2), Peć*

247 *The Evangelist Luke. The Four Gospels of Prince Stephen III (the Great) of Moldavia. 1504. Museum, Cetinje*

248 ANDRIJA RAIČEVIĆ. *The Rotation of the Stars. Miniature painting in Topographia christiana by Cosmas Indicopleustes. 1649. Monastery of the Holy Trinity, Plevlja*

249 *The Evangelist Luke. The Four Gospels of Cetinje. 1613. Treasury of the Cetinje Monastery (Ms. 5, 161), Cetinje*

250 *Panel of judges deliberating the Law on Mining promulgated by Despot Stephen Lazarević. Code of Mining. 16th century. Archives of the Serbian Academy of Sciences and Arts (f. 2 v.), Belgrade*

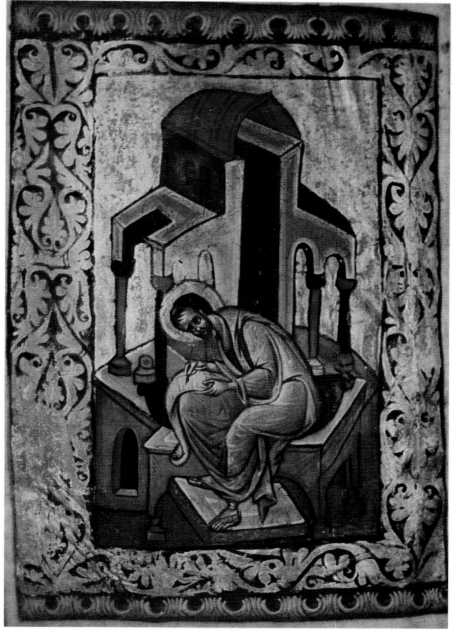

247

250

248

249

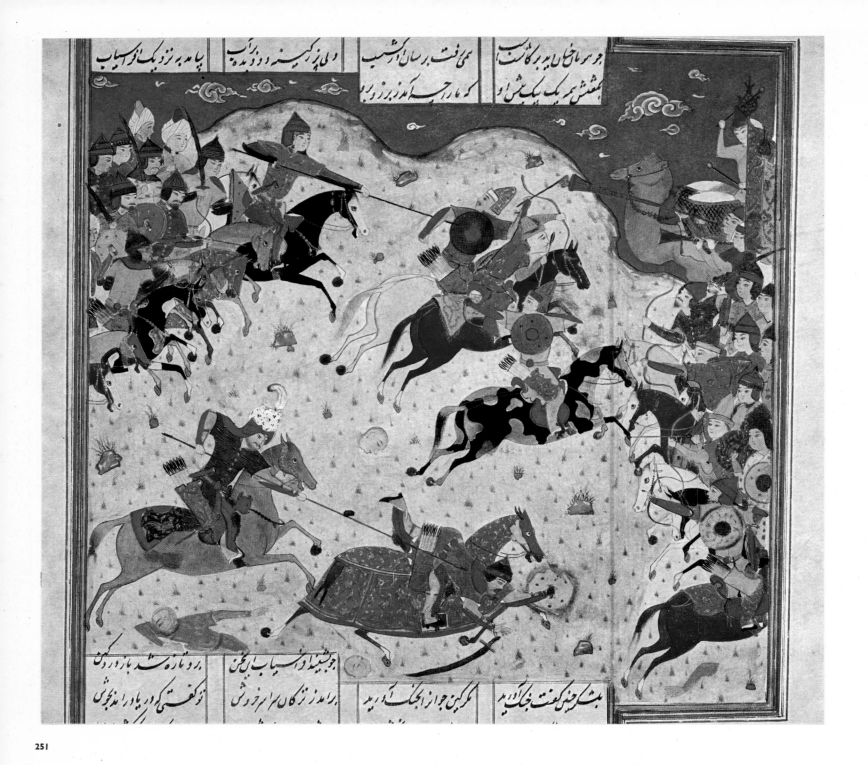

251

251 *Battle scene. Shah-namah by Firdausi. 1574.*
*Croatian Archives (MJ. A I f. 328), Zagreb*

252

253

252 Scene from the life of the Apostle Peter. *Breviary of Ercole d'Este. 16th century. Strossmayer Gallery of Old Masters (f. 2), Zagreb*

253 St. George Slaying the Dragon. *Missal of Juraj de Topusco. 1495. Cathedral Treasury (Ms. 354 f. 173), Zagreb*

254 The Annunciation to the Shepherds. *Book of Hours. French, latter half of 15th century. Strossmayer Gallery of Old Masters (Ms. 385, f. 69), Zagreb*

254

235

ואת הברכה אשר ברך משה

עלה אל הר העברים  ויהושע בן נון מלא רוח חכמה

255 Above, *Moses blessing the children of Israel
(Deut. 33:1).* Below, right, *Moses at the foot
of the mountain of Abarim (Num. 27:12); left,
his successor, Joshua (Deut. 34:9). Sarajevo
Haggadah. North Spanish, mid-14th century.
National Museum, Sarajevo*

255

# XI   THE ROMANESQUE

Jovanka Maksimović
*Professor of Art History, University of Belgrade*

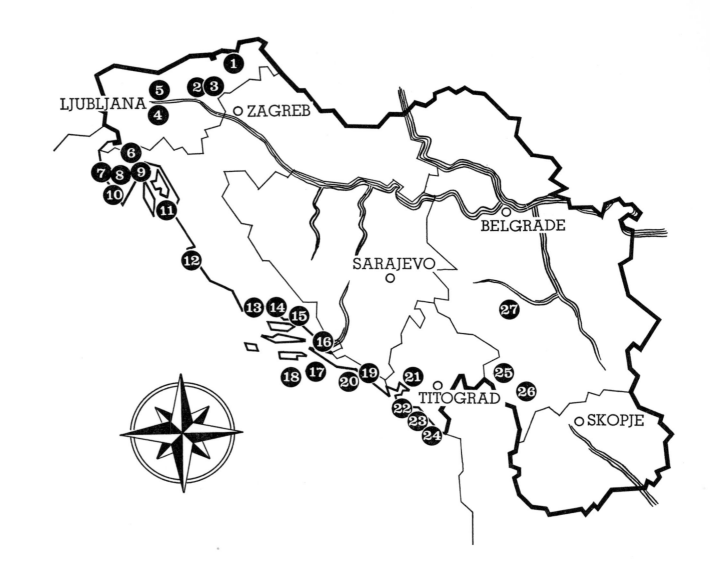

ROMANESQUE MONUMENTS

| | | | | | |
|---|---|---|---|---|---|
| 1 | Vuzenica | 10 | Church of St. Foška, near Peroj | 19 | Dubrovnik |
| 2 | Laško | 11 | Rab | 20 | Lopud |
| 3 | Loka | 12 | Zadar | 21 | Kotor |
| 4 | Stična | 13 | Trogir | 22 | Budva |
| 5 | Kamnik | 14 | Split | 23 | Bar |
| 6 | Hum | 15 | Omiš | 24 | Ulcinj |
| 7 | Poreč | 16 | Ston | 25 | Dečani |
| 8 | Church of St. Lovreč, near Poreč | 17 | Mljet | 26 | Prizren |
| 9 | Church of St. Agatha, near Kanfanar | 18 | Lastovo | 27 | Studenica |

238

In the Middle Ages the regions making up present-day Yugoslavia, like the Balkan Peninsula as a whole, were exposed, on the one hand, to Byzantine ecclesiastical and political influences — to Eastern interpretations of Christianity and the cultural predominance of Byzantium — and on the other hand, running counter to this, to the influence emanating from the West, with Benedictine monks as the standard-bearers of political and religious concepts originating in Rome. With them came the attendant Western artistic ideas and elements, first from various centers in Italy and later from the more distant France and Germany. As one century followed another, Eastern and Western influences alternated, depending on the political and economic policies of the moment. After the Slavs in the Balkans had been converted to Christianity, the art of Western Europe began to exert a more pronounced influence on the western Yugoslav regions. For two hundred years, from the ninth to the close of the eleventh century, the style of architecture termed pre-Romanesque held sway, bringing certain Romanesque elements to full realization while merely hinting at the future development of others. We find chiefly small churches, free in form, constructed of dressed stone, with stone vaults, frequently domed, their walls articulated by pilasters and blind arcades that lend richness to their otherwise modest facades. Of those that have weathered the assaults of time, some are situated along the Adriatic coast, some on the islands, and others farther inland. The coastal region has the Church of the Holy Cross in Nin, a cross shape, roughly; the Church of St. Peter in Priko, near Omiš, and the Church of St. Michael in Ston, both single-aisled, domed structures; the ruins of the church in Ošlje, near Ston, showing a sexfoil plan.

*Pl. 258*

Pre-Romanesque stone sculptural ornament was concentrated on portals and windows, altar screens, baptisteries, and ciboria. It formed an integral part of the architecture, to which it was subordinated; it was neither three-dimensional nor modeled in depth but was reduced to surface relief, in which all forms and motifs were equal in sculptural value. All elements — geometric and floral ornaments, animal and human figures — were stylized, forming intertwining double or triple bands. "Graphic" sculptures in stone of this type have been preserved in goodly number in the churches and museums of Istria, Dalmatia, Dubrovnik, and Kotor, and even much farther inland, in Bosnia and Herzegovina, Slavonia, ancient Ras, and Srem. Perhaps the purest and most refined expression of this pre-Romanesque style can be found in the relief panels from the Church of St. Nedelja in the Zadar Museum, with their scenes from the Gospels. The stylistic origins of this decorative shallow carving can be traced to debased antique sculpture, which, reinvigorated by fresh elements from medieval Christianity and from the barbarian peoples, achieved new forms and modes. It appeared in a number of variants — pre-Romanesque, Byzantine, Islamic — in the ruins of the antique world, largely on the shores of the Mediterranean.

a. *Reliquary cross, 7th-8th century. Monastery of St. Mary, Zadar*

b. *Detail of wooden stall back, latter half of 12th century. Cathedral of Split*

A late arrival in the Yugoslav regions, the Romanesque, once introduced, showed considerable staying power. It persisted from the twelfth almost to the end of the fourteenth century, mingling, toward the end of this period, with the Gothic to form a local version of the Romanesque-Gothic style. Far removed from the centers of Western Europe where the great art styles were taking shape, these regions received their artistic impulses late. But, for all that, the local architects and sculptors imbued them with a freshness drawn from the special atmosphere of the coastal area and the color of the stone peculiar to the region. Far from being a homogenous phenomenon, in Yugoslavia the Romanesque was at once rich and variegated, as it was in certain other countries, for instance France and Italy. Certain basic conceptions were common to all Romanesque architecture. The prevailing type of structure was basilican, single-aisled or triple-aisled, sometimes with transept, crypt, and bell tower. The facades, articulated by portals, series of blind arcades, niches, and even galleries, reflected a wealth of forms and, in the play of light and shade, a restless vigor. The art of the Romanesque was the art of the Benedictine monks; in erecting their monasteries they were disseminating the ideas of their church and their order and, along with them, the artistic forms of expression of other centers. In Slovenia, Croatia, and Dalmatia, churches and monasteries were constructed entirely in the Romanesque tradition, but along the coast of ancient Zeta and in the valleys of Serbia under the Nemanya dynasty — which is as far as this wave of Westernized art penetrated — architectural elements of the Romanesque changed as they were adapted to Orthodox liturgical requirements and also to Byzantine canons, which had left a profound imprint on the taste and aesthetic attitudes of the cultivated portions of the population.

Romanesque art was also the art of advanced municipalities on the coast — Zadar, Šibenik, Trogir, Split, Dubrovnik, Kotor — where majestic cathedrals were erected on the main squares. These were supplemented by other ecclesiastical and public buildings, stone private dwellings, and narrow alleyways into which the sun rarely penetrated. Romanesque sculpture, adapted to monumental architecture, achieved a high level, in terms both of pure Romanesque style and of capacity to blend with Byzantine elements. Spacious wall surfaces afforded room for fresco decoration, of which not much remains; it is, unfortunately, less well preserved than the miniature painting and manuscript illumination that is the subject of Chapter X. Among the first regions to be subjected to Western religious and cultural influences, Slovenia acquired in the twelfth century great monastery churches in the Romanesque style, but these later underwent considerable change. Outstanding examples are a triple-aisled basilica with transept in Stična and a two-story chapel with crypt in Mali Grad, near Kamnik. Also noteworthy are Late Romanesque structures in Laško and Loka, near Zidani Most, and in Vuzenica, as well as the remains of a monastery in the village of Žiča, near Slovenske Konjice.

*Pl. 257*

In Istria art forms developed both in the coastal cities, then still bound by the traditions of the Romans and of Justinian (Pula, Poreč), and in small towns in the interior. The Romanesque monuments of architecture that survive are rare; they include the simple square stone churches, roofed with stone slabs, with semicircular or rectangular apses — the work of local builders — and the massive Romanesque bell towers, pierced by double-arched windows, which contribute much to the atmosphere of these towns.

The largest and most magnificent structures of the Romanesque period are to be found in the coastal towns of Dalmatia and points farther south. Great cathedrals, usually long in the building, bear the imprint of work by many masters and show a diversity of elements. Common features are the rich architectural carving, stone vaults over side aisles, and great sculptured portals and wheel windows in the western facades, as seen in the ancient Church of St. Grisogonus (Sv. Krševan) in Zadar, reconstructed in 1175, a triple-aisled basilica with three semicircular apses and richly wrought facades. It has the characteristic series of arcades with slender engaged columns and niches into whose openings

the bright Dalmatian sun shines, creating a lively changing pattern of light and shadow. A facade of this type, familiar especially in the Romanesque buildings of such towns as Pisa and Lucca, with which the Dalmatian towns traded, is also seen in the Cathedral of *Pl. 268* St. Anastasia in Zadar, which underwent numerous alterations even in the Middle Ages. This monumentally conceived Romanesque building, with its three aisles, galleries over the side aisles, elevated sanctuary over an ancient triple-aisled crypt, three portals, and two wheel windows along the western facade, in addition to series of blind galleries and arcades along all facades and apses, remains compact and homogeneous despite reconstruction. The same cannot be said of the cathedral in Trogir, the other of Dalmatia's two churches in the grand manner. Conceived along Romanesque lines, it acquired, in the course of many years of construction, Gothic, Renaissance, and Baroque additions. Its Romanesque ground plan has three aisles, a porch at the western end, and three apses *Pl. 266* at the eastern end. Series of small blind arches terminating in carved masks form an arcature beneath the eaves, and these, with the vertically thrusting columns and colonnettes *Pl. 267* on the facades, are the only decorative notes, apart from the great portal by Master Radovan at the western end and an earlier and much more modest portal to the south.

Little is known about the cathedral in Dubrovnik. Like most of the other buildings in this ancient town, it was demolished by the catastrophic earthquake of 1667. A number of surviving descriptions and drawings indicate that its wide walls were in keeping with architectural usage in Apulia, a conclusion bolstered by the knowledge that the original masters who worked on the cathedral came from that region across the sea. It is unfortunate that nothing remains of the cathedral save a few sculptural fragments from the portal, since it probably was the inspiration for later churches not only in Dubrovnik but in Serbia, where masters from Dubrovnik and elsewhere along the coast worked on the foundations of the Serbian rulers and nobles. The cathedral in Kotor, erected on the site of an earlier,

circular church, and dedicated in 1166, was also damaged by the earthquake; it under-
went reconstruction in a later period, under the Baroque influence. Of its basically Roman-
esque conception there remain only the ground plan of a triple-aisled basilica with two
bell towers and a dome (destroyed) and the triforium on the eastern apse.

Numerous monastery buildings, churches, courtyards, small churches, chapels, and
bell towers have survived. Great fascination attaches to the Church of St. Mary of the old
Benedictine monastery on the island of Mljet, dating from the end of the twelfth century.
On the one hand the church maintained contact with the Benedictines of Italy, and
on the other with ancient Raška, to which the island belonged territorially. This accounts
for its resemblance to the Church of the Virgin in Studenica, dating from about the same *Pl. 184*
period, as evidenced by the combination of a Byzantine central and a Romanesque longi-
tudinal layout, with dome and Romanesque facade. The intermixture of Byzantine with
Romanesque elements is a feature of other buildings as well: the Church of St. Luke and
the Church of St. Mary in Kotor, and such representative buildings of the Raška school
as the Church of the Virgin in Studenica and the Church of the Holy Saviour in Dečani,
where Byzantine spatial plans are mingled with Romanesque exteriors and stone deco-
ration (Banjska, Studenica, Dečani). *Pl. 265, 274*

The final flowering of the Late Romanesque style before it vanished in the mid-four-
teenth century is exemplified by the cloister of the Franciscan monastery in Dubrovnik.
The work of a master named Miho, from the seaport town of Bar, where his tombstone *Pl. 273*
can still be seen, the cloister is enclosed on four sides by Romanesque arcades supported
by slender columns with imaginatively conceived capitals.

Romanesque houses, fashioned of stone, were notable for their windows with semi- *Pl. 271*
circular arcades, consoles in the shape of animal heads, and stone-framed doorways. We
find them today, in a state of partial preservation, in Koper, Poreč, Pula, Kotor, and most

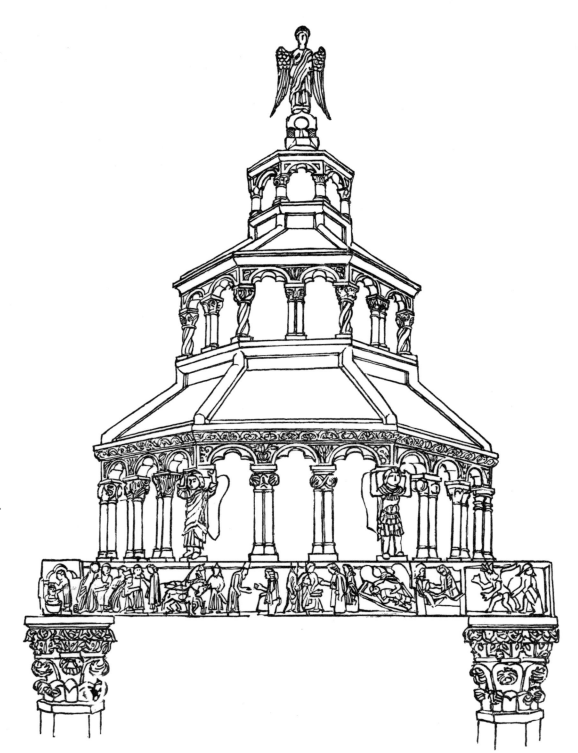

*d. Romanesque-Gothic ciborium, 14th century. Cathedral of St. Tryphon, Kotor*

of all in Trogir and Split, where they still conjure up the atmosphere of the Middle Ages.

Sculpture developed the characteristics of the Romanesque style in the course of the twelfth century. Accentuated plasticity of form, richer and more complex representation of human and animal figures, subject matter from the Old and the New Testament — all elements unknown in the preceding epoch — began to appear, at first tentatively, then more and more emphatically, to come to full flower in the thirteenth century.

A variety of factors and influences met and crossed in the Yugoslav regions in the twelfth century. Just as the syncretic art of South Italy grew out of an intermingling of Byzantine, Arabic, Romanesque, and Classical currents and traditions, so art forms in Dalmatia and along the southern Adriatic coast had similarly heterogeneous origins. The

combinations of sculptural forms that developed along the Adriatic coast evolved under cultural conditions analogous to those that nurtured the South Italian variant of the Romanesque style. The magnificent but unfortunately only partially preserved wooden choir stalls in the cathedral in Split (once Diocletian's mausoleum), dating from the second half of the twelfth century, afford the best example of such a symbiosis. Islamic fretted openings and decorative animals, Byzantine medallions of saints, and a number of Romanesque figural representations were integrated into an ornamental whole that displays all the features of an early Romanesque style not yet arrived at purity of form or substance. The great wooden doors at the entrance to the cathedral, dating from the early thirteenth century, are the work of the master Andrea Buvina. They are carved with a series of square panels depicting scenes from the life of Christ. The simplicity of the narration and composition, as well as numerous iconographic details, point to Byzantine artistic inspiration, whereas other aspects, notably the workmanship, mark these doors as a step in the direction of the true Romanesque. The same can be said of the stone relief of the Annunciation on the bell tower in Split, which, despite the Christian content of the theme, exhibits a certain Classical spirit and character — in the balance and harmony of the composition, in the feeling for volume, in the sensuous strength and beauty of the human figure, devoid of any allusion to the transcendental Christian ideas typical of the Romanesque. It is the working of Classical and Byzantine influences on Europe in the thirteenth century that set such works apart from the pure Romanesque. Civilized Europe in the thirteenth century manifested a heightened interest in antiquity, in its history and science, literature and art. This was the case in the Nicaean empire of Byzantium, in the South Italian kingdom of Frederick II, in the proto-Renaissance period in central Italy, in the classical Gothic phase in France. It produced a certain community of inner content in all the arts, regardless of differences in artistic expression and stylistic tendencies.

*Fig. b, Pl. 37*

*Pl. 260*

Even in the west portal of the Trogir cathedral, otherwise the clearest and most pronounced expression of the Dalmatian Romanesque, it is evident that the Yugoslav regions did not escape these influences. The work of Master Radovan, who carved his name on his masterpiece in 1240, the Trogir portal is closely related to the architecture of the cathedral in its entirety. Although Radovan entrusted some of the work to associates and followers, the portal presents an integrated whole, both thematically and sculpturally. The principal themes are Original Sin and Redemption, with others worked in around them (the apostles; the months, each with its appropriate tasks). Radovan's strongest point is probably his natural and charming details. They attest a serious study of nature — man and animals, foliage and fruit — and they set Radovan somewhat apart from the school of Romanesque sculptors in France, England, and certain parts of Italy, where artists transformed elements from nature into linear stylizations, divesting them of life and vibrancy in order to accentuate their spiritual or, rather, religious essence. Radovan, quite otherwise, emphasized lusciousness and volume, everyday details, the minor joys of life, natural movement, and beauty of form. This he achieved by rich sculptural gradations, from very low relief to the fully three-dimensional treatment of the figures of Adam and Eve.

*Pl. 264*

*Pl. 256*

*Pl. 35, 267*

The impact of Radovan's art was felt throughout Trogir and Split, engendering such similar conceptions of the Romanesque as the pulpit in the cathedral in Split and th figures at the entrance to the bell tower there, and the pulpit and ciborium in Trogir.

The fourteenth century, during which Gothic was at its zenith in Western Europe, witnessed an upward surge of the Romanesque in Yugoslav regions. The loveliest works in this Late Romanesque style are the imaginative capitals and decorative details in the cloister of the Franciscan monastery in Dubrovnik, dating from the mid-fourteenth century, and, from the same period, the ciborium in the Roman Catholic Cathedral of Kotor, with capitals and friezes illustrating the legend of St. Tryphon, patron saint of Kotor. The Late Romanesque of the fourteenth century intermingled with the first elements of

*Pl. 38, 272, Fig. d*

*e. Historiated initial from the Origen manuscript, ms. 626, Scr. C., f. 102. End of 12th century. Treasury of the Cathedral of Split*

the Gothic to produce the Romanesque-Gothic style, representing a harmonious new stylistic integration.

The intermixture of Romanesque sculptural motifs and workmanship with Byzantine elements was characteristic also of the magnificent architecture of medieval Serbia, the finest examples of which are Studenica, Dečani, and the ruined Church of the Archangels near Prizren, with their wealth of stone decoration. A special world takes shape, adroitly carved in stone: interlaces, luxuriant foliage and luscious fruits, a variety of real and imaginary animals, intertwined or freestanding, human figures, some majestic, others playful.

*Pl. 269, 270, Fig. c*  Romanesque motifs on the tombtones *(stećci)* of ancient Herzegovinian, Dalmatian, and Bosnian cemeteries, clumsy in interpretation, awkward in carving, hold for us, despite their frequently nebulous symbolism, the charm of primitive sculpture, with all its appeal for modern man. (See Chapter XIII.)

The painting of this period is less expressive and less well preserved than the carving. The earliest and largest group of Romanesque-Byzantine frescoes are to be found in the *Pl. 262*  small Church of St. Michael in Ston. Frescoes also survive in the ruined Benedictine monastery on the island of Lokrum and in the Church of St. Elijah on the island of Lopud, and fragments of compositions are to be seen in the belfry of the Church of St. Mary in Zadar, the Church of St. Peter in Zadar, and the tiny Church of St. Mary in Srima, near Šibenik. Still others exist in the Church of St. Grisogonus (St. Krševan) in Zadar and in Donji Humac on the island of Brač. Scattered among churches along the coast and on the islands are numerous fragments in so poor a state of repair as frequently to be hardly legible. The wall paintings of Ston perhaps most merit our interest, since their state of

preservation, while far from good, permits an insight into the concepts underlying the decorative scheme and the manner in which details were painted. Of particular significance is the portrait of the donor, King Michael of Zeta, depicted holding a model of the church; this is the pose in which all members of the Nemanya dynasty were later to be portrayed in their various foundations. Two-dimensional treatment of the figures, devoid of any attempt at modeling, emphatic outlines, flat areas of color, a plethora of geometric ornaments, all are characteristic of Romanesque murals, as is the disposition of themes that places the Original Sin in the eastern apse, the Evangelists near their symbols, and schematically portrayed saints in the niches. A clear-cut and representative Romanesque style is also evident in the frescoes of the belfry of the Church of St. Mary in Zadar, dating from the beginning of the twelfth century. The *Christ in Majesty* and the other typically Romanesque frescoes are painted flat, with strong emphasis on outline, stylized and decorative drapery, large eyes, and pink circles on the cheeks.

Romanesque paintings in Istria are in a relatively good state of preservation. In the Benedictine Church of St. Mihovil on the Lim, the Church of St. Lawrence in Poreč, the Church of St. Agatha near Kanfanar, the Church of St. Fosca in Peroj, and, farther inland, in the Church of St. Jerome in Hum, there are groups of eleventh- and twelfth-century paintings originating either in the framework of the activities of the Benedictine order or along the path of the aspirations of the patriarchs of Aquileia, in the Veneto. This dualism is reflected in the frescoes themselves, the *Ascension* in St. Fosca being   *Pl. 259* executed with the angular linearity and geometric schematism of the Western Romanesque and the *Crucifixion* and other frescoes in Hum showing such connections with Byzantine   *Pl. 276* monumental painting as were typical of the art of Aquileia in this period.

Few Romanesque panel paintings have come down to us, owing to the perishability of wood. Of those that survive, most portray the Crucifixion or are icons of the Virgin with Christ; in these the Byzantine traditions of painting are interwoven with Romanesque stylistic interpretations reminiscent particularly of the art of Tuscany in the thirteenth century. The great painted *Crucifixion* in low relief from the Franciscan church in Zadar   *Pl. 263* is in a pure twelfth-century Romanesque style, whereas other paintings from Zadar — the *Crucifixion* from the Church of St. Mihovil and a devastated *Crucifixion* from the Church of St. Mary, icons of the Virgin from the Cathedral and the Church of St. Mary — bear a close resemblance to the painterly conceptions of Tuscany and of Venice, dominated by the Romanesque interpretation of Byzantine traditions. The same is true of a group of icons from Split, outstanding among them the *Virgin with Christ* from the Church of   *Pl. 261* Our Lady of the Belfry; although they exhibit the same Tuscan tendency toward strong contours, vivid colors, and intensified expression, they could easily be works of local origin. An intermingling of styles similar to that seen in the icons from Split is observable in icons from the islands of Hvar and Korčula and from Dubrovnik.

No treatment of the flowering of the Romanesque in these regions can omit mention of the special branch of art fostered in the scriptoria in towns and monastic centers, where ecclesiastical books were written and copied in great numbers — the art of the illumination and illustration of books, which is the subject of the previous chapter. As was indicated there, despite the fact that numbers of manuscripts have been destroyed through the centuries, or have found their way to great libraries in other parts of the world, many libraries and monastery treasuries of Yugoslavia still rejoice in the possession of early manuscripts — Bibles and Gospel books, missals, and antiphonaries. There is in Split, for instance, a celebrated thirteenth-century manuscript, secular in content, the *Historia salonitana* of the Archdeacon Toma, its decoration consisting entirely of modest initials. Outstanding among the earliest Romanesque miniatures, from the eleventh century, are those in the Gospels of Osor (Vatican Library), and those in the Gospels of Zadar (Bodleian Library, Oxford University), the former exhibiting a resemblance to earlier miniatures from South

Italy, especially Apulia, and the latter, with its large zoomorphic initials, stylized in form and vivid in color, demonstrating greater affinity with the broad spectrum of Beneventan art. Both manuscripts originated in the scriptorium of St. Grisogonus in Zadar. Scriptoria were also in existence, as we have seen, in other towns, among them Trogir, Split, Dubrovnik. Worthy of mention among the ten-odd Romanesque manuscripts preserved in the Cathedral of Split are the Missale Romanum and the Split Evangelistary, both of the *Fig. e* twelfth century, in contemporaneous silver covers, and a twelfth-century Origen, which, like the two preceding manuscripts, is decorated with numerous initials and shows the range of interlaces, animals, and human figures typical of Romanesque manuscript illumination. The Cathedral of Trogir has among its treasures a manuscript dating from the thirteenth century which probably originated in that city during the lifetime of Radovan; it contains, among others, miniatures with the characteristic combination of Byzantine and Romanesque elements. A Breviary written and illuminated in Split in 1291 and now in the Museo Civico in Venice illustrates a similar Byzantine-Western symbiosis. One of the most important of the illustrated manuscripts in this category is the Gospels *Pl. 238, 242, 243* of Prince Miroslav, written in the Cyrillic alphabet at the end of the twelfth century (National Museum, Belgrade), in which the miniatures and initials exhibit a mixture of Byzantine and Romanesque motifs and stylistic features. Many manuscripts were to be illustrated later in line with this syncretic tradition, especially in Bosnia in the fourteenth and even in the fifteenth century.

Thus artistic activity from the eleventh through the fourteenth century in towns and centers of culture in Slavic countries on the Balkan Peninsula has left a considerable legacy of monuments in the Romanesque style. The inspiration derived from the artistic achievement of neighboring regions served as a point of departure and model for local master masons, stoneworkers, and painters, who, working under the specific conditions characterizing this part of the world, gave a different turn to their production, transforming it into a variant of the Romanesque peculiar to the area.

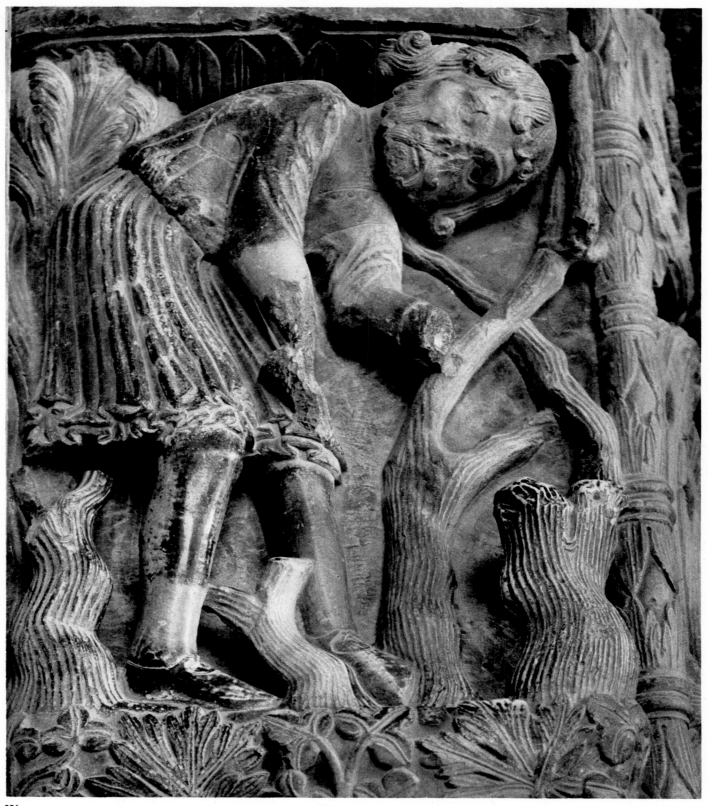

256

256 MASTER RADOVAN. *The Month of March: a wine-*
*grower cutting the vine. Detail of west portal,*
*Cathedral of St. Lawrence, Trogir. 1240*

258

257

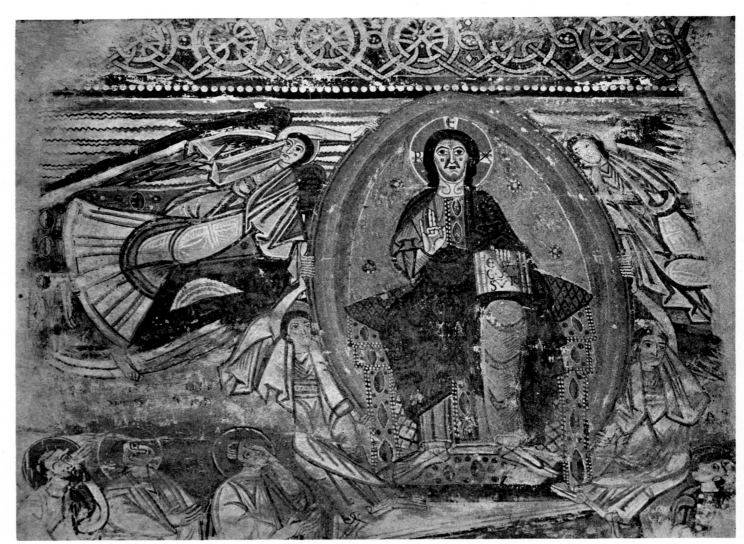

257 *Two-story chapel with crypt. Mali Grad, near Kamnik. 12th century*

258 *Church of St. Peter. Priko, near Omiš. 11th century*

259 *The Ascension. Fresco, Church of St. Fosca, Peroj. 12th century*

259

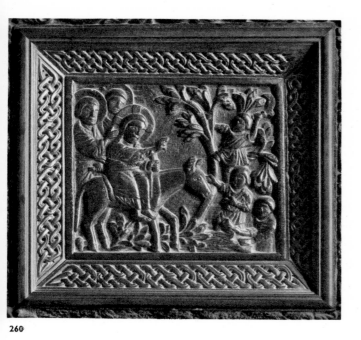

260

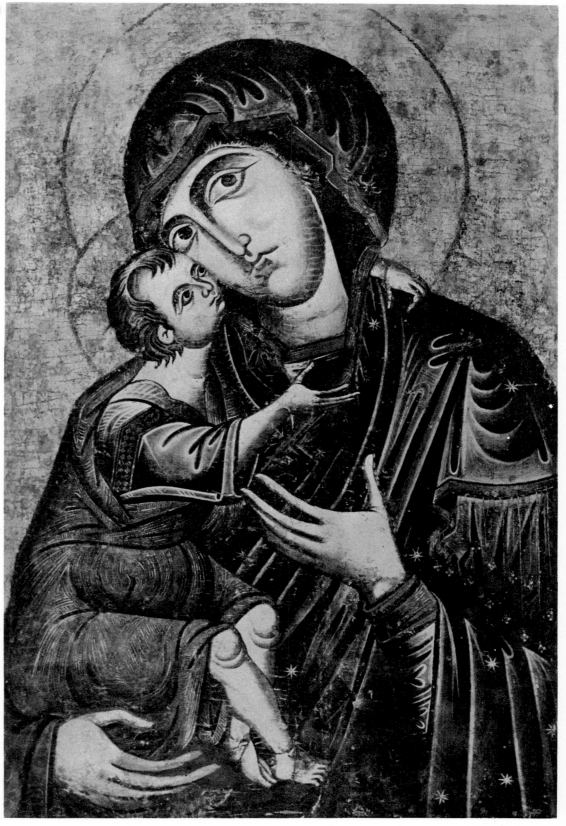

261

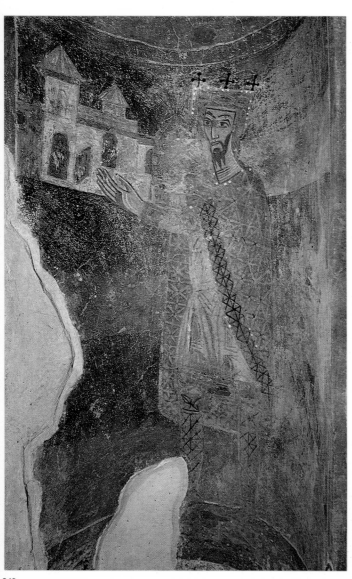

262

260  *ANDRIJA BUVINA. Christ's Entry into Jerusalem. Detail of wooden door, Cathedral of St. Lawrence, Split. Early 13th century*

261  *The Virgin with Christ. Icon on wood, Church of the Madonna of the Belfry, Split. 13th century*

262  *King Michael as Donor. Detail of fresco, Church of St. Michael, Ošlje, near Ston. 11th century*

251

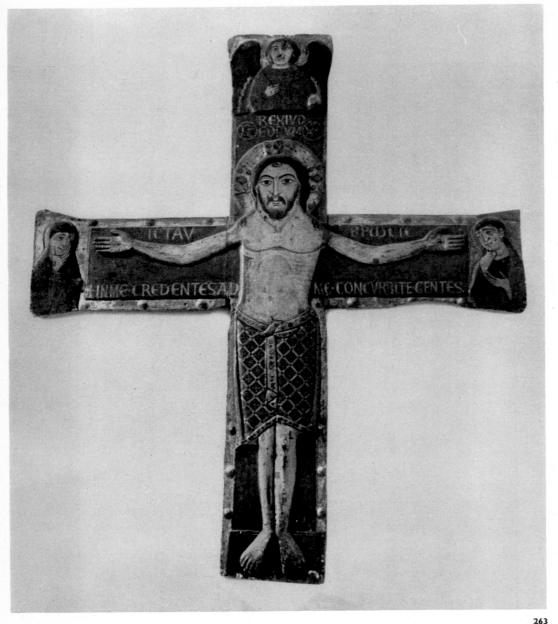

263

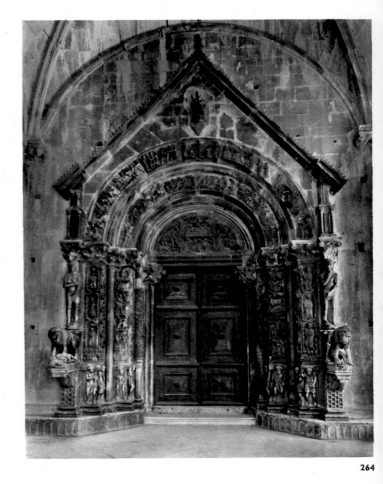

264

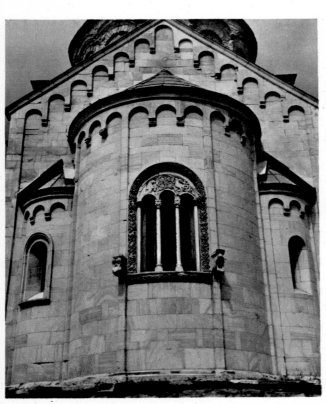

265

266

263 *Crucifixion. Painted wood relief, Franciscan Church, Zadar. 12th century*

264 MASTER RADOVAN. *West portal, Cathedral of St. Lawrence, Trogir. 1240*

265 *Apse, Church of the Virgin, Studenica. Late 12th century*

266 *Apse, Cathedral of St. Lawrence, Trogir. Early 13th century*

267 MASTER RADOVAN. *West portal (detail), Cathedral of St. Lawrence, Trogir. 1240*

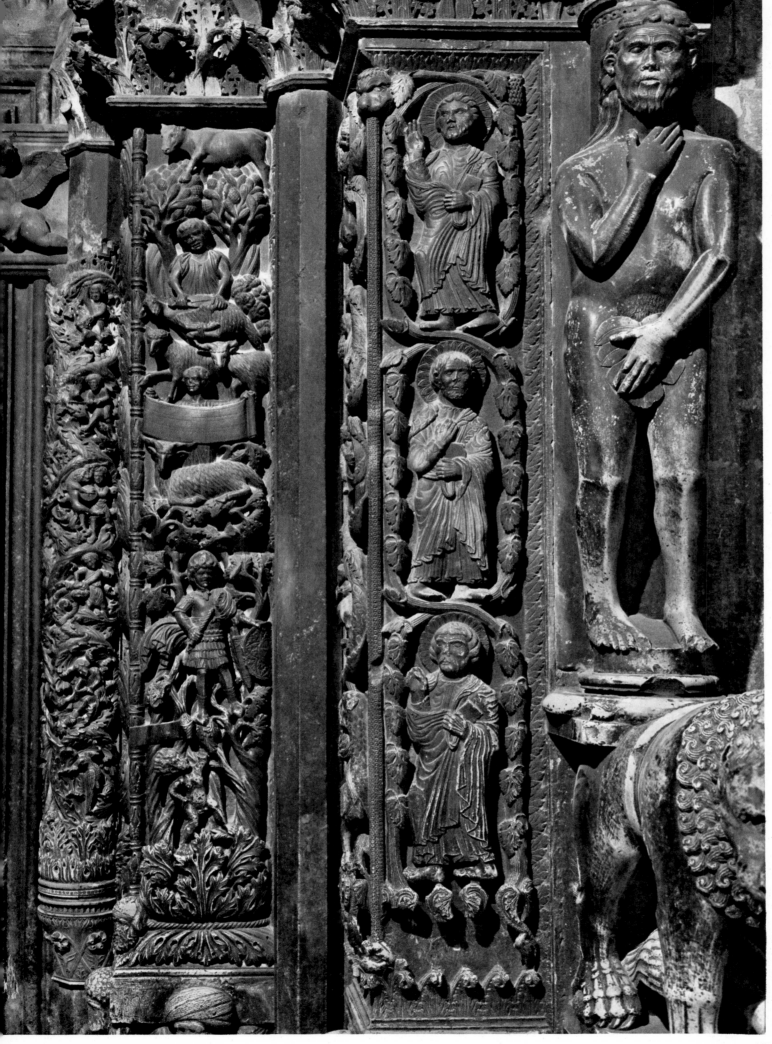

267

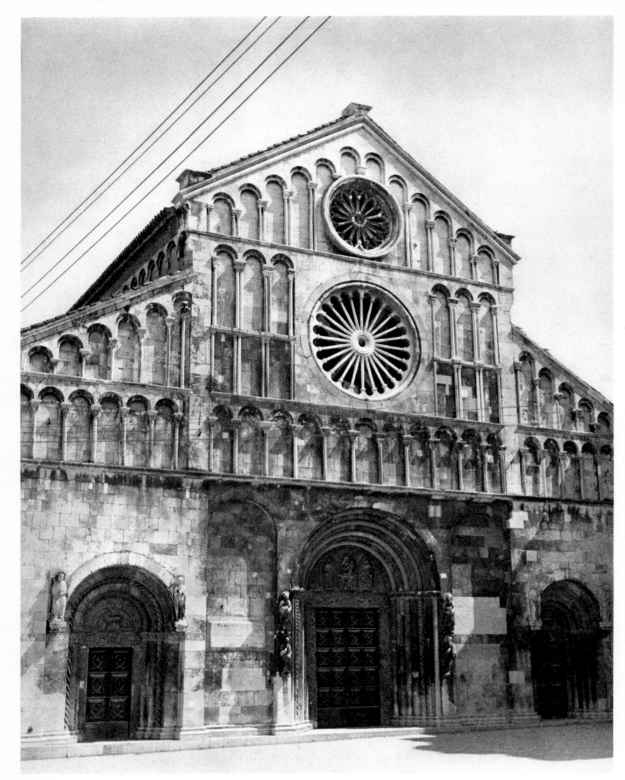

268

269

270

268 *West facade, Cathedral of St. Anastasia, Zadar. 12th-14th century*

269 *Griffin. Detail of west portal, Church of the Virgin, Studenica.*
*Late 12th century*

270 *Apostle. Detail of west portal, Church of the Virgin, Studenica. Late*
*12th century*

271 *Saint. Detail of so-called House of Two Saints, Poreč*

272 *Detail of ciborium, Cathedral of St. Tryphon, Kotor. 14th century*

273 MASTER MIHO OF BAR. *Cloister of Franciscan Monastery, Dubrov-*
*nik. 14th century*

274 *Church of the Holy Saviour, Dečani. Chief architect, Vita of*
*Kotor. 1328-35*

271

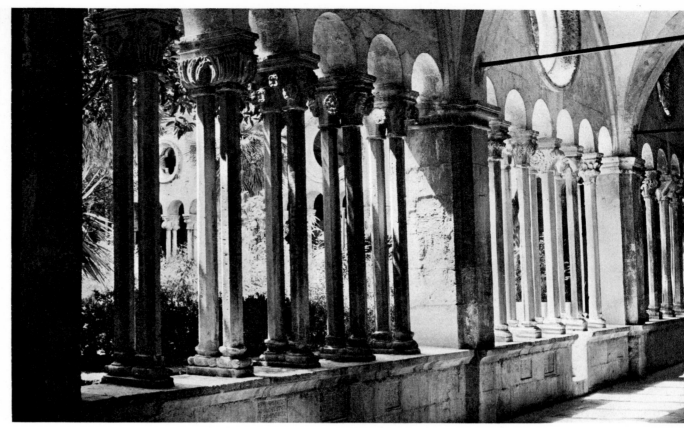

273

272

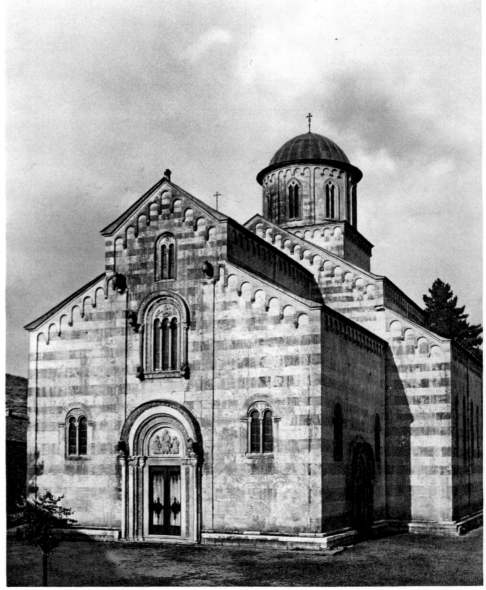

274

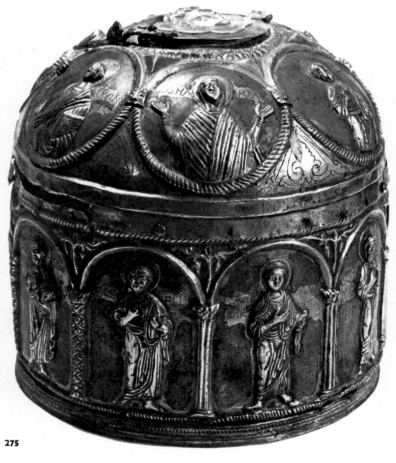

275

276

*275 Reliquary of St. James. Gift of Božna, wife of Kaža, Prior of Zadar. Cathedral Treasury, Zadar. Late 11th century*

*276 Crucifixion. Detail of fresco, Church of St. Jerome, Hum. 12th century*

# XII  THE GOTHIC

Emilijan Cevc
*Professor of Art History, Slovene Academy
of Sciences and Arts, Ljubljana*

## GOTHIC MONUMENTS

| | | | |
|---|---|---|---|
| *1* | *Murska Sobota, Martijanci* | *22* | *Lepoglava* |
| *2* | *Maribor, Radlje* | *23* | *Križevci* |
| *3* | *Ptuj, Ptujska Gora* | *24* | *Vočin* |
| *4* | *Celje* | *25* | *Topusko* |
| *5* | *St. Primož, near Kamnik* | *26* | *Rab* |
| *6* | *Ljubljana, Stična* | *27* | *Cres* |
| *7* | *Škofja Loka, Suha* | *28* | *Zadar* |
| *8* | *Kranj* | *29* | *Šibenik* |
| *9* | *Church of St. Janez, Bohinj* | *30* | *Trogir* |
| *10* | *Tolmin* | *31* | *Split* |
| *11* | *Kojsko* | *32* | *Hvar* |
| *12* | *Koper* | *33* | *Korčula* |
| *13* | *Oprtalj* | *34* | *Dubrovnik* |
| *14* | *Draguć* | *35* | *Kotor* |
| *15* | *Church of St. Mary, Škriline,* | *36* | *Bar* |
| | *near Beram* | *37* | *Ulcinj* |
| *16* | *Lindar* | *38* | *Dečani* |
| *17* | *Poreč* | *39* | *Gradac* |
| *18* | *Lovran* | *40* | *Studenica* |
| *19* | *Cerknica* | *41* | *Kalenić* |
| *20* | *Žužemberk* | *42* | *Jajce* |
| *21* | *Zagreb* | *43* | *Bihać* |

It would be difficult to point to another European region whose artistic heritage makes possible the study of the expansive dynamics of the Gothic, as an integral artistic style, in so great a variety of modifications and adaptations of form as does that of the ethnically, culturally, historically, and morphologically heterogeneous area comprising present-day Yugoslavia. The regions under consideration are wedged in between Central Europe and the eastern Alps to the north, the Mediterranean zone to the west, the eastern plains and the Byzantine sphere of cultural influence to the south. In the mountainous heartland of the state the ancient cultural heritage lives still. It was precisely those regions of Yugoslavia which achieved the greatest political power in the Middle Ages — Orthodox Serbia and Macedonia — that remained inaccessible to the influence of the Western Gothic style. Leaving only the barest of traces on the architecture of those regions, Gothic took firm root in the Catholic areas: the local nobility had disappeared in the Kingdom of Croatia after it was annexed by the Hungarian crown in 1102, and in Slovenia after it was incorporated into the Frankish Empire during Charlemagne's lifetime. On the other hand, most of the towns along the Adriatic, subjected to long years of political and economic upheaval, wavering between the traditions of their indigenous Croatian and Serbian hinterlands and Byzantine and Venetian influences and intrigues, came under the control of the Venetian Republic in 1420.

Under these historical circumstances it is little wonder that the motive force required for the launching of the Gothic style was lacking — and that the new style appeared a hundred years late. During its initial stages, the politically disunited nobility was in no position to undertake large-scale ventures in the cultural sphere; further, it was only in the fourteenth century that the towns achieved a level of power that enabled them to turn their attention to major artistic enterprises. Thus it happened that the first Gothic elements were brought to the area by monastic orders from the West — Cistercians, Minorites, and Dominicans — although, to be sure, such stylistic innovations frequently reached the Yugoslav regions either in dilute form or as adaptations of the Italian manner. Hence only in the fourteenth century was the Gothic able to prevail over the tenacious Romanesque, a style highly suited to the Mediterranean cultural climate.

Far removed from the great art centers, provincial southeastern Europe was late in receiving Gothic impulses, which by the time they reached there were not — or were only rarely — capable of engendering the monumental achievements for which they had been responsible in the central and the western parts of Europe. The northernmost Yugoslav region — Slovenia — was the site of the earliest and most powerful manifestation of the Gothic; there it may even be said to represent the first artistic trend that, as a genuine reflection of the "spatial style," became firmly entrenched as a popular and regional art form. In terms of art the Slovenian region was at the time included in the larger ge-

*a. Ground plan of the church in Ptujska Gora.
c. 1400*

*b. Ground plan of Late Gothic parish church
in Kranj. First half of 15th century*

ographic framework of the great sub-Alpine curve extending from the Gulf of Genoa at the foot of the Alps to the Kvarner Gulf; there the Central European and the Mediterranean basic ideas of form, modified by characteristic national developments, confronted each other. Continental Croatia, under Central European influence, was also receptive to impulses from Hungary emanating from a feudal class that was in a position to commission works of art. However, the Turkish incursions, transforming Croatia into a permanent battlefield in the sixteenth century, destroyed so many monuments that no clear picture can be formed of its artistic styles and output. Even in Slovenia the number of monuments decreases as one travels toward the southeast and the Croatian border. In Dalmatia the "Latin" artistic tradition, with its three-dimensional vision, conditioned by the Mediterranean ambience, had prevailed since the time of antiquity. Similar factors played a decisive role in Istria and in the coastal part of Slovenia. This tradition had percolated down to the folk; as an element in rustic art, dear both to artists and to plebeian patrons, it imbued works shaped by more progressive stylistic trends, becoming a constant underlying element of local color. Moreover, with its feeling for space and predilection for the plain wall surface, the tradition also reached the Alpine region, which had many connections with northern Italy. It was natural under the circumstances for a sharp contrast between the Romanesque heritage and the new Gothic elements to emerge — a contrast typical of the thirteenth century and also, in part, of the fourteenth. A characteristic example is the portal of Trogir Cathedral, carved in 1240 by the local master Radovan: architecturally still Lombard Romanesque, the portal is sculpturally already a product of the Gothic view of the world and the new stylistic language.

An approach to the Gothic style was made in the triple-aisled Cistercian church in Kostanjevica on the river Krka in Slovenia, dating from the mid-thirteenth century. With its budding and flowering capitals, clustered columns, and pointed arches, it had already transcended Romanesque massiveness. But in the third quarter of the century, reverberations of the cathedral Gothic of Western Europe, which had reached as far as Santiago de Compostela in Spain, were felt in Slovenia, as is evident in the capitals of the Benedictine abbey in Gornji Grad and in the Church of the Teutonic Order of the Knights of the Cross in Ljubljana, as well as in two reliefs of the Virgin with characteristic sharply broken folds in the draperies, in Solčava and in the Krakovo section of Ljubljana; by the eighties

of the thirteenth century the workshop responsible for these was to wield influence as far as Graz in Austria (the Leech-Kirche). Also in the mid-thirteenth century there emerged, with the Minorite Church in Ptuj, the long choir characteristic of preaching churches, a feature commonly found in monumental parish churches in the cities.

The eastern section of Zagreb Cathedral containing the three choirs was constructed *Pl. 284* between 1263 and 1287, its ground plan, with the adjoining chapel of St. Stephen, having been derived from the Church of St. Urbain in the French town of Troyes. Thus, in the beginning, Croatian Gothic took its inspiration from Western models, as is confirmed by the Cistercian church in Topusko, near Karlovac, which was reconstructed in 1300.

Gothic penetrated more slowly to Dalmatia, where it was initially manifested only in the slender proportions of the bell towers and in some architectural details.

Certain types of structure, having won early acceptance, were to retain a foothold in the interior of the country until the Baroque period. The churches with painted wooden ceilings are a case in point. Such ceilings are found in both Romanesque and Early Gothic monumental architecture (at one time they were a feature of the triple-aisled parish churches in Maribor and Celje). Fine Late Gothic ceilings have been preserved in the Church of St. Peter near Kamnik. In churches in the Mediterranean zone, naves frequently had no ceilings at all, the underside of the roofing being exposed to view.

Bell towers were initially the exception rather than the rule in Gothic structures. In the earlier periods, freestanding belfries modeled on Mediterranean campanili were constructed on the littoral and in the Kranj region. The builders of smaller churches were usually satisfied with tiny wooden steeples on the roof or, in the area under the influence of the littoral and in Dalmatia, with openings for the bells above the facade. But a certain spiritual factor — perhaps pre-Christian — must not be lost sight of: the urge to build churches on hilltops or on slopes, with the result that they strike a dominant note in the Slovenian landscape. Surrounded by walls, they were used as refuges and encampments during the Turkish invasions.

No large-scale building was undertaken in the early fourteenth century; rather, old buildings were reconstructed or completed, castle complexes extended, and townships expanded. Artistic initiative gradually passed from the hands of lay and clerical landowners to the hands of town dwellers. However, in the second half of the century a Central European artistic trend tracing its beginnings to the town of Gmünd in Swabia, and fostered by Peter Parler (1330-1399) and his followers, triumphantly penetrated Slovenia, and perhaps Croatia as well. Around 1380, large stained-glass windows were built into the Lady Chapel attached to the parish church in Celje (Church of St. Daniel); this chapel, with its wealth of carving and figural details, gives evidence of the Parler influence and suggests the existence in Celje of workshops whose master masons traveled as far afield as Pöllau near Graz. In layout the chapel resembles the presbytery of Maribor Cathedral, whereas the west gallery of the parish church in Ptuj (Church of St. George) represents a transition to the group of simpler edifices along the Mura Valley, which probably owe their inspiration to Radgona (Radkersburg, Austria), birthplace of the painter and architect Janez (Johannes) Aquila (fl. c. 1400).

One of the finest Gothic buildings in Yugoslavia, the village church in Ptujska Gora, *Pl. 278, Fig. a* near the town of Ptuj, which dates from about 1400, is a product of the fruitful "autumn of the Middle Ages." Its slender clustered columns support the vaults of three attenuated aisles which terminate in a triple apse. The architecture and carved ornamentation show this to be the work of master masons from the most advanced art center of Central Europe — Prague — whose Cathedral of St. Vitus was constructed by Peter Parler and his associates. The Ptujska Gora church was commissioned jointly by Ptuj nobles and Baron Ulrich Walsee. Even before commencing work on it, the workshop responsible had constructed other buildings in Ptuj; also, in the neighboring township of Hajdina, it had erected the parish

church, with the country's earliest stellar-vaulted presbytery, and with fantastic figural consoles identical with those in Prague. The products of the master masons' workshop functioning in Ptuj in the first half of the fifteenth century (including the Dominican Priory and, in 1415, the baptistery of the parish church) attest that the flame of Central European genius still burned bright.

During the fourteenth century the Slovenian province of Štajerska held the lead artistically. In the fifteenth century, pride of place went to Kranjska, the central region of Slovenia, where the town of Kranj and also Ljubljana, Kamnik, and Škofja Loka were enjoying a rapid economic development. Here the urban ideal of Late Gothic church building *Fig. b* came to maturity, as exemplified by the parish church in Kranj, dating from the fourth decade of the fifteenth century, which in turn inspired the builders of parish churches in Škofja Loka and Radovljica, in Šentrupert in the Dolenjska district, and in Cerknica in the Notranjska district. In the third decade of the fifteenth century, Master Jurko of Škofja Loka added a large, bright, hall-type presbytery to the three gloomy aisles of the church in Crngrob. It is highly probable that this manner of building, which lasted almost a hundred years, was in line with the Parler legacy and with Late Gothic building as practiced by Hans Stettheimer (Stethaimer; c. 1360-1432) and his circle in Bavaria. The abundance of carved keystones and consoles, disposed in keeping with the established iconographic system, attests a link with the stone-dressing tradition of the Karst region. This architectural influence also spread to small provincial churches with stellar-ribbed vaults: monuments in this category are most frequently seen in Gorenjska and Gorica (the church in Podnanos, near Vipava; St. Urh in Tolmin; the "Kamnik group," comprising the Church of St. Primož, near Kamnik, the Church of St. Peter in Begunje, and others). The same architectural approach was taken by Master Mason Andrej of Škofja Loka and is in evidence as far away as Friuli; it also cropped up in Trieste on the coast (Kontovelj) and penetrated as far as central Istria (the parish church in Oprtalj). In central Istria (once attached to Austria), it is associated with the local group of stellar vaults, including the first choir of the parish church constructed in Pazin in 1441. The local Istrian tradition was maintained, alongside the mature Late Gothic style, in the small churches with elongated naves and rectangular choirs covered by pointed vaults, deriving from the Romanesque (Church of St. Catherine in Svetvinčenat). In the Istrian towns on the coast Venetian Gothic also established itself (lower part of the facade of the cathedral in Koper).

As Gothic neared its twilight, a peculiar type of single-aisled church — conceived, however, along hall-church lines — with net vaulting, developed in Štajerska (parish church, St. Lenart, near Maribor). Building in this style was to cease after the appearance of the Renaissance-inspired church, as exemplified by the Church of the Magi in Slovenske Gorice, erected in the mid-sixteenth century.

In Croatia, buildings have fewer features in common. The influence of the Parler school spread there in the early fifteenth century; the southernmost point reached was Za- *Pl. 283* greb, where it is clearly evident in the fantastic animal figures on the windows of the north aisle of the cathedral and in the south portal of the Church of St. Mark, the most richly worked Gothic portal in Yugoslavia, stylistically akin to the portal of the Church of Our Lady of Tyn in Prague. Both churches exhibit a tendency toward organic spatial expansion into a hall. Despite the fact that the archives show that a relative of Parler's had taken up residence in Zagreb, the evidence is that these two churches had no "descendants." The fine architecture of the church in Lepoglava is concealed by later, Baroque additions. But, as is proved by the Church of St. James in Očura, and by churches in Remete, near Zagreb, in Križevci, and elsewhere, the Central European structural conception — with its cruciform plan and stellar and net vaults — prevailed in continental Croatia as well. The Slovenian type of sculptured keystone found echoes in the Medjumurje district (Nedeljišče, St. Martin on the Mura, etc.). In Slavonia the loveliest Gothic churches are the Church of

*c. Apostle. Detail of fresco in presbytery of church in Suha, near Škofja Loka. Latter half of 15th century*

St. Anne in Velike Baštaje (1412) and the church in Vočin, near Virovitica, with its richly wrought portal dating from the end of the fifteenth century.

In Dalmatia, even after the influence of the Gothic forms had made itself apparent in details, the general conception was influenced by the traditions of Mediterranean architecture: cupolas and barrel vaults, plain wall surfaces and severe exteriors. It was for this reason — by virtue of the already underlying tendencies and not simply by virtue of foreign influence — that regional Gothic soon adapted itself to Renaissance formulas. Among the earliest harbingers of the Gothic were the Franciscan and Dominican churches (Trogir, Zadar, and elsewhere), where severity and simplicity were broken only by the application of Gothic details. In the fifteenth century, South Italian forms from Apulia and Ancona frequently predominated in those areas where the Romanesque and the Byzantine still lingered. The Romanesque appearance of the trecento cloister of the Franciscan monastery *Pl. 273* in Dubrovnik, built by Mihoje Brajkov (Miho of Bar), is modified only by the slender proportions of the columns and capitals. As the Republic of Dubrovnik maintained its independence even after Venice had conquered Dalmatia, South Italian influence continued to be felt there in the fifteenth century. The construction of the Rector's Palace, for instance, was, initially supervised by the Neapolitan master Onofrio Giordani de la Cava, who was first and foremost an engineer, while the work itself was executed by local stone carvers. Petar Martinov (Pietro di Martino da Milano) had a hand in the carving of the capitals. But despite the ribbed vaults and Gothic window details, the Rector's Palace is more Renaissance than Gothic, particularly in its later construction, which was entrusted to the Florentine Michelozzo Michelozzi. Gothic also merges with Renaissance in the ambulatory of the Franciscan monastery, which was constructed (after 1456), on the basis of plans provided by Maso di Bartolommeo of Florence, by local masters, among them Djuka Utišenović, Radonja Grubašević, and Tomkuša Vlatković. Apulian models were the determining factor in the reconstruction of the Cathedral on the island of Korčula. *Pl. 288*

Venetian Gothic did not appear in Dalmatia until the first decades of the fifteenth

century, and then with a perceptible regional accent imparted to it largely by local builders.

*Pl. 280* The cathedral in Šibenik, commenced in 1431, turned out to be a veritable school of Dalmatian architecture. The oldest portions — the walls, the north and principal (west) portals, most of the columns marking off the three aisles — give evidence of the proximity of the Venetian workshop of the Dalle Masegne, as its first builders were Venetians (Francesco di Giacomo and, later, Pier Paolo Busato), but the use of earlier Dalmatian models *Pl. 347, 348, 349* cannot be overlooked. The second phase of construction was entrusted to Juraj Dalmatinac of Zadar, the master who brought geniune Venetian Flamboyant Gothic to his homeland. He was in fact more sculptor than builder, and despite his reputation as the last Gothic master in Dalmatia, he made no attempt to resist Renaissance currents. The baptistery of Šibenik Cathedral exhibits truly barbarian audacity and invention in the use of Gothic structural elements although Dalmatinac's approach is in essence hardly Gothic; neither, however, is it Renaissance. In this building the decoration has relegated structural forms to the background.

The secular Gothic architecture of Slovenia and continental Croatia is far inferior to that of the churches, with their wealth of forms. True, in some of the cities the medieval *Fig. d* core of the town is still preserved (Kranj, Radovljica, Škofja Loka, Ptuj), but, for all their Gothic portals, windows, and consoles, the remaining buildings do not transcend the utilitarian. Most of the medieval castles have either been reconstructed, in Renaissance or Baroque style, or have been demolished (Gothic elements are, however, very much in evidence in the castle of Otočec on the river Krka, near Novo Mesto). Town ramparts, too, have survived only in part; the best-preserved examples are along the Istrian seaboard (Piran) and in Dalmatia (Dubrovnik). The same state of partial preservation characterizes the finest Gothic houses, in Piran, Poreč, Trogir (Ćipico Palace), Split, and elsewhere.

Along the Montenegrin coast the Gothic style is by and large confined to architectural details (exceptions are the Italianate Franciscan monasteries in Kotor, Bar, and Ulcinj). This holds also for the Gothic in Bosnia, where the most celebrated Gothic monument is the ruined castle in Jajce, a one-time royal residence, with a fifteenth-century carved stone portal. Only faint traces of Gothic penetrated to Serbia from the seaboard towns, sometimes brought by artists from the coast; in the triumph of Eastern architecture, the expression of Western elements was less than full. It is true that ribbed vaulting may be found here *Pl. 184* and there (Studenica, Djurdjevi Stubovi), but in the monastery church in Gradac on the *Pl. 286* Ibar, for instance, the only Gothic element is the portal, fashioned on the model of Franciscan coastal architecture. However, at least the soaring perpendicular lines of the *Pl. 274* Gothic were reflected in the tall proportions of the Visoki Dečani Monastery and the *Fig. f Chap. VIII* churches belonging to the Morava school of architecture (Lazarica, Kalenić, Ljubostinja) and in the shape of their windows, whose surface relief ornamentation still derived its inspiration from Eastern styles of decoration.

Similar components and constants may be noted in sculpture. The greatest number of Gothic sculptures, and the most closely associated in terms of development, ranging in date from the mid-thirteenth to the sixteenth century, are found in Slovenia. The reliefs of the Virgin in Solčava and Ljubljana (Krakovo) have already been mentioned as exemplifying the style characterized by sharply broken drapery folds. The strong French and Upper Rhenish influence notable in the early fourteenth century is represented by the *Madonna* from Šentpeter, near Celje (c. 1320), whereas the ethereal style of the mid-fourteenth century is represented by the slender *Virgin* from Radlje (National Art Gallery, Ljubljana). Further, the iconographic type of the monumental *Pietà* extended as far as the river Sava (Breg, near Sevnica). But the peak in Slovenia was reached in the architectural and sculpturesque altar in Ptujska Gora, which takes its inspiration from the legacy of Peter Parler and the Prague school of sculpture; there is also an obvious link with the Master of the Beautiful Madonnas (*Schönen Madonnen*), especially with the *Madonna* in

Thorn (Poland). This places the Ptujska Gora sculptors among the major Central European representatives of the international "soft style" dating from the beginning of the fifteenth century; notable among these works with their distinctive iconography is the *Madonna* under whose cloak eighty individually sculptured figures seek refuge. Fine harmony has been attained in three carvings from Velika Nedelja, now in the Regional Museum of Ptuj, approaching in style the Česky Krumlov *Madonna* (Vienna, Kunsthistorisches Museum).

*Pl. 47, 289, 277*

*Pl. 285*

In the fifteenth century the Kranj region began to take the lead in sculpture as well, and here the Mediterranean affinities are by no means obscure. In the third quarter of the century, the Ljubljana sculptors' workshop became distinctive for certain specific features combining the belated idealism of the "soft style" with the realism of the second half of the century and the southern predilection for condensed mass; works from this studio traveled as far afield as Istria (Završje near Oprtalj). Friulian sculpture, which had penetrated to the Gorenjsko district by the middle of the century (*Virgin* in Brdo, near Lukovica), wielded an influence in terms of form even on the local wood carvers, as can be seen in the *Virgin* in Sopotnica, near Škofja Loka, and the *Virgin* in Primskovo, near Kranj, although both are marred by a rustic solidity and linear treatment of folds. A stylistic trend prefiguring Baroque exuberance came to the fore as early as 1440 (*Annunciation* in Ptujska Gora). Genuine Late Gothic naturalism finally prevailed only at the end of the century (*St. Ann* from Radgona, National Art Gallery, Ljubljana), achieving Baroque picturesqueness in the statues after drawings of the Master E. S. turned out in the early sixteenth century by the workshop in Škofja Loka. The unusually productive Carinthian sculptors supplied statues and winged altarpieces for churches in Štajerska, Gorenjsko, and Gorica. The winged altarpiece for the Church of the Holy Cross in Kojsko, in the Gorica area, was produced by a workshop in Villach in 1515.

*Pl. 292*

Local Istrian sculpture was restricted to Cubistic-looking representations of figures, which did not as a rule surpass in quality the work of provincial studios; the seaboard towns were under the influence of the Italian style, as is evidenced by the beautiful sarcophagus of St. Nazariah in Koper Cathedral (c. 1370), combining Venetian and Tuscan elements.

As yet, no large groups of sculpture have been discovered in continental Croatia, and Gothic carvings are rare. Mention has already been made of the Parler-influenced sculptures in Zagreb; for the rest, the carvings originated, in the main, in the late fifteenth century. Figuring most significantly among the altars is a Late Gothic work from Remetinec (Museum of Arts and Crafts, Zagreb) and another in Remete, showing the influence of Pannonian art. In Dalmatia the cultural inheritance is richer, although it is for the most part restricted to architecture.

*Pl. 282*

Here too the carvings in wood took their inspiration from Central European sources and Italian models; all, however, still cling to earlier styles and the characteristic Adriatic geometric forms. This applies to a series of Crucifixions (some from the fourteenth century), seated Madonnas, and statues of saints (Split, Zadar, Trogir, Rab, Dubrovnik). Since all the larger Dalmatian towns boasted their own local stone carvers' workshops, and the islands of Korčula and Brač, with their quarries, had highly developed schools of sculpture, it is natural to find more local than foreign works there; nevertheless, Italian stylistic influence cannot be denied. The relief on the portal of Zadar Cathedral dating from 1324 is a reflection of the Tuscan trend; the sarcophagus of St. John Orsini (Sv. Ivan Ursini) in the chapel of that saint in Trogir Cathedral is reminiscent of the Venetian workshop of Andriolo de Sanctis; and the Šibenik Cathedral portals have, in provincialized form, features calling to mind the circle of the Dalle Masegne. All the evidence suggests that Venetian Gothic established itself in Dalmatia, first in sculpture and then in architecture, even before the Flamboyant style had become prevalent. In Zadar (Church of St. Simeon) there is an isolated but important evidence of Italian influence: the silver shrine of St. Simeon, the work (1380) of Francesco da Sesto, a goldsmith of Milan, and a number of

*Pl. 291*

local masters; it was the gift of Queen Elizabeth (Jelisaveta Kotromanić), consort of the Hungarian king Louis the Great.

The greatly reduced forms of the international "soft style" characterize Orlando's (or Roland's) Pillar in Dubrovnik, the work of Antun Dubrovčanin, erected in 1418 as a symbol of the city's freedom and independence. But the quintessence of mature Gothic is represented by the carvings of Juraj Dalmatinac, whose major achievement in Yugoslavia — although its composition was inspired by the earlier altar of Sv. Dujo completed by

*Pl. 281*  Bonino da Milano (1427) — is the chapel and altar of Sv. Staš (St. Anastasius) in the Cathedral of Split (1448). Under an altar ciborium with triangular fields, the sarcophagus

*Pl. 350*  bears figural decoration that would warrant classifying it as Late Gothic naturalism with a southern cast were it not for the purely Renaissance feeling for volume. In architecture as in sculpture, Juraj's latest works belong to the Renaissance. The fact that Gothic forms persisted in Dalmatia even after the triumph of the Renaissance is confirmed by the portal

*Pl. 290*  of the Franciscan monastery in Dubrovnik, carved in 1499 by Leonard and Petar Petrović; their *Pietà* in its Gothic frame is iconographically a Mediterranean variant of the Central European type.

Among Gothic wood carvings, mention must be made of the sumptuous choir stalls in the parish church in Ptuj (1446) and the Italo-Venetian choir stalls in Poreč, Trogir, Zadar, Hvar, Cres, and elsewhere.

Gothic influences and stylistic elements are among the interesting aspects of the patently autochthonic relief decoration on the *stećci*, the tombstones of the fourteenth and fifteenth centuries that form the subject of Chapter XIII. Found chiefly in Bosnia and Herzegovina, these tombstones are undergoing intensive study, which has not yet led to conclusive results.

In all the Yugoslav regions, medieval painting is best represented by frescoes. Notwithstanding the great icon-painting tradition, this is also true of regions where Byzantine art held sway. Though the painted wall — the pigment-permeated plaster surface decorated with symbolic or narrative content — is first and foremost a Mediterranean product, in coastal Dalmatia alone the advantage is held by paintings on wooden panels. But the richest heritage of Gothic painting is to be found in Slovenia and Istria, provinces whose artistic destinies were frequently bound together, or at least closely related, during the Gothic period. It was precisely in the Gothic period that through the medium of fresco painting the Slovenian and Istrian regions asserted themselves with unusual activity, for the first time in their history achieving mature expression in both style and iconography.

The Early Gothic style with sharply broken folds in the draperies prevailed in the frescoes (c. 1290) of the destroyed Minorite Church in Ptuj, probably owing to the influence of Carinthia. But as early as 1300 it had been replaced by the flat style of the frescoes in Vrzdenac, near Ljubljana; in Crngrob; in Spodnja Muta, near Dravograd; and in Bohinj (Church of St. Janez). However, in the second half of the fourteenth century, Giotto's new style spread to Slovenia, transmitted by painters of the "Friulian trend" belonging to the circle of Vitale da Bologna. About 1400 this group of itinerant artists formulated the Italian variant of the "soft style"; this made its way to Carinthia and southern Štajerska but took root most firmly in Kranjska (Church of the Holy Cross near Selce, Crngrob, Gosteče, Church of St. Janez in Bohinj, Church of St. Mohor near Dolič, etc.). In Prekomurje, Giotto's legacy, enriched by Czech elements, was represented by the school of painters headed by Janez Aquila of Radgona (Turnišče, Martijanci, Velemér on the Hungarian side of the border), whereas in Ptujska Gora, among the frescoes under the choir gallery, commissioned by members of the nobility, the loveliest examples of the "soft style" came from the brush of a painter whose work is highly reminiscent of Master Johannes von Bruneck (Giovanni da Brunico; fl. c. 1420).

Two trends matured concurrently in Slovenia in the fifteenth century. The first might

BISHAFFLACKH
Statt vnd Schloß

Das Schloß

Wildonlock

d. *Škofja Loka, after a copperplate engraving from Johann Weikhard, Freiherr von Valvasor,* Ehre des Herzogthums Crain *("In Praise of the Duchy of Kranj"), Ljubljana, 1689*

be called the Primorsko-Gorenjsko style, continuing along lines laid down by the Friulian masters in the frescoes in Suha near Škofja Loka, Avče, Prilesje and Goljevica near Kanal on the Soča, Bodešće, and elsewhere; it is distinguished by expressive and graphic stylization which had analogies in Istrian painting, in frescoes in Dvigrad and in Oprtalj (Church of St. Mary), and underwent its final decline in Božje Polje. The second trend originated in Carinthia, in the work of a master of the Tyrolean school, Friedrich von Villach, whose son, Janez Ljubljanski (Johannes de Laybaco), after moving to Kranjska, painted in Stična; in Visoko, near Kurešček (1443); in the village of Muljava in Slovenia (1456); and in Kamni Vrh, near Ambrus (1459). A similar stylistic conservatism recalling the "soft style" distinguishes the work of Master Bolfgang in Crngrob (1453) and of a related group from Mače, Krtina, and Podzid, near Trojane.

Pl. 295, Fig. c

Pl. 294

Works typical of these two trends represent the maturing of the classical formulation and iconographic principle of what is known as the "Kranj presbytery," closely associated with the architectural system of the stellar vault: Christ is depicted in the central portion of the vault, surrounded by the symbols of the Evangelists and angels with scrolls; along the walls stand the apostles; the triumphal arch bears the figures of Cain and Abel, or of the Last Judgment, and on the outer side the Annunciation; the north wall of the nave usually bears a large painting of the Adoration of the Magi. The presbytery in Suha is aesthetically the most mature example of the application of this principle. Toward the close of the fifteenth century, even the lyricism of the Slovenian frescoes was invaded by an emphatically realistic mood — partly due to influence from Bavaria (the Church of St. Urh at Tolmin; Jezersko) — which reached its culmination in the frescoes in Križna Gora, near Škofja Loka (1502); by contrast the frescoes in the Church of St. Primož near Kamnik, dating from

Pl. 364

1504, imbued with a revived idealism, opened the door to the Renaissance. Noteworthy among the rare panel paintings are the *Christ on the Mount of Olives*, in the Wolgemut style, in the Church of St. Michael in Čadram (1485), the Cologne-inspired Kranj altarpiece (c. 1510, Österreichische Galerie, Vienna), and a mid-fifteenth-century altarpiece by the Salzburg painter Konrad Laib, presented to Ptuj by the Archbishop of Salzburg.

It is virtually impossible to define the boundaries of the activity of the Istrian group of fresco painters, whose work may be found in areas as far off as central Slovenia (Senično, near Tržič). Even in the mid-fourteenth century, echoes of Giotto's work reached Istria (Rakotule) through masters schooled in Italy, while explicitly Venetian stylistic features are to be found in Paz in the frescoes of Master Albert (1461). However, a local variant of the Venetian style was not long in appearing (Lindar, 1409); enriched above all by the characteristic South Tyrolean spirit, inspired by the frescoes in the presbytery of the parish church in Pazin (mid-fifteenth century), it took shape as an unusually original style created by the circle of painters around Vincent of Kastav, in the frescoes in the Church of St.

*Pl. 293, 296* Mary at Škriline, near Beram (1474), and those of his follower Ivan of Kastav in the church of Hrastovlje, near Koper (1490). Working with cartoons based on North Italian models and embodying Mediterranean linearity, the artists of the Kastav school, in the two fresco cycles mentioned above and in the paintings in the parish church of Lovran, proved them-selves the most impressive exemplars of the local genius. The greatest fascination attaches

*Pl. 39* to the two fine compositions of *The Dance of Death*, one in Beram, the other in Hrastovlje. It goes without saying that powerful Northern stylistic impulses also penetrated to Istria (Žminj). But with the works of Anton of Padove in Draguć began the transition of Istrian medieval painting to a folk-art version of the Renaissance, in the same way as Gothic painting in Slovenia died out with the frescoes of Jernej of Loka and Tomaž of Senj, and by 1530 had acquired the character of folk decoration.

Continental Croatia was able to salvage a very few Gothic paintings from the flames of destruction that swept over it recurrently throughout its turbulent history. Those works, though influenced by Central European models, remained stylistically isolated (Martinščina, in the Hrvatsko Zagorje, fifteenth century; Očura, near Krapina, beginning of the fifteenth century; Kalnik, near Križevci, end of the fourteenth and beginning of the sixteenth century; etc.). But while all these frescoes are popular in character, those of the mid-fourteenth century are distinguished by their quality: for instance, the paintings in St.

*Pl. 278* Stephen's Chapel in the Archbishop's Palace in Zagreb, offering evidence of Italian influences, from Rimini and Siena.

Up to the thirties of the fifteenth century Dalmatia remained stylistically bound to Italian painting, particularly Venetian and Tuscan, with Byzantine overtones, although the influence of Serbia is also discernible. Most of the pictures were painted on wooden panels; some of them were imported from Italy and others were the work of local masters. It is obvious that they were influenced by Michele Giambono, Paolo Veneziano, and other Venetians. A fertile synthesis of the gravity of the Byzantine icons with the charming grace of the Italian Gothic was achieved by Master Blaž Trogiranin (Blaise of Trogir), who is

*Pl. 279* mentioned in chronicles between 1412 and 1448 (polyptych in Trogir Cathedral). The principal representative of the Venetian trend was Djivan Ugrinović, a painter of Dubrovnik (polyptych in Koločep). But the major Dalmatian masters soon began to tend toward the

*Pl. 358* Renaissance style; this is true, for instance, of Lovro Dobričević, a master of Kotor and Dubrovnik, who showed an affinity for Antonio Vivarini. Among the real "Gothics" — albeit with a Dalmatian accent — is Matko Junčić, who also came to Dubrovnik from Kotor.

In Serbia a hint of the Gothic was discernible in painting, but the style found fuller expression in the artistic crafts. Doubtless many ornamental products of gold- and silversmiths were imported to Serbian regions from foreign parts, but others may be attrib-uted to local artificers, particularly in the areas where silver was mined.

277

277 *Detail of relief of the Madonna of Mercy above the high altar of the church in Ptujska Gora (Plate 289). Early 15th century*

278

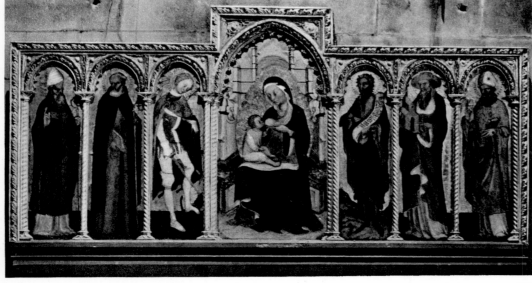

279

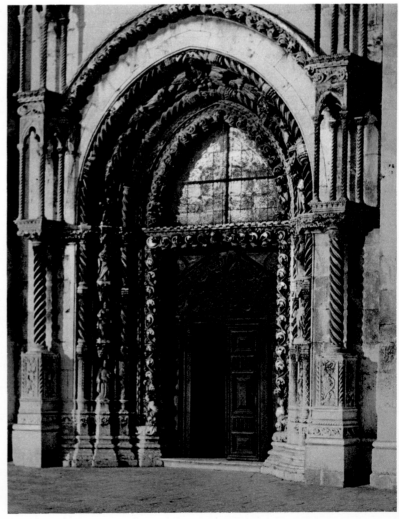

280

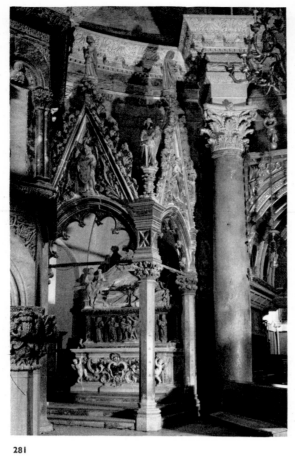

281

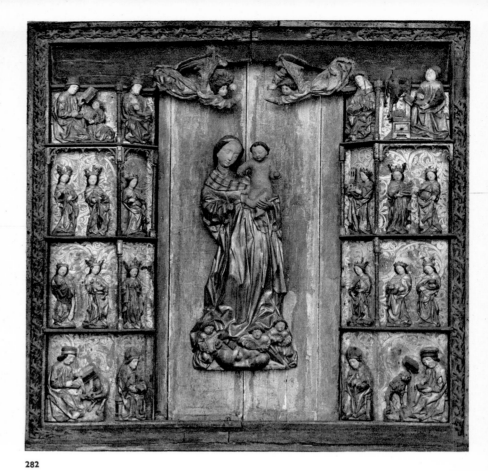

282

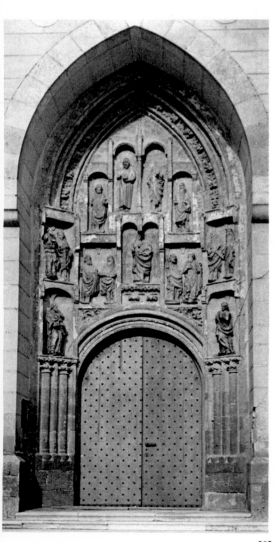

283

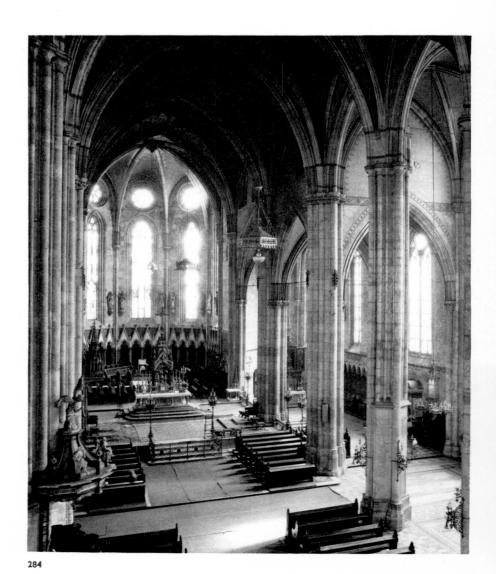

284

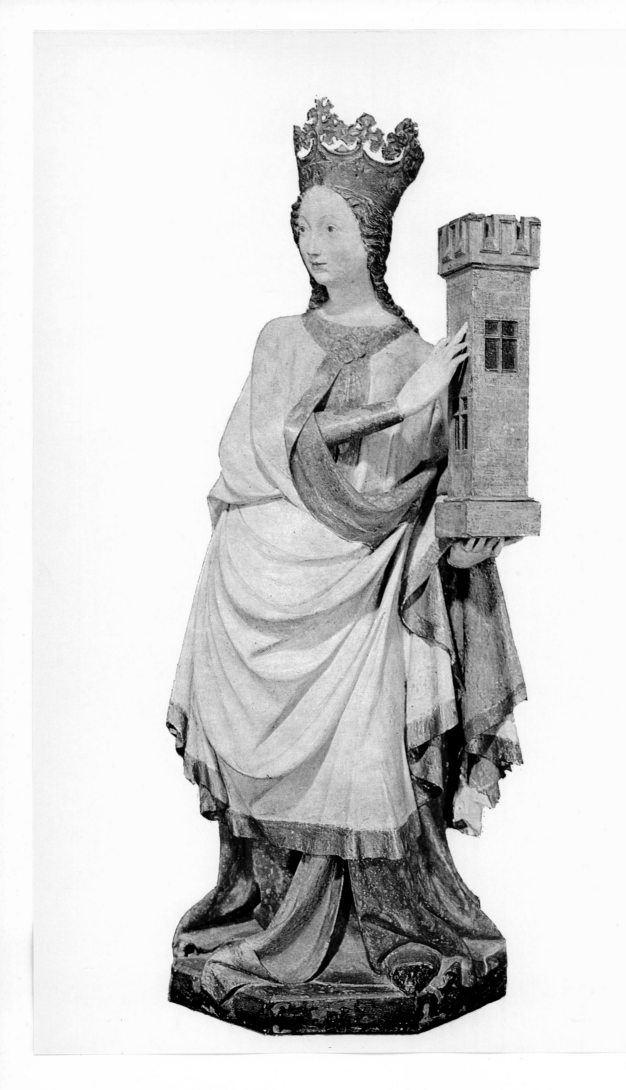

285

286

285 *St. Barbara, from the chapel of the castle in Velika Nedelja. Beginning of 15th century. Regional Museum, Ptuj*

286 *West portal of monastery church in Gradac, near Raška. End of 13th century*

287 *Interior of the church in Ptujska Gora. c. 1400*

288 *Facade of Cathedral of St. Mark, Korčula. 15th-16th century*

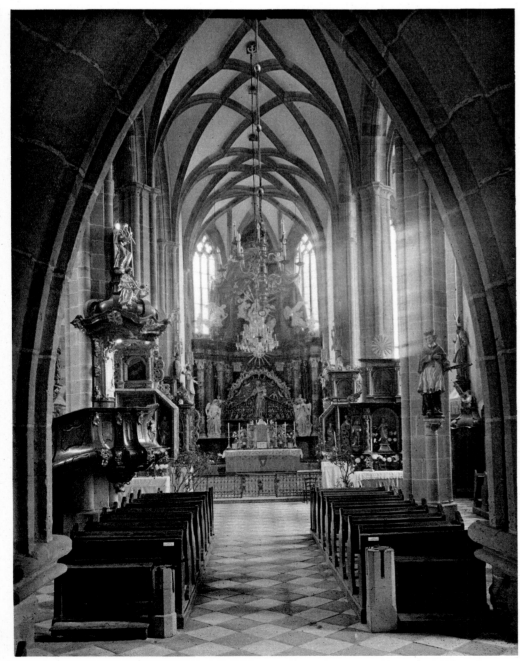

287

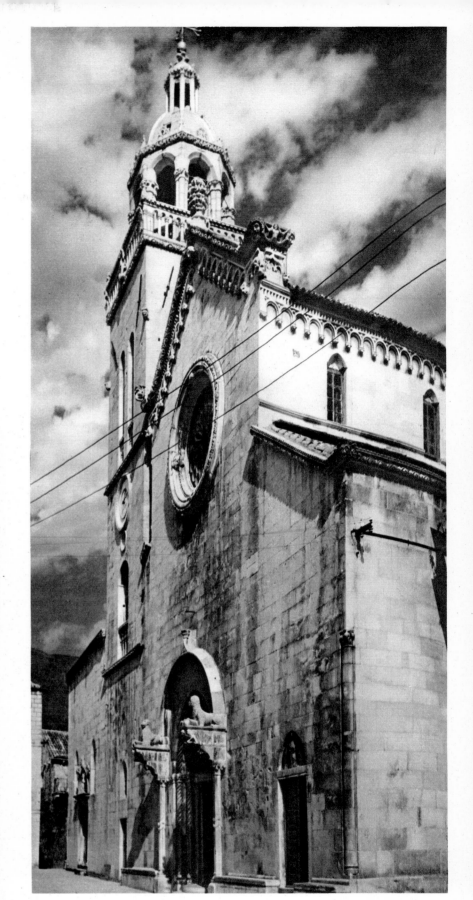

288

273

289

290

289 *Madonna of Mercy. Relief above the high altar, Ptujska Gora. Early 15th century*

290 *LEONARD and PETAR PETROVIĆ. Tympanum of portal, Franciscan Church, Dubrovnik. 1499*

291 *FRANCESCO DA SESTO and ASSOCIATES. Silver shrine of St. Simeon, Church of St. Simeon, Zadar. 1380*

292 *Winged altarpiece. Church of the Holy Cross, Kojsko. 1515 (crucifix modern)*

293 *VINCENT OF KASTAV. Cavalcade of the Magi. Detail of fresco, St. Mary on Škriline, Beram. 1474*

294 *JANEZ LJUBLJANSKI. St. Nicholas Rescuing Three Innocents Condemned to Death. Detail of fresco in the church in Visoko, near Kurešček. 1443*

295 *Two apostles, detail of fresco, church presbytery, Suha. Latter half of 15th century*

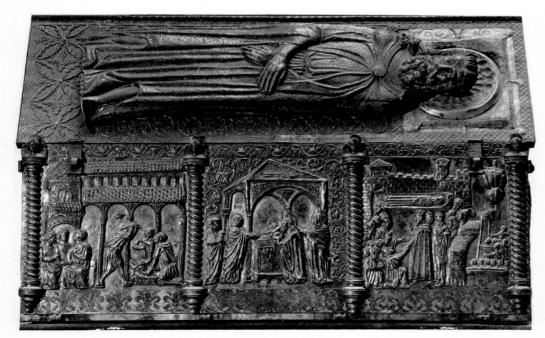

291    292

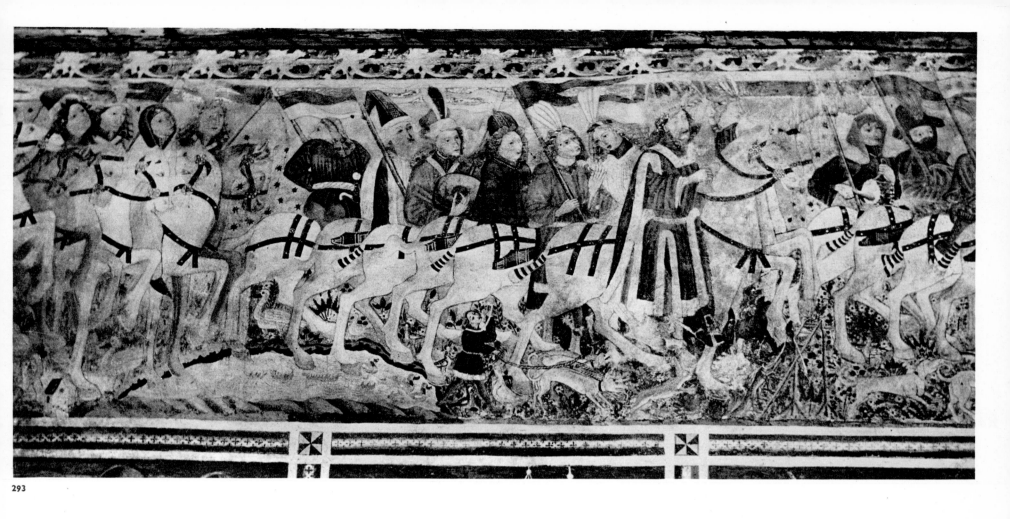

293

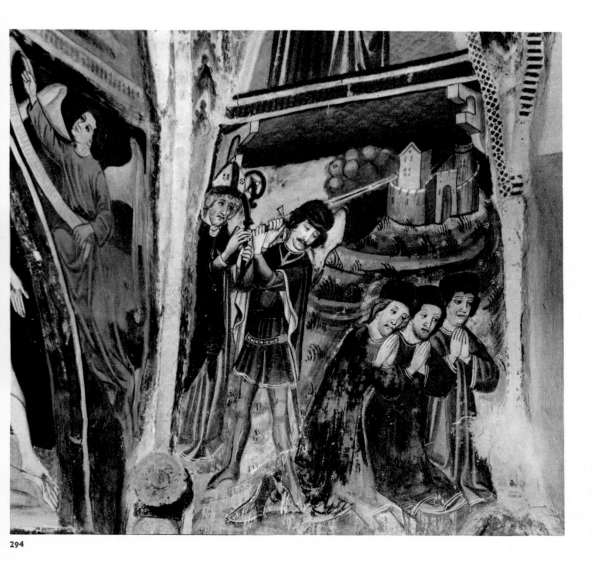

294

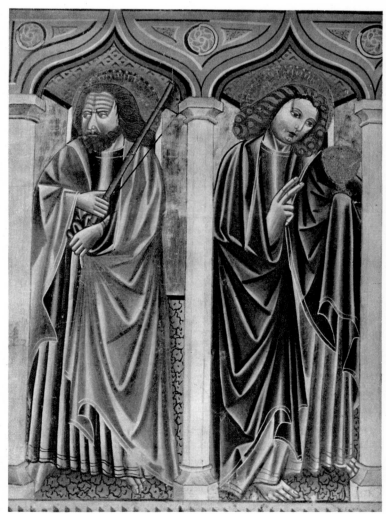

295

275

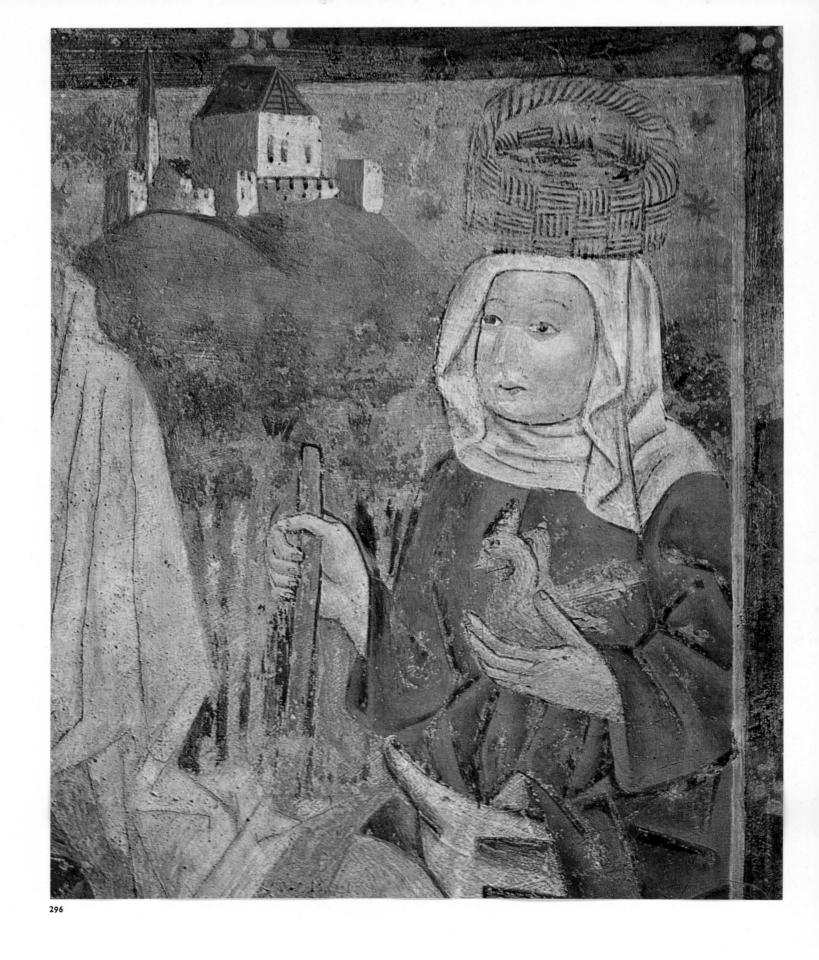

296

*296 Vincent of Kastav. Detail of fresco* The Flight
into Egypt, *St. Mary on Škriline, Beram. 1474*

# XIII MEDIEVAL TOMBSTONES (STEĆCI)

Alojz Benac

*Professor of Archaeology, University of Sarajevo*

# NECROPOLISES WITH STEĆCI

| | | |
|---|---|---|
| *1 Tekija* | *10 Radmilovića Dubrave* | *19 Knežpolje* |
| *2 Srpski Sopotnik* | *11 Brotnjice* | *20 Barevište* |
| *3 Banjevići* | *12 Ubosko* | *21 Mokro* |
| *4 Radeljevac* | *13 Premilovo Polje* | *22 Borje* |
| *5 Opravdići* | *14 Radimlja* | *23 Ledinac* |
| *6 Hrnčići* | *15 Hodovo* | *24 Posušje* |
| *7 Križevići* | *16 Boljuni* | *25 Ravanjska Vrata* |
| *8 Mesići* | *17 Žijemlje Polje* | *26 Gornja Glavica* |
| *9 Bašići* | *18 Gošića Han* | |

The medieval Bosnian state has left no legacy of monumental works of art comparable to the frescoes in Serbia and Macedonia and the wealth of stone decoration on churches and monasteries along the Adriatic coast. This means not that such works never existed in Bosnia but that what there was has, under the pressures of a turbulent history, vanished forever from the treasury of cultural tradition. The most recent research, in the ruins of the medieval town of Bobovac (central Bosnia), reveals that an artistic style worthy of comparison with the finest that Western Europe had to offer at that time was fostered in at least the major political centers of the Bosnian state. But even in a city of kings such as Bobovac once was, only modest remains of the artistic output in architecture and wall painting have been found.

However, the medieval Bosnian state, whose area included the region of Herzegovina, has left tangible proof of the existence of another, highly original kind of art, which though not on a par in terms of monumentality with the art of other countries surpasses many great works in immediacy and suggestiveness. This is the art of the memorial tombstones known as *stećci*. It must be stated at the outset that such tombstones are not found only in Bosnia and Herzegovina; they are now known to be scattered throughout Montenegro, the Sandžak, western Serbia, Dalmatia, the Lika, and Slavonia. But as they are most numerous and exhibit the greatest variety in Bosnia and Herzegovina, this region is considered their place of origin.

The *stećci* have been the subject of research for a century. At first they aroused only wonder; later, as material about them was gathered, various historical interpretations were put forward; after that, the results of research began to be systematized and subjected to scientific examination. We might therefore be led to expect that by this time all the findings had been analyzed and that no further problems remained to be solved in this particular sphere of the history of art. Such is not the case, however. What has been achieved thus far is that the territory over which these monuments are scattered has been defined with considerable accuracy, a typological picture has been worked out in terms of the forms and decoration involved, several monographs have been written about various necropolises or groups of necropolises, and a number of theses, frequently at odds with one another, have been proposed. In broad terms this outlines the most recent steps in the study of these tombstones, the result of research completed in the past two decades. But the problem of how the tombstones originally came into being has not been solved definitively, nor has a conclusive explanation of the relief sculpture that constitutes their ornamentation been arrived at. It is clear that the problem is a complex one and that many particulars await clarification. Experts in many fields have turned their attention to the *stećci*: archaeologists, historians, art historians, ethnologists, folklorists, and specialists in other spheres of research. Judging from the number of works written on the subject and the

*a. Huntsman wearing a horned cap.
Decorative motif on a tombstone (stećak)*

considerable bibliography that has been amassed, these studies have perhaps already engendered a new branch of knowledge. Within this context, the material presented here must be regarded as informative rather than conclusive.

Herzegovina and eastern Bosnia have the greatest concentration of necropolises with *stećci*; next in order of importance are southwest Bosnia, the Imotska Krajina, the territory of ancient Montenegro, the Sandžak, and Dalmatia. Areas with only a scattering of the tombstones are of little significance for the purposes of this survey. It was in the first two regions mentioned that the two principal schools of decoration emerged; *stećci* in the remaining areas either take their cue from these or introduce into the same basic system of ornamentation certain original elements of their own.

*Pl. 298, 311, 305, 307, 309*
In form the tombstones range from ordinary slabs to enormous crosses. Within this range the following are included: slabs (or tablets), caskets, tall caskets, gabled sarcophagi, upright tablets, obelisks, and crosses.

*Pl. 301, 316*
Particularly characteristic of Herzegovina are sarcophagi and tall caskets, but tablets are also found in considerable numbers. The dimensions of the monuments are frequently surprisingly large, which is certainly attributable to the abundance of stone in Herze-
*Pl. 312, 314*
govina. In eastern Bosnia many of the memorial stones are shaped like sarcophagi, but their dimensions are smaller and their form somewhat elongated. Most typical of Bosnia are the upright forms: standing slabs, prism shapes, and tall obelisks. In contrast to Herzegovina, Bosnia has no cross-shaped monuments.

In each of the remaining regions one or another form prevails, depending on the influences reaching it from the central areas. In the large-scale necropolises, irrespective of region, there is one general rule that applies: the taller monuments are situated in the center of the burial grounds and the lower and smaller tombstones are ranged around them. Plainly, the central section of the necropolis was reserved for the tribal dignitaries and clan elders, and their graves were marked in the most conspicuous manner.

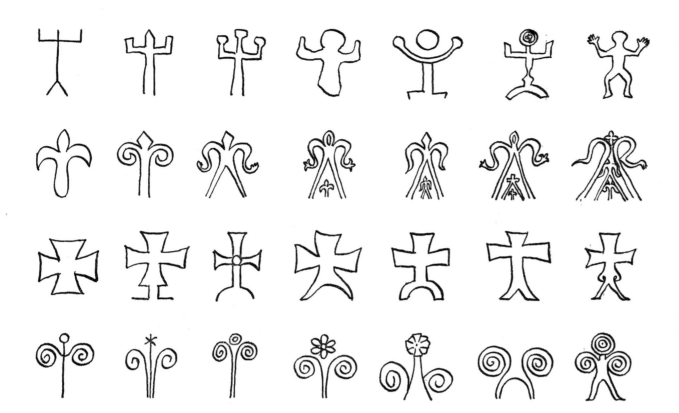

*b. Evolution of four linear decorative motifs commonly found on tombstones* (stećci)

The placing of such heavy stones on the graves had a double purpose: to make the burials of the deceased secure and to make them distinctive. This is essentially an old, indeed primeval, custom, which was practiced in all parts of the world but acquired an original aspect in this region of the Balkans.

Inscriptions on the tombstones indicate the designations — *bilig* (mark, sign), *lieto* (bed), *kuća* (house) — that are applied to monuments of this type. The last term is particularly interesting, since it expresses a specific spiritual concept. In the endeavor to indicate, through the form, that the grave is really a home, the medieval artist frequently fashioned it in the shape of a house; the very lines of the gabled sarcophagus, with its sloping top, inevitably call forth such associations. But this is not all. In working out his details the master carver, apparently aiming to dispel any doubt as to what was involved in the house-shaped sarcophagus, used such devices as accentuating the eaves of the roof, stressing the roof ridge, carving the gable ends, and depicting arcades in relief along the perpendicular sides. Some of these columns in the arcades have a base and a capital, others are schematic; others again are totally stylized. With time the arcade became a decorative motif, and this explains its appearance in stylized form even on the cross- or other-shaped stone having no connection with a house; presumably the motif itself became the symbol for a house. Naturally, the custom of including the arcade motif obtained in areas which felt the influence of the Herzegovinian school as well as in rockbound Herzegovina.

In eastern Bosnia, a wooded region, the same symbolic effect was achieved by somewhat different means. There emphasis was laid on the representation of wooden shingles on the roof, wooden beams on the upright sides, and so on. An excellent example is a gabled sarcophagus-shaped *stećak* on whose sides perpendicular logs, arranged in close order, were simulated to suggest a mountain hut. This seems to be the clearest imitation of a house among these monuments. Of greater importance in classifying the artistic and other aspects of the tombstones is the ornamentation, however. Usually in bas-relief (high relief

*Pl. 305*

*Pl. 316*

*Pl. 314*

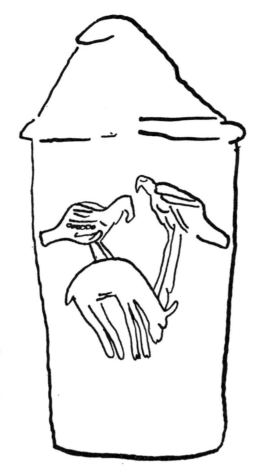

*c. Birds attacking a fawn. Decorative motif on a tombstone* (stećak)

*d.* Stećak *decoration featuring anthropomorphous cross*

being exceptional), on one side of the monument, it appears most often on the gabled sarcophagi and on coffer- and pillar-shaped stones.

As has been said, the two principal artistic schools that have been posited on detailed analysis of the decorative motifs on the tombstones are the Herzegovinian and the East Bosnian. These will be treated separately.

In addition to the architectural ornaments described above as belonging to Herzegovina, the following are found on the tombstones: hunting scenes, reel dances, knightly scenes, individual human figures, family scenes, individual animal figures, fantastic animals, feudal insignia, symbolic representations, and purely decorative motifs such as the spiral.

*Pl. 43, Fig. a, c*

*Pl. 297, 298, 299, 301*

*Pl. 304, 306, Fig. g*

*Fig. f, Pl. 307*

The first seven may be classified as figural decoration, and they represent the fundamental expression of this school. Variations are numerous. The hunting scenes, for instance, include hunters on horseback and on foot, with dogs and with falcons, individually and in groups, with spears and with arrows. Most frequent is the deer hunt; more rarely the boar or some other animal is being pursued. The reel dance usually includes both male and female figures. The leader of the dance may be astride a horse or a deer but more often he is one of the many participants. The positions in which the dancers' hands and arms are held vary. In sum, there are endless variations of each of these motifs.

*Fig. d*

The sword and the shield are the feudal insignia most frequently seen on the Herzegovinian tombstones. Other categories of weapons are less common. Certain combinations of these motifs may be interpreted as representing the coats-of-arms of nobles. The cross, the sun disk, and the crescent moon are among the favorite symbolic ornaments; there is hardly a necropolis in Herzegovina that does not show at least one of these.

*Decorative motifs found on* Stećci

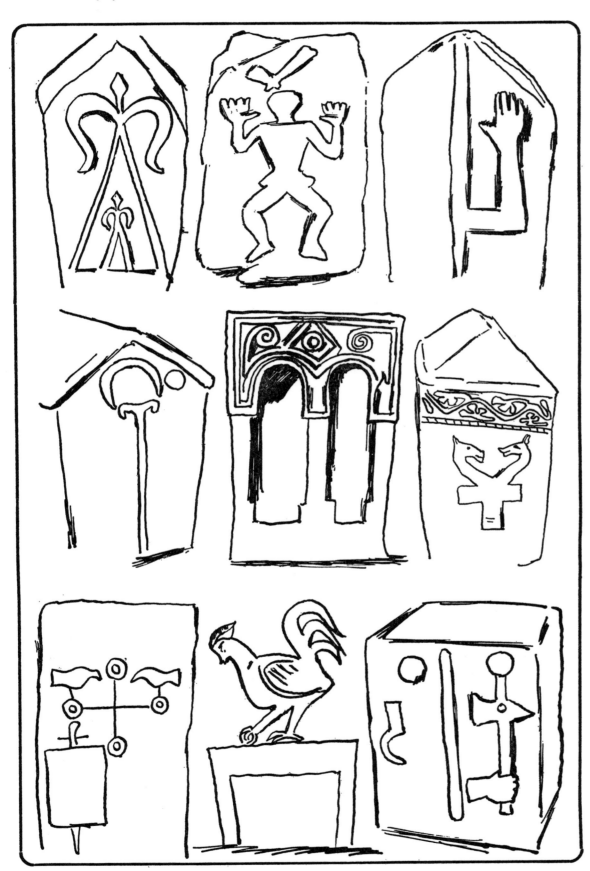

*Left to right: stylized human figures; man with upraised hands; symbolic raised hand*

*Left to right: grandfather's stick, crescent moon, and sun; decorated arcade; cross combined with animal heads*

*Left to right: cross with birds and sword with shield; cock; symbolic motifs including hand wielding battle-ax*

*Pl. 309, 310, 311*   The monuments of eastern Bosnia are distinguished primarily by floral motifs; here the Herzegovinian figural representations have no counterparts, a few portraits of the de-*Pl. 302*   ceased comprising virtually the entire inventory of figural ornaments of the east Bosnian school. Second in order of importance are the numerous spiral ornaments, simple but*Pl. 308*   striking. Whereas in Herzegovina the spirals were often combined with grape clusters or crosses, here they are largely independent motifs. Eastern Bosnia was not entirely without its feudal motifs, but we find the bent arm with long sword or spear repeated over and over again, in place of the more varied repertory of Herzegovina. The East Bosnian school might be said to be considerably more modest than the Herzegovinian, although productive of many original ideas.

In other districts the influence of the Herzegovinian school is felt more strongly than that of the East Bosnian. Variants of the lily motif, used with great frequency in southwestern Bosnia, give the monuments of this area more individuality than some of the others, although they cannot compete with those of the two principal schools.

Inscriptions occur on almost three hundred monuments, most of them in Herzegovina, which probably boasted the ablest practitioners of the technique of stone engraving. The inscriptions are in an old Cyrillic script known as *bosančica* (Bosnian script) and usually offer data about the deceased or about the master mason. Some of the inscriptions mention historical events or moralize on life and death. At the beginning of many of the inscriptions a cross is carved, probably to indicate the religious affiliation of the deceased.

The following are typical inscriptions from tombstones, with their locations:

*Here lies Jerina Ivković.* Boljuni, Herzegovina

*This stone was carved by Boško Semunović.* Hutovo, Herzegovina

*Here lies Vuk, son of Duke Obrad, with his sister Jela, under the stone laid by his mother Ana. A plague and a curse on those who touch me.* Podgradinje, Herzegovina

*e. Figure leading two horses, with crescent moon above. Decorative motif on a* stećak

*f.* Stećak *decorative motif of arm attacking wild beast with sword*

*g. Knight with mount. Decorative motif on a* stećak

In addition to the names of masters who fashioned and decorated these unique monuments, the names of scribes, or writers of inscriptions, are found. The most famous stonecutters were Grubač, Miogost, Radič, and Pribil Bjelopčelanin. Outstanding among the writers of inscriptions were Semorad, Bolašin Bogačić, and Radoje. As the stonecutters and the authors of the inscriptions are mentioned separately, it appears that these two crafts were practiced by different groups of persons. It is most probable that the scribes, who may have been attached to courts or church communities in the Bosnian state, composed and wrote out the inscriptions, which were then incised by the stonecutters. There would seem to be no other explanation for the frequent occurrence of clumsy letters and mistakes in spelling.

The dating of the *stećci* is based on the information contained in inscriptions, on the type of military costumes and weapons depicted, and on certain other decorative details. The data collected so far seem to indicate that the tablet form of tombstone predominated between the end of the twelfth and the middle of the fourteenth century. This was no doubt true throughout Europe and cannot be considered a peculiarity of the region in question. It was only in the mid-fourteenth century that the other forms — which essentially are the monuments properly known as *stećci* — began to come into use. This has led to the theory that the overwhelming majority of the larger decorated tombstones belong to the fourteenth and fifteenth centuries, in other words to the advanced Middle Ages in this region. At present it is difficult to determine the extent to which such tombstones were used after Bosnia and Herzegovina fell to Ottoman rule. According to one segment of opinion, for some time after the invasion, groups of the Christian inhabitants of the occupied areas maintained the traditions of the local tombstone art. Unquestionably this is a possibility.

The most recent statistics indicate that there are about fifty thousand *stećci* still *in situ.* It is safe to say that at least double that number once existed, for in the course of time not only individual tombstones but entire necropolises have been destroyed. Most

of the present burial grounds are situated on suitable elevations, and their locations are clues to the topography of medieval settlements. In some cases these burial grounds supply the only documentation we have of the population of the region during the period under consideration.

Many questions as to the origin and interpretation of the memorial stones remain unanswered. There is a variety of opinion on the subject, and it may be a long time before a wholly satisfactory interpretation is reached. Folk ideas about the tombstones are extremely simple. Among the local peasant population there are two ways of referring to a necropolis containing such tombstones — as a "Greek" cemetery or as a "marriage party" cemetery. The interpretation implied in the first designation is the broader one, since it attributes the memorials to another people, a people having no ethnic link to the Slav inhabitants of the region. In the second designation the ethnic thread remains, but there is an allusion to legend, the tombstones being supposed to be those of rival wedding guests who, in the dim past, fought each other to the death. There is no firm tradition linking the present population with the medieval master masons of the tombstones; the chain of tradition was probably broken during the period of Turkish rule of Bosnia and Herzegovina.

During the Austro-Hungarian occupation there was a growing body of opinion supporting the theory that the tombstones were part of the spiritual legacy of the Bogomil heresy. Certainly the simplest explanation, this was the thesis of Franjo Rački, and it was widely accepted. It was also supported by Sir Arthur Evans and Johann Asboth; a similar view was held by Ćiro Truhelka and certain other researchers during this period.

Between the two world wars other scholars, principally historians, advanced other ideas about the origin of the tombstones. Thus Vaso Glušac maintained that these memorials originated among the Orthodox population of Bosnia and Herzegovina, since many of them are clustered around or are located in the immediate vicinity of Orthodox churches. Jaroslav Šidak categorically rejected the idea of any connection between the tombstones and Bogomil teaching, contending that the determining role in the emergence of the art of the tombstones was played by ancient conceptions of the afterlife, the primeval cult of the dead, and later influences emanating from the culturally more developed neighboring areas. It is true that later Šidak abandoned his own earlier thesis about the Bogomil creed and teachings, but his thinking along these lines at the time exercised a powerful influence on subsequent research and initiated many serious discussions. Finally, mention must be made of Vladislav Skarić, who submitted that the sarcophagus tombstones were in fact stone imitations of wooden huts such as the early Slavs had placed over the graves of the dead in their native Carpathians.

Since World War II, the most consistent advocate of the theory attributing the origin of the tombstones to the Bogomils has been Aleksandar Solovjev. He has elaborated his thesis with systematic thoroughness in a number of papers, making exhaustive use of the material at his disposal. Solovjev asserts that the decorative motifs on the tombstones can only be Bogomil; explaining certain motifs as deriving from the spiritual concepts of the Bosnian heretics, he has created a unified picture of a heretical Bosnian art.

Solovjev's theory has been challenged by a number of present-day investigators into the problem of the tombstones, some — among them M. Vego, D. Sergejevski, A. Benac, Š. Bešlagić, D. Vidović, and N. Miletić — hailing from the area itself, and others —among them S. Radojčić and M. Wenzel — coming from other regions. They have collected new factual material that appears to undermine the thesis claiming exclusive Bogomil origin for the tombstones.

In the first place, it has been established that the greater number of necropolises containing *stećci* are situated near the ruins of medieval churches, evidence of an organic link between the churches and the funerary monuments. If these tombstones were ranged around Christian churches, it is fairly certain that the deceased were also Christians.

But since the churches were certainly not places of worship for the Bogomil heretics, who, according to Western sources, scorned churches, it must be concluded that at least the necropolises around such churches were not Bogomil. A further serious challenge to the Bogomil hypothesis is that the latest data show that the most ubiquitous ornament on the tombstone was the cross.

A number of scholars have directed their investigations toward the search for wider parallels. Among the noteworthy developments along these lines is S. Radojčić's endeavor to demonstrate a correspondence between the figural representations on the tombstones and certain motifs on medieval tapestries and other decorated objects in Western and Central Europe. Taking another tack, M. Wenzel has devoted much effort to exploring the deeper meanings of the individual motifs on the tombstones; the results of her research do not tally with the Bogomil thesis put forward by Solovjev. Bosnian researchers are also endeavoring to prove that a link existed between the art of the tombstones and the artistic folk crafts of more recent times in wood and textiles; they, too, have turned their attention to a fresher and more thorough investigation of historical sources.

On the whole, the thesis is taking shape, and winning wide acceptance, that the tombstones were a nationwide phenomenon of the medieval Bosnian state, that they were certainly utilized by the entire population (at least in the central areas, where they are found) and cannot therefore be associated exclusively with any single religious community. The region over which they are scattered coincides, by and large, with the territory encompassed at one time or another by the Bosnian state. There is consequently no denying that Bosnian influence was of decisive importance. No other claim can be put forward for the present.

The question of the Bogomil heresy, that is, of the Bogomil creed, is a special problem in itself and cannot be solved by this approach. Once a solution is found to the puzzle of the Bogomils in Bosnia, an investigation into the relation of Bogomil teachings to the ornamentation of the tombstones can be undertaken. Until then no one can assert that such a relation did not exist within a certain chronological, territorial, and stylistic framework. But the elements entering into that relation cannot yet be determined because of the controversy over the nature of the Bosnian church and its heresy.

As the study of the tombstones has now been largely divorced from the narrower problem of the Bogomil heresy, investigation at this stage is focused on defining the cultural components making up the entire mosaic of art work on the tombstones. In the final analysis, this is the direction that is most likely to lead to the conclusive solution, which has so far been sought in vain. The mosaic certainly had among its components ancient Slav beliefs, the beliefs of other ethnic groups, local cultural traditions, influences from culturally more developed neighboring areas, Christian and perhaps heretic symbols, and so on. It remains to be established how these elements are linked together, the conditions under which they were brought into association, and how they came into general use in the territory over which the *stećci* are scattered.

At first glance the art work on the tombstones appears rustic and naive, but this is only a superficial impression. After more careful observation these works emerge as the product of an inspired ambience, sometimes tending toward the epic, producing its own artistic style in a highly original manner. And originality of this order is hard to find even in many culturally far more advanced environments in Europe.

*Note. The drawings in this chapter are after M. Wenzel,* Ukrasni Motivi na Stećcima, *Sarajevo, 1965.*

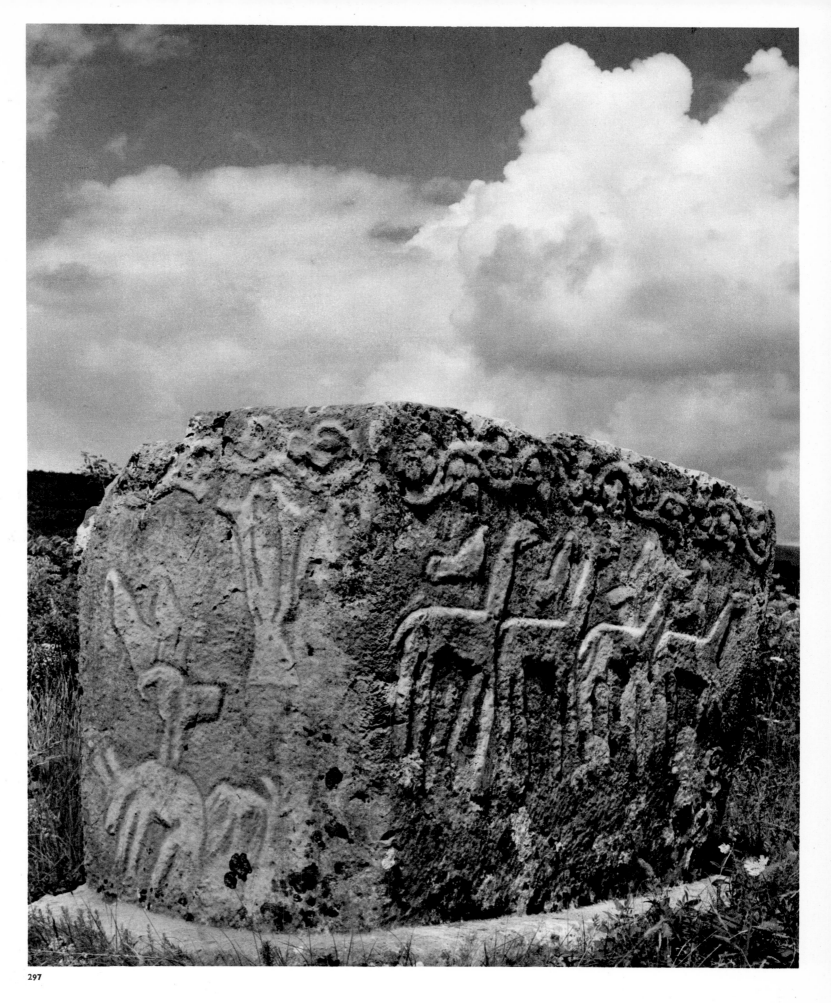

297

297 Tombstone (stećak) *with deer and bird motifs in relief. Necropolis in Ubosko, near Stolac, eastern Herzegovina*

298

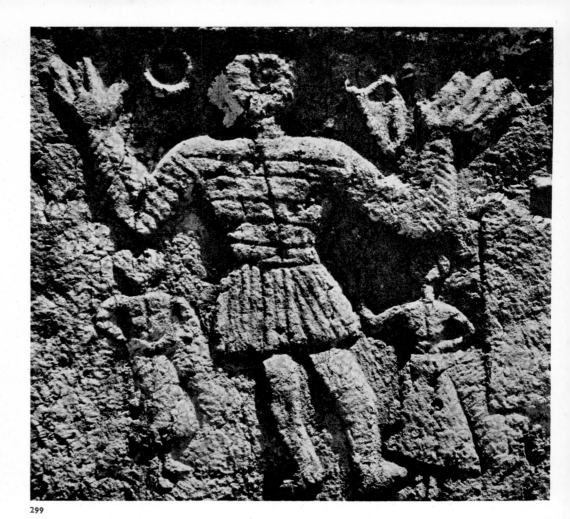

299

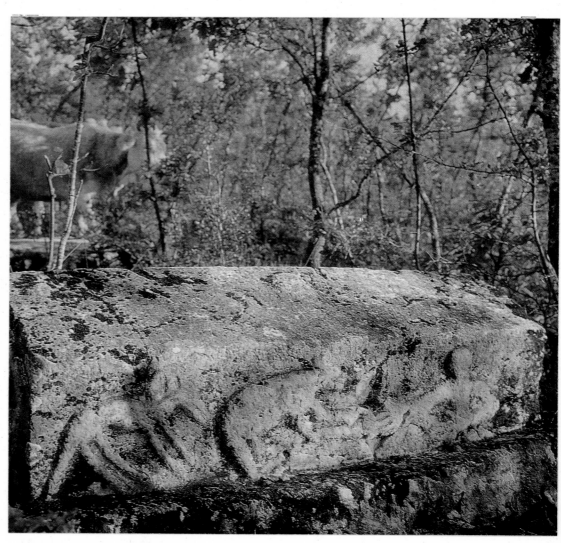

298 Tombstones (stećci) in the necropolis in Radimlja, near Stolac, eastern Herzegovina

299 Relief depicting the deceased with his children. Detail of tombstone (stećak) shown in Plate 43. Necropolis in Radimlja, near Stolac, eastern Herzegovina

300 Tombstone (stećak) in gabled-sarcophagus form with relief of hunting scene. Stjenice, near Rogatica, Bosnia

301 Tombstones (stećci) in the necropolis in Radimlja, near Stolac, eastern Herzegovina

302 Tombstone (stećak) with relief depicting the deceased with arms crossed. Necropolis in Banjevići, eastern Bosnia

303 Figure with raised arms. Detail of tombstone (stećak) in Bukovik, near Arandjelovac, Serbia

300

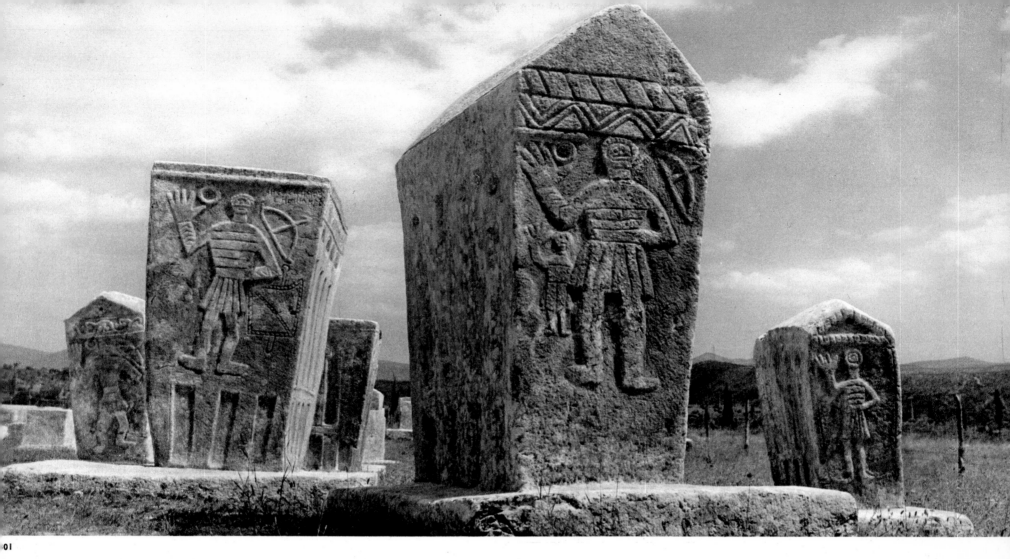

301

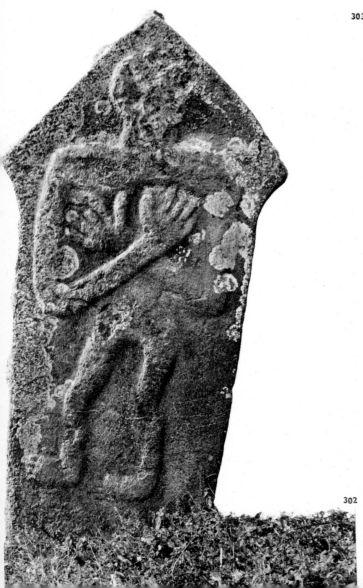

302

303

304

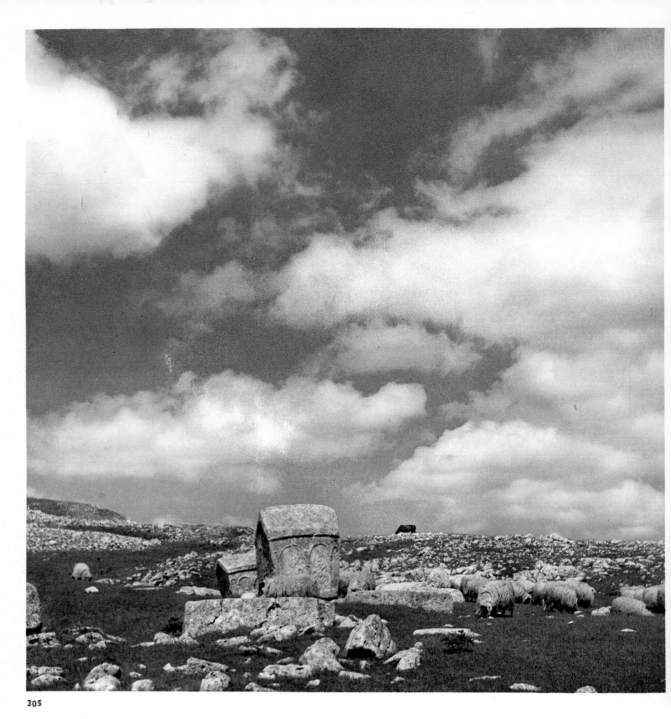

305

306

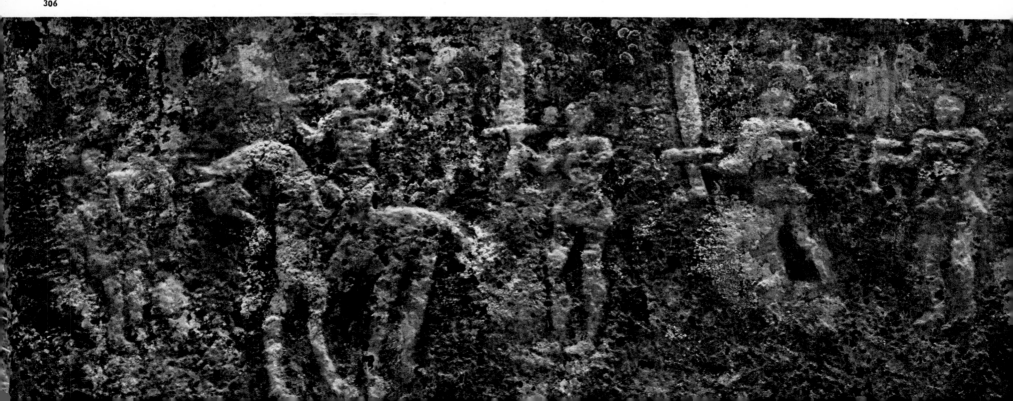

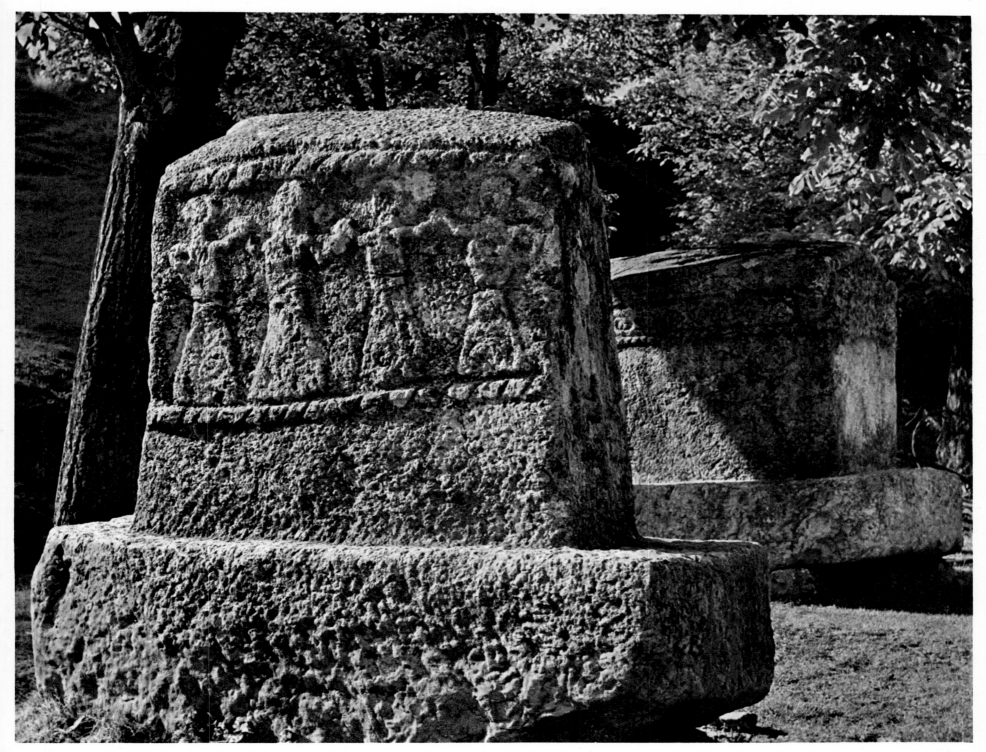

307

304 *Warrior on horseback. Detail of relief on tomb-*
*stone* (stećak) *in the necropolis in Radmilovića*
*Dubrave, near Bileća, eastern Herzegovina*

305 *View of the necropolis in Ravanjska Vrata,*
*southwestern Bosnia*

306 *Procession of knights. Relief on tombstone* (stećak)
*in the necropolis in Ubosko, near Stolac, eastern*
*Herzegovina*

307 *Section of the necropolis in Gošića Han, near*
*Konjic, Herzegovina*

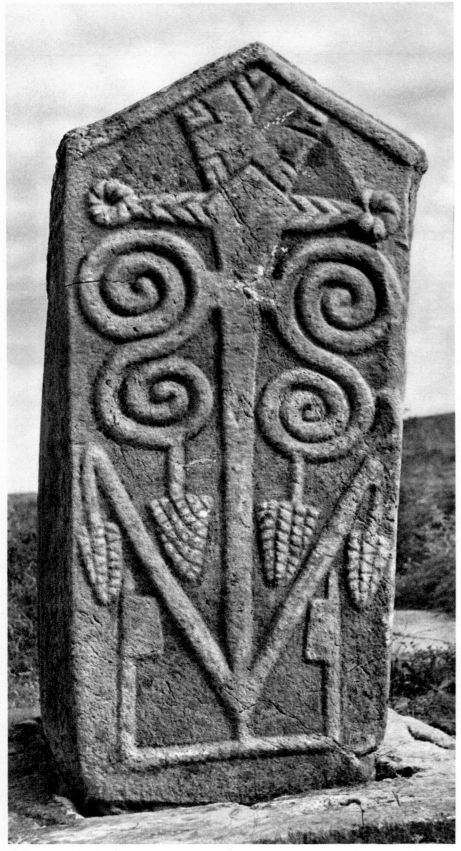

308

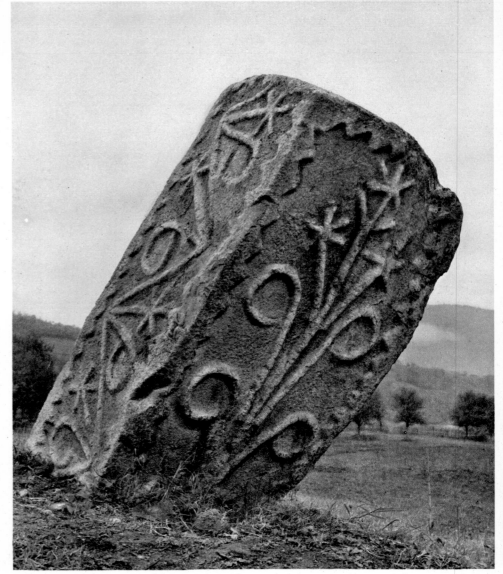

309

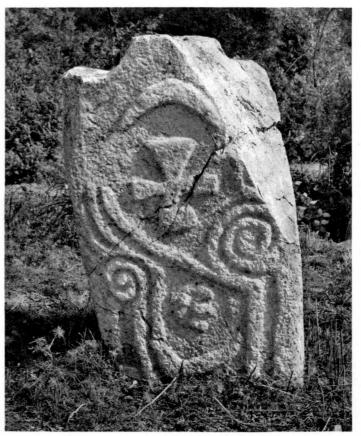

310

308 *Tombstone (stećak) with cross motif. Necropolis in Radimlja, near Stolac, eastern Herzegovina*

309 *Tombstone (stećak) with floral decoration. Necropolis in Srpski Sopotnik, near Srebrenica, eastern Bosnia*

310 *Tombstone (stećak) with symbolic motifs. Necropolis in Hrnčići, near Srebrenica, eastern Bosnia*

311 Tombstone (stećak) *with lily motif. Necropolis in Ravanjska Vrata, southwestern Bosnia*

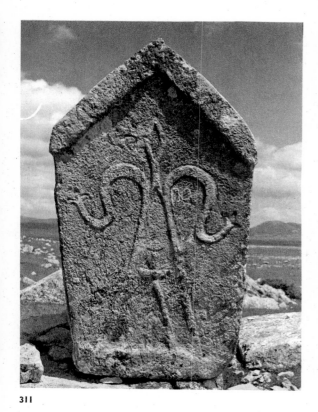

311

312

312 Sarcophagus-shaped tombstones (stećci) *in the necropolis in Mesići, near Rogatica, Bosnia*

313 Tombstone (stećak) *with linear motifs. Necropolis in Hrnčići, near Srebrenica, eastern Bosnia*

314 Sarcophagus-shaped tombstone (stećak) *with spiral ornaments and shingle motif on the gabled top. Necropolis in Križevići, eastern Bosnia*

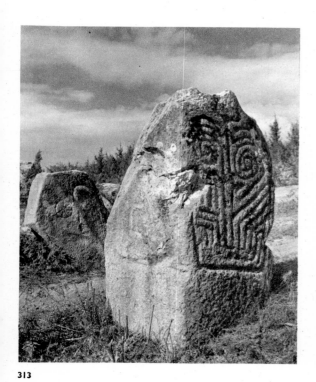

313

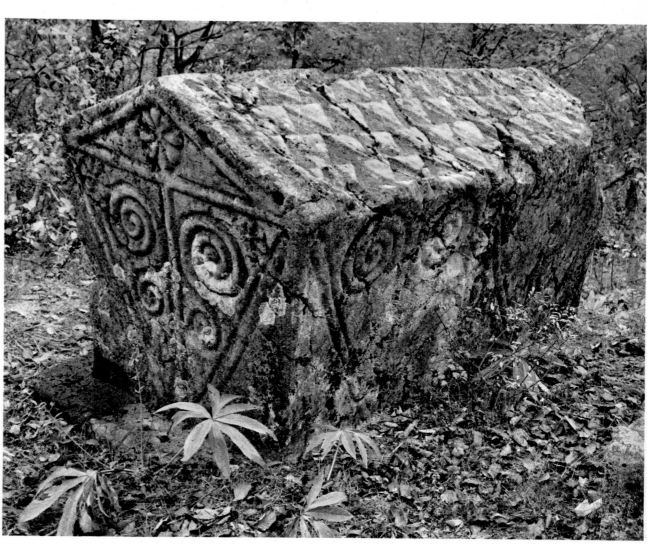

314

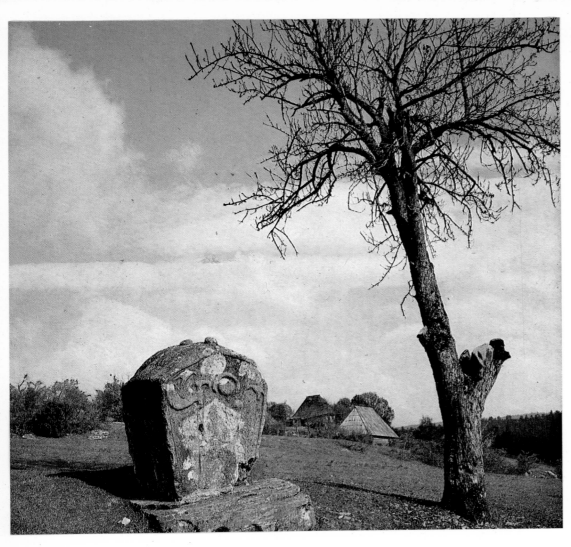

315

315 Tombstone (stećak) *in the Baština area, near Skender-Vakuf, Bosnia*

316 Tombstones (stećci) *in the form of sarcophagi and caskets. Necropolis in Radmilovića Dubrave, eastern Herzegovina*

316

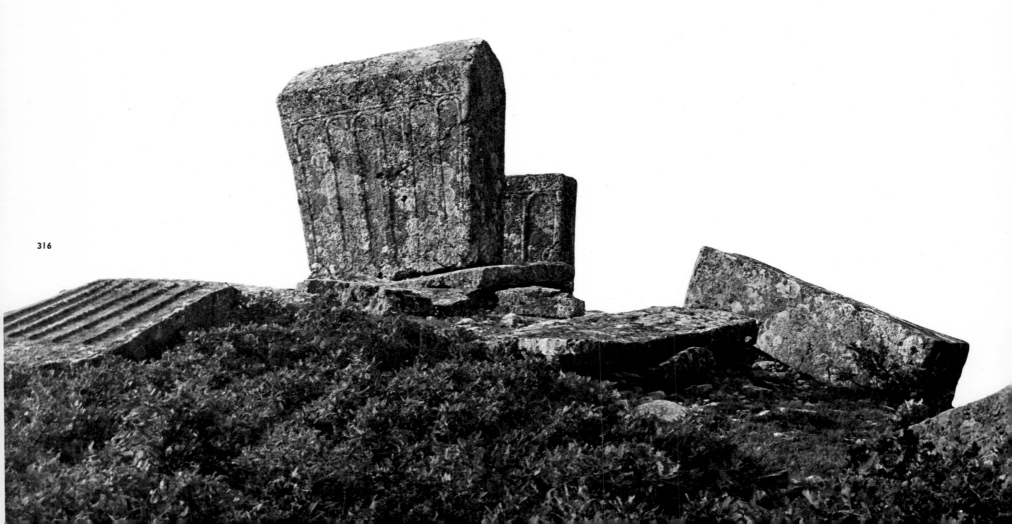

# XIV  ISLAMIC ARCHITECTURE AND DECORATIVE ART

## Husref Redžić

*Professor of the History of Architecture, University of Sarajevo*

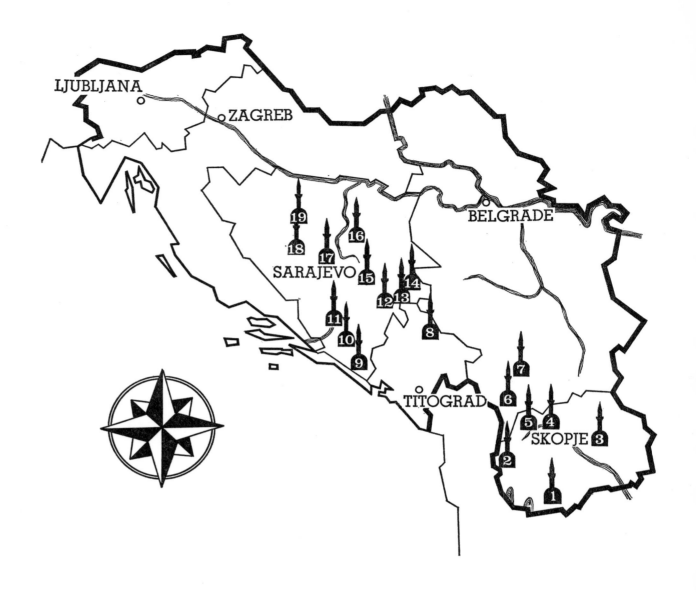

# ISLAMIC MONUMENTS

1  Bitola. Mosque of Haydar Kadi, 1562; bezistan
   (covered market)
2  Bridge over the Radika River between Debar and
   Mavrovi Hanovi
3  Štip. Bezistan
4  Skopje. Mosques: Sultan Murad II, 1436; Ghazi
   Ishak Bey, 1438; Ghazi Isa Bey, 1475; Mustafa
   Pasha, 1492; Burmali (Karlozade), 1495; Daud
   Pasha Hammam (baths), 1484; Turbeh (mauso-
   leum); šadrvan (ceremonial fountain); bridges
5  Tetovo. Colored Mosque, 1495
6  Prizren. Mosque of Sinan Pasha, early 17th
   century
7  Priština. Mosque of Sultan Muhammad Fatih,
   1461
8  Pljevlja. Mosque of Husain Pasha, 1590
9  Trebinje. Arslanagić Bridge

10  Počitelj. Mosque of Hadži Alija, 1563
11  Mostar. Mosques: Karagoz Bey, 1557; Koski
    Mehmed Pasha, 1612; šadrvan; bridge over the
    Neretva River
12  Foča. Aladža Mosque, 1550
13  Čajniče. Mosque of Sinan Bey, 1570; turbeh,
    šadrvan
14  Višegrad. Bridge over the Drina River
15  Sarajevo. Mosques: Čekrekči, 1526; Ghazi Husref
    Bey, 1530; Ali Pasha, 1561; Ferhad Bey, 1562;
    Imperial (Careva), 1565. Turbehs: Ghazi Husref
    Bey and Ghazi Murad Bey, 16th century
16  Maglaj. Mosque of Yusuf Pasha, 1560
17  Travnik. Yeni Mosque, 1549; turbehs
18  Jajce. Mosque of Esma Sultan, with šadrvan
19  Banja Luka. Mosques: Ferhad Pasha, 1583;
    Defterdar, 1594; turbehs

One of every ten inhabitants of Yugoslavia has ties with Islamic culture and civilization as a result of his lineage or his upbringing, or both; the purely religious aspects of this relation are little in evidence compared with the complex spiritual pattern in which every individual is involved. In those parts of Yugoslavia where there is a large Muslim population the influence of Islamic culture on the non-Islamic environment is unmistakable; this is particularly true in the urban areas of the former pashalics of Bosnia.

In Yugoslav towns where the architecture and the decorative design of articles of everyday use bear the stamp of Muslim art, these continue, even today, to affect the molding of taste, the relation between people and the surroundings in which they live and work, people's conceptions of the beautiful, and attitudes toward art generally.

Thus in the broad spectrum of cultural influences in Yugoslavia the influence of Islamic culture is not inconsiderable. The historical fact that a section of the nation adopted and developed this culture makes it a part of the heritage of all the Yugoslav peoples.

Most of the builders of the monumental edifices of the classical period of Islamic art in Yugoslavia (sixteenth century) were Ottoman architects; they certainly drew up the plans and probably also had a hand in the construction. Since most of the work was anonymous, individual identification is difficult, even in the case of the master builders who were at the top of their profession. We do, however, have information about two local master builders, Nedjar Hadji Ibrahim and Koja Mimar Sinan, who lived in Sarajevo in the sixteenth century and left two small mosques as personal memorials.

The largest contribution to the specific features of Yugoslav towns dating back to Ottoman times was made by the carpenters — exclusively local men — with their work on the actual building of dwelling houses, madrasahs (Muslim religious schools), khans (or caravansaries, rest houses for merchants and travelers), shops, warehouses, and small mosques. Even the churches built by the carpenters of those days contain a number of Islamic stylistic elements.

Today we are in a position to reconstruct the appearance of the fortified towns and outposts of pre-Turkish Yugoslavia. Descriptions that we have of the settlements of Turkish times by travel writers of various nationalities reveal that in the fifteenth and sixteenth centuries these settlements underwent a radical change in appearance, receiving an Eastern, or rather Ottoman, stamp.

*Pl. 320*

In Turkish times, then — except for the Christian section of the community, which continued, by and large, to construct its sacred buildings in earlier styles because it had an enduring architectural tradition — settlements began to be built on the new principle of division into a center for crafts and commerce (the čaršija, or bazaar) and residential quarters (mahalla). This came about because in pre-Turkish times there had been no true urbanized settlements to speak of.

The new urban dwelling house introduced by the Ottoman Turks was a highly developed type in comparison with the existing rural wooden cottage. This accounts for the change in the methods of building towns and small settlements, and of constructing residential, public, and crafts-and-commerce buildings, not only in the regions constituting present-day Yugoslavia but in all the Balkan countries conquered by the Turks.

In all Islamic countries, including those forming part of the Ottoman Empire, architecture was the most highly developed branch of art. The palaces of the rulers and, especially, the institution known as wakf (whereby followers of Islam were required to invest personal wealth in projects useful to the community) were the prime stimuli to building activity, in the religious and in the public and economic spheres as well. Ecclesiastical organizations such as those in Christian countries, where the Church was in the forefront in advancing monumental architecture, find no parallel in Islam. In Muslim countries the wakf assumed this role.

The principal features of Ottoman Muslim architecture are the dwelling houses and the monumental domed religious and public buildings.

The origins of Turkish domestic architecture go back to the yurt, the tent of the nomads, and reflect the nomadic temper. A man does not build a house for posterity; who can tell where the morrow may take him? Some of the attitudes of the wandering herdsmen persisted, and that is why houses were built of light materials. Only the ground floors, with their small openings for doors and windows, were built of stone; the actual living quarters, on the floor above, were built of timber faced with unbaked brick or boards bonded with mortar. This type of wall, though relatively light, was still much firmer than the tent wall made of hide.

A lightly constructed open staircase of wood, with all the emphasis on the exterior, led to a sort of open combination sitting room and smoking room (divanhana) which was overhung with climbing vines. Generally, rooms had low timber ceilings with decoration composed of arrangements of thin laths of wood, usually geometrical, rarely floral. The overall impression was rich although the materials were modest. The floor was carpeted, except for the center of the room. In the daytime the family had their meals together at a low table; at night they slept on beds laid out on the carpet. During the day the bedding

was kept in built-in wooden cupboards, with carved doors, occupying one wall of the room. Like the cupboard doors, the wooden walls were carved, floral motifs and pointed arches predominating in their decoration. Under a row of lattice windows, there was a low wall bench with a padded seat and cushions. A low door in the wall led to a small bath with a tiled stove and earthenware pots; in the houses of the wealthy every room had such an adjoining bath.

Balconies overhanging the ground floor projected from the rooms, but these were not built to extend the floor space. Utilitarian function was here secondary to the expression of the human yearning to overcome the force of gravity, to be air-borne, as it were. Even the projecting eaves were not purely utilitarian; their purpose was to establish between the main body of the roof and the upper story a relation similar to that between the projecting upper story and the ground floor.

Houses were clearly designed as a tripartite entity: the stone ground floor, the lightly built upper story, with its rows of windows and open divanhana, and the roof, with its four sloping planes whose pitch and material were determined by climatic conditions.

The style of domestic architecture that the Ottomans introduced into parts of Yugoslavia underwent changes in the course of the centuries. Originally the house and garden and the wall around them were a long way from the street. The house, built around the garden, was thus sheltered from the inquisitive gaze of passersby. Gradually, houses were built nearer and nearer to the wall; by the nineteenth century the balconies were actually *Pl. 333, 334* overhanging the street, which meant that the residents, sitting on their window seats, could watch the bustle below from the privacy afforded by the lattice windows.

The more imposing feudal residences had two courtyards, one for men and one for women. Anyone could enter the men's courtyard; opening on it were the guest rooms, the servants' quarters, and the stables. The women's courtyard, which had a well or drinking fountain and was planted with flowers and shrubs, was reserved for members of the family. A low wall separated it from the large garden.

In its fulfillment of domestic and utilitarian requirements, and in the beauty of its proportions, this type of house is an example of a fully worked out, mature architecture.

The Christian population adapted the Islamic type of house to their own socioeconomic circumstances and their own customs and religious practices. Their houses had rather small plots around them; even where they were constructed, as frequently happened, on irregular ground, they followed the same basic principles, functional and dimensional, and precisely because of the handicaps imposed by topography they assumed extremely picturesque forms. Thus the Christian multi-storied houses on their cramped sites along the shores of Lake Ohrid, like the houses in the Christian "Podkaljaja" settlement in Prizren, with their more elaborate features and greater freedom of design, owe their charm to the unevenness of the terrain.

*Pl. 326*

The Islamic feudal mansion in Yugoslavia is typified by, among others, the house of Jusuf Ćata in Ohrid; Havzi Pasha's konaks in Bardovci, near Skopje (nineteenth century); Hakki Pasha's konak in Tetovo (nineteenth century); Svrzo's house in Sarajevo (seventeenth century); Djerdjelez's house in Sarajevo (eighteenth century); Selmanović's konak in Pljevlja.

It may safely be said, of the small urban dwelling house and the feudal mansion alike, that the main impression of the interior as a whole is that the governing concept is an explicit concern for human well-being; it is emphasized in the general functionalism and in the specific dimensions, which permit everything in the house to be, as it were, within easy reach. The dwelling house had a certain influence on the architecture of the keeps of the landowners and military leaders, particularly in respect to the wattle-and-daub top story, and on the architecture of the tekke (dervish monastery), the madrasah, the khan, and the country cottage.

The domed building that originated in the Seljuk period (eleventh and twelfth centuries) is a cube-shaped stone structure. The principal exterior feature is the door, lightly incised in a pattern comprising a profusion of floral motifs. It is as though the builder was attempting to translate into stone the Turkish nomadic tent, whose entrance was covered by an ornately patterned carpet. In the architecture of the mosque, the madrasah, the bezistan (covered market, or arcade), and the hammam (public baths), this tent-inspired concept remained the basic formula of the Ottoman, as it had been earlier of the Seljuk, architect.

The most important predecessor of the single-celled mosque so frequently seen in Yugoslavia was the Seljuk type of single-celled domed mosque with multi-domed arcade along the front, which appeared in various beylics, or principalities, after the downfall of the united Seljuk-Anatolian empire (c. 1300).

The multi-chambered domed building of Yugoslavia also traces its origins to the Seljuk mosque, specifically the so-called Great Mosque (Ulu Cami) in Bursa (Anatolia), the first Ottoman capital. The Ulu Cami, which is covered with several domes, all of the same size, served as a model for numerous public buildings — caravansaries, covered markets, public baths, and madrasahs.

In the course of the dynamic development of their empire during the fifteenth and sixteenth centuries the Ottomans elaborated these inherited types of monumental Muslim architecture; concurrently, the Byzantine domed building, particularly Hagia Sophia in Constantinople, exercised a definite, if limited, influence. The "soaring," or "hanging," Byzantine dome, mounted on four freestanding piers, which can be seen in Hagia Sophia and other great foundations of Justinian, had its effect on the structural conception behind the great Constantinopolitan mosques. The combination of domes and semidomes and the space gained by this means can undoubtedly be traced to Byzantine models.

But the Byzantine influence on the shape of the great monumental spaces of Ottoman buildings was restricted to constructional matters. In the approach to space there were marked divergences. Common to Byzantine and Ottoman building is the rejection of any tectonic division of the structure enclosing the given space; yet the ways by which this rejection was arrived at, and the space forms themselves, are completely different. The

*c. Inscription on bridge spanning the Drina at Višegrad, built by Sinan for the vizier Mehmed Pasha Sokolović. 1577*

differences become apparent when the spatial relations of Hagia Sophia and the great mosques of Constantinople are compared or, in Yugoslavia, when any single-celled domed mosque is compared with a medieval Byzantine church.

It was Bursa that produced the early Ottoman artistic style, and buildings erected between 1299 and 1453 are classified as being in the Bursa style. Buildings erected in the latter half of the fifteenth and the beginning of the sixteenth century belong to the early Constantinopolitan style, the finest examples of which date from the reign of Muhammad II, the Conqueror (1451-81). Building in the first part of the reign of Sultan Bayazid II (1481-1512) was in the early Constantinopolitan style, which lasted until 1506, when the Mosque of Bayazid II in Constantinople, by the architect Khair al-Din, marking the beginning of the classical style of Ottoman architecture, was completed. Khair al-Din and his school were the predecessors of the greatest of all Ottoman architects, Sinan, who held the office of chief imperial architect from 1539 to 1588, and whose work shows the widest range of building in the classical Ottoman style.

In Yugoslavia two fine examples of the Bursa style have been preserved: the Mosque of Sultan Murad II (1436) and the Mosque of Ghazi Ishak Bey (1438), both in Skopje. The first, a triple-aisled basilica with quadripartite roof, has a flat timbered ceiling; the second is a multi-aisled mosque with dome and vaults.

The domed structure is a rejection of tectonic principle. Here stereotomy reaches its perfection. Space seems to have been hewed out of stone and rendered altogether tranquil. The forces operative in the structure are nowhere felt. The sense of space creates a feeling of perfect peace, of isolation from the outside world, an effect intensified by the almost complete absence of decoration. This austerity and striving to create a structure in which the accent is on serenity can be said to be the main characteristic of the Bursa style, which found its finest expression in the Yesil Cami (Green Mosque) in Bursa. The two mosques in Skopje mentioned above, although spatially entirely different from the Yesil Cami, embody the essential concept of this style.

Although architects working in the Bursa style took over the Byzantine method of building in alternate layers of stone and brick, the technique never became predominant.

*d. Capital in porch of Mosque of Ferhad Pasha,
Banja Luka. 1583*

In the early Constantinopolitan style a whole series of new stone-and-brick combinations were applied to the building of mosques, caravansaries, covered markets (bezistans), madrasahs, and mansions.

All the earlier types of mosques continued to be built during the period of the early Constantinopolitan style and a new, broader-fronted type with a semidome extending the dome-covered area appeared. The predominant type of mosque in this style was one with side aisles, a domed portico, and an elongated prayer hall surmounted by two equal-sized domes or one dome and a semidome.

In the early Constantinopolitan style, which is the expression of a clearly defined effort to create vast open interiors, a slight tendency toward tectonic articulation is beginning to be felt. The decoration is still austere. The stalactites, the tiled facings, the painted floral and geometrical designs are completely subordinated to the function of the structure. All the architectural decoration remains as it was in the Bursa style.

The outstanding examples of the early Constantinopolitan style in Yugoslavia are to be found in Macedonia and in the Kosovo region in southwest Serbia. They are the Mosque of Sultan Muhammad Fatih in Priština (1461) and the Mosque of Ghazi Isa Bey in Skopje (1475), the Colored Mosque in Tetovo (1495), the Mosque of Mustafa Pasha in Skopje (1492), and the Burmali Mosque in Skopje (1495). The Daud Pasha Hammam in Skopje (1484) belongs to the same style of monumental public building.

*Pl. 327, 328*
*Pl. 318*
*Pl. 323*

In the Mosque of Ghazi Isa Bey and the Burmali Mosque in Skopje, and in the Colored Mosque in Tetovo, the prayer hall is laid out longitudinally. In the Mosque of Isa Bey it consists of two rectangular areas covered by domes of equal size, forming an elongated space. The model for this building was the somewhat earlier Mosque of Mahmud Pasha in Constantinople (1463).

The Mosque of Fatih in Priština has a rectangular prayer hall covered by a dome more than 44 feet in diameter. Erected just eight years after the conquest of Constantinople, and nine years before the Mosque of Fatih in Constantinople was built, it is a clear sign of the aspiration of Ottoman architects to enclose a vast space under a single dome. At the time of its building this was the largest dome in Yugoslavia.

The Mosque of Mustafa Pasha in Skopje is of the same type and marks a continuance of the same tendency. Its dome has a span of 53 1/2 feet; compared with contemporaneous building, even in Constantinople, this represents a great feat of construction. Its portico of white marble with columns, arches, ornate doorway and front wall is the best example in Yugoslavia of an approach embodying all the architectural elements of the early Constantinopolitan style.

The great Daud Pasha Hammam, in the ornate Byzantine mode, with monumental interior embellished by stalactite decoration, is among the finest public buildings in the early Constantinopolitan style.

The beginning of the classical Ottoman style in Constantinople came, as has been said, with the building of the Mosque of Sultan Bayazid II in 1506 by the architect Khair al-Din. If the interior of the Yesil Cami in Bursa (1421) symbolized total exclusion of the outside world and serene harmony of constructional forces, the original structure of the Mosque of Muhammad II, the Conqueror, in Constantinople (1463-69) was beginning to show the signs of constructional articulation and an emphasis on tectonic factors, and the structure of the Mosque of Sultan Bayazid II carried this tendency a stage further.

The several occupants of the post of chief architect of the empire following the death of Khair al-Din introduced nothing new into the development of Ottoman architecture. The appointment of Sinan to the post in 1539 marked the beginning of a new advance. The influence of the school of Sinan was felt in all the imperial provinces not only in the second half of the sixteenth century but also throughout the seventeenth century.

The classical Ottoman period is characterized by harmony — by felicitous proportions of architectural mass, surface, and line. Although tectonic articulation is nowhere so pronounced as, for example, in the domed interiors of the Italian Renaissance, all the principal elements of the classical Ottoman monumental building are plastically or chromatically differentiated and slightly accentuated. Pier, column, arch, squinch, pendentive — all these features are individualized and articulated with an exceptional sense of proportion; they divide and blend at one and the same time.

At the end of the fifteenth century the process of Islamization and cultural transformation in Macedonia and southwestern Serbia was in its final phase. By the middle of the fifteenth century these parts of present-day Yugoslavia had been incorporated politically, socially, and economically into the state and feudal organization of Turkey; this paved the way for cultural and artistic change and made possible the adoption of the Bursa style and the early Constantinopolitan style. During the period of the ascendancy of these two styles, Bosnia had been subjugated only militarily. By the end of the fifteenth century, towns in Macedonia and southwestern Serbia had already acquired an Eastern cast, whereas in Bosnia during the same period a few urban settlements were beginning to have their first buildings in the new mode, by the same process of Islamization as had taken place earlier in Macedonia and southwestern Serbia. Thus the golden age of Islamic architecture in Macedonia and southwestern Serbia was the second half of the fifteenth century, whereas in Bosnia and Herzegovina and the Sandžak (which was part of the Bosnian pashalic) it was the sixteenth century.

In accepting Islam the Slavs of Bosnia came into the orbit of a great culture — which they soon adopted and to which they were to make their own contribution in succeeding centuries. The greatest number of monuments that have been preserved are in the areas formerly within the bounds of the Bosnian pashalic. And today most of the old towns

*e. Mosque of Yusuf Pasha (1560) and the ancient castle in Maglaj, before the attack by Eugene of Savoy. After an engraving of 1697*

in these areas have an explicitly Eastern aspect so far as architecture and town planning are concerned. Most of the surviving architecture in these towns belongs to the classical Ottoman style.

The classical domed mosque in Yugoslavia is of two types: in the first, the prayer hall is covered by a single dome; in the second, by a dome and a semidome. The first type, whose origins go back to the Seljuk period, is more common. The development of this type of mosque virtually resolved itself into a quest for the perfect proportional relations between the enclosed cube and the open entrance portico; between the respective heights of the cube, the drum, and the dome; between the volume and height of the main body of the mosque and the volume and height of the minaret. In the interior, decoration is centered on the dome, the squinches or pendentives, the mihrab (the niche indicating the direction of prayer), the pulpit, the gallery, the windows, and the door.

The single-celled domed mosque is a very simple piece of architecture: the exterior is subordinated to the interior, which is the ultimate artistic concern, and the result is a unity of external and internal design such as is rarely found in any other kind of architecture. The elements of construction, spatial articulation, and even decoration are few. The pulpit and gallery are in the nature of furnishings rather than integral parts of the interior architecture. The artistic merit of the interior and exterior architecture derives from their clarity and simplicity, proportion and balance. The design would remain unimpaired even with all the decoration removed.

In the classical Ottoman period many mosques of this type were built in Yugoslavia. *Pl. 324* They include the following, to mention only the finest: the Čekrekči Mosque in Sarajevo (1526); the Yeni Mosque in Travnik (1549); the Aladža Mosque in Foča (1550); the mosques *Fig. e, Pl. 332, 329* of Karagoz Bey in Mostar (1557), Yusuf Pasha in Maglaj (1560), Ali Pasha in Sarajevo *42, 321, 322* (1561), Ferhad Bey in Sarajevo (1562), Haydar Kadi in Bitola (1562), and Hadži Alija in Počitelj (1563); the Imperial Mosque (Careva Džamija) in Sarajevo (rebuilt 1565); and the

mosques of Sinan Bey in Čajniče (1570), Husain Pasha in Pljevlja (1590), Defterdar in Banja Luka (1594), Sinan Pasha in Prizren (early seventeenth century), and Koski Mehmed Pasha in Mostar (1612).

*Pl. 40, 331*

The only mosques of the second type (with dome and semidome above the prayer hall) are the mosques of Ghazi Husref Bey in Sarajevo (1530) and of Ferhad Pasha in Banja Luka (1583). Built in the period before Sinan had begun to set the seal of his genius on the classical Ottoman style, the former is a work of the Khair al-Din school. It is one of the most impressive of the mosques in the early classical style.

Of mosques with quadripartite roofing and flat timbered ceiling the most beautiful are the mosques of Suleiman in Travnik and of Roznamedji in Mostar. The mosques of Yahya Pasha in Skopje, Tabačica in Mostar, Ghazan Fihri in Banja Luka, and Maghrib in Sarajevo are covered with a decorated wooden dome or barrel vault.

Akin to the domed mosque in respect to structural design, though here the ground plan is usually not rectangular but octagonal, is the mausoleum, or turbeh. Two types of turbeh were built, an enclosed type and an open type with dome resting on four pillars. Noteworthy examples of the enclosed type with dome are the turbehs of Ghazi Husref Bey and of Murad Bey in Sarajevo, of Ferhad Pasha in Banja Luka, of Sinan Bey in Čajniče, *Pl. 340* of Mustafa Pasha and of Ishak Bey in Skopje, the last two in the early Constantinopolitan style. There are two turbehs of the open type in the Alifakovac section of Sarajevo, one of *Pl. 337* them next to the dervish monastery of Sinan, and several in Travnik.

Library buildings, such as the Ghazi Husref Bey Library adjoining the Imperial Mosque in Sarajevo, are in the same category architecturally as domed mosques and turbehs.

Public baths belong structurally to the type of building represented by the Ulu Cami in Bursa and the covered market, or bezistan, but in regard to design they rank ahead of the covered market. The ground plan is more highly elaborated; the characteristic features of the exterior are the dome and vaults of unequal size which rise out of the main body of the structure. As early as the sixteenth century, every small township in the eastern parts of Yugoslavia had one or more public baths. In the larger towns the baths were monumental buildings constituting a significant feature of the bazaar. Mention has already been made of the Daud Pasha Hammam in Skopje, the largest public baths in Yugoslavia. *Pl. 323* Next in size is the Ghazi Husref Bey Hammam in Sarajevo. Similar, but smaller, are the baths in Prizren.

The Seljuks encountered the Hellenistic inner courtyard with arcades in Persian architecture, and they took it to Asia Minor, where they had great success in adapting it first to the madrasah, then to the caravansary. The Ottomans inherited both these types of buildings from the Seljuks.

The Ghazi Husref Bey Madrasah in Sarajevo (1537), although relatively small, is a *Pl. 330* monument of great artistry. The inner courtyard, with domed arcade and ceremonial fountain, is in very subtle structural partnership with the adjoining Mosque of Ghazi Husref Bey, whose main dome and minaret, seen from the courtyard, strike a new and unexpected architectural note.

The Kuršumli Khan in Skopje also belongs to the classical Ottoman period of the sixteenth century. Built in 1550, it has two interior courtyards, two-tiered arcades and a ceremonial fountain, and numerous vaulted rooms above the square guest rooms, closed off from the outside and oriented toward the inner courtyards. It represents the high point of Ottoman monumental public architecture in Yugoslavia.

The basilican form adopted by the Ottoman architects was used only in the building of the longitudinal covered market, the bezistan: the center aisle was virtually a roofed-over street, and the shops were located in the side aisles, which were not continuous but made up of a series of small booths covered by domes or vaults. A remarkable example of the basilican type of bezistan is the Ghazi Husref Bey Bezistan (over 350 ft. long) in Sarajevo

Pl. 336
Pl. 319

(1540), in whose construction Dubrovnik stonecutters, no doubt familiar with this Romanesque architectural concept, are known to have taken part. The covered markets in Bitola and Štip belong to the same type.

The typical ceremonial fountain consists of a low stone-paved basin, octagonal or round, and a sculptured column containing a number of stoups with the water spilling over from one into another; above the basin is a light wooden roof, resting on stone piers. The design is not unlike that of the open type of mausoleum, but the effect created is altogether different. The flowing water and the mirroring pool in the basin endow the structure with a certain poetic vitality. The most beautiful examples of the ceremonial fountain are those outside the Koski Mehmed Pasha Mosque and the Mosque of Karagoz Bey in Mostar, and the mosques of Sinan Bey in Čajniče, of Esma Sultan in Jajce, of Mustafa Pasha in Skopje, and of Ghazi Husref Bey in Sarajevo.

The drinking fountain is typically a small stone construction consisting of a low wall terminating in a shallow pointed arch with an incised inscription in Arabic and a stone trough below. The running water brings into architectural unity the modest trough and the decorative stylized arch and inscription. Many such fountains can be seen today in the eastern parts of Yugoslavia, particularly in the former Turkish towns.

In the town center — the čaršija, or bazaar, where the activities of merchants and craftsmen focused — the typical street was composed of the wooden shops flanking it on either side. Architectural interest attaches not to the individual shop but to the stretch of the street as a whole, with the low, projecting eaves and the uncovered center. This is a pattern in which the variety of scenic effects opens up unexpected vistas. Behind the individual shop was a masonry storehouse, invisible from the street, to protect the goods from hazards such as fire. A group of storehouses disposed around an inner courtyard was called a *daira*. This arrangement, though unpretentious, emphasizes the importance of the courtyard. In the Sarajevo bazaar there are still a few examples of the characteristic wooden shop with its shutters and storehouse and there is one *daira*.

The principal changes introduced by the Ottomans in existing fortified towns were made at the corners of the fortress, where a low bastion *(tabya)* was built as a gun emplacement. The Ottomans also built a whole series of new fortified towns in Yugoslavia. Innovations were introduced into the design of fortress gates, windows, recesses for munitions, and breast walls. Decorative elements were reduced to a minimum; rooms in the fortress were small and devoted exclusively to defense, with no pretensions to monumentality.

The contours of fortified towns changed as a reflection of the construction of the mosque, with its slender minaret, and of the clock tower, which became the chief vertical landmark in both the smaller settlements and the larger townships in Yugoslavia. The most beautiful clock towers are those in Skopje, Sarajevo, and Banja Luka.

The Ottoman builders can be said to have shown a remarkable talent for the design and construction of bridges. In the classical Ottoman period these bridges embodied the qualities of the monumental, the bold, the elegant. In every single case the design is free of standardization and routine formulas and gives evidence of a striving for free and imaginative design. Wherever it was functionally justifiable, the river was spanned by a single arch; where that was impossible, and more than one arch was required, the arrangement of arches is in every case individual. There are no hard and fast rules: more than with any other kind of structure, the architect was free to set his own imprint on the plan of the bridge.

Pl. 339

The architect Sinan built a huge bridge over the Drina at Višegrad; his pupil Khair al-Din the Younger was the creator of one of the most beautiful bridges of the time, that spanning the Neretva at Mostar. Similar to it are the Kozja Bridge over the Miljacka in Sarajevo and the Žepa Bridge, near Goražde. The bridges across the Vardar at Skopje and Tetovo, the bridges spanning the Miljacka in Sarajevo, the Arslanagić Bridge at Trebinje, the bridge across the Radika on the road between Debar and Mavrovi Hanovi, and many

*f. Stylized inscription in a decorative medallion in the form of a vessel on the wall of tekke of Hadži Sinan in Sarajevo. 18th century*

*g. Stylized cypress on the west facade of Mosque of Suleiman, Travnik. 1815*

others can be cited as showing a diversity of architectural design within the framework of a mature artistic style.

Although painting and sculpture, owing to religious injunctions, did not enjoy the freedom that these arts had in the West, their significance in the overall pattern of Islamic art is not thereby diminished. The task of design was to embellish architecture, fabrics, carpets, clothes, weapons, pottery. The professional painter as such did not exist; painting was a skill deployed by the craftsman who created a product with painted or pictorial decoration. This inevitably resulted in a stereotyped ornamental system which had no artistic individuality but followed a traditional scheme. Painting was abstract and anonymous; it was for the most part a reflection of prevailing tastes and standards and, it might even be said, of the philosophical and artistic conceptions, not of the artisan class alone but of the nation as a whole.

All this holds true for sculpture as well. An art without individual identity, it nevertheless afforded scope for work in stone, wood, metal, clay, and glass, either in connection with architecture or in the production of articles for daily use. Everyday objects were decorated to increase their attractiveness and incidentally to increase their value as craft products, that is, as merchandise.

The metalworking crafts, which had existed in Yugoslavia in pre-Ottoman times, included the production of weapons (side arms and firearms), vessels, and ornaments. Some craftsmen were free, others were bound to feudal estates. There were blacksmiths, swordsmiths, bronzefounders, coppersmiths, brass-smiths, and locksmiths. The goldsmith's craft flourished in Dubrovnik, Zadar, and Kotor, and its products came to Bosnia. A goldsmith's workshop is known to have existed at the court of Serbia's King Dragutin in the thirteenth century. Along with the metal crafts, carpet weaving and various types of em-

broidery flourished in pre-Ottoman times. With the arrival of the Ottoman Turks, the development of existing crafts received a vigorous stimulus and new crafts were introduced; free craftsmen organized themselves into guilds in the bazaars. The association of Muslim, Christian, and Jewish craftsmen working in the same guild gave rise to variations in decorative treatment. The Christian craftsmen continued to employ the old motifs (Byzantine, Romanesque, Gothic, Renaissance, and Baroque), combining them with the new motifs introduced by the Turks. The Church continued its patronage, which made for the retention of both Western and Byzantine motifs. There is no doubt that the Eastern ornament brought by the Turks, and the development of a whole range of new crafts, gave the new decorative art an Eastern character. At the same time the blending of motifs from various styles diversified and enriched artistic products.

Motifs of various origins, treated in a variety of ways, were employed in Turkish ornamentation; they range from the prehistoric symbolic to the zoomorphic, floral, ideographic, and geometric. The orb of the sun, the cross, stars, the heavenly vault and the sun's rays, the eye, the tree of life, the holy mount, clouds, the bow and arrow, the dragon, *Fig. g* the dragon's claw, foliage, branches, sheaves, the palm, the cypress, the tree trunk, the vine, the tulip, the hyacinth, the rose, the line (in rectangle, square, pentagon, hexagon, octagon, and other polygons) — these were the common motifs employed, through various techniques and in various materials, in Ottoman decorative art.

The Seljuk style of decoration known as "Rumi" (from the Turkish term for Rome and Byzantium) employed abstract floral and faunal motifs. In contrast to Rumi decoration, which placed equal value upon all motifs, was the "Hatay" style, of Chinese derivation, which employed plant motifs, delineated with strong realism, and emphasized certain parts of the design more than others. In Ottoman decorative art, from the early days of the Bursa style to the end of the classical period, geometric, Rumi, and Hatay designs were employed on various materials and sometimes even combined in the same ornament.

Architectural decoration came into its own in the later period. Beneath more recent *Fig. b* coats of paint, the walls of the interior and the portico of the Aladža Mosque in Foča are covered with original sixteenth-century decoration. The motifs are floral and the treatment a combination of the Rumi and Hatay styles. What has so far been uncovered is decorative art of a very high caliber.

In the metalwork industries, which, as has been said, had been active in pre-Ottoman *Pl. 345, 346, 341, 338* times, producing side arms (daggers and yataghans), firearms, vessels, jewelry, and various ornaments, a new development brought to the Yugoslav regions by the Turks was the craft of the coppersmith.

In the ornamentation of metalwork the techniques of engraving, embossing, incrustation, and filigree were all employed; the chief metals used were steel, copper, brass, silver, and gold. Embossing, the technique of producing bas-relief on sheet copper or sheet silver, was also introduced by the Turks.

The engraver's technique of incising designs was employed on tinned copper (mostly used for vessels); this kind of decoration was the province of the coppersmith.

Incrustation, a purely Eastern technique in which designs incised in wood, steel, bronze, or ivory are filled in with gold or silver wire, was employed almost exclusively in the orna- *Pl. 317* mentation of side arms and firearms. Filigree was a branch of metalcraft that remained for the most part in the hands of Christians; hence it is known in Yugoslavia as "monastery work." The metals used were silver and, to a lesser extent, gold.

The best-known centers for the production and ornamentation of side arms were Foča, Travnik, Titovo Užice, Prizren, and Skopje. Muskets were produced in Skopje, Fojnica, and Foča. Noted for their engraved and embossed work were the craftsmen of Sarajevo, Travnik, and Mostar; in filigree work the craftsmen of Skopje, Prizren, Banja Luka, Foča, Sarajevo, Fojnica, Kreševo, Čajniče, and Livno excelled.

Stone, plaster, stucco, wood, iron, and glass were employed for decorative purposes in architecture. Ornamental limestone or marble had a place in all the prominent parts of the building — mihrab, pulpit, gallery, doors, window casings, piers, arches, arcadings, grilled openings and screens, ceremonial fountains and drinking fountains. The chief decoration was stalactite-like ornamentation. Plaster and stucco were employed in bas-relief decoration. Wood was used for decorating gates, window shutters, and lattices and as the material for the pulpit, the gallery, ornamental ceilings, the *musandira* (raised reading-desk in a mosque), sarcophagi in mausoleums, and wall paneling. Wrought iron was utilized in decorative fittings for gates and doors in residential and public buildings, and for grilled windows in mosques and other edifices. *Pl. 343*

Leather was used for bookbinding, for boxes and lids, for bags, purses, saddles, for ornamental footwear, slippers, gloves, and, very rarely, for clothes. The ornamentation on leather was embossed and finished off by tooling, embroidering, painting, and gilding. The bookbinders *(mudželiti)* of the Sarajevo bazaar had a considerable reputation. *Pl. 335*

Carpet weaving was practiced in some areas in pre-Ottoman times; the Turks enriched the existing designs with new motifs and developed carpet weaving on a much larger scale. There were famous centers of the rug trade in Stolac, Gacko, Foča, Livno, Sarajevo, Više-grad, Pirot, and Pljevlja. The rugs varied in coloring and design from one town to another.

All kinds of materials were used as a base for embroidery, which was worked in gold and silver wire, cotton and silk thread. A whole range of techniques was employed in Muslim households. Embroidery was worked on towels, handkerchiefs, shawls, women's underwear and dresses, tunics, men's and women's accessories, bags, slippers, horse trappings, and belts. The commonest motifs were flowers, branches of trees, bouquets, landscapes, geometric figures, Arabic letters, cypress trees, and stereotyped animal figures. *Pl. 344*

Calligraphic decoration was applied to tombstones, sacred and secular buildings, manuscripts, articles for various uses, and clothes; in fact it would be safe to say that in Islamic art epigraphy can be found anywhere that ornamentation has a place. The epigraphic decoration on the arcade wall of Sinan's dervish monastery in Sarajevo is well known; the Sarajevo calligrapher and poet Mejlija (eighteenth century) has left many remarkable examples of this kind of decoration on tombstones. *Fig. f*

Working with the other craftsmen in the big towns of Ottoman times, professional calligraphers *(hattati)* applied their skill to inscribing epigraphs on manuscripts, tombstones, and buildings. In addition to decorative lettering, manuscripts were also embellished with colored designs; rosebud, flower and leaf, trefoil, tendril, stylized cloud (symbol of the dragon), line, three-ply braid, wicker, rope, chain, arrows, crown, orb, star, and stylized branches — these were all common motifs. *Fig. a, c* *Pl. 41*

The most famous Turkish illustrated manuscript is the *Hüner-nama* (Book of Accomplishments) painted in 1577 by Mirza Ali and Nakkas Osman, the latter a native-born Bosnian. The *Hüner-nama* relates the heroic exploits of the Ottoman sultans. Compared with Persian miniatures, in which stylization prevails in the overall composition as well as in the detail, Ottoman miniatures are more realistic, both in coloring and in the portrayal of drapery, facial features, and gestures. In this rare illustrated manuscript of the *Hüner-nama*, Osman, who was one of the most celebrated miniaturists of the sixteenth century, depicted, among other events, the siege of Belgrade in 1521.

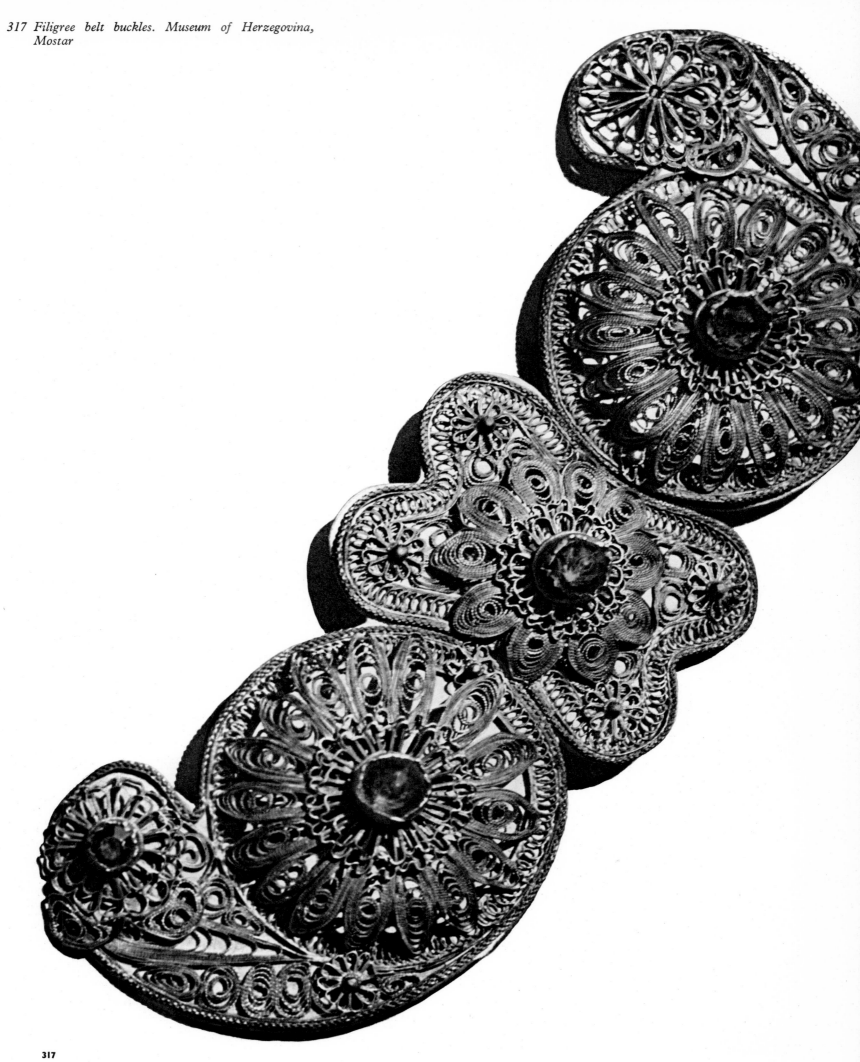

*317 Filigree belt buckles. Museum of Herzegovina, Mostar*

317

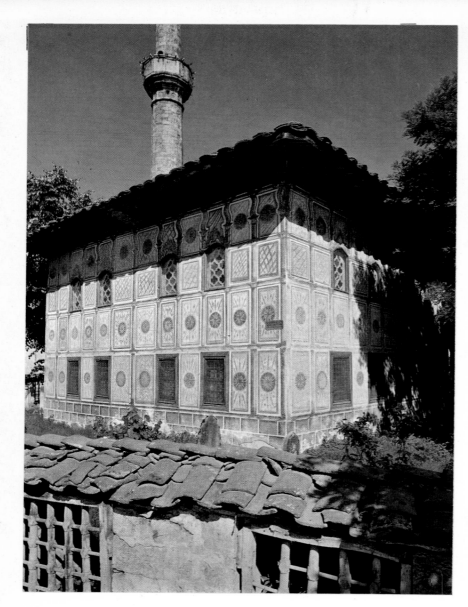

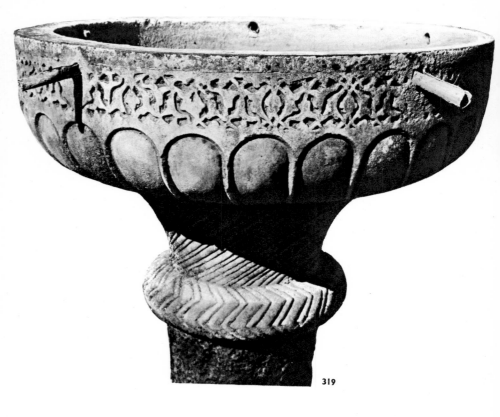

319

318

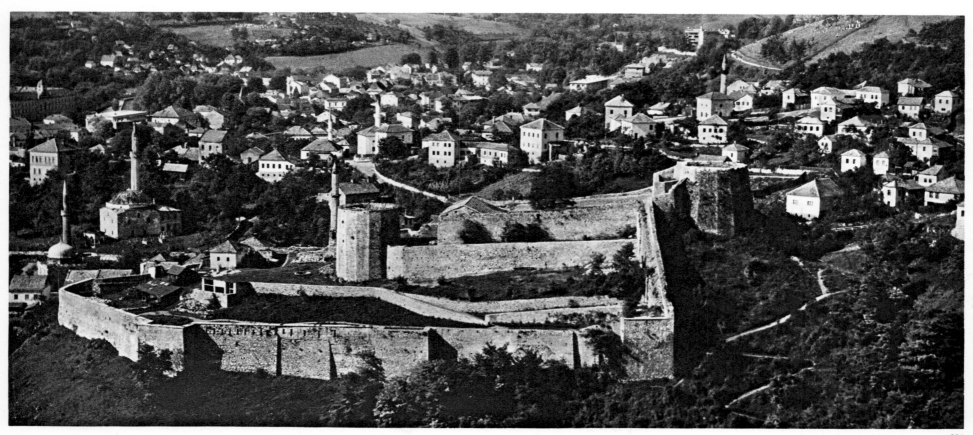

320

314

318 *Šarena Džamija (Colored Mosque), Tetovo.*
1495

319 *Basin of a fountain in the Aladža Mosque,*
*Foča. 1550*

320 *View of the old quarter of the town of*
*Travnik*

321 *Mosque of Hadži Alija, Počitelj. 1563*

322 *Doorway of the Mosque of Hadži Alija,*
*Počitelj (shown in Plate 321)*

323 *The Daud Pasha Hammam (public baths*
*built by the Grand Vizier Daud Pasha),*
*Skopje. 1484*

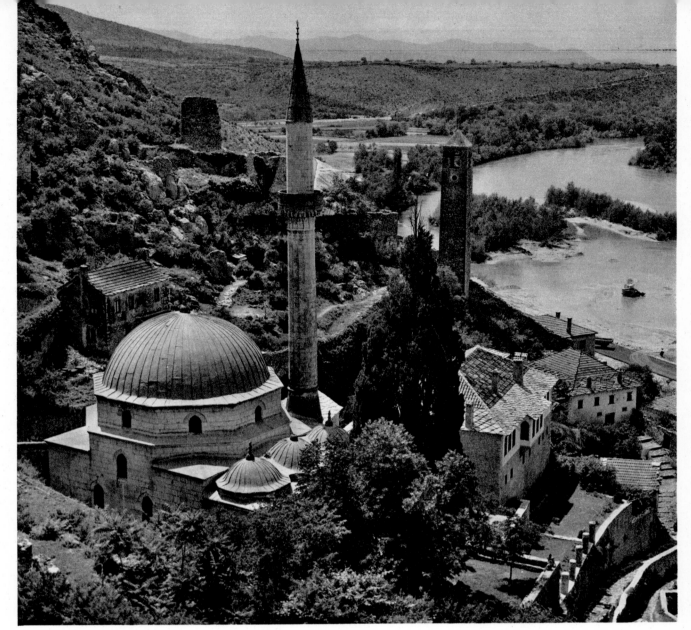

321

322

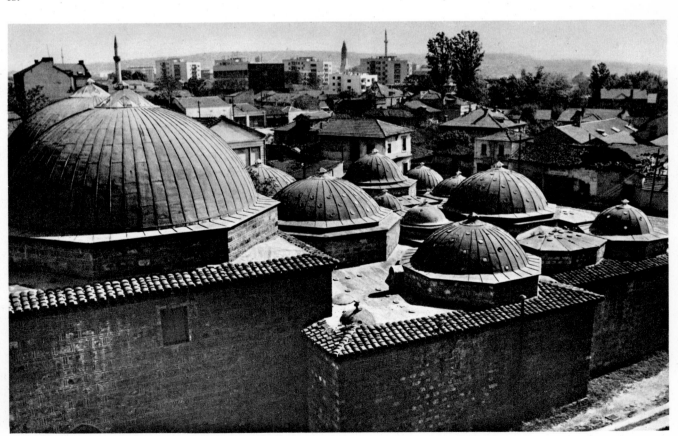

323

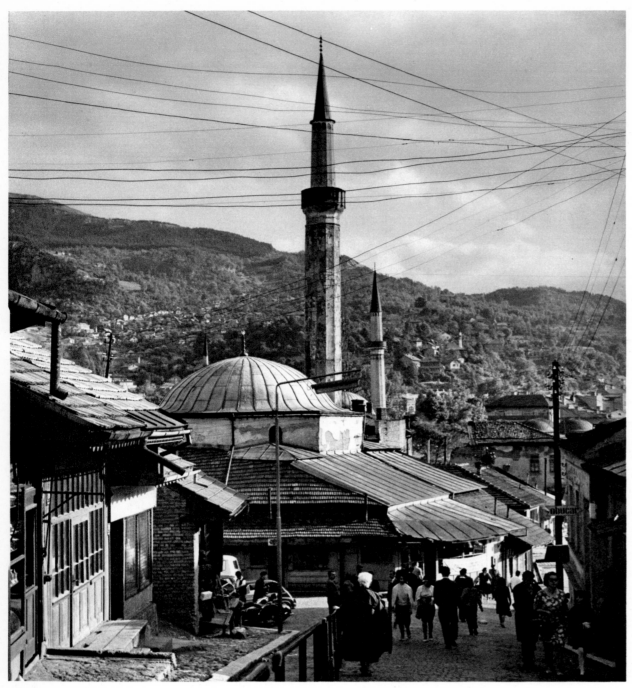

324

325

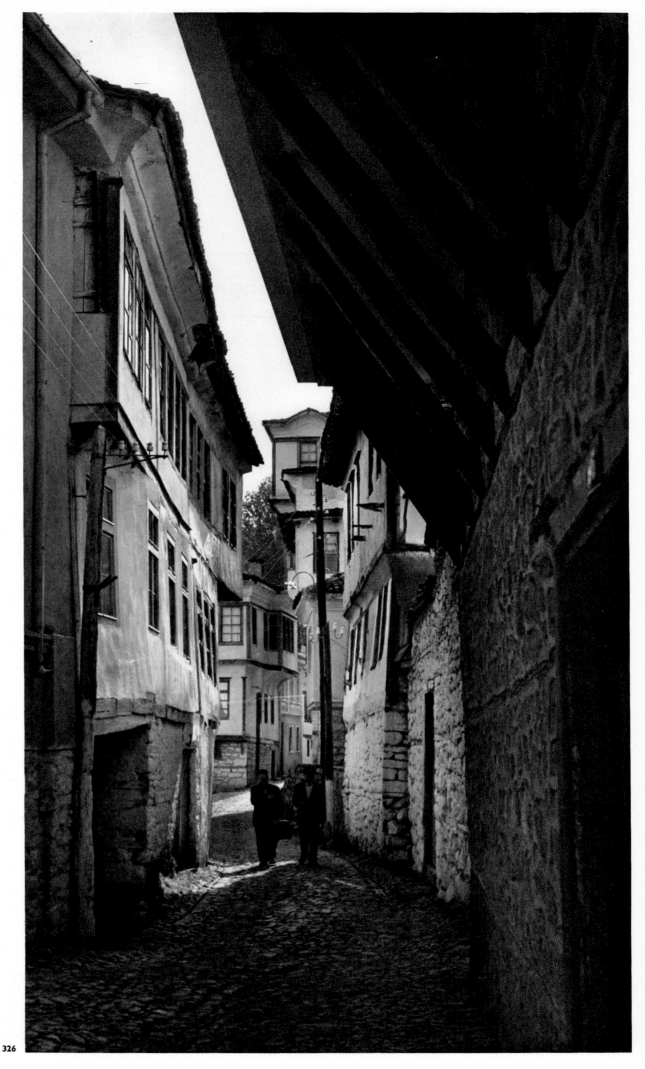

324 *The Čekrekči Mosque in the Sarajevo bazaar.*
    *1526*

325 *Kazandžiluk, a street in the Sarajevo bazaar*

326 *A typical street in Ohrid*

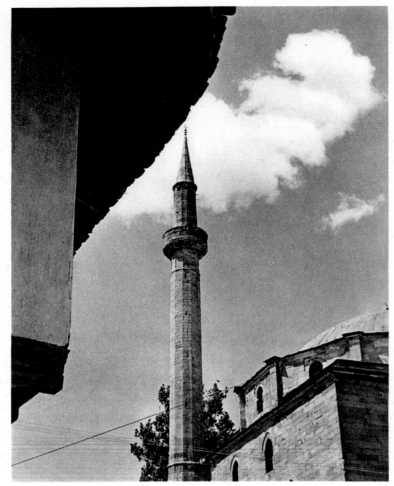

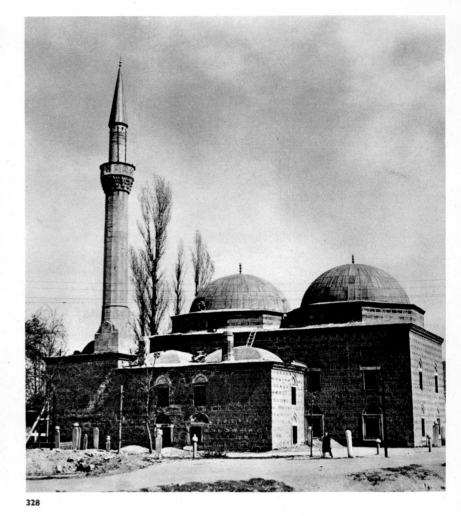

327　328

329　330

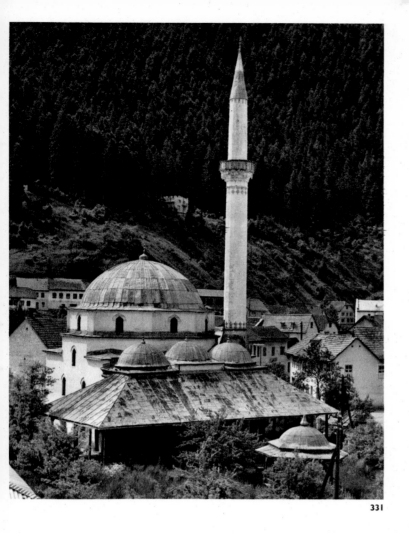

**331**

327 *Mosque of Sultan Muhammad Fatih, Priština.*
*1461*

328 *Mosque of Ghazi Isa Bey, Skopje. 1475*

329 *Entrance to the Mosque of Ali Pasha, Sarajevo.*
*1561*

330 *Ghazi Husref Bey Madrasah, Sarajevo. 1537*

331 *Mosque of Sinan Bey, Čajniče. 1570*

332 *Mosque of Ali Pasha, Sarajevo. 1561*

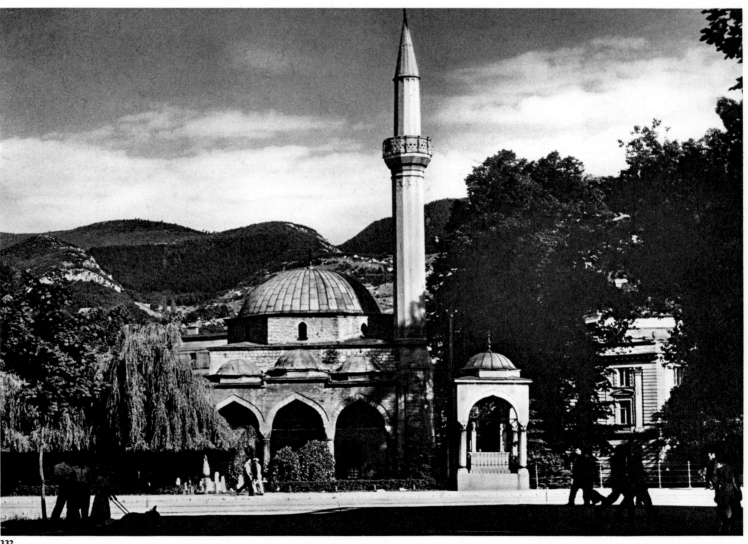

**332**

333

334

333 The Biščević house, Mostar

334 Interior of the Biščević house, Mostar

335 Silver cartridge case made in Sarajevo at the beginning of the 19th century. Military Museum, Belgrade

336 Fountain in the courtyard of the Mosque of Ghazi Husref Bey (1530), Sarajevo

337 Cemetery with turbehs of the open type in the Alifakovac section of Sarajevo

338 Engraved and embossed plate, inscribed "Much time have I spent in writing this. When I die, let one gift remain for my friend; may fortune be blessed, the year 1023 [1614]". Copper, diam. 13″. National Museum, Sarajevo

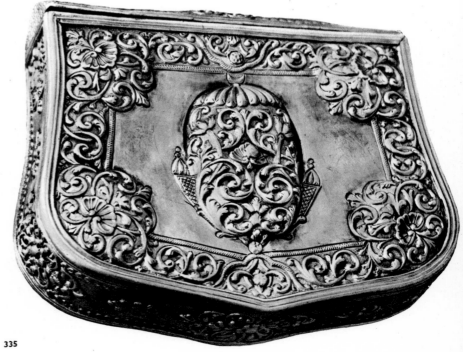

335

336

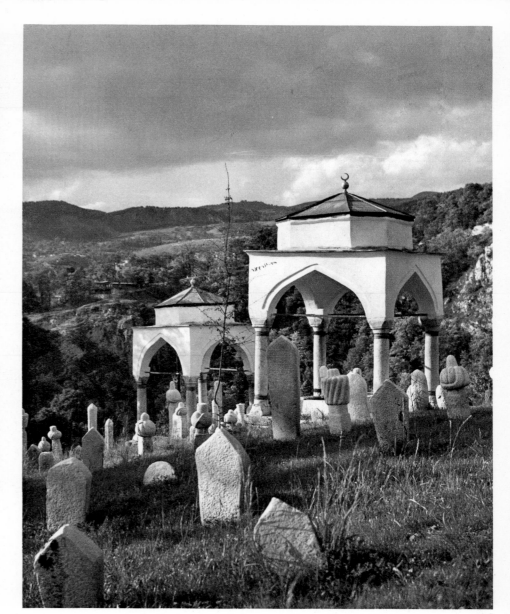

337

338

339

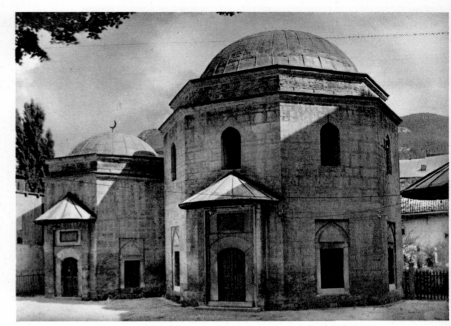

340

339 Bridge over the Neretva River at Mostar. Built by the architect Khair-al din the Younger. 1567

340 The turbehs of Ghazi Husref Bey and Ghazi Murad Bey (sixteenth century) in the courtyard of the Mosque of Ghazi Husref Bey (1530), Sarajevo

341 Ewers inscribed "... produced in the province of Bosnia, in Sarajevo 1127 [1714]," and signed with the name of Master Mustafa. National Museum, Sarajevo

342 Tekke (dervish monastery) at the source of the Buna River

343 Wooden ceiling in the tekke shown in Plate 342

344 Embroidered towel for ritual washing before prayer, detail. Worked with silk and gold thread. Museum of the City of Sarajevo

341

342

343

344

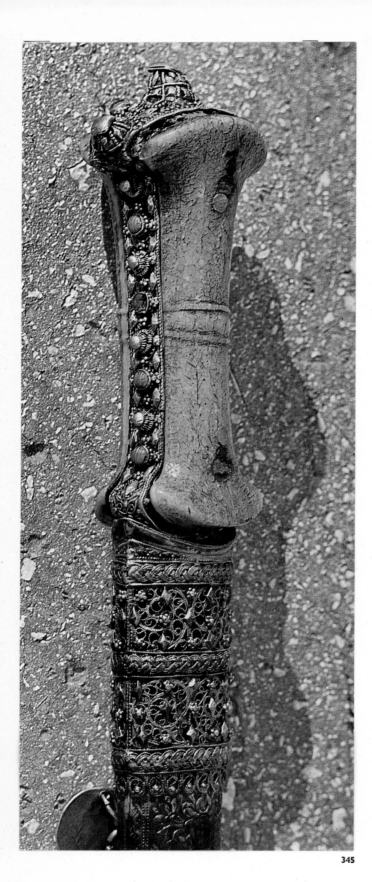

345

345 *Top part of a dagger with sheath, silver-mounted. Latter half of 18th century. Military Museum, Belgrade*

346 *Top part of sword and scabbard, silver-mounted. Latter half of 18th century. Military Museum, Belgrade*

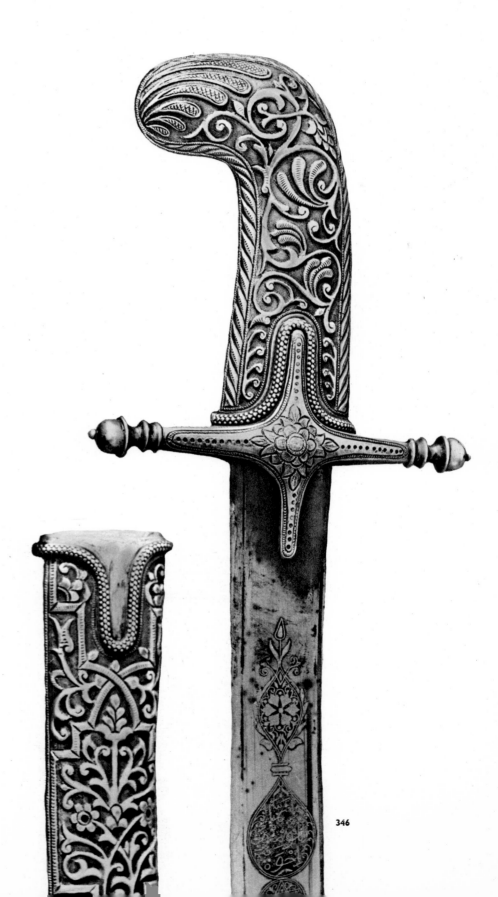

346

# XV  THE RENAISSANCE

Kruno Prijatelj
*Director, Art Gallery of Split*

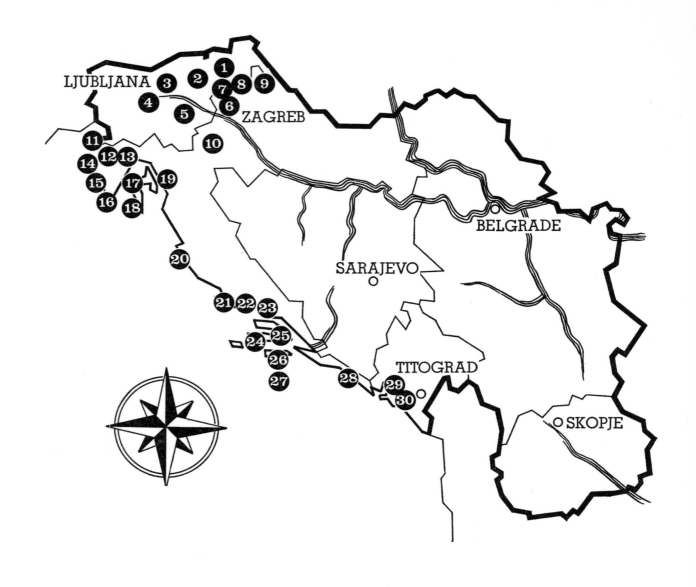

RENAISSANCE MONUMENTS

| | | | | | |
|---|---|---|---|---|---|
| 1 | Ptuj | 11 | Koper | 21 | Šibenik |
| 2 | Celje | 12 | Oprtalj | 22 | Trogir |
| 3 | Kamnik | 13 | Draguć | 23 | Split |
| 4 | Ljubljana | 14 | Piran | 24 | Hvar |
| 5 | Novo Mesto | 15 | Poreč | 25 | Vrboska (Hvar) |
| 6 | Zagreb | 16 | Pula | 26 | Korčula |
| 7 | Veliki Tabor | 17 | Cres | 27 | Lastovo |
| 8 | Lepoglava | 18 | Osor | 28 | Dubrovnik |
| 9 | Varaždin | 19 | Senj | 29 | Kotor |
| 10 | Karlovac | 20 | Zadar | 30 | Cetinje |

Of all the provinces that once existed in political isolation and now are part of Yugoslavia, Dalmatia was most profoundly influenced by the Renaissance. The Renaissance style appeared there first, struck roots more deeply than in any other part of Croatia, or in Yugoslavia generally, experienced a more logical development, and attained a higher level of excellence.

Even before the Renaissance style had been definitely established there, largely through the efforts of Nikola Firentinac (Niccolo Fiorentino), the architecture and sculpture of Dalmatia exhibited a number of manifestations and breakthroughs of the new style.

Renaissance elements already appear in the narrative style and modeling of the Little Onofrio Fountain, erected in Dubrovnik in 1440 in front of the town guardhouse, and carved by Petar Martinov (Pietro di Martino da Milano) with reliefs of nude boys carrying bags and goatskins, whips and shields, and women bearing baskets of fruit or bathing. By the same artist are a number of sculptures in the Rector's Palace of Dubrovnik, including an angular capital with a representation of Aesculapius and a capital with a carving of *Fig. b* the Judgment of Solomon, which, though dominated by Gothic elements, foreshadows the new style. This master was later to work on the triumphal arch of Alfonso V of Aragon at the entrance to the Castel Nuovo in Naples and on the castle of King René d'Anjou in Aix-en-Provence.

Of much greater importance are the Renaissance elements in the sculpture of Juraj Dalmatinac (Georg Matejević). While this great master was a representative of Flamboyant Gothic, both in architecture and in ornamental detail, his sculptures, particularly his approach to the human figure, derive many features from the Renaissance and echo the work of Jacopo della Quercia and, to an even greater extent, of Donatello. These Renaissance elements are to be found in such works of Juraj as the putti and amorini in Šibenik Cathedral and the admirable frieze of portrait heads around the apse of the cathedral; the dramatic *Flagellation* and the realistic portrayal of St. Anastasius (Sv. Staš) on the altar of that saint *Pl. 350* in Split Cathedral and the tomb of the Blessed Rainerius there; and certain of his sculp- *Pl. 347, 348, 349* tures in Ancona, across the Adriatic.

Donatello's influence on Dalmatian art is aptly illustrated by a letter written in 1453 by Bishop Vallaresso of Zadar to Bishop Ermolao Barbaro of Treviso, requesting him to order drawings from the Florentine sculptor for *feste romane*, probably sketches of decorative festoons and garlands for the windows of the Bishop's Palace in Zadar.

A place of importance in this prelude to the Renaissance in Dalmatia must be assigned the sojourn in Dubrovnik (1461-64) of a major Renaissance master, Michelozzo Michelozzi. The distinguished Florentine sculptor and architect was invited to Dubrovnik by the government of the republic but was set to work on the fortifications for its capital (and for nearby Ston) during his stay. Unfortunately, his plans for the reconstruction of the Rector's

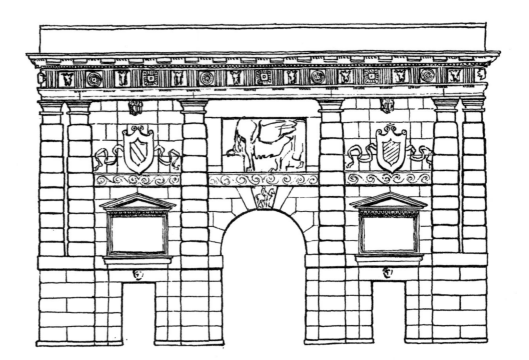

*a. Land Gate built by Gian Girolamo Sanmicheli in Zadar. 1543*

Palace, which had been destroyed by an explosion, were rejected; it was probably this blow that caused him to leave Dubrovnik. Despite the fact that he was not engaged to rebuild the palace, it is certain that his contacts in Dubrovnik were instrumental in disseminating the new style. Probably they were also responsible for the appearance of Renaissance features in the renovated palace, since reconstruction was entrusted to local masters and to a Florentine, Salvi di Michele, mentioned in 1468 as chief architect *(protomagister)*. *Pl. 351* The picturesque heads on the columns of the loggia, in which Late Gothic intermingle with Renaissance motifs, were most probably the work of local masters; the Renaissance reliefs on the piers of the arch over the main doorway to the palace, with their themes of play, battle, and love, can in all probability be attributed to Pavle Antojević, a goldsmith and medalist of Dubrovnik who had studied with Donatello in Padua and who later executed a number of medallions for the royal court in Naples.

In view of his long sojourn and many activities there, and his collaboration with numerous local masters, there can be little question that the sculptor and architect Nikola Firentinac, a pupil of Donatello, was the principal protagonist of the Renaissance in Dalmatia and that his activities marked the definitive penetration of the new style. The year 1468 is mentioned in Dalmatian documents in connection with Nikola, but, as has been indicated, there is reason to believe that the style had already made some headway a number of years earlier.

*Pl. 352* Two paramount undertakings stand out among the vast number of works executed by Nikola: the chapel of St. Ivan Ursini, Bishop of Trogir from 1062 to 1111, in Trogir Cathedral, and the final phase of construction (1477-1505) of Šibenik Cathedral. Nikola introduced into the architectural conception of Trogir Cathedral a number of elements deriving from the small Temple of Jupiter (Baptistery) in Diocletian's Palace in Split. He also contributed Renaissance features to the rich carvings of the chapel, so well integrated with the architecture — from the relief of the putti holding a wreath above the niche (a feature that had appeared earlier, certainly under Nikola's influence, in Andrija Aleši's baptistery in Trogir Cathedral) to the reliefs on the candelabra and the nude boys bearing torches. Nikola also built an audacious slender cupola with octagonal drum over a rectangular cross base in Šibenik Cathedral and a remarkable barrel vault in stone, eschewing the use of wood and brick, as well as the tripartite facade. His powerful sculptures, clearly influenced by Donatello's plastic conceptions, are permeated by a strong and spontaneous sense of

drama. This is particularly apparent in his statues of the Virgin, St. John the Baptist, St. Peter, and St. Paul in the Ursini chapel in Trogir Cathedral and in the reliefs of the Lamentation on the tomb of the Sobota family in the Church of St. Peter in Trogir and on the tomb of the Cipico family in the Church of St. John the Baptist in Trogir. His work both as architect and as sculptor strongly influenced the local stonemasons' and stonecutters' workshops.

*Pl. 354*

The distinguished Dalmatian Renaissance sculptor Ivan Duknović (Giovanni Dalmata) also executed for the Ursini chapel in Šibenik Cathedral an exceptional figure of St. John the Evangelist, pure in its approach to volume and notable for the spiritualized and individualized rendering of the facial features. This artist, who lived intermittently in his native land, executed a number of works there but did his finest work abroad. Outstanding among his sculptures for the tomb of Pope Paul II in the Grotte Vaticane under St. Peter's are the statue of Hope and the reliefs of the Creation of Eve and the Resurrection; in Rome he also collaborated on the tombs of Cardinals Eroli and Roverella, and in Hungary he executed sculptures commissioned by its king, Matthias Corvinus. All his statues and reliefs bear the particular stamp of his genius — an expressly Classical use of the chisel; an individual treatment of folds, flesh, and hair; original plastic conceptions in which lyric feeling and a restless dynamism combine in a pure and integrated sculptural synthesis.

*Pl. 353*

The plenitude of local masons and carvers may be credited with spreading Renaissance forms throughout Dalmatia — forms that are essentially Renaissance, although in the initial phases these forms were not pure and still bore traces of the Gothic. Outstanding among the famous local masters were Marko Andrijić, architect of the top story of the bell tower of Korčula Cathedral (1481) and the ciborium in the same church (1486), and his son, Petar Andrijić, whose finest works include Dubrovnik's Church of St. Saviour (Sv. Spas), with its tripartite facade (1520), and Church of the Annunciation, whose lovely portal (1534) he was responsible for; Paskoje Miličević, who was engaged in the construction and fortification of the harbor of Dubrovnik, his most outstanding work being designs for the Sponza Palace (also called the Divona building) in Dubrovnik (1516). This structure presents the harmonious combination of Late Gothic and Early Renaissance forms that was to be typical of a number of edifices in Dubrovnik and environs, probably under the influence of the facade of the Rector's Palace.

*Pl. 355*

*Pl. 356*

Building activity waned in the sixteenth century as a result of the deteriorating political and economic situation. Nevertheless many buildings date from these troubled decades, and they show Renaissance forms, frequently with provincial and conservative accents. Among them are the Church of St. Mary in Zadar and the parish church in Pag, on the island of that name; summer residences in Dubrovnik (for example, the Skočibuha mansion), Gruž, and Lapad; the country house of the poet Hanibal Lucić outside the walls of Hvar on the island of that name; the fortified summer residence of the poet Petar Hektorović ("Tvrdalj"; c. 1520) in Stari Grad on Hvar; and finally the fortifications of any number of coastal towns. The special form of the fortified Church of St. Mary in Vrboska on the island of Hvar seems to sum up the political and psychological situation of the times.

Two leading Venetian architects, Michele Sanmicheli and his nephew Gian Girolamo, who drew up the specifications for the Land Gate (Porta Terraferma) in Zadar (1543) and the Fort of St. Nicholas in the harbor of Šibenik (1540-47), hold a prominent place in connection with the defensive architecture of Dalmatia during the period when it was under the control of Venice. The influence of the robust and monumental architectural conceptions of the Sanmicheli was manifest also in loggias in Zadar, Šibenik, and Hvar.

*Fig. a*

A number of Late Renaissance sculptors of Dalmatia are worthy of mention: Franjo Čiočić (Čučić), Pavao Gospodnetić, Nikola Lazanić, Antun Nogulović. Together with the last members of the families of local master masons, whose craft was handed down from father to son, from generation to generation — the Bokanići, Karlići, and Pomenići

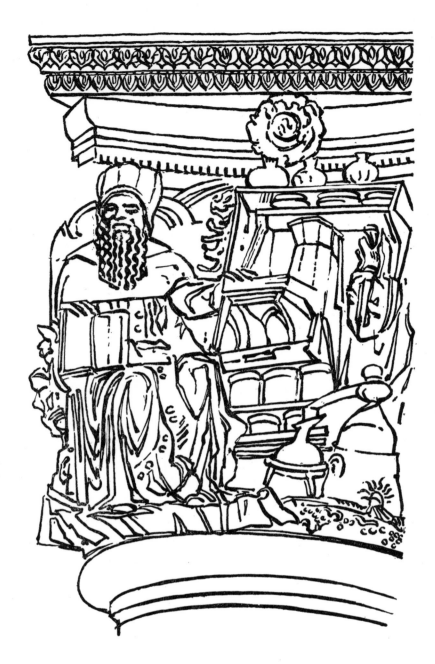

*b. Capital with figure of Aesculapius. By Petar Martinov (?) in the Rector's Palace, Dubrovnik*

— these sculptors wrote the last pages of the chapter of Renaissance architecture and sculpture in Dalmatia. This should be rounded out by at least a passing reference to the woodcarvers and goldsmiths, whose products, though often anonymous, were no less significant and no less outstanding in their excellence.

The painting of the Dalmatian school developed until nearly the end of the quattrocento within the basic framework of Gothic stylistic forms as typified by the solemn and sumptuous Gothic polyptychs in which figures of saints on gold backgrounds were set in richly gilded carved wooden frames. Renaissance influence on painting in Dalmatia was essentially sporadic and restricted in scope throughout the fifteenth century. The new style, even then somewhat restricted by the traditions of the past, was first to appear in the art of Dubrovnik toward the close of the quattrocento and in the first few decades of the cinquecento, culminating in significance and quality in the work of Nikola Božidarević.

*Pl. 357*

An enumeration of scattered Early Renaissance elements in painting in Dalmatia, before the style had struck roots there, could begin with the nude male figure on the lectern in the Gothic representation of St. Matthew in the frescoes by Dujam Vušković and Ivan

Pavlov (Ivan Petrov of Milan?), dating from the year 1429, in the chapel of Sv. Dujo in Split Cathedral. Then, note should be taken of the work of the Crivelli — Carlo (mentioned in a document of 1465) and Vittorio (mentioned in documents of 1465, 1469, and 1472). They spent considerable time in Dalmatia and clearly influenced artistic trends there, as is evidenced by a painting of Dalmatian origin now in Zagreb attributed to Vittorio, and by the effect of their art on the output of Petar Jordanić, a *retardataire* provincial painter active in Zadar at the end of the fifteenth and the beginning of the sixteenth century. Further, the sculptural approach to the human figure and the luscious colors of the latest extant polyptych by Lovro Dobričević in the votive church on the promontory of Danče, in Dubrovnik, dating from 1465-66, reflect the earliest, barely perceptible penetration of the Renaissance into early Dubrovnik painting. Finally, there are the works imported into Dalmatia — paintings by celebrated artists of the Venetian quattrocento, including Antonio and Bartolomeo Vivarini, Gentile and Giovanni Bellini, and Carpaccio, testifying to the refined taste of the Dalmatian patrons of the arts and to the many ties they maintained with foreign parts.

*Pl. 358*

An entire chapter might well be devoted to Juraj Ćulinović of Skradin. After completing his training in Padua (1456-60), this painter returned to his homeland, where he remained for almost half a century. However, the most significant paintings of his that survive were initiated during his sojourn in Italy. In the stimulating atmosphere of Squarcione's studio, and under the impact of work being done in Padua under Donatello's influence, Ćulinović launched his own individual style, characterized by a frenetic, deliberately dramatic sculptural quality, and by grotesque, almost expressionistic physiognomies. His paintings, with their fresh approach to space and new concept of volume, are a personal variant of the profound and intense artistic drama, involving an entire generation, that reached its culmination in the works of the Crivelli, Mantegna, and Tura.

*Pl. 360*

An artist who both developed and worked in Dalmatia and who figures most significantly among its Renaissance painters is the already mentioned Dubrovnik painter Nikola Božidarović. The son of the painter Božidar Vlatković, and in his youth a pupil of their compatriot Petar Ognjanović, Božidarović executed his celebrated paintings in his native city and its vicinity. The earliest work that has come down to us, dating from the start of the sixteenth century, is a severely schematic triptych, now in the chapel of the Bundić family in the Dominican church in Dubrovnik; later, in 1513, at Lopud, Božidarović painted his *Annunciation* (now in the same church), with the figures of Mary and the Archangel Gabriel in the central field of a broad, free expanse. In a pala for the Djordić family, in the Dominican monastery in Dubrovnik, he brought Mary and the saints together in a *sacra conversazione,* thereby abandoning the earlier scheme of the polyptych, which had separated the figures of saints into panels and surrounded them with gold frames. Returning, in his latest surviving work, the polyptych of 1517 in the votive church of Danče, Dubrovnik, to the older form — probably on the insistence of his patrons — he produced truly Renaissance effects of space and composition in the predella and lunette, reaching the pinnacle of his achievement in the figures of the Madonna, St. Gregory, and St. Martin, which he imbued with a refined melancholy and wistful lyricism. Despite manifold influences and his retention of many of the aspects of local tradition, positive and negative, Božidarović created a personal and consistent style in terms of composition, color scheme, and, particularly, typology, achieving extraordinary variations in the sensitive, melancholy visages of his Madonnas and visionary saints.

Contemporary with Božidarović was Mihajlo Hamzić, a disciple of Mantegna. In his painting *The Baptism of Christ* (1509) for the Rector's Palace in Dubrovnik, he placed three bony protagonists against the broad backdrop provided by a Mantegna-like landscape of subdued tonalities. A later altar painting of his (1512), executed (in conjunction with Pietro di Giovanni of Venice) in the older, triptych form for the chapel of the Lukarević family

*Pl. 362*

in the Dominican church in Dubrovnik, is emphatic in its use of color and its inclination toward the decorative, with figures of saints reminiscent of Classicism and permeated by a profound inner intensity.

To these two great names in Dubrovnik painting in this period may be added a third, that of Vicko Lovrin Dobričević (son of Lovro Dobričević), whose great polyptych (1509-10) in the Church of St. Blaise (Sv. Vlaho) in Cavtat demonstrates a skillful blending of elements of the conservative local tradition and Early Renaissance features stemming from the Vivarini school.

The death within the space of a single year of Božidarović (end of 1517), Vicko Lovrin Dobričević (1517/18), and Mihajlo Hamzić (1518) seems to symbolize the beginning of the decline of the Dubrovnik school. Although the development of painting there may be traced for another half century (which cannot be done for the rest of Dalmatia), the work produced was but a shadow of the achievements of earlier years. The conservative tendencies that held the remaining local painters in their grip, the increasing importation of works from Italy and Flanders, and the influence of a number of minor foreign artists who settled in Dubrovnik (Pier di Giovanni of Venice, Pier Antonio Palmerini of Urbino, and later Bernardino Ricciardi, Simone Ferri, and others) contributed to the slow decline of the school. Some of the Dubrovnik artists made an effort, which was crowned with only modest success, to infuse the *retardataire* and already bloodless tradition of the moribund school with the irrepressible new elements that were penetrating the area. Another group of painters, outstanding among them Frano Matijin Milović, reverted to the Byzantine tradition and style of composition while retaining some of the elements of Roman Catholic iconography. Yet another group imitated the imported paintings of Italian artists without ever grasping their spirit or their essence (Krsto Antunović Nikolin).

The importation of paintings which satisfied the tastes of cultured and humanistically educated patrons was one of the reasons for the decline and demise of the local school in Dubrovnik, whose conservative artists no longer had the old vigor or skill. The same was true of the rest of Dalmatia, where the knell had tolled for the local masters even earlier, leaving as more or less the sole legacy of the painting of the cinquecento imported paintings *Pl. 361* by foreign artists. Even the briefest survey must make mention of Titian, Tintoretto, Veronese, Lotto, Jacopo Bassano, and other artists whose works were incorporated into the Dalmatian artistic inventory. Especially worthy of note is the considerable number of paintings by Francesco and Girolamo da Santacroce, whose talents were peculiarly gratifying to conservative Dalmatian — and Istrian — patrons.

A review of the Renaissance in Dalmatia should not fail to point out the contribution made to West European art in the quattrocento and cinquecento by artists from the Dalmatian coast whose finest works remained outside their homeland.

Mention has already been made of the work of Juraj Dalmatinac in Ancona, Pavle Dubrovčanin in Padua and Naples, Ivan Duknović (Giovanni Dalmata) in Italy and Hungary, and Juraj Ćulinović in Italy.

Two famous Dalmatian-born artists (from Vrana) produced all, or virtually all, their works away from their native soil: the sculptor Franjo Vranjanin (Francesco Laurana), whose female portrait busts with delicately modeled features, lowered eyelids, sensuous lips, and soft hair exhibited a new conception of volume with a personal approach to purely plastic and spatial rhythms; and the architect Lucijan Vranjanin (Luciano Laurana), whose masterly work on the Ducal Palace of Urbino (especially the superb courtyard) is chiefly responsible for its harmony and beauty. Luciano's feeling for space, synthesizing values of volume and light, marked an important stage in the evolution from Early Renaissance architectural conceptions to High Renaissance expression. In all probability Laurana had originally, as a youthful artist, found inspiration in the Late Classical architecture of Diocletian's Palace in Split.

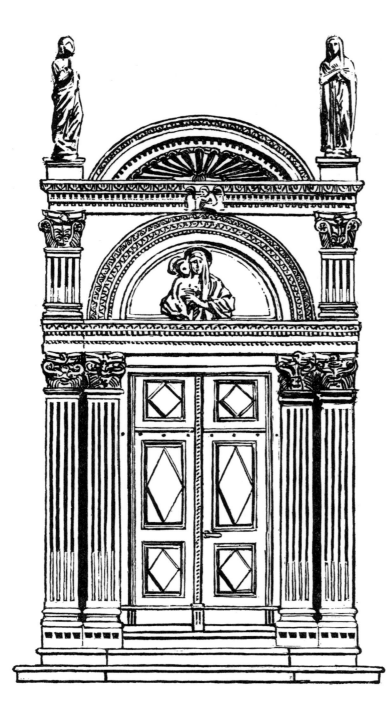

*c. Detail of portal of parish church in Cres, on the island of Cres, showing characteristic trilobate form*

Bypassing some minor artists, we might, in conclusion, mention Andrija Medulić *Pl. 45* (Andrea Meldolla, called Schiavone), who introduced innovations into Venetian art in the second and third quarters of the cinquecento through a fresh interpretation of light, atmosphere, and pictorial subject matter — an approach that in a sense marks him as the harbinger of Tintoretto, Bassano, and El Greco.

Although Renaissance art reached the peak of its development in the Yugoslav territories in the Dalmatian towns, even a brief survey such as this cannot ignore the more modest manifestations and echoes of the Renaissance in other parts of the country, attesting the dissemination of the new style and the continuity of artistic contact with the development of West European art.

Despite the fact that the small towns of the Croatian part of Istria had already acquired their salient features in earlier periods, and that the economic and political situation in that area caused a noticeable decline in artistic activity at the end of the fifteenth and in the course of the sixteenth century, elements of the Renaissance style did penetrate there, although on a modest scale.

Indeed Renaissance architectural features put in a very early appearance in Istria (portal of the now demolished abbey of St. Mihovil-on-the-Hill in Pula, 1456; gateway of the courtyard of the episcopal palace in Poreč, 1461), but these early manifestations of the new style were not destined to lead to further development. Reminiscences of Venetian Renaissance forms (late quattrocento) are perceptible in the facades of the cathedral in Osor and the parish church in Cres. The tripartite facade of Osor Cathedral recalls similar facades of Venetian and Dalmatian churches. The facade of the parish church in Svetvinčenat has Venetian affinities. (It was in Svetvinčenat that the Loredan family, of the Venetian nobility, had a palace and loggia constructed in the Renaissance style.)

It was thus to a limited extent, and frequently in conjunction with *retardataire* Gothic forms, that the Renaissance affected Istria toward the close of the fifteenth century — more through decorative forms than through new architectural spatial conceptions. We find Renaissance influence in loggias, cloisters, fortifications, and palaces, and in even greater measure in isolated decorative details on ornamented portals, biforia and triforia, tombstones and fountains. Specific mention might be made of the facade of the cathedral in Vodnjan, the episcopal palace in Osor, several mansions in Poreč and Rovinj, and loggias in Labin, Cres, and Kastav.

*Fig. c*

The Renaissance also put in a belated, discreet, and unobtrusive appearance in Istrian painting, where Gothic forms, with their popular, naturalistic, and narrative components, still prevailed in the work of the masters who decorated the interiors of the Istrian churches in the fifteenth century. The triumphal arch in the Chapel of St. Mary in Oprtalj bears Renaissance frescoes of Venetian inspiration, executed in 1471 by Master Klerigin the Younger (Klerigin III), of a family of painters hailing from Koper. At the beginning of the sixteenth century Master Blaž of Dubrovnik painted the small Church of the Holy Spirit in Nova Vas, near Šušnjevica, abandoning the artistic idiom of his native Dubrovnik and acquiring a naive, popular narrative style. The frescoes in the Church of St. Roch in Draguć (1529), by Master Anton from the Istrian village of Padove (mod. Kaščerga), also claim attention by virtue of their naive, popular tone. To this complex development of Istrian painting, certain minor masters from Friuli also made a contribution in the second half of the cinquecento. Works by Italian masters, among whom the most outstanding were the Vivarini and Francesco and Girolamo da Santacroce, round out this short survey of painting in the Renaissance style in Istria. Also from Istria was Master Bernard of Poreč, who takes his place in the history of painting in the Apennine peninsula under the name of Bernardo Parentino; he stands out for his cycle of frescoes on the life of St. Benedict in Santa Giustina in Padua.

*Pl. 359*

In the banat of Croatia, or Croatia proper, the Renaissance was even more modest in its manifestation. Throughout the entire period, the Turks stood poised to invade the area; large portions of Croatian territory had already been annexed to the Ottoman Empire. In those troubled times every iota of physical and material energy was poured into defense, and a general impoverishment and decline in trade — to say nothing of art — were among the many consequences.

Their greater distance from the Turkish menace, their more favorable economic situation, and their proximity to Italy enabled a number of townships along the Croatian coast, particularly Senj, to adopt certain Renaissance forms. In continental Croatia the Renaissance is discernible — more in spirit than in form, to be sure — only in the arcades of courtyards in some of the ancient towns (Varaždin, Kerestinec, Veliki Tabor, Klenovnik) and in some of the fortifications constructed during this turbulent period (Karlovac, Sisak, Zagreb); in church architecture Renaissance forms were to appear only in details on seventeenth-century structures that belong chronologically to the Baroque.

*Fig. d*

Renaissance sculptures grace a number of stone tombs portraying feudal lords or prelates recumbent on ornamented biers or in an attitude of worship (Trsat, Senj, Novi, Za-

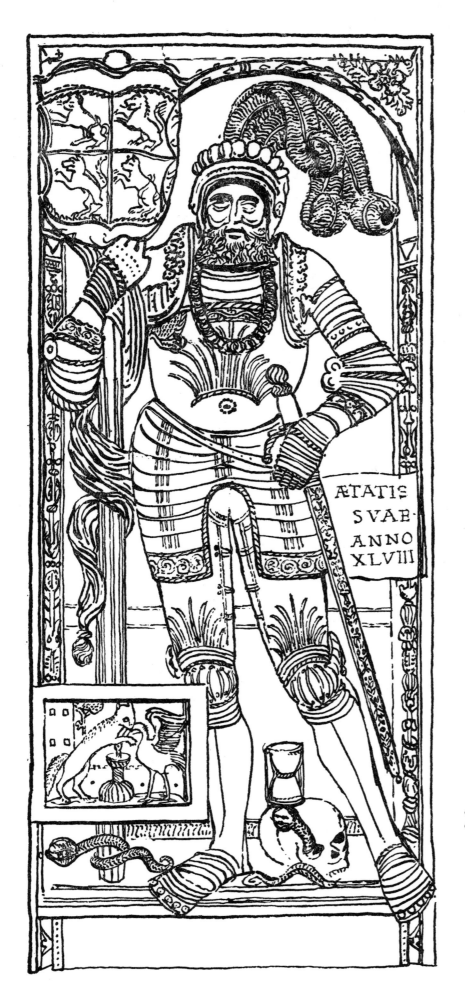

Inside the illustration:

ÆTATIS
SVAE·
ANNO
XLVIII

*d. Tombstone plaque of Ivan Kacianer in parish church, Gornji Grad. c. 1533*

greb, Ilok, Lepoglava, Donja Stubica), a few reliefs and tabernacles (Bribir, Senj, Hreljin, Požega), the wooden choir stalls of Zagreb Cathedral, and, as a belated reflection of Northern Renaissance forms, various seventeenth-century pulpits and retables.

While it is true that Renaissance painting in Croatia chiefly comprises imported pictures of no special importance, recognition must be accorded to a fine Croatian artist, who was the last great miniature painter of the Late Renaissance in Europe — Julije Klović (Giulio Clovio Croata).

Slovenia did not fare much better in regard to the Renaissance. As was to be expected, the new style established itself, albeit modestly, largely in the towns along the coast; the upper part of the facade of Koper Cathedral is particularly noteworthy. Also belonging to this area, broadly speaking, was the church on Sveta Gora, near Gorica, destroyed during World War I. By the mid-sixteenth century the Renaissance had made its way into church construction in Slovenia proper; the churches, though essentially still Gothic in spirit, owe to the Renaissance their brighter interiors and certain decorative details. Renaissance churches in Slovenia that deserve mention include the parish church in Leskovec, near Krško, and the Protestant church in Govče, near Celje (demolished during the Counter-Reformation), with its centralized, twelve-sided ground plan. The Renaissance also put in a belated appearence in certain fortifications, country residences, and mansions built during the Baroque period (Celje, Ljubljana, Maribor, Ptuj, Zemono near Vipava).

In the sphere of sculpture the new style was manifested in Slovenia particularly in numerous carved tombstones (Gornji Grad, Ptuj, Laško, Celje, Maribor, Ljubljana, Novo Mesto) and in altar carvings; in painting, Renaissance elements appear in the frescoes of numerous Slovene churches. Some distinctive murals in this category are those in the nave *Pl. 364* of the Church of St. Primož, near Kamnik (1504), with scenes from the life of the Virgin, and those in the Church of St. Mary Gradec near Laško (1526). Renaissance features may also be discerned in the frescoes by Master Jernej of Loka, who executed the decorations in many churches along the seaboard and in upper Kranjska. Provincial Renaissance elements inform a number of paintings on panels and on canvas, sometimes locally produced; of the imported works, certainly worthy of note are Carpaccio's paintings in Koper and Piran and Tintoretto's in Novo Mesto.

The Renaissance made virtually no headway in the other areas of Yugoslavia, or was so modest in its manifestations as hardly to warrant consideration. In Serbia the style was reflected solely in the ornamental initials of Serbian books printed in Venice; in Bosnia it is represented by certain mediocre paintings of Italian origin in Franciscan monasteries; in Montenegro early engravings give indication that the palace and church constructed toward the close of the fifteenth century by Ivan Crnojević bore the Renaissance imprint. In the coastal towns of Montenegro, Renaissance architectural elements are most frequently ancountered on buildings in which Late Gothic stylistic characteristics are dominant; the two styles also merged in decorative carvings. There too the Turkish menace precluded even the planning of any major architectural undertaking.

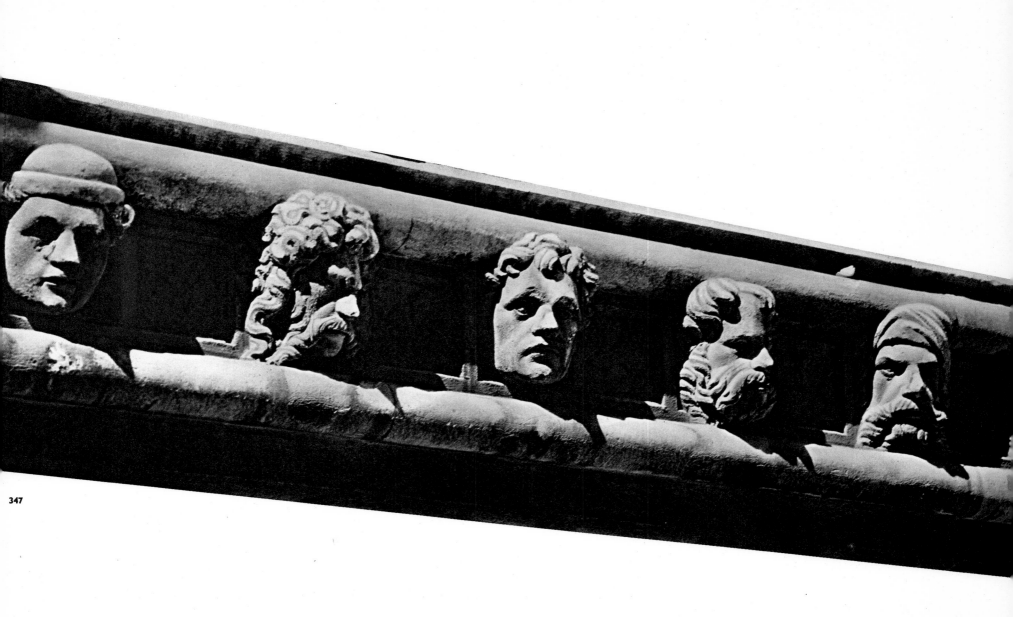

347

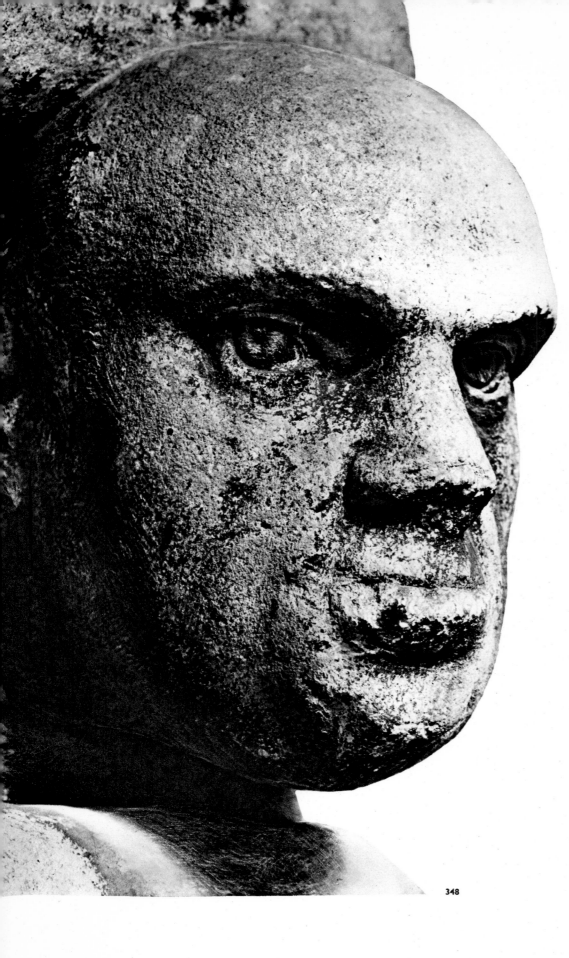

348

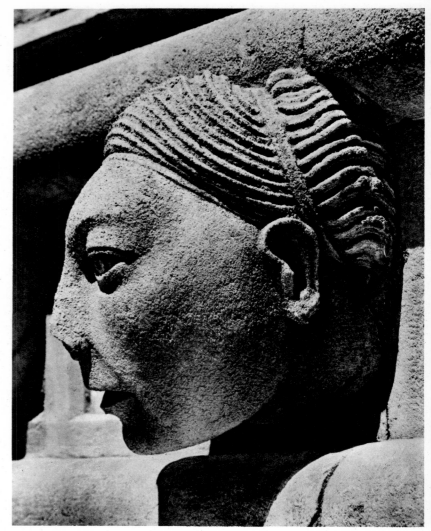

349

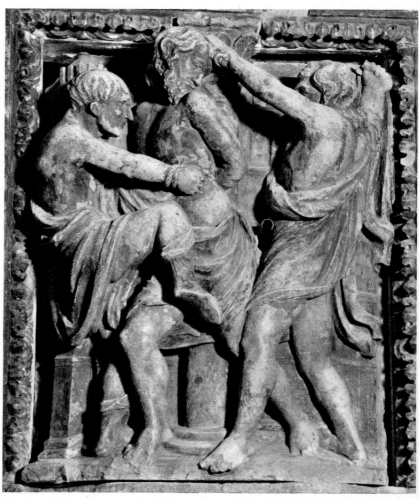

350

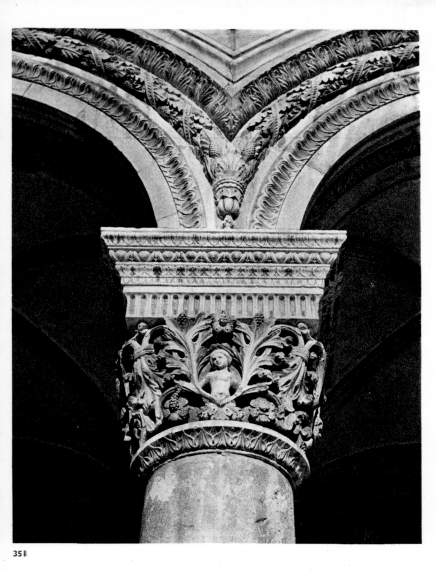

351

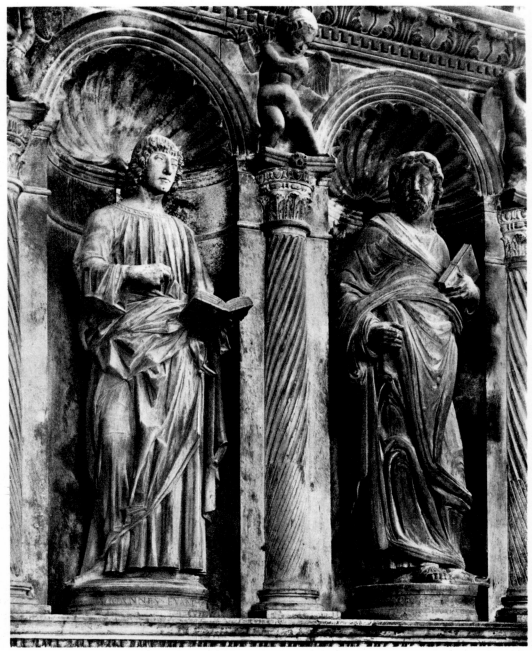

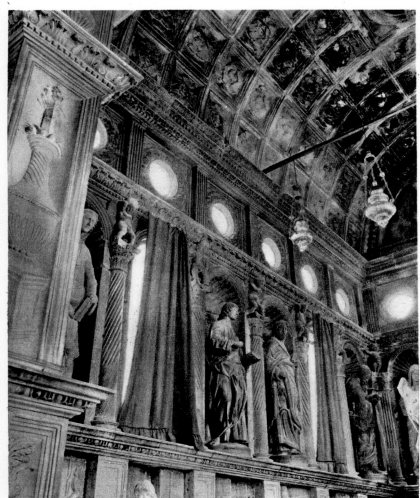

352

353

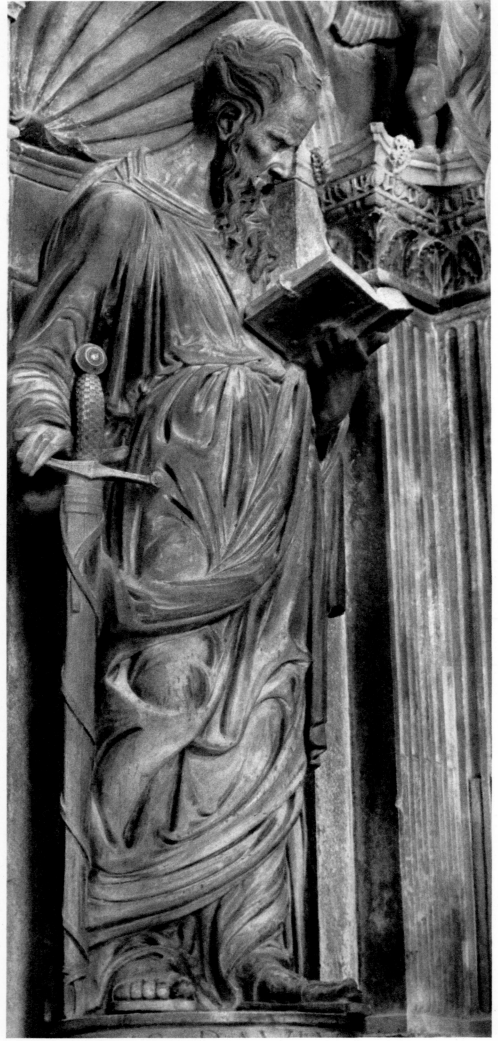

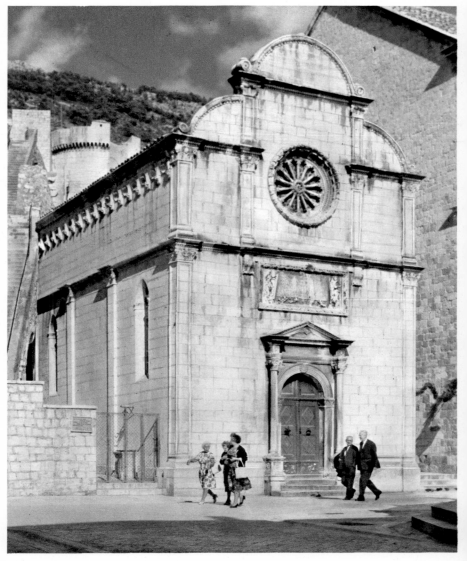

354 NIKOLA FIRENTINAC (NICCOLO FIORENTINO). *Figure of the Apostle Paul in the Chapel of St. John Orsini (Sv. Ivan Ursini), Cathedral of Trogir*

355 PETAR ANDRIJIĆ. *Facade of the Church of St. Saviour, Dubrovnik. 1520*

356 *The Sponza Palace (Divona building), Dubrovnik. Designed by Paskoje Milićević, constructed by members of the Andrijić family. 1516-22*

354    355

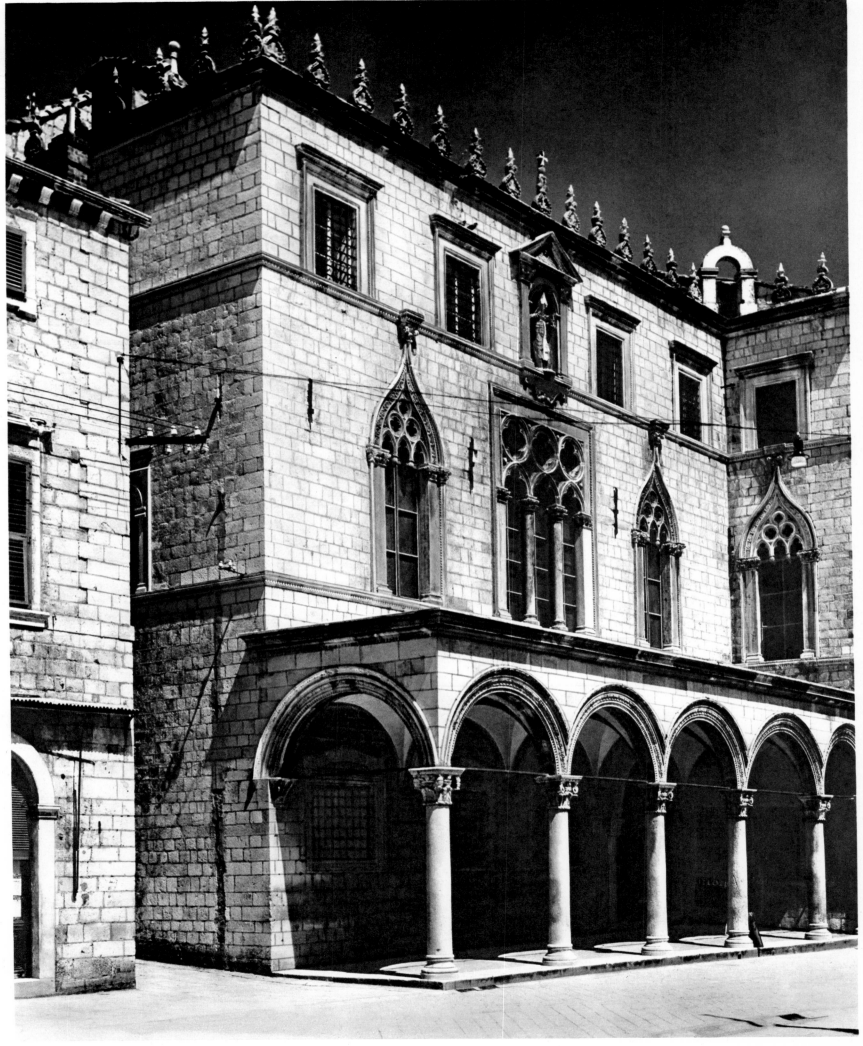

357

358

359

357 NIKOLA BOŽIDAROVIĆ. St. Martin on Horseback Sharing His Cloak with Christ Disguised as a Beggar. *Detail of polyptych, votive church of Danče, Dubrovnik*

358 LOVRO DOBRIČEVIĆ. Angel playing an instrument. *Detail of polyptych on the main altar, votive church of Danče, Dubrovnik. 1465-66*

359 MASTER KLERIGIN THE YOUNGER OF KOPER. *Detail of fresco on triumphal arch in the Church of St. Mary, Oprtalj, Istria. 1471*

360 JURAJ ĆULINOVIĆ (?). Virgin and Child. *15 3/8 × 11 3/4". Gallery of Art, Split*

361 TITIAN. St. Mary Magdalene with St. Blaise, Tobias and the Angel, and the Donor. *(The donor is traditionally identified as a member of the Pucić family of Dubrovnik.) Altar painting in the Dominican church, Dubrovnik*

362 MIHAJLO HAMZIĆ. St. Mary Magdalene and St. Mark. *Right wing of a triptych painted for the Lukarević family of Dubrovnik. Dominican church, Dubrovnik, 1512*

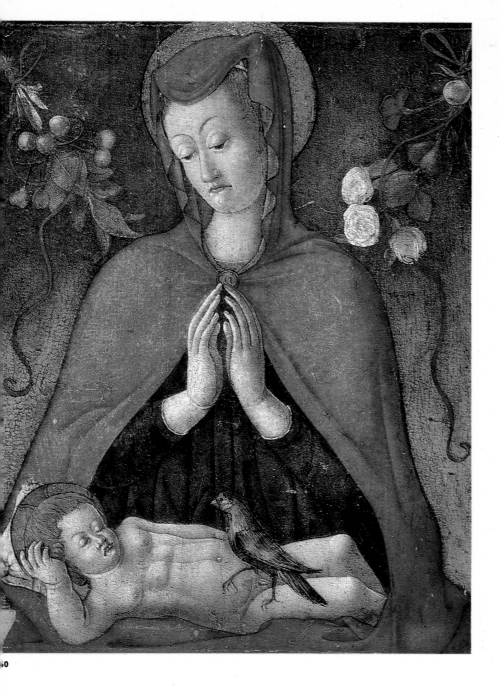

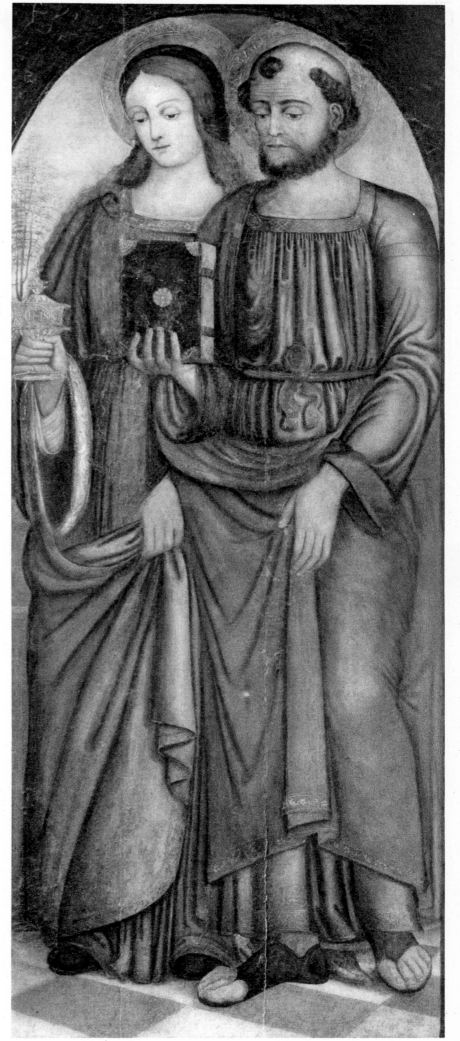

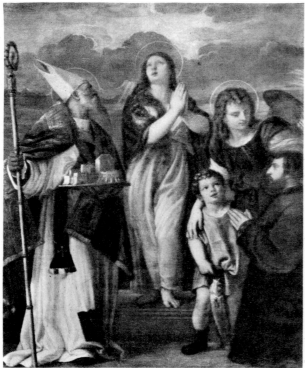

361

362

qui eduxit filios israel de
tra egypti. sz uiuit dns
qui eduxit 7 adduxit se
me domus israel de tra aq
lonis 7 de tris cunctis ad
quas eieceram eos illuc.
7 habitabunt i tra sua. Dic
dominus omnipotes. Eua
glin. Cu sbleuasz ihc o
culos. Require dnica 4
letari euagelio. Abiit ihc.
In dedicatioe ecclie a d. As
pges. ℣. Dnica nob. ℣. Domu
tuam dne decet sctitudo. Oro

Eus qui inuisibiliter
contines omnia 7 tam
p salute humani geneis i
signa tue potetie uisibilit
ondis. teplin hoc tue po
tetie ihabitantis illustr.
ut oes qui h depcat adue

pti. Oz dilect
tua domne uit
Eus qui
annos hu
tu consecrati
die. 7 sacs se
presetas icol
di sces ppli tu
quis hoc tepl
petitur igred
se impetiasse
Leo lib. apost
17 diebz illis.
te scam iherlin
uente de celo
sic sponsam o
suo. Et auo
gna de thron
ce thabernac
homimibz. 7 l
eis. Et ipi p

363 *Julije Klović (Giulio Clovio Croata). Page
of the Missal of Juraj de Topusko. Treasury of
the Cathedral of Zagreb*

364 The Adoration of the Magi. *Fresco. Church of
St. Primož, near Kamnik. 1504*

364

# XVI   THE BAROQUE

France Stelè

*Professor of Art History, Slovene Academy of Science and Arts, Ljubljana*

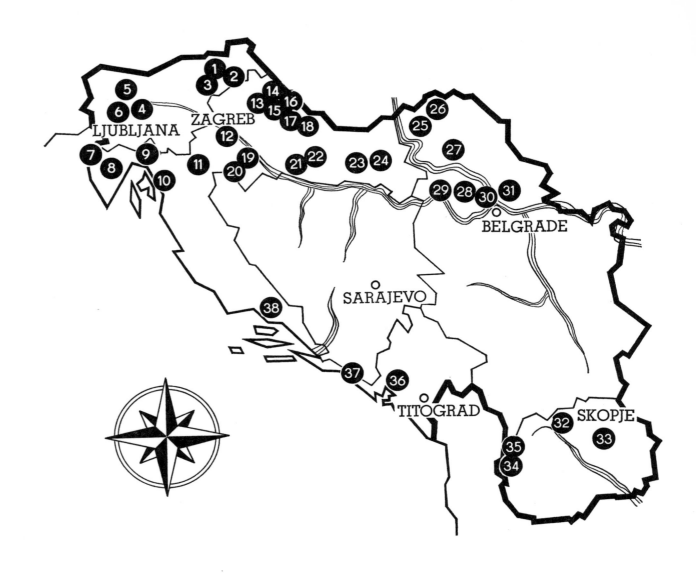

## BAROQUE MONUMENTS

*1*    *Maribor, Slovenj Gradec, Vuzenica, Ruše*
*2*    *Ptuj, Dornava, Slovenska Bistrica, Štatenberg*
*3*    *Celje, Sladka Gora, Rogatec, Marija Devica, Galicija, Petrovče*
*4*    *Ljubljana, Šmarna Gora, Limbarska Gora*
*5*    *Velesovo, Kamnik, Mekinje*
*6*    *Dobrova, Cerkno*
*7*    *Koper, Izola, Piran*
*8*    *Church of St. Peter in the Wood (Sv. Petar u Šumi), near Pazin*
*9*    *Rijeka, Trsat, Bakar*
*10*    *Senj*
*11*    *Karlovac*
*12*    *Samobor, Remete, Zagreb*
*13*    *Krapina, Belec, Church of the Holy Cross (Sv. Križ) in Medjumurje, Church of St. Mary of the Mountain (Sv. Marija Gorska) near Lobor, Trški Vrh, Vina Gora*
*14*    *Čakovec, Štrigova, Sv. Juraj*
*15*    *Lepoglava, Purga, Prelog*
*16*    *Koprivnica*
*17*    *Križevci, Majka Božja Koruška*

*18*    *Bjelovar*
*19*    *Sela*
*20*    *Petrinja*
*21*    *Nova Gradiška*
*22*    *Slavonska Požega*
*23*    *Djakovo*
*24*    *Osijek*
*25*    *Sombor*
*26*    *Subotica*
*27*    *Novi Sad*
*28*    *Jazak, Krušedol, Ruma*
*29*    *Sremska Mitrovica, Šišatovac*
*30*    *Zemun*
*31*    *Pančevo, Hopovo*
*32*    *Skopje*
*33*    *Lesnovo*
*34*    *Debar*
*35*    *Sv. Jovan Bigorski, monastery near Galičnik*
*36*    *Kotor, Perast, Dobrota, Gospa od Škrpjela (island with Church of Our Lady of Škrpjel)*
*37*    *Dubrovnik*
*38*    *Split*

The last universal style in the history of European art, the Baroque, asserted itself for the first time after the Council of Trent (1545-63) within the framework of a triumphant and militant Catholic Church. Rome, the Church's center, became also the starting point for all the influences that served as incentives to Baroque art. The first and most enthusiastic exponents of the new style were the Jesuits, a circumstance that led to its frequently being termed the Jesuit style. Owing to its explicitly representational character, and owing also to its compatibility with the tendency toward assuming a leading role in society — for these two reasons it was accepted by the ruling absolutists and adapted to their own representational purposes. In consequence, even the secular art of this epoch acquired many characteristic ecclesiastical and religious features. As a phenomenon in the history of art the Baroque may be described as a blend of the medieval mystical heritage and the rationalism of antiquity, welded together by a dynamic and zealous personal creativity that derived inspiration from the achievements of the High Renaissance. The Renaissance had drawn upon antiquity for artistic elements; the Baroque, freeing these elements of their static character, developed them further, molding them to suit its own exalted moods. It arrived at a synthesis of the sensory and the suprasensory, of the Christian view of the world and the humanism of antiquity; this is reflected above all in the iconographic syncretism of Baroque allegory and symbolism. It was in the Baroque that the sensuous, merging subtly with religious feeling and directed toward suprasensory experience, came to the surface. The artistic expression of the Baroque is dynamically tense and ecstatic: elements of the pathetic, the theatrical, and the picturesque contribute to the individual creation. Its supreme goal was the integrated work of art, a blend of architecture, sculpture, painting, and ornamentation. In this context, a role of great importance was assigned to illusionism in painting, which seemed to expand space, and to the stucco-like effect of relief, which seemed to efface the boundaries between architecture, painting, and sculpture in the round.

In its universality the Baroque was not confined to the sphere of art; it conveyed its message by subordinating to its means of expression the living environment of the time, from everyday objects to supreme achievements in applied and pure art. Similarly, the Baroque was not universal simply because it eradicated the line between the sacred and the profane — and in large measure also the line between the artistic aspirations of the Catholic and other religious communities — but also because it was truly international, even inter-class, in character. It is true that it was aristocratic in origin, but its release of the senses enabled the ordinary townsman, and the peasant as well, to adapt it to his own level of understanding. Accordingly, its universality was also reflected in its coming to represent, in the course of two centuries, the last characteristic national expression in the history of the European peoples and regions up to the present. Its significance in this sense was also subject to hierarchical gradation in keeping with the pattern of Baroque society, but the

*a. Deësis from a Pentecostarion printed in the Mrkša Church, 1556. Museum of the Serbian Orthodox Church, Belgrade*

transitions between the classes were nebulous, like those between artists in various mediums cooperating on a joint work. But the end product was such an integrated whole that even folk art, which drew inspiration from its own sources and tendencies, is not sensed as alien. Although religious features prevailed to the point where they impressed their stamp even on secular art, the two categories were so closely allied that finally the profane, particularly the element of the sensuous, penetrated, under all sorts of guises, into the clerical and ecclesiastical sphere in such measure as sometimes to take precedence over the sacred, especially in sculpture and painting.

In Italy the Baroque was launched at the turn of the sixteenth century; it passed through three stages: the early Baroque, from 1580 to 1630; the mature Baroque, from 1630 to 1730; and the late Baroque, from 1730 to 1800. Outside Italy, however, despite the fact that after 1600 the Catholic revival made rapid progress in other countries, circumstances did not favor its development at the same time and in the same way. Even in Italy its flamboyant development was checked in the north, especially in Venice and Vicenza, by Palladian Classicism. Abroad, the Baroque made the greatest headway in the Latin countries and in Catholic Central Europe. Drawing inspiration from their legacy of the plateresque style, Spain and its colonies in America fostered the picturesque fantasy of the Baroque, carrying it still further. In the seventeenth century the response to the Baroque in France — which for reasons of its own developed the Rococo in the first half of the eighteenth century but later reverted to Classicism — was lukewarm. Its militantly religious and mystical overtones caused Anglican England, Protestant Holland, North Germany, and the Scandinavian countries to reject the Baroque with even greater firmness; on the other hand, it was adopted wholeheartedly by the Central European countries, which took it a step further in terms of infinitely elaborated architecture and painterly illusionism. However, in the first half of the seventeenth century, Central Europe was in the grip of turbulent events. The religious wars (Thirty Years' War, 1618-48) and the pressure of the advancing Ottoman Empire shook it to its very foundations, leaving little room for the full flowering of the arts. It was only after the Treaty of Westphalia (1648) and the victory over the Turks at Vienna (1683) that obstacles to artistic activity were overcome. But the Baroque did not come into its own in Central Europe until the eighteenth century, at a time when it had already reached its pinnacle elsewhere: in Italy with the architecture of Bernini, Borromini, and Guarini, the sculpture of Bernini's school, and the illusionism in painting of Pietro da Cortona and

Andrea Pozzo; in Spain with Velázquez; in France with Mansard and Lebrun; in the Low Countries with Rubens and Rembrandt.

Central European Baroque was the final stage in the development of the Baroque art that had been launched in Italy. It is characterized particularly by its dependence, in sculpture and painting, on the Late Gothic development known as Gothic Baroque. This legacy merged with Borromini's and Guarini's architectural fantasies, and Pozzo's illusionism, into the common artistic product of the infinitely elaborated Baroque, which, with its pilgrimage and monastery churches, monumental monasteries, residences and palaces, figured significantly in enriching the cultural expression of South Germany, Bavaria, Austria, Bohemia, Slovakia, Poland, and Hungary, and even influenced the neighboring territories of Yugoslavia. The time span covered by Central European Baroque, if we include the Rococo, was about a century. (Developing French trends, Rococo was actually to achieve its real triumph in Central Europe.) In the closing decade of that century, however, the Baroque — here too — surrendered to Classicism.

Within the general context of Baroque art, the Yugoslav Baroque, in terms of geography, represents the extreme southeast periphery, the line where further penetration was obstructed by the boundaries of the Turkish Empire and the sphere of influence of Byzantine culture. The very position of these territories, as well as their history, gave the Baroque here specific characteristics. An important factor to be considered is the powerful Turkish pressure brought to bear on Central Europe by way of these areas. The first to throw off this pressure, at least in its direct form, was Slovenia, after the victory over the Turks at Sisak in 1593; Croatia, Slavonia, and the Vojvodina were subject to it until after 1683 and the conclusion of the Peace of Karlowitz (Karlovci) in 1699. Clearly, the Baroque could not assert itself either at the same time or in the same way in the various Yugoslav territories. Four areas must therefore be defined in dealing with this subject: Slovenia, Croatia and Slavonia, the Vojvodina, and Dalmatia (with Istria). The differences between them arise from the diversity of sources, the varying cultural and geographic conditions, and the wide range of social factors. In Slovenia, which was in a backwater between 1583 and 1683, the Baroque made headway only after 1693, when the learned society called Academia Operosorum was founded in Ljubljana. Two sources provided the impetus: directly, Italy, especially Venice, and indirectly, Central Europe, specifically Graz. Slovenian Baroque was thus invested with a dual character. The initiators were the Jesuits and their principal supporters, the lay and clerical intelligentsia and the feudal aristocracy. Of all the territories of Yugoslavia, only Slovenia established, in Ljubljana, its own secondary center, possessed of a sufficient number of artists and craft workshops to cover all branches of activity in the arts. The sphere of influence of the Ljubljana center included the entire area inhabited by Slovenes and tended to expand southward toward the Croatian seaboard and southeastward up to and including Zagreb. Stylistic trends reached Croatia via Ljubljana and Maribor (that is, from Graz); to this may be attributed the interesting difference between the Baroque in Medjumurje and Hrvatsko Zagorje on the one hand and Zagreb and the western districts on the other. These influences were introduced by the Jesuits, too, and later furthered by the Cathedral clergy and the Franciscans; works were commissioned by the Church, the nobles, and the townspeople. Hungarian Baroque was the paramount stimulus to the style in the Vojvodina, works there being commissioned both by the Church and by the laity. Italy, with Venice in the forefront, was primarily responsible for the penetration of Dalmatia and Istria by the Baroque, but the influence of the Ljubljana center was also notable in Istria and along the Croatian coast, the chief patrons there being the Church and the townspeople.

The Baroque was destined to attain its fullest development in Slovenia, which, after the defeat of the Turks at Sisak in 1593, enjoyed so great a degree of security that the Thirty Years' War and the Turkish invasions no longer represented a direct threat. The first to

*b. Ceiling in the town palace of the Counts of Celje, in Celje. c. 1600*

disseminate the new artistic style there after the reaction to the Reformation were the Jesuits. In the second half of the seventeenth century they were followed by the newly established nobility, the clergy, and the urban intelligentsia, educated in Italy, who succeeded in raising the prestige of the new trend from the middle of the century onward. The year 1693 is considered to mark the nascence of the Ljubljana Baroque, for it was in that year that the Academia Operosorum was founded and turned its attention to the arts. After the founding of the Academy, Ljubljana became a beehive of artistic activity, directed by a company of patriotic, European-educated intellectuals from diverse classes. This guiding circle acted in close association with artists from a variety of workshops, linked by ties of family, religious brotherhoods, and guilds. These workshops, the focus of art and craft activities, proceeded to develop their own traditions — the most reliable indication of leadership in such a center. Attesting to their achievement is the uninterrupted hundred-year history of the Ljubljana Baroque, which may be divided into three stages: the initial period, the mature period, and the period of moderate Classicism. The three branches of art — architecture, painting, and sculpture — developed along parallel lines.

As in other parts of Central Europe, the launching of the new style in Ljubljana was influenced by Italian workshops in which Slovene artists and craftsmen had been trained; the second generation, however, received its education at home. In architecture the Baroque got under way with the construction of a new cathedral designed (1761) by an Italian painter and architect, Andrea Pozzo; the Križanke (the Church of the Teutonic Order of the Knights of the Cross), designed by a Venetian, Domenico Rossi; and the Ursuline Church, *Pl. 369* constructed by an anonymous Palladian-oriented architect from North Italy. The last in the series was the parish Church of St. Peter, designed by Fusconi. In painting, Giulio Quaglio, who painted the frescoes on the cathedral vaulting, had a decisive influence on the transition to the new style and particularly on the originator of the Slovenian brand of illusionism, Franc Jelovšek. Mihael Kusa (Cussa) and Luka Mislej headed enterprises that, working hand in hand with Venice and Padua, fulfilled commissions for marble statues as well as marble altars and other church furnishings. Kusa imported to Ljubljana and

*c. Prince Lazar, woodblock print. 17th century.*
*Museum of the Serbian Orthodox Church, Belgrade*

incorporated into his own compositions sculptures purchased in Venice. Mislej, in his Ljubljana workshop, employed Angelo Pozzo and Jacopo Contieri of Padua and executed commissions in conjunction with them; the most significant are the monumental portal with atlantes for the Seminary, and the altar for the Chapel of St. Francis Xavier in the Church *Pl. 367* of St. James. In the 1720s, local artists trained in the Italian manner or in Italian workshops began to assert themselves. The foundations for Ljubljana's Baroque architecture were laid between 1710 and 1740 by Gregor Maček, whose major achievements include the Magistrates' Court in Ljubljana and churches in Dobrova, Šmarna Gora, Cerkno, and Limbarska Gora. Maček's architecture, following Italian models and drawing upon the legacy of local tradition, was enriched with motifs from Štajerska by his son-in-law, Mathias Persky; this trend was continued by his disciple L. Prager (who later married Persky's widow) and by his son, Ignac, also an architect. Fresh motifs from Central Europe were introduced into Ljubljana's architecture by J. G. Schmidt; the transition to Classicism in architecture was effected by Daniel Gruber and J. Schemerl. Testimony to the work of these masters is provided by churches in Groblje, Gornji Grad, Velesovo, and Tunjice *Pl. 377* and by Goričane castle and numerous mansions in Ljubljana.

In painting, four names stand out, after Quaglio's, in the annals of the Ljubljana Baroque: those of the illusionistic fresco painter Franc Jelovšek, of the naturalized French artist Valentin Metzinger, of Fortunat Bergant, and of Anton Cebej. In the seventies they *Pl. 371* were joined by an Austrian, M. J. Kremser-Schmidt, who was responsible for an important series of altar paintings in Velosovo and elsewhere. The Baroque was continued into the first two decades of the nineteenth century by Leopold Layer and Janez Potočnik.

Baroque sculpture in Ljubljana reached its high point in the work of Venetian-inspired Francesco Robba; the son-in-law of Luka Mislej, he directed the Mislej workshop after *Pl. 368, 365* that artist's death. Robba's principal works in Ljubljana are the *Fountain of the Carniolan* *Pl. 366* *Rivers,* the main altar in the Church of St. James, the main altar in the Ursuline Church, and two angels on the altar of the Holy Sacrament in Ljubljana Cathedral. In the middle of the century he moved to Zagreb, where he died; worthy of note are the altars he fashioned

for the cathedral and the Church of St. Catherine in that city. A particularly fine altar by Robba is that in the Church of the Holy Cross in Križevci. Robba's workshop was taken over by his associate, Franz Rottmann, who executed a number of works for Slovenia, Zagreb, and Klagenfurt in Austria.

The art of carving in wood also flourished, thanks to the functioning of the Tyrolean- and Bavarian-inspired Franciscan workshop in Ljubljana (principal work: the main altar at Mekinje) and the workshop of H. M. Löhr.

Another Baroque focus for Slovenia was the Austrian city of Graz, which developed into a center of considerable importance under Italian influence in the seventeenth century; in Slovenian Štajerska the influence of Graz mingled with that of Ljubljana. Under the sway of Austrian and South German development there was introduced into architecture an exuberant type of structure which also had its effect on Ljubljana, through the medium of the architects mentioned above. The efforts of the aristocratic Attems family of Graz were largely responsible for the construction, in Slovenian Štajerska, of a number of important castles, outstanding among them those of Slovenska Bistrica, Štatenberg (by the architect Camesini), Dornava (by the architect J. L. Hildebrandt and associates), Bre-

*Pl. 372*
*Pl. 370*
žice. Another structure of note is the Rococo addition (1744), with decorated stairway, to the castle of Maribor. Distinctive among the monasteries are the Minorite monastery in Ptuj, with its marvelous refectory, and, for its facade, the former Dominican monastery (now a museum) in Ptuj. Of the churches, Sladka Gora stands out for its picturesque exterior and its effective blend of sculpture and painterly illusionism. The most distinguished of the local architects was Johann Fuchs of Maribor, who designed the Church of St. Aloysius in Maribor and the Church of St. Peter in Kronska Gora.

In painting, the dominant group was the circle of altar painters and illusionistic painters around the Attems family: J. B. J. Raunacher, J. C. Vogl, Wolf Weissenkirchner, I. F. Flurer, Joannecky, and others. The group was centered in Graz, and impressive works by them have been preserved in the castles of nearby Slovenska Bistrica and Brežice. The influence of the Croatian form of Paulist illusionism is discernible in Olimlje, Rogatec, and Pesek (Church of the Holy Virgin). Of the local painters' workshops, two hold a place of importance in Slovenian Štajerska: the first in the town of Slovenj Gradec, where the altar painters, portraitists, and landscape artists F. Mihael and J. A. Strauss worked in the eighteenth century, the other in Rogatec, where worked the illusionistic painter A. Lerchinger, whose works are to be found in Petrovče, Grad near Slovenjgradec, Glažuta near Celje, Olimlje, Trški Vrh in Croatia, and elsewhere.

In sculpture, Maribor was important as a secondary center associated with Graz and Vienna; its workshops — the major ones being in the hands of F. K. Reiss, J. Straub, and Jožef Holzinger — served a large part of southern Štajerska. All the workshops were allied, either through their work or by family ties, with the great families of sculptors: Schoy, Messerschmidt, Königer, and Schokotnigg in Graz and Vienna, whose combined output represents an important chapter in the history of Central European Baroque sculpture. Minor workshops more accessible to people on all levels were those in Ptuj and Celje (Ferdinand Gallo and J. G. Božic), in Konjice (M. Pogačnik), in Rogatec (J. Mersi), and Slovenj Gradec; the largest of these were the workshops in Rogatec and Slovenj Gradec. The workshops in Maribor and Graz also supplied neighboring Croatia.

In Slovenia the Baroque tendency also expressed itself in characteristic folk-art forms. Painting on glass was one such expression; another was the decoration of wooden beehives, a feature of the Slovenian landscape, for the Slovenes have always been famous apiarists. The painting and carving on the front panels of numberless beehives give evidence of the Baroque impulse at work.

Croatia was to experience the Baroque intensely only after the threat of Turkish invasion had been lifted, that is, after 1683. The true flowering of the style in Croatia paralleled

that in Slovenia in the eighteenth century. Currents reached Croatia from Slovenia, especially through the center in Ljubljana, and also to some extent from Maribor and Graz; in Medjumurje, Hungarian influence must also be taken into account. As in Central Europe and Slovenia, the Baroque was a universal phenomenon in Croatia. The first proponents in the seventeenth century were the Jesuits (Zagreb: Jesuit college and monastery and Church of St. Catherine), and in the eighteenth century the Franciscans and Paulists (the Order of St. Vincent de Paul). The type of church architecture favored by the Jesuits included the characteristic vaulted hall, flanked on both sides by chapels. In this category, along with the Church of St. Catherine in Zagreb, are the Franciscan churches in Krapina, Varaždin, Samobor, and elsewhere. Among the Gothic structures with Baroque elements is the Paulist church in Lepoglava. The eighteenth century saw the building of larger and more elaborately planned structures, more definitely Baroque in type, such as Our Lady of the Snows in Belec, St. Jerome in Štrigova, the Holy Cross in Medjumurje, the Holy Virgin of Carinthia, near Križevci. The Church of St. Francis Xavier and the Church of St. Mary in Zagreb are domed. A bell tower at the west end gives the exterior of some churches a special accent (Slavonska Požega, Church of St. Theresa; Petrinja; Bjelovar); other churches (St. Michael in Osijek, St. Jerome in Štrigova, St. Mary Magdalene in Sela, near Sisak, and the Holy Virgin of Carinthia, near Križevci) have two bell towers.

Pl. 384

Pl. 382, 383

A peculiar feature of the Baroque in Croatia is the *cinktura,* a defensive wall built of masonry, typically encircling a pilgrimage church (St. Mary Gorska, near Lobor; the Holy Virgin of Jerusalem in Trški Vrh, near Krapina; Our Lady of the Snows in Belec; St. Mary in Vina Gora, and St. George in Medjumurje). In Zagreb, Varaždin, Slavonska Požega, Samobor, Krapina, Križevci, and elsewhere, Baroque town planning made such remarkable advances that it fundamentally changed the appearance of streets, squares, and entire neighborhoods. Monasteries, law courts, castles, administrative buildings, and obelisk-like memorials enriched the appearance of these towns, frequently with monumental effect. In addition to the Jesuit college and monastery in Zagreb, mention should be made of the Jesuit monastery in Osijek, the Paulist monastery in Lepoglava, and the Franciscan monasteries in Vukovar, Slavonski Brod, Osijek, and Krapina. Among other Baroque structures deserving of attention are the episcopal palaces in Zagreb and Djakovo, the Oršić-Rauch mansion in Zagreb, the administrative buildings in Križevci, Slavonski Brod, and Varaždin, the new palace in Čakovac, and a number of mansions in Varaždin.

Pl. 375

An entire chapter might well be devoted to the architecture that emerged in the seventeenth and the first half of the eighteenth century in the centers of the military border area established as a buffer zone to protect Croatia and Slovenia against Turkish incursions. These planned settlements are notable for their layout, with streets intersecting at right angles and rectangular plazas in the centers of the towns, around which more important public buildings are ranged (Bjelovar, Nova Gradiška, Sisak, Petrinja, Osijek). Particularly remarkable were the star-shaped fortifications constructed, for instance, in Varaždin, Koprivnica, Osijek, and, especially, Karlovac.

For its painting and sculpture, western Croatia, including Zagreb, drew upon the workshops in Ljubljana, Graz, and southern Štajerska. All four of the leading Ljubljana painters carried out commissions from Croatia: Fortunat Bergant executed works for Lika and the Croatian coast; Franc Jelovšek and his son Andrej were responsible for the largest Baroque altarpieces in the Church of St. Catherine in Zagreb and the Franciscan church in Samobor; Valentin Metzinger executed altar paintings for Zagreb, Samobor, Karlovac, Bakar, and Trsat, and Anton Cebej for the Church of St. Mary in Zagreb. The Franciscan sculpture and wood-carving workshop in Ljubljana is represented by sculptures and altar complexes in the Franciscan monastery churches in Samobor, Karlovac, Trsat, and Senj. Francesco Robba executed a number of his most important works for Zagreb Cathedral and the Church of St. Catherine in Zagreb, while his successor, Franz Rottmann, supplied the Church of St. Mary in Zagreb with its altars. The pulpit in Zagreb Cathedral is one of the most distinguished works of Mihael Kusa.

In Croatia, the Order of St. Vincent de Paul fostered independent activity in painting and sculpture. A Tyrolean member of the order, Ivan (Johann) Ranger, distinguished himself as an illusionistic painter (Our Lady of the Snows, Belec; Lepoglava; Purga; Remete). Wood-carving and sculpture workshops of the Paulist order produced Baroque ecclesiastical furnishings: altars, pulpits, and the like. In addition to the churches in Lepoglava, Belec, and certain other localities in the Zagorje area, these wood carvings enriched the Paulist Church of St. Peter in the Wood in Istria.

The major early Baroque painter of Croatia was Bernardo Bobić; working in association with the Ljubljana painter Ivan Eisenhort, he painted and gilded the altar of the Madonna in the Cathedral of Zagreb and in 1688 he also painted for it six scenes from the life of the Madonna. In the same year he accepted a commission for twelve paintings illustrating the life of St. Ladislas; these indicate that Venetian influences, transmitted to him, perhaps, by his associate from Ljubljana, had a strong bearing on his development.

*Pl. 381*

Influences from Graz and Slovenian Štajerska affected the painter A. Lerchinger and the sculptor Mersi of Rogatec, to judge from their work in the church at Trški Vrh, near Krapina. The altar for Virovitica was executed by Jožef Holzinger of Maribor, and the exceptionally fine altar in the parish church in Prelog by Veit Königer of Graz.

Despite its dependence on outside art centers, Croatian Baroque acquired sufficient special features of its own to warrant its recognition as a specific entity on the map of Baroque art.

The political and cultural links of Dalmatia and the Istrian seaboard with Venice, and the particular artistic inclinations resulting in considerable measure from their marginal position in respect both to Venice and to Croatia as a whole, gave the Baroque in these areas a character different from the Baroque of Croatia and Slovenia. Less favorable economic conditions in the period under consideration precluded the commissioning of large-scale works of art; in consequence, the Baroque style is more manifest in individual examples than as an all-embracing phenomenon. The general attitude of reserve toward Baroque flamboyance may be attributed in large part to the influence of Venice, where Baroque exuberance was checked by Palladian Classicism. Despite the Baroque mansions and church furnishings and decorations in Koper, Izola, Piran, Rijeka, and elsewhere, it cannot be

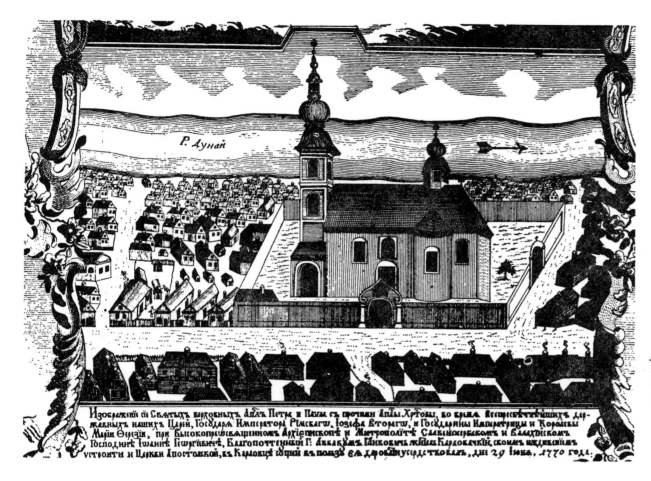

*f. Zaharije Orfelin.* SS. Peter and Paul with Church of the Apostles in Sremski Karlovci, *detail. 1770. Copperplate engraving. Gallery of the Matica Srpska, Novi Sad*

claimed that on the Istrian seaboard the Baroque overshadowed the ubiquitous Venetian Gothic and Renaissance features. The most notable Baroque monument in Istria, the Church of St. Vitus in Rijeka (a rotunda), is in a way a distant relation of Baldassare Longhena's Church of Santa Maria della Salute in Venice. *Pl. 380*

Like Istria, Dalmatia also reacted with restraint toward the Baroque in architecture, sculpture, and painting. The highly developed stonecutters' craft in the area made it possible, however, to execute in solid fashion even modest architectural projects like the construction of small churches, the summer residences in the vicinity of Dubrovnik, and houses for prominent families such as were erected, after the earthquake of 1667, in Kotor and other towns (Perast, Dobrota) on the Gulf of Kotor (Boka Kotorska). Four Venetian architects worked in the area: Giovanni Fonta, Giuseppe Beati, Bernardino Maccarucci, and Bartolo Riviera. An outstanding example of the Baroque is the interior of the Church of St. Anastasia in Dobrota. In the closing decades of the eighteenth century, Nikola Foretić, in the church of the Savina monastery, blended elements of the Baroque style, Byzantine art, and local traditions, with fascinating results. Dubrovnik experienced an upsurge of building activity after the great earthquake of 1667, when the main street, the Stradun, was reconstructed in solid, monumental, though modest, fashion on the basis of designs by the architect Cerutti (il Colonnello), from Rome. A new cathedral was constructed in the eighteenth century, designed by Andrea Buffalini; to the same period belong the Church of St. Blaise, built by a Venetian, Marino Gropelli (1706-14), and the Jesuit Church of St. *Pl. 386, 388* Ignatius by Andrea Pozzo. A noteworthy urbanistic motif is the monumental stairway (by the Italian architect Padalacqua) leading to the square on which the Jesuit church faces.

Venetian imports accounted for most of the sculpture. Statues and altars were executed by Francesco Gai, Antonio Cappellano (of Genoa), Giovanni Bonazza, Francesco Cabianca, and G. M. Morlaiter (altar of St. Doimus in Split Cathedral).

Painting, too, depended upon Venice (G. B. Piazzetta, Francesco Fontebasso, G. Ricci, Cristoforo Tasca), and it only rarely achieved significance. Among the more notable local artists were Matej Ponzoni (Pončun) and Tripo Kokolja, responsible for the paintings in the Church of Our Lady of Škrpjel in Boka Kotorska, who took his inspiration from the Venetian painter Palma Giovane.

After the great emigration of the Serbs from Hungary to the Vojvodina in 1690, the Baroque began to make itself felt in this region in works commissioned by wealthy burghers, not only in secular but in ecclesiastical art. This held true especially for architecture. The characteristic bell towers of the Vojvodina arose (Krušedol, Velika Remeta, Šišatovac, *Pl. 387* Hopovo, Jazak), old churches were reconstructed in the new style, and new churches were built (Grabovac, Šišatovac, Fenek). The most noteworthy of the newly erected churches is the cathedral in Sremski Karlovci (1758-62). Differences between the exteriors of Roman Catholic and Orthodox churches diminished considerably. Mansions and residences for prominent families were constructed in the new style: the Andrejević house in Sremski Karlovci, the Gražalković house in Sombor, and the Karamata house in Zemun, to mention only a few. Baroque urban planning took firm hold in Novi Sad, Subotica, Zemun, Sremski Karlovci, Ruma, Sremska Mitrovica, and other towns. Between 1754 and 1780 the largest fortress in the area was erected, at Petrovaradin.

Also highly developed as an art was wood carving, applied in the production of iconostases, choir stalls, and other complements to church architecture. The work in this medium of Marko Gavrilović of Pančevo and his sons is highly esteemed. Outstanding examples are the iconostases in churches in Sremska Mitrovica, Sremski Karlovci (cathedral), Novi Sad (Church of the Ascension), and Zemun (Church of St. Nicholas, Church of Our Lady).

Figuring significantly as a manifestation of the Baroque of the Vojvodina are the en- *Fig. f* gravings of Hristifor Žefarović and of Zaharije Orfelin (who received his training in Vienna and in Venice). In painting, the conservative trend persisted, but a trend away from traditional painting toward freer Baroque creativity is noticeable in the works of Hristifor *Pl. 385* Žefarović and Amvrosije Janković. The mid-eighteenth century saw the appearance of itinerant painter-artisans specializing in icons, historical scenes, still lifes, and portraits. Among the more skilled portraitists were Stephan Tenecki and Nikola Nešković. The younger artists trained in local workshops began going to Vienna and Venice for further training, which signified the definitive triumph of the Baroque. The principal representa- *Pl. 46, 389* tive of the style was Teodor Kračun; close to him were Teodor Ilić Češljar and Georgije Tenecki. In the paintings of Jakov Orfelin the transition to Classicism can already be perceived.

In eighteenth-century architecture, on which local builders worked alongside their German and Italian colleagues, and in painting and wood carving, which were the exclusive domain of local masters, Baroque and Byzantine elements frequently coexisted, the result being a peculiar syncretism which deserves attention as an expression of Baroque art in a single province.

The development of wood carving in the Vojvodina was paralleled, indeed surpassed, in Macedonia; in Debar an even more significant school of wood carving, which reached its peak in the first half of the nineteenth century, achieved fame throughout the Balkan Peninsula. With its use of floral, animal, and figural motifs, varied in accordance with the promptings of fertile imaginations, this style was more reminiscent of the wood carving of the early Baroque in the seventeenth century than it was of the mature Baroque. Most outstanding was the workshop of Petar Filipović, which produced iconostases for St. Michael's Church in Lesnovo (1811-14), for the Church of the Holy Saviour in Skopje (1819-24), and for the Monastery of St. John Bigorski (1830-40), near Galičnik.

365

365 *Francesco Robba. Allegorical figure, detail
of* The Fountain of the Carniolan Rivers,
*Ljubljana (shown in Plate 368)*

366

367

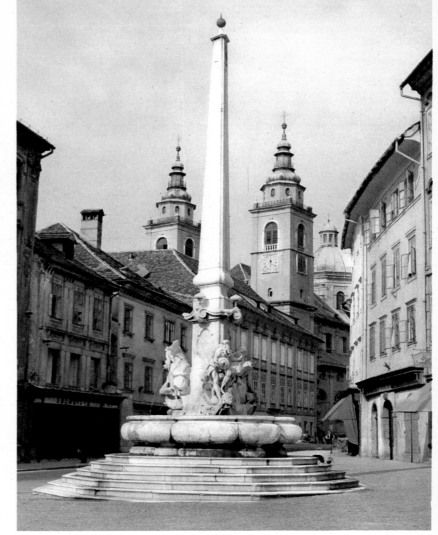

368

366 FRANCESCO ROBBA. *High altar in the Church of St. James, Ljubljana. 1732*

367 ANGELO POZZO and LUKA MISLEJ. *Portal of the theological seminary, Ljubljana. 1714*

368 FRANCESCO ROBBA. The Fountain of the Carniolan Rivers, *Ljubljana, 1751 (inspired by Bernini's* Fountain of the Four Rivers *in the Piazza Navona, Rome). Seen in the background, the Cathedral of St. Nicholas, designed by Andrea Pozzo, 1700-1707, with bell tower by Giulio Quaglio and dome (1841) by Matej Medved*

369 UNKNOWN NORTH ITALIAN ARCHITECT. *Facade of the Church of St. Ursula, Ljubljana. c. 1720*

370 *Staircase in the castle of Maribor with sculptures by an unknown sculptor from Štajerska dating from the mid-18th century. In the foreground, Diana, the allegory of summer*

370

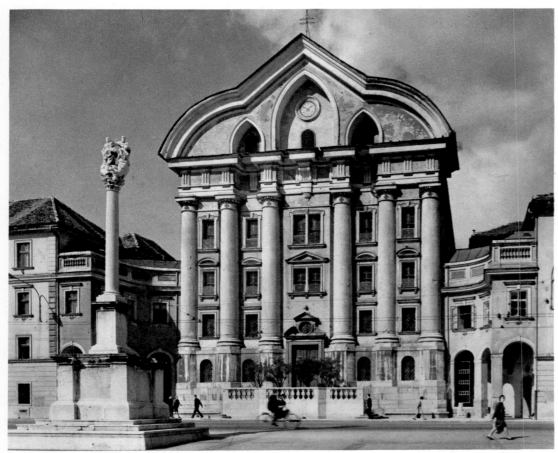

369

371

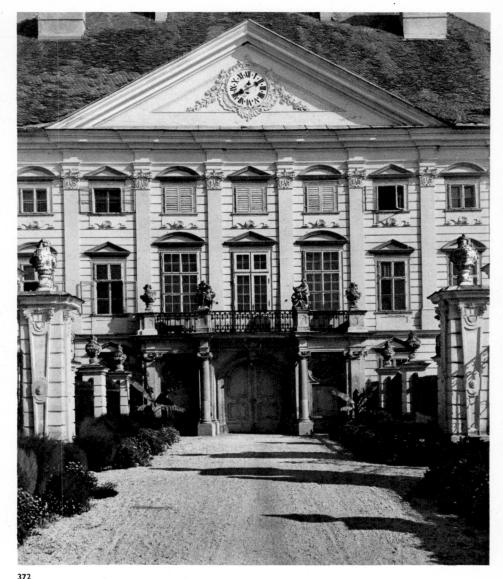

372

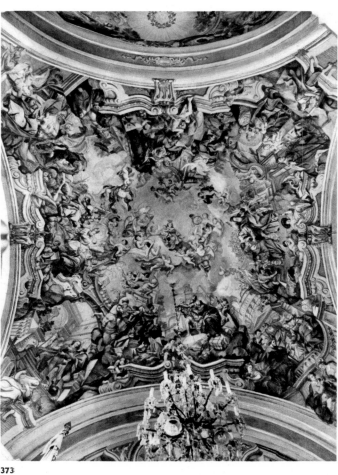

373

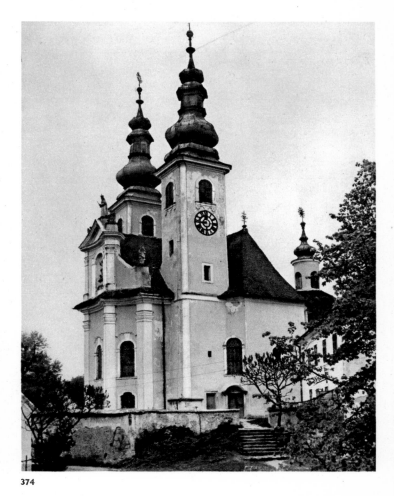

374

371 FORTUNAT BERGANT. Portrait of Volbenk Daniel Erberg. *Oil on canvas, 43 1/4 × 33 1/2". National Art Gallery, Ljubljana*

372 Main facade of the castle, *Dornava, near Ptuj, by an Austrian architect in the circle of Johann Lucas Hildebrandt. 1739-45*

373 FRANC JELOVŠEK. The Glorification of the Virgin, *interior of the dome, parish church, Sladka Gora (shown in Plate 374)*

374 Parish church, Sladka Gora, *by an unknown architect from Štajerska. c. 1758*

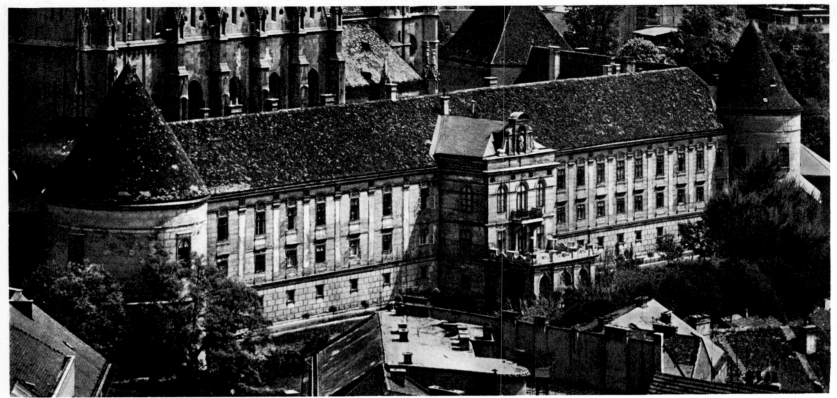

375

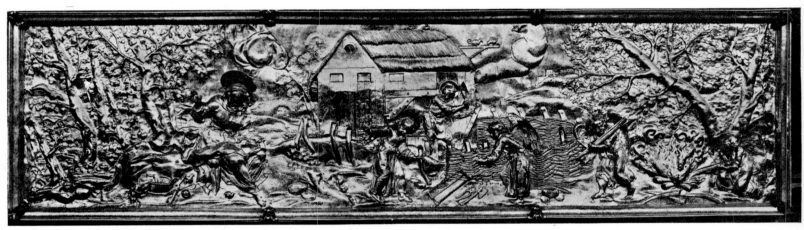

376

377

378

379

375 *Archbishop's Palace, Zagreb, enclosed on three sides by wall dating from Renaissance times. c. 1730*

376 G. C. MEICHEL. *Silver relief with a scene from the childhood of Christ, a panel on the main altar of the Cathedral of Zagreb. 1721*

377 *View of interior of the church in Velesovo, built by Gregor Maček and associates, 1732-71, showing pulpit and altar, c. 1770, and painting of the Annunciation by Martin Johann Kremser-Schmidt, 1773*

380

381

378 *Scene of the battle of St. Ladislas and the Cumans, detail of Plate 376*

379 FEDERIKO BENKOVIĆ. The Sacrifice of Isaac. *Oil on canvas, 87 × 65″. Strossmayer Gallery of Old Masters, Zagreb*

380 *Church of St. Vitus, Rijeka, designed by a Venetian architect*

381 BERNARDO BOBIĆ. Helen Entreating Ladislas for Help, *one of a cycle of ten pictures painted by this artist for the altar of St. Ladislas in the Cathedral of Zagreb. c. 1690. Museum of the City of Zagreb*

382

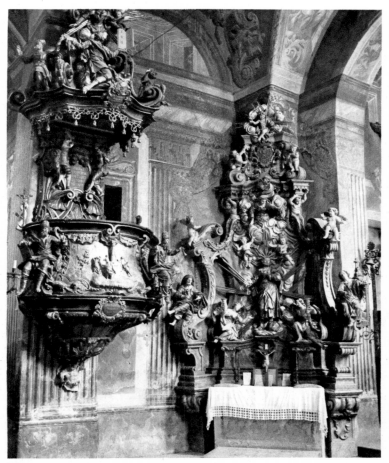

383

384

385

386

387

388

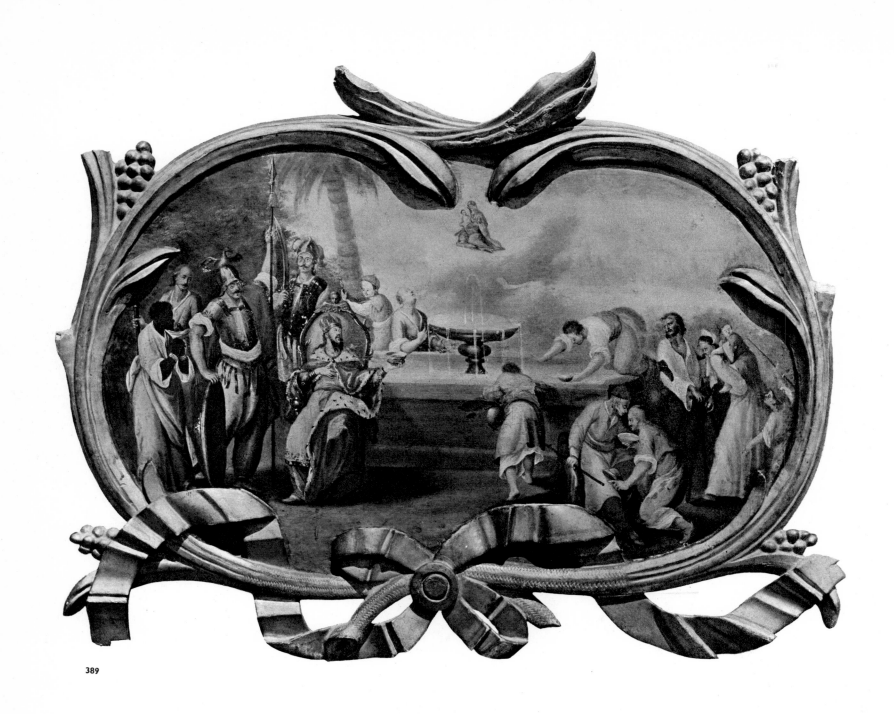

389 *Teodor Kračun.* The Source of Life. *c. 1770.*
*Oil on wood, 21 1/4 × 30 1/4". Gallery of the*
*Matica Srpska, Novi Sad. Collection Serbian*
*Orthodox Church*

# XVII   THE NINETEENTH CENTURY

Dejan Medaković
*Professor of Art History, University of Belgrade*

The Yugoslav regions were the scene of turbulent events during the nineteenth century. The western portions of the country, which were included in Napoleon's Illyria, emerged from that episode, despite its short duration, acquainted with the progressive aspirations of middle-class society; in the east, the process of breaking free from centuries of Turkish domination got into full swing, and in the ensuing rebellions and uprisings the Serbs took their place on an equal footing in the process of driving the Ottomans out of Europe. As a result of these heroic events, the first free states, after an interlude of several centuries, reappeared on Yugoslav territory — Serbia and Montenegro. The middle classes, both in the east and in the west, gradually shattering the old and outdated Austrian and Turkish feudal system, underwent a process analogous to the development then under way throughout Europe.

The awakening of a national consciousness and a feeling for and understanding of the common destiny binding all the South Slavs, a romantic, exuberant interest in the discovery and exaltation of their own values (above all in respect to folk poetry), the upsurge of Pan-Slav solidarity, the formation of political parties and movements, the foundation of scholarly societies for the study of their own past, the appearance of a number of major literary figures, among them the three titans France Prešern (1800-1849), Ivan Mažuranić (1814-1890), and Petar Petrović Njegoš (1813-1851) — all these phenomena bear witness to a rapid national development, to the deliberate and conscious resistance to any attempt to keep the dreams and desires of the Yugoslav peoples trammeled within the narrow and oppressive confines of existence as an Austro-Turkish province. On all sides, throughout every Yugoslav region, the nineteenth century saw the disintegration of these rigid, conservative confines. In this building of a modern society many victims were claimed; the national forces, once activated, were no longer to be halted in their drive to realize the great ideal of political and spiritual liberation.

Quite understandably, nineteenth-century art in these areas faithfully reflected the social and political unrest. The problems involved in transcending provincial limitations and traditionalistic restraints are easily discernible in the works of the artists of the period. Much as in Austria, the full development of bourgeois painting was in opposition to the long and tenacious tradition of feudal Baroque art. Until well into the nineteenth century the Church, as sponsor and patron, was able to exact fulfillment of its demands; not until the rise of the newly worked out formulas for religious art of the Nazarene school could the long life of Baroque church painting in these regions be terminated. As in the more developed art centers, at the end of the eighteenth century, masters had emerged here whose concepts were close to those of the Classicists. In their adoption of subjects from antiquity, their descriptive draftsmanship, their clarity of composition, their replacement

*a. Dimitrije Avramović.* Expression of Suffering or Compassion. *1832. Ink, 10 1/4 × 10 3/4".* National Museum, Belgrade

of the earlier flamboyance of Baroque colors by a restrained palette, and their emphasis on the more plastic values, we see the qualities proclaimed by Jacques Louis David in his *Oath of the Horatii* of 1785. The Slovenian painter Franc Kavčič (1762-1828), working in this spirit, poured his highest aspirations into his large-scale paintings with the clear intent of bringing his program of work into conformity with the celebration of the middle-class virtues. His scenes from antiquity *(Phocion and the Women)* stand out for their confident composition and drawing, qualities that are also fully evident in his excellent pen-and-ink sketches *(The Wedding Contract, The Fall of Troy).*

This form of Neoclassicism reached the Yugoslav area primarily from Vienna, and only in isolated cases from other centers — from Rome, for example, whence Rafo Martini (1771-1846) and Carmelo Reggio (died 1813?) brought it to a Dubrovnik in decline, to be imposed there as an artistic ideal. However, the artistic bond with Vienna — then the only real tie with the cosmopolitan world — was to be fatal to art in Yugoslavia for a long span of years. In these regions the "Viennese manner" was indelibly stamped both on Classical art and, with even more fateful consequences, on Romantic art. By 1815, just as the Napoleonic threat that had swept over this traditionalistic and multi-national area was ending, Vienna had evolved its own special variant of Classicism, which the satirists of 1848 were to call "Biedermeier" to mock the now blunted but once militant social ideals of the German bourgeoisie. The one-time champions of the restriction of feudal rights, now enriched by the growth of industry and capital, soon modified the artistic — as they had other — ideals of their times. The earlier severity of form was gradually lost: in portraits, realistic immediacy and simplicity began to give way to minor decorative elements. Suddenly, the powerful *nouveaux riches* required idealization, the use of glazes and monochrome grounds in painting, while the importance of the personage represented was brought out in draperies, jewelry, incidental landscapes, and architectural backdrops. Against these carefully staged settings, materialistic values reached their peak.

But if society in a large metropolis such as Vienna craved this type of painting — and

those who bowed to these demands included Friedrich von Amerling (1803-1887), M. M. Daffinger, Josef Kriehuber, and F. G. Waldmüller, all of them teachers looked up to by the Yugoslav painters of the period — it was clear that once again all the conditions had been created for curtailing the latent capabilities of the faithful pupils in the workshops Nevertheless, no Viennese prescriptions for painting, no rigid academic program, proved capable of entirely stultifying a certain inborn talent in Yugoslav painters, that specific feeling for color native to this time-honored region of the arts — a land that had once belonged to antiquity, where Byzantine art demonstrated the durability of its spiritual quality, where the plasticity of Romanesque had blossomed richly, where, in the Dalmatian communes, the great masters of the Italian Renaissance had found patrons, and finally, where, in the Danube basin, an utterly distinctive synthesis of Byzantine and Baroque painting had emerged. These painters — among them Josip Tominc (1790-1866), Matevž Langus (1792-1855), Vjekoslav Karas (1821-1858), Arsa Teodorović (1767-1828), Pavel Djurković (1772-1830), Pavle Petrović (1818-1856), Katarina Ivanović (1817-1882), Konstantin Danil (1798-1873), Mihael Stroy (1803-1871), Nikola Aleksić (1808-1873) — maintained a rapport with their models, for the most part representatives of the small towns of the plains: merchants, members of the clergy, frontier officers, local gentry. This relation was at the same time naive and sophisticated, precisely because of the artists' sensitivity to color. It was their great virtue — and one that these painters could hardly have learned from their more erudite teachers. This was a style of painting that came into being free of any previously proclaimed artistic program. Unpretentiously, and with the apparent docility of acquiescent pupils, the powers among the young bourgeoisie sat for their portraits. The forceful Prince Miloš was no exception: the ruler of the recently semi-liberated Serbia is hardly distinguishable in the artistic treatment of his portraits from any unknown frontier officer, newly rich merchant, or burgher of one of the many small towns on the Pannonian plain.

*Pl. 405*
*Pl. 390*
*Pl. 397*
*Pl. 401, 407*

The above-mentioned painters of this period can be considered as a unified stylistic group only within the loosest possible framework of Classicism. Of them all, Tominc and Langus solved the problems of the group portrait most successfully and with the greatest daring, portraying their individual figures with a rich wealth of decorative detail; Karas, Teodorović, Djurković, Danil, and Aleksić directed their efforts mainly to the representation of single personages, only exceptionally venturing the formal official portraits which appear among their works as a reverberation of vanished Baroque concepts (Arsa Teodorović's portraits of Bishop Kiril Živković and Gavrilo Bozitovac, benefactor of the Matica Srpska; Pavel Djurković's later portrait of the physicist Atanasije Stojković, painted about 1830). What all these artists have in common is a serious, inquisitive, and careful approach: their paintings constitute an appraisal and analysis of their subjects.

In the forties of the nineteenth century, on the threshold of the period of Romanticism, painting in the Yugoslav regions seems increasingly to abandon its earlier severity, to lose its original pictorial innocence. Portrait painting seems to lack the authentic psychological honesty, the slightly tart analytical intuition of earlier years. The quiet, almost imperceptible, transition to Romanticism, accompanied by an augmented artistic sophistication, takes place in the more than oppressive social and political atmosphere of Austria approaching the mid-century. After the Hungarian revolution of 1848 and the defeat of the republic, a sinister bureaucratic police-state regimen once again prevailed, bringing all its power to bear in an effort to slow down its impending and inevitable disintegration. Hence it is no mere chance that the older Biedermeier variant of Neoclassicism persists in the portraits of the period, while the favorite subjects from the national past are conceived without the heroic, almost monumental, gusto and drama so characteristic of French Romanticism. Slightly cramped by their rationalism, sometimes naively anecdotal, as though taken over from the chaste and much admired *tableaux vivants* of the youthful Romantic

theater, are the historical compositions of Ferdo Quiquerez (1845-1893; *The Maid of Kosovo, Zrinjski and Frankopan*), Pavle Simić (1818-1876; *Ilija Birčanin, Hadži Ruvim*), Stevan Todorović (1832-1925; *Tanasko Rajić at the Cannon*), and Novak Radonić (1826-1890; *The Death of Uroš V*). There is evidence of a sincere desire and serious effort to arouse their diffident public with these patriotic themes, but also, unfortunately, of an utter inability to achieve dramatic effects artistically. The handling of light, especially in the process of attempting to attain greater compositional cohesion, remained a problem for the majority of these painters, who were still influenced by the persistent tradition of Viennese Neoclassicism. It was indeed naiveté in the highest degree to try to apply the religious compositional patterns of the Nazarene school to Yugoslav historical painting.

*Pl. 398* So determined an individualist as the writer and painter Djura Jakšić (1832-1878), strictly an exception during the period of Yugoslav Romanticism, could succeed in creating dramatic effects. In his play of light and shade, and his enthusiastic use of color, he went back to Rembrandt, having come to feel the obsolescence of Viennese artistic dictates. A new, intimate relation to the subject also emerged in his portraits; moreover, he extended his approach to color and his use of broad brushstrokes to the backgrounds, formerly dark green and neutral. Despite the misfortunes of his personal life and the resistance of a public brought up on different artistic concepts, Jakšić produced work that represents the peak of Yugoslav Romanticism. In the name of emotional values he consistently rejected the old principle of Classicism requiring that the painter's brush be dipped in Rea-
*Pl. 394, 395, Fig. c* son — a principle still observed, albeit in attenuated form, in the works of Pavle Simić *(Gospođa Mladenović)* and Novak Radonić *(The Fairies Crowning Branko)*.

At about this point, landscape was freed of its subordinate, accessory function. For
*Pl. 410* instance, Anton Karinger (1829-1870) and Marko Pernhart (1824-1871) painted heroic Alpine landscapes of lakes and deep-shaded forests in an indisputably high lyrical vein without any of the usual incidental figures. Their canvases won for this previously neglected genre the right to an independent artistic existence, in anticipation of the exuberant
*Pl. 400* appearance on the scene of the Slovenian Impressionists. Ferdo Quiquerez did very much the same among the Croats in 1875-76 with the silvery-olive tones he used in his outstanding landscapes *(Landscape with Pelicans, The Porta Terraferma in Zadar, The House of a Montenegrin Noble, Montenegrin Mountains)*.

Perhaps indeed it was Romanticism that brought Yugoslav art to the crossroads, the crucial point where in its search for new exemplars it was able to break decisively with the old. However, during the generation of the Realists, this process of abandoning the notion of Vienna as the one and only center where painting could be studied was only partial, for now the aspiring artist rushed to Munich, turning, in the Bavarian capital, to the study of the German variant of Realistic painting, and so once again postponing the discovery of the great art of Paris.

From the year 1874 on, the Academy in Munich was ruled by Karl von Piloty, champion of coloristic theatricality and himself under the influence of Paul Delaroche and Louis Gallait. Not until the advent of Piloty did Germany, weary of Kaulbach's Romantic-monumental *Kartonstil*, produce a painter whose compositions stood out for their glowing colors, dramatically posed figures, and skillful rendering of even the slightest details. Piloty's influence on German painting can be traced in the most varied manifestations, from the work of Franz von Defregger through that of Lenbach, Wilhelm von Diez, Gabriel Max, Hugo von Habermann, Wilhelm Leibl. It was Piloty's disciples who, as independent teachers at the Academy, directly or indirectly brought Yugoslav painters under his influence. From this point on, the style of this famous nineteenth-century school of painting is a factor in the painting of Yugoslav artists.

The generation of Yugoslav Realists brought certain new concepts to the painting of landscapes in Yugoslavia. By way of Munich came the echoes of the Barbizon school and,

*b. Dimitrije Avramović.* Sketch for The Apotheosis of Lukijan Mušicki. *1840. Pencil, 11 5/8 × 14 1/2". National Museum, Belgrade*

through their canvases, of the old Dutch landscape painters. They were also attracted by the still life and the peasant genre picture, of which the paintings of Jožef Petkovšek (1861-1898), whose production was cut short by his premature death, are an example. A refinement of tones in a subdued palette was also achieved; dark browns, greens, reds, and silvery gray make their appearance. Nevertheless, the gradual break with Romanticism, with its anecdotal sentimentality, patriotic content, and even ecclesiastical subjects, was not followed through to completion by the Yugoslav Realists. Yugoslav artists, through the greater part of their creative activity in this period, were still feeling the antithetical pulls of, on the one hand, the lessons of their teachers and the demands of their relatively uneducated clientele and, on the other, of their own discoveries.

*Pl. 403*

Such discoveries make themselves evident in the work of idyll-loving Nikola Mašić

Pl. 406 (1852-1902). Although he also executed such realistic works as *The Man of Lika,* already the beginnings of pleinairism in Croatian art — of which Miloš Tenković (1849-1890)

Pl. 399 and Celestin Medović (1857-1920) are representative — are discernible in his tonal solutions. But tonal discoveries are especially characteristic of the works of Djordje Krstić (1851-1907), whose landscapes of Serbia *(Čačak, Ovčar-Kablar Monastery, Kosovo)* are veritable chro-

Pl. 408 matic masterpieces. His large still life *The Fisherman's Hut,* with its delicate silvery gray-brown tones, is closest to the Munich school à la Courbet. Finally, of the two brothers Janez (1850-1889) and Jurij Šubic (1855-1890), the former painted in a spirit akin to that of the Romanticist landscapes of Anselm Feuerbach, while the latter dabbled in the problems of pleinairism. Living in Paris, Jurij was an isolated harbinger of the future reorientation of Yugoslav art toward that city, in which the painting of light had already inflicted a resounding artistic defeat on outdated academic principles. The generation of Croatian Re-

Pl. 404 alists also includes Menci Klement Crnčić (1865-1930), whose tonally conceived black-and-whites place him among the founding fathers of the modern idiom in this art form in

Pl. 402 Yugoslavia; Ferdo Kovačević (1870-1927) is another member of this group. Enamored of the regions along the river Sava, he depicted them in intimate sketches free of decorativeness.

In an environment in which many of the demands growing out of national aspirations had not yet been met, it seemed impossible for the time not to exact its tribute. During this period ambitious historical painting thus makes its appearance in the politically torn regions of Yugoslavia; behind the pompous decorativeness of these paintings pulses the beat of the political struggle. This trend, born amid the agitations of the foreign political maneuvering that disturbed the Yugoslav scene, coexisted during the last decade of the nineteenth century with a sophisticated cosmopolitan element that finally blunted the potential force of Yugoslav Realism, the fine pictorial enthusiasm being gradually snuffed out by the cloying superficiality of the academic manner, by the often doubtful echoes of the then prevailing official taste of artistic reactionaries. Those seductive eclectics Cabanel, Makart, and Meissonier insistently tried, fortunately without succeeding, to smother the true art on the path toward which the Impressionists had already victoriously set up signposts.

The Yugoslav academic Realists also experienced moments of confusion when they found themselves unable to grasp the magic of Impressionism. The pleinairist and divisionist experiments that intrigued artists like Marko Murat (1864-1944), Vlaho Bukovac (1855-1922), and Paja Jovanović (1859-1957) disclose their persistent efforts to fuse opposites, to preserve realistic forms while giving them expression through a brighter palette and an altered technique. The decorative facility and bright colors pleased the Yugoslav public, and cosmopolitan taste momentarily coincided with the ambitions of the Yugoslav bourgeoisie to keep in step with the fashions of the times, to feel included, on a footing of equality, in the doubtful brilliance of Europe's *fin de siècle.* And, in fact, the nineteenth century closed in Yugoslavia with sporadic inroads by that German courier of artistic revolt, the Munich Secession. These incursions were to be felt more keenly, however, in sculpture and architecture during the short span between the turn of the century and the outbreak of World War I. Their influence is to be seen in the work of the sculptors Robert Frangeš Miha-

Pl. 431, 432, 433 nović (1872-1940), Toma Rosandić (1878-1958), and Ivan Meštrović (1883-1962), and the architects Josip Plečnik (1872-1957), Viktor Kovačić (1874-1924), and Branko Tanazević (1876-1945).

An isolated restless spirit makes his appearance late in the nineteenth century in Munich:

Pl. 409 the painter Anton Ažbe (1862-1905), with his own school of painting, was one of the most significant opponents of the prevailing style of the Academy. Ažbe was the master who sowed the first seeds of serious doubt as to the merits of the Munich teachers in the minds

*c. Novak Radonić.* The Forum in Rome. *1859.*
*Pencil, 5 7/8 × 9''. National Museum, Belgrade*

373

of Yugoslav Impressionists; his dissident precepts are reflected in the works of virtually all Yugoslav modern painters of the early twentieth century, and even in the work of Igor Grabar, Alexei von Jawlensky, and Vassily Kandinsky.

In contrast to the number of painters, Yugoslavia did not produce many representatives of the plastic arts. Academic Realism reigned supreme throughout the nineteenth century in Yugoslav sculpture, and only with the penetration of Secessionist elements and the *Pl. 393, 391* influence of Rodin did modern Yugoslav sculpture begin, through the works of Meštrović *Pl. 392* and Mihanović, to find its direction. Ivan Rendić (1849-1932), Ivan Zajec (1869-1952), Rudolf Valdec (1872-1929), Petar Ubavkić (1852-1910), and Djordje Jovanović (1861-1953) produced the first commissioned sculptural monuments, responding, like the painters, to the political demands of their times. Given the nature of their assignments, they were unfortunately often obliged to work out compromise solutions between a lyrical and intimate experience of form and the monumentality required of works intended for outdoor settings. It is in no way surprising that in the end it was the Mediterranean-Dalmatian tradition that prevailed in Yugoslav sculpture.

In Macedonia a specific social and political background — above all, the long centuries of Turkish domination — led to the insistent fostering and preservation of a distinct variant of Levantine Baroque, an interesting mixture of early Orthodox iconography with elements of High Renaissance painting and Mannerism. Whole guilds and families of artists, such as the Frčkovci family of Galičnik and the Dičovci family of the village of Tresonče, worked continuously throughout the nineteenth century, decorating churches even beyond the immediate vicinity of their native districts. By the 1850s there appeared the first portraits in which the centuries-old iconographic forms are blended with efforts at a Realistic approach. Macedonians, especially members of the Filipovci family, produced the most important wood carving in these regions. They turned out a number of large iconostases, again in the spirit of the Levantine Baroque, which ultimately decorated the interiors of the old churches on Mount Athos. Despite repeated devastations and persecutions, and all the efforts of the Turkish authorities to subjugate and pacify this area, artistic continuity in Macedonia was never interrupted.

Like all other aspects of the nineteenth century, the course of artistic development in the regions of present-day Yugoslavia was marked by turmoil. During that century, the land was divided by the frontiers of foreign states; everywhere, monuments of earlier epochs stood abandoned, inaccessible, or devastated — venerable testimony of national artistic impulses, waiting to be discovered and to deliver their messages. Throughout the nineteenth century the aspiration to understand and adopt cosmopolitan art formulas is far stronger than any interest in native ones. However, the frequently unfavorable social and political situation retarded the assimilation of these formulas, and indigenous talents were beyond doubt sufficiently deep and vigorous, despite the inexorable dictates of the Viennese and Munich schools, to preserve in many masters a true artistic sensitivity — that age-old coloristic immediacy so vitally present in the color harmonies of even the folk art of Yugoslavia.

Certainly the nineteenth century produced its share of genuine painters, masters who knew how to maintain their individuality, that perpetual ideal in the artistic dreams of every epoch. It was a time marked by an ambition to achieve much — perhaps too much — and, it would seem, all at once. An entire gallery of portraits, numerically impressive, of members of Yugoslav society bears witness to the social upheavals forming the background of all these efforts. The bourgeoisie in the eighteenth century had already taken over in part the social primacy which had historically belonged to the Church in the feudal way of life. By the nineteenth century this young bourgeoisie was ready to impress its stamp on art in Yugoslavia. Its outlook, its ups and downs, were all noted by the hands of its artists, whose works serve as illustrations for the great chronicle of the century's history.

Not until the end of the nineteenth century, with its expanded political and artistic perspectives, did it become clear that Yugoslavia's inevitable parting with Vienna — after hundreds of years during which that center had represented not only the political but also the artistic forum of more than one of the Yugoslav nations — was well under way. Nevertheless, it is no exaggeration to conclude that the continuity of artistic individuality was never broken in the Yugoslav area. From time to time, from under all the layers of borrowed mannerisms, from behind the schoolroom style of craftsmanship, a spark kindled by the indomitable talent and long artistic experience of this land would fly forth. The attentive observer perceives beyond the superficial aspects of the art of the Yugoslav peoples during the nineteenth century the essential gifts of the region, which are generously revealed to the inquisitive eye.

390

390 *Vjekoslav Karas*. Boy with Whip. *1850. Oil on canvas, 27 × 21 5/8''. Academy of Fine Arts, Zagreb*

391

392

393

391 IVAN ZAJEC, The poet France Prešern, *detail.*
*Ljubljana*

392 PETAR UBAVKIĆ, Vuk Karadžić, 1889. *Marble,*
*height 35 3/4". National Museum, Belgrade*

393 IVAN RENDIĆ. Ivan Gundulić. 1871. *Plaster,*
*height 27 1/2". Rector's Palace, Dubrovnik*

394 PAVLE SIMIĆ. Madame Mladenović. *c. 1857.*
*Oil on canvas, 10 1/4 × 8 1/8". National*
*Museum, Belgrade*

395 NOVAK RADONIĆ. The Fairies Crowning
Branko. *c. 1852. Oil on canvas, 9 3/4 × 13".*
*National Museum, Belgrade*

396 STEVAN TODOROVIĆ. The Monastery of Ma-
nasija. *c. 1860. Oil on canvas, 9 1/4 × 13 3/4".*
*National Museum, Belgrade*

397 PAVLE PETROVIĆ. Portrait of Woman with Red
Shawl. *c. 1840. Oil on canvas, 27 3/4 × 19 1/4".*
*Gallery of the Matica Srpska, Novi Sad*

394

395

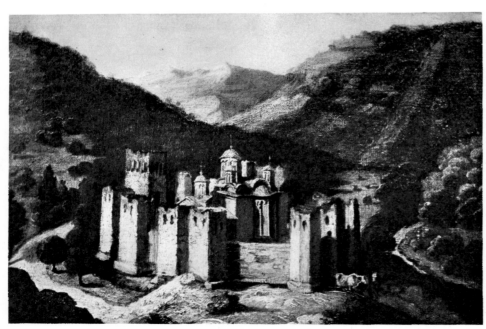

396

397

399

398 *Djura Jakšić*. Girl in Blue. *1855. Oil on canvas, 24 3/8 × 20". National Museum, Belgrade*

399 *Celestin Medović*. Bacchanal. *c. 1890. Oil on canvas, 79 5/8 × 139 7/8". Academy of Fine Arts, Zagreb*

400 *Ferdo Quiquerez*. The Mountains of Montenegro. *1875-76. Oil on canvas, 11 1/4 × 14 3/8". Academy of Fine Arts, Zagreb*

401 *Konstantin Danil*. Portrait of Pavle Kengelac. *c. 1833. Oil on canvas, 24 3/4 × 19 1/4". National Museum, Pančevo*

400

401

402 FERDO KOVAČEVIĆ. Autumn. 1925. Oil on canvas, 16 5/8 × 23 1/8". Academy of Fine Arts, Zagreb

403 JOŽEF PETKOVŠEK. Still Life. 1884. Oil on canvas, 22 1/2 × 16 5/8". National Art Gallery, Ljubljana

404 MENCI CLEMENT CRNČIĆ. Seascape. 1906. Oil on canvas, 13 × 21 3/4". Academy of Fine Arts, Zagreb

402

403

404

405

406

407

*405 JOSIP TOMINC. The Artist's Father. 1848.
Oil on canvas, 35 1/2 × 29 3/4″. National
Art Gallery, Ljubljana*

*406 NIKOLA MAŠIĆ. Man of Lika. 1890. Oil on
canvas, 17 × 12 5/8″. Academy of Fine Arts,
Zagreb*

*407 MIHAEL STROY. Lujza Pesjakova. 1850.
Oil on canvas, 38 1/8 × 29 7/8″. National
Art Gallery, Ljubljana*

408

409

410

408 DJORDJE KRSTIĆ. Fisherman's Hut. 1882. Oil on canvas, 82 × 39 3/8". Museum of the City of Belgrade

409 ANTON AŽBE. Negress. 1895. Oil on wood fiber board, 21 3/4 × 15 1/2". National Art Gallery, Ljubljana

410 MARKO PERNHART. A View of the Sava River from Šmarna Gora. 1851. Oil on canvas, 15 1/2 × 18 5/8". National Art Gallery, Ljubljana

# XVIII THE ARCHITECTURE OF THE TWENTIETH CENTURY

Marjan Mušič
*Professor of the History of Architecture, University of Ljubljana*

Using the course of historical events as a framework, it is convenient to divide the development of twentieth-century architecture in Yugoslavia into three phases: the period up to 1919, the period between the two wars, and the period after World War II. During the first of these periods Croatia and Slovenia, sharing many features, were in advance of Serbia, which, owing to centuries of national suppression, lagged considerably behind. Early in the period between the two wars, national schools of architecture were founded in Slovenia and in Croatia; the school in Slovenia is associated with the name of Jože Plečnik, in Croatia with that of Viktor Kovačić. In other parts of Yugoslavia the revival of architecture followed somewhat later. During the entire period, that is, from the turn of the century to the present, modern trends became increasingly predominant in the architecture of the country. They tended to even out the existing differences, making it possible to speak of common bases and points of departure as early as the 1930s. This observation holds true particularly for the period following World War II, when, after initial uncertainties and vacillations, there evolved, on the part of each of the Yugoslav peoples, a clearer orientation, in its own distinctive terms, toward the expression of a common architectural program.

During the first decade of this century the type of architecture on which various stylistic periods had set their mark died out in Slovenia. The Viennese Secession played the dominant role in the emergence of modern Slovene architecture. A nationally and culturally awakened Ljubljana was the focus of the new development: the turning point coincides with the period following the earthquake of 1895. The leading architect was Maks Fabiani (1865-1962), who achieved worldwide renown with work done concurrently in Ljubljana and in Vienna. His town plan and many buildings gave Ljubljana a distinctive quality of its own after the earthquake. He approached urbanism as a spatial phenomenon; his point of departure, based on thorough analysis of complex functions, was the basic motivations inherent in the nature and the requirements of human settlements. The regional character of his buildings in Ljubljana, Gorica, and Trieste, in which modern concepts merge with free and sensitive reminiscences of the traditional culture, represents a positive achievement under the given conditions, harmonizing as it does with organic development of urban areas through the centuries.

In Zagreb, as in Ljubljana, the concentration of public affairs gave rise to vigorous building activity. Historicism yielded to eclecticism, which characterizes the monumental public buildings, planned by famous foreign architects, for the most part from Vienna. The Secession came to Croatia first from Vienna, later from Budapest. The more important buildings in addition to those in Zagreb are in Osijek, Varaždin, Križevci, and Opatija, where architecture attained a level comparable to that in the rest of Europe. The decisive trend toward the modern in the first decade of the twentieth century is associated with the name of Viktor Kovačić (1874-1924).

*a. Milorad Pantović. The Belgrade Fair Grounds, 1957*

*b. Viktor Kovačić. Project for the regulation of the Kaptol, Zagreb*

*c. Jože Plečnik. Sketch for a church, 1910*

The number of Kovačić's works is not large, but the developed an individual note in architectural design and passed his methods on to the younger generation, thereby paving the way for contemporary Croatian architecture. Domestic architects steered a course between eclecticism and the modern: Martin Pilar (1861-1942), Ćiril Metod Iveković (1864-1933), Josip Vancaš (1859-1932), and Rudolf Lubinski (1873-1935). In addition to Kovačić, Hugo Ehrlich (1879-1936) and Edo Šen (1877-1949) also fought the battle for a purer modern.

In Serbia the long centuries of Turkish rule and the resulting cultural isolation tended to hamper the development of architecture. Here too historicism was followed by eclecticism. In the latter half of the nineteenth century a number of talented architects came to Serbia from the Vojvodina, bringing with them Central European cultural trends. The leading Serbian eclecticists in Belgrade in the first decade of the twentieth century were Jovan Ilkić (1857-1917), Andra Stevanović (1859-1929), and Nikola Nestorović (1868-1957). Modern architecture, which in Central Europe was identified with the Secession and the Jugendstil, remained a sporadic and inorganic manifestation in Serbia.

The Austrian occupation of Bosnia and Herzegovina (1878) introduced West European influences, although in the beginning colonial architecture, Moorish in style (which, however, had nothing in common with domestic Islamic architecture) prevailed. The subsequent trend was eclecticism, modeled upon work in the countries of origin of the architects — Karlo Paržik (1857-1942), Knežarek, Iveković, Vancaš. After the annexation (1908), a number of buildings were constructed in the Secessionist spirit, the finest of them being the former Slavija Bank building in Sarajevo by Jan Kotera (1871-1923).

In the changed political and social conditions after World War I, a new framework existed for the development of architecture. These conditions, however, tended more to obstruct this development than to lend it impetus: unplanned urbanization, with its negative effects on the pattern of towns and settlements, is particularly characteristic of the period. The very rhythm of construction was sluggish, except in Serbia (particularly Belgrade), where building activity was relatively brisk. The architectural concepts underlying the more important public buildings rarely went beyond stereotypes, with the accent on formal monumentality. Nevertheless a positive assessment must be made of the contribution of ranking progressive-minded architects. Through them, Yugoslav architecture acquired points of contact with, and was incorporated into, progressive world trends. The excellence of these architects is attested by prizes won in international as well as domestic competitions.

The Zagreb architectural school, founded by Viktor Kovačić, gained a place of primary importance. A professor of design, Kovačić trained his students in logical analysis of spatial concepts and purity of architectural modeling. The monotony of the predominantly stereotypical works of that time is broken by Kovačić's Exchange building, an artistic creation with freely applied Classical forms. Thus was founded the Zagreb school, in which Kovačić's work was carried on by Ehrlich and Šen. The first generation of architects produced by the Zagreb school that appeared on the scene numbered in its ranks Alfred Albini (born 1896), Juraj Denzler (born 1896), Zvonimir Vrkljan (born 1902), Stanko Kliska (born 1896), and Josip Pičman (1904-1936). A second group was the last prewar generation of foreign-trained architects, including Stjepan Hribar (born 1889), Ivan Zemljak (1893-1963), Stjepan Gomboš (born 1895), Vlado Antolić (born 1903), Antun Ulrich (born 1902), Juraj Neidhardt (born 1901), Zdenko Strižić (born 1902), and Ernst Weissmann. In a third group were Drago Ibler (born 1894), Mladen Kauzlarić (born 1896), Drago Galić (born 1907), and Stjepan Planić (born 1900). The efforts of all three groups — joined later by Josip Seissel (born 1904), Marijan Haberle (born 1908), Kazimir Ostrogović (born 1907), and Vladimir Turina (born 1913) — were determinedly and uncompromisingly oriented toward progressive architecture; circumstances did not permit them, however, to carry out their plans in full. Although architectural output was uneven in terms of quality, historicism was not revived; rather the foundations were firmly laid for progressive trends that began to assert themselves only after World War II.

*Fig. d*

In Slovenia the new era was ushered in with the appearance of the Ljubljana school of architecture. Its ideological founder was Jože Plečnik (1872-1957), whose work in Vienna and Prague had already placed him securely among the elite of Central European architects. After pursuing for a time the radical approach characterizing his early Viennese period, he sought a point of contact with tradition, achieving an architectural idiom that merged organically with the new environment. It is to the credit of Plečnik that architecture became an indivisible part of cultural development. Working in a direction parallel to Plečnik's from the very beginning was Ivan Vurnik (born 1884), who, after an initial period of searching for a national style, settled down to a moderate functionalism; he was the first to devote serious attention to the spatial problems of workers' housing projects and to the functionalism of apartment buildings. Working in a wide range of styles were other architects of the Ljubljana school: France Tomažič (born 1899), Stanko Rohrman (born 1899), Herman Hus (born 1896), Dragotin Fatur (born 1895), Janko Omahen (born 1898), Emil Navinšek,

*Fig. c*
*Pl. 423*

389

*d. Josip Pičman. Sketch for the Central Club in Sušak (Rijeka), 1934*

Jože Platner (1904-1968), Saša Dev (born 1903), and Jaroslav Černigoj (born 1905). The last generation of architects who were schooled abroad included Josip Costaperaria (1876-1951), Vladimir Šubic (1894-1946), and Vladimir-Braco Mušić (born 1930), all of whom had the opportunity to do a relatively large amount of building. Immediately before the outbreak of World War II, conditions improved, and talented young architects came to the fore in public competitions, particularly those, like the outstanding Edo Ravnikar (born 1907), who were fresh from the studio of Le Corbusier.

Considerably more building was in progress during the first decade of the twentieth century in Serbia, in Belgrade especially, than in other parts of the country. Requirements were tremendous, but the level of architecture was relatively low. The wartime years 1912-19 saw many gaps opened in the ranks of architects; these were filled in by émigré Russians. Improvement set in with the appearance of the first generation of architects who had abandoned eclecticism and opted for the modern trend of rational functionalism. The most active standard-bearer in the movement representing these tendencies was Milan Zloković (1898-1965). The development from Central European eclectic architecture to the modern was coincident in quality and quantity with the major work of Dragiša Brašovan (born 1887), who was responsible for many of the impressive public buildings in Serbia and the

*e. Bogdan Bogdanović. Partisan Cemetery in Mostar, 1965*

Vojvodina. Ruling circles favored eclecticism in the spirit of Serbo-Byzantine architecture, though without much success. Fierce conflicts and polemics, particularly on the occasion of competitions, broke out between proponents of official and of progressive trends; against this background Nikola Dobrović (born 1897) was outstanding for his uncompromising attitude. A generation of architects that was determinedly progressive matured on the eve of World War II; the most distinguished among them were Milorad Pantović (born 1910), Vladeta Maksimović (born 1910), and Ratomir Bogojević (born 1912).

In Bosnia and Herzegovina, efforts were directed in substantial measure to eliminating eclecticism and adopting modern architecture, a process paralleled by profound theoretical and analytical study of the regional features of local tradition. This valuable contribution to the affirmation of the modern was made by Juraj Neidhardt and Dušan Grabrijan (1899-1952) and their associates, whose efforts were indeed preparations for the future; their work may be considered pioneering even on a Yugoslavia-wide scale. Among the architects responsible for a great deal of building, especially in Sarajevo, were Dušan Smiljanić, Muhamed Kadić (born 1906), Jahiel Finci (born 1911), and Mate Baylon (born 1903), the last outstanding for his freewheeling conceptions and purity of form.

Conditions during the first few years following the end of World War II were not favorable for the development of architecture. The devastation of the war and the occupation made it necessary to do an enormous amount of reconstruction and to concentrate on building the most essential housing and industrial projects. The great need for economy in construction and the lack of material resources obstructed the advance of architecture. Furthermore, its development had already been hindered by a negative and uncritical attitude toward modern architecture in the world. It is therefore understandable why most of the buildings are uninventive and mediocre. This does not, however, mean to say that the architectural potential of the time was at the same low ebb. The high level of excellence and the progressive orientation of Yugoslav architects were reflected in the blueprints submitted for the federal Novi Beograd competition in 1947, in which the following participated: Vladimir Potočnjak (1904-1952), Zlatko Neumann (born 1900), Antun Ulrich, Mladen Kauzlarić, Lavoslav Horvat (born 1901), Kazimir Ostrogović, Edo Ravnikar.

After the consolidation and adjustments of the initial period, tasks with a broader functional differentiation began to be posed. As efforts were stepped up to raise production and increase prosperity, the foundations were laid for development of construction in terms of new architectural undertakings with greater pretensions to quality and scope.

*f. Edo Ravnikar. Sketches for the Technological Institute in Ljubljana*

*Fig. g, f, h, Pl. 415*

A number of city planners displayed enviable excellence in town layout, theoretical analysis, and concrete achievement: Seissel, Ravnikar, Neidhardt, Dobrović, Aleksandar Djordjević (born 1917), Antolić, Zdenko Kolacio (born 1911), and others. The following concentrated on analysis and theory in the field of architecture, urbanism, and regional planning: Djurdje Bošković (born 1904), Boris Čipan (born 1918), Dušan Grabrijan, Branislav Kojić (born 1899), Branko Maksimović (born 1900), Andrej Mohorovičić (born 1913), Oliver Minić (born 1915), Braco Mušič, Marjan Mušič (born 1904), Husref Redžić (born 1919), Sotir Tomovski (born 1899), Krum Tomovski (born 1924). Many creative forces were unleashed, and as architecture developed throughout the world, Yugoslav architecture made perceptible headway; particularly in recent years it has kept pace with the rest of the world while cultivating a regional manner and forms emerging from the environment.

Bearing testimony to the unfavorable conditions characterizing the early postwar years in Serbia are the large public buildings and complexes on the Terazije and on Marx and Engels Square in Belgrade. From the mass of mediocre architecture the complex of Novi Beograd rises as a major achievement, the result of the efforts of a number of architects, among them Uroš Martinović (born 1918), Mihajlo-Mika Janković (born 1911), Branislav Milenković (born 1926), Leonid Lenarčić, Mihajlo Mitrović (born 1922), Leon Kabiljo (born 1910), Ivan Antić (born 1923), and Ivanka Raspopović (born 1930). On the right bank of the Sava River rose the Belgrade Fair Grounds, in which the rationalistic scheme of cubic forms was replaced by a subtle play of spherical volumes (architect, Milorad Pantović; builders, Krstić and Žeželj).

*Pl. 411, Fig. a*

Among Belgrade's modern buildings noteworthy for their excellence are the State Secretariat of National Defense, the work of Nikola Dobrović;

*Pl. 413*

the Surčin Airport; the television tower on Avala Mountain, and the Museum of Modern

*Pl. 412*

Art. Also worthy of note is the complex represented by the main square in the town of Titovo Užice, the work of Stanko Mandić (born 1915) and Milorad Pantović. Also part of the repertory of architectural compositions are the many memorials of the National Liberation

*Pl. 417, Fig. e*

War, outstanding among them the monuments by Bogdan Bogdanović (born 1922).

During the initial period, when the accent was on reconstruction, architecture of consequence asserted itself in Croatia only in larger complexes and industrial projects in Zagreb, Slavonski Brod, Karlovac, Kaštela, Šibenik, and elsewhere (architects: Kauzlarić, Gomboš, Horvat, Galić, Ostrogović). Despite material restrictions, certain public buildings and apartment-house projects are of a high caliber, tanks to the efforts of such architects as Albini, Denzler, Galić, Haberle, Ibler, Kauzlarić, Ostrogović, Neven Šegvić (born 1917), Turina, Ulrich, Ivo Vitić (born 1917). Over the past decade, in new towns and settlements both

*g. Josip Seissel. Sketch for crematorium and ceremonial halls of the Central Cemetery in Novi Sad, 1966*

*h. Juraj Neidhardt. Tourist bungalow on Trebević Mountain, 1948*

on the mainland and in the island-dotted coastal regions of Croatia, architectural activity has been progressing along a broad front with sweeping construction programs notable for their variety and for coming to grips with problems of design. Mention must be made of Novi Zagreb-Trnje and of the housing projects Turnic and Ogranak in Rijeka. Among the most successful achievements are those of architects Galić, Šegvić, Ostrogović, Kolacio, Vitić, Budimir Pervan (born 1910), Jerko Marasović (born 1923), Zdravko Bregovac (born 1924), Božidar Rašica (born 1912), Zdenko Sila (born 1915), Lovro Perković (born 1910), and, particularly, of the world-renowned Vjenceslav Rihter (born 1917). *Pl. 418*

In Slovenia, too, the initial postwar phase was dedicated primarily to the reconstruction of towns and villages in the provinces. Concomitantly with the long-term planning of the economy, new settlements were projected (Nova Gorica, Kidričevo, Velenje), as were large architectural complexes. A variety of large-scale tasks were set after the conditions characterizing the earlier period had become stabilized. As industrialization and construction techniques advanced, new methods and new materials were used in architecture and began to wield a decisive influence over its spatial and artistic features. Architectural activity, which had been focused on Ljubljana, spread to all parts of Slovenia, both to the towns and to their regional hinterlands. Fresh inventiveness and clarity, with a wealth of refined structuring, were essential characteristics of the work of Edo Ravnikar, the leading Slovene *Pl. 424, Fig. f* architect, who was also active in the other republics of Yugoslavia, and, as the winner of a number of competitions, abroad as well. Also preeminent is the work of Edo Mihevc *Fig. i* (born 1911). to whom was given the opportunity of setting his stamp on the architecture of the Slovenian coastal belt. Apart from the architects of the older generation — Rohrman, Ivo Spinčić (born 1903), Jože Platner (1904-1968), Jaroslav Černigoj (born 1905), Vinko Glanz (born 1902), Franc Novak (1906-1959), Oton Gaspari (born 1911), Ivo Štrukelj (born 1921), Emil Medvešček (1911-1963), Danilo Fürst (born 1912) — architecture of excellence was fostered by the younger generation of the Ljubljana school, among them Branko Kocmut (born 1921) and Ivan Kocmut (born 1926), Stanko Kristl (born 1922), Niko Kralj (born 1921), Marko Šlajmer (born 1927), Milan Mihelič (born 1925), Anton *Pl. 422* Bitenc (born 1920), Savin Sever (born 1927), and Svetozar Križaj (born 1921).

The first postwar phase in Bosnia and Herzegovina was characterized by reconstruction, and architecture was conceived along utilitarian and functional lines, no effort being made to harmonize buildings with the surrounding terrain. However, in the second postwar decade, tendencies toward a specific regional form of modern expression began to assert themselves everywhere: inspiration emerged from tradition, reassessed by a pleiad of do-

*i. Edo Mihevc. Shopping center in Ljubljana, 1968*

mestic architects. All these maturing efforts were synthesized in the new housing projects in the towns and industrial centers, where the ideal of spatial integrity was realized. In addition to the aforementioned Neidhardt, Smiljanić, Kadić, and Finci, who continued to practice their profession after the liberation, vigorous activity was carried on by the middle generation: Zdravko Kovačević (born 1913,) Milivoj Peterčić (born 1923), Živorad Janković (born 1924), and others. In the past few years a younger generation of architects, launched on their careers after sound preparation and under more favorable conditions, have come to the fore, notable among them Ivan Strauss (born 1928), David Finci (born 1931), and Milan Kušan (born 1928).

The difficult political situation and attendant social and economic hardships in prewar Macedonia, deprived as it was of national rights and freedom, were reflected in architecture as in other spheres. An expression of the needs of the moment, the architecture of the period shows traces of economic exhaustion and of improvisation in design and is devoid of urbanistic perspective. Secondhand eclecticism prevailed, alongside of imported functionalism. Local architects working in Macedonia include Sotir Tomovski, J. Mihajlović, Miho Čakelja (born 1909); architects Zloković, Kojić, and Nestorović, of Belgrade, and Ibler, of Zagreb, were also active. After the period of reconstruction, city planning was introduced for a number of towns. Architects from other regions were joined by the local designers Sotir Tomovski, Čakelja, Čipan, Ljube Pota (born 1918), Dragan Tomovski. Considerable attention was paid to the rehabilitation and renewal of towns and villages and to the construction of new industrial centers. In the second postwar decade, marked by more intensive building activity, local architects predominated: Slavko Brezovski (born 1921), Aleksandar Serafimovski (born 1923), Dušan Pecovski (born 1924), R. Šekerinski. After the devastating earthquake of 1963, all forces were concentrated on constructing the new, modern Skopje, and in this phase local architects came fully into their own: Petar Muličkovski (born 1931), Blagoja Mičevski (born 1931), Dimitar Dimitrov (born 1925), and others.

*Pl. 414*

The course of architecture in Montenegro was similar to that followed in Serbia, except that the development was less intensive and less expressly provincial. The demand created by the enormous problems and urgent tasks that followed liberation, combined with the needs of reconstruction, far outstripped the resources. All available means were poured into the making of the new Titograd. Conditions began to improve in the mid-sixties, when the Montenegrin coast became the center of activity. Enviable progress has been made there through the efforts of such of the younger architects as Vladislav Plamenac (born 1934), Milan Popović (born 1934), Dušan Bajić (born 1930), and Svetlana Radević (born 1937).

*Pl. 416*

411 MILORAD PANTOVIĆ. *The Belgrade Fair Grounds. 1957*

412 IVAN ANTIĆ. *Museum of Modern Art, Belgrade. 1965*

412

411

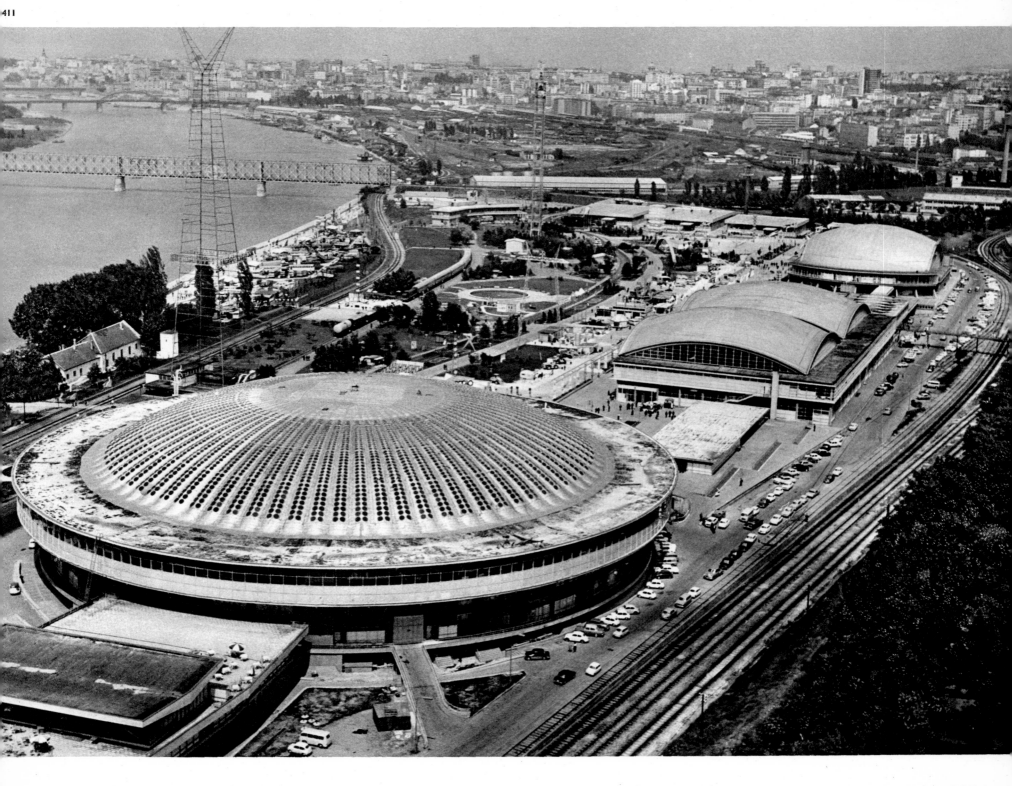

413

414

413 NIKOLA DOBROVIĆ. *State Secretariat for National Defense, Belgrade. 1965*

414 DIMITRIJE and TRAJKO DIMITROV. *Airport in Skopje. 1966*

415 JURAJ NEIDHARDT. *Department of Philosophy of the University of Sarajevo. 1959*

416 SVETLANA RADEVIĆ. *Hotel Podgorica, Titograd. 1967*

417 BOGDAN BOGDANOVIĆ. *Memorial Cemetery, Prilep. 1962*

415

416

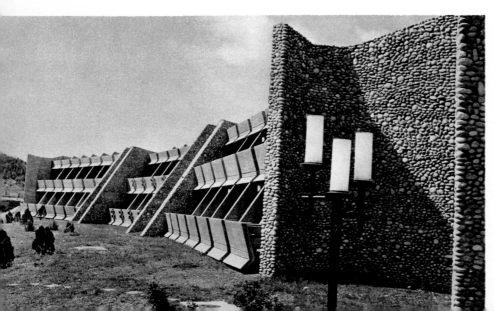

417

418

419

418 VJENCESLAV RICHTER. Caterers' School,
Dubrovnik. 1967

419 IVAN VITIĆ. Simo Matavulj Elementary
School, Šibenik. 1949

420 KAZIMIR OSTROGOVIĆ. Town Hall, Zagreb.
1958

421 DRAGO IBLER. Apartment and office building,
Martićeva Street, Zagreb. 1960

420

421

422

423

*422 Savin Sever. Astra Complex, Ljubljana.
1967*

*423 Jože Plečnik. French Revolution Square
with obelisk, Gregorčić Memorial, and
University Library, Ljubljana. 1940*

*424 Edward Ravnikar. Apartment house block,
Ferantov Vrt, Ljubljana. 1968*

424

# XIX   THE TWENTIETH CENTURY

Miodrag B. Protić
*Director, Museum of Modern Art, Belgrade*

*a. Branko Miljuš. Formation. 1965. Ink, diam. 6 1/2". Collection the artist, Belgrade*

Contemporary Yugoslav art is developing in an area with a rich past, whose influences continue to act subtly and indirectly upon the present. Generally speaking, the blend of the old and the new, the national and the universal, is one of its most fundamental characteristics, and goes far toward explaining the unceasing striving for synthesis and fuller expression.

In terms of chronology, the years 1914, 1918, 1941, and 1945 are the boundaries not merely of political but also of artistic epochs, each of which possesses clear-cut features and a spiritual climate all its own. (The peoples of Yugoslavia were brought together in a single state in 1918, at the close of World War I.)

The turn of the century was attended by numerous shifts and contradictions; existing concurrently were, on the one hand, concepts favoring an academic, "immortal" art and, on the other, fresh concepts which, though belated in comparison with those underlying European art as a whole, signalized a turning point and a revolution in taste and outlook. The transition involved pleinairism and academicism; the modern came in under the aegis of the Secession and, even more, of Impressionism, which rapidly evolved, in the first decade, into an Expressionistic idiom.

The transition between the nineteenth and twentieth centuries is epitomized by the Croatian painters Josip Račić (1885-1908), Miroslav Kraljević (1885-1913), and Vladimir Becić (1886-1954), who reflected a pre-Impressionist, Manetesque spirit and style and, simultaneously, a condensation and generalization of form anticipating the trends in this direction between 1920 and 1930. The awakening of a new sensitivity, the idea of the ceaseless movement of light in which the forms of the visible world were broken down into color and matter, is represented by the Slovenian and Serbian Impressionists Milan Milovanović (1876-1946), Kosta Miličević (1877-1920), Ivan Grohar (1867-1911), Matija Jama (1872-1947), and Matej Sternen (1870-1949). The Secession, reconciling tradition, Romanticism, and Symbolism with the poetry of modern sculpture and painting, is reflected in the work of that figure of worldwide importance Ivan Meštrović, and of Ljubo Babić (born 1890) and Emanuel Vidović (1879-1953), its representatives par excellence. The genuinely modern spirit of the twentieth century found its exponents in Nadežda Petrović (1873-1915) and Rihard Jakopič (1869-1943), who, with the penetration and audacity of their vision, the sonority of their colors, the dynamic spontaneity of their performance as a whole, simultaneously carried Impressionism to its climax and took advantage of the opportunity it afforded them to move in the direction of a coloristic and formal intensification of vision, that is, toward European coloristic Expressionism.

All these names, which represent seminal elements in the emergence of modern art in Yugoslavia, figure in the complex spiritual and artistic situation existing at the end of the nineteenth and the beginning of the twentieth century in a Europe still artistically divided between Munich and Paris; after the International Exhibition in Rome in 1911,

*Pl. 426, 427, Fig. c*

*Pl. 430*

*Pl. 429*
*Pl. 428*

*b. Krsto Hegedušić. Three Women. 1934. Ink, 26 3/4 × 19 3/4". Museum of Modern Art, Belgrade*

*c. Miroslav Kraljević. A Promenading Couple. c. 1912. Ink, 11 3/4 × 7 1/2". Museum of Modern Art, Belgrade*

Meštrović became a generally recognized *signum temporis*. The works of Nadežda Petrović may also be classified as belonging to the most radical Expressionism of the time. In brief, this period was a logical evolution toward the idea of the autonomy of art, of the work of art as an independent aesthetic entity conditioned by reality itself.

The second period (1918-1941), which falls within the epoch of the already unified state, is longer and more dynamic, more highly developed in terms of artistic endeavor. Even at first glance the two decades involved are seen to differ appreciably. The first, fraught with striving, shifts, wavering between traditionalism and vanguardism, was for that very reason in a certain sense contradictory and preparatory; the second decade was a time of settling down, maturing, a period of definitive orientation.

The third decade of this century (1920-1930) was marked by the search for form, just as the first and second passed in the search for light and color, punctuated by echoes of Cézanne, moderate Cubism, expressionism of form, and traditionalism. Empirical reality was not radically disintegrated and replaced by a new, aesthetic reality, as was the case in Cubism. The most daring transposition of reality is found in a small number of works, among them Sava Šumanović's *Composition with Clock* (1921), Milan Konjović's *Cubist Still Life* (1922), Jovan Bijelić's *Abstract Landscape* (1920). These were truly exceptional breakthroughs of the utmost creative audacity. For in Cézanne and in Cubism, Yugoslav artists — the monads of a still patriarchal, provincial milieu — more frequently sought the old than the new. No matter how avant-garde, Cubism, with its striving for solid architecture in painting, for geometry, for value, paradoxically awakened in the environment of Yugoslavia a nostalgia for tradition. Generally, the influence of the past, of the great epochs of art, was considerable in this period (the "Zograph" group with Vasa Pomorišac, 1893-1961, and Živorad Nastasijević, 1893-1966), paralleling other influences, ranging from the Italian Renaissance to Poussin and Ingres.

It was, however, precisely in the contradictory shifts of this period that certain painters reached their apogee. This applies above all to Marin Tartalja (born 1894), who reconciled geometrically reduced form touched by the subtle play of light with tonally sensitive nuances of gray-green and brown, and also to Veljko Stanojević (born 1892), Vilko Gecan (born 1894), and the Slovenian Expressionists France Kralj (1895-1960) and Tone Kralj (born 1900). During the same period others were creating their first, but nonetheless impressive, works — among them Ignjat Job (1895-1936), with his small paintings on panel, dreamily narrative scenes from the life of the coastal towns, reminiscent of eighteenth-century Venice.

Pl. 439    Toward the close of this decade and during the first few years of the next, Milo Milunović

(1897-1967), a modern classic, obsessed with the idea of completeness and perfection, was to create in Paris a number of masterpieces.

In contrast to the third decade, in which a common denominator is apparent in the works of the various artists, the stylistic and spiritual constellation of the fourth decade (1930-1940) was variously reflected — in coloristic Expressionism, social realism, Surrealism, poetical realism, and Intimism.

Coloristic Expressionism — continuing the interrupted experience of Nadežda Petrović and Rihard Jakopič — was the vehicle of several of the greatest artists. In Yugoslavia, Expressionism retained virtually all its typical characteristics: preoccupation with the subjective, restless images of the essential aspects of reality and life ("man added to nature," Van Gogh); powerful exposition of inner experience; ethical dilemmas ("in interiore homine habitat veritas," St. Augustine); pure, elementary color and emphatic contours and movement. Also present, apart from the ethical, was the ethnic factor, as these painters frequently localized their symbols and mediums. Bijelić sought his more often than not in *Pl. 438* Bosnia: his confident, virtually academic nudes were followed by agitated landscapes with spiritual power and breadth of movement; Job sought out in coastal taverns in Dalmatia *Pl. 437* bacchanalian and Anacreontic scenes in which overtones of transience and death are nevertheless heard; Konjović painted the serene motifs afforded by the Vojvodina in a tempes- *Pl. 441* tuous, ecstatic manner; Lazar Ličenoski (1901-1964) found his inspiration in the poppies, the poplars, and the rugged hills of Macedonia. The same, or similar, regional attachments are seen in the work of Petar Dobrović (1890-1942), hedonist and sun worshiper, in love with the shimmering summers of Dalmatia and Dubrovnik; Sava Šumanović (1896-1942), who after his early Cubist experiments and the masterly *Drunken Ship* (1927) painted nudes, compositions, Srem landscapes; Zora Petrović (1894-1962), with her monumental female figures, nude or wearing regional costume; Oskar Herman (born 1886), whose works strike a biblical note, evoke the mystery of life, show a vein of fatalism.

The Croatian group known as the Trojica ("The Three"), founded in Zagreb in 1929, represents a special variant of Expressionism. The members of this group were Ljubo Babić, Vladimir Becić, and Vilko Gecan. Working along the same lines were Anton Gojmir Kos (born 1896) in Slovenia and Nikola Martinoski (born 1903) in Macedonia.

Toward the end of the third and the beginning of the fourth decade — a period of economic, social, and political crisis — a tendency toward social protest developed. This criticism of society was formulated by the Belgrade Surrealists — poets rather than painters — who, aware of the "crisis of civilization" and inspired by the example of André Breton, demanded a revision of all the norms and values of the bourgeois order. Simultaneously, criticism less metaphysical and more sociopolitical was leveled at society by the Zemlja ("Earth") group founded in Zagreb in 1929, the purpose of which was to utilize actual social conditions (the village, the city suburb) to expose the senseless squalor of contemporary society and call for action and revolution. As for their artistic idiom, the members of the group, drawing their inspiration from Bosch, Breughel, Grosz, translated anecdote and narrative into plastic terms, reconciling synthetic form with clear color and graphic approach, volume with surface. The group is best represented by Krsto Hegedušić (born 1901), *Pl. 450, Fig. b* Željko Hegedušić (born 1906), and Marijan Detoni (born 1905). Founded in the village of that name, the Hlebine school of painting, which gathered around Krsto Hegedušić a number of peasant-painters, the most celebrated of whom was Ivan Generalić (born 1914), is an integral part of this atmosphere of searching examination of everyday life, its sordidness and its poetry. But the range of social involvement was considerably wider. In addition to narrative Expressionism with a social message (the Hegedušić brothers, Detoni) that is very bold and transposed, we find the calm critical realism and neohumanism (Petar Lubarda, born 1907) focused in Belgrade (the Zivot, or "Life," group, the Boycotters' Salon, etc.) and including Djordje Andrejević-Kun (1904-1964), Mirko Vujačić (born 1901), Moša

Pijade (1890-1957), Vinko Grdan (born 1900), Djordje Teodorović (born 1907), Boro Baruh (1911-1942).

To the agitation and emotional restlessness of Expressionism (at times reflecting a Dionysian exaltation, at others a Munch-like mystery) and to the ideological and critical attitude of the social painters, Intimism was antithetic; here and there the influence of Bonnard, Vuillard, and Filippo de Pisis became apparent, only to disappear with the reversion to poetic realism, "normal guarantees," the consistent object (Kosta Hakman, 1899-1961), particularly characteristic of the school of Paris and the aesthetics of 1935. The ideal of Intimism was culture, gentleness, inner light, refinement of mediums and feelings, careful introspective observation and "listening to life" — the poetic evocation of figures and land-scapes, and especially interiors breathing an atmosphere of sympathy, warmth, contemplative serenity. Tone is more important than color, light and space than surface. The transition

*Pl. 440*    between this approach and the Expressionist attitude is represented by Marko Čelebonović (born 1902), with his greater internal movement and the force of his evocative portraits and interiors, the blending of the sculptural and psychological, the material and spiritual,

*Pl. 442*    in his figures. A similar place is occupied by Pedja Milosavljević (born 1908), a painter who combines the grayish register of his palette with powerful sweep in a range of subjects that encompasses ethnogeny, Parisian rooftops, Dubrovnik, Venice, old Belgrade. Other genuine representatives of this school are Stojan Aralica (born 1883), Ivan Radović (born (1894), Nedeljko Gvozdenović (born 1902), Ivan Tabaković (born 1898), and Milenko Šerban (born 1907), all of whom, in the years under consideration, presented variations of a Bonnard-like *Weltanschauung.* Allied to them are Antun Motika (born 1902), notable for the spiritualized and ethereal quality of his silvery tones, and Slavko Šohaj (born 1908), for his warm, dense atmosphere. In another group of the same artistic family are Emanuel Vidović, with his later series of gloomy interiors of studios and churches, full of a tense stillness and mystery; Juraj Plančić (1889-1930), who observes the daily life of the coast people through the lyrical, retrospective eye of the eighteenth century; and Marin Tartalja (born 1894), for whom tone is a purely emotional value (second, dark-gray phase). It must be stressed that Gvozdenović, Milosavljević, and Tabaković were to achieve full development only after 1945, the first two remaining within their original spiritual sphere and the third, inspired by science, abandoning that sphere to extend the boundaries of the real to the limits of perception.

The art world of 1935 also encompasses the Surrealism of Milena Pavlović-Barili (1909-1945) and Stane Kregar (born 1905), marked by traditionalism, gentleness and melan-choly, and the absence of protest, then the work of Leo Junek (born 1899), with its inner tension, and, particularly, the work of artists who became known as World War II (which took the lives of some of the most gifted of them) loomed on the horizon: Jurica Ribar (1918-1943), Bogdan Šuput (1914-1942), Ljubica Sokić (born 1914).

The period after 1945 appears the most dynamic and fascinating, owing to the establish-ment of many new cultural centers, to collaboration among a number of generations of artists, and to the new social and cultural atmosphere. It was during this period that contemporary Yugoslav art took its place in the modern art world.

Initial hesitation and confusion associated with the idea of a rigorously utilitarian art were rapidly transcended, and by 1950 there emerged a feverish search for new paths, at first reflected in the logical individual development of excellent, still youthful artists

*Pl. 443*    of the prewar period. Special stress must be laid on the name of Petar Lubarda (with partic-ular reference to his exhibition of 1951), who turned, after his prewar poetic realism, to legends from national history *(The Battle of Kosovo)* or to epic Montenegrin landscapes, in which a modern metaphor is applied to the sphere of associative or abstract Expressionism. Milo Milunović's preoccupation with the symbols of the Mediterranean world makes itself felt through the medium of his incisive lines, his blue and brown colors. Marij Pregelj

d. *Francè Mihelič*. Carnival Figures. *1963. Charcoal, 39 3/8 × 27 1/4". Museum of Modern Art, Belgrade*

e. *Vladimir Veličković*. Sketch. *1968. 15 3/4 × 11 3/4". Private collection, Belgrade*

(1913-1967) reflects in his work the pressure of his Expressionistic obsession with concentration camps, with suffering and death. Gabrijel Stupica (born 1913), whose gloomy, "museumish" still lifes and psychologically perceptive and plastically suggestive portraits were followed by a descent into a world of melancholy and isolation, into the white nothingness of his brides, resorts to an extremely subtle and intellectualized ostensible infantilism. In the impressive oeuvre of Krsto Hegedušić, war, crime, the absurd, are perceived with an almost existentialist vision that is simultaneously protest and catharsis. We might also include here Frano Šimunović (born 1908) and Oton Gliha (born 1914), with their divergent interpretations of the fields and rough walls of the Karst region; Lojze Spacal (born 1907), with his fixation on the magic of Mediterranean landscapes and architecture; Anton Gojmir Kos, with his vehement compositions done with broad palette knife. Other members of this generation developed more or less along the lines of their prewar tendencies.

 Without questioning the importance of the role played by the older generation, it must be recognized that the passion for the new has, naturally, been primarily a passion of the young and the very young. With more enthusiasm than experience, after some initial wandering they finally, around 1960, assumed motivated positions. Among their preoccupations are the relativity of objects, abstract landscapes, symbols, *Informel*, Action Painting. The aesthetic roster of the period includes the modern figural artist Mladen Srbinović (born 1925), who has elevated the brilliance and symbolism of folklore to the level of intellectualized composition, and such painters of abstract imaginary landscapes as Boris Dogan (born 1923), Stojan Ćelić (born 1925), in love with purity, simplicity, light, and the organic, chromatic scale of plant life, and Miodrag B. Protić (born 1922). The representatives of Action Painting, Abstract Expressionism, and similar trends are artists of international renown: Edo Murtić (born 1921), Zlatko Prica (born 1916), Milorad-Bata Mihajlović (born 1923), Josip Vaništa (born 1924). A fascination, stimulated by *Informel*, with the

*Pl. 453*

*Pl. 444*

*Pl. 446*

*Pl. 448, Fig. f*
*Pl. 449*

*Pl. 445, 447*

plastic possibilities of matter, as well as the use of unorthodox materials — the so-called

*Pl. 460* non-mediums (tin, rope, burlap, etc.) — appears in the work of Ordan Petlevski (born 1930), laureate of the Paris Biennale (in whose works the fugue of Surrealism nevertheless persists), Lazar Vozarević (1925-1968), Zoran Petrović (born 1921), Mića Popović (born 1923), Branko Protić (born 1931), Živojin Turinski (born 1935), Zoran Pavlović (born 1932), and Janez Bernik (born 1933). There is a streak of naiveté in the canvases of Lazar Vujaklija (born 1914), Bogoljub Ivković (born 1924), and Milan Kečic (born 1910), and in the tapestries of Milica Zorić (born 1909).

The magical, the metaphysical, and the surreal are strongly present in the paintings of the youngest artists, especially in Belgrade. The evocation of poetic phantasmagoria,

*Fig. a* gentle and lyrical, is sensed as the aim of such artists as Branko Miljuš (born 1936), Slobodan Samurović (born 1928), Marko Šuštaršič (born 1927), and, best-known among them, Miljenko Stančić (born 1926), whose oeuvre encompasses the surreal as well as the magical. Surrealists in the strict sense of the term include Ljubo Popović (born 1934), Leonid Šejka (1932-1970), Milić Stanković (born 1934), Vasilije Jordan (born 1934), Spase Kunoski

*Fig. e* (born 1929). Vladimir Veličković (born 1935) stands at the crossroads of Surrealism and contemporary "black," or "demonic," realism. These painters, and others of like mind, are extremely "realistic" and logical in painting their highly subjective, alogical visions. The aesthetics of ugliness, torture and sadism, provocation and protest frequently preoccupy them more than compassion. They contribute less on the narrower plane of form than on the level of content — psychologically, semantically, and sociologically.

The painters of what are known as the "new tendencies" (Zagreb), representing the impulse of geometric abstraction, emanating from the Bauhaus and De Stijl — new possibilities of purely visual investigation, supplemented by kinetic and light effects — seek to reconcile art and industrial civilization, to replace subjectivism with the objectively beautiful,

*Pl. 456* to create a fresh visual reality. This group includes Ivan Picelj (born 1924), Vlaho Kristl (born 1923), and Miroslav Šutej (born 1936). Sometimes closely related to them is Radomir

*Pl. 451* Damnjanović-Damnjan (born 1936), who, however, retains a certain metaphysical atmosphere and aura of magic.

In the broad register of conceptions the above-mentioned artists dominate, but there are others, among them Ksenija Divjak (born 1924), Radenko Mišević (born 1920), Aleksandar Luković (born 1924), Aleksandar Tomašević (1921-1968), who employ an authentic idiom based on traditional perceptions and traditional mediums. Thus a variety of artistic movements, often contradictory in their essential characteristics, appeared on the scene in the 1945-1965 period. There is a simultaneous striving for external and internal cosmic reality corresponding to newly acquired knowledge; for the expression and not the description of feelings; for "direct painting"; for the work of art as an abstract sublimation of the real; for unity of gesture, sign, and action; for nontraditional mediums; for a new figuration which often places in parentheses, as it were, the traditional concept of beauty.

During the first few decades of this century, contemporary Yugoslav sculpture could not boast a large number of personalities or trends, for reasons having a sociological common denominator: apart from purely utilitarian purposes (public monuments and statues), its purpose was considerably restricted and indeterminate. A vital change set in after 1945, with the altered conditions inside the country and its inclusion as a recognized participant in international artistic life.

The name that stands at the beginning of modern Yugoslav sculpture is an illustrious

*Pl. 431, 432, 433* one. Ivan Meštrović (1883-1962), under the influence of Rodin and the Viennese Secession (and through it also that of the great epochs), after his exhibition in Rome in 1911, emerged as a monumental figure in European art. Ranging from realism and naturalism to Expressionistic, integrated, linear stylization, he everywhere exhibited — in numberless monumental sculptures, monuments, chapels, and shrines — sweep and power, a sovereign control

f. *Stojan Ćelić*. The Curse of Theseus. *1965. Coppperplate engraving, 19 3/4 × 25 1/2". Collection the artist, Belgrade*

of his idiom. Imbued by a similar spirit, and striving in his religious compositions, nudes, and portrait busts for the modernization of the sculptor's canon, reconciling pathos with lyricism, was Toma Rosandić (1878-1958). Also belonging to Meštrović's school, centered in Zagreb, were Antun Augustinčić (born 1900) and Vanja Radauš (born 1906); the latter, however, evolved toward a more contemporary approach to the problems of sculpture, retaining at the same time his note of inward turmoil. Working along the same lines in Slovenia are the Slovene Expressionists Lojze Dolinar (born 1893), France Kralj and Tone Kralj, and Tine Kos (born 1894).

Pl. 434

In contrast to this school stands a group of artists whose work is characterized by a Mediterranean balance and lightness of spirit. Outstanding representatives of this trend are Frano Kršinić (born 1897), with his nudes, dense and reduced in form; Petar Palavičini (1887-1958), with his synthetic, post-Cubist portraits and intimate figurines; Risto Stijović (born 1894), also known as an animal sculptor, with his nudes carved in wood, as generalized and as simplified as totems.

Pl. 436
Pl. 435

A third trend is more realistic and psychological. Most frequently, the realism is modern in bent, incorporating new experience, such as Impressionistic treatment of surface. It is typified by Sreten Stojanović (1898-1960), the creator of the psychological portrait in Serbia, by Boris Kalin (born 1905), and by Zdenko Kalin (born 1911).

Pl. 425

The work of a number of other sculptors falls into categories between the first and the third trend. Among these, mention should be made of Ivo Lozica (1910-1943), Dušan Jovanović-Djukin (1891-1945), Mihajlo Tomić (born 1902), Stevan Bodnarov (born 1905), Živojin Lukić (1890-1934).

After 1945, with the coming of age of the younger generation, a major polarization of concepts took place, and Yugoslav sculpture was transformed. A number of powerful personalities appeared in Zagreb: Vojin Bakić (born 1915) evolved from traditional, fully mastered concepts, through reduced forms and associative curving volumes, to geometrical abstraction-sculptures in aluminum, steel, or brass in line with the new tendencies. Kosta

Pl. 459

Pl. 455   Angeli-Radovani (born 1916) made use of tectonic mass and subtle archaicism in his figu-
Pl. 458   ration. Dušan Džamonja (born 1928) was preoccupied with the sculptural symbol, with internal and external space, and with a variety of materials. Ivan Kožarić (born 1921),
Pl. 454   Branko Ružić (born 1919), Ksenija Kantoci (born 1908), and Šime Vulas (born 1932) are other important contemporary sculptors.

In Belgrade conceptual modernization can be attributed to a number of sculptors. The projects of Olga Jevrić (born 1922) for public monuments and sculptures embody a number of plastic antitheses of amorphous or "organic" masses of concrete linked together by iron bars. Olga Jančić (born 1929) made the transition from expressionistically slanted figurative works to closed, generalized mass, usually curving and organic in form. Jovan Kratohvil (born 1924), after a series of portraits and figures in the archaic manner, went on to create abstract, spherical forms in metal. In connection with this series of transformations, mention must also be made, to single out a few names, of Boris Anastasijević (born 1926), Matija Vuković (born 1925), Nandor Glid (born 1924), Oto Logo (born 1931), Vida Josić (born 1921), Miša Popović (born 1925), and Mira Jurišić (born 1928). In contrast to them, Nikola Janković (born 1926) and Milan Vergović (born 1928) maintained a traditional approach.

In Slovenia a number of representatives of the new generation of sculptors have asserted
Pl. 457   themselves: Drago Tršar (born 1927), who translated the motif of social protest into ordinarily symmetrical forms, first elaborated in the Baroque manner and later acquiring an increasingly closed and geometrically severe aspect; Stojan Batič (born 1925), who in his figures of miners reconciles a number of elements, blending the tectonics of mass with a graphic approach to surface; Jakov Savinšek (1922-1961); Slavko Tihec (born 1928); and Janez Boljka (born 1931).

The graphic arts have also produced a number of artists of international repute. By and large, this field has followed the patterns of painting and has had a similar evolution; however, certain ideas have frequently been expressed more forcefully in this medium than in painting (social involvement, for instance). In any case, many painters are also excellent
Fig. d   graphic artists — Francè Mihelič, Stojan Ćelić, Janez Bernik, Zlatko Prica, Ordan Petlevski, Branko Miljuš, to cite a few. New names that should be mentioned in connection with the graphic arts include the following: Tomislav Krizman (1882-1955), Božidar Jakac (born 1899), Mihailo Petrov (born 1902), Vilim Svećnjak (born 1906), Branko Šotra (1906-1960), Riko Debenjak (born 1908), Pivo Karamatijević (1912-1963), Milivoj Nikolajević (born 1912), Mario Maskareli (born 1918), Nikola Rajzer (born 1913), Ankica Oprešnik (born 1919), Albert Kinert (born 1919), Dragoslav Stojanović-Sip (born 1920), Miodrag Nagorni (born 1932), Boško Karanović (born 1924), Radovan Kragulj (born 1934), Vladimir Makuc (born 1926), Marko Krsmanović (born 1930).

It may be said, in conclusion, that contemporary Yugoslav art has undergone a radical change in the course of its development: it has been transformed from a follower into an active and recognized participant in present-day international art. As such it has attracted attention at all international exhibitions (Venice, Paris, Sao Paulo, Tokyo, etc.). It has added a number of authentic names to the roster of modern graphic art, sculpture, and painting. Another of its salient features is that its most frequent point of departure is the real, from which it moves radially toward diverse goals, from old to new figuration, from objects to symbols. On one level, or in one sphere of expression, where its character is conditioned by the cultural-historical environment, by sociological factors, it confirms the words of the philosopher who declared that poetry is the core of art. On another level, still in its inception, it is dedicated to rational, functional beauty, to an aesthetic program motivated by human and social considerations, seeking a place for beauty in industrial civilization and in the new, unexpected conditions engendered by the series of social, scientific, and technological revolutions.

425

425 SRETEN STOJANOVIĆ. Portrait of a Friend. 1920. Bronze, height
16 1/8''. Museum of Modern Art, Belgrade

426

427

**428**

**429**

426 *Josip Račić.* Lady in a Hat. *1907. Oil on canvas, 23 5/8 × 19 5/8".*
*Modern Art Gallery, Zagreb*

427 *Miroslav Kraljević.* Self-Portrait with Pipe. *1912. Oil on canvas,*
*16 × 13". Council for Science and Culture, Belgrade*

428 *Rihard Jakopič.* Plowmen. *c. 1923/25. Oil on canvas,*
*43 1/4 × 53 1/8". Museum of Modern Art, Belgrade*

429 *Nadežda Petrović.* Shepherd. *c. 1912. Oil on cardboard,*
*28 3/8 × 19 5/8". National Museum, Belgrade*

430 *Ivan Grohar.* Škofja Loka in the Snow. *1905. Oil on canvas,*
*34 1/4 × 39". Modern Art Gallery, Ljubljana*

**430**

431

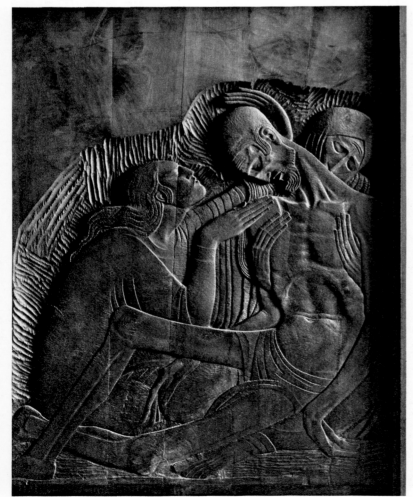

432

433

431 IVAN MEŠTROVIĆ. *Detail of* The Descent from the Cross *(Plate 432)*

432 IVAN MEŠTROVIĆ. The Descent from the Cross. *1917. Wood, 68 1/8 × 51 1/8″. Meštrović Gallery, Split*

433 IVAN MEŠTROVIĆ. Memories. *1908. Marble, height 59″. National Museum, Belgrade*

434 *Antun Augustinčić.* Female Torso. *1941. Bronze, height 35 1/2".*
*National Museum, Belgrade*

435 *Risto Stijović.* Nude. *1959. Walnut, height 43 1/4". Federal*
*Executive Council, Belgrade*

436 *Frano Kršinić.* The Awakening. *1928. Marble, height 56 3/4".*
*National Museum, Belgrade*

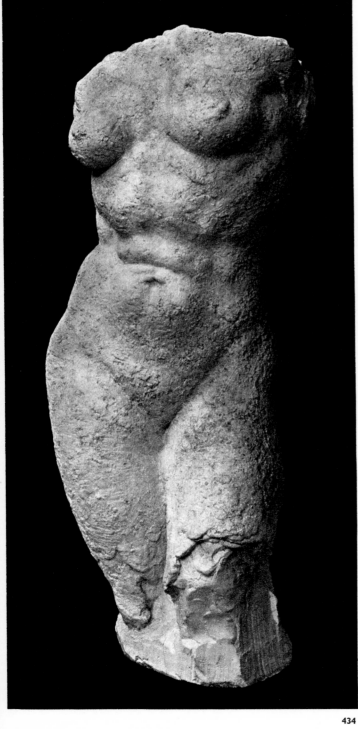

434          435          436

413

437

438

437 IGNJAT JOB. *Wine.* 1935. *Oil on canvas, 39 1/4 × 47 1/4''.*
*Modern Art Gallery, Zagreb*

438 JOVAN BIJELIĆ. *Baby Girl in Perambulator. c. 1935. Oil*
*on canvas, 30 × 26 1/2''. Museum of Modern Art, Belgrade*

439 MILO MILUNOVIĆ. *Sea Urchins. 1960. Oil on canvas,*
*25 1/4 × 33 3/4''. Private collection, Belgrade*

440 MARKO ČELEBONOVIĆ. *Still Life with Broken Bust. 1932.*
*Oil on canvas, 13 × 16 1/8''. Museum of Modern Art,*
*Belgrade*

439

440

441

442

443

444

441 MILAN KONJOVIĆ. The Drunken Poplar. 1961. Oil on wood fiber board, 14 3/8 × 28 3/8″. Collection the artist, Sombor

442 PEDJA MILOSAVLJEVIĆ. Summer Festival. 1965. Oil on canvas, 76 3/4 × 57″. Museum of Modern Art, Belgrade

443 PETAR LUBARDA. Composition. 1961. Oil on canvas, 93 1/4 × 116 1/4″. Collection the artist, Belgrade

444 OTON GLIHA. Stone Walls 6-60. 1960. Oil on canvas, 30 3/4 × 59″. Collection the artist, Zagreb

417

445

446

*445 EDO MURTIĆ. Red Dot. 1965. Oil on canvas, 65 × 51 1/4″. Collection the artist, Zagreb*

447

*446 MLADEN SRBINOVIĆ. The Fall. 1964/65. Oil on canvas, 67 × 57 1/8″. Collection the artist, Belgrade*

*447 ZLATKO PRICA. The Finest Day of the Summer. 1964. Oil on canvas, 37 3/4 × 55 1/2″. Collection the artist, Zagreb*

*448 STOJAN ĆELIĆ. Simple Landscape. 1958. Oil on canvas, 35 × 51 1/8″. Collection the artist, Belgrade*

*449 MIODRAG B. PROTIĆ. Composition with Two Shells. 1965. Oil on canvas, 44 1/2 × 57 1/2″. Private collection, Belgrade*

*450 KRSTO HEGEDUŠIĆ. The Brčko-Banovići Train. 1956. Oil on canvas, 56 × 64 1/8″. Collection the artist, Belgrade*

448

449

450

419

**451**

**452**

451 *RADOMIR DAMNJANOVIĆ-DAMNJAN.* Cabins on Sandy Shore. *1961. Oil tempera, 19 3/4 × 17 3/4". Private collection, Belgrade*

452 *FRANCE MIHELIČ.* Clocks. *1961. Tempera, 39 3/4 × 50 3/8". Modern Art Gallery, Ljubljana*

453 *GABRIJEL STUPICA.* Self-Portrait (Selinge). *1961. Tempera on canvas, 46 1/2 × 33 1/2". Modern Art Gallery, Ljubljana*

**453**

**454** BRANKO RUŽIĆ. *Korablja. 1966. Wood, 15 3/4 × 13 3/4 ×*
*35 1/2". Modern Art Gallery, Zagreb*

**455** KOSTA ANGELI RADOVANI. *Dunja IV. 1963. Bronze,*
*21 1/4 × 33 × 24". Modern Art Gallery, Zagreb*

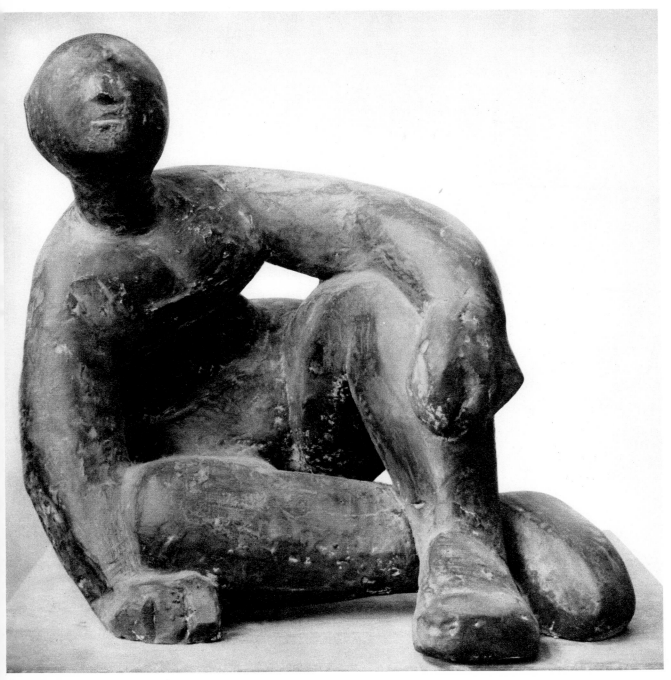

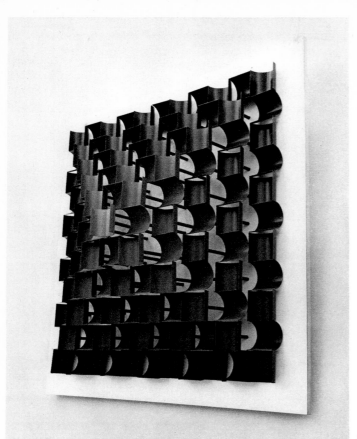

**456**

456 *Ivan Picelj.* Programmed Relief. *1966. 39 3/8 × 39 3/8''.*
*Collection the artist, Zagreb*

457 *Drago Tršar.* Four Groups. *1960. Bronze, 44 1/2 × 51 1/8''.*
*Museum of Modern Art, Belgrade*

**457**

458 DUŠAN DŽAMONJA. Sculpture XVI. 1961. Wood and metal,
24 3/8 × 17 × 14 1/2″. Museum of Modern Art, Belgrade

459 VOJIN BAKIĆ. Forms of Light. 1964. Duralumin, 64 1/2 ×
51 1/4″. Museum of Modern Art, Belgrade

**458**

**459**

460

*460 ORDAN PETLEVSKI. Sand and Ashes. 1959. Oil on canvas,
39 3/8 × 31 1/2''. Museum of Modern Art, Belgrade*

# SELECTED BIBLIOGRAPHY

"*Yugoslavia,*" Encyclopedia of World Art, XIV, New York, 1967, cols. 882-934.

*L'art en Yougoslavie de la préhistoire à nos jours*

*(exhibition catalogue), Grand Palais, Paris, 1971.*

ALEXANDER, J. *Yugoslavia before the Roman Conquest*, London, 1972.

## GENERAL

HÖRNES, M., RADIMSKY, W., and FIALA, F. *Die neolithische Station von Butmir bei Sarajevo in Bosnien*, I-II, Vienna, 1895-98.

VASIĆ, M. *Preistoriska Vinča*, I-IV, Belgrade, 1932-36.

VULIĆ, N., and GRBIĆ, M. *Corpus vasorum antiquorum*, vol. XI, Yougoslavie, fasc. 3: *Musée du Prince Paul*, Belgrade, 1937.

GARAŠANIN, M. *Hronologija vinčanske grupe*, Ljubljana, 1951.

BENAC, A. *Prehistorisko naselje Nebo i problem butmirske kulture*, Ljubljana, 1952.

ARANDJELOVIĆ-GARAŠANIN, D. *Starčevačka kultura*, Ljubljana, 1954.

GALOVIĆ, R., and STALIO, B. *Katalog keramike, Narodni Muzej, Beograd*, 1955 (*National Museum, Belgrade. Vorgeschichte II*).

TASIĆ, N. "*Praistorisko naselje kod Valača,*" Glasnik Muzeja Kosova i Metohije, II, Priština, 1957, pp. 3-47.

GARAŠANIN, M. "*Neolithikum und Bronzezeit in Serbien und Makedonien,*" Bericht der Römisch-germanischen Kommission, XXXIX, Berlin, 1958, pp. 1-130.

GALOVIĆ, R. *Predionica, neolitsko naselje kod Prištine*, Priština, 1959.

TASIĆ, N. "*Završna istraživanja na praistoriskom naselju kod Valača,*" Glasnik Muzeja Kosova i Metohije, IV-V, Priština, 1959-60.

BENAC, A. *Studije o kamenom i bakarnom dobu zapadnog Balkana*, Sarajevo, 1964.

SREJOVIĆ, D. *Europe's First Monumental Sculpture: New Discoveries at Lepenski Vir*, London, 1972.

## THE NEOLITHIC AGE

VALTROVIĆ, M. "*Zemljani preistorijski kip iz Kličevc,*" Starinar, VII⁴, Belgrade, 1890, pp. 110-14.

MILLEKAR, B.Ä. *Vattinai Östelep*, Temesvar, 1905.

VASIĆ, M. "*Preistoriska votivna grivna i uticaji Mikenske kulture u Srbiji,*" Starinar, n.s. I¹, Belgrade, 1906, pp. 1-35.

VASIĆ, M. "*Žuto Brdo,*" Starinar, n.s. II¹, Belgrade, 1907, pp. 147; n.s. V¹⁻², 1910; n.s. VI¹⁻², 1911, pp. 1-93.

FILOV, B. *Die archaische Nekropole von Trebenište am Ochrida-See*, Berlin, 1927.

HOFFILLER, V. *Corpus vasorum antiquorum*, vol. VII, Yougoslavie, fasc. 1-2: *Zagreb-Musée archéologique*, Paris, 1933-37.

VULIĆ, N., and GRBIĆ, M. *Corpus vasorum antiquorum*, vol. XI, Yougoslavie, fasc. 3: *Musée du Prince Paul*, Belgrade, 1937.

SCHMIDT, R. *Die Burg Vučedol*, Zagreb, 1945.

KOROŠEC, J. "*Pećina Hrustovača, novi lokalitet slavonske kulture,*" Glasnik Državnog Muzeja u Sarajevu, I, Sarajevo, 1946, pp. 7-38.

GAVELA, B. *Keltski oppidum Židovar*, Belgrade, 1952.

VASIĆ, M. "*Kličevačka nekropola,*" Starinar, n.s. III-IV, Belgrade, 1952-53, pp. 1-16.

STARE, F. *Prazgodovinske Vače*, Ljubljana, 1954 (*Thesis, Letters, University of Ljubljana*).

GARAŠANIN, D. *Katalog metala, Narodni Muzej, Beograd*, 1954 (*National Museum, Belgrade. Vorgeschichte I*).

STARE, F. "*Prazgodovinske posode iz Slovenije,*" Zbornik Filozofske fakultete, Univerza v Ljubljani, II, Ljubljana, 1955, pp. 103-90.

BENAC, A., and ČOVIĆ, B. *Glasinac I-II, Zemaljski Muzej*, Sarajevo, 1956-57 (*Katalog prehistoriske zbirke, I*).

POPOVIĆ, LJ. *Katalog nalaza iz nekropole kod Trebeništa, Narodni Muzej, Beograd*, 1956 (*National Museum, Belgrade. Antika I*).

VINSKI, Z., and VINSKI-GASPARINI, K. "*Prolegomena k statistici i kronologiji prethistoriskih ostava u Hrvatskoj i u Vojvodjanskom području Srijema,*" Opuscula Archaeologica, I, Zagreb, 1956, pp. 57-109.

GARAŠANIN, M. "*Neolithikum und Bronzezeit in Serbien und Makedonien,*" Bericht der Römisch-germanischen Kommission, XXXIX, Berlin, 1958, pp. 53-106, 120-25.

LAHTOV, V. "*Skica hronologije Starijeg železnog doba Makedonije,*" Arheološko društvo Jugoslavije, Praistorijska sekcija, I, Ohrid, 1960, pp. 101-49.

MARIĆ, Z. "*Donja Dolina,*" Glasnik Zemaljskog Muzeja u Sarajevu: Arheologija, XIX, Sarajevo, 1964, pp. 5-128.

KASTELIC, J., MANSUELLI, G., and KROMER, K. *Situla Art: Ceremonial Bronzes of Ancient Europe*, London, 1965 (1966).

## ART IN THE AGE OF METALS

BRUNŠMID, J. *Kameni spomenici Hrvatskog narodnog muzeja u Zagrebu*, Zagreb, 1904-12.

TRUHELKA, Ć. *Kulturne prilike Bosne i Hercegovine*

*u prethistoričko doba*, Sarajevo, 1914.

PATSCH, K. *Zbirka rimskih i grčkih starina u Zemaljskom muzeju*, Sarajevo, 1914.

## THE ART OF ANTIQUITY

Österreichisches Archäologisches Institut in Wien. Forschungen in Salona, I-III, Vienna, 1917, 1926, 1939.

ABRAMIĆ, M. Poetovio, Ptuj, 1920.

BULIĆ, F., and KARAMAN, LJ. Palača cara Dioklecijana u Splitu, Zagreb, 1927.

BRONSTED, J., DYGGVE, E., and WEILBACH, F. Recherches à Salone, I-II, Copenhagen, 1928-33.

SERGEJEVSKI, D. "Japodske urne," Glasnik Zemaljskog Muzeja u Sarajevu, IV-V, Sarajevo, 1949-50, pp. 45-92, 8 plates.

GORENC, M. Antikna skulptura u Hrvatskoj, Zagreb, 1952.

MANO-ZISI, DJ. The Antique in the National Museum in Belgrade, Belgrade, 1954.

RENDIĆ-MIOČEVIĆ, D. "Ilirske predstave Silvana na kultnim slikama sa područja Dalmata," Glasnik Zemaljskog Muzeja u Sarajevu, X, Sarajevo, 1955, pp. 5-40.

ŠAŠEL, J. Vodnik po Emoni, Ljubljana, 1955.

POPOVIĆ, LJ., Katalog nalaza iz nekropole kod Trebeništa, Narodni Muzej, Beograd, 1956 (National Museum, Belgrade. Antika I).

GRBIĆ, M. Odabrana grčka i rimska plastika u Na-

rodnom Muzeju u Beogradu, Belgrade, 1958.

ČREMOŠNIK, I. "Spomenik sa japodskim konjanicima iz Založja kod Bihaća," Glasnik Zemaljskog Muzeja u Sarajevu: Arheologija, n.s. XIV, Sarajevo, 1959, pp. 103-11.

PAŠALIĆ, E. "Rimsko naselje u Ilidži kod Sarajeva," Glasnik Zemaljskog Muzeja u Sarajevu, Arheologija, n.s. XIV, Sarajevo, 1959. pp. 113-36.

DRECHSLER-BIŽIĆ, R. "Rezultati istraživanja japodske nekropole u Kompolju 1955-1956," Vjesnik Arheološkog Muzeja u Zagrebu, III², Zagreb, 1961.

KLEMENC, J. Rimske izkopanine u Šempetru, Ljubljana, 1961.

PETRU, S. "O spomeniku emonskega meščana," Arheološki Vestnik — Acta Archaeologica, XIII-XIV, Ljubljana, 1962-63, pp. 513-44.

SUIĆ, M. "Mediteranske baštine jadranskih Ilira," Radovi Filozofskog fakulteta u Zadru, god. 4, sv. 4, Razdio Historije, Arheologije i Historije umjetnosti II, 1962-63, Zadar, 1966, pp. 44-58.

LAHTOVI, V. Problem Trebeniške kulture, Ohrid, 1965.

TOMAŠEVIĆ G. "Portik so počesni i votivni spomenici," Herakleja, II, Bitola, 1965.

## MOSAICS OF ANTIQUITY

TRUHELKA, Ć. "Zenica und Stolac," Wissenschaftliche Mitteilungen aus Bosnien und der Herzegowina, I, Vienna, 1893, pp. 273-302.

FIALA, F., and PATSCH, C. "Untersuchungen römischer Fundorte in der Herzegowina," Wissenschaftliche Mitteilungen aus Bosnien und der Herzegowina, III, Vienna, 1895, pp. 257-83.

FIALA, F. "Beiträge zur römischen Archäologie der Herzegowina," Wissenschaftliche Mitteilungen aus Bosnien und der Herzegowina, V, Vienna, 1897, pp, 169-72.

GERBER, W., ABRAMIĆ, M., and EGGER, R. Die Bauten im nordwestlichen Teile der Neustadt von Salona, Vienna, 1917 (Österreichisches archäologisches Institut in Wien. Forschungen in Salona, I).

BRONSTED, J., DYGGVE, E., and WEILBACH, F. Recherches à Salone, I, Copenhagen, 1928, pp. 114-33.

VOUKSAN, D. "Les mosaïques romaines de Risan," Albania: Revue d'archéologie, d'histoire, d'art et des sciences appliquées en Albanie et dans les Balkans, IV, Paris, 1932, pp. 77-86.

DYGGVE, E., and EGGER, R. Der altchristliche Friedhof Marusinac, Vienna, 1939 (Österreichisches archäologisches Institut in Wien. Forschungen in Salona, III), pp. 53-79.

MOLAJOLI, B. La basilica Eufrasiana di Parenzo, 2nd ed., Padua, 1943.

KITZINGER, E. "A Survey of the Early Christian Town of Stobi," Dumbarton Oaks Papers, III, Cambridge, Mass., 1946, pp. 81-162.

MANO-ZISI, DJ. "Iskopavanja na Caričinom Gradu 1949-1952 godine," Starinar, n.s. III-IV, Belgrade, 1953, pp. 127-68.

MANO-ZISI, DJ. "Le castrum de Gamzigrad et ses mosaïques," Archaeologia Jugoslavica, II, Belgrade, 1956, pp. 67-84.

PRELOG, M. "Poreč: Grad i spomenici," Izd. Savezni institut za zaštitu spomenika kulture, Belgrade, 1957, pp. 93-121.

MANO-ZISI DJ. "Prolegomena uz probleme kasnoantičkog mozaika u Ilirikumu," Zbornik radova Narodnog Muzeja, II, Belgrade, 1959, pp. 83-109.

PAŠALIĆ, E. "Rimsko naselje u Ilidži kod Sarajeva," Glasnik Zemaljskog Muzeja u Sarajevu: Arheologija, n.s. XIV, Sarajevo, 1959, pp. 113-36.

KOCO, D. "Basiliques paléochrétiennes dans la région du Lac d'Ohrid," Zbornik na trudovi, Narodni Muzej Ohrid, Ohrid, 1961, pp. 15-33.

STRIČEVIĆ, DJ. "Arheološkite iskopuvanja vo Herakleja Linkestidska 1936-1938 godina," Herakleja, I, Bitola, 1961, pp. 35-43.

MLAKAR, S. "Novi antički nalaz u Puli," Arheološki radovi i rasprave, Jugoslavenska Akademija Znanosti i Umjetnosti, Zagreb, 1962, pp. 429-50.

JOVANOVIĆ, V. "Novi kasnoantički mozaik u Petrovcu na moru," Starine Crne Gore, I, Cetinje, 1963, pp. 129-37.

ČREMOŠNIK, I. "Rimska vila u Višićima," Glasnik Zemaljskog Muzeja u Sarajevu: Arheologija, n.s. XX, Sarajevo, 1965, pp. 147-260.

MANO-ZISI DJ. "La question des différentes écoles de mosaïques gréco-romaines de Yougoslavie et essai d'une esquisse de leur évolution," La Mosaïque Gréco-Romaine: Colloque sur "la mosaïque gréco-romaine," 1963, Actes, Paris, 1965, pp. 287-95.

RIEGL, A., and ZIMMERMANN H. *Die spätrömische Kunst-Industrie nach den Funden in Österreich-Ungarn*, 2 vols., Vienna, 1901-23.

ABERG, N. *Die Franken und Westgoten in der Völkerwanderungszeit*, Uppsala, 1922.

ABERG, N. *Die Goten und Langobarden in Italien*, Uppsala, 1923.

ALFÖLDI, A. *Der Untergang der Römerherrschaft in Pannonien*, 2 vols., Berlin, 1924-26.

JENNY, W. A. VON, and VOLBACH, W. *Germanischer Schmuck des frühen Mittelalters*, Berlin, 1933.

BAUM, J. *La sculpture figurale en Europe à l'époque mérovingienne*, Paris, 1937.

ABERG, N. *The Occident and the Orient in the Art of the Seventh Century*, 3 vols., Stockholm, 1943-47.

SALIN, É. *La civilisation mérovingienne d'après les sépultures, les textes et le laboratoire*, 4 vols., Paris, 1949-59.

FETTICH, N. *Archäologische Studien zur Geschichte der späthunnischen Metallkunst*, Budapest, 1951 (Archaeologia Hungarica, XXXI).

HOLMQUIST, W. *Germanic Art during the First Millennium A.D.*, Stockholm, 1955.

WERNER, J. *Beiträge zur Archäologie des Attila-Reiches*, Munich, 1956 (Bayerische Akademie der Wissenschaften. Philosophische-Historische Klasse. Abhandlungen. N.F. Heft 38 A-B).

VINSKI, Z. "Zikadenschmuck aus Jugoslawien," Jahrbuch des Römisch-Germanischen Zentralmuseums, IV, Mainz, 1957, pp. 136-60.

VINSKI, Z. "Arheološki spomenici velike seobe naroda u Srijemu, Situla," Glasnik Narodnog Muzeja, II, Ljubljana, 1957.

VINSKI, Z. "O Nalazima 6. i 7. stoljeća u Jugoslaviji s posebnim obzirom na arheološku ostavštinu iz vremena prvog avarskog kaganata," Opuscula Archaeologica, III, Zagreb, 1958, pp. 13-67, 18 plates.

VINSKI-GASPARINI, K. "Ranosrednjovjekovna kadionica iz Stare Vrlike," Starohrvatska Prosvjeta, series 3, VI, Zagreb, 1958, pp. 93-103, 5 plates.

CSALLÁNY, D. *Archäologische Denkmäler der Gepiden im Mitteldonaubecken*, Budapest, 1961 (Archaeologia Hungarica, n.s. XXXVIII).

DIMITRIJEVIĆ, D., KOVAČEVIĆ, J., and VINSKI, Z. *Seoba naroda; Arheološki nazivi jugoslovenskog Podunavlja*, Zemun, 1962.

WERNER, J. *Die Langobarden in Pannonien usw.*, Munich, 1962 (Bayerische Akademie der Wissenschaften. Philosophische-Historische Klasse. Abhandlungen. N.F. Heft 55A-55B).

MITSCHA-MÄRHEIM, H. *Dunkler Jahrhunderte goldene Spuren; die Völkerwanderungszeit in Österreich*, Vienna, 1963.

VINSKI, Z. "Okov Teodorikova vremena s ostrva Sapaja na Dunavu," Zbornik radova Narodnog Muzeja Beograd, IV, Belgrade, 1964, pp. 157-78.

VINSKI, Z. "Betrachtungen zur Kontinuitätsfrage des autochtonen romanisierten Ethnikons im 6. und 7. Jahrhundert," Problemi della civiltà e dell'economia longobarda: Scritta in memoria di Gian Piero Bognetti, raccolti e presentati da Amelio Tagliaferri, Milan, 1964 (Biblioteca della rivista "Economia e Storia," 12), pp. 101-16.

**ART DURING THE GREAT MIGRATIONS**

Bibliographies for the history of Serbian art can be found in the following:

For the period up to 1930: Millet, G., Ibrovac, P. E., and Kašanin, M. *L'art byzantin chez les Slaves*, II, Paris, 1930 (Orient et Byzance, IV).

For the period 1930-39: Bošković, Dj., "Bulletin Yougoslave. B. Archéologie et histoire de l'art," Byzantion, XIV, Brussels, 1939, pp. 425-58.

For the period 1939 to the present: yearly bibliographies in the periodicals Byzantinoslavica: International Journal of Byzantine Studies, Prague, and Starinar, Belgrade.

MILLET, G. *L'ancien art serbe; les églises*, Paris, 1919.

OKUNEV, L. *Monumenta artis Serbicae*, I-IV, Prague, 1928-32.

PETKOVIĆ, V. *La peinture serbe du moyen-âge*, 2 vols., Belgrade, 1930-34.

MILLET, G. "L'art des Balkans et de l'Italie au XIIIᵉ siècle," Atti del V Congresso internazionale di studi bizantini, II, Rome, 1940, pp. 272-97, plates LXXVI-LXXXIX.

PETKOVIĆ, V., and BOŠKOVIĆ. DJ. *Dečani*, 2 vols. and 1 vol. of plates, Belgrade, 1941 (Academia Regalis Serbica. Monumenta Jugoslaviae Artis Veteris. Serie prima. Monumenta Serbica Artis Mediaevalis, Liber II).

LAZAREV, V. N. *Istoriia vizantiiskoi zhivopisi*, 2 vols., Moscow, 1947-48.

PETKOVIĆ, V. *Pregled crkvenih spomenika kroz povesnicu srpskih naroda*, Belgrade, 1950.

GRABAR, A. *Byzantine Painting*, Geneva, 1953.

RADOJČIĆ, S. *Frescoes of Sopoćani*, Belgrade, 1953.

MILLET, G., and FROLOW, A. *La peinture du moyen-âge en Yougoslavie*, 4 vols., Paris, 1954-69.

RADOJČIĆ, S. *Majstori starog srpskog slikarstva*, Belgrade, 1955.

RADOJČIĆ, S. *Yugoslavia: Mediaeval Frescoes*, Paris, 1955.

RADOJČIĆ, S. *Les fresques dans les églises du moyen-âge en Serbie, au Montenegro et en Macedoine*, n.p., n.d. 1955.

RADOJČIĆ, S. "Die Entstehung der Malerei der paläologischen Renaissance," Jahrbuch der Österreichischen Byzantinischen Gesellschaft, VII, Graz and Cologne, 1958, pp. 105-23.

DJURIĆ, V. "Solunsko poreklo Resavskog živopisa," Zbornik radova Vizantološkog instituta Srpske

**MEDIEVAL WALL PAINTING AND ARCHITECTURE IN SERBIA AND MACEDONIA**

Akakemija Nauka, VI, *Belgrade, 1960, pp. 111-28.*

LAZAREV, V. N. *"Živopis XI-XII v. v Makedonii,"* Actes du XII Congrès internationale des études byzantines, I, *Belgrade and Ohrid, 1961, pp. 105-34, 36 plates.*

DJURIĆ, V. *Sopoćani, Belgrade, 1963.*

RADOJČIĆ, S. *"La pittura in Serbia e in Macedonia dall'inizio del secolo XII fino alla metà del secolo XV,"* Corsi di cultura sull'arte ravennate e bizantina, X, *Ravenna, 1963, pp. 293-325.*

TASIĆ, D. *Crkvena arhitektura i fresko slikarstvo Srbije—znamenitosti i lepote, Belgrade, 1965.*

## THE ICONS OF SERBIA AND MACEDONIA

KONDAKOV, N. *Makedonija, St. Petersburg, 1909.*

MESESNEL, F. *"Manastir Morača i njegove ikone,"* Narodna Starina, XXVIII, *Zagreb, 1932, pp. 133-34.*

MIRKOVIĆ, L. *"Crkvene starine iz Dečana, Peći, Cetinja i Praskavice,"* Godišnjak Muzeja Južne Srbije, I, *Skoplje, 1940.*

RADOJČIĆ, S. *Starine crkvenog muzeja u Skoplju, Skoplje, 1941.*

KAŠANIN, M. *Ohridske ikone, umetnost i umetnici, Belgrade, 1943.*

LJUBINKOVIĆ, R. *"The Silver Icon Casings in St. Kliment's Church at Ohrid,"* Yugoslavia (Macedonia issue), *Belgrade, 1952, pp. 77-80.*

ĆOROVIĆ-LJUBINKOVIĆ, M. *The Icons of Ohrid, Belgrade, 1953.*

LJUBINKOVIĆ, R. *"Stvaranje zografa Radula,"* Naše Starine, I, *Sarajevo, 1953, pp. 123-31.*

RADOJČIĆ, S. *"Hilendarske ikone svetog Save i svetog Simeona Stefana Nemanje,"* Glasnik Srpske pravoslavne crkve, XXXIV²⁻³, *Belgrade, 1953, pp. 30-31.*

MILJKOVIK-PEPEK, P. *"Avtorite na nekolku ohridski ikoni od XIII-XIV veka, Eutihije ili Mihajlo?"* Glasnik, izd. Muzejsko-konzervatorskoto društvo na NR Makedonija, I, *Skopje, 1954, pp. 23-50.*

MILJKOVIK-PEPEK, P. *"Značajot na natpiste od ikonata-Bogorodica Pelagonitisa od manastirot Zrze za

delanosta na Makarije Zograf,"* Glasnik izd. Muzejsko, konservatorskoto društvo na NR Makedonija, I, *Skopje, 1954-55, pp. 143-49.*

ĆOROVIĆ-LJUBINKOVIĆ, M. *Pećko-Dečanska ikononisna škola od XIV do XIX veka, Belgrade, 1955.*

RADOJČIĆ, S. *Majstori starog srpskog slikarstva, Belgrade, 1955.*

RADOJČIĆ, S. *"Umetnički spomenici manastira Hilandara,"* Zbornik radova Srpske Akademije Nauka, XLIV, *Belgrade, 1955, pp. 163-94.*

BLAŽIĆ, Z. *Konzervacija ohridskih ikona i nove konstatacije, Skopje, 1957 (Kulturno-istorisko nasledstvo vo NR Makedonija, III).*

TOMIĆ, G. *Bokokotorska ikonopisna škola XVII-XIX veka, Belgrade, 1957.*

BALABANOV, K. *"Novootkriveni ikoni od XIII, XIV i XV vek,"* Razgledi: Umetnost, Kultura, Opštesveeni prašanja, serija treta, I, *1958-59.*

MACAN, J. *"Ohridskite ikoni,"* Kulturno-istorisko nasledstvo vo NR Makedonija, V, *Skopje, 1959, pp. 61-84.*

BIHALJI-MERIN, O. *Byzantine Frescoes and Icons in Yugoslavia, New York, 1960.*

MIJOVIĆ, P. *Bokokotorska slikarska škola XVII-XIX vijeka, I, Titograd, 1960.*

DJURIĆ, V. *Ikone iz Jugoslavije, Belgrade, 1961.*

RADOJČIĆ, S. *Ikoni di Serbia e Macedonia, Belgrade, 1962.*

## ILLUMINATED MANUSCRIPTS

FOLNESICS, H. *Die illuminierten Handschriften in Dalmatien, Leipzig, 1917 (Beschreibendes Verzeichnis der illuminierten Handschriften in Österreich, VI).*

MOLE, V. *"Minijature jednog srpskog rukopisa iz god. 1649 sa Šestodnevom bgr. eksarha Joana i Topografijom Kozme Indikoplova,"* Spomenik Srpske Kraljevske Akademije, XLIV², *Belgrade, 1922.*

KOS, M. *Srednjeveški rokopisi v Sloveniji; s sodelovanjem Fr. Steleta, Ljubljana, 1931.*

KARAMAN, LJ. *"Umjetnička oprema knjige u Dalmaciji,"* Hrvatska Revija, VI⁷, *Zagreb, 1933, pp. 408-19.*

KNIEWALD, D. *"Misal čazmanskog prepošta Jurja de Topusko i zagrebačkog biskupa Šimuna Erdödy,"* Rad Jugoslovenske Akademije Znanosti i Umjetnosti, *Zagreb, 1940, pp. 45-84.*

KNIEWALD, D. *"Zagrebački liturgijski kodeksi XI-XV stoljeća,"* Croatia Sacra: Arhiv za crkvenu povijest Hrvata, *Zagreb, 1940.*

MIRKOVIĆ, L. *Miroslavljevo evandjelje, Belgrade, 1950 (Srpska Akademija Nauka, Posebna izdanja, CLVI).*

RADOJČIĆ, S. *Stare srpske minijature, Belgrade, 1950.*

*Exposition des manuscrits et des livres du XIe au XVIIIe siècle, University Library, Zagreb (catalogue), CCLXVIII Zagreb, 1954.*

JANC, Z. *Islamski rukopisi iz jugoslovenskih kolekcija: Muzej primenjenih umetnosti, Belgrade, 1956.*

RADOJČIĆ, S. *"Hilandarske freske: Srpske minijature XIII veka,"* Glas Srpske Akademije Nauka, CCXXXIV, Odeljenje društvenih nauka, VII, *Belgrade, 1959.*

MOŠIN, V. *"Rukopisi na Narodniot Muzej vo Ohrid, Posebno izdanie,"* Zbornik na trudovi, Narodni Muzej Ohrid, VII, *Ohrid, 1961, pp. 163-243.*

RADOJČIĆ, S. *Zakon o rudnicima Despota Stefana Lazarevića, Belgrade, 1962 (izdanje Srpske Akademija Nauka).*

ROTH, C. (intro.). *The Sarajevo Haggadah*, New York, 1963.

*Minijatura u Jugoslaviji (exhibition catalogue)*, Mu-seum of Arts and Crafts, Zagreb, 1964.

DJURIĆ, J., and IVANIŠEVIĆ, R. "*Jevandjelje Divoša Tihoradića*," Zbornik radova Vizantološkog In-stituta, VII, Belgrade, 1964, pp. 153-60.

## THE ROMANESQUE

VASIĆ, M. *Arhitektura i skulptura u Dalmaciji od početka IX do početka XV veka*, Belgrade, 1922.

KARAMAN, LJ. "*Portal majstora Radovana u Trogiru*," Rad Jugoslovenske Akademije Znanosti i Umjet-nosti, CCLXII, Zagreb, 1938, pp. 1-76.

PETKOVIĆ, V., and BOŠKOVIĆ, DJ. *Dečani*, 2 vols. and 1 vol. of plates, Belgrade, 1941 (*Academia Regalis Serbica. Monumenta Jugoslaviae Artis Veteris. Serie prima. Monumenta Serbica Artis Mediaevalis. Liber II*).

KARAMAN, LJ. "*O srednjovjekovnoj umjetnosti Istre*," Historijski Zbornik, II, Zagreb, 1949, pp. 115-30.

FISKOVIĆ, C. "*Romaničke kuće u Splitu i u Trogiru*," Starohrvatska Prosvjeta, ser. III, sv. II, Zagreb, 1952, pp. 129-78, 58 plates, 2 maps.

KARAMAN, LJ. *Pregled umjetnosti u Dalmaciji*, Za-greb, 1952.

DEROKO, A. *Monumentalna i dekorativna arhitektura u srednjevekovnoj Srbiji*, Belgrade, 1953.

FISKOVIĆ, C. "*Fragments du style roman à Dubrovnik*," Archaeologia Jugoslavica, I, Belgrade, 1954, pp. 117-37.

GAMULIN, G. "*Bogorodica s djetetom i donatorom iz Zadra*," Peristil, II, Zagreb, 1957, pp. 143-51.

MAKSIMOVIĆ, J. "*Studija o studeničkoj plastici: I,* Ikonografija," Zbornik radova Vizantološkog in-stituta Srpske Akademiia Nauka i Umetnosti, V, Belgrade, 1958, pp. 137-48; "*II, Stil*," VI, Belgrade, 1960, pp. 95-109.

KARAMAN, LJ. *Andrija Buvina, vratnice splitske kate-drale: Drveni kor u splitskoj katedrali*, Zagreb, 1960.

PETRICIOLI, I. *Pojava romaničke skulpture u Dalma-ciji*, Zagreb, 1960.

STELĖ, F. *Umetnost v primorju*, Ljubljana, 1960.

DJURIĆ, V. *Icônes de Yougoslavie (exhibition catalogue)*, XII Congrès international des études byzantines, Belgrade and Ohrid, 1961.

MAKSIMOVIĆ, J. *Kotorski ciborij iz XIV veka i ka-mena plastika susednih oblasti*, Belgrade, 1961.

HORVAT, A. "*Rudine u požeškoj kotlini — ključni pro-blem romanike u Slavoniji*," Peristil, V, Zagreb, 1962, pp. 11-28.

FUČIĆ, B. *Istarske freske*, Zagreb, 1963.

KORAĆ, V. "*Crkva Sv. Marije na Mljetu*," Zbornik Filozofskog fakulteta u Beogradu, VII[1], Belgrade, 1963, pp. 213-27, 8 pages of plates.

FISKOVIĆ, C. *Dalmatinske freske*, Zagreb, 1965.

KORAĆ, V. *Graditeljska škola Pomorja*, Belgrade, 1965.

## THE GOTHIC

VASIĆ, M. *Arhitektura i skulptura u Dalmaciji, od početka IX do početka XV veka*, Belgrade, 1922.

IVEKOVIĆ, C. M. *Bau- und Kunstdenkmale in Dal-matien*, 6 fasc., Vienna, 1927.

STELĖ, F. *Monumenta artis slovenicae*, I, Ljubljana, 1935.

STELĖ, F. *Cerkveno slikarstvo med Slovenci, I: Sred-nji vek*, Celje, 1937.

STELĖ, F. "*Gotske dvoranske cerkve v Sloveniji*," Zbornik za Umetnosto Zgodovino, XV, Ljubljana, 1938, pp. 1-43.

FISKOVIĆ, C. "*Drvena skulptura gotičkog stila u Spli-tu*," Vjesnik za arheologiju i historiju dalmatinsku, LI, Split, 1940, pp. 208-23.

SZABO, GJ. *Kroz Hrvatsko Zagorje*, Zagreb, 1940.

FISKOVIĆ, C. *Drvena gotička skulptura u Trogiru*, Rad Jugoslavenske Akademije, 1942, pp. 97-133.

FISKOVIĆ, C. *Naši graditelji i kipari XV i XVI sto-ljeća u Dubrovniku*, Zagreb, 1947.

KARAMAN, LJ. "*O umjetnosti srednjeg vijeka u Hrvat-skoj i Slavoniji*," Historijski Zbornik, I, Zagreb, 1948, pp. 103-27.

KARAMAN, LJ. "*O srednjovjekovnoj umjetnosti Istre*," Historijski Zbornik, II, Zagreb, 1949, pp. 115-30.

KARAMAN, LJ. *Pregled umjetnosti u Dalmaciji*, Za-greb, 1952.

HORVAT, A. "*Skulptura Parlerovog kruga u zagrebač-koj katedrali*," Zbornik za Umetnostno Zgodovino, n. s. V-VI, Ljubljana, 1959, pp. 245-67.

KOMELJ, I. "*Gotska arhitektura v Sloveniji*," Kronika, časopis za Slovensko Krajevno, VII, Ljubljana, 1959, pp. 138-48; VIII, 1960, pp. 111-22.

DEROKO, A. *Monumentalna i dekorativna arhitektura u srednjovekovnoj Srbiji*, Belgrade, 1962.

"*Gotika u Jugoslaviji*," Enciklopedija Likovnih Umjet-nosti, II, Zagreb, 1962, pp. 418-26.

CEVC, E. *Srednjeveška plastika na Slovenskem*, Lju-bljana, 1963.

FUČIĆ, B. *Istarske freske*, Zagreb, 1963.

DJURIĆ, V. *Dubrovačka slikarska škola*, Belgrade, 1964.

STELĖ, F. "*Eine slowenische Wariante der 'Sonder-gotik*,'" Jahrbuch des Kunsthistorischen Institutes der Universität Graz, I, Graz, 1963, pp. 1-18, 15 plates.

KORAĆ, V. *Graditeljska škola Pomorja*, Belgrade, 1965.

## MEDIEVAL TOMBSTONES (STEĆCI)

TRUHELKA, Ć. "Starobosanski mramorovi," Glasnik Zemaljskog Muzeja u Sarajevu, III, Sarajevo, 1891.

BENAC, A. Radimlja, Zemaljski Muzej, Sarajevo, 1950 (Srednjevjekovni nadgrobni spomenici Bosne i Hercegovine, sv. I).

BENAC, A. Olovo, Savezni institut za zaštitu spomenika kulture, Belgrade, 1951 (Srednjevjekovni nadgrobni spomenici Bosne i Hercegovine, sv. II).

SERGEJEVSKI, D. Ludmer, Zemaljski Muzej, Sarajevo, 1952 (Srednjevjekovni nadgrobni spomenici Bosne i Hercegovine, sv. IV).

VIDOVIĆ, D. "Bibliografski podaci o stećcima," Zbornik zaštite spomenika kulture, III, Belgrade, 1952, pp. 149-80.

BENAC, A. Široki Brijeg, Zemaljski Muzej, Sarajevo, 1953 (Srednjevjekovni nadgrobni spomenici Bosne i Hercegovine, sv. II).

BEŠLAGIĆ, S. Kupres, Sarajevo, 1954 (Srednjevjekovni nadgrobni spomenici Bosne i Hercegovine, sv. V).

KATIĆ, L. "Stećci u Imotskoj Krajini," Starohrvatska Prosvjeta, III, Zagreb, 1954, pp. 131-69.

VEGO, M. Ljubuški, Zamaljski Muzej, Sarajevo, 1954 (Srednjevjekovni nadgrobni spomenici Bosne i Hercegovine, sv. VI).

SOLOVJEV, A. Simbolika srednjevjekovnih grobnih spomenika u BiH, Godišnjak Istoriskog društva Bosne i Hercegovne, Sarajevo, 1956.

BEŠLAGIĆ, Š. Stećci na Blidinju, Zagreb, 1959.

RADOJČIĆ, S. Reljefi bosanskih i hercegovačkih stećaka, Letopis Matice Srpske, knj. 387, sv. 1, Novi Sad, 1961, str. 1-15.

BEŠLAGIĆ, Š. Kalinovik, Sarajevo, 1962 (Srednjevjekovni nadgrobni spomenici Bosne i Hercegovine, sv. VII).

VEGO, M. Zbornik srednjevjekovnih natpisa BiH, Zemaljski Muzej, Sarajevo, I, 1962; II, 1964; III, 1965.

WENZEL, M. "Bosnian and Herzegovinian Tombstones: Who Made Them and Why," Südost-Forschungen, XXI, Munich, 1962, pp. 102-43.

BIHALJI-MERIN, O., and BENAC, A. Bogomil Sculpture, New York, 1965.

WENZEL, M. Ukrasni motivi na stećcima (Ornamental Motifs on Tombstones from Medieval Bosnia and Surrounding Regions), Sarajevo, 1965.

## ISLAMIC ARCHITECTURE AND DECORATIVE ART

ARSEVEN, C. Les arts décoratifs turcs, Istanbul, 1937.

SKARIĆ, V. Sarajevo, Sarajevo, 1937 (Izd. Opštine grada Sarajeva).

CRESWELL, K. A. C. Early Muslim Architecture, II, Oxford, 1940.

MARÇAIS, G. L'art de l'Islam, Paris, 1946.

BERK, N. La peinture turque, Ankara, 1950.

DEROKO, A. Srednjevekovni gradovi u Srbiji, Crnoj Gori i Makedoniji, Belgrade, 1950.

FILIPOVIĆ, N. "Pogled na osmanski feudalizam," Godišnjak Istoriskog društva Bosne i Hercegovine, IV, Sarajevo, 1952.

VOGT-GÖKNIL, U. Türkische Moscheen, Zurich, 1953.

ČELEBIJA, E. Putopis, 2 vols., Sarajevo, 1954-57.

EGLI, E. Sinan, der Baumeister osmanischer Glanzzeit, Erlenbach and Zurich, 1954.

TOMOVSKI, K. "Džamil vo Bitola," Zbornik Univerziteta Skopje, god. II, knjiga II, Skopje, 1956-57.

ŠABANOVIĆ, H. Bosanski pašaluk: postanak i upravna podjela, (Naučno društvo NR Bosne i Hercegovine. Djela, XIV. Odjeljenje istorijsko-filoloških nauka, X). Sarajevo, 1959.

ÜNSAL, B. Turkish Islamic Architecture in Seljuk and Ottoman Times, 1071-1923, London, 1959.

REDŽIĆ, H. "Ko je graditelj Gazi Husrevbegove džamije u Sarajevu — Qui est le constructeur de la Mosquée de Gasi Housrevbey à Sarajevo," Naučno društvo NR Bosne i Hercegovine. Radovi, XIII. Odjeljenje istorisko-filoloških nauka, V, Sarajevo, 1960, pp. 117-59.

KREŠEVLJAKOVIĆ, H. Esnafi i obrti u Bosni i Hercegovini, Sarajevo, 1961 (Naučno društvo NR Bosne i Hercegovine. Djela, XVII).

AYVERDI, E. Yougoslavya da türk abideleri ve vakiflari, Ankara, 1962.

ZDRAVKOVIĆ, I. Izbor gradje za proučavanje spomenika islamske arhitekture u Jugoslaviji, Belgrade, 1964.

## THE RENAISSANCE

STELÈ, F. Oris zgodovine umetnosti pri Slovencih, Ljubljana, 1924.

KARAMAN, Lj. Umjetnost u Dalmaciji, XV i XVI vijeka, Zagreb, 1933.

STELÈ, F. Monumenta artis Slovenicae, 2 vols., Ljubljana, 1935-38.

FISKOVIĆ, C. Naši graditelji i kipari XV-XVI stoljeća u Dubrovniku, Zagreb, 1947.

FISKOVIĆ, C. "Umjetnički obrt u XV i XVI stoljeću u Splitu," Zbornik u proslavu petstogodišnjice rodenja Marka Marulića 1450-1950, Zagreb, 1950, pp. 127-64.

FISKOVIĆ, C. "Dubrovački gotičko-renesansni stil," Republika, VII, Zagreb, 1951, pp. 52-62.

KARAMAN, Lj. Pregled umjetnosti u Dalmaciji, Zagreb, 1952.

TADIĆ, J. Gradja o slikarskoj školi u Dubrovniku XIII-XVI veka, 2 vols., Belgrade, 1952.

432

PRIJATELJ, K. *Ivan Duknović*, Zagreb, 1957.

PRIJATELJ, K. *"La pittura della scuola dalmata,"* Arte Veneta, XI, Venice, 1957, pp. 7-22.

MEDAKOVIĆ, D. *Grafika srpskih štampanih knjiga XV-XVII veka*, Belgrade, 1958.

FISKOVIĆ, C. *Zadarski sredovječni majstori*, Split, 1959 (*Bibl. suvrem. pisaca*, XIII).

STELÈ, F. *"Vloga reformacije v naši umetnostni zgodovini,"* Drugi Trubarjev zbornik, Ljubljana, 1959.

GAMULIN, G. *Stari majstori u Jugoslaviji*, 2 vols., Zagreb, 1961-64 (*Društvo historičara umjetnosti Hrvatske*, VI, X).

PRELOG, M. *"Dva nova 'putta' Jurja Dalmatinca i problem renesansne komponente u njegovoj skulpturi,"* Peristil, IV, Zagreb, 1961, pp. 46-60.

PRIJATELJ, K. *Juraj Čulinović*, Zagreb, 1962.

DJURIĆ, V. *Dubrovačka slikarska škola*, Belgrade, 1963.

FISKOVIĆ, C. *Juraj Dalmatinac*, Zagreb, 1963.

FUČIĆ, B. *Istarske freske*, Zagreb, 1963.

PRIJATELJ, K. *Studije o umjetninama u Dalmaciji*, I, Zagreb, 1963 (*Društvo historičara umjetnosti Hrvatske*, IX).

CEVC, E. *"Renesančna plastika na Slovenskem,"* Zbornik za Umetnostno Zgodovino, n.s. VII, Ljubljana, 1965, pp. 119-70.

CEVC, E. *Slovenska umetnost*, Ljubljana, 1966.

*"Prelog, M.,"* Enciklopedija Likovnih Umjetnosti, IV, Zagreb, 1966, pp. 18-19.

*"Renesansa,"* Enciklopedija Likovnih Umjetnosti, IV, Zagreb, 1966, pp. 77-82.

## THE BAROQUE

MAL, J. *Zgodovina umetnosti pri Slovencih, Hrvatih in Srbih*, Ljubljana, 1924 (Ljubljana, Narodna Galerija. Knjižnica, I).

STESKA, V. *"Ljubljanski baročni kiparji,"* Zbornik za Umetnostno Zgodovino, V, Ljubljana, 1925, pp. 1-24, 81-104.

IVEKOVIĆ, C. M. *Bau- und Kunstdenkmale in Dalmatien*, 6 vols., Vienna, 1927.

VURNIK, ST. *"K slikarstvu v Slovenskem na prehodu od XVII v XVIII stoletje (Skica stilnega razvoja),"* Zbornik za Umetnostno Zgodovino, VIII, Ljubljana, 1928, pp. 1-18.

KUS-NIKOLAJEV, M. *"Hrvatski seljački barok,"* Etnološka biblioteka VII, Zagreb, 1929.

SZABO, Gj. *Umjetnost u našim ladanjskim crkvama*, Zagreb, 1929.

STELÈ, F. *Monumenta artis slovenicae*, II, Ljubljana, 1938.

HORVAT, J. *Kultura Hrvata kroz 1000 godina*, Zagreb, 1939.

KAŠANIN, M. *200 Jahre serbischer Malkunst*, Belgrade, 1942.

STELÈ, F. *Slovenski slikarji*, Ljubljana, 1949.

KARAMAN, LJ. *Pregled umjetnosti u Dalmaciji*, Zagreb, 1952.

KOLARIĆ, M. *Srpska umetnost XVIII veka* (exhibition catalogue), National Museum, Belgrade, 1954.

STELÈ-MOŽINA, M. *"Ljubljanska frančiškanska podobarska delavnica,"* Zbornik za Umetnostno Zgodovino, n.s. III, Ljubljana, 1955, pp. 161-64.

HORVAT, A. *Spomenici arhitekture i likovnih umjetnosti u Medjumurju*, Zagreb, 1956.

PRIJATELJ, K. *Umjetnost XVII i XVIII stoleća u Dalmaciji*, Zagreb, 1956.

STELÈ, F., and STELÈ-MOŽINA, M. *L'art baroque en Slovénie* (exhibition catalogue), National Art Gallery, Ljubljana, 1957.

STELÈ-MOŽINA, M. *"Ljubljansko baročno kiparstvo v kamnu,"* Zbornik za Umetnostno Zgodovino, n.s. IV, Ljubljana, 1957, pp. 30-70.

*"Barok,"* Enciklopedija Likovnih Umjetnosti, I, Zagreb, 1959, pp. 249-72.

HORVAT-PINTARIĆ, V. *Francesco Robba*, Zagreb, 1961.

ŠUMI, N. *Ljubljanska baročna arhitektura*, Ljubljana, 1961.

VRIŠER, S. *Baročno kiparstvo na Slovenskem Štajerskem*, Maribor, 1963.

STELÈ, F. *Oris zgodovine umetnosti pri Slovencih*, 2nd ed., Ljubljana, 1966.

## THE NINETEENTH CENTURY

PETROVIĆ, V., and KAŠANIN, M. *Srpska umetnost u Vojvodini*, Novi Sad, 1927.

BABIĆ, LJ. *Umjetnost kod Hrvata u XIX stoljeću*, Zagreb, 1934.

STELÈ, F. *Monumenta artis Slovenicae*, II, Ljubljana, 1938.

KAŠANIN, M. *L'art yougoslave des origines à nos jours*, Belgrade, 1939.

KAŠANIN, M. *200 Jahre serbischer Malkunst*, Belgrade, 1942.

SIMIĆ-MILOVANOVIĆ, Z. *Srpska umetnost novijeg doba*, Belgrade, 1950.

CANKAR, I. *Klasicizam in romantik na Slovenskem* (exhibition catalogue), National Art Gallery, Ljubljana, 1954.

KOLARIĆ, M. *Rano gradjansko slikarstvo kod Srba*, Belgrade, 1957.

SIMIĆ-BULAT, A. *Vjekoslav Karas*, Zagreb, 1958.

MACAN, E. *Makedonskiot ikonopis vo XIX vek.*, Kulturno-istorisko nasledstvo VII vo NR Makedonija, Skopje, 1961.

*Slikarstvo XIX stoljeća u Hrvatskoj (exhibition catalogue), Galerija slika "Benko Horvat," Zagreb, 1961.*

DOBIDA, K. *Anton Ažbe in njegova šola, Ljubljana, 1962.*

MACAN, E. *Makedonski portret XIX i XX veka, catalogue, Skopje, 1962.*

KOLARIĆ, M. *Klasicizam kod Srba, 1700-1848, Belgrade, 1965 (National Museum, Belgrade. Pos. izd. I).*

## THE ARCHITECTURE OF THE TWENTIETH CENTURY

STRAJNIĆ, K. *Josip Plečnik, Zagreb, 1920.*

STELÈ, F. *Oris zgodovine umetnosti pri Slovencih, Ljubljana, 1924.*

SCHÖN, E. *Viktor Kovačić, Zagreb, 1927.*

ŠEGVIĆ, N. *Stvaralačke komponente arhitekture FNRJ, Urbanizam i arhitektura, Zagreb, 1950.*

*Katalog izložbe RPF Yougoslavie, Exposition internationale d'Architecture de l'Union Internationale des Architectes, Rabat, Maroc, 1951, SAJ, Ljubljana, 1951.*

ALBINI, A. *Uslovi razvitka nove arhitekture u NRH, Zagreb, 1953.*

ŠUMI, N. *Arhitektura secesijske dobe v Ljubljani, Ljubljana, 1954.*

GRABRIJAN, D. and NEIDHARDT, J. *Arhitektura Bosne i put u savremeno (preface by Le Corbusier), Ljubljana, 1957.*

*Katalog izložbe jugoslovenske arhitekture organizirane za I. kongres arhitekata Jugoslavije, Belgrade, 1958.*

KAPETANOVIĆ, E. *Arhitektura Bosne i Hercegovine nakon 1919, Enciklopedija Likovnih Umetnosti I, Zagreb, 1959.*

SMILJANIĆ, V. *Arhitektura Bosne i Hercegovine nakon 1919, Enciklopedija Likovnih Umjetnosti III, Zagreb, 1959.*

*Katalog Savremena jugoslavenska arhitektura, Savez arhitekata Jugoslavije i Komisija za kulturne veze sa inostranstvom, Belgrade, 1959.*

MUŠIČ, V. *Naša arhitektura na novim putevima, Tehnika, Belgrade, 1960.*

ŠIJANEC, F. *Sodobna slovenska likovna umetnost, Maribor, 1961.*

MOHOROVIČIĆ, A. *Razvoj arhitekture XX st. u Hrvatskoj, Enciklopedija Likovnih Umjetnosti, II, Zagreb, 1962.*

NESTOROVIĆ, B. *Arhitektura novog veka, Belgrade, 1964.*

TOMOVSKI, K. *Arhitektura XX st. u Makedoniji, Enciklopedija Likovnih Umjetnosti III, Zagreb, 1964.*

MUŠIČ, M. *Arhitektura XX st. u Sloveniji, Enciklopedija Likovnih Umjetnosti, IV, Zagreb, 1966.*

MINIĆ, O. *Arhitektura XX st. u Srbiji, Enciklopedija Likovnih Umjetnosti, IV, Zagreb, 1966.*

POZZETO, M. *Max Fabiani architetto, Gorizia, 1966.*

## THE TWENTIETH CENTURY

PETROVIĆ, N. *"Hronika: Prva jugoslovinska umetnička izložba u Beogradu," Delo, list za nauku, književnost i društveni život, III, Belgrade, 1904, pp. 120-28.*

VASIĆ. M. *"Jugoslovenska umetnička izložba," Srpski Knijiževni Glasnik, br. II, Belgrade, Sept. 1904.*

PIJADE, M. *Kroz jugoslovensku izložbu, Mali Žurnal, Belgrade, 1912.*

STOJANOVIĆ, S. *"VI Jugoslovenska izložba u Novom Sadu," Misao, god. IX, 178-80, Belgrade, 1927, pp. 227-31.*

BABIĆ, LJ. *Hrvatski slikari od impresionizma do danas, Zagreb, 1929.*

HAKMAN, ST. *"Izložba slika, skulpture i arhitekture umetničke grupe 'Oblik,'" Misao, Belgrade, 1929.*

MANOJLOVIĆ, T. *"Izložba umetničke grupe 'Oblik,'" Srpski Knijiževni Glasnik, br. I, Belgrade, Jan. 1930.*

POPOVIĆ, K., and RISTIĆ, M. *Nacrt za jednu fenomenologiju iracionalnog, Belgrade, 1931.*

KRLEŽA, M. *"Predgovor Podravskim motivima" Krste Hegedušića, Zagreb, 1933.*

BABIĆ, LJ. *Umjetnost kod Hrvata, Zagreb, 1943.*

GAMULIN, G. *Juraj Plančić, Zagreb, 1953.*

BABIĆ, LJ. *Između dva svijeta, Zagreb, 1955.*

GAMULIN, G. *Marino Tartaglia, Zagreb, 1955.*

VIŽINTIN, B. *Oton Gliha, Zagreb, 1958.*

BAŠIČEVIĆ, D. *Sava Šumanović, Zagreb, 1960.*

STEVANOVIĆ, M., KOLARIĆ, M., and MILOVANOVIĆ, M., *Kosta Miličević (exhibition catalogue), National Museum, Belgrade, 1960.*

NOVAK, V. *Josip Račić (exhibition catalogue), Modern Art Gallery, Zagreb, 1961.*

PROTIĆ, M. *"Milena Pavlović-Barili," Književnost, Belgrade, Nov. 1961.*

TRIFUNOVIĆ, L. *"Srpsko slikarstvo XX veka," Savremenik, VII, Belgrade, 1961, pp. 286-96.*

KRLEŽA, M. *Miljenko Stančić, Zagreb, 1964.*

ČELEBONOVIĆ, A. *Savremeno slikarstvo u Jugoslaviji, Belgrade, 1965.*

# INDEX

438

441

# PHOTOGRAPHIC CREDITS

The editor and publisher wish to thank the libraries, museums, and private collectors for permitting the reproduction in color or black-and-white of paintings, prints, and drawings in their collections. Photographs have been supplied by the owners or custodians of the works of art except for the following, whose courtesy is gratefully acknowledged:

*Colorplates*

A. Courvoisier, La Chaux-de-Fonds: 11, 15, 30, 32, 92, 96, 99, 133, 183, 187, 198, 243, 244; T. Dabac, Zagreb: 300, 315; M. Đorđević, Belgrade: 184, 186; N. Gattin, Zagreb: 262, 276, 285, 292, 296, 357, 358, 360, 371, 410; M. Grčević, Zagreb: 21; A. Held, Ecublens: 33, 200, 218, 318, 380, 426; D. Kažić, Belgrade: 52, 57, 62, 75, 80, 85, 111, 175, 226, 229, 345; S. Krstanović, Sarajevo: 40, 343; M. Pfajfer, Ljubljana: 161, 162; Scala, Florence: 92, 142; D. Tasić, Belgrade: 180, 196; Institute for the Preservation of Ancient Monuments (Zavod za spomeniško varstvo), Celje: 4.

*Black-and-white photographs*

B. Balić, Zagreb: 50, 455; K. Bilbilovski, Skopje: 328, 414; T. Dabac, Zagreb: 2, 9, 17, 25, 26, 35, 37, 43, 46, 56, 95, 100, 101, 102, 104, 113, 122, 124-125-126-127, 134-135-136-137, 151, 153-154-155-156-157, 164, 165, 170, 173, 174, 189, 201, 205, 210-211-212-213, 215, 232, 237, 260, 263, 269, 270, 275, 279, 280, 281-282-283, 288, 290, 291, 297-298-299, 301-302-303-304-305-306-307-308-309-310-311-312-313-314, 316, 326 350-351-352, 354, 355, 361, 375, 388, 390, 393, 399, 400, 402, 404, 406, 420, 426, 427, 431-432-433-434-435, 448, 454; B. Debeljković, Belgrade: 36, 64, 65, 67; B. Drnkov, Skopje: 93, 323, 417; M. Đorđević, Belgrade: 182, 185, 389; N. Gattin, Zagreb: 120, 258, 259, 264, 266, 267, 271, 348, 349, 353, 359, 369, 370, 372, 373; M. Grčević, Zagreb: 1, 5, 6, 13, 14, 38, 73, 74, 76-77-78-79, 81, 86, 88, 109, 112, 114, 121, 145, 146, 147, 214, 217, 222-223-224-225, 227, 228, 268, 272, 284, 293, 327, 328, 365, 368, 378, 379, 383, 384, 418, 421; Jugoturist, Belgrade: 386; J. Kališnik, Ljubljana: 422, 424; M. Karamehmedović, Sarajevo: 317, 325, 338, 341; A. Karolyi, Zagreb: 444; D. Kažić, Belgrade: 3, 7, 8, 10, 16, 20, 49, 51, 53-54-55, 59-60-61, 63, 66, 68-69-70-71-72, 82, 83, 89-90-91, 98, 103, 105, 107, 116-117-118-119, 128, 129, 131, 132, 140, 143, 144, 150, 152, 190-191-192-193-194-195, 203, 221, 233, 238, 256, 295, 321, 324, 329, 331, 335-336-337, 39, 340, 342, 344, 346, 382, 385, 387, 392, 394, 401, 408, 425, 438, 451; Kompas, Ljubljana: 257; Institute for the Preservation of Historical Monuments (Konzervatorski zavod), Rijeka: 380; S. Krstanović, Sarajevo: 42, 319, 320, 322, 330, 332, 415; Z. Mikas, Zagreb: 439; Modern Art Gallery, Ljubljana: 452, 453; Z. Movrin, Zagreb: 432; I. Munitić, Split: 261; Museum of Modern Art, Belgrade: 363, 428, 429, 442, 456, 457, 458, 459; National Art Gallery, Ljubljana: 367, 374, 377, 391, 395, 396, 403, 405, 407, 409, 430; National Museum, Belgrade: 97; National Museum, Ljubljana: 78; H. Nastasić, Belgrade: 413, 446, 449; T. Obradović, Belgrade: 413; Photo Orel, Pula: 19; M. Pešić, Titograd: 416; J. Polzović, Novi Sad: 123; G. Popov, Skopje: 202; M. Pfajfer, Ljubljana: 159, 160, 163; Ć. Rajić, Mostar: 334; K. Rozman, Ljubljana: 294; D. Stanimirović, Paris: 48, 273, 274, 333, 347, 356; M. Szabo, Zagreb: 106, 115, 362, 436; B. Štajer, Ljubljana: 47, 108, 110, 277, 289; K. Tadić, Zagreb: 240-241-242, 246, 248, 249, 252, 253, 254; D. Tasić, Belgrade: 31, 34, 158, 166-167-168-169, 171, 172, 167, 177, 178, 181, 188, 197, 199, 206, 208, 209, 216, 219, 220, 286; N. Vranić, Zagreb: 278, 287, 364, 376; F. Vodopivec, Zagreb: 445, 447; National Museum, Sarajevo: 18, 58, 84, 87, 130, 138, 139; V. Zuber, Zagreb: 22.

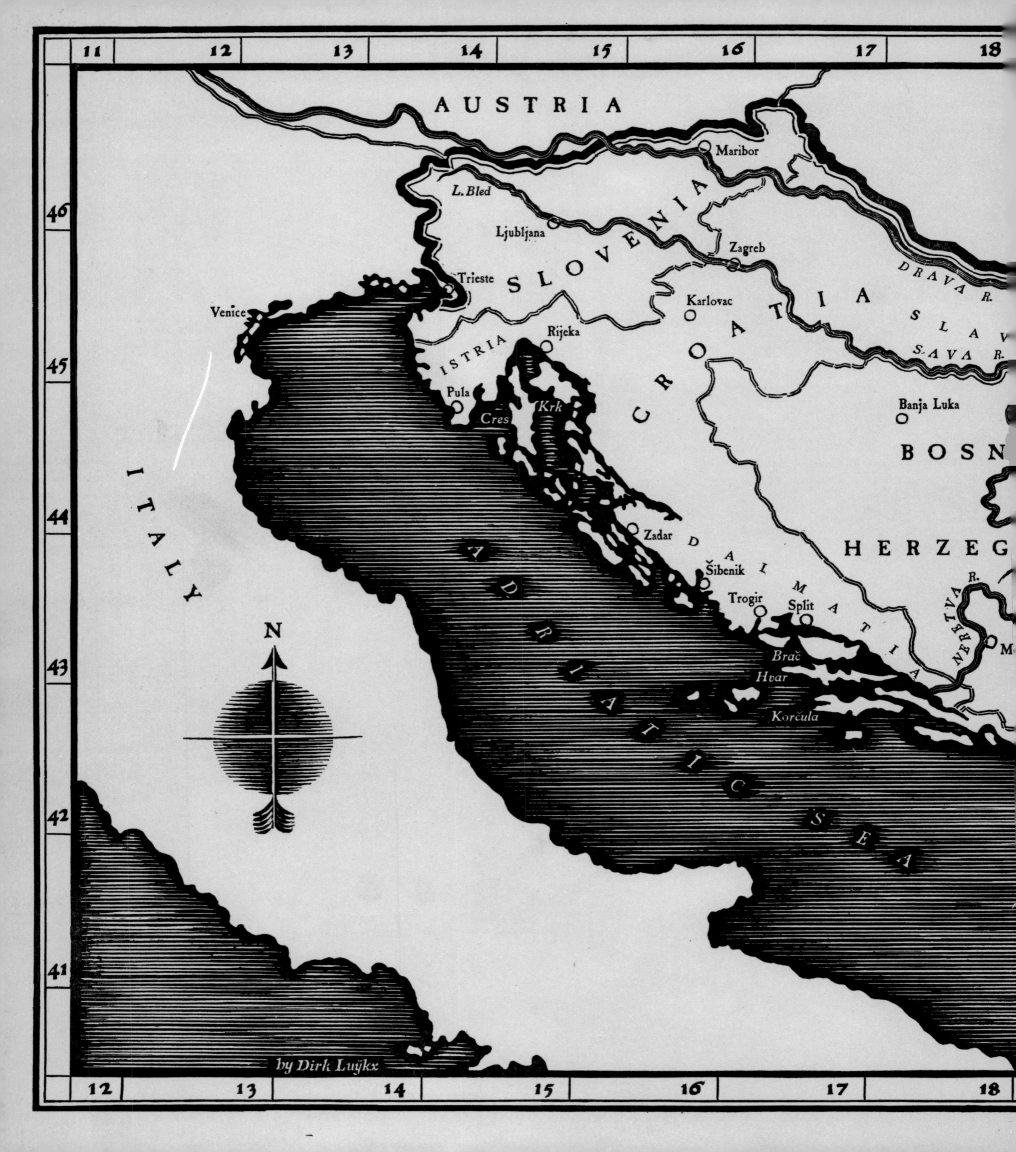